Past Meets Present
Archaeologists Partnering with Museum Curators, Teachers, and Community Groups

Edited by

John H. Jameson, Jr.
National Park Service
Tallahassee, Florida
USA

and

Sherene Baugher
Cornell University
Ithaca, New York
USA

 Springer

John H. Jameson, Jr.
Southeast Archaeological Center
National Park Service
2035 East Paul Dirac Drive
Tallahassee, FL 32310
USA
john_jameson@nps.gov

Sherene Baugher
Archaeology Program
Cornell University
261 McGraw Hall
Ithaca, NY 14853
USA
sbb8@cornell.edu

ISBN-13: 978-0-387-76980-6 eISBN-13: 978-0-387-48216-3

Library of Congress Control Number: 2008923062

9 8 7 6 5 4 3 2 1

springer.com

Contents

Past Meets Present

Archaeologists Partnering with
Museum Curators, Teachers,
and Community Groups

Contributors

Patricia Allen, Archaeological Services/Services d'archéologie, Parks Canada, Fredericton, New Brunswick, Canada

Madeline Augustine, Metepenagiag Heritage Park, Red Bank, New Brunswick, Canada

Whitney Battle-Baptiste, Africana Studies & Research Center, Cornell University, Ithaca, New York, USA

Sherene Baugher, Archaeology Program, Cornell University, Ithaca, New York, USA

Dorsey Bodeman, Historic St. Mary's City Commission, St. Mary's City, Maryland, USA

George Brauer, Baltimore County Center for Archaeology, Oregon Ridge Nature Center, Cockeysville, Maryland, USA

Lisa C. Breglia, Anthropology Department, Wheaton College, Norton, Massachusetts, USA

Julia Clark, Port Arthur Historic Site Management Authority, Port Arthur, Tasmania, Australia

Pamela J. Cressey, Alexandria Archaeology, Alexandria, Virginia, USA

Lu Ann De Cunzo, Department of Anthropology, University of Delaware, Newark, Delaware, USA

Dena Doroszenko, Ontario Heritage Trust, Heritage Programs and Operations Branch, Toronto, Ontario, Canada

Carol J. Ellick, SRI Foundation, Rio Rancho, New Mexico, USA

Lance M. Foster, Helena, MT, USA

Jonathan Fowler, Anthropology Department, Saint Mary's University, Halifax, Nova Scotia, Canada

Bruce Fry, Fortress of Louisbourg National Historic Site of Canada, Louisbourg, Nova Scotia, Canada

Pedro Paulo A. Funari, Department of History and Center for Strategic Studies (NEE/UNICAMP), Campinas State University (UNICAMP), Campinas, Brazil

Brooke Hansen, Department of Anthropology, Ithaca College, Ithaca, New York, USA

Denise Hansen, Parks Canada—Atlantic Service Centre, Historic Properties, Halifax, Nova Scotia, Canada

Silas D. Hurry, Historic St. Mary's City Commission, St. Mary's City, Maryland, USA

Greg Jackman, Port Arthur Historic Site Management Authority, Port Arthur, Tasmania, Australia

John H. Jameson Jr., Southeast Archeological Center, National Park Service, U.S. Department of the Interior Tallahassee, Florida, USA

Patrice L. Jeppson, Historical Archaeologist and Independent Scholar, Philadelphia, PA, USA

Joseph Last, Archaeological Services, Ontario Service Centre, Parks Canada, Cornwall, Ontario, Canada

Ann-Eliza H. Lewis, Massachusetts Historical Commission, Boston, Massachusetts, USA

Dorothy Lippert, Repatriation Office, National Museum of Natural History, Smithsonian Institution, Washington, DC, USA

Henry M. Miller, Historic St. Mary's City Commission, St. Mary's City, Maryland, USA

Stephen F. Mills, Aardvark Archaeology Ltd, St. John's, Newfoundland, Canada

Harold Mytum, Department of Archaeology, University of York, York, UK

Nanci Vieira de Oliveira, Human Anthropology Laboratory (LAH), Rio de Janeiro State University (UERJ), Rio de Janeiro, Brazil

Janet L. Pape, Office of Cultural Resource Studies, California Department of Transportation, Oakland, California, USA

Elisa Phelps, Collections/Library Division, Colorado Historical Society, Denver, Colorado, USA

Peter E. Pope, Department of Anthropology & Archaeology, Memorial University of Newfoundland, St. John's, Newfoundland, Canada

Jack Rossen, Department of Anthropology, Ithaca College, Ithaca, New York, USA

Jody Steele, Historic Heritage Section, Parks & Wildlife Service, Hobart, Tasmania, Australia

Gaynell Stone, Suffolk County Archaeological Association, Professor, Suffolk County Community College, Wading River, New York, USA

Elizabete Tamanini, Center for Strategic Studies (NEE/UNICAMP), Campinas State University (UNICAMP), Campinas, Brazil

Dirk Van Tuerenhaut, Houston Museum of Natural Science, Houston Texas, USA

Richard Tuffin, Port Arthur Historic Site Management Authority, Port Arthur, Tasmania, Australia

Christopher Turnbull, Archaeological Services, Heritage Branch, Parks Canada, Fredericton, New Brunswick, Canada

Nina M. Versaggi, Public Archaeology Facility, Binghamton University (SUNY), Binghamton, New York, USA

Natalie Vinton, NSW National Parks and Wildlife Service, Sydney South, New South Wales, Australia

Pamela Ward, Enkatasik Wetepecksultik, Metepenagiag Heritage Park Incorporated, Red Bank, New Brunswick, Canada

Patricia (Pam) Wheat-Stranahan, Texas Archaeological Society, Fulton, Texas, USA

Part 1
Historic Sites and Museums

Public Interpretation, Outreach, and Partnering: An Introduction

John H. Jameson, Jr. and Sherene Baugher

If we open up a quarrel between the past and the present, we shall find that we have lost the future.

—Winston Churchill

Just as a tree without roots is dead, a people without history or culture also becomes a dead people.

—Malcolm X, African American activist

In our greed and self-absorption, we have pushed our old ones to a forgotten past and our young ones to an uncertain future. We must again fuse past to future. Through an early understanding of the human continuum and condition, youth learns reverence, respect and responsibility, to wonder, to be sensitive, to feel important, and to hope.

—Navajo Musician, Silent Witness Videotape, National Park Foundation

Background

In the first decade of the new millennium, many archaeologists have come to realize that they cannot afford to be detached from mechanisms and programs that convey archaeological information to the public. In conjunction with efforts to instill a greater awareness and appreciation of archaeology, both in and out of formal classroom settings, many archaeologists and cultural resource specialists are devising new approaches to public interpretation in a variety of settings. The venues for these activities can include visiting an excavation, a reconstructed site, stabilized ruins, museum exhibits, or a site treated as an open-air museum. Archaeologists bring archaeology to public schools through traveling exhibits, lectures, teacher and student workshops, and hands-on activities with artifacts. In the face of an increasing public interest and demand for information, archaeologists are collaborating with historians, educators, interpreters, museum curators, exhibit designers, landscape architects, and other cultural resource specialists to devise the best strategies for translating an explosion of archaeological information for the

public. In turn, some communities are partnering with archaeologists to become active players in the excavation, interpretation, and preservation of their heritage.

The last decade has witnessed numerous applications of public interpretation and outreach models and an increased interest in establishing partnerships between professional practitioners in public interpretation and educational institutions such as museums and schools. The lessons to be derived from these modestly funded projects are that *attitudes and initiatives of people* make the difference. These developments have occurred in the context of a realization that community-based partnerships are the most effective mechanisms for long-term success.

In the context of our international discussions and case studies on public interpretation and outreach, with an expected diversity of readers, some clarifications in terminology are appropriate. What we mean by "community," "target audience," "values-based management," and "public stewardship," for example, needs to be defined within the framework of our discussions.

Emphasis on Partnerships and Community Involvement

In the 1980s, having a commitment to public outreach was a major step forward beyond merely presenting and sharing the results of research among colleagues. However, these early archaeological outreach efforts often involved archaeologists working in isolation from community groups. It was the archaeologists who decided, without substantive input from community members, what type of archaeological outreach and what messages the public needed and wanted. The public lectures, tours of sites, exhibits, films, brochures, pamphlets, and articles were based on what the archaeologist wanted to say and the information that the professional archaeologist felt was most important. Questions such as, who is the target audience, and what questions do they want answered were often not on the archaeological radar screen. However, slowly, archaeologists started to move out of the isolation model and partner with non archaeologists to develop more meaningful public programing. Archaeologists study communities as part of their research agenda, but now community members are moving from the category of "research subject" into "partner in outreach."

Who are these new community partners? "Community" has become a buzzword that is often used without a clear definition. Is it simply a local community or a community in a clearly defined geographic area? Is it a descendant community? Or is it something larger and more complex? Webster's Dictionary (1984: 288) provides six definitions of "community," but the three definitions that are applicable to our use of the word "community" in this book are as follows:

1. A group of people residing in the same locality and under the same government;
2. A group or class having common interests, as in academic community;
3. Likeness or identity.

We are using the word "community" in the broader definition rather than limiting the term to the first definition. All the authors in this volume have partnered with a community group, but the groups differ. The communities include educational, professional, academic, governmental, descendant, and local. These communities are not discrete and they can and do overlap. For example, members of a descendant community may also be part of the educational and the professional communities. When we discuss the educational community we include teachers, principals, superintendents, school boards, parents, and children to develop innovative programs in archaeology. In the governmental community, officials can and do address and represent the concerns of members of diverse communities. The professional community can include people in allied disciplines such as history and preservation, or design professionals such as graphic designers, architects, and landscape architects, or people in very diverse professions from medicine to engineering. Each author notes the specific community with which he or she is partnering and the nature of the partnership. The members of the diverse communities discussed in this book have one thing in common: they have partnered with archaeologists in creating meaningful outreach projects.

The authors discuss the lessons learned from interaction with, and involvement of, the community. Results and measures of success are expressed qualitatively rather than quantitatively. What type of feedback did they receive from the community? How did working with, rather than for, a community change their project? How did including "other voices" change the project planning and/or management? The case studies demonstrate that there is no single "right way" to carry out successful public outreach.

Some theoreticians believe that only one approach should be adhered to in order to accomplish successful community partnerships. For example, some sociologists believe that community work must be "participatory action research" (PAR). This approach requires that the community members be equal partners in all phases of the project. The reality is that many archaeological outreach projects have evolved with community involvement changing over time. One must ask: Why would a community initially become involved with an archaeologist who they do not know? Why would community members trust this person? Why would community members invest their time to help in an archaeological project? The various case studies in this book demonstrate that trust, friendships, and partnerships evolve over time. Moreover, mistakes are made, and archaeologists must learn from these mistakes. Community partnerships do not just happen because that is the way the theoretical model is supposed to work. The case studies clarify that true partnerships involve years of work with both partners learning

from each other. And most importantly, the case studies in this book demonstrate that there are many diverse ways for archaeologists to be involved in public outreach and also different levels of community involvement. The goal of our book is to give the readers many different successful models for community engagement, but in the end, the readers must decide for themselves what level or type of community partnership is appropriate for their project.

The international scope of this book has resulted in uses of terminology from the culturally diverse authors. "Target audience" is a term often used synonymously (and in some contexts, interchangeably) with "public," "select public," "publics," "community," "audience," "constituency," and "visitor(s)." It usually refers to a particular group of listeners, readers, or other defined audience types. The term is derived from market analysis and demographics terminology where a "target audience" is a profiled group for which an advertising campaign, promotion, or sales pitch is specifically designed. It is generally not used in the context of participatory education and public interpretation where members of a community actively participate in developing, carrying out, delivering, or otherwise producing the program or elements of the program or interpretive product. The U.S. National Park Service uses the term when referring to specifically defined audiences according to categories such as background, ethnicity, age, gender, education, and media delivery technique. For example, the 2006 Web site for Yellowstone National Park was designed by park staff to appeal to a variety of "target audiences" of Internet users encompassing local, regional, national, and global perspectives on resource management, conservation, education, recreation, and economics. They also targeted younger audiences with "Kids' Stuff" Web pages designed with simultaneous entertainment and educational goals tied to perceived cognitive capabilities and needs of pre teens and younger audiences. This is similar to the concept of layering in exhibit theory where varying aspects of presentation and modes of delivery are designed to appeal to a variety of "target" audiences according to age, educational level, ethnicity, impaired (handicapped) access, and other factors. In most personal services presentations, such as interpreter talks and demonstrations, as well as nonpersonal services, such as museum and wayside (outdoor) exhibits, members of the intended (target) audience have not directly and actively participated in molding the interpretive presentation/ product.

When we discuss "partnering" we mean participation, dialogue, and exchange of ideas. The traditional academic or institutional hierarchy is gone. In partnerships colleagues work together and respect each other. Each side has something to bring to the table. In some of our case studies, the project began without community input, but as the project evolved, the insights, commentary, and suggestions from community members helped it to change over time. Some of our case studies were partnerships from the start. However, the one thing that all the case studies share is the lessons learned from those partnerships.

Values-Based Heritage Management and Public Stewardship

In many recent discussions on public interpretation and education standards, the term "heritage" is used synonymously with "cultural resources" and the old acronym "CRM" has become "cultural heritage management" or "CHM." This is especially the case in international forums where heritage is an emotionally charged term that connotes cultural inheritance from the past, which is the evidence of human activity from Native or First Nation peoples. "Cultural heritage" commonly refers to both Native and non-Native places and objects, and associated values, traditions, knowledge, and cultures. "Heritage" in the broader sense includes natural resources and the environment: it is a particular version or interpretation of the past that belongs to a person or group. Concepts of heritage play important roles in shaping group or community identities and political ideologies. Heritage attracts the attention of visitors to a location or site by providing a sense of place, a sense of purpose, and a sense of uniqueness for the community or group. Heritage also provides education about the results of research. Heritage offers distinctive experiences, fascinations, and forms of entertainment that are out of the ordinary.

"Values" relate to tangibles and intangibles that define what is important to people. In all societies a sense of well being is associated with the need to connect with and appreciate heritage values. An understanding of how and why the past affects both the present and the future contributes to people's sense of well being. In heritage management, we articulate "values" as attributes given to sites, objects, and resources, and associated intellectual and emotional connections that make them important and define their significance for a person, group, or community. Site managers should strive to identify and take these values into account in planning, physical treatments, and public interpretation efforts. In heritage tourism, we harness people's fascination and sense of connection to the past and turn it into a commodity. Those of us whose primary goals and interests are conservation should be determined that our values and standards in this scenario are not compromised or diminished.

It is important for those of us who manage, study, and present the past to be aware of how the past is understood within the context of socioeconomic and political agendas and how that influences what is taught, and how it is valued, protected, authenticated, and used. We must understand the philosophical, political, and economic forces that affect how sites and parks are managed. We know that archaeological resources, as well as the built environment, are being affected. Dwindling budgets and reductions in personnel are exacerbating the problem. Political currents are threatening to weaken long-standing principles, standards, and commitments to public stewardship. Heritage tourism pressures have become important elements of interpretive messages at parks, historic sites, and museums.

The Challenges of Heritage Tourism

One of the most serious threats to effective site management and public interpretation, and consequently for outreach and educational programs, is the juggernaut of heritage tourism. By definition, heritage tourism is collaboration between conservationists and commercial promoters. It is often an uneasy association because the motives of these respective groups are not always compatible. While there is general recognition that heritage tourism can work to promote preservation of communities' historic and cultural resources, and also educate tourists and local residents about the resources, the resulting effects are not always viewed as beneficial, especially from those of us on the conservationist side of the fence. Nevertheless, because heritage tourism is a growth industry in almost every part of the world, the issues it conjures up, good and bad, must be addressed.

Globalization is changing our world in ways that we are just beginning to understand. Heritage tourism, with its ties to the currents of rapidly evolving global economies, is causing increasing needs and demands for crosscultural and international communication and interdisciplinary training. Emphasis is on transferable skills such as the application of interdisciplinary approaches, writing for both academic and nonacademic audiences, oral presentation, and experience with multimedia packages.

Public interpretation and outreach, by delivering conservation, education, and stewardship messages, are among the most important activities that occur at a cultural or historic site. In the U.S. National Park Service, interpretation is seen as instrumental in carrying out the agency mission of preserving America's cultural and natural heritage in that it instills a sense of public appreciation and resource stewardship. Interpretation is therefore a key component of the conservation side of the conservation/tourism partnership.

Purpose of this Volume

It is clear that there is a need for a volume that addresses these latest trends and provides case studies of successful partnerships. Moreover, although professional archaeological organizations have been more actively promoting outreach to the public, only short editorial or commentary articles on public archaeology have been published, usually in "gray literature" such as newsletters. Despite the fact that sessions on outreach work have been presented at professional conferences, they are rarely published. Exceptions include the *Presenting Archaeology to the Public: Digging for Truths* volume (Jameson, 1997) and a more recent book on public outreach efforts published by the Society of American Archaeology (Derry and Malloy, 2003). These conference presentations, newsletter editorials, and newsletter commentaries have created a need and demand for published information on public interpretation and outreach topics. With tighter budgets for archaeology and archaeology

interpretation, project planners would benefit from examples and models of successful projects, especially those with modest budgets.

This volume is a logical sequel to Jameson's 1997 book that presented theories on public interpretation of archaeology, including case studies. Among the purposes of that book were to provide theoretical approaches to public interpretation and outreach and to address various perspectives in the debate on the validity and need for public outreach by archaeologists. However, we have moved beyond these theoretical debates. The strong international response to *Presenting* from professional and academic audiences, including archaeologists, interpreters, educators, museum curators, as well as the general public, testifies to the relevance, importance, and demand for detailed and exemplary case studies and models for effective interpretation. Readers have inquired about the logistics and problems of doing outreach, and the big question many raised was of the affordability of outreach projects. Most archaeologists now agree that public interpretation and outreach are important and crucial parts of their work; i.e., the theoretical debates are no longer needed. The publication of recently edited volumes such as Little (2002), Shackel and Chambers (2004), Jameson (2004), and Merriman (2004) attests to this. A big stumbling block, however, has been affordability. Archaeologists want examples of case studies of projects that were done without big budgets and examples of projects that they can afford to do in their own communities. Because of these inquires we started looking out for projects that could serve as case studies for other communities.

Since the mid-1990s, when the articles for *Presenting Archaeology to the Public* were compiled, we have witnessed numerous international applications of the original models from *Presenting* and an increased interest in establishing partnerships between professional practitioners in public interpretation and educational institutions such as museums and schools. These developments have occurred in the context of a realization that community-based partnerships are the most effective mechanism for long-term success.

The need for a second volume that addresses these latest trends and presents case studies of successful partnerships became obvious. As an initial testing ground for the idea of a second book, Jameson organized a symposium at the 2000 Society for Historical Archaeology (SHA) conference in Quebec City, Canada, entitled "Giving the Public Its Due: Public Interpretation and Outreach in Archeology," with a largely North American focus. The editors of this proposed volume (Jameson and Baugher) evaluated the papers from the SHA symposium and discussed what could be accomplished in a new volume. As a result of editors' evaluation, this volume carries forward revised versions of selected symposium papers (one-third of the articles in this book), plus additional articles from the United States and international contributions from Australia, Brazil, Canada, Great Britain, and Mexico to enhance topical variety and international application. Similar to the *Presenting* volume, the intended audience includes archaeologists, resource managers, professional staff at traditional and site museums, interpreters, public administrators,

preservationists, as well as high school and middle school social studies teachers, elementary school teachers, and all students of archaeology and resource management.

Volume Organization and Subject Matter Diversity

Topical Grouping of Chapters

We have divided the book into five parts that represent different topical thrusts of public interpretation and outreach; historic sites and museums, ethnic communities, colleges and universities, public schools, and public agencies and professional organizations. However, as we noted, these categories are not discrete areas of outreach. Many of the articles could be placed in more than one section. For example, Hansen and Rossen are university archaeologists and their chapter could be in the section on university outreach, but the main focus of their paper is on partnering with Native American communities, therefore we placed their article in the section on ethnic communities. The following introduction to each section addresses some of the common problems facing outreach efforts. Each article addresses how the archaeologists dealt with outreach work and the partnerships that were formed.

Historic Sites and Museums

Historic sites, and to a large extent, historic-site archaeologists, have been at the forefront in engaging the public. They have probably been decades ahead of other institutions in active public outreach programs for both children and adults. A number of the interpretative programs at our historic sites have enabled the past to come alive. Books such as Freeman Tilden's *Interpreting Our Heritage* (1977) have served as guidelines for interpretative programs. Outdoor education programs, especially ones that involve diverse senses beyond just seeing and hearing, can help visitors relate to another time and place. The challenge for archaeologists has been to make archaeology "come alive," to present archaeology as the dynamic field we know it to be. This has been especially challenging when archaeology is within the setting of an historic site. Do other programs overshadow it? Does it simply get relegated to just a small exhibit in the orientation museum explaining how archaeological discoveries provided important data for both the reconstructions at the site and the interpretations of daily life? How can archaeology be successfully integrated into the visitor experience? The authors in this section have successfully met these challenges.

Bruce Fry looks at 40 years of archaeological work at the Fortress of Louisbourg on Cape Breton Island, Nova Scotia. Louisbourg was more than a military fortress, it was a fortified village. Because it is the archaeology of a

whole community, there were craft shops, stores, taverns, homes, gardens, a church, plus all the military buildings found at a fort. The Louisbourg project was the largest major undertaking of Parks Canada. It has been called the "Williamsburg of Canada." It was a model for archaeology and preservationists. Fry discusses 40 years worth challenges, set backs, and successes.

Henry Miller provides a broad overview of the historic outdoor museum, St. Mary's City, the first capital of Maryland (1634–1695). While the first archaeological excavations were undertaken in the 1930s, systematic, long-term excavations began in 1970 and continue today. For over 35 years archaeologists have been continuously excavating the whole community, interpreting the diverse sites to the public, and endeavoring to preserve the remains. Miller's chapter discusses the variety of ways the archaeologists have engaged the public, how they confronted challenges, and practical insights gained from their experiences.

While Henry Miller provides a broad overview of the work at St. Mary's City, Silas Hurry and Darcy Bodeman provide the reader with an in-depth view of the issues related to one site and one museum exhibit. St John's site, the home of John Lewger, the first secretary of the colony, existed from 1638 to ca. 1715. The site was excavated for many years and the foundations survive. A new museum building surrounds and shelters the foundations and provides a permanent exhibit space. Hurry's chapter discusses the long process of exhibit development and building design and how archaeology actually "drove the development process." The chapter analyzes how archaeologists working in partnership with specialists in diverse fields produced an innovative museum building and interpretative space.

Jody Steele, Greg Jackman, Julia Clark, and Richard Tuffin take the reader from the North American examples to Australia. Port Arthur historic site is located in Tasmania. Unlike the seventeenth-century community of St. Mary's city, or the eighteenth-century fortified Louisbourg, nineteenth-century Port Arthur was a prison settlement. It is one of Australia's popular cultural tourism destinations. The penal settlement was self-sufficient with a variety of trades and industry. After the prison closed, it became a historic site in 1915. The archaeologist faced many of the same challenges faced in North America. The authors describe the challenges of how archaeologists integrated their work into the over-all public interpretation and educational programs.

Ethnic Communities

Heritage tourism is not only a catch word in archaeology and preservation, but it is also becoming a major source of money for local communities. When archaeologists engage in work connected to heritage tourism are they really providing a service? Is it civic engagement? Lisa Breglia challenges these assumptions in her case study on a Mayan community. The Maya were proud that they had been able to finally achieve ownership of their land. They wanted to remain as farmers. But the archaeological and heritage tourism

development of the local Maya site would mean a transformation of the cultural landscape. Roads would be built. Hotels and restaurants would be constructed for the tourist industry and new jobs would emerge. However, land for the roads and hotels would be taken from Maya farmland. Is this what the community wanted? Did they have a say? Was this a partnership project or yet another example of archaeologists making assumptions without input from the community? Breglia raises the question of whether archaeologists should be partnering with cultural anthropologists to better understand the values in a non-western community.

Within western descendant communities there certainly are differences of opinion regarding the importance of community history. Charles Orser (2004) contrasted the strong interest among Irish Americans in his archaeological excavations of sites of the "Great Famine" of the 1840s versus the lack of interest in his work among the Irish in Ireland. Carol McDavid (2004, 2003) has noted the problems she had in getting African-American community members to discuss their enslaved past or even being interested in archaeological work on a plantation site. In this book, Whitney Battle-Baptiste, an African-American archaeologist, discusses the challenges and rewards she faces in working with descendant communities.

In 1997, the Society of American Archaeology book, *Native Americans and Archaeologists: Stepping Stones to Common Ground* (Swidler *et al.* 1997), presented diverse Native American perspectives on archaeology and historic preservation, including articles emphasizing the need to consult with tribes at various levels of archaeological work. This book was an important first step. Native American Joe Watkins (2000, 2003) has written at length about the long-standing ethical, religious, and scientific problems and conflicts between archaeologists and Native American communities. Lance Foster's commentary continues that dialogue. He provides the reader with some background on the negative experiences he has had as an American Indian who is also an archaeologist. He describes terminology still used commonly by archaeologists in the twenty-first century that have negative connotations for Native Americans. Finally, he suggests ways to reach out to Native American communities.

The rest of the articles in this section provide positive examples of community outreach. In the post-NAGRPA world, where museums legally are required to inform American Indian Tribal governments if they have any objects of sacred or cultural patrimony in their collections, there is still a reluctance among many museums to include Native Americans in exhibit or program planning. The Houston Museum of Natural Science is one of the exceptions. Pam Wheat-Stranahan, Dorothy Lippert, Dirk Van Tuerenhout, and Elisa Phelps describe how the Houston Museum of Natural Science has moved into successful, innovative partnerships with Native Americans.

How do archaeologists become involved in civic engagement? When does archaeology become public anthropology? What are the personal and

professional risks and sacrifices that might have to be made? Brooke Hansen and Jack Rossen address these questions. Hansen and Rossen have developed a true partnership with Cayuga Chiefs, Clan Mothers, and other members of the Haudenosaunee (Iroquois) in a contested homeland in central New York. Their innovative outreach partnership with the Haudenosaunee has also involved college students, public school children and their teachers, and non American Indian community members.

Finally Madeline Augustine, Christopher Turnbull, Patricia Allen, and Pamela Ward describe how the Metepenagiag Mi'kmaq Nation of New Brunswick, Canada has involved archaeologists in excavating their cultural sites. This has been a true partnership that has been continued since the early 1970s when the late Joseph Michael Augustine, a former Chief of the Metepenagiag Mi'kmaq First Nation discovered a 2,500 year old burial mound and contacted archaeologists to work with him to investigate the mound. Chief Augustine also introduced his community to archaeology. At a time when there were strained relationships between archaeologists and Native American communities, this project was and still is a very positive example of people working together, respecting each other, and learning from each other.

Colleges and Universities

While museums and government agencies have taken the lead in outreach efforts, archaeologists in the academy are stepping up to the challenge. Archaeologists Peter Pope and Stephen Mills describe the innovative outreach program at Memorial University in Newfoundland. Archaeologists have worked with community members and government agency staff to help archaeology become a key issue in community economic development. Impoverished former fishing communities have benefited financially and educationally from this partnership.

Sherene Baugher explains how a national college-level community service initiative known as "service-learning" can easily be integrated into an archaeological curriculum. Service-learning provides opportunities for college students to become involved in public archaeology and public partnerships but within the context of college courses. She suggests ways to integrate outreach efforts into more than just a summer field school.

Nina Versaggi describes an innovative program known as CAP (Community Archaeology Program) in which college students, work with both public school children and adults in preserving and protecting sites. Community members are involved in lectures, discussions, and excavations. CAP has promoted grassroots preservation in Central New York.

Pedro Funari, Nanci Vieira de Oliveira, and Elizabete Tamanini describe three diverse case studies from Brazil. In some ways reflecting issues raised in the section on community partnerships, they described the mixed success

they have had with community outreach. They have faced the challenge of "whose history is it" and the dilemma of dealing with a divided community.

Public Schools

At the twenty-first century, we find negative changes in public school education where innovation and creative teaching are becoming more difficult with state mandated tests and curriculum changing to simply "teach for the test." How do you integrate archaeology into a public school curriculum? Patrice Jeppson and George Brauer provide wonderful, successful examples of how archaeology can survive in twenty-first-century public schools. One of the key ingredients is partnering archaeologist with educators. Without a thorough knowledge of social studies curriculum and new state mandated requirements, archaeologists are simply working in the dark. Archaeologists are not trained in educational philosophy or child development; therefore, the partnership with educators can ensure age appropriate programing.

Not all education takes place in a formal school classroom. Educator and historian Freeman Tilden (1977: 47) noted: "Interpretation addressed to children . . . should not be a dilution of the presentation to adults, but should follow a fundamentally different approach. To be at its best it will require a separate program."

Carol Ellick not only acknowledges the different programing needs for children versus adults but more importantly she addresses the different strategies for both formal (classroom) and informal (museum or site related) outreach programs for children. She provides useful guidelines and examples of outreach programs.

Both Dena Doroszenko in Toronto, Ontario and Gaynell Stone on Long Island, New York have had multiple years experience with partnering with local educators and providing outreach programs for school-age children. Both discuss how their programs, including visits to archaeological sites and an excavation component, have evolved over time. Both stress how their programs benefited from planning and input from educators.

Ann-Eliza Lewis provides examples from a museum/historical society perspective on outreach programs for children. The "Big Dig," a multi year cultural resource management excavation in Boston, unearthed diverse sites spanning almost a 10,000-year history of the cultural landscape now known as Boston. Artifacts and research from the excavation have been used in educational outreach programs, traveling exhibits for elementary schools, and museum exhibits. The design and content of these programs resulted from a collaboration with educators.

Public Agencies and Professional Organizations

Denise Hansen and Jonathan Fowler present a Canadian perspective on outreach by Parks Canada. Their work with educators mirror some of the successes discussed in the previous section on educational outreach. John

Jameson of the National Park Service describes that agency's long history of providing education programs for the public and gives examples of successful educational partnerships and programs as well as other national and international initiatives.

Joseph Last, from Parks Canada, describes how CRM work can be positively linked with public outreach. He provides examples of the archaeological public programing at Parks Canada's military sites in Ontario Province. The archaeological outreach has involved site tours, on-site laboratories, hands-on workshops, and short-term exhibits.

Janet Pape from the California Department of Transportation agrees that successful public interpretation programs have been linked to CRM work. She describes successful community participation in exhibits and a film that resulted from a major highway project in Oakland. Pamela Cressey in Alexandria, Virginia and Natalie Vinton in Sydney, Australia describe the value integrating archaeology directly into government laws. However, it is not just the letter of the law that makes for a successful program. They demonstrate how archaeologists partnering with community members make preservation goals become a reality.

James Deetz (1996) has discussed gravestones as above-ground artifacts. These historic cemeteries are archaeological sites that need preservation and protection. Harold Mytum describes how archaeologists might work with churches, private cemetery managers, and community members to engage the public in an awareness and appreciation of historic cemeteries and community history.

The final article in this section and in the book brings the issue of outreach back to the professional community. What steps, however painful, must professional organizations take to make public outreach more visible within the professional community? Lu Ann DeCunzo and John Jameson describe the Society of Historical Archaeology's 10-year saga in bringing the project known as "Unlocking the Past" to fruition.

Commonality in Diversity

The authors in this volume address a wide range of developments and standards for effective public education and interpretation of archaeology. The chapters also represent a cross section of case studies from both the United States and abroad. Fifty percent of the case studies are from outside the United States (including First Nations Indigenous groups): Australia, Brazil, Canada, Great Britain, and Mexico. The diverse articles from Canada and Mexico demonstrate that, although these are all case studies from "North America," the political, social, economic, and cultural backgrounds make them noticeably different from the projects in the United States. For example, readers from other countries in the Commonwealth (such as Australia and New Zealand) find common ground with the Canadian challenges to outreach. The diverse case studies may apply to particular places, but we

believe the approaches and lessons learned are applicable to many countries. They provide the reader with models for implementing public education and outreach programs with an emphasis on collaborative partnerships. The contributors, who have all been involved in long-term public outreach programs, bring their wealth of experiences to share with the reader. The chapters provide diverse examples in successful collaborations that can help project planners avoid reinventing the wheel.

The authors share their successes and problems; they discuss what was redesigned and why, what did not work, and what was beneficial. In these times of decreasing funding and support to humanities and social sciences, program directors are reluctant to undertake outreach projects that they assume require large budgets. Therefore, we have selected case studies that reflect modest start-up costs, demonstrating that success need not be tied to big bankrolls. To reiterate, we believe that the main lesson to be derived from these modestly funded projects is that attitudes and initiatives of people are what make the difference.

Only when archaeologists are willing to reach out to people in other professions and work with and learn from the community can successful partnerships be formed. This book describes effective models of collaboration that enable the archaeology of the past to meet the educational and interpretive needs of the present.

References

Deetz, J., 1996, *In Small Things Forgotten*. Expanded and Revised Edition (original 1977). Doubleday, New York.

Derry, L. and Malloy, M., editors, 2003, *Archaeologist and Local Communities: Partners in Exploring the Past*. Society for American Archaeology, Washington, DC.

Jameson, J.H., Jr., editor, 1997, *Presenting Archaeology to the Public: Digging for Truths*. AltaMira Press, Walnut Creek, California.

Jameson, J.H., Jr., editor, 2004, *The Reconstructed Past: Reconstructions in the Public Interpretation of Archaeology and History*. AltaMira Press, Walnut Creek, California.

Little, B.J., 2002, *Public Benefits of Archaeology*. University Press of Florida, Gainesville, Florida.

McDavid, C., 2003, Collaboration, Power, and the Internet: The Public Archaeology of the Levi Jordan Plantation. In *Archaeologist and Local Communities: Partners in Exploring the Past*, edited by L. Derry and M. Malloy, pp. 45–66. Society for American Archaeology, Washington, DC.

McDavid, C., 2004, From "Traditional" Archaeology to Public Archaeology to Community Action. In *Places in the Mind: Public Archaeology as Applied Anthropology*, edited by P.A. Shackel and E.J. Chambers, pp. 35–56. Routledge, London.

Merriman, N., editor, 2004, *Public Archaeology*. Routledge, New York.

Orser, C.E., Jr., 2004, Archaeological Interpretation and the Irish Diasporic Community. In *Places in the Mind: Public Archaeology as Applied Anthropology*, edited by P.A. Shackel and E.J. Chambers, pp. 171–191. Routledge, London.

Shackel, P.A. and Chambers, E., editors, 2004, *Places in Mind: Archaeology as Applied Anthropology*. Routledge, New York.

Swidler, N., Dongoske, K.E., Anyon, R., and Downer, A.S., editors, 1997, *Native Americans and Archaeologists: Stepping Stones to Common Ground*. AltaMira Press, Walnut Creek, California.

Tilden, F., 1977, *Interpreting Our Heritage*. Third edition. The University of North Carolina Press, Chapel Hill.

Watkins, J., 2000, *Indigenous Archaeology: American Indian Values and Scientific Practice*. AltaMira Press, Walnut Creek, California.

Watkins, J., 2003, Archaeological Ethics and American Indians. In *Ethical Issues in Archaeology*, edited by L.J. Zimmerman, K.D. Vitelli, and J. Hollowell-Zimmer, pp. 129–141. AltaMira Press, Walnut Creek, California.

Webster's Dictionary, 1984, *Webster's II: New Riverside Dictionary*. Houghton Mifflin Company, Boston, Massachusetts.

1
Reaching Out to the Bureaucracy and Beyond: Archaeology at Louisbourg and Parks Canada

Bruce Fry

Two centuries after its destruction and abandonment, Louisbourg emerged from its long slumber to become Canada's largest historical reconstruction and best-known national historic site. Originally a thriving seaport and capital of the short-lived French colony of Ile Royale (1713–1759), the fortified town on the east coast of Cape Breton Island, which forms the northeastern part of what is now Nova Scotia, was, from the day it was founded, at the center of the protracted struggle between Britain and France for control of the Atlantic seaboard, and ultimately the entire North American continent. Besieged and taken in 1745 by militia from New England, supported by the British Navy, only to be returned to France in 1749 after the warring nations signed a peace treaty, Louisbourg was finally taken by British forces in 1758 as a prelude to the capture of Quebec and New France. Ironically, despite its strategic location athwart the trade routes from Europe to the Americas and its proximity to the vast riches of the Atlantic fishing banks, Louisbourg ceased to be of interest to the British government; its fortifications were systematically demolished in 1760 and what was left of the town after the siege gradually fell into ruin, occupied by only a few discharged army veterans and their descendants over the years. For their centers of commerce and government, the British concentrated on the port city of Halifax they had established in 1749 as a counterpoint to Louisbourg in Nova Scotia. Even the subsequent fishing community that grew to become the modern-day Louisbourg shifted from the original townsite and began anew on the more sheltered northeast shore of Louisbourg Harbor.

In short, the abandoned town and its fortifications became transformed into an ideal archaeological site: Apart from some local quarrying for building materials, a few scattered smallholdings, and sporadic attempts in the early years of the twentieth century to stabilize some of the more prominent ruins, the site lay undisturbed beneath a thin cover of topsoil and vegetation. The surrounding countryside, too, was relatively pristine—a terrain of low hills covered by dense woods of fir and spruce interspersed with peat bogs. In these hills and along the coastline around Louisbourg were visible traces of the last conflict: French entrenchments and outlying artillery positions, British encampments, and siege trenches.

In 1926, Louisbourg was designated a National Historic Site, and in the 1930s, the federal government built a museum within the ruined walls so that the few visitors who arrived could have some information about the site; beyond this and a caretaker role, the Canadian Parks Branch, later to become Parks Canada, did nothing. All this changed in 1961 when the federal government, driven by political and socioeconomic imperatives, along with a surge of patriotic fervor as the country's centennial celebrations drew closer, embarked upon the ambitious program of reconstructing the French town. Louisbourg was not the first historic site in Canada to be excavated archaeologically (Kidd, 1994: 49–65), and was only one of several that the newly formed Historic Sites Service began to investigate (Rick, 1970: 10–44). It was, however, by far the largest. The actual townsite, including the remains of its fortifications, covered 65 acres, but with the decision to reconstruct came another significant development: Areas of the surrounding countryside and coastline that bore evidence of outlying defenses and siege activity were expropriated and became part of the larger entity that covered approximately 25 sq. miles. Subsequent investigation has identified over 500 sites within the expanded perimeter, the majority associated with the siege of 1758 (Burke, 1989). Louisbourg thus became comparable to a small National Park in terms of its administration of an extensive land area, and acquired commensurate infrastructure and organization, including a permanent staff of researchers and conservators. This was a radical departure at a time when the professional activities of the National Historic Sites Service were still centralized in Ottawa. Even after the establishment of regional offices in the 1970s, Louisbourg remained the only site with a substantial in-house research and conservation capacity, a distinction that holds to this day.

As expressed in a government-commissioned study to recommend ways of relieve chronic unemployment in the area, the long-term vision—to recreate an authentic eighteenth century French fortified town, complete with furnishings and costumed animators, that would become an international tourism attraction—was consciously modeled on the Williamsburg example, but in the short term, the objective of rebuilding was considered an engineering exercise; researchers were present simply to provide structural plans and details according to a rigorous and unrealistic schedule that would culminate in the completion of the project in the year of Canada's Centennial (1967). Responsibility for the project therefore went to the Engineering Division of the Canadian Parks Branch, not the Historic Sites Service, and the first manager appointed was an engineer, who, along with his construction team, had no knowledge of nor little sympathy for the niceties of historical and archaeological research. Pleas for more time to excavate and analyze research results were rejected. Nevertheless, as the full costs of reconstruction became more evident, the initial proposal to rebuild the entire town was discreetly scaled back. Henceforth, although the same tight schedule would apply, only an area representing roughly one-third of the site was to be reconstructed—an unintended benefit to future archaeologists, if not the ones then on staff.

Clearly, the archaeologists needed to raise awareness within the organization responsible for the reconstruction, and among the general public, who were ultimately footing the bill, of the intrinsic heritage value of the buried ruins and the artifacts they contained. Archaeology at that time was not a widely popular subject and historical archaeology was barely recognized, even within academic circles. In Britain, the discipline had a much greater appeal, thanks in large part to the endeavors of Sir Mortimer Wheeler, whose much publicized excavations on Roman and Iron Age sites drew crowds while earning derisive comments about "circuses" from more academically straight-laced colleagues; he was a pioneer in producing film documentaries as well as books that popularized his work, and became one of the first television academic "personalities." This determination to make archaeology interesting and accessible to a wide audience crossed the Atlantic in the person of Ivor Noel Hume, who had worked with Wheeler on Roman sites in and around London, and assumed direction of the archaeological program at Colonial Williamsburg in 1957. Noel Hume's public lectures and erudite but popular publications dealing with life in Colonial America, together with his introduction of that mainstay of British archaeological tradition, the society of local amateurs, brought a wide range of people into immediate contact with the past: "He knew how to simplify archaeology and make it understandable" (Kelso, 2002).

One of Wheeler's most famous sites was Verulamium, a Roman town 25 miles northwest of London, which he excavated in the early 1950s. In the same year that Noel Hume came to Williamsburg, the curator of the Verulamium museum, John Lunn, came to Canada, joining the curatorial staff of the Royal Ontario Museum. When the Canadian Government began the Louisbourg reconstruction project, Lunn was designated the first superintendent once the reconstruction was complete. In the meantime, he was appointed during the construction phase as head of interpretation. Although the politicians and bureaucrats responsible for the Louisbourg development had used Williamsburg as their model, and envisaged the completed product as one that would offer the same sort of "journey through time" with fully reconstructed buildings and animators in period costume bringing the past to life, Louisbourg boasted no intact structures and no inhabitants save for a few subsistence fishermen–farmers who had built new dwellings amid the ruins of the fortifications. Located on a remote region of the east coast, the site received few visitors and offered them little in the way of interpretation. There was the museum, built in the 1930s, that offered some explanation of Louisbourg's significance, a random sampling of artifacts recovered from various make-work programs of ruins stabilization, and a scale model of the town and its fortifications, painstakingly built in great detail by the volunteer curator from archival documents. Apart from this museum, only the ruins of the fortifications and major buildings, some of them stabilized in the 1930s, were available to assist the visitor to comprehend the history and significance of what had been the largest French town on the eastern seaboard.

The planning sequence for the reconstruction project followed what was then standard practice for park development: Engineers would build the infrastructure—work compound, headquarters offices, access roads, visitor reception center—and at the same time begin the reconstruction of major components of the French town; these were identified as the King's Bastion complex, the fortification front extending from the bastion to the main gate, and various government buildings, a selection of private residences and commercial establishments within the town. As Louisbourg was first and foremost a port, and most people, goods and supplies arrived by sea, the quay and its wharves were also essential to the reconstruction. Researchers would supply the necessary details.

The newly appointed head of interpretation would meanwhile begin assembling a team of specialists who would prepare plans for furnishing the completed buildings in authentic detail and make costumes for the animators who were to portray the various aspects of eighteenth century life, military and civilian. It was very much a production-line model, orchestrated by the engineers, everyone else working on their components and placing them in the approved sequence on the assembly line until finally the completed product could be handed over to the superintendent and the visitors would start to arrive. The only problem was that the simplistic unilinear approach did not work.

The difficulties of carrying out archaeological and historical research within the constraints of a predetermined construction schedule have been discussed elsewhere (Fry, 2004: 201–214). Problems also arose in interpreting the site to the public. The political and bureaucratic proponents of the project had not given any thought to anything but the finished product, and were taken unawares when, in response to the publicity the Louisbourg project generated, the numbers of visitors began to increase alarmingly. Of course, many were from the immediate area, curious to see the radical changes taking place in their own backyard; but as the federal government proclaimed its achievement in job creation and tourism in a region of chronic unemployment, Louisbourg became a frequent subject of coverage in national newspapers and other media. Vacationers from Ontario and elsewhere, drawn to the Maritimes by the unspoiled scenery and beaches, now had an additional destination. Faced with this unforeseen interest, Lunn had to devise plans for visitors immediately as well as for the future.

Drawing upon his experience of the Wheeler excavations at Verulamium, Lunn recognized the potential that the site offered, even in its undeveloped condition: People are innately curious about any signs of unusual activity involving excavation and construction. If visitors could not at this juncture journey back through time to a French equivalent of Williamsburg, they could at least observe a work in progress and feel as if they had been allowed to see the story behind the eventual finished product. To this end, Lunn arranged for walkways around the archaeological excavations; visitors were kept away from the trenches by barriers of snow fencing, but were able to

observe the archaeological crews in action. The artifact conservation building was located off-site, within the project headquarters compound about a mile and a half away, and here, too, the more determined visitors were able to observe conservators and assistants washing and treating artifacts as they came in daily from the site. The single-storey building had been designed with one wall almost entirely consisting of windows beginning 3 ft from the floor so as to provide a good source of natural light, so installation of a wooden viewing deck along this wall was a simple addition that gave visitors an unobstructed view into the building. At first somewhat self-conscious and reserved about their roles as "performers in cages," crews on-site and at the laboratory soon adjusted to their situation.

Because of the danger, visitors could not get as close to the construction work that was already underway. The area to be reconstructed, however, represented only about one-third of the original site, the rest remained as grassed-over ruins. To provide some sense of the size and layout of the original town, Lunn and the archaeologists identified the alignment of the streets and town blocks on the ground; maintenance crews carefully mowed the grass short along the streets so that visitors could wander them at their leisure. At each intersection, signs identified the names of the streets assigned by the French and by the occupying New England forces who held the town from 1745 to 1749. Where ruins were visible, such as those of the hospital—an imposing building that took up an entire block—additional interpretive signs provided information on the features. And finally, to convey the extent of the French occupation in the surrounding area, as well as the wide-ranging nature of the siege campaigns, viewing kiosks or "belvederes" were placed at significant locations throughout the park beyond the fortification walls: at the sites of the landings, the army encampments, the Royal Battery and the lighthouse, as well as outside the Dauphin Gate, the entranceway through which all visitors had to approach the site at the time. Inside these were interpretive displays using detailed models and photographic enlargement of historical maps and plans.

Driven by the necessity of having to respond to increased interest in Louisbourg, this was an innovative solution that focused on aspects of the undisturbed archaeological features of the site as well as the work in progress. In contrast to the direct contact with the public that archaeologists at Williamsburg and in the US Park Service took for granted, however, Parks Canada relied upon a formalized structure in which dealing with the public was a job for guides and interpretation specialists: If archaeology was being explained, it was not considered the role of the archaeologists to do the explaining.

There were organizational reasons for this: Parks Canada was a highly centralized branch of government, divided into two very unequal parts. Its public image was as the guardian of the nation's unspoiled natural wilderness areas—vast tracts of land set aside for future generations to enjoy and in which no resource exploitation was permitted. The national parks were akin

to feudal domains, self-sufficient units with large operational crews, naturalists, wardens, and guides under the authority of the park superintendent, who was accountable to the director headquartered in Ottawa. But legislation had also decreed that this same organization would also be responsible for national historic sites. At the beginning of the Louisbourg project in the early 1960s, there were some 70 designated National Historic Sites across the country, the majority being located in Ontario, Quebec, and the Maritimes. The Historic Sites and Monuments Board of Canada, comprising respected historians from all provinces, advised the minister responsible for Parks Canada as to the national significance of sites under consideration, but criteria for designation were archaic and somewhat narrow, reflecting a fundamentally nineteenth century view of history that saw the past in terms of war, politics, great statesmen, and explorers. On-site interpretation was understated, to say the least, consisting of panels of text prepared by interpreters in Ottawa on the basis of historical reports, supplemented by rudimentary display cases of various objects, many of which had little or nothing to do with the site or its reasons for designation. Local staff functioned essentially as caretakers and groundkeepers, the main activity being the assiduous mowing of lawns, or, in the case of fortifications, the earthen slopes and ditches. Frequently, especially at the former military sites, the person in charge was a retired veteran, for whom the role of looking after such sites was considered appropriate. In addition, given the title of superintendent, the site manager reported to the Historic Sites director in Ottawa, but neither the pay scales nor the influence exercised by these positions approached the levels of the equivalent positions in the National Parks hierarchy.

Until the early 1960s, archaeology played virtually no role in the management of either national parks or national historic sites. But its contribution to verifying locations of potential national historic sites gradually became apparent, and shortly before the beginning of the Louisbourg project, the National Historic Sites Service hired an archaeologist for this specific purpose. As Louisbourg was conceived as a construction project and became the responsibility of the Engineering division, the Historic Sites division had no say in the development, focusing its attention instead on other sites with evident ruins and foundations that could be stabilized or rebuilt, such as Coteau du Lac in Quebec and Signal Hill in Newfoundland, or investigating other sites to determine if there were sufficient surviving resources to warrant consideration by the Board. Unlike their natural science counterparts who were permanently based in the national parks, Historic Sites archaeologists went out to various sites on specific assignments only in the summer season, returning to the head office for the rest of the year if they were full-time employees; but frequently, at this time, they were on short-term contracts and went back to academic careers after the fieldwork. In either case, there was virtually no contact with the public at large, nor even with other Parks Canada employees.

At Louisbourg, an archaeological staff became part of the permanent establishment as soon as the project began in 1961, augmented during the

summer by students from Canadian and American universities, but there was little communication beyond the immediate project staff. In large part, this was due to the isolated location and the composition of the neighboring communities: the modern town of Louisbourg numbered some 1,200 inhabitants, most of whom worked in the local fish plant or were themselves fishermen, supplementing their income in the winter months by cutting softwood for pulp mills. The nearest towns of any size, more than 20 miles away, were Sydney and Glace Bay—communities based on the steel and coal industries, both in serious decline. There were no large, wealthy, and diversified metropolises within easy reach of Cape Breton, and correspondingly, no groups who would have the leisure time or the interest in learning about archaeology. The notion that teams of dedicated volunteer excavators working at the site could contribute to the Louisbourg reconstruction project was rejected: On the one hand, bureaucrats in the Ottawa office worried about issues of liability and insurance, and on the other hand, the prospects of bringing in unpaid workers, thereby taking away paying jobs in an area of high unemployment, were politically unacceptable. Noel Hume's example in Virginia could not be emulated here. Culturally, too, there was the difficulty that Louisbourg did not constitute a strong link with their past for modern-day Cape Bretoners. A strong appeal of archaeology has always been either the exotic, almost mythical, image of cultures like ancient Egypt, or the more chauvinistic sense of direct descent. Noel Hume was able to evoke images of founding fathers and intrepid pioneers among communities who could trace their lineage back to the early settlers. In the same way, Julian Richards in Britain establishes an implicit linkage in the title of his popular documentary series "Meet the Ancestors," squarely in the Wheeler tradition. Louisbourg was a French colony, and there is no sense of continuity in the present populace, made up for the most part of Scottish and Irish settlers. Whereas some French communities have survived in North America after the British conquest, none remained in the area after the fall of Louisbourg, and there is little sense that Louisbourg is an integral part of the local heritage. To the extent that there is any direct connection, it is with the families that are descendants of British army veterans who participated in the 1758 siege, left the army, and settled in the Sydney area. Thus community groups are willing to attend talks on how their ancestors attacked Louisbourg rather than ones on eighteenth century French life.

Within such confines, the most tangible form of "outreach" the archaeologists at Louisbourg achieved was to their co-workers in other disciplines. The "Design Team," so necessary to the accuracy and quality of the end product, brought the research disciplines to the table as equal partners with the architects and engineers, and ensured the timely and ongoing incorporation of historical and archaeological information into the building design process. The origins and application of the design team approach are discussed in detail elsewhere (Fry, 2004: 201–214). In the present context, however, it is worth reiterating that it was by means of this concept that the

researchers at Louisbourg succeeded in reaching out to other specialists and to management, and thereafter played a significant role in the reconstruction and interpretation of the site. An innovative approach, it broke away from the "production-line" model Parks Canada used in the development of parks and sites. Because a large number of Parks Canada's archaeologists and historians came to work at Louisbourg during the reconstruction phase at some stage in their careers, the team approach spread to other parts of the organization and became an accepted part of the planning process.

The team concept did not confine itself to structural design: As more elements of the town and its fortifications arose, and more research evidence was forthcoming, so too the need to synthesize the information for the visiting public became more challenging. On the ground, guides shepherded groups of tourists around, explaining what was being uncovered or rebuilt. As these guides were predominantly seasonal employees, a basic knowledge of history and the ability to communicate were essential. In an effort to break away from the time-honored practice of hiring based upon family or political connections, archaeologists and historians worked together with interpreters and guide supervisors to devise fair and objective selection methods, which included giving presentations on selected topics. The next step was the establishment of formal preseason training sessions for the successful candidates: Researchers could be spared time apart from their primary tasks for this crucial exercise. The archaeologists gave brief lectures on basic methods and principles, followed by tours of the site and the collections.

The same team approach was also used in the preparation of exhibits: Designers and interpreters worked directly with research staff to choose the subject matter and to discuss methods of presentation. This was in contrast to the compartmentalized approach then prevalent in the headquarters office in Ottawa, whereby researchers were only allowed access to the finished product and could comment only any perceived "factual" errors.

Thus the researchers—archaeologists and historians alike—at Louisbourg were able to reach out to the public at large, but only through intermediaries and by contributing behind the scenes to the story. The two disciplines were intertwined, and the emphasis of the interpretation programs was on the explanation of various historical themes rather than on the individual disciplines that yielded the information. And this vital input has not gone unrecognized: One section of the vast barracks building in the King's Bastion is used not as a period presentation but as an exhibit explaining all the work that had gone into the reconstruction. Visitors move from room to room, each one outlining the contributions of documentary and archaeological research, artifact conservation, structural design and reconstruction, iron-working, carpentry and masonry, and costume-making. Artifacts found during the course of archaeological excavation are on display in this area and also in other theme exhibits located in reconstructed buildings elsewhere in the town.

As more buildings were finished and opened to the public, the need for costumed animators grew. Unlike Williamsburg, there are no houses that

function as residences, and there is no on-site population at the end of the day (or season): The site becomes an abandoned movie set as all personnel board buses and leave to go to their own homes. But during the day, employees in the guise of soldiers, fishermen, servants, merchants, and aristocracy bring the place to life and attempt to convey aspects of eighteenth century daily activities. However, even before the era of government cutbacks which began in the late 1980s, there were insufficient funds to hire an entire garrison and have occupants in all the buildings; nor would hiring practices permit children, thereby effectively blocking an essential ingredient of the desired authentic atmosphere.

Unable to achieve this within the regular framework of government operations, the Louisbourg managers initiated an innovative form of outreach: Working with a few dedicated leaders of the local community, they formed the Fortress of Louisbourg Volunteers Association, a nonprofit society that had the dual objectives of exposing local school children to a significant part of the nation's history and of increasing employment in the area. The Association undertook to provide costumed animators, particularly children, to complement the Parks Canada workforce, to operate the on-site restaurants and gift shops, and to organize special events at the Fortress. Through fund-raising and the revenues generated by their operations, the association was able to offer wages to their workers, thereby overcoming the objections to unpaid volunteers, and to give greater depth to the visitor experience by having more people in period dress and offering a wider range of services than Louisbourg could otherwise have afforded. Over the years, the association has grown and is now an efficiently run, successful organization that has become indispensable to the operation of the site as a whole. At first sight, it might appear that the Volunteers Association has little to do with archaeology, but it is another example of the way in which the various disciplines work together, often behind the scenes, to achieve the common goal of presenting Louisbourg to the public. It is now established practice that all who come into direct contact with the public be well grounded in the major themes of Louisbourg's history and culture: A formal preseason training session of 2-week duration based upon the earlier guide-training program is mandatory. Research staffs give lectures and tours related to their particular fields of interest, and in addition, there is a comprehensive training manual as a reference for all new employees and volunteers.

Archaeologists at Louisbourg are also involved with special events that frequently combine the resources of the regular staff and the Volunteers: such was the case with the Grand Encampments of 1995 and 1999, in which military re-enactment groups from throughout North America and France gathered together at the fortress to commemorate the anniversaries of significant dates in Louisbourg's history. Hundreds of period tents, inside and outside the walls, occupied by men, women, and children in eighteenth century apparel, gave the place a more lively, authentic flavor than is usual during the summer season, and proved to be great tourist attractions. The Volunteers

provided canteen services for the participants and assisted in camp layout and crowd control. The archaeologists' primary role in this event was to ensure that the creation and operation of the camps did no damage to archaeologically sensitive areas. In addition, however, because of the military specialization of the re-enactors, there was great interest in the archaeological collections and in tours of some of the more accessible siege-related features outside the walls—areas the visiting public do not normally get to see.

A joint venture between the Fortress and the Volunteers with a more predominant archaeological focus was serendipitous: study of the ceramic collections revealed a high proportion of Chinese import porcelain, and enough pieces could be reassembled in their entirety to form the basis of a meaningful and aesthetically pleasing museum exhibits. The Nova Scotia College of Art and Design obtained the loan of some of the restored Louisbourg porcelain for an exhibit on dinner plates. It attracted the attention of a Chinese ceramics expert resident in Canada, who recognized the exact provenience of many of the specimens, and was happy to inform the Louisbourg staff that the city of Jingdezhen, the "porcelain city" situated on the Yangtse River in northeastern Jiangxi Province, was still producing similar wares, using traditional methods as it did in the eighteenth century. Reproduction wares, as at Williamsburg, serve several functions: as part of the fully furnished and animated displays; as tableware in the period-style restaurants; and as collectibles for sale in the gift shops. From this initial contact, it was a logical step for staff to see if the Jingdezhen potters could reproduce examples of the eighteenth century types found at Louisbourg. Thus began a long association with the Chinese potters, who began supplying thousands of plates, bowls, and cups to the Volunteers, conforming to the archaeological prototypes that Louisbourg researchers and Material Culture specialists in Parks Canada Headquarters had determined were the most common of the imported wares.

As these examples show, outreach at Louisbourg was from the beginning an integrated endeavor rather than an initiative by the archaeologists alone. Such an approach was a direct result of the multidisciplinary teams in place at the site. But, in spite of its uniqueness, Louisbourg is not an independent operation, but is part of a system of national parks and historic sites; the extent and nature of any form of outreach programs put into place there are best understood in the context of archaeology within the Parks Canada system. The first full-time archaeologists to be hired worked exclusively on the historic sites that were either part of the network administered by Parks Canada or were being investigated to determine if they should be considered for acquisition. Because the discipline of historical archaeology was in its infancy in the 1960s, and not widely taught in the universities at the time, the development of an in-house capability was seen as the most efficient way of building a knowledge base and of maintaining the collections of artifacts recovered. In contrast, managers of the National Parks program could call upon experts in the museum and university community to carry out

inventories of aboriginal sites. In response to broader political agendas, however, Parks Canada began to expand and decentralize its operations in the late 1960s and 1970s, establishing regional offices across the country to administer the parks and sites within their designated regions. These offices were all eventually fully staffed with trained personnel in the various functions that already existed in the Headquarters, including research and conservation, which entailed the recruiting of many more specialists. Unlike Headquarters, however, the regional offices were not organized into separate divisions, one responsible for the parks and the other for the sites, but managed both with the same teams: Engineers, for example, could be assigned to the restoration of a historic structure 1 month, and the following month to the improvement of roadways in a national park.

Likewise, the archaeologists were now responsible for researching and protecting sensitive areas throughout their region, regardless of whether they were historic or aboriginal sites. Parks Canada archaeologists, looking at developments south of the border, observed the development of cultural resource management (CRM) in the early 1970s, and in particular how, in contrast to their limited role within their own agency, their counterparts in the US National Park service had successfully introduced formal review processes geared to inventorying, identifying, and protecting resources in areas threatened by development (Fowler, 1982: 1–50). By now, senior management was, because of the work at Louisbourg and on other historic sites, accustomed to the idea of archaeological input whenever restoration or reconstruction was undertaken. To this extent, the design team approach pioneered at Louisbourg became a norm, encouraged by the Restoration Architecture group that itself was a direct result of the Louisbourg experience, and added to the Parks Canada headquarters several years before decentralization.

The new and expanding role, more research oriented than tied to site-development schedules, offered the opportunity to break away from the narrow historic sites focus and to examine the diversity of sites, primarily of native origins, within the vast national parks. This entailed a further round of bringing management onside: The degree to which archaeologists were able to broaden their operations initially varied from region to region depending on the balance between parks and sites and the receptiveness of regional management to the concept of resource management, but by the end of the 1970s, archaeological input into the planning of all construction activities was an accepted part of the process, as was the monitoring of any work that entailed disturbing the ground. Parks Canada was slow to formally recognize CRM as an essential element of fulfilling its mandate—the term did not appear in official policy statements until 1993—but in practice, regional archaeological services were applying its principles by including cultural resources on the categories to get evaluated in all environmental impact assessments.

By the 1980s, the expansionist euphoria of the 1970s was evaporating in the face of ever-increasing national debt and deficits: Parks Canada was

finding it increasingly difficult to maintain the parks and sites under its care as the government began major expenditure reductions. In order to most effectively target the spending of its limited fiscal resources, it became essential for Parks Canada to have a clear idea of what the total asset inventory consisted of, where the problem areas were and what were the greatest threats.

Since very little in the way of major development could take place in a time of economic retrenchment, archaeologists were able to concentrate on carrying out resources inventories and site protection. At Louisbourg in particular, timing was propitious for the change in emphasis: After the reconstruction phase had ended, the archaeologists began consolidating the wealth of information that the previous decades had uncovered. Don Harris undertook the monumental task of synthesizing historical and archaeological data into a five-volume "event" summary of all properties excavated within the town (Harris, 1982) and subsequently, Andree Crepeau began the equally monumental job of organizing the collections: over 5 million artifacts, plus the photographic and written records emanating from the excavations. Freed from the constraints of reconstruction schedules, the archaeologists were now able to consider the significance of resources within the larger boundaries of the site. The most significant resources in terms of the military history of Louisbourg were, of course, those associated with the two sieges, but there were also dwellings and fishing establishments outside the walls to be located, and in addition the patterns of nineteenth and early twentieth century settlements to be considered. A systematic survey over 4 years was carried out to inventory these outlying resources as part of the Resource Description and Analysis, a component of the Resource Management Planning Process normally used for managing national parks but well suited here for a national historic site with a large land base.

Louisbourg, by virtue of its large boundaries, encompassing some 25 sq. miles, included forest, coastline and open bog land, lakes and streams with a variety of flora and fauna, warranted its own staff of wardens, whose primary focus was protecting the natural environment within the park. In addition to the natural resource inventory, the warden service was also responsible for screening all activities for environmental impact. The archaeologists at Louisbourg aggressively expanded on the screening procedure to ensure that they could assess all potential impacts on cultural resources for all work proposed, thus clarifying what had been a contentious issue of long standing. Prior to this, various forms of routine maintenance activity, such as ditch clearing, road grading, installation of signs, and even digging for underground services, frequently took place without the archaeologists' knowledge. It had become apparent that, even within the reconstructed area, sections of undisturbed soil—in the backyards and in the streets, for instance—still remained, and contained significant quantities of artifacts in stratified contexts, while throughout the rest of the park, all kinds of unsuspected evidence lay close to the surface. Henceforth, there would be no excuse for intruding upon buried

resources: All activities had to be screened; archaeologists and wardens both had to review and sign off screenings before work could proceed.

For the archaeological section at Louisbourg, as elsewhere, government austerity over the past decade or more has meant that there has been little in the way of major new research projects: Charles Burke's wide-ranging and thorough survey of resources outside the town was the last major undertaking, and the unit's duties thereafter have consisted of monitoring intrusive activities and safeguarding threatened areas. Not that these were always insignificant operations: A major waterline replacement project required considerable archaeological mitigation over several years. New safety regulations called for the installation of sprinkler systems in all buildings open to the public—a modern intrusion in the eighteenth century atmosphere that Louisbourg had obtained an exemption from initially, but now had no choice but to install. The existing waterline, installed in the 1960s, and showing signs of deterioration, was inadequate to the task and had to be upgraded—an expensive task taking several years. The original installation avoided the archaeological ruins by running down the centers of the streets, the assumption at the time being that there would be no features there. But the new specifications called for much wider and deeper trenches, taking up virtually the entire street. Such an operation would disturb the cobblestone sidewalks on each side of the streets, and in some areas, a series of drains throughout the town, installed by the French at different intervals during the existence of the town to alleviate flooding after heavy rains. Environmental screening, together with the new CRM guidelines, provided the archaeologists the justification to implement a thorough program of mitigation prior to the installation. Aware that the work represented an opportunity to show something different to the visiting public, the archaeologists, in conjunction with the interpretive and guide services, arranged for display panels beside the excavations, which were open to view but provided with barriers to keep tourists at a safe distance. A low-key form of "outreach," to be sure, but one that enabled visitors to see the significance of work in progress and understand how the present linked to the past, in a way that harked back to the early years of the reconstruction. Similarly, Burke's survey of the siege-related sites could be regarded as a successful example of local outreach: As previously noted, sites associated with the British military attracted far more local interest than those of French origin, and throughout the project, the archaeologist was invited to give lectures and radio interviews in the community.

At the turn of the millennium, Parks Canada intensified its efforts in marketing, conscious that more than ever, its ability to survive as an agency depended on encouraging more visitors, and operating as a revenue-generating business. Managers began talking in terms of "outreach," even if there was no clear consensus as to what it might be or how to achieve it. In somewhat predictable fashion, it was decided that "outreach" was an activity in itself, and since it consisted of dealing with the public, it should by definition be one assigned to Visitor Services (now referred to, in keeping with the

newly adopted CRM policy, as Heritage Presentation), rather than becoming an integral part of how employees went about their business, thereby perpetuating the segregation of specialists from the public at large.

There are some advantages to this compartmentalization: Specialists are not distracted from the tasks they are employed to perform, and dealing with the public is left to those who have an aptitude for and interest in doing so. Moreover, it is a way of communicating messages about the full significance of a site, rather than just the focus of one discipline—this is left to the papers given at professional conferences. In such a structured organization, archaeologists work in obscurity, usually not coming into contact with the general public; with rare exceptions, such as the Norse site of L'Anse aux Meadows in Newfoundland and the Basque whaling station and shipwreck in Red Bay, Labrador and Louisbourg, the archaeological wealth and variety within the Parks Canada system are not widely publicized. For decades, the "outreach" challenge to Parks Canada archaeologists had been strictly internal: To persuade their own bureaucracy of the contributions the discipline could bring to managing the archaeological resources of national historic sites and national parks and to enhance current understanding of the history of parks and sites for the benefit of both scholars and the public at large.

Archaeology, however, is in the public eye to a greater extent than ever before, owing to legislation in the provinces and major cities that require environmental and cultural screening of any construction activities, to increase awareness of native concerns involving heritage, and the proliferation of specialty channels on television that popularize the discipline. Because of financial constraints, archaeologists can no longer expect to be able to carry out research or mitigation by simply submitting a budget; they are found to be more creative in assembling the necessary components to do the job. When Parks Canada first began its archaeological operations, the dearth of qualified archaeologists, particularly in the field of historical archaeology, necessitated on-the-job training and led to an inward-looking mind set, reinforced by a rigid bureaucracy. Initiatives to form partnerships with universities or provincial services were a rarity, although the Red Bay project (1978–1985), a partnership between Parks Canada, the government of Newfoundland and Labrador and Memorial University stands out as a laudable exception. More recently, the Service Centre for the Atlantic region has achieved some of its goals at its Grand Pre Historic Site by having excavations carried out as a field school run by the Anthropology Department of St. Mary's University, Halifax.

Louisbourg, by its remoteness from major population centers, has not been so successful in forming such partnerships: The local university, the University College of Cape Breton, has been at best lukewarm in its interest in the site, its own funding and staffing problems precluding any serious commitment. The scope for some form of "outreach" partnering is nevertheless quite wide: The collections alone represent a storehouse of information about eighteenth century French-colonial life from a uniquely closed context. As curators

develop new interpretive themes to enhance the visitor experience, opportunities abound for researching specific problems or topics without being subjected to the pressures of reconstruction. Both inside and beyond the walls of the town, military and civilian sites are in danger of disappearing because of coastal erosion, and are deserving of investigation. To date, the only professional to take advantage of the situation has been Robert Laroque, a physical anthropologist from Laval University, Quebec, whose interest in the physical characteristics of French settlers led him to examine skeletal remains from eroding burial sites. The potential at Louisbourg for more and larger programs of similar nature is virtually limitless, and indeed will most likely be the only way in which any further research beyond the most urgent mitigation can be undertaken. Archaeology will always be a "niche market," but for visiting researchers and students, even enthusiastic amateurs with sufficient means, a partnering arrangement offers an opportunity to delve into some of Louisbourg's unexplored resources. The artifact collection in particular, meticulously organized into "events" which are identifiable in the historical documentation, could serve as the basis for a wide range of material culture studies. Such projects could form the nucleus of lectures and professionally guided tours during the tourist season, finally realizing the site's potential as the "Williamsburg of the North."

References

Burke, C., 1989, Archaeological survey at the Fortress of Louisbourg National Historic Park 1986–87. Research Bulletin No. 273, Parks Canada, Ottawa—undated. Resource description and analysis, Fortress of Louisbourg National Historic Park, vols 2–4. Internal document on file, Fortress of Louisbourg.

Fowler, D.D., 1982, Cultural Resources Management. In *Advances in Archaeological Method and Theory*, edited by M.B. Schiffer, vol 5. Academic Press, New York.

Fry, B.W., 2004, Designing the Past at Fortress Louisbourg. In *Reconstructing the Past* edited by J.H. Jameson Jr., pp. 201–214. Altamira Press, Lanham.

Harris, D.A., 1982, *A Summary of the Archaeology of the Town Site of Louisbourg, 1959–1979*, 4 vols. Internal document on file, Fortress of Louisbourg.

Kelso, W., 2002, Address to the Annual Archaeology Conference of the Archaeological Society of South Carolina.

Kidd, K.E., 1994, The Phoenix of the North. In *Pioneers in Historical Archaeology* edited by S. South, pp. 49–65. Plenum Press, New York.

Rick, J., 1970, Archaeological investigations of the National Historic Sites Service, 1962–1996, Canadian Historic Sites Occasional Papers in Archaeology and History No. 1, Indian and Northern Affairs, Ottawa, pp. 10–44.

2
When the Digging is Over: Some Observations on Methods of Interpreting Archaeological Sites for the Public

Henry M. Miller

2.1. Historic St. Mary's City

Archaeological findings can be presented to the public in many ways. Some involve lectures, exhibits, and publications that are not physically connected with the site, while others utilize the actual locations of discovery. In this article, the ways sites themselves can be used to tell people about the fascinating revelations and the rich stories derived from archaeological and historical exploration are considered. This is an issue that confronts many archaeologists, including those working at St. Mary's City, the site of Maryland's seventeenth-century capital. Nearly 40 years ago, St. Mary's archaeologists were given the tasks of discovering a vanished city, interpreting it on the original sites, while at the same time endeavoring to preserve most of the unique 350-year old remains. The effort has included many different approaches in exhibiting the sites and called upon experts in a variety of fields to reach the best solutions. This article is not a theoretical treatise, but one that seeks to share the practical experiences obtained from four decades of doing archaeological interpretation.

2.2. St. Mary's City

Maryland was founded in 1634 as a proprietary colony owned by an English Catholic noble, Cecil Calvert, Lord Baltimore. Perhaps the most memorable features of the colony are that it established the first official policy of religious freedom in English America and had separation of church and state, both extremely unpopular ideas in the seventeenth century. After a brief period of exploring the Potomac River and establishing peaceful relations with local Piscataway Indian Chiefdom, the settlers purchased a Yaocomico Indian village, moved into the vacated Indian homes and founded Maryland, naming the place St. Mary's City (Carr et al., 1978). St. Mary's became the center of government and the only settlement in the colony during the seventeenth century that displayed an urban

character. Maryland's capital grew slowly at first, with setbacks due to war and rebellion. Growth was most dynamic between ca. 1660 and 1694, when an elaborate Baroque-inspired urban plan was created and major public architecture erected (Miller, 1999). This expansion would have continued, but for a rebellion in 1689 that was inspired by the Glorious Revolution in England. Disgruntled Maryland Protestants rose up against Lord Baltimore, captured St. Mary's City and overthrew the government. England's new monarchs, William and Mary, made Maryland a royal colony. In 1695, Royal Governor Sir Francis Nicholson moved the capital from St. Mary's City with its strong Lord Baltimore association to a Protestant population center—Annapolis (Carr, 1974). Most of the St. Mary's residents followed the government, since it was their chief source of employment, and the original capital was largely abandoned. By the mid-1700s, nearly every above ground trace of the city had vanished under farmland. St. Mary's City remained an undeveloped rural setting into the mid-twentieth century, a circumstance that allowed most of its archaeological sites to remain well preserved under fields and pastures bordering the tranquil St. Mary's river.

Although few above ground clues survived of the city, the citizens of Maryland never forgot the state's founding site. Commemorative events and pilgrimages to St. Mary's began in the early nineteenth century. For the 300th anniversary of the colony's founding in 1934, a huge celebration was held at the site, attended by over 100,000 people (*The Baltimore Sun*, June 17, 1934). The centerpiece of the event was the reconstruction of the 1676 State House, a project that involved limited archaeological investigation. In addition, the festivities included the first public exhibition of the archaeological remains of St. Mary's City. Local citizens uncovered the brick ruins of the seventeenth-century Van Sweringen site, so they could be displayed to visitors during the celebrations (Howard, J Spence Jr, 2004, personal communication). After the ceremonies, the city once again returned to its long slumber. In the 1960s, rapidly increasing development in the area sparked public concern. A group of citizens, led by a retired four-star Marine Corps general, began lobbying for preservation of the state's founding site. In 1966, the Maryland Assembly agreed to create a state museum at the site, and passed legislation that defined the museum's purpose as preserving, studying and interpreting St. Mary's City to the public (Bill 835, Article 41 Annotated Code of Maryland, Acts 1966). This legislation was revised in 1997 with the intention of enhancing the museum's ability to "preserve, protect, and appropriately use the historical and archaeological assets" of the founding site (Education: 24–501 to 24–525, Annotated Code of Maryland 1997). The first question confronting the new museum staff, and one that visitors continue to ask today, is "Where is the City?" Intensive documentary research by staff historian Lois Green Carr found that no maps or good written descriptions of the city survived, and many of the land records burned in a courthouse fire. Only by collecting

archaeological evidence and linking it with the few historical records could the museum hope to discover Maryland's "ancient and chief seat of government."

2.3. Discovering the City

The first archaeological investigations of St. Mary's City were conducted in the mid-1930s by architectural historian H. Chandlee Forman, who summarized his findings in a captivating volume entitled *Jamestown and St. Mary's: Buried Cities of Romance* (1938). Only with the founding of the Historic St. Mary's City (HSMC) museum three decades later was attention again given to the rich archaeological heritage of the city. Rescue archaeology began in 1968 and systematic archaeological research began in 1970 under the direction of Garry Wheeler Stone and continues today. The St. Mary's City program is the longest running archaeological research project in Maryland. Labor for this work comes from an annual archaeological field school jointly sponsored by the museum and St. Mary's College of Maryland, paid excavators and volunteers. Funds for the research derive from a variety of sources including state appropriations, federal and private grants, and donations. In 1971, the museum began inviting the public to visit its excavation sites, learn about the research process, and interact directly with archaeologists, initiating the first public archaeology program in the state. Work during the 1970s primarily focused upon individual sites to learn about the nature of the early architecture and landscape, the material culture of seventeenth-century Maryland, and to develop the best methods of collecting and analyzing data from sites of this era. Projects included the Tolle-Tabbs site, a suspected early site that turned out to be an eighteenth-century plantation house, the 1638 St. John's plantation site (Keeler, 1978; Stone, 1982; also see the Chapter 3), and a 1660s government office that Dutch immigrant Garrett Van Sweringen converted into the finest hotel in Maryland (King and Miller, 1987; King, 1990). Later studies explored the ca. 1667 Brick Chapel and its surrounding cemetery (Riordan, 2003), an associated Priests' House, and a 1680s structure used for a time as a printing house.

Between 1979 and 1996, the museum directed major efforts toward archaeological survey and testing to identify all the cultural resources for management purposes and to trace the development of the seventeenth-century capital. Key to this task was finding the center of the original city. We achieved this in 1984 when the Country's House, the ca. 1635 home of the first governor Leonard Calvert, was discovered to lie under and around a 1840s plantation house and its outbuildings (Miller, 1986, 1994). Many seasons of archaeology since then have produced a massive amount of data. While seventeenth-century sites are the main targets for interpretation, excavators also recover vast quantities of prehistoric materials, artifacts from eighteenth-century plantations and quarters, and remains from nineteenth- and twentieth-century farms (cf. Neuwirth, 1997).

2.4. Interpreting Seventeenth-Century Sites

What are the methods by which these rich archaeological resources can be presented to the public? Some possibilities have been reviewed in previous publications (cf. Jameson, 1997). Artifacts and summaries of the findings have been presented in traditional gallery exhibits at St. Mary's (Hurry et al., 2001), but the actual sites demand different approaches. For these, our interpretive efforts have ranged from simple signs to full scale reconstructions. Selection of a specific approach is influenced by many factors including the nature of the site and its significance, a desire to preserve as much of the archaeology *in situ* as possible, construction costs, Americans With Disabilities Act (ADA) requirements, staffing needs, the long-term maintenance requirements of an exhibit, and the amount of information each interpretive approach requires to produce a credible exhibit. Perhaps the key issue is the nature and condition of the archaeological remains at a particular site. Some sites offer little of visual interest while others have complex brickwork, cellar holes, shell pits, and other features. The visiting public readily understands brick ruins as architectural remains, in part because this material continues to be used in contemporary construction. But only a few seventeenth-century buildings were made of brick. In early Maryland, the vast majority of the structures were of wooden, post-in-the-ground construction (Carson et al., 1981; Stone, 1982, 2004). If masonry was used on these sites, it was generally in the chimneys. As a result, most colonial structures are indicated by subtle sol discolorations representing postholes and molds that are less than dramatic in appearance and often difficult for visitors with no dirt reading skills to even recognize. After being excavated, the empty holes in the ground are very hard to make exciting. Such sites are a challenge to display. Thus, the nature of the archaeological remains has a central role in determining the best way of presenting a specific site to the public.

Given these factors, HSMC archaeologists have experimented with a variety of exhibit approaches on sites for the past four decades. These include interpreting the architecture and landscape elements, while striving to leave portions of the sites preserved for future generations. Besides simple signs, the approaches are:

1. Stabilizing and partially rebuilding ruins with masonry elements.
2. Wooden outline of building plans and interior fill material.
3. Ghost buildings or three-dimensional wooden outlines.
4. Full reconstruction with variations.
5. Re-creating landscape components.

Stabilized and Partially Rebuilt Masonry: A few sites at St. Mary's have masonry elements such as chimneys, footings, or veneer walls. They offer structural elements that may be easily enhanced for interpretation. The building walls can be permanently defined above ground by laying five to ten

courses of new reproduction brick over the original, after taking appropriate precautions to protect the authentic bricks. With chimneys, they can be rebuilt to a height of 5 or 6 ft, thus creating a more three-dimensional interpretation. With internal chimneys, partially rebuilding them also gives a stronger sense of the original room divisions to visitors. Interior ground surfaces may be covered with a distinct material such as pea gravel, mulch, or soil consolidant to better distinguish them from the yard areas. This approach was first used on the Tolle-Tabbs house at St. Mary's City in 1975 (Figure 2.1) , and later employed for the stabilization and exhibition of the Van Sweringen and the Leonard Calvert sites (Miller, 1994), all under the direction of Garry Wheeler Stone. Signs are used to give details about site history and the archaeological findings. Figure 2.2 shows the Van Sweringen site's partially rebuilt brick chimneys and veneer walls using brick custom-made to match the originals. A reconstructed wooden kitchen and cooling house are seen in the background.

Brick walls that are stabilized and partially rebuilt represent the oldest exhibit method used in historical archaeology. It was first employed by Samuel Yonge at Jamestown in 1906 (Yonge, 1907; Cotter, 1958). Later in 1957 at Jamestown, the National Park Service built replicas of many of the brick foundations uncovered by archaeology in the first large-scale application of this method. These rose 1 to 2 ft above the ground surface and were painted white to emphasize that they were not originals. Artists' conjectural

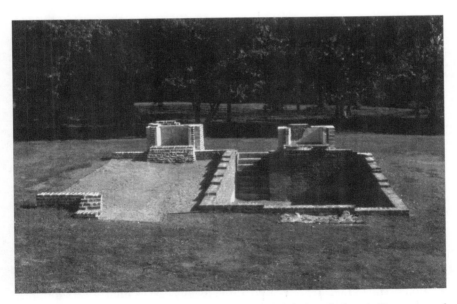

FIGURE 2.1. The stabilized and partially rebuilt brick foundations, chimneys, and cellar of the ca. 1740 Tolle-Tabbs house. (Courtesy of Historic St. Mary's City)

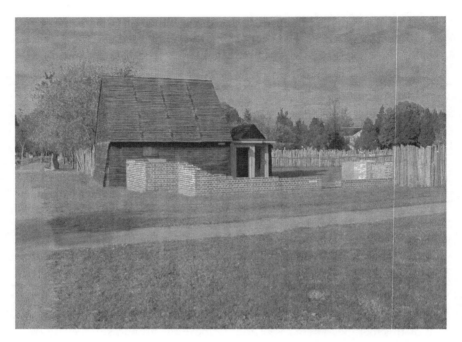

FIGURE 2.2. Partially rebuilt brick veneer and chimney bases of the Van Sweringen site, ca. 1677. Van Sweringen's kitchen and cooling house reconstructions are in the background. (Courtesy of Historic St. Mary's City)

paintings of the structures and informational signage supplemented the replica foundations. Input in designing these exhibits was provided by archaeologists J. C. Harrington, John Cotter, Edward Jelks, and others (Jelks, Edward, 19 May 2004, personal communication). This interpretive method effectively created the appearance of ruins in what was an otherwise undistinguished setting.

Ruins convey romance and fascination in a way that the public responds to and connects with. This is a cultural response reinforced by television and magazine images from places like Egypt, Rome, and Stonehenge. Ruins provide teaching opportunities by sparking interest in the past. Most historic sites in America lack such evocative ruins, but this exhibit approach produces a reasonable simulation. By working with traditional brick makers or commercial firms that can do custom work, accurate reproduction materials may be obtained. To successfully build this type of exhibit, archaeologists must work closely with skilled restoration masons who have the knowledge and ability to lay colonial era bonds. While the cost of obtaining accurate reproduction brick and having them laid authentically can be high, a very durable, and long-lasting exhibit results. The permanence of this exhibit method and the evocative ruins it creates makes it an appropriate interpretive strategy for

some sites. Nevertheless, this stabilization approach also has disadvantages. One is the high-initial cost. Another is that the original brick must be well buried with only reproduction brick used near or above ground level. If the original brick is at or near the surface, it can fragment from repeated freeze-thaw cycles, thereby making the above grade reconstructed walls unstable and potentially dangerous for visitors. If original walls are capped with new brick, the finished grade should be raised well above the original remains so that only reproductions are exposed. There is also a problem that the public tends to see the exhibit bricks as all being original, despite signs clearly indicating that they are reproductions. Equally challenging are visitors, who have a hard time visualizing the connection between the foundations and a standing structure. Adequate signs with good graphics can help overcome this and are a crucial element of this exhibit approach.

Outdoor signs have the advantages of durability, low cost, and low-site impact. Their disadvantages include relatively low-information content, maintenance needs such as weed removal and cleaning the surfaces to remove bird droppings, accidental damage from mowers and vehicles, and gradual fading from long exposure to ultraviolet light. Extensive use of graphics is essential to attract and hold attention, convey information and break up the text into small, quickly read segments. Indeed, good graphics are so crucial that archaeologists should consider the direction and angle from which the public will eventually view a site when taking site photos, especially overall views. With the many daunting demands of conducting an excavation, this is often forgotten but the exhibit potential and need for good images must be considered while the excavation is underway. Obviously, they cannot be taken afterward. Signs are most effective when graphically rich and used as part of a larger site interpretation. By placing them in direct relationship to the exhibited structural remains, the archaeological site and the signs are linked and better understood by visitors.

Wood Outline of the Building Floor Plan: Archaeology usually provides reliable information about the location and general dimensions of a structure, even one lacking masonry elements. This evidence can be used to outline the structure's floor plan with 6–8 in. thick timbers laid along the original wall lines. The interior "room" areas are covered with a material such as pea gravel to visually distinguish inside from outside space. Signs then provide the site information. The advantages are very low cost, fair durability, and establishing a clear connection between the archaeological building location and the signs. A major disadvantage of this approach is that it creates an exhibit that some have described as resembling "giant cat litter boxes." While visitors do get a sense of the location and area enclosed by a building, the exhibit is too flat. People have trouble intellectually translating the unfamiliar site plan perspective into an actual structure. Discussions with visitors at HSMC and observation of their reactions shows that people best comprehend a site having a three-dimensional interpretation. Another problem with this floor plan method is that it demands frequent mowing since, even moderately high grass

and other vegetation will rapidly conceal the wall lines. The two-dimensional outline is the least costly approach to site exhibition, but it has proven ineffective and is not recommended, based upon the St. Mary's City experience.

Ghost Buildings: Helping visitors understand the vanished built environment uncovered by an archaeological investigation needs other solutions. Fully reconstructing a structure solves this problem very nicely, but it requires a large quantity of information, major excavation of the building remains, and is very costly if done to proper museum standards. How does one go about creating the visual impression of a house site or a city landscape with modest funds, nothing visible above ground, limited evidence about the structures, and the overriding goal of preserving as much of the archaeology as possible? This has been especially challenging at St. Mary's City because the museum has never intended nor had the funds to fully reconstruct the town, as is done at places like Williamsburg. But we still have the obligation of giving visitors a sense of Maryland's first urban setting and allowing them to grasp the scale and layout of the early city in a modern landscape that is mostly old agricultural fields and pasture land.

A solution was inspired by an innovative concept John Cotter and the National Park Service used for the Benjamin Franklin House exhibit in Philadelphia (Stubbs, 1984). This three-dimensional steel outline of Franklin's house suggested a way to present the wooden buildings of St. Mary's City. A variant of this idea was later developed by Ivor Noel Hume and landscape architects Kent Brinkley and Gordon Chappell for the early seventeenth-century settlement of Martins Hundred on the James River in Virginia (Baugher, 2002). In the mid-1980s, they built two-dimensional wooden outlines of the various buildings with one gable being fully defined for each structure. Encouraged by these efforts, I proposed using the full three-dimensional forms at St. Mary's in 1984, but it was 10 years before the funds and permissions could be obtained to try it out. Called ghost frames by the St. Mary's City archaeologists, these wooden outlines are intended to evoke the form of seventeenth-century Chesapeake structures with high-pitched gables, and are supplemented with door and window frames. To create these exhibits, it was necessary to work closely with skilled carpenters, defining the goals for them and laying out a general design concept, while relying upon their knowledge, experience, and advice about wood construction methods. As a state agency, the museum also had to meet a 20-year life expectancy for exhibit structures. To collect the required information, HSMC installed five different prototypes of these wooden frames in 1994 using private funds, and tested them for a number of factors including durability, structural weaknesses, and visitor response. Although these were only prototypes, they inspired other archaeologists to experiment with this method, beginning with a slave quarter at Poplar Forest (Heath, 1997: 188–189). Based upon the knowledge gained from 5 years of weathering and storms, more refined designs were developed in 1999 and 16 new ghost buildings erected in 2000 (Figure 2.3).

FIGURE 2.3. A Ghost building over a late seventeenth-century archaeological site. (Courtesy of Historic St. Mary's City)

Various sizes are built. In some cases, archaeologists fully uncovered a structure so that its exact dimensions are known and these details are employed to construct the ghost building. But archaeological survey and testing have identified many other building sites where the level of investigation is insufficient to reveal the architecture. For those sites that had domestic habitations and date to the ca. 1660–1695 era, a standard model of a house is used. Measuring 20 ft. by 20 ft. with a simulated wattle and daub chimney outline on one gable, this model is based upon 1680s St. Mary's City legislation that required a landowner to build a house of this size to maintain the patent for their lot (Figure 2.3). But not all buildings were houses. The city also contained stables, smoke houses, work sheds, tobacco barns, and other outbuildings. Where archaeology indicates the presence of a ca. 1660–1695 structure that had a nondomestic function, different frames were designed. For example, a stable or tobacco barn is represented by a 15 ft by 30 ft ghost building with a central door, but without a chimney. By using a variety of forms, we can convey something of the architectural diversity the city would have displayed. At the same time, this approach allows us to utilize limited survey level and Phase II test findings and integrate them into a broad city-wide interpretive program.

All these frames are made of pressure-treated wood for durability; the principal timbers assembled using rugged mortise and tenon joints, and the

joint seams filled with caulking to deter water intrusion. Each frame rests slightly above ground level on masonry blocks that are set into the plowzone. They are anchored with rebar driven through the sill and into the ground, causing only a one-half inch intrusion into subsoil. Experience with storms, especially Hurricane Isabel in 2003, demonstrates that such anchoring is essential. Maintenance costs are low, consisting of mowing around and inside the frames, and the application of a preservative to the wood every 5 years. Ghost buildings serve as relatively low-cost visual placeholders, interpreting where buildings once stood without disturbing their preserved archaeological remains. When the need arises in the future to conduct archaeology on a specific building, the wood frame can be moved to the location of another comparable site. Visitor reactions to the ghost buildings are highly favorable, and they specifically state that seeing the building frames gives them a much better understanding of the scale and layout of the city. A similar result is to be expected on a farm or plantation site where a variety of outbuildings can be interpreted in this manner. One caution is needed, however. Since this is a new exhibit idea for visitors, it is necessary to explain the concept to them. Without this, some think the frames are unfinished building projects and they wonder why construction was halted. Nevertheless, this approach is a very cost effective and successful way of utilizing limited archaeological evidence to give visitors a sense of the presence, general form and volume of long-demolished structures.

Full Reconstruction: Perhaps the most popular, demanding and costly exhibit approach on archaeological sites is the full reconstruction of a building; for more discussion of this important topic, see Jameson (2004). Reconstruction requires as much evidence about the original structure as possible, which at St. Mary's City means conducting major excavations. There are no paintings, detailed drawings, or architectural plans of seventeenth-century Chesapeake buildings and few written descriptions. Due to the post-in-the-ground construction method that predominated in the Chesapeake, very few buildings have survived centuries of termites and rot (Carson et al., 1981; Stone, 2004). Standing structures that can provide insight are limited to the study of the five surviving seventeenth-century buildings in the region, and precedents derived from surviving structures in England and New England. Archaeology must be the chief means of gathering evidence. Extensive excavations over the past 40 years have revealed that earthfast construction was widely used and the vast majority of the region's structures were built in this way (Stone, 2004). Understanding what these buildings were like requires complex architectural excavation and intensive analysis. Despite the costs and effort, there are many advantages to reconstructions. They provide invaluable interpretative opportunities that cannot be achieved in other ways. Living history demonstrations and presentations on architectural history, decorative arts, and daily life are significantly enhanced with authentic period settings. While ghost buildings can depict the presence of structures, earthfast architecture is not fully understood by

visitors without providing real examples. Indeed, seventeenth-century architecture, living spaces and material needs were so different from those of twenty-first-century America that many people must experience the physical spaces of life to grasp the nature and significance of the cultural distinctions that separate us from the early settlers. For these interpretive reasons, St. Mary's City has reconstructed a few of the original buildings in the city— a public inn dating from 1667, a merchant's storehouse and office, a ca. 1690 kitchen, and a 1680s printing house. Currently, Maryland's first brick build-ing—the 1660s Jesuit chapel—is being meticulously rebuilt after intensive archaeological and architectural research (for information on the Print House and Chapel reconstructions, go to new projects on the HSMC web site (www.stmaryscity.org).

Excavation of the public inn or ordinary as they were called in the early Chesapeake revealed the postholes of a structure that had burned. Artifacts, features and documents identify it as William Smith's Ordinary, built in 1667 and destroyed by fire in March of 1678. Archaeology showed that it had an unusual end-passage plan with a wattle and daub firehood, a rare form of vernacular architecture found mostly in Northern England. Reconstruction required that the archaeologists work closely with architectural historians and period craft specialists to develop the most credible design. In so doing, new questions arose that caused further evaluation of the site's archaeologi-cal record in seeking answers. With the help of Plimoth Plantation house-wrights and Chesapeake area artisans, this structure was rebuilt in 2000 and 2001 (Figure 2.4). It provides an authentic setting for interpreting one of the main businesses of the city—innkeeping. At the same time, the museum staff assigned to this building use it as a device to discuss archaeological evidence. They do this by describing how the original structure burned to the ground and asking visitors what evidence would be left to find. Interpreters point out a range of clues, from the postholes and melted glass to garbage dumps that indicate door locations. One of the findings that visitors seem especially intrigued by are daub plaster fragments that have wood grain impressions on their backside with a calcium deposit over most of that surface. This deposit is the remains of whitewash. The ordinary's clapboard walls were originally whitewashed on the interior and a daub plaster finish later installed on the clapboard wall during a renovation phase. Our reconstruction represents the original, unaltered building since the archaeological data were strongest for the initial phase, and its walls are therefore left whitewashed. By using the actual site evidence, visitors are more readily brought into the reasoning process behind a reconstruction. As part of this interpretation, the staff points out that many aspects of the building leave no traces for archaeologists to discover. Because of this reality, we note that the exhibit is not a 100% accurate reconstruction, but is only as good as scholarship and the surviving evidence can make it at this time. As an exhibit, Smith's Ordinary is very popular. It not only serves general visitors, but over 30,000 school children each year.

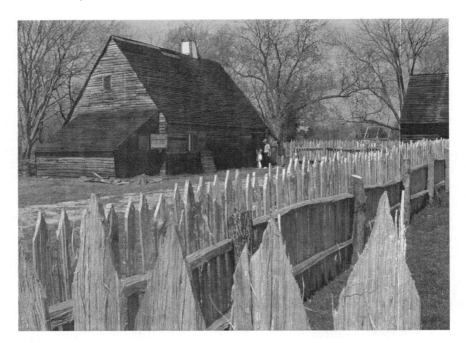

FIGURE 2.4. Reconstruction of Smith's Ordinary (1667–1678) with its fences indicated by archaeology. (Courtesy of Historic St. Mary's City)

There is another variation on reconstruction that HSMC has used. A disadvantage of full reconstruction is that the archaeological evidence of the building usually must be either fully excavated or concealed under the new structure. This deprives visitors of the opportunity to see authentic remains. To overcome this problem, Garry Wheeler Stone used a new approach for the kitchen reconstruction at the Van Sweringen site. Excavators found a small 1670s kitchen that Van Sweringen had enlarged around 1690. Among his improvements was a rare brick floor. This brick floor and the brick chimney base are well preserved. Realizing the exhibit potential of the floor, Garry stopped the excavations and did not dig features under the brick floor, as would have been the normal procedure. After the rest of the earthfast structure was excavated, we analyzed the remains and fully rebuilt the wooden components of the 1690 kitchen, while leaving its interior unfinished. Visitors can view the architecture and learn about earthfast construction while also seeing the seventeenth-century brick floor and chimney base of the kitchen (Figure 2.5). By considering the exhibit potential while digging was underway, it was possible to take advantage of what the site offered to produce a much more powerful exhibit than would have otherwise been the case. While some sites will not have displayable remains like this, where they do exist, this

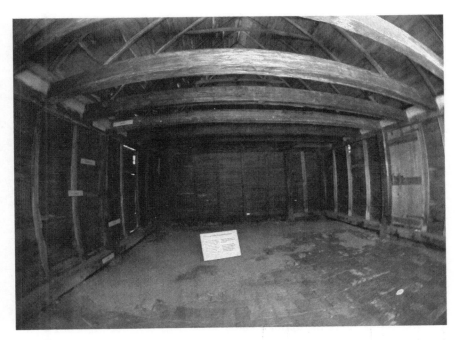

FIGURE 2.5. The reconstructed Van Sweringen kitchen with its 1690s brick floor displayed to the public. (Courtesy of Historic St. Mary's City)

is a highly effective method that allows visitors to see the original archaeology within its context inside a recreated building. It overcomes a principal drawback of reconstruction for archaeology—hiding most of the original fabric from view. This also provides an evocative experience for visitors. As one person remarked to me at the site, "seeing the brick floor that people actually walked on 300 years ago makes the history real for me."

2.5. Recreating the Landscape without Harming the Archaeology

Interpreting buildings, either with outlines or reconstructions, addresses only one element of a site. The landscape around the structures is equally significant and archaeology retrieves a wide variety of data about this subject. Artifact distributions indicate activity areas and dumps. Excavations reveal the remains of fences, boundary ditches, borrow pits, gardens, orchards, and other site elements. Streets were the physical expression of the urban plan. Although the streets of St. Mary's were never paved, their presence is indicated on aerial photographs as crop marks and by the archaeological evidence of bordering fence lines. Selective depiction of these landscape features

is important to provide the public with the sense of a city. Without landscape elements, the ghost buildings and few reconstructions are disconnected structures that seem to be randomly scattered over a large space. Recreating the yards and fences that linked these buildings and streets into a cultural composition is essential. Our problem is that few of the original landscape features have been fully excavated. Archaeologists only sampled portions of these features, leaving the majority of them still preserved in-place. How could we rebuild the fences without either completely excavating their original remains or seriously disturbing them? The large postholes that are crucial for the stability of seventeenth-century style fences, and the deep trenches between these posts for the pales would have caused much damage to the archaeology. To solve this problem, we developed a new approach. First, instead of setting the bottoms of the wooden pales or pickets into a trench, we left them slightly above the ground, thereby avoiding the digging and greatly extending the lifespan of the fence elements. Since, wandering pigs were a principal reason for a deeply buried fence and they are now less of a problem, we felt this was a reasonable compromise. Next, workers cut durable locust posts and drilled a narrow hole about 18 in. deep into the bottom of them. Into this hole they drove a 3 ft long piece of 3/4th-in. iron rebar, so that half of it was firmly imbedded in the post. Small shallow postholes were then dug every 10 ft along the approximate route of the seventeenth-century paling fence line, but offset slightly from its original location to avoid disturbance of the features. These postholes only extended to the bottom of the plowzone (8–10 in.), so that no cultural features were impacted. We then placed a prepared post with its exposed rebar in the center of this hole and drove it into the ground until the wooden post rested firmly on the bottom of the hole. Backfilling and tamping the soil around the post provided more support. This technique allowed the fences to the rebuilt while leaving nearly all of the landscape archaeology preserved *in situ* for future researchers (see Figure 2.4).

Defining the original streets of the city was another challenge. Their routes were determined by archaeology and the analysis of early aerial photographs, but no traces of these 300-year-old dirt roads remained visible on the surface. The first attempt to define them was made with selective grass mowing, keeping the "streets" at a lower level than the surrounding areas. While it provided a useful visual contrast, this method proved difficult to maintain, the intent was not always clear to the visitors and it did not satisfy ADA requirements. A permanent surface of some type was needed over what were originally unpaved colonial streets. Unfortunately, typical paving does not look natural and it normally requires that topsoil be removed down to a suitable subgrade surface. Given the amount of unexcavated archaeology in St. Mary's City and our preservation responsibilities, cutting away long swaths of plowzone through the city for this purpose was simply not acceptable. Mitigation of these long linear areas by plowzone excavation would be prohibitively expensive. Instead of taking this approach, the museum's historical horticulturalist,

Mary Alves, and I began working directly with engineers and paving specialists to seek an alternative. Initially, the engineers were highly resistant to any approach that did not involve grading. Topsoil was the enemy of a durable paved surface, since it was unstable and "nobody builds streets like that." Only after much discussion and repeatedly emphasizing why we did not want to grade away the topsoil was an alternative developed. Rather than grading away the topsoil, the land surface would be left intact with the vegetation first killed off by applying herbicides. Next, workers rolled the intended route of the street to compact the soil. A layer of geofabric was laid directly on this surface along the route of the "street" and layers of gravel fill were placed over it. These fill layers were also compacted by rolling. Then a 4-in. thick layer of asphalt was applied with a paving machine over the 10 ft street width. During this process, the machine operator was given instructions to not drive straight, as is normal, but to regularly wiggle the machine to better reproduce the irregular edges of a dirt road. This proved one of the hardest parts of the entire operation because the driver had trouble understanding why those weird archaeologists did not want a good straight road.

There was still the problem of making the asphalt not look like asphalt. As part of the planning for this effort, we conducted experiments by laying down different grades of asphalt, trying to determine which yielded the best "dirt road" appearance. This revealed that the most coarse grade available had the desired effect. Finally, the problem was how to hide the black color? We resolved this by coating the new "street" with a special acrylic polymer called the *StreetBond* surfacing system, developed especially for asphalt. To create a color that would accurately simulate a seventeenth-century dirt road, I collected samples of the natural topsoil in the area and determined their precise color. The *StreetBond* fluid was then manufactured to this exact specification and applied over the black asphalt, fully masking it. Afterward, topsoil was added to the road edges to create smooth, gently sloping shoulders and we planted grass to stabilize the soil. The result is a hard, permanent pedestrian surface that simulates the appearance and routes of the original streets of the city, meets all ADA requirements, and blends into the outdoor setting (see Figure 2.6).Drawbacks are that very heavy vehicles such as dump trucks cannot drive over the paving without laying down protective shielding (due to its shallow depth), rubber-tired vehicles can occasionally cause scuffing of the surface, and the acrylic needs to be reapplied approximately once every decade. But despite the misgivings of the engineers, the surface has proven durable without significant cracking or other damage in the 6 years since the "streets" were recreated, and visitors absolutely like it.

Through these efforts, some semblance of the seventeenth-century landscape in the center of the city has been recreated and the structures integrated into a more urban setting. From the center of the town square, visitors can finally see the radiating street network, inspired by Baroque design concepts (Miller, 1999), and revealed by archaeology. They can also grasp the spatial plan and scale of Maryland's first city. At the same time, nearly 90% of the

FIGURE 2.6. A recreated seventeenth-century street at St. Mary's City with signs and other exhibits. This street leads to the 1660s Brick Chapel that is being reconstructed. (Courtesy of Historic St. Mary's City)

archaeology of this early community is still preserved under the feet of passing visitors, leaving ample opportunity for future generations to conduct their own explorations and derive new interpretations of Maryland's seventeenth-century capital.

2.6. Conclusions

The experiences of St. Mary's City encompass many ways of interpreting historic period sites. Appropriate methods vary by site, and monitoring of visitor reactions shows that some methods are more effective than others. Indeed, each site possesses its own unique potentials for interpretation. The best exhibits on sites are created by combining the skills and ideas of specialists from many different fields, with the archaeologist playing a key creative role. When the fieldwork and analysis are completed, the process of converting the archaeological discoveries into exhibits must receive sufficient attention and thought. Only by partnering with experts in varied fields (history, architectural history, engineering, masonry, landscaping, exhibit design, lighting, carpentry, etc.) can the best exhibit possibilities be realized. Ideas, alternative approaches and unrealized possibilities are all raised through this

collaborative process of exhibit conceptualization, design, and installation. But it is the archaeologists who have the most comprehensive understanding of the site, its resources, and its meanings. They must have a central role in the creative development of the exhibit so that the potential of the site as a teaching tool is most fully realized with the available resources.

Important archaeological discoveries and new insights are the result of hard physical work and intellectual toil. Reports and collections are the crucial and indispensable products that possess enduring value. But it is through the inspired translation of these findings into effective, long-lasting exhibits that the greatest direct public benefit is achieved and people learn about their past through archaeology.

References

Baugher, S., 2002, Echoes of the Past: Visibility of Archaeological Sites in Modern American Landscapes. Paper presented at the Annual Meeting of the Council for Educators in Landscape Architecture, Syracuse, NY.

Carr, L.G., 1974, The Metropolis of Maryland: a Comment on Town Development along the Tobacco Coast. *Maryland Historical Magazine* 69(2):124–145.

Carr, L.G., Menard, R., and Peddicord, L., 1978, *Maryland... at the Beginning*. St. Mary's City Commission and the Maryland State Archives, Annapolis.

Carson, C., Barka, N.F., Kelso, W., Stone, G.W., and Upton, D., 1981, Impermanent Architecture in the Southern American Colonies. *Winterthur Portfolio* 6(2–3):135–196.

Cotter, J.L., 1958, Archaeological Excavations at Jamestown, Virginia. Archaeological Research Series Number Four. National Park Service, Washington.

Forman, H.C., 1938, *Jamestown and St. Mary's: Buried Cities of Romance*. The Johns Hopkins University Press, Baltimore.

Heath, B.J., 1997, Archaeology and Interpretation at Monticello and Poplar Forest. In *Presenting Archaeology to the Public* edited by J.H. Jameson, Jr., pp. 177–192. Altimira Press, Walnut Creek, CA.

Hurry, S.D., Sullivan, M.E., Riordan, T.B., and Miller, H.M., 2001, *"Once the Metropolis of Maryland:" the History and Archaeology of Maryland's First Capital*. A Historic St. Mary's City Commission Publication, St. Mary's City, MD.

Jameson, J.H., editor, 1997, *Presenting Archaeology to the Public: Digging for Truths*. AltaMira Press, Walnut Creek, CA.

Jameson, J.H., 2004, *The Reconstructed Past: Reconstructions in the Public Interpretation of Archaeology and History*. Rowman and Littlefield, London.

Keeler, R.W., 1978, *The Homelot on the Seventeenth-Century Chesapeake Tidewater Frontier*. Ph.D. Dissertation, University of Oregon, Eugene, OR.

King, J., 1990, *An Intrasite Spatial Analysis of the Van Sweringen Site, St. Mary's City, Maryland*. Ph.D. Dissertation, University of Pennsylvania, Philadelphia.

King, J. and Miller, H.M., 1987, The View from the Midden: an Analysis of Midden Distribution and Variability at the Van Sweringen Site, St. Mary's City, Maryland. *Historical Archaeology* 21(2):37–59.

Miller, H.M., 1986, Discovering Maryland First City: a Summary Report on the 1981–1984 Archaeological Excavations in St. Mary's City, Maryland. *St. Mary's City Archaeology Series No. 2*. St. Mary's City, MD.

Miller, H.M., 1994, The Country's House: an Archaeological Study of a Seventeenth-Century Domestic Landscape. In *Historical Archaeology of the Chesapeake* edited by P. Shackel and B. Little, pp. 65–83. Smithsonian Institution Press, Washington, DC.

Miller, H.M., 1999, Archaeology and Town Planning in Early British America. In *Old and New Worlds: Historical/Post Medieval Archaeology Papers* edited by G. Egan and R.L. Michael, pp. 72–83. Oxbow Books, Oxford.

Neuwirth, J., 1997, *Landscapes of Authority and Nostalgia: Modernization of a Southern Maryland Plantation, St. Mary's City, Maryland: 1840–1930.* Ph.D. Dissertation, University of Pennsylvania, Philadelphia.

Riordan, T.B., 2003, *Dig a Grave Both Wide and Deep: An Archaeological Investigation of Mortuary Practices in the 17th-Century Cemetery at St. Mary's City, Maryland.* St. Mary's City Archaeology Series No. 3. St. Mary's City.

Stone, G.W., 1982, *Society, Housing and Architecture in Early Maryland: John Lewger's St. John's.* Ph.D. Dissertation, University of Pennsylvania, Philadelphia.

Stone, G.W., 2004, The Roof Leaked but the Price was Right: The Virginia House Reconsidered. *Maryland Historical Magazine* 99(3):313–328

Stubbs, J.H., 1984, Protection and Preservation of Excavated Structures. In *Conservation of Archaeological Excavations* edited by N.P. Stanley-Price, pp. 79–96. ICCROM, Rome, Italy.

Yonge, S.H., 1907, *The Site of Old "James Towne," 1607–1698: A Brief Historical and Topographical Sketch of the First American Metropolis.* Hermitage Press, Richmond, VA.

3

The Whole Site is the Artifact: Interpreting the St. John's Site, St. Mary's City, Maryland

Silas D. Hurry and Dorsey Bodeman

3.1. Introduction

The St. John's site is located in St. Mary's City on the western shore of the Chesapeake Bay. St. Mary's City is a 1,500-acre National Historic Landmark that commemorates the founding settlement and first capital of Maryland. John Lewger, the first secretary of the colony, built the main house on the St. John's site in 1638, a mere four years after the founding of the colony. It was one of the earliest major tobacco plantations in Maryland and its "great house" was used repeatedly for meetings of the colonial legislature and governor's council. With many repairs and modifications to extend its life, St. John's stood until ca. 1715.

The Historic St. Mary's City Commission, an agency of the state of Maryland, has owned the main area of the St. John's site since the early 1970s. Situated overlooking a tidal pond, the site is completely surrounded by the campus of St. Mary's College of Maryland. St. John's has been investigated by archaeologists on the staff at Historic St. Mary's City (HSMC) since 1972. Excavations have generated over 350,000 artifacts, a group that comprises one of the premier collections of seventeenth-century materials in the USA. Analysis of the site has supported three Ph.D. dissertations, numerous reports, and articles, and provided data for dozens of related studies. St. John's continues to yield new insights into early America as scholars restudy the collections and ask new questions.

A Maryland state capital project is creating a major permanent interpretive building that will surround and shelter the ruins of St. John's as well as provide gallery space for exhibiting the artifacts from the site. Architectural and exhibit planning is completed and construction is anticipated to start in 2004. The basic plan for the exhibit will encompass and explain the remains of the main house within a new structure. The exhibit will interpret the archaeology of the site, the role of colonial Maryland in fostering representative government, liberty of conscience, and individual rights, as well as the adaptation of European and African immigrant peoples to the environment of the Chesapeake.

This chapter discusses the process of exhibit development and how the archaeology drove the development process. After reviewing the archaeology completed at the site, the steps undertaken to develop the exhibit will be described. Five specific themes will be explored in the nearly 5,000 square foot exhibit. Primary educational areas were outlined by a joint task force of museum staff, college faculty, and an outside educator/facilitator. The subsequent design process involved architects, engineers, exhibit designers, lighting specialists, audio visual experts, and HVAC specialists. The results from focus group information and outside consultants will be presented along with the big "takeaway" messages that the exhibit is designed to impart.

3.2. Site History

St. John's is one of the most significant historic sites in the USA. Research directed by Dr. Lois Green Carr, the museum's distinguished historian, documented the known facts concerning the property and the house. St. John's was built in 1638 by John Lewger, the first secretary of the colony. It was one of the earliest major tobacco plantations in Maryland and its "great house" was used repeatedly for meetings of the colonial legislature and governor's council. Events that took place there included the first effort by a woman (Margaret Brent) to vote in a colonial legislature, and the first participation in a legislative body by a person of African descent (Mathias de Sousa). After Lewger sold the property it was owned by Simon Overzee, a merchant and planter of Dutch extraction. During the Overzee period, Augustine Herrman visited and mentioned the location in his report on his ambassadorial mission to the Maryland colony. For a period, the site was the home of Governor Charles Calvert, who became the third Lord Baltimore. St. John's served as a major inn for part of the seventeenth century and as a records storage office late in the century. With many repairs and modifications to extend its life, St. John's stood until ca. 1715.

3.3. Archaeological Research

The first archaeological excavations at the St. John's site were undertaken by Dr. H. Chandlee Forman in the late 1960s. Dr. Forman, a pioneer in Chesapeake architectural studies, had worked previously at Jamestown, Virginia in the 1930s and had explored numerous sites in St. Mary's City.

Historic St. Mary's City began archaeological investigations at the St. John's site in 1972. Under the direction of Garry Wheeler Stone and Alexander H. Morrison II, archaeological students excavated the remains of the main house, the kitchen and other outbuildings, and numerous other cultural features representing fences, borrow pits, and refuse deposits. Excavations at the site

continued from 1972 to 1974 (Figure 3.1). Following the initial excavations, the primary remains of the main house were covered with a fiberglass "A"-frame structure to preserve and exhibit the site. This structure was built using treated wood and fiberglass roofing panels and was considered a short-term expedient covering for the site until a full-site exhibit plan could be formulated. As it turned out, this "temporary structure" continued to protect the site until 2004. Limited additional excavations were undertaken in 1982 to complete sampling in the yard areas. Together, these investigations resulted in the excavation of over 350,000 artifacts representing nearly 1,000 different cultural contexts.

The 1970s excavations at St. John's marked the development of several new methods for analyzing an historic archaeological site. The concentration on archaeology in the yard areas was particularly innovative, in that much historical archaeology of that era was driven by an emphasis on architectural remains, rather than other evidence of human activity. Another pioneering approach used in the St. John's excavations was the systematic recovery of artifacts from plow-disturbed contexts within the site. In addition to plow zone artifact recovery, early work at the site also included soil chemical analysis. Systematic sampling of the soil from the plow zone allowed the definition of areas of activities that did not leave direct evidence in the form of artifacts. The results of these early plow-disturbed artifact and soil chemistry analyses

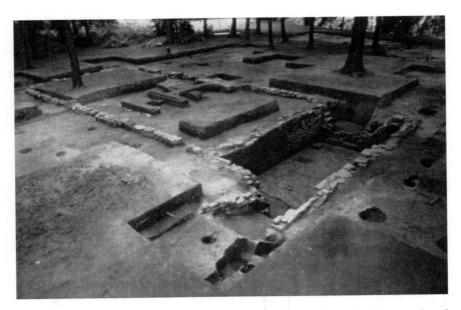

FIGURE 3.1. St. John's archaeological site following excavation of primary cultural features. (Courtesy Historic St. Mary's City)

are reported in Keeler's (1977) dissertation, *The Homelot on the Seventeenth Century Chesapeake Tidewater Frontier*.

Significant investigations into architectural detail were undertaken as part of the St. John's project. Some of the first professionally excavated earthfast structures investigated in Maryland were at the St. John's site. These post-supported structures were quite rational on a frontier where wood was plentiful but labor was hard to find. A major study in *The Winterthur Portfolio* entitled *Impermanent Architecture in the Southern American Colonies* by Carson et al. (1981), drew upon the work at St. John's and used its buildings and others in St. Mary's City as representative-type examples. Stone (1982) undertook a significant study of colonial architecture and its relationship to early Maryland history and society in his *Society, Housing, and Architecture in Early Maryland: John Lewger's St. John's*. His research compared the architecture of St. John's to contemporary buildings in both England and the early American colonies in the Chesapeake and New England, to create a context for the building. The subsequently built outbuildings show adaptation to the frontier setting by the use of less labor-intensive methods. These include earthfast construction and a reliance on split clapboard technology that took advantage of the Chesapeake's extensive forests and wood stocks.

While field observations grounded a number of these major research contributions, laboratory analyses produced many of the most important findings. The process of undertaking a minimum ceramic vessel estimate led to a better understanding of the range of ceramic types generally found in the Maryland colony in the seventeenth century. After the fragments were attributed to given vessels, individual vessel documentation was completed which described the paste, glaze, form, decoration, and any attribution or dating information. The ceramic vessel analysis provided much of the support data for more elaborate artifact studies. Beaudry et al. (1983) jointly authored *A Vessel Typology for Early Chesapeake Ceramics: The Potomac Typological System*. This study created an emic typology of ceramic forms in use in the early Chesapeake based on documentary and archaeological data drawn from St. John's.

Another series of significant artifact studies involved the use and types of clay tobacco pipes recovered in the excavations of St. John's. Henry (1979) investigated the locally made red clay pipes for her master's thesis at Catholic University, and produced an article entitled *Terra-Cotta Tobacco Pipes in 17th-Century Maryland and Virginia: A Preliminary Study—1600–1720*. The white clay pipes were reported by Hurry and Keeler (1991) in an article entitled *A Descriptive Analysis of White Clay Tobacco Pipes From the St. John's Site in St. Mary's City, Maryland* in the British Archaeological Reports International Series.

Another major study to emerge from the work at St. John's is Miller's (1984) dissertation *Colonization and Subsistence Change on the 17th-Century Chesapeake Frontier*. While drawing from a variety of archaeological sources,

this study relied heavily on the discoveries at St. John's. An additional study into subsistence behaviors that relied on the data sets from St. John's deserves special comment. While drawing samples from a variety of sites in the St. Mary's River valley, many of the well-dated samples used in the creation of the manual, *Making Dead Oysters Talk: Techniques for Analyzing Oysters from Archaeological Sites* (Kent 1988) were drawn from the St. John's site. These analysis methods could only be developed with the well-dated oyster samples from St. John's and have become the standard approach to this type of material.

Subsequent to the 1970s excavation, some additional fieldwork was done at St. John's in the 1980s. Specifically, additional sample squares of plow-disturbed soils were excavated in 1982 to fill out the overall sample from the immediate site area and its environments. This information was used by Neiman (1990) as part of his dissertation *An Evolutionary Approach to Archaeological Inference: Aspects of Architectural Variation in the 17th-Century Chesapeake*. Further data analysis includes studies exploring midden formation and details of formation process as reported in *A Comparative Midden Analysis of a Household and Inn in St. Mary's City, Maryland* by King (1988).

3.4. History of Exhibit Planning

Planning began for the St. John's site exhibit while the initial excavations were still underway. As the site was being excavated, the interpretation of the archaeology was shared with visitors and temporary signage was created to explain the process and findings. Formal planning for a more permanent exhibit began as the laboratory processing and analysis were underway. In November 1976, as part of a "Seminar on the Interpretation of History" sponsored by the American Association of State and Local History and the Maryland Historical Society, a discussion about how to best exhibit the St. John's site took place at St. Mary's City. The seminar's faculty consisted of staff members from HSMC and James Deetz, then with Plimoth Plantation, and served as a forum for discussing interpretive techniques with 20 visiting young museum professionals. The ideas that emanated from this seminar are included in a draft exhibit plan prepared by Garry W. Stone in February 1977. Stone summarized the recommendations as follows:

The exhibit . . . has four main components: 1) a protective structure composed of a "17th-century shell" and a modern shed addition; 2) flood-lighted archaeological remains explained by guide and dioramas; 3) furnishings and slides illustrating the uses of the building; and 4) artifact exhibits (Stone 1977).

Stone's exhibit plan called for visitors to enter through a central door on the south side of the main house and then proceed through the archaeological

features on elevated platforms. Both lighting and signage would focus attention on architectural features and relate them to the larger story of adaptation of English housing and other cultural patterns to the New World environment—including the natural environment and the unique challenges of a colonial economy. The story would be advanced by models and dioramas, explaining what the archaeological features meant and how the building evolved over time. The interpretation was planned to take advantage of multimedia and theatrical quality lighting to relate the story of the house to the story of the archaeology and the people who lived there.

Because of a lack of budgetary support, this very ambitious exhibit plan never proceeded beyond the discussion phase. The "temporary structure" erected in 1974 continued to shelter the primary architectural remains but was beginning to deteriorate. In 1980 and 1981, the same basic exhibit plan was forwarded for state funding support, but the selected architect proved not to be equal to the task and was subsequently dismissed by HSMC and the Maryland Department of General Services. In 1987, in an effort to protect the site from decay a much scaled back version of the plan was proposed for capital funding, but was subsequently withdrawn at the direction of the Secretary of Housing and Community Development, which at that time oversaw HSMC. It was not until 1998 that HSMC again focused its attention on developing the St. John's archaeological site into a significant interpretive exhibit. By that time, the institutional structure of HSMC had been reorganized so that it was no longer part of the Department of Housing and Community Development, but was instead an independent state agency closely affiliated with St. Mary's College of Maryland. Under this new organizational scheme, interest and focus on the St. John's site as a cooperative project to be undertaken by the Commission and the College gained momentum since the site was located in the midst of the college campus. To forward this process, a task force of HSMC staff and faculty from St. Mary's College began meeting to develop a joint initiative. This task force was chaired by John Krugler, a colonial historian at Marquette University in Wisconsin, who also served on the governing board of HSMC.

The Krugler task force met three times over the next five months with occasional subcommittee meetings to explore specific areas of interest. The first meeting generated a list of over 30 themes and subjects which should be addressed in the St. John's exhibit. It was quickly very clear that it was not feasible to address so many issues in a single exhibit and actually do justice to any of them. Subsequent meetings and subcommittee discussions were able to organize the original list of over 30 issues into three broad interpretive themes: archaeology/architecture, archival/analysis, and adaptation. The task force further recommended constructing a building which would mimic the appearance of the original house at St. John's on the south façade while extending a shed roof to the north to create a gallery space to communicate

the more complex stories. This proposal also called for recreating within the new museum building specific architectural elements of the kitchen, a number of landscape features such as fences, and the quarter structure which was originally located off the southeast corner of the house. The latter would be adapted as an open orientation pavilion. The primary intellectual departure points were to allow visitors to view the original foundations and associated archaeological features as a large artifact and interpret this large artifact through signage and interactives. Principal interpretive devices suggested by the task force included partial reconstructions of sections of the building frame to show the association of the archaeology to the architecture. Interactive devices proposed included computer-driven "windows," which would use video to depict vignettes of the many stories that occurred at the St. John's site.

After the Krugler task force reports were completed, HSMC staff was asked to produce the bid papers which outlined the request for proposal that was to be submitted as part of the Maryland state system for developing projects based on the capital budget. These documents, together with materials generated by the Maryland Department of General Services, were then forwarded to a list of possible architectural and exhibit firms to submit proposals to design the actual exhibit. The successful bidder was an architectural firm based in Pennsylvania working cooperatively with an exhibit design firm from Massachusetts.

3.5. Designing the Exhibit

Once the architect and exhibit designer were selected, teams from both consulting firms and HSMC staff from the Research and Collections, Public Programs, and Administration departments began meeting on a regular basis. From the extensive work done previously by the Krugler task force, HSMC had a well-developed idea of what the St. John's exhibit should include. We believed that it should encourage people to make connections on an affective level in order to "make meaning" of the past. While the exhibit would not be a full-immersion experience similar to what one would encounter at our recreated plantation exhibit, we wanted to ensure that each visitor would be provided access to the "emotional richness" that underlies the artifacts found at St. John's.

The museum's interpretive master plan, revised in 2001, provided clear direction that the exhibit should focus on the history of the house and its various occupants as well as the surrounding environments. We also wanted the exhibit to tie into the larger legacies, i.e., the manner in which St. Mary's City is remembered and its lasting influence on the state and the nation. Just as important, though, was the plan's mandate that, "the interpretation of Maryland's beginnings must be based on on-going research,

and the process of discovery itself should be shared with our audiences as an underlying theme whenever possible" (HSMC Interpretive Master Plan 2001). In other words, we wanted to share with the visitor how we know what we think we know about St. John's by presenting information about the documentary research and archaeological work that had been done at the site.

Throughout the Krugler task force meetings, discussion focused on identifying the various audiences who would visit the St. John's exhibit. Based on demographic information gathered from post-visit surveys, the typical adult visitor to HSMC falls in the 35–59 age group, is not accompanied by children under 18, is a first-time visitor, and comes from the greater Chesapeake region. In spite of being surrounded by a college campus, our visitation by college-aged students is relatively low. However, about half of the museum's visitors are school children—primarily fourth graders studying Maryland history. Creating an exhibit to attract, accommodate, and engage a variety of audiences in terms of their needs and interests, learning abilities, age relevancy, and physical accessibility without compromising either the exposed remains or the interpretive concepts had to be addressed early in the design stage. It was decided by the exhibit development team that while the exhibit would have some components designed to engage the younger visitor who would typically be part of a family group, the overall focus would be more attractive to older students and adults. In conversations with teachers of our fourth-grade student audience, the HSMC education staff determined that due to the limited amount of time classes have during their field trip here, they would most likely choose the living history sites which supported their Maryland history curriculum at an academic level better suited to their age. The exhibit will give HSMC the opportunity to focus on developing programs targeted especially for the middle and high school student.

In recent years, museums have come to understand that to ensure an exhibit's success, input from the potential audiences must be solicited and used as part of the planning process (Falk and Dierking 1992). Fifteen participants from the local community were invited to discuss the goals of the St. John's project with some of the HSMC staff. Participants were selected to represent a variety of backgrounds and demographic groups and included some who were familiar with HSMC and some who were not. An elementary school teacher was part of the group. The various discussion topics included how to get visitors to understand that this would not be a full reconstruction as are most of HSMC's outdoor exhibits, how to "layer" the historical content with the discovery process, and how to avoid visitor burnout by overloading them with too many stories. Participants were also asked what kinds of information they would like to receive while visiting the site and the interpretive methodology they thought would be most useful for them to understand that information. A recurring concern

that came out of the discussions was how to ensure that a modern exhibit gallery, as planned for the St. John's site, would not lose the sense of time and place so necessary to make history come alive for visitors. Of equal importance was how to integrate the visitor's experience at this site with the experiences they would have at the rest of the museum—especially at the living history sites which are full reconstructions staffed by people in costume. Conversations with the discussion group proved useful as more detailed planning began.

Exhibit development meetings begin in earnest in the summer of 2001. Participants included the HSMC team assigned to the project, representatives of St. Mary's College, the architects, the exhibit designers, and at times, various consultants from the fields of audio visual programming, landscaping, lighting, and interior environmental control. Typical meetings included roundtable discussions, review of proposed ideas, reactions to three-dimensional models, and reports from different members of the group. Meetings were usually followed up by further conversations via e-mail and phone.

Throughout the planning process, HSMC continued to address a major concern—how to preserve and protect the archaeological remains throughout the whole project. For the architects, designing a structure that would sit over a seventeenth-century site without disturbing the remains was an absolute necessity. Of further concern was how to ensure that the exterior structural elements of the building did not look like a poor attempt at a full reconstruction and that the interior elements would complement but not overwhelm the interpretive exhibits and the archaeological remnants. The design would also need to protect the remains from the visitors without making them feel isolated from the focal point of the exhibit. The excitement and enthusiasm for the project on the part of the designers and consultants was valuable; however, many of their suggestions in the early planning sessions made us realize that we would need to provide them with a better understanding of the seventeenth century, of St. Mary's City in particular, and remind them of our mission and goals and the preservation constraints facing the site. Underlying all of these issues was the question of how to make it work within the budget.

Examples of these challenges are best illustrated by some of the initial design ideas the consultants brought to the first charette. The architects envisioned expanses of stainless steel supporting cantilevered glass surrounds, which would create the sense of the structure hovering above the archaeological site. While intellectually stimulating and stylistically evocative, the long-term maintenance costs alone made such a design impractical at St. John's. The consultants had difficulty grasping that the archaeological site was not restricted to the parts that were exposed under the fiberglass "A" frame so that impact beyond that area would necessitate extensive archaeology and thereby violate the basic premise of site preservation.

Similar challenges were encountered with the landscape architect who proposed extensive, rather mature tree plantings which would have required additional excavation of otherwise protected site elements.

We do not want to imply that the process of designing the structure and the exhibit components was simply a matter of the client bending the will of others to fit a museum perspective. Many useful contributions flowed from the architects and environmental engineers. For example, our original sequence of visitor experience had to be changed to create the airlocks and transition zones needed for the HVAC to work. Our idea of entry into the site through the front door proved unpractical since this would have led to repeated exchanges of interior conditioned air with the unconditioned exterior. Such rapid and fluxing change would have been worse on the archaeological remains than no environmental conditioning at all. We also benefited from the presence in these discussions of professional architects and engineers with the Maryland Department of General Services who both "spoke the language" of the consultants and could honestly evaluate alternatives from strictly engineering concerns with the interests of the client (the state of Maryland) foremost.

Narrowing down the interpretive messages of the site proved to be challenging. St. John's represented more than 60 years of occupation during which the site had changed hands several times and had undergone physical alternations and additions. The master interpretive plan guiding the exhibit design outlined broad core concepts that would support the fact that the site bore witness to a variety of events—many unique to Maryland—during that 60-year period. However, the concepts also had to complement themes at other locations elsewhere in the museum. Visitors would learn that St. John's was an integral part of the city even though its location today is actually some distance away from the hub of the other outdoor exhibits.

The HSMC staff was very familiar with the stories that could advance the core concepts, especially those that could be linked to artifacts or archaeological elements, and we had strong feelings as to what should be highlighted. We brought to the table a well-outlined and thought-out plan. The exhibit designers were equally enthusiastic about the broad range of information that could be included but were less inclined to start from this point. Although willing to compromise, we did not want to abandon our original plans in favor of those they preferred. Given the effort of the Krugler task force, the HSMC staff worked hard to convince the designers and architects that we did not need or want to start over again at square one.

Further discussions focused on how to balance the overall plan. How would we successfully allow the visitors the immediacy of being within the gallery structure while at the same time keeping them in close proximity to the largest artifact that would be displayed—the house's exposed foundation? Because nearly all of the interpretive messages reverted back to activities in and around the house in one way or another, the exhibit's design would have to ensure that the visitor always felt a connection to the remains

even if they could not actually see them from all points in the gallery. Although this would not be a traditional historic house museum where one could actually walk among the rooms and furnishings, we saw the house's foundation as an eyewitness to the stories we would tell. The fact that the visitors would not be required to circulate through the exhibit in a strictly linear fashion also ensured that they could move back and forth between different areas as they chose. Where necessary, some messages would be repeated or layered in such a way that visitors would not have to interact with the interpretive themes in a chronological fashion. Our goal was to make sure that the final exhibit plan would succeed in connecting the visitor and the remains of the house and its stories. By the end of the design stage, everyone involved was satisfied that the exhibit would meet that goal.

3.6. An Exhibit Walk-Through

Visitors will arrive at the St. John's exhibit at a gateway through the fenced forecourt so that they see the south facade of the structure as it may have appeared in the seventeenth century. (Figure 3.2). They then enter the quarter pavilion, an unheated, unconditioned space that serves to orient the visitor, explain some of the metaphors to be used in the exhibit, and help them organize their thoughts for the exhibit experience (Figure 3.3). Large questions will be posed, and important individuals will be introduced to prepare the visitor for the stories we are about to tell. In addition to graphic and sign texts, this area will use an audio visual introduction and provide the visitor with time scale and time context. The transition from this zone into the actual excavated site will be accomplished by glass-enclosed areas with environmental controls that protect the site. As one continues into the glass enclosure, the extent of the archaeological site becomes apparent with a large open cellar in the foreground and the building foundations extending across the site. Wrapping around the archaeological remains on two sides is an interpretive rail. This rail holds text, graphics, interactive devices, and in some cases, actual artifacts. The site archaeological excavation area is interpreted by a number of specific

FIGURE 3.2. Elevation of proposed museum building for the St. John's exhibit. (Courtesy Historic St. Mary's City)

devices. The most significant of these is a partial reconstruction showing the progression from the archaeological remains to the building frame and finally, to the fully clad building with windows, doors, and plaster. This progression of reconstructions stretches across the exhibit building and is carefully lit to highlight specific architectural features, which relate to the archaeological findings. While first seen from this perspective, the building frame and its relationship to the archaeological remains continues throughout the exhibit with interpretive signage and visitor-triggered interpretive lighting. The visitor will learn that the main house at St. John's was built much like contemporary structures in England and represented a huge investment in materials and labor.

As one moves around the edge of the cellar, the visitor path becomes a bridge that passes over the corner of the cellar where the detached kitchen is closest to the main house. The kitchen, like the main house, has an interpretive rail containing graphics and text. Partial recreation of the building's structure is indicated and the archaeological features are highlighted. The kitchen is a very different building from the main house and shows how colonists adapted their architectural traditions to a frontier setting. The entire back wall of the kitchen is designed as a screen where stories about the house can be projected along with ambient sounds of life from this, the most functional of buildings. Like the interpretive rail in the main house area, the rail in the kitchen will contain the controls for the interpretive lighting and also scenario selections for video vignettes.

Returning to the main house, the ways archaeologists interpret architecturally what they find in the ground, will be conveyed by the text, graphic,

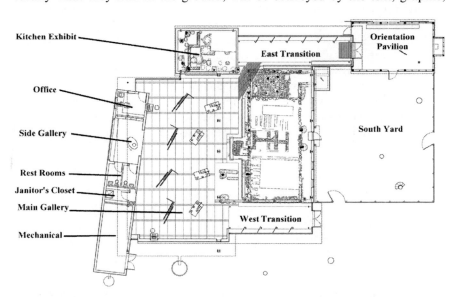

FIGURE 3.3. Plan for the St. John's exhibit. (Courtesy Historic St. Mary's City)

and spotlighted reconstructed features. Archaeological time and the fact that we see the modifications of a 60-plus year existence in the archaeological record will be taught through these various devices. We will stress that we are not looking at a frozen moment in time but instead an accumulation of lives and experiences as expressed in that record. Specific elements that will be explained include a small dairy cellar from early in the building's life, super-imposed chimney bases showing change in the main structure, and the addition of a lightly framed room called the nursery. One particular type of device we are using at the St. John's site is a lenticular screen. With a lenticular screen, two or more images are superimposed and printed in such a way that depending on the location of the viewer, two different scenes representing two different time periods appear. The visitors need only to move their perspective slightly to produce the image shift.

Moving away from the interpretive rail and the excavated archaeological remains, the visitor will encounter a range of exhibit cases which will be used to explore increasingly "bigger story" ideas. The transition from the displayed remains into these significant ideas will begin with a series of object cases that address the various occupants who lived at St. John's throughout the seventeenth century. These cases are organized chronologically by the households who lived at St. John's. The cases will contain artifacts that relate to the story of each household and how it fits into the entire story of St. John's. The households of John Lewger, St. John's builder, Simon Overzee, a merchant of Dutch descent, Charles Calvert, the colony's governor and eventual Lord Baltimore, and the various innkeepers who used the house in the later seventeenth century will each be featured. How they used St. John's will be explained and illustrated by the artifacts discovered on the site (Figure 3.4).

Following this series of household cases, even larger ideas that relate to the various legacies and consequences of the seventeenth century experience will be conveyed to the visitor in a combination of text, graphics, and artifacts. St. John's witnessed the early stirrings of representative democracy in America. The initial meetings of the assembly, Margaret Brent's demand for a vote, and Mathias De Susa's participation in the assembly all speak to a legacy of democratic interaction. A second major concept to be conveyed in this area is freedom of conscience and the right to worship freely. Another type of freedom to be discussed in this part of the exhibit is the freedom to succeed. Maryland, like all colonial ventures, had a strong capitalist drive which expressed itself as freedom of opportunity. The challenges of the new colony and her polity are also discussed within this part of the exhibit along with those presented by a diverse, multicultural society. Maryland was part of a larger Atlantic world with players from three continents interacting with extremely varying levels of power, access, and control. In addition to the graphics, text, and object illustrations used to convey these concepts, we will also use multimedia, both sound and video, to tell these stories.

An important theme, which permeates throughout the visitor experience at the St. John's exhibit, will be the notion of adaptation. The English colonists

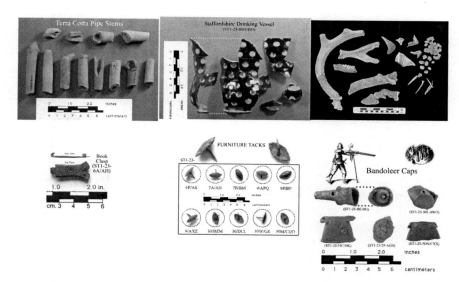

FIGURE 3.4. Examples of artifact to be used in exhibits detailing households at St. John's. (Courtesy Historic St. Mary's City)

and other Europeans adapted to the natural environment that was the New World in many different ways, and in turn, intervened in that natural environment. The idea of adaptation runs through all the elements of the exhibit but is particularly brought into focus by a series of installations which allow the visitor to see the "cultural baggage" brought into the New World and how it needed to change. Specifically, the types of buildings that provided the prototypes for the new houses to be built in Maryland will be explained, and how, through time, elements of various housing traditions became dominant in various geographical areas. The issue of human impact on the natural environment will be investigated in its own small gallery space. A series of computer generated "fly-throughs" will show how the environment changed over time while text, graphics, and objects will show how archaeologists can document environmental change through animal bones and other remains.

The final elements of the St. John's exhibit offer the visitor some answers to questions raised elsewhere, and point to the various important questions that can still be explored archaeologically on a site like St. John's when care is taken to preserve as much of the site as possible. Answers to the questions "what happened to . . . ?" will be addressed with brief statements about what the various *dramatis personae* did after they left St. John's. The final element of this part of the exhibit is what we have referred to as the "archaeology" wall. Here, ideas about archaeological dating change through time, and the potential for additional research will be explicated. This element of the exhibit will include a special artifact case that recreates the strata within a cultural deposit, with a separate drawer holding the artifacts from each

stratum. We have chosen a feature near to the heart of all archaeologists for this special exhibit—a filled privy.

Following this very intensive experience of history and archaeology, we want to offer the visitor a little decompression time as they exit the building. We will remind them of the big "takeaway" stories we have introduced, but primarily we will ask the visitor to reflect on the stories and take a moment to reabsorb the setting. The visitor will exit into the same forecourt they entered through originally to give them the sense of having come full circle.

3.7. Conclusions

Developing a public interpretation of an archaeological site is always a daunting task—how much of the story is about the site and how much is about the archaeology? Developing a public interpretation of the St. John's archaeological site was particularly difficult since the site has been under archaeological analysis for nearly 30 years—close to half the time the site was actually occupied. We have far too much detail to share it all with the visitor, but the richness of the story could not be abbreviated into a postcard version. This tension as to how to proceed led to an interpretive framework which recognized the actual archaeological site as a huge, multifaceted artifact which encompassed the entire story of the seventeenth century in St. Mary's City. Many important stories could be told at this site, but we had to decide if these stories could be as effectively told elsewhere in the museum or with other forms of media. By starting with the site as an artifact, we could then transition from the truly down-to-earth aspects of life at St. John's in the seventeenth century as manifested in the ground to the more cerebral and revolutionary ideas which emanated from Maryland's seventeenth century experiment.

From a practical perspective, HSMC was very well situated to create a worthwhile exhibit experience with the St. John's archaeological site. Staff members include the historian and archaeologists who know the site extremely well, and also specialists in public interpretation with lengthy experience working with our story and the visiting public. There was much more information than an exhibit could ever hope to convey, as well as strongly held staff ideas about the basic metaphors we wanted to use. It was sometimes a challenge to convince the architects and designers that we knew the story and our audience better than they did. This is not to imply that their expertise was not useful. The architects suggested new materials we had not considered. The consultants provided very meaningful input about what was practical and feasible, particularly in regard to how to control the environment to best preserve the archaeological remains. Design proposals for effective means of conveying ideas were quite helpful. We particularly benefited from consultation with audio visual experts. Their insights into effectiveness and durability were essential as we entered into areas far outside our expertise.

Our exhibit planning and development process may provide two take-away lessons for other museums that decide to develop a large archaeology-based exhibit. The first of these is to be true to your site and its mission. Working daily with the issues of discovering and conveying past stories to a range of constituencies hones the skill of the staff in ways that no consultants can ever approach. It is the staff of the institution who will be responsible for actually making the exhibit work, after the consultants have moved on to another client. The second lesson from the St. John's exhibit development process is to remember that if the site is important enough to interpret, it is important enough to preserve. A site that is destroyed in the process of telling its story is a site lost from future research. We are avoiding this conundrum at St. John's by making preservation a major part of the story and will continue to study this unique artifact for many years to come.

References

Beaudry, M.C., Long, J., Miller, H.M., Neiman, F.D. and Stone, G.W., 1983, A Vessel Typology for Early Chesapeake Ceramics: the Potomac Typological System. *Historical Archaeology* 17(1):18–43.

Carson, C., Barka, N.F., Kelso, W.M., Stone, G.W. and Upton, D., 1981, Impermanent Architecture in the Southern American Colonies. *Winterthur Portfolio.* 16(2–3):135–196.

Falk, J.H. and Dierking, L.D., 1992, *The Museum Experience.* Whalesback Books, Washington, DC.

Henry, S.L., 1979, Terra-Cotta Tobacco Pipes in 17th-Century Maryland and Virginia: A Preliminary Study—1600–1720. *Historical Archaeology* 13:13–37.

HSMC, 2001, *Historic St. Mary's City Interpretive Master Plan.* MS on file, Historic St. Mary's City, St. Mary's City, MD.

Hurry, S. and Keeler, R., 1991, A Descriptive Analysis of White Clay Tobacco Pipes from the St. John's Site in St. Mary's city, Maryland. In *The Archaeology of the Clay Tobacco Pipe XII. Chesapeake Bay*, edited by P. Davey and D. Pogue. Liverpool Monograph in Archaeology and Oriental Studies No.14, the British Archaeological Reports International Series 566 (1991). B.A.R.122, Banbury Road, Oxford, UK.

Keeler, R., 1977, *The Homelot on the Seventeenth Century Chesapeake Tidewater Frontier.* Ph.D. dissertation, Department of Anthropology, University of Oregon.

Kent, B., 1988, *Making Dead Oysters Talk Techniques for Analyzing Oysters from Archaeological Sites.* Maryland Historical Trust, Crownsville, MD.

King, J., 1988, A Comparative Maiden Analysis of a Household and Inn in St. Mary's City, Maryland. *Historical Archaeology* 22(2):17–39.

Miller, H.M., 1984, *Colonization and Subsistence Change on the 17th Century Chesapeake Frontier.* Ph.D. dissertation, Department of Anthropology, Michigan State University.

Neiman, F.D., 1990, *An Evolutionary Approach to Archaeological Inference: Aspects of Architectural Variation in the 17th-Century Chesapeake.* Ph.D. dissertation, Department of Anthropology, Yale University.

Stone, G.W., 1977, *St. John's Archaeological Site: Draft Exhibit Plan.* MS on file, Historic St. Mary's City, St. Mary's City, MD.

Stone, G.W., 1982, *Society, Housing, and Architecture in Early Maryland: John Lewger's St. John's.* Ph.D. dissertation, American Studies Department, University of Pennsylvania.

4

The Archaeology of Conviction: Public Archaeology at Port Arthur Historic Site

Jody Steele, Julia Clark, Richard Tuffin, and Greg Jackman

4.1. Introduction

The Port Arthur Historic Site, located in the state of Tasmania, is popularly regarded as one of Australia's foremost heritage tourism attractions. Attracting over 250,000 visitors every year, the historic site is a 'must see' destination for tourists coming to Tasmania (Port Arthur Historic Site Management Authority [PAHSMA] 2005: 26). Visitation reaches a peak during the summer months of January and February, when over 1,500 people visit the site per day. It is during these months that conservation management at Port Arthur is at its most visible. Each summer, Port Arthur's Conservation Department conducts an annual interpretation program that encompasses Public Archaeology, architecture and education.

Running since 2001, the Port Arthur Public Archaeology Program has become a key component of the historic site's summer activities. Built around the framework of a full-scale research excavation, the program utilises hands-on public excavation, site tours, trenchside signage, and museum displays to convey key archaeological messages to visitors. It is the intention of this paper to discuss how Port Arthur formulates and delivers its archaeology program. (Figure 4.1).

4.2. A Laborious Past

The Port Arthur penal settlement, established in 1830 in the first decades of Tasmania's European settlement, began its life as a small timber station on the geographically isolated Tasman Peninsula, in the colony's southeast. The combination of plentiful natural resources and the utilisation of the station for re-offending convicts, resulted in an exponential increase in settlement size and population: from a camp with a mixed bag of prisoners and guards, to a thriving industrial prison with over 1,100 convicts working as blacksmiths, carpenters, shoemakers, tailors, timber-getters, stonemasons and gardeners. Overseeing their activities was the military

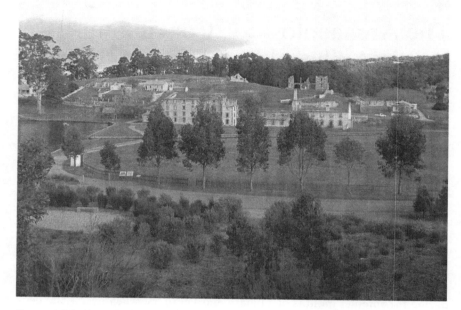

FIGURE 4.1. Port Arthur historic site today. In the foreground is the site's most imposing structure representing the settlements penal days, the Penitentiary Behind on the hill top is the ruin of the hospital, whilst the Commandant's house can be seen at the far left. (Photo: J. Steele, 2005.)

detachment and police constabulary; along with men of religion and medicine (Figure 4.2).

The end of convict transportation to Tasmania from Great Britain in 1853 caused a slow decline in the settlement's convict population. However, due to the remunerative nature of its industries, the Port Arthur settlement was able to remain operational for a further 24 years; finally closing as penal institution in 1877. Post-closure, the land was subdivided for sale, the resultant patchwork of privately owned allotments renamed Carnarvon.

The closure of the penal settlement heralded the end of the convict period and ushered in a phase that has continued unabated to the present day: tourism. Arriving initially by pleasure steamer and later by road, the public that had hitherto been barred from the penal peninsula began to arrive in droves. Carnarvon, set amidst the ruins of a sensational convict past, acquired the trappings of a tourist town.

In 1915, the first portion of the township was gazetted as a historic site, the remainder of the main settlement being resumed by the state over the following decades. By 1979, with the establishment of the Port Arthur Conservation and Development Project (PACDP), a fully fledged Conservation and Interpretation program was underway at the historic site. The site has been managed since 1987 by the Port Arthur Historic Site Management

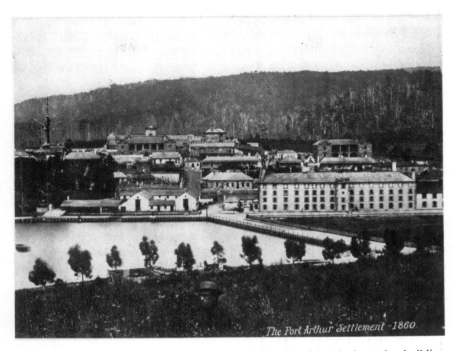

FIGURE 4.2. Port Arthur settlement in 1860. The Penitentiary, the imposing building in the foreground right, the hospital high above on the hill behind. The military barracks and semaphore are top left. (Source: PAHSMA#1853.)

Authority (PAHSMA), a Tasmanian Government Business Enterprise, which is charged with conserving, researching and interpreting its rich convict past.

As part of the national convict story, Port Arthur assumes an important place in the history of Australia. It is a window into the lives of the convicts, free men, women and children who did time within its boundaries and the system that brought them there. The buildings and ruins that dot the landscape also serve as reminders of post-convict uses and meanings; of a thriving tourist town set amidst the ruins of a past that has sat curiously, but uncomfortably, within the present. Today, archaeology is helping us to understand convict period lives, to challenge accepted myths about the convict past, and to make the past and its study relevant to the wider public.

4.3. Archaeology at Port Arthur

Over the past 50 years, archaeology as a field of study has progressed through a number of paradigm shifts. Growing from roots steeped in culture history through an adolescence of reactive positivism, the discipline has matured to be more accepting of the perspectives and claims of others. It is arguably more reflexive and welcoming of other potential uses and meanings of

places and objects. In doing so, it has gone from a largely elitist discourse to a more inclusive discussion about archaeological resources and knowledge. This democratisation of archaeology has occurred largely in tandem with evolving notions of contemporary cultural identity and the construction of 'useful' heritages (Carman, 2002).

The changing appreciation of the potential historical and social facility of archaeological residues has fostered increased public veneration of 'the archaeological heritage', giving rise to a strong resource preservation and rescue movement (Lowenthal, 1998). Paradoxically, this has led to a reaction against pro-active research in many quarters, following the rationale that the remaining *in situ* resource was either too precious to interrogate invasively and ought to be retained intact for posterity, or was the exclusive domain of a particular group (Baram and Rowan, 2004:3–26). In more recent times, initiatives such as public archaeology have helped bring archaeologists and heritage consumers together, to share and discuss their respective claims to resources and knowledge and develop the ground rules for exploring divergent perspectives. All of these disciplinary developments are historically visible at Port Arthur. Over time they have moulded the resource, prescribed its stories, and defined its audience.

Archaeology has been carried out at Port Arthur for 30 years; however, the chief constituents of the fabric resource and the principal driving force behind its historical management are the product of a deep vein of popular heritage consciousness. The reserve embodies celebratory notions of Tasmanian self-identity, which over the past century have centred on the imagined role and significance of Port Arthur in the social development of the Tasmanian community; one that was perceived to have evolved from a pack of thieves into a free and prosperous society (Reynolds, 1969). Before the advent of archaeological studies in the 1970s, those aspects of Port Arthur's physical fabric that were retained or conserved comprised the visible heritage of that imagined triumphal trajectory, exemplifying the foundation myths that were necessary to justify the reactive politics and morality of the post-convict period. Those aspects of the fabric that did not meet the aspirational needs of the late nineteenth and twentieth centuries were erased, ignored or transformed (Young, 1996).

Archaeology commenced at Port Arthur in 1977 with excavations by the University of Sydney on the site of the first Prisoner Barracks. While this involved undergraduate students, it was not until 1982, under the aegis the PACDP, that large-scale archaeology involving public volunteers became a regular summertime activity at the site. Recommencing in the early 1990s, and running annually since 1998, the Archaeology Summer Program and associated Public Archaeology program are key elements within the overall site conservation strategy and provide an important opportunity for re-engaging with visitors and the Tasmanian community on a range of historical and contemporary social issues (Figure 4.3).

Effectively managing the archaeological values of the historic site involves both stewarding the physical resources and facilitating the processes of

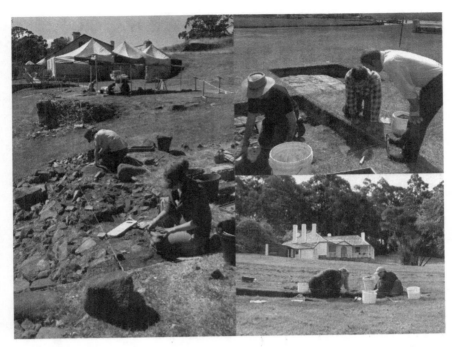

FIGURE 4.3. Archaeological excavation at Port Arthur. Port Arthur has hosted many successful Summer Archaeology Programs. Clockwise left to right: excavations of the Chaplain's Quarters in 2006; Workshops site in 2003; Dockyards in 2004. (Photo: PAHSMA 2006, J. Steele 2003, PAHSMA 2004.)

archaeology; which encompass all elements of research, conservation, communication and outreach. These core archaeological management functions are defined in the key statutory and planning documents for the reserve. The most specific planning document is the *Archaeology Plan* (PAHSMA, 2003). The *Archaeology Plan* coins a Statement of Archaeological Significance for the site that in turn supports over 40 broad-scoping policies and 11 allied implementation programs for creating knowledge, managing resources, site interpretation and community engagement.

The *Archaeology Plan* reflects the increasing public expectation that archaeology should be accessible and relevant to the wider community. This has significant benefits for archaeology at the site. Sharing the archaeological experience through a range of approaches that cater to differences in ability, interests and learning styles, enables

Sidebar #1

Port Arthur Statement of Archaeological Significance

The archaeology of Port Arthur encompasses the structures, deposits, objects and cultural landscapes that hold meaning for modern

public participation in the process of creating knowledge about the past, which empowers individuals to challenge established notions and accepted histories, and thereby better understand and shape the society in which they live. An inclusive process also increases public awareness and appreciation of the archaeological disciplines, which can translate into political support for research programs, site conservation and further outreach. This extends the skill base and remit of archaeological inquiry, promoting both methodological rigour and theoretical vitality.

4.4. Interpretation and Archaeology at Port Arthur

Of the 250,000 visitors who visit Port Arthur annually, over 70% take the Introductory Walking Tour. Each of these tours refer to some extent to archaeology as a fundamentally important means of knowing and understanding the evidence of Port Arthur's past. Port Arthur has adopted the thematic approach to interpretation initially developed by Freeman Tilden (Tilden, 1957:3–11) and refined and systematized by Ham (Ham, 1992: 3–33). Using the thematic framework for developing and delivering programs, each archaeological

communities because of their capacity to connect people with Port Arthur's past. Aboriginal, penal and post-convict fabric and associations are melded together at Port Arthur, positioning archaeology as the principal means by which the many stories written into the fabric of the place may be explored, and perspectives shared.

At the present time, the principal value of archaeology at Port Arthur relates to its research potential to yield insight into the varying experiences, life-ways and operations of the convict system, and the ways in which our own lives are shaped by the legacies of that system.

The physical resources amenable to archaeological research are unique, finite and unrenewable, and can contribute information not available from other sources. The universe of potential research questions is infinite, and those asked will evolve and change. The Port Arthur archaeological resource is significant because of things we have wanted to know in the past, desire to know now, and may wish to know in the future about Port Arthur and its place in the World.

Archaeology at Port Arthur is an essential tool for enabling people to experience and participate in the processes of learning about the past.

Port Arthur is an important place for teaching and learning about archaeology (PAHSMA, 2003).

interpretive activity is based on a theme, or take-home message. The theme for each activity is developed in discussion between the Managers of Interpretation and of Archaeology. It may be a message about the process and importance of archaeology itself, or about the site or sites on which the archaeologists are currently working. At the Point Puer boys' prison,

for example, the theme is Point Puer as the site of a bold social experiment; it was the first prison built for juvenile male offenders in the British Isles. On the guided tour of that site, every guide uses that theme in their introduction.

Eventually the thematic approach will make its way into signage. The new guide book is also based on a theme, that Port Arthur was designed as 'a machine for grinding rogues honest', Jeremy Bentham's prescription for his Penitentiary (Clark, 2005: 2). These themes are periodically reviewed for the purposes of refinement, but have not been changed since they were introduced. The signage system is now some years old and when it is renewed it will also refer, although not always directly, to elements of the theme. For example, the cogs of Bentham's reforming machine include work and trade training. These will obviously form the key messages on any new sign for the Industrial complex, which is an archaeological site.

The archaeological evidence is also fundamental to the reinstatement of vanished elements in the landscape. In the development of an interpretive programme for a particular precinct, archaeological evidence is added to the heady mix of documentary, pictorial and perhaps oral evidence to provide key guidelines to what was found where. As a result, building footprints, fences and paths can be reinstated with a fair degree of confidence. Such a process is currently being undertaken in the formerly busy precinct that was Port Arthur's dockyards (Inspiring Place, 2005).

While the message about the fundamental importance of archaeology to everything we do is most commonly communicated to our visitors, to which we find they are attentive and receptive, it is also a critically important message for other stakeholders. These range from the immediate local community to Government. PAHSMA has in the past been the focus of criticism that far too much money and time is spent on activities for which, to outsiders, it seems to have nothing to show. It may be clear to even the most casual interest when, for example, the Government Gardens have been reconstructed; but few realise that meticulous planning and research are essential for the satisfactory outcome of such a project. Once we are able to explain and describe the kinds of archaeological and other research that have gone into such a project, visitors, including government ministers, key public servants, journalists and other opinion makers, are both comforted that their funds have been well spent and fascinated with the processes themselves.

By making the archaeological process a significant part of our interpretive program we are able to demonstrate the kind of evidence that archaeology yields, the interpretation of that evidence, the fact that it is a resource-intensive activity that, ideally, leaves no trace, but instead provides unique information that makes an essential contribution to successful conservation.

While archaeologists know and love every detail of every dig, interpreters must not blind themselves to the fact that interpreting archaeology is a very special challenge. Few of Port Arthur's guides have any background in archaeology, so they are the first audience that needs to be

informed, inspired and motivated. Although a public archaeologist is on site during the dig season to coordinate the major activities, visitors also ask regular guides about archaeology at Port Arthur and what they can see happening in trenches at various points of their Introductory Tour. Ways must be found to help the guides deal with those questions confidently and interestingly.

This is a real challenge to their normal mode of interpretation which, given the shortness of the Introductory Tour and the abundance of standing structures, tends towards the 'See and Say' approach. When they cannot see what they need to interpret, or they can only see a tiny ruinous fraction of it, it requires a considerable shift in focus and approach. If groups are small enough, guides might pass around photographs. We are trying to avoid littering the landscape with more signs, which are both ugly and intrusive, and serve to 'museumify' the place. If the place did not feel dead before the signs went up, it will afterwards, like a butterfly in a museum drawer. We hope, through good archaeological interpretation delivered face-to-face, to convey our message in ways that visitors find more enjoyable and more accessible than reading signs.

Carefully integrated into the wider interpretive approaches of the historic site, Port Arthur's Public Archaeology program can raise awareness of archaeological, conservation and interpretation issues at the site, as well as enhance the acceptance and development of historical archaeology at state and national levels.

4.5. Public Archaeology at Port Arthur

Port Arthur Historic Site implemented its first official Public Archaeology program in 2001, the program playing a vital role in the annual Archaeology Summer Programs ever since. For the past five archaeology summer seasons (2002–2006), over 22,000 visitors have been involved in the Public Archaeology program on varying levels: be it through tours, public excavation or trench-side talks. In

Sidebar #2

Learning to Use Archaeology in Interpretation without an Archaeologist

Lack of alternatives to the 'see and say' method has been a major issue for the guides who take tours at Point Puer, the Boys' Prison site, which is an archaeological site with few visible remains. Most guides stand in front of those remains and, while gesturing in their direction, essentially deliver a history-based tour derived from documentary sources. Guides have found actively and imaginatively with the archaeological resource difficult to achieve and more training and support is required.

Learning to understand and 'read' the archaeological resource is an important component of Port Arthur's new curriculum-focused education program. Students will not necessarily

combination with the trenches excavated as part of the research and conservation program, the Public Archaeology trenches are a window into Port Arthur's hidden past.

Despite their keen interest, members of the public can often be a hindrance to archaeologists working to a strict deadline. Taking time out of a busy excavation schedule to repeatedly answer questions from interested laypeople is often just not feasible. However, as is argued throughout this whole publication, it is absolutely necessary.

participate in excavations, but will work with the resource in other ways to explore self-generated questions. For example, to understand the living conditions of the boys at Point Puer, students will survey the foundations of the barracks building and, having ascertained how many boys slept there at any one point in time, and the space allocated for sleeping, will plot the layout to assess privacy, health and hygiene, personal safety, etc.

Well-executed Public Archaeology can educate the public towards the discipline, help encourage support for archaeology and share new knowledge. The Port Arthur Public Archaeology Program is designed with several objectives in mind:

- to foster an understanding of cultural heritage management practices, educating visitors towards the worth of the discipline and its role in conserving the heritage of Port Arthur.
- generate and share new knowledge pertaining to the convicts, civilian and military population of the prison settlement.
- allow archaeologists carrying out research and management excavations on the historic site to concentrate on the excavation by drawing 'first contact' tourist questions, thereby
- to ensure that visitors are more archaeologically aware in order to positively inform further questions.
- create an 'experience' that visitors will remember.

To ensure the smooth running of the public program, it is essential that the program be conducted by an archaeologist with a comprehensive knowledge of the historic site, Port Arthur archaeological procedures and the site's approach to public interpretation. This is not to say that volunteers or non-archaeologists should not be involved in the interpretation process, but rather, in order to ensure only correct information is being disseminated, a professional archaeologist must be placed in charge of the program. It is essential that the program manager have a good grasp of public interpretation and the importance of making things understandable to the layperson. The archaeologist who overuses scientific jargon is an archaeologist without a public.

The target audience should also be identified. At Port Arthur a great variety of visitors pass through the historic site: from 'tag-along' bus tour groups, to those with a genuine interest in the site and its history. Few come to the site

with a primary desire to see archaeology, unlike those who attend dedicated archaeological sites or museums. Therefore Port Arthur's Public Archaeology program must be designed to cater for an audience approaching archaeology from a range of backgrounds and at a variety of levels. This diversity of visitor interest is accommodated by offering an array of activities with differing levels of interpretation; ranging from basic to detailed.

Yet, no matter how diverse the visitor population, the public archaeologist should be ready to counter a handful of frequently asked questions:

- What are you looking for?
- Have you found any gold?
- Are you looking for dinosaurs?
- What is the best thing you have found?
- That must be exciting!
- What are you expecting to find?
- How did you know where to look?

If these and other basic questions can be answered, the process explained and discoveries shared, by the time visitors come into contact with the other project archaeologists working on the site, the visitor will have formulated questions of a more specific nature.

During the program, the public archaeologist is tasked to run at least one trench; though they very often supervise more. The number of trenches opened is governed by the aims of both the public program and the overarching research, conservation and interpretive framework. Two archaeological supervisors are a minimum requirement to manage the trenches, with volunteers being rostered from the concurrent research and conservation excavations.

The public trenches are designed to comply with the established research objectives of the historic site. The positioning of trenches must be carefully considered. This is for the protection of the site, sensitive deposits and the safety of the public. The site must be easily accessible. In order to allow members of the public around and into an archaeological trench, the archaeologists need to be sure that the site will not be damaged and the research aims not compromised. Therefore a robust area with sturdy deposits and stable foundations and/or robust stratigraphy is desirable.

At the end of the season the public archaeologist must produce reports as per standard archaeological procedures. With a need to juggle both the public aspect of their excavation and a research and conservation imperatives makes the job of the public archaeologist one of the hardest on the historic site.

4.6. Reading the Signs

The simplest archaeological interpretative tool used during the public program is on-site signage. However, as mentioned, this method should not be overused to avoid 'littering the landscape'. These signs should be placed at the first point of contact between visitors and the archaeological areas. The signs enable visitors to understand what it is that the archaeologists are doing, as

well as answering the initial questions that visitors ask: 'what are you looking for?' and 'what are you hoping to find?' The signs also should include an abridged history of the specific site, as well as images highlighting changes to the site over time. These images help the visitor better understand site change, locating the archaeological site in the landscape. On a practical level, the signage is temporary, waterproof and encased in sturdy frame. Importantly, the content can be quickly and easily modified as new information comes to light (Figure 4.4).

With their initial questions answered by the signage, some visitors may be satisfied and feel no further need to interact with the archaeologists. Other visitors may still want to pursue a line of questioning. With the background knowledge obtained from the signage, visitors often feel more comfortable enquiring in more detail about the work being conducted. This higher level of base knowledge results in more informed questions. This helps the archaeologists to avoid the frustration of the common questions and opening witticisms, allowing for a more constructive and comprehensive discussion.

FIGURE 4.4. Answering the questions. Visitors reading signage explaining the research and purpose behind one of the excavations. Flash cards serve as a useful mechanism for updating recent finds. (Photo: T. Owen, 2003.)

4.7. Touring the Trenches

Archaeological site tours are one of the most popular components of Port Arthur's public program. These tours enable visitors to be introduced to many of the stages involved in archaeology at Port Arthur: including geophysics, excavation and artefact processing. The tours also encompass sites where archaeological work has resulted in interpretive advances, demonstrating how archaeological results feed historical interpretation. Tours enable visitors to see the site from a different perspective and help non-archaeologists understand how archaeology helps tell the story of Port Arthur's past and by implication, reconstructs historical meaning more generally. Conducted by an enthusiastic knowledgeable professional archaeologist, the tour can also help encourage both understanding and support for the discipline (Figure 4.5).

Like all tours conducted at the historic site, the Public Archaeology tours begin at the Visitor Centre, an easy locale for visitors to congregate. Most years, the group is first led into the site's Government Gardens. The garden is

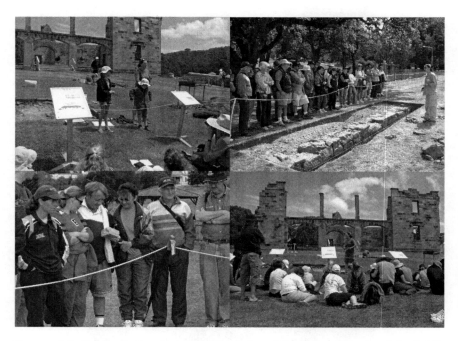

FIGURE 4.5. Public Archaeology at Port Arthur. Clockwise from top left: Public archaeologist Jody Steele uses volunteer children from the audience to explain geophysics; Jody taking a tour via a fully excavated trench highlighting what is buried beneath the site's grassy oval; visitors relax as the public archaeologist explains the excavation; the tour group inspects a convict thumb print in a Port Arthur brick. (Photos: T. Owen, 2003; A. Murphy, 2005.)

one of Port Arthur's premier examples of how archaeology can assist interpretations of vanished elements at the site. Archaeology was conducted throughout the gardens in the late 1990s and, as a result of excavation and palynological analysis, the garden has been fully replanted, re-pathed and reconstructed to represent the garden of the mid-1800s (Clark and Viney, 2002).

The garden stop provides a perfect opportunity to talk with the group to ascertain their level of interest and knowledge of archaeology, building a rapport with the audience. The broad aims of that season's archaeological works are explained, without the distraction of live archaeology occurring in the background. The first stop also allows the archaeologist to explain many of the pre-excavation techniques.

As mentioned, it is important that the dedicated Public Archaeology trench is the first 'real' archaeology that visitors encounter. When the visitor encounters the other excavations, their thirst for archaeological knowledge has been somewhat sated, allowing the archaeologists to work relatively free of the 'uniformed' line of questioning. During the tour, moving from the completed project of the gardens to the active Public Archaeology trench site allows the visitors to better understand the process of conducting an archaeological project at Port Arthur from inception to completion. Whilst at the public excavation, the group can be instructed in the detailed procedures and methods of excavation and artefact recovery. It also allows discussion of the post excavation processes involved. Tools and techniques are discussed and demonstrated; the visitors are encouraged to ask questions about the site and the work.

The public trench stop on the tour route also enables the archaeologists to show some of the finds recovered from the excavations. Showing a variety of artefacts is a crucial part of this component of dialogue; highlighting to visitors that even items that may seem insignificant and fragmentary can tell a story. This is the opportunity for the archaeologist to challenge perceptions about the 'worth' of finds, stressing the importance of protecting all deposits, including those that may seem 'uninteresting' to the untrained eye. Rusty nails can tell as much of a story about the site as an intact bottle.

The archaeology tours are a great opportunity for archaeologists to explain the rationale, process and results of archaeology at Port Arthur. However, there is no guarantee that a tour, no matter how well-conducted, will have a long-lasting impact on those who take part. Visitors should ideally take home an 'experience' from Port Arthur, something that they will always remember. In this vein, the public excavation plays an enormously significant role in the program.

4.8. Experiencing the Past 'First-Hand'

The public excavation allows members of the public the opportunity to experience archaeology, and in essence, experience the past. It is a chance for the archaeologists to share their passion, whilst instilling in the public an

appreciation of the skill, patience, and discipline required to run and acquit an excavation.

It is vital that the public excavation is well-supervised. It is the role of the public archaeologist to ensure that the public excavation satisfies Port Arthur's research objectives, protects the archaeological integrity of the site, and meets public access and safety requirements. Two supervisors are at the dig site during the excavation, as well as a number of archaeology volunteers rotated from the other archaeological works. Supervision ratios are usually kept lower than 1:3, allowing the archaeologists to build a relationship with the public excavator, as well as supervise the proceedings. Though the ratio limits the number of public allowed in the trench at any moment, such is the appeal of public excavation that visitors will often wait for their turn at excavating. During this process of waiting they will often read the signage, making for a more informed experience.

Before any member of the public steps into a trench they are given a demonstration of digging techniques (even if they were on an earlier Public Archaeology tour) by one of the supervising professionals. They are instructed on the rules of the site and safety issues associated with excavating (such as trip hazards and sharps) and then given a trowel, brush, pan and bucket. Although designed originally as an activity for children, it soon became apparent that unless the parents were also invited to have a go, it was not long before the kids were standing trenchside whilst their parents 'showed' them what they were supposed to do!

Once given a task within the trench, the public 'volunteer' is supervised at all times in order to maintain the excavation's integrity and to offer guidance. As the intention of the excavation is first and foremost archaeological research, leaving members of the public to carry out the excavation for extended periods of time is not desirable. Allowing them to excavate for as long as it takes to create a bucketful of dirt to sieve is a good way of controlling the amount of dirt moved. This restriction lowers the impact of untrained excavators, whilst allowing archaeologists to cycle through visitors who are interested in participating. Obviously these factors are heavily subject to visitor numbers, site sensitivity and time (Figure 4.6).

The public excavation is designed to give a brief structured introduction to fieldwork. Although excavation is often the drawcard, it is not the only activity that people can be involved in. Sieving is the easiest to conduct with a public 'volunteer' and lends itself to the excitement of discovery. Using a hand sieve, children need assistance to support the weight of a bucket of soil, therefore lending to a shared activity with a parent, sibling or friend. Sieving enables visitors to understand the painstaking as well as selective process involved. Once the artefacts are recovered from the sieve, they are sorted into the appropriate contextual and typological categories for bagging.

The public excavation allows visitors to get their hands dirty and experience the intimate processes of a discipline, which is often hidden from the public. It is a chance to allow the tactile senses to create a memory, and perhaps recover

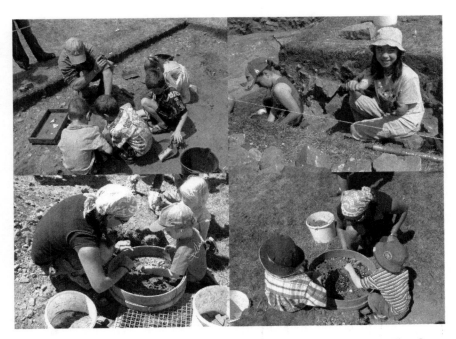

FIGURE 4.6. Public excavation. Clockwise from top left: archaeologist Tim Owen closely supervises a team of 'little' volunteers; regular public program excavation enthusiasts—local children Maddy Kube and Heather Howard; archaeologist Jody supervises some small sievers. (Photos: J. Steele, 2003 and A. Murphy, 2005.)

a piece of the long lost past. The public program offers the opportunity for visitors to experience the past first hand.

4.9. Showcasing the Recovered Past

Many visitors to Port Arthur wish to experience the site on their own, without following tours or participating in structured activities. The establishment of an archaeology exhibit gives these visitors a chance to encounter artefacts and information recovered from prior seasons. Usually containing three or four cases, the exhibits walk visitors through the excavations, their history, discoveries and interpretations. This component also allows visitors who have participated in the tour or excavation to see some of the results of the archaeological work and how new stories are told through every excavation.

In addition to the exhibit, the public program also allows visitors to follow the progress of excavations after they leave the site through a website. This enables visitors, or other interested members of the public, to see new finds, new interpretations and follow the progress of the archaeological projects. The website includes histories of the individual projects, the process of the

excavations and some of the more interesting finds of the season. This creates an easily accessible resource for both the public and other archaeologists. The website is online at: http://www.portarthur.org.au and is found by following the archaeology links.

4.10. Conclusion

The Port Arthur Public Archaeology Program (2001–2006—a total of 25 weeks) has involved the participation of more than 22,000 visitors. All these thousands of visitors—members of the local and wider Tasmanian community, inter-state tourists and international travellers—have one very important thing in common: an interest in the past, and the eagerness to understand how archaeology can help in recovering forgotten information and meanings.

Archaeology is a fantastic means for gaining public interest and support for research and management, as well as creating a relevant and tangible history. As such, Port Arthur continues to develop its archaeological interpretation offerings. New archaeological understandings are incorporated in Introductory Tours and interpretation projects. Each year the Public Archaeology program grows with the knowledge of the previous year's successes and shortcomings. With visitor feedback in abundance, interpretation approaches are continually expanded to meet the expectations of those on whose behalf the site is managed: the public. With each year come new questions, new techniques and new visitors, meaning new opportunities to jointly explore the past and future of a place that holds such a prominent place in the national imagination.

Acknowledgements. The Archaeology Summer Program and the Public Archaeology Program have only been made possible by the hard work of many people. Jim and Christie Prichard, Tim Owen, Justine Hobbs and Melinda Button, at the frontline of Port Arthur Public Archaeology. Especial thanks to the archaeological volunteers (all 116 of you) who have participated in the program since 2001.

References

Baram, U. and Rowan, Y., 2004, Archaeology after Nationalism: Globalisation and the Consumption of the Past. In *Marketing Heritage: Archaeology and the Consumption of the Past*, edited by Y. Rowan and U. Baram. AltaMira Press, Walnut Creek, CA.

Carman, J., 2002, *Archaeology and Heritage: An Introduction*. Continuum, London.

Clark, J., 2005, *Your Guide to Port Arthur*. PAHSMA, Tasmania.

Clark, J. and Viney, C., 2002, *Gardens of Exile*. PAHSMA, Tasmania.

Ham, S., 1992, *Environmental Interpretation*. North American Press, Colorado.

Inspiring Place, 2005, *Implementation Master Plan: Port Arthur Dockyards*. Report prepared for PAHSMA, Port Arthur.

Lowenthal, D., 1998, *The Heritage Crusade and the Spoils of History*. Cambridge University Press, Cambridge, UK.

Port Arthur Historic Site Management Authority, 2003, *Port Arthur Historic Site Archaeology Plan*. PAHSMA, Port Arthur.

Port Arthur Historic Site Management Authority, 2005, Annual Report 2004–05, PAHSMA.

Reynolds, H., 1969, That Hated Stain: The Aftermath of Transportation in Tasmania. *Tasmanian Historical Studies* 14(53): 19–31.

Tilden, F., 1957, *Interpreting Our Heritage*. University of North Carolina Press, Chapel Hill.

Young, D., 1996, *Making Crime Pay: The Evolution of Convict Tourism in Tasmania*. Tasmanian Historical Research Association, Hobart.

Part 2
Ethnic Communities

Part 2
Enhancer chemistries

5
Engaging Local Communities in Archaeology: Observations from a Maya Site in Yucatán, México

Lisa C. Breglia

5.1. Introduction

How do we—whether cultural resource managers, heritage professionals, museum curators, educators, or archaeologists—measure either the significance or success of a public archaeology outreach project? Further, to what degree and upon what terms do the differently constituted "publics" of archaeological work engage in outreach endeavors? In this chapter, I present the case of a developing archaeological site, Chanmulá, located in the northwest of Mexico's Yucatán Peninsula.[1] The account I give is drawn from my ethnographic research in the site's neighboring communities over the course of their increasing involvement in the excavation work of a US-based archaeological team over the past several years. At this site, archaeologists have made great efforts toward maintaining a high degree of transparency in their motives and methods. They have reached out to the affected public by seeking local participation in the production of archaeological knowledge and the creation of tourism development plans centered on the site. Yet as these archaeologists strive toward a reciprocal engagement with the local Yucatec Maya community, a series of miscommunications and misunderstandings have arisen due in part to the complexities of cross-cultural differences in legal, ethical, and ideological realms. While local residents called into question the motives of foreign archaeologists as well as legalities of work on their communal agricultural land, researchers assume that locals would (and indeed should) welcome archaeological development—and its promises to rejuvenate the weak local economy—with open arms. While archaeologists see their work as strengthening local cultural identity by using the site as a pedagogical tool to link ancient and contemporary Maya populations, Chanmulá's neighboring residents challenge the expediency and appropriateness of this cultural continuity model. For them, "heritage" is a modern, not

[1] Name of site and affected communities I discuss here have been changed for the respect and protection of my informants.

ancient, assemblage of events, experiences, beliefs, and collective memory. Theirs is a heritage that lives on the surface of everyday life, not buried under ancient ruins (Breglia, 2006). Thus, how can archaeology present "heritage" to this public? Further, what happens when, despite its best efforts toward community collaboration, archaeology finds within its most intimate sphere of influence an ambivalent local public? Should archaeology be made relevant for them?

This case is instructive for two reasons. From experiences at Chanmulá, we learn that archaeology and its attendant interpretive hermeneutic does not always neatly coincide with or fully account for what local communities count as their "heritage." Additionally, this case gives us pause to consider the possibility that public or community outreach—though practiced with the best of intentions—may reassert rather than challenge the boundaries between archaeology and the public interest. More than a documentation of a single outreach project, the case study I discuss here points to a generalized public nature of archaeological work, especially of large-scale excavation projects on monumental structures situated within living landscapes. Additionally, this case study may productively contribute to a more generalized discussion of the factors to consider in the dissemination and engagement between archaeology and its publics across cultural and national borders.

5.2. Cultural and Historical Context of Archaeology at Chanmulá

Situated between the indigenous Maya communities of Chanmulá Pueblo (pop. 951) and Ichmukil (1,237) is the archaeological zone officially designated as Chanmulá. This zone covers approximately 16 km of mound-studded land in the Northwest of Mexico's Yucatán Peninsula, just inland from the Gulf coast. Through examination of settlement, subsistence, and household patterns, archaeologists of the US-based Project Chanmulá believe the site to represent a large, specialized trading center dating to the Classic Period (400–800 CE) of ancient Maya civilization. Though the site has a long-standing presence in archaeological record, only recently archaeologists are rediscovering the wealth of information buried within this tract of agricultural land. Presently in the site of Chanmulá, there are no entirely reconstructed buildings; only portions of walls, exposed floors, and some stairways are visible. Indeed it would be difficult for a nonspecialist to surmise what the exposed areas actually represent.

Though the existence of the ruins at Chanmulá has been recognized by explorers, archaeologists, landowners, and, of course, local residents for decades, no sustained investigation had taken place in the site before this project began excavating in 1998. Of course, for the generations of local people, the mounds were neither new nor discovered. For many (especially older)

residents from the site's surrounding communities, the mounds are part of the natural landscape,[2] present since their grandfathers' times. Thus, for local Maya, mounds are not strictly "archaeological" features upon an otherwise ordinary landscape. Here, mounds are part of an integrated landscape valued not specifically as archaeological heritage, but as what they call ejido heritage—or *patrimonio ejidal* (Breglia, 2006). This land is their ejido, or federal land granted to rural communities in the 1930s to serve dispossessed indigenous population in subsistence agricultural production. Before the establishment of the ejido system, Maya people across northern and western Yucatán were resettled from their agricultural communities onto privately haciendas dedicated to the mass production of henequen—a strong and durable hemp-like fiber which fetched high prices on the international market. More than 200 settlements such as Chanmulá and Ichmukil were henequen haciendas that for decades relied on the forced labor of Maya people through a system of debt-peonage.

Thus, for the Maya people who lived in the forced labor regime of Mexico's hacienda system through the nineteenth and into the twentieth centuries, ejido land represents a hard won heritage. More than an economic system, the ejido serves as an important organizing factor in family and community life throughout Yucatán and throughout Mexico. Thus land—how much is held, for how long, under what legal frameworks, and perhaps most important of all, by whom—is key to the organization of everyday life in these communities.

Throughout the past years of excavation work with laborers from Ichmukil, talk about the project and its members, the findings at the sites (though these have, to date, been undramatic to the untrained eye), and the excavation work itself has definitely been food for thought, and of late, is growing into terms for debate. In the latest local political contest, two factions within the same political party were divided along lines delineated by, amongst other key issues, positions favoring or opposing the archaeology project. Though the ejidatarios and other residents of Ichmukil are hearing more and more about plans beginning to be implemented by the archaeologists and their hired development consultants to open the area to tourism development, this is not a tangible reality for many community residents, who are uncertain and even unwilling to give up the ejido land—much of which lies within the new boundaries of the archaeological zone—that they have only held for two or three generations.

Currently, Chanmulá has no large architectural structures excavated or reconstructed and many *ejidatarios* (participants in the cultivation of ejido land) use this land, even the site center, for the cultivation of corn and other crops. During the time of my cultural anthropological research at the site, it

[2] Specifically, it was expressed to me that the mounds were "natural" rather than "man-made."

was not unusual to find Maya farmers from Chanmulá's surrounding communities planting maize seed atop archaeological mounds within eyeshot of excavators. Because Chanmulá is both an ancient and a contemporary living landscape, the site has proven to be a challenge for researchers, not just in an intellectual sense, but also in the everyday organizing and carrying out of excavations and other on-site work. The inception of an archaeological excavation project in the site in 1998 brought more than a new source of wage labor to these communities. Recent work at Chanmulá additionally provided an occasion upon which foreign archaeologists found it necessary to negotiate the value, import, and meaning of this land as it quickly became a zone of contestation claimed by archaeological science, on the one hand, and the weight of local history and belief, on the other.

When a US-based team of archaeologists began mapping, and later excavating the large (some up to 20 m), crumbling mounds on a stretch of communally held agricultural land between two small Maya towns in the northwest of the Peninsula, local residents immediately became involved in the endeavor. Some landholders (*ejidatarios*) joined in the work as contracted wage laborers. Schoolchildren, escorted by archaeologists, took field trips to the site only a few kilometers from their homes. Project directors, in coordination with local community leaders, organized town assemblies to discuss the work, to look at artifacts, and initiate discussions about the future of tourism development based on Chanmulá as a cultural resource. Given these multiple forms of involvement in archaeological research and development, an ongoing relationship between the archaeological project and residents of the two towns most closely flank the site (Chanmulá Pueblo and Ichmukil).

5.3. Archaeology and the Public: Complex Relations

The relationship between archaeology and local communities is simultaneously economic, legal, and ideological, each of which I'll discuss in turn below. In my assessment, the success of public outreach and involvement efforts at Chanmulá depended on the mutual recognition of the foundations and terms of these relationships, and the responsibilities held by different parties in each articulation. As we will see, this proved to be a difficult, perhaps insurmountable, challenge.

Economic: After several seasons of exploration and mapping of the site and region, Project Chanmulá, a group of archaeologists representing various US universities, undertook the employment of Maya laborers from Ichmukil in the work of clearing land, test pitting, excavation, and masonry for architectural consolidation. This hiring of wage workers represents a primary element in the economic relationship between the project and the local communities. The majority of locals hired by Project Chanmulá were employed as excavation laborers, men varying age from mid-teens to sixties.

The project also hired domestic workers—local women hired to cook, clean, and otherwise look after the needs of project personnel and in some cases, their families (including young children). Alongside, these established trans-actional ties exists another kind of economic relationship—one based not upon the immediate, tangible exchange of money, but instead hinged upon an intangible promise of economic benefits-to-come. This future-oriented eco-nomic relationship is organized around a local tourism development plan sponsored by the project—a plan based on the exploitation of Chanmulá as an archaeological heritage resource. In public assemblies and more intimate conversations, archaeologists strongly encouraged residents of Chanmulá Pueblo and Ichmukil to imagine a future for Chanmulá that would include two museums (one housing artifacts and the other, a living history museum) and an array of infrastructural elements to sustain a flow of off-the-beaten-track tourism.

Pope and Mills (this volume) observe, "Communities grasp at any initiative that might aid economic survival." Perhaps to the consternation of Project Chanmulá archaeologists, this is not always the case. If this were true at Chanmulá, local residents would have jumped at the mention of the short- and long-term economic benefits offered by the site. Yet at Chanmulá, the archaeologists' tourism development plans met a less-than-lukewarm response. Residents, still getting accustomed to the idea of foreigners digging up their farmland and (as they saw it) extracting valuable commodities, were wary about how they themselves could benefit from the archaeologists' ambi-tious plans. Perhaps their doubt lay in the understandable difficulty in rein-terpreting the landscape so familiar as something radically different: as a site of ancient rather than modern heritage, as a site that would draw tourists (foreigners and nationals alike) who would support, rather than exploit, their communities. But did the project development ideas constitute an unassail-able "good" for the community? At what (noneconomic) cost would devel-opment come? These questions began to be voiced even before the plans got off the ground. As we will see below, it turns out that the economic relation-ship—existent and promised between archaeologists, their enterprise, and local communities—could not be separated from either legal mandates (which significantly reduce the autonomy of foreign archaeologists in pros-ing and carrying out extra-investigatory plans) or the ideological implications (specifically, archaeology's insistence that local residents are a population descendent form the ancient Maya).

Legal: Even if local residents were to jump on board with the Project's development plans, left unaddressed and thereby unresolved are the many prickly and complicated issues over the legal status of Chanmulá's ejido *cum* archaeological heritage site. At Chanmulá, as in many places around the world, an archaeological site is not a space necessarily distinct from house plots, yards, gardens, playgrounds, and farmland. When these public and pri-vate spaces are slated for excavation, a series of *de jure* and *de facto* customary and legal regulations are brought to bear. Archaeologists must negotiate both

sides of the coin. *De jure* legal procedures are the realm of the Mexican state as all archaeology is government archaeology. The official recognition of Chanmulá as an archaeological zone, the granting of permissions to carry out investigation, and the negotiation of access to the site are all issues. The legalities of ownership, custodianship, and access to archaeological remains in Mexico are dictated by the Constitution, and carried out by a federal agency known as the National Institute of Anthropology and History (INAH). Given the scope of their responsibility and power, the INAH could legitimately fence the site, postguards, and effectively deny access to local residents. Indeed the INAH, backed by the federal government, could transform *ejidatarios* into trespassers on their own land. But as far as the *de facto*, on the ground practice, chronic lack of personnel and funds prohibits the INAH from implementing such practices—not only at Chanmulá, but at hundreds if not thousands of major and minor archaeological sites across the nation.

Though the site of Chanmulá has now been granted by INAH the official status of *zona arqueológica,* the site has no guards or nightwatchmen, it is not fenced in nor otherwise visibly demarcated as to its official boundaries. Ejidatarios from Ichmukil regularly use the land to make milpa (the traditional corn plot) and at one point initiated the cultivation of other crops within the zone itself. Once officially established as an archaeological zone, rules as what can and cannot happen in the space, as well as what may or may not happen are set out. Farmers face new regulations as where they may plant their maize crops in relation to the mounds. They are also prohibited from burning their fields in the manner of swidden (slash and burn) agriculture to which they are accustomed. This traditional practice of clearing the land has been used for centuries in order to enrich the poor, thin soil characteristic of the region.

It is important here to keep in mind—as I mentioned before—that the archaeological zone of Chanmulá was not created out of an otherwise unclaimed or uncontested landscape. Historically, this 16 km^2 stretch of land area has been demarcated, boundaried, and parceled. Upon the foundations of an ancient Maya commercial center, the land has continuously been, over several centuries, cleared and planted, built and leveled, to make way for a variety of human activities. Now that the land is finally in the hands of the Ichmukil *ejidatarios*, many see it as a target for yet another intervention, this time, in its most physical and visual sense. According to Mexican law, archaeologists have explained to landholders, the state heritage agency has the right to close off access to the site with a wall or fence. The possibility of enclosure of the community's federal land grant by another arm of the federal government is perceived by these farmers as radically unjust. Local landholders do not see themselves as a public that would benefit from the regulations and procedure that the official establishment of a site entails. The activities of archaeology, for them, are extractive, exploitative activities with which, given their histories as *henequen haciendas*, they are intimately familiar.

In addition, within the legal realm is the issue of foreign archaeologists working on Mexican soil. Foreign projects are allowed to work in Mexico only

through explicit permissions and guidelines set by the INAH. Thus the archaeologists at Chanmulá were legally constrained from autonomous action in their scientific investigation. To the best of my knowledge, the archaeologists of Project Chanmulá followed all dictated legal guidelines in obtaining permission for and carrying out their scientific research. But the public outreach and development projects proposed and enacted by project directors fall into a murkier area of cross-border ethics. There are no clear parameters for the exercise of public or community archaeology in Mexico. There does not exist an equivalent or even approximation of the US *Native American Graves Protection and Repatriation Act* (NAGPRA). Recognition of ancestral affiliations and right and the indigenous participation in archaeological activities (whether excavation or interpretation) is purely ad hoc. In the case of Chanmulá, we can clearly recognize how the community oriented plans as a northern import. While some might argue for the overriding "good" of US archaeology's ethical standards, others might take a more critical position.

Ideological: While above two recognized and continuously negotiated, the ideological realm hidden, unspoken. While some would say that economic is most important, especially as communities are waging constant financial struggle with few resources, can be most powerful relationship: when one group is in a position to name another group, to describe them, to demonstrate and assess their historical and contemporary significance, to place them in the world, to choose their cultural identity. Contemporary Maya who live nearby the archaeological zone believe themselves not to be descendants of the ancient Maya, neither through biological descent nor through cultural affiliation. Many residents of Chanmulá Pueblo and Ichmukil believe that the mounds (*cerros* or hills) were built and inhabited by another race (*raza*) of people corporeally distinct from living Maya people. According to some, this race of people that came before the people who are living today, commonly referred to as "hunchbacks," or the *ppuzob*. This other race of people looked different, spoke a different language (*hach*, or true, Maya), and lived in stone houses. This understanding of the ancient Maya—no ethnographic secret—agrees with what social scientists and folklorists have found across the Peninsula since the 1930s (Redfield and Villa Rojas, 1934: 330; Redfield, 1935: 24; Burns, 1983: 51).

Is this merely a neutral difference of interpretation or does it have tangible, practical implications for the outreach efforts of Project Chanmulá archaeologists? I'll give an example which points toward the possibility of tangible implications. Earlier, I discussed Project Chanmulá's tourism development plans based on the exploitation of the site as an archaeological heritage resource. The agenda featured ambitious plans for two museums, one to benefit each of the two communities closest in proximity to the archaeological zone. On the one hand is an artifact museum to be located in Chanmulá Pueblo. Here, archaeologists stressed, the community would be able to not only keep excavated materials in local reserve, but would have a material cultural resource to ground and express their Maya heritage. On the other hand is a "living museum" of ancient Maya lifeways loosely based on Colonial Williamsburg—in which local

community residents would move out of their towns into the archaeological zone to demonstrate daily life practices of the ancient Maya in the excavated ejido land pertaining to the farmers of Ichmukil. I'll ask the obvious question: if archaeologists were to take seriously the oft-expressed rejection of cultural (and certainly biological) descent form the ancient Maya, why would local communities need artifacts to strengthen their cultural identity? This implies that the identity (as farmers, as *campesinos*, as survivors of the hacienda system) which they hold very dear is ungrounded—and perhaps unfounded. Further, the idea of making a space where contemporary residents physically embody and actually live as ancient Maya calls to mind perhaps the worst of the tradition of exploitation of culture; others through so-called ethnographic display. The creation of a living museum of ancient Maya culture on the grounds of their modern land grant is an act on the part of archaeologists that fails to recognize or take into account this local public.

Under the weight of attending to (indeed, juggling) the economic, legal, and ideological dimensions of their presence in addition to the workaday responsibilities of scientific investigation, the Project's relationships with surrounding communities became strained and tense. As Foster (Chapter 7) suggests, "Native peoples are often in conflict with archaeology." But, as he goes on to qualify, this is not an across-the-board, generalized conflict. Instead, it is restricted to specific issues: burials and questions of origins. At Chanmulá, it is much more difficult to distil the precise nature of the conflict between local Maya and "archaeology" mostly because, as very much is the case at Chanmulá, "archaeology" as a mode of inquiry, as a way of understanding the past, as a method of developing the future—arrived, so to speak, unannounced. Public perception of archaeology's activities were initially understood according to the categories of local knowledge and experience. The tensions precipitated by archaeological work at Chanmulá are not exclusively founded in concerns of land access and use, but in terms of cultural identity—in other words, how local residents understand themselves *vis-à-vis* their own historical experiences on the one hand, and on the other hand, the ancient Maya. As we assess the public outreach efforts of Project Chanmulá, we must question the degree to which local communities are able to come freely and willingly to a table already set within the parameters of archaeological knowledge. In short, archaeologists wanting to establish ethical, relevant public outreach programs must cautiously reflect upon the nature and effects of their presence and promises *vis-à-vis* local communities.

5.4. Understanding the Cultural Contexts of Archaeology

Over the past two decades, archaeologists have become increasingly concerned with the significance and impact of their work in contemporary society. Though the discipline of anthropology poses ethnography and

archaeology as none-too-sympathetic cousins, my experience at Chanmulé fuels my attempts to reconcile the two subfields. In other words, rather than in short, I find ethnography is a useful method for disentangling the complexities of the social, cultural, economic, and political contexts of archaeological work as it affects contemporary communities (Breglia, 2006). As a qualitative research process and product, ethnography has as its goal the historically informed, critical interpretation of cultural forms and practices that structure everyday life from the local point of view. Working at Chanmulá and in surrounding communities, I carried out an ethnographic study of what the inception of excavation work at Chanmulá means for local residents (their conception of heritage, their relationship to the ancient Maya, their access to land, how they earn their livelihoods, etc.). I call this kind of research "ethnography of archaeology," referring to an ethnographic study which foregrounds archaeological practice as a culturally and historically contingent activity. Thus, while neither archaeological data nor its scientific methods of investigation figure in anyway into my own research, the activities of archaeology, particularly as they relate to the local communities, serve as a springboard for much of my ethnography.

Archaeological sites (whether sites of mass heritage tourism like nearby Chichén Itzá or landscapes where nary a trowel has revealed an artifact) are intensely rich and complicated spaces of social relations. I believe that ethnographic study of archaeological sites can offer a detailed, historically and culturally specific context to aid in bridging the problem of understanding the perspectives of local communities involved in and affected by archaeological projects. At the same time, ethnography of archaeological development might offer us a picture beyond the workaday parameters of what is thought to be directly relevant to archaeology, or what I call the extra-archaeological context of an excavation site. In the case of Chanmulá, the key extra-archaeological context as I understand it is the modern history of land dispossession and tenure. It is, after all, this context that informs what local people think of as their heritage. The legacy of the henequen hacienda in this case is an essential component rather than an ethnographic aside, when assessing the significance of archaeology and development—not only for local residents, but for researchers as well.

The process of identifying the descendant community culturally affiliated to the Chanmulá archaeological site appears, at least on the surface, fairly straightforward. From the archaeological point of view, modern Maya people exist in a relationship of cultural continuity with ancient Maya civilization. Ethnographic inquiry allows us to understand how contemporary Maya understand themselves *vis-à-vis* the ancient past. These findings may or may not coincide. In the case of Chanmulá, the local community's refusal of affiliation with the ancient perhaps works its way into a refusal of archaeology. Perhaps the public outreach efforts of Project Chanmula's archaeologists should look beyond the mounds, so to speak, into the larger landscape. Therefore, unlike other conceptions of "ethnography of archaeology"

(Shankland, 1996; Bartu, 2000), I did not restrict my investigation only to the local communities' perceptions of the mounds, the interventions of archaeology, the future of heritage development, or a combination of the three. Instead, the archaeological project was only an occasion upon which other local histories were narrated, political ideologies were espoused, and hopes and fears about the past, present, and future were expressed.[3] Results from this kind of research conducted at heritage sites large and small, developed and underdeveloped, would (1) aid substantially in the assessment of the degree to which a community is receptive to archaeology and (2) integrate archaeology with a range of other community concerns, beliefs, and needs.

5.5. Conclusion: Understanding Local Histories and Communities

"You know what," an official representing Mexico's *National Institute of Anthropology and History* once commented to me, "sometimes archaeologists get too involved with the local communities. They make complications where they shouldn't." What this official posed as "complications" is the very stuff that archaeologists, cultural resource managers, and heritage professionals in other parts of the world take to be most significant points of engagement between archaeology and its publics. Rather than entanglements best avoided, many in the field of archaeological heritage embrace the "complications" as fertile spaces of dialogue and negotiation. The case of Chanmulá reminds us that while always worthwhile, working through the complications of public outreach and involvement is not easy.

Indeed, all archaeologists—especially those working in cross-cultural or transnational contexts—expect that the knowledge they produce will be very significant not only to the scientific or professional communities, but to the people whose everyday lives are affected by the presence and practice of archaeological work in their own backyards. Nowadays we find greater consensus in both the academic and professional communities that archaeology, though science is neither a detached nor neutral activity. Archaeology is, as we have become increasingly aware, embedded in social, cultural, political, and economic relations. Subsequently, archaeologists carry a heavy responsibility to maintain sensitivity and flexibility in cross-cultural situations. What I have come to understand is that (1) "archaeology" does not always represent what local people understand as their heritage; and, what's more (2) public or community outreach, though it may be practiced with the best of intentions always carries the potential danger of ethnocentrism. By this I refer to using the values and standards of one's own culture as a yardstick by which to measure what is significant in another. As we develop, enact, and evaluate public outreach efforts, we should also understand how they are

[3] For the complete results of this study, please see Breglia (2003, 2006).

always embedded within a broader framework of social, cultural, and economic relations. I contend that ethnographic study of the communities destined to become the publics of archaeology complements outreach efforts. Any public outreach effort would, it seems, have to measure its success on the degree to which the interests of archaeology could be reconciled with other local concerns. Ethnography of archaeology might strengthen dialogues between archaeologists, government officials, and local residents so that the good intentions of one party match the needs of the other.

I discuss the case of Chanmulá not to highlight the peculiarity of archaeology in the Maya area, but in hopes of accomplishing the reverse; in other words, to focus attention on the difficulties faced by all public and community-oriented research projects who must negotiate the tensions and ambivalences of bringing knowledge about the past into the present. Certainly, this is not an isolated phenomenon. What is unique, I think, about the Chanmulá case is a powerful lesson for public archaeology. From Chanmulá, we see that desire on the part of archaeologists to bring the local communities into their work and how the strength of this conviction prevented them from taking into consideration how local people use and value their landscape (mounds and all). This effort falls squarely within the "public interpretation of archaeology" (Jameson, 1997), though in a less institutionalized form. Ethnography might become an integral component of this effort as it aids in the development of richer contexts for public outreach endeavors—whether to local communities or the visiting public—to promote a just and responsible archaeology.

References

Bartu, A., 2000, Where is Çatalhöyük? Multiple Sites in the Construction of An Archaeological Site. In *Towards a Reflexive Method in Archaeology: the Example at Çatalhöyük*, edited by I. Hodder, pp. 101–110. McDonald Institute for Archaeological Research, Cambridge, UK.

Breglia, L., 2003, *Docile Descendants and Illegitimate Heirs: Privatization of Cultural Patrimony in Mexico*. University Microfilms, Ann Arbor, MI.

Breglia, L., 2006, *Monumental Ambivalence: the Politics of Heritage*. University of Texas Press, Austin.

Burns, A., 1983, *Epoch of Miracles: Oral Literature of the Yucatec Maya*. University of Texas Press, Austin.

Jameson, J.H., editor, 1997, *Presenting Archaeology to the Public*. Altamira, Walnut Creek, CA.

Redfield, M.P., 1935, *The Folk Literature of a Yucatecan Town*. Contributions to American Archaeology No. 13. Carnegie Institution of Washington, Washington, DC.

Redfield, R. and Villa Rojas, A., 1990 [1934], *Chan Kom: a Maya Village*. Waveland Press, Prospect Heights, IL.

Shankland, D., 1996, Çatalhöyük: the Anthropology of an Archaeological Presence. In *On the surface: Çatalhöyük 1993–95*, edited by I. Hodder, pp. 349–358. McDonald Institute for Archaeological Research, Cambridge, UK.

6
The Other from Within:
A Commentary

Whitney Battle-Baptiste

Even our Black women's style of talking, testifying in Black language about what we have experienced, has a resonance that is both cultural and political. We have spent a great deal of energy delving into the cultural and experimental nature of our oppression out of necessity because none of these matters have ever been looked at before (Combahee River Collective, 1982: 17).

I am of African descent. I am a woman. I am an anthropologist. I am a scholar of the African Diaspora. I am an archaeologist. I carry with me a style of expression, a language that has been used in the past to express the cultural and political struggles of people who have experienced oppression in various forms. I carry with me an identity that at times is at odds with the interpretive process of archaeological analysis.

This commentary is an interruption from the types of archaeological investigation and material culture analysis that I have written about in the past. I would like to use this opportunity to provide a narrative about my experiences as an archaeologist of African descent in a field that does not always understand the complexities of living with this identity. Often I find myself faced with the challenge of living up to a strong Black intellectual tradition (a part of my personal training) that I feel loyal to and simultaneously realizing that I must negotiate my relationship with that powerful museum that employs me (a part of my political training).

For over a decade, there has been a lively debate about how African American and African Diaspora archaeology should move forward. How do we reconcile the sensibilities of descendant communities with the practice of archaeology? On the one hand, as critical theorists, we should seek to combine many elements in order to come to socially relevant conclusions, keeping in mind the rare relationship between archaeologists and marginalized peoples (Potter, 1991). Therefore, we must be persistent, patient, and committed to engaging from the beginning with descendant communities when constructing our research agendas (Leone, 1991: 11). On the other hand, the question remains, is reality a little more complicated than that? If so, do we admit that if not careful we lean toward a one-sided approach that ultimately fosters a form of research dictated by descendant communities that in the end

is beneficial to no one (McKee, 1994)? I bring this dilemma to the front of my commentary because it is very relevant to my entrance into the world of African Diaspora archeology.

The irony of my writing a commentary in an edited volume on public interpretation and partnerships is that I, in many ways, embody what Larry McKee posited more than 10 years ago as a plausible solution for enhancing the role of descendant communities in the interpretive discussion of the African-American past. He suggested, "One solution to the problem of minimal interaction between archaeologists and the African-American community is of course to combine the two into individuals who are both black and archaeologists" (McKee, 1994). Although, I serve as an example of this possibility, I want to make clear that being a woman of African descent does not guarantee me an interpretation that is better or easier to attain, I would like us all to leave that myth behind immediately. Although my experiences have been admittedly different from my non-Black colleagues, the reality is, I am viewed as an archaeologist and that perception is a part of my larger identity, especially in relation to the Black communities I have interacted with (Potter, 1991; Franklin, 1997; LaRoche and Blakey, 1997; McDavid, 1997).

As an archaeologist of African descent, I have often felt what scholar Michelle Wright describes as the "Other—from—within," a self-reflexive concept completely neglected in my archaeological training. Although Wright's critique is focused on people of African ancestry in Europe, some of my experiences are quite similar to her overall theory. I have experienced a form of "Othering—from—within," from my own community (Wright, 2004). Let me explain further, the work of archaeology, how excited I am about it, is not always perceived by the Black community as a necessary component in a strategy for obtaining social justice. The relationship between archaeology and marginalized peoples has not always been positive. On one particular occasion a descendant community leader asked me, if my work in any way maintained the status quo? Was archaeology being used as a method to continue the long history of racism and the telling of an unbalanced or marginalized history where slavery was an afterthought? At that moment I had no answer. The realities of institutional and systematic racism that are a part of the everyday lives of Black people, have, in my opinion, never really been incorporated into the interpretation of archaeological sites I have been associated with. Therefore, it became obvious to me that contemporary issues of the descendant community were a part of my personal development as a scholar and came to serve as a reminder of the duality of my personal and political identity.

Along these lines, I would like to talk briefly about my entrance into the world of African Diaspora archaeology. The Hermitage museum, which has been discussed at various professional meetings and has been the subject of a multitude of journal articles, is where my story begins. Recognizing the iconic image, this plantation site holds in the world of African-American

archaeology, I wanted to write something about my personal experience there. I felt compelled to voice the delicate balance between the spoken and silent realities of working at a plantation museum as well as the political quagmire that must be delicately navigated by an up-and-coming scholar (me) who clearly comprehends the power of "wrong words" when thinking about the safety of her career. Yet, through all of my tact and concern of how passion can be misunderstood as a form of dangerous subjectivity, I now see that this duality that I live with as who I am as an archaeologist of African descent. This is the reasoning behind my opening quote. It is from one of my main sources of intellectual strength. It is taken from, "A Black Feminist Statement," a manifesto originally composed by an amalgam of Black women (The Combahee River Collective) who named themselves after a famous river in South Carolina. This river, significant in several trips taken by Harriet Tubman, was known by enslaved African women and men as the "River Jordan" and ultimately symbolized the boundary between bondage and freedom. The words in the manifesto and the metaphor of bondage and freedom is also my source of strength and a reminder that my struggles are not unique or unusual, but something to embrace and use to maintain my own sense of freedom.

Now, back to my tenure at the Hermitage, my relationship with the museum began in the summer of 1997 as an archaeological intern. As my understanding of the nature of public archaeology was developing, I could physically see no contact with a living descendant community. My archaeological experience at that point was limited, I had only worked at Colonial Williamsburg and my first site was Rich Neck Plantation, where I worked alongside of five women of African descent (Maria Franklin, Anna Agbe-Davies, Ywone Edwards-Ingram, Jackie Denmon, and Cheryl LaRoche). With the constant stream of local African-American volunteers and employees from Colonial Williamsburg's African American Interpretation and Presentation Department, the excavations were lively and thought provoking every day. The Hermitage was very different and marked a significant change in my development as an archaeologist. At this site, I immediately became an "authority," one who provides the public information from an educated position. The visitation was also different, there were virtually no African-American visitors to the site, and I came to understand that many of my colleagues had no training in African or African-American studies; something I had assumed was the standard. It was then when I felt as if in a vacuum, detached in some way, not sure if the rest of my career would be like this.

To be a woman of African and Cherokee descent and work day after day over a span of seven summers at the plantation home of Andrew Jackson, was a personal and political experience I will never forget. As the child who grew up with the Black Nationalist movement of the 1970s as a backdrop, working on a plantation was not that easy to explain to my family or community back in New York City. As I stated before, there is a certain duality that I deal with on a daily basis and I quickly began to understand how

different my perspective and approach to the African and African-American past was in comparison to some of my anthropologically trained colleagues.

In all honesty, on bad days to find the strength to be cordial to the public with excitement, inform visitors about recent finds on a daily basis, give museum tours without holding back, and positively interacting with my colleagues that had no idea what my problem was, was a personal and political act. The feeling of isolation and resentment was at times unavoidable, yet I have met every visitor with honesty and respect and began to see the museum as a possible space to engage in a struggle that would ordinarily be overlooked or simplified by others. It was my own remedy that I began to feel would eventually lead to a relief from oppression in various forms from within, a transformative and subtle form of activist archaeology (LaRoche and Blakey).

After three consecutive summers, however, the one question that continued to resonate with me was, "where was the descendant community?" Although my questions were never dismissed or ignored, my burning question was never fully addressed. That all changed in July of 1999 when an Earth Watch volunteer from Boston needed to go to church. She easily found an African Methodist Episcopalian (AME) church in the area, and to my surprise came back to dinner that night with an incredible story to tell. This moment marked the beginning of my personal oral history project. From that point on, Sunday after Sunday I attended church services all around the area, attended Barbeques, visited community elders and began getting to know the Black community around me and looking for the possibility of forging a relationship between the museum and the people. However, I quickly discovered that it would never be that easy. I often imagined having scores of local folks touring the Hermitage and seeing how incredible the archaeological assemblage was, how the artifacts were telling a neglected side of history at the site. That never really happened; instead my interactions became a source of my own personal development and helped in the overall writing of my dissertation.

How could I understand this plantation without understanding how the land operates in the minds of contemporary people? Through my interactions with the local descendant community, I learned about when the Hermitage became a segregated place, the history of mistrust and even hatred for what the plantation came to stand for, and the continued invisibility ascribed to the descendants of enslaved Africans at the museum. This was not my starting point, yet it was my method of understanding the enslaved community from a critical archaeological perspective. Archaeologists excavate, they recover discarded and lost material. After the pottery is washed, identified, and cataloged, then what happens? I wanted my work to teach, communicate, and cause a little bit of discomfort, yet generate knowledge that would help the descendant community (my community) carry forth a struggle from within. But, could it really be that simple?

Honestly, this relationship was not initiated by my own activist agenda, instead, it was a volunteer who went out and explored and created the bridge

for me to develop how I understood the plantation museum. In hindsight, I have often wondered what would have happened if Joan was not dedicated to her faith, would I have continued to be frustrated without taking action? I still do not have an answer for that question.

In the summer of 2000, I arrived to find a buzz in the air at the Hermitage. There was something major about to happen. It was the first reunion of the Hermitage Slave Descendant Organization. This was for me a transformative moment that allowed me to bring the work I was doing in the field together with the work I was doing with the descendant community. The duality with which I was struggling with privately, became a positive aspect of my identity and made me see the meaning within my work. An example is described below:

The museum wanted to highlight their accomplishments, the recent archaeological finds (I must stress that the archaeology program was focused on life under slavery and was the biggest selling point for the Hermitage during the summer months). I was more than happy to provide this service and was excited about the possibility for dialogue with members of the organization. I was just beginning my fifth tour and lead a group of Hermitage Slave Descendant Organization members into the main museum gallery, which housed an exhibit about life under slavery based primarily on the archaeology of recent years. By this time, I was beginning to feel as if I was in full tour mode and just stringing practiced sound bites together, when I came to a display case that housed an assortment of sewing equipment. I had seen and described these items hundreds of times before. There were needles, needle cases, hand-carved instruments, buttons, thimbles, straight pins, and marbles. As I was explaining the assemblage, I also explained how a woman named Gracey, who was purchased by Jackson in Washington, DC, was known for her phenomenal seamstress skills. I was about to tell the story of her role in the larger enslaved community, when one of the members of the group moved toward the case and studied it closely. As I turned to look at her, she raised her head and said with a steady voice, "Gracey was my ancestor and why we are here today." At this same moment, I felt as if we were the only ones in the gallery. It began to hit me, Gracey was not a seamstress, Gracey was a human being, the mother, grandmother, great-grandmother of people like the ones on my fifth tour of the day. A younger woman stepped closer to the case and asked if I was saying that Gracey may have touched these items, I couldn't answer, instead, I shook my head yes. And we all stood there in silence, realizing the connection between strangers, a personal bridge made possible by artifacts in a display case. The material, the archaeologist, the descendants, all gathered on a plantation museum in middle Tennessee—I was never the same.

I no longer struggle with some of the more complex aspects of my identity as a woman of African descent and an archaeologist. For me it provides strength and a symbolic River Jordan, which I no longer attempt to straddle. Instead I stand firmly on the banks letting the water wash over me to refresh my commitment to telling the story of those who have passed before me.

I am currently housed in a department of Africana Studies. I am the only archaeologist there and it has taken me a while to connect my work with the work of the collective body, but I have been successful. The explanations of my work are becoming shorter and shorter and students have responded positively to what I contribute to the department. My classes are filled with engaged students from many disciplines (including archaeology), but at the base of it all, is the simple idea that archaeology is but one tool in the interpretation of the African and African-American past. I have come to see that the dualities I live with no longer a handicap, but an asset.

My hope is that this commentary has provided a glimpse into the complexity of one archaeologist's journey for understanding the delicate balance between the personal and the political. I am no longer afraid to discuss the existence of either of these factors in my work. I am confident that this narrative has allowed me to express, through a language used by many Black women before me, my experiences both culturally and politically that have until now have been neglected as a source of understanding the African and African-American past.

References

Franklin, M., 1997, Why are there so Few Black American Archaeologists? *Antiquity* 71:799–801.

LaRoche, C. and Blakey, M., 1997, Seizing Intellectual Power: the Dialogue at the New York African Burial Ground. *Historical Archaeology* 31(3):84–88.

Leone, M., 1991, Setting Some Terms for Historical Archaeologies of Capitalism. In *Historical Archaeologies of Capitalism*, edited by L. Mark and P. Parker, pp. 3–20. Kluwer Academic Publishers, New York.

McDavid, C., 1997, Descendants, Decisions, and Power: the Public Interpretation of the Archaeology of the Levi Jordan Plantation. *Historical Archaeology* 31(3):114–131.

McKee, L., 1994, Commentary: is it Futile to Try to be Useful? Historical Archaeology and the African American Experience. *Northeast Historical Archaeology* 23:1–7.

Potter, P., 1991, What is the Use of Plantation Archaeology? *Historical Archaeology* 25(3):94–107.

The Combahee River Collective, 1982, A Black Feminist Manifesto. In *All the Women are White, All the Blacks are Men, but Some of Us are Brave: Black Women's Studies*, edited by G. Hull, P. Bell Scott, and B. Smith. The Feminist Press, New York.

Wright, M., 2004, *Becoming Black: Creating Identity in the African Diaspora*. Duke University Press, Durham, NC.

7
Archaeological Outreach and Indigenous Communities: A Personal Commentary

Lance M. Foster

Aho, darixga. Baxoje min ke, mahto wokigo. I am a member of the Ioway tribe, a people descended from the makers of the Effigy Mounds of the American Midwest. I took up anthropology in the early 1980s to help preserve our tribal language and traditions. I became interested in archaeology, but I was brought up to be morally opposed to doing it. After talking with my elders, who thought it was necessary to understand archaeology and its growing impact on native communities, I agreed to explore archaeology and set up some rules. I would never deal with burials, and I would leave if they were found. And I would always first make offerings at the site, to the guardians of the place, to explain who I was and why I was there, and to leave if or when I was not welcome.

I worked for several years as a field tech (also known as a "shovel bum") on many sites in the 1980s and 1990s, from California to Virginia, prehistoric and historic sites, both Euro-American and Native. I worked for private firms and for the feds. I always consulted my elders in my choices and actions.

I ran into a peculiar gulf in archaeology between prehistoric and historic archaeology. I remember working on a historic site in the east, that when someone found a chert flake or sherd of Woodland pottery amongst the broken glass and square nails, the crew chief would take a quick look and flip it over their shoulder into the backdirt with the remark, "Abo-shit." I also remember working on prehistoric sites in the west, that while lithics and pictographs were drooled over, historic cabins were often "managed with a match."

Based upon my experiences, there are a few observations I would share with anyone trying to put together outreach efforts to involve Native communities with archaeology.

It is true that Native people often have conflicts with archaeology, but if you really look at what's going on, the conflicts usually boil down to: (1) respect for burials and (2) questions of origins, with Kennewick Man as an example of both. Burials will always be problematic, for both prehistoric and historic archaeology. The great thing about focusing on historic archaeology

in outreach to indigenous communities is that the question of distant origins has no part. That divisive issue can be avoided; with historic archaeology the recent past becomes the focus, a past in which it is easier to find common ground.

The separation between what is "historic" and what is "prehistoric" is not always clear-cut. How does oral history fit in? But also, what about all the written history by Native peoples, either in indigenous scripts and languages, or in the colonial languages? For some tribes, the boundary between "prehistory" and written history begins 500 years ago whereas for others it really only begins a little over 100 years ago. "Contact" and "pre-European contact" have much more utility and acceptance in the community.

The whole idea of what is acceptable "history" or "oral history" (not just to archaeologists but also to various tribes with differences in their viewpoints) is a mire, which is perhaps best sidestepped. Even dreams can provide the basis for workable and testable hypotheses—because scientific proof comes through scientific testing, not from the inspiration for the hypothesis.

Besides the ideas of "prehistory" and "history," using common archaeological terms can also be tricky. Do not use the word "abandoned." Although no one may reside at a site anymore, it may not be "abandoned" at all. Plant, animal, and mineral resources may still be gathered, or prayers made and graves maintained. Because everyone is in the living room watching television, do you call the kitchen or the bedrooms "abandoned?" Time has a different meaning to many, and movement is made freely between the rooms of a landscape "house." Sites should be considered as activity areas on a larger archaeological landscape, and the unseen and unmarked often are as important as the seen and the marked. People may have been pushed out by neighbors or by federal policy, but Grandma's house will always be Grandma's house. Such places are not "abandoned," though they may no longer have residents at least ones that can be easily seen.

The word "ruin" is also not a good one to use. Everything has a life span, a life cycle of birth, growth, maturity, dotage, and death. This is not only true for people, but also for places. The indigenous way is to respect that cycle, not to interfere. Just because Grandma isn't what she was at age 20, or even 40, do you call her a "ruin?" Just use the term "site" or "structure," "village" or "town."

Native peoples easily accept the question of stewardship, but the idea or what constitutes stewardship may differ. In many cases in traditional communities, preservation in a frozen state may not be feasible or desirable. One respects Grandma by visiting and loving her—and after she passes on, by remembering her in stories and visiting her grave, not by sticking her full of tubes and dipping her in varnish.

The word "trashpile," especially if human remains are associated, is a problem, as if the person was considered "garbage." The term "trashpile" is often used in Puebloan sites for certain features containing remnant elements. The ashes, sherds, and detritus of a person's life are a part of that life. The dead are

reintegrated with their past when they are interred among those remnants. Remains among remnants, and all return back to the earth together.

Another thing to try to remember—not to overinterpret the past. Let people make up their own minds. They will anyway, and respect goes a long way in building trust and support. Reveal the evidence, but place evidence side-by-side with opposing evidence. Tell people how you came to think the way you do, reveal the process of your reasoning. You never know, but that archaeologists can learn something from ordinary folks.

I was working on a site in Montana with my brother Garth. We came down on a very strange black stain. We tried to tell the principal investigator that it looked like oil and not ashes or charcoal. But we did not have Ph.D.s so we were dismissed with a wave of the hand, while a geomorphologist was called in, and another archaeologist consulted. We were told to keep working backup slope and keep revealing the stain, where some odd process was going on. They were very excited. This took several days, and it ended with an oil filter from the 1950s that had been discarded and had leaked downhill.

I worked on the site of an Indian boarding school in California, and one of the main questions was the location of the graveyard. They were getting ready to use remote sensing and random testing of soils to find out where it might be, and of course the added cost would be a big hit to the budget. During my lunch break, I walked up slope to a high point, and saw a large level area with a number of cedar trees. Here and there were small stones, and river cobbles with flecks of light blue and white paint on some surfaces. I told them this was the likely spot for the graveyard. They asked why I thought so, and I told them that people often ringed graves with stones, and whitewashed or painted them blue, plus the presence of the cedars. They asked me for my citation, which source I had used, and I replied it was what I had often seen. They said they needed a citation, so I suggested I write it up, so I could cite myself. They did not take me seriously but proceeding with their grand, budget-busting plans. They later found it to be the graveyard. The nice thing now is that since this essay is to be published, anyone in a similar situation can now use this essay as a citation.

When I worked for the Forest Service, we were told that to reconstruct what happened at a historic mine, we should inventory the machinery which would tell us about the ore and the processes used at the mine. I wanted to talk to an old miner who had worked at the site, but was told the old guy was a troublemaker and would make things up. I ran into a lot of problems and inconsistencies, such as the machinery and the ore type not matching up, so I finally got the go-ahead to talk to him about a well-preserved piece of equipment which the interpretive specialists wanted to spotlight as being integral to the mine. The old miner just laughed and said, "Hell, we never used that—we just dragged it down from another old mine to use for scrap!"

Now, these stories are not meant to embarrass archaeologists, but more to point out a problem. Archaeologists often laugh at how indigenous people are nervous around burials, but many archaeologists seem to have a fear of

living people, who can be cantankerous, contradictory, and inconvenient—not to mention downright brilliant in messing up some cherished scheme with living, breathing experience.

Archaeology must take a hard look at why it wants to do outreach to Native communities. Outreach may be described as a professional responsibility, but just because you make a movie doesn't mean anyone else wants to see it. Your project is always in competition for time and money with other issues, like water, sovereignty, health care, and education. Why should the tribe care? What solutions or assistance do you offer? Possibilities in economic development? Assistance in education or compliance? If you want active participation, you have to make it worthwhile on a practical level, and you have to understand the particularities of the tribe with whom you are working.

Every tribe has at least two authority structures, the legal Indian Reorganization Act (IRA) government with its corporate structure of chairmen and committees, and the traditional governments which may be as complex as those of the southwestern Pueblos or as simple as groupings of families in very small communities. Some IRA governments work well with traditional governments; many do not. Archaeological consultation, due to preservation law requirements, needs to go through the IRA governments, though ultimately it will face its greatest challenges and rewards on the traditional level.

The IRA governments constitute legal authority whereas traditional governments constitute cultural authority. Add to that mix the various schisms and a long history not only of traditions but also of generations of people a tribal member is supposed to be allied with or against, and things can get tricky. There is no "Native American viewpoint." You have to deal with peoples, which always involves both the high points and the low points in human character, the latter including jealousy and gatekeeping. Knowledge is power often wielded as a club in a small community.

Besides making the project useful and relevant to the community itself, and learning about the particular tribe or community, you have to plan on collaboration and the accompanying hiccups from the very start. To get the needed support, you have to give not just an opportunity to enjoy your efforts as a passive and appreciative audience, but to be part of the decision-making process in what sites and problems to investigate.

It would also be good to consider that when you have your own program funds, reach out to smaller tribes and remnant peoples, who are less well-funded. Here are a few ideas for outreach that will help bridge tribal and archaeological interests:

1. Recording and conserving cemeteries
2. Conservation of family heirlooms and photographs
3. Genealogical projects
4. Programs for lay people on cultural preservation laws and programs

5. Place name projects
6. Recordation of still existing traditions
7. Any projects that combine school kids with elders
8. Exhibits and tables at the community center and at cultural events such as powwows

The state of Iowa has done well in its outreach to indigenous communities, and in many of its efforts, historical archaeology has a large role. Bill Green, a past state archaeologist now at Beloit, did research on the 1837 map presented by Ioway chief No Heart, a map which showed many of the Ioway tribe's settlements and migrations through Iowa. Larry Zimmerman, who has since relocated to the Department of Anthropology & Museum Studies at Purdue, developed a field school at Fort Atkinson, Iowa, historically associated with the Ho-Chunk or Winnebago. At this field school, which ran for several seasons, University of Iowa students worked in collaboration with Ho-Chunk people, and an intertribal advisory committee also served as a resource.

Don't be intimidated. You may end up making some mistakes, but no mistake is as big as not trying. Expect to take some lumps, expect some scolding. Just like the old stories say, keep on going while looking straight ahead, because there is really no other choice if archaeology is to survive in the next several centuries. Be humble and listen; other archaeologists have succeeded and you will too. Historical archaeology in particular has the stuff to win people over.

I am no longer a contract archaeologist. Inspired by settlement patterns and archaeological landscapes, I earned a graduate degree in historical landscape architecture, and worked for the National Park Service in the cultural landscapes program. I wrote the first version of this essay (Indigenous Communities and Historical Archaeology: Perspectives and Relevance) as one of two papers I gave at the Fifth World Archaeological Congress (WAC) in Washington, DC in June of 2003. My personal situation has changed since then, and the challenges became greater. In November of 2003, I became Director of Native Rights, Land and Culture at the Office of Hawaiian Affairs (OHA). OHA has a constitutional mandate to protect Native Hawaiian rights and cultural properties, and it is through compliance reviews that I generally have contact with archaeology and archaeologists these days.

Unfortunately, at least in Hawaii, there is still a long way to go in dealing with a situation where burials and sites are disappearing en masse before the bulldozers of resort developments that are obliterating sites and native communities as completely as one of Mauna Loa's lava flows. Hawaii is in the midst of a development boom driven by greed that is erasing history everyday. Deception, corruption, cronyism, and expediency are the watchwords.

Archaeology here has no substantive place for historic archaeology, especially in relation to Native Hawaiians, and considers only pre-European contact sites as "really Hawaiian." In Hawaii, every other newspaper story is about poor archaeological strategy leading to destruction at sites like a historic

cemetery at Wal-Mart. The courts are rife with cases relating to archaeological issues, including Wal-Mart and the Forbes Cave artifact reburial controversy. Here, a hard-won statewide Burial Program constructed in partnership between professional archaeologists and Native Hawaiians through the 1990s was erased in a matter of months through fiat of a terribly understaffed and underfunded State Historic Preservation Office.

The current economic boom in Hawaii is resulting in the destruction of sites and natural resources, and archaeological work is racing before the face of a tsunami of asphalt and golf courses. The inflated housing markets and taxation is making it impossible for Native Hawaiians to remain in their homeland. There are now more Hawaiians outside the state than in it. Imagine the outcry if a similar situation existed with Lakota in South Dakota or Navajo in Arizona. In Hawaii, archaeological outreach is the least of the native community's concerns.

In terms of the mainland, I would like to think things have changed since the 1980s and 1990s; some things have, and some seemingly have not. There has been a huge increase in the number of indigenous people getting graduate degrees in archaeology and working in the field. They, and others working closely with native communities, are doing innovative and significant work in making the field relevant to the needs and interests of native people, especially in adding oral tradition as part of the interpretive strategy. The publications of Joe Watkins (2001), Angela Waziyatawin Wilson (2005), Janet Spector (1993), Nina Swidler et al. (1997), Larry Zimmerman (2005), and many others come to mind as a starting point for those interested in learning more. But one needs only to have a discussion like Kennewick come up to realize that a gulf still remains between two worlds.

In short, there is no "Native Perspective" when it comes to archaeology, but there is unified Native concern over the treatment of the past. *Warigroxi. Malama pono.*

References

Spector, J., 1993, *What this Awl Means: Feminist Archaeology at a Wahpeton Dakota Village.* Minnesota Historical Press, Minnesota.

Swidler, N., et al., editors, 1997, *Native Americans and Archaeologists: Stepping Stones to Common Ground.* AltaMira Press, Lanham, MD.

Watkins, J., 2001, *Indigenous Archaeology: American Indian Values and Scientific Practice.* AltaMira Press, Lanham, MD.

Wilson, W.A., 2005, *Remember this Dakota Decolonization and the Eli Taylor Narratives.* University of Nebraska Press, Lincoln, NB.

Zimmerman, L.J., 2005, First, Be Humble: Working with Indigenous Peoples and Other Descendant Communities. In *Indigenous Archaeologies: Decolonizing Theory and Practice*, edited by S. Claire and H.M. Wobst, pp. 301–314. Routledge, London.

8
New Ways of Looking at the Past: Archaeological Education at the Houston Museum of Natural Science

Patricia (Pam) Wheat-Stranahan, Dorothy Lippert, Dirk Van Tuerenhout, and Elisa Phelps

The Houston Museum of Natural Science initiated a variety of programs aimed at educating patrons about the Hall of the Americas after it opened in 1998. In the Hall, Native American cultures are explored through the science of anthropology. Consultation with Native Americans was part of the development and installation of exhibits but faded into the background after the opening. The educational programs brought Native Americans into active partnership with the museum once again. Programs included teacher workshops, artistic demonstrations, scholarly lectures, symposia, and festivals. Each program educated the public about how archaeology illuminates the Native American past and how modern Native American peoples link to the past. These programs presented archaeology as a useful means of understanding the past with equal input and insight from the Native American community. This approach helped the museum address certain problematic areas for Native peoples such as stereotyping and racism and brought new cultural awareness to many visitors.

Historically, American museums built collections of Native American objects with little consultation with the communities from which the objects were drawn. The period of collecting that occurred in the early part of the twentieth century was influenced by the prevailing stereotype of Indian communities. Coming some 20 years after the end of the so-called Indian wars, it was commonly thought that these communities were near the end of their existence (Bieder, 1986).

This image of "the vanishing Indian" was reflected in many areas of popular and academic thought (Berkhofer, 1978). It continues to this day and is often reinforced through well-intentioned educational activities that focus on the Native American past to the exclusion of the present (Hirschfelder, 1982). Another idea persists that contemporary Indian groups are not "authentic" unless they live and act in the ways that their ancestors did. Many people are unwilling to accept that Native Americans live in ways no different than those of the rest of the population. Tipis are not the most prevalent housing style, nor do most Native people ride horses to get where they are going. These stereotypes often dominate the world of children and it is quite

common to encounter them when talking to school groups (Hirschfelder, 1982; Slapin and Seale, 1998).

In the 1960s, Native Americans began to expand their social and political powers. Tribes had a strong impact on legislation at both the state and federal levels. Consultation with Indian people on a variety of issues began to take place. These struggles led to the Red Power movement of the 1970s and eventually to the passage of numerous laws that affect the relations between museums, anthropologists, archaeologists, and Native Americans. The Native American Graves Protection and Repatriation Act (NAGPRA) has had a wide-reaching effect.

In the post-NAGPRA era, archaeology as a discipline was challenged to accept the relevance that modern Native perspectives have for archaeological study. In most cases, archaeologists have accepted this new situation (Swidler et al., 1997). Many new studies and projects are enhanced through consultation. This new attitude toward Native input has also affected the museum world and museum education (Connolly, 2000). While the museum community may have been prompted by NAGPRA, it moved beyond requirements mandated by the law to benefit from the voices and experiences of Native Americans.

8.1. The John P. McGovern Hall of the Americas

The Houston Museum of Natural Science was founded in 1909 and is one of the most highly attended museums in U.S. in the state of Texas. It was the fourth most attended museum in the USA. The museum contains five facilities: an IMAX theater, an observatory, a planetarium, a butterfly center, and natural science exhibit halls.

The exhibit halls examine the natural world from a scientific perspective. The halls cover the areas of chemistry, paleontology, energy, gems and minerals, shells, Texas and African wildlife, and Native American cultures. In addition, changing exhibits present many subjects including Egyptology, religions of India, and wildlife photography.

The John P. McGovern Hall of the Americas opened in June 1998. Taking an anthropological approach to exhibiting Native American objects, the Hall consists of galleries devoted to the Native peoples of the Americas. The first gallery provides an introduction to the study of culture and uses objects from cultural groups from across the Americas to illustrate concepts that are universally human. Each of the eight core galleries of the Hall of the Americas explores a culture of different geographic region including the Arctic, the Northwest Coast, the Southwest, the Plains, the Southeast, Central Mexico, and the Andes (Figure 8.1). The final gallery featured temporary and long-term thematic displays until the final gallery now displays rotating exhibits on Amazon cultures (Figure 8.3).

While taking a traditional, textbook approach to the organization of cultural groups by geographic region, museum staff agreed that two

FIGURE 8.1. Arctic gallery in the Houston Museum of Natural Science. (Original photo: Dirk Van Tuerenhout.)

interpretive themes were paramount. Interpretation would (1) highlight the diversity of the Native peoples of the Americas and (2) emphasize the fact that dynamic Native cultures exist today with contemporary photographs, quotes, and objects.

In planning for the Hall, museum staff felt that it was important to include personal perspectives on the significance of objects from both Native individuals and tribal groups. In pursuit of this ideal, anthropology curator, Elisa Phelps, sought the counsel and involvement of Indian advisors and colleagues who had worked with the museum on past projects. The ability to build on these existing relationships keenly highlights the important role of consultation and collaboration beyond that mandated by federal repatriation legislation. Sharing content authority between anthropologists and Native people allowed for a richer, more fully realized experience for visitors and an extraordinary learning opportunity for staff. Two geographic areas in particular were the focus of the collaborative development process.

8.1.1. Northwest Coast

The extraordinary visual appeal of Northwest Coast art and the turbulent history of First Nations in that region led the museum to identify the potlatch as a key entry point for understanding aspects of historic and contemporary Northwest Coast cultures. In the early 1990s, the Houston

Museum of Natural Science had been fortunate to host *Chiefly Feasts: The Enduring Kwakiutl Potlatch,* a major traveling exhibit organized by the American Museum of Natural History. Drawing on relationships established during *Chiefly Feasts,* museum staff worked with Kwakwaka'wakw artists and other individuals to develop the Northwest Coast gallery. One of the most extraordinary commitments the museum made in developing the Hall of the Americas was commissioning several large-scale Northwest Coast objects. These pieces, including a carved cedar housefront, provide tangible and publicly visible recognition of the importance of contemporary Indian art and the role it plays in traditional life and the economy of Native communities. The primary artist was Doug Cranmer, Kwakwaka'wakw, who completed the housefront on Vancouver Island, British Columbia. Working directly with the artists afforded the curatorial staff the chance to collect not just the objects but the artists' stories and personal observations about their work (Figure 8.2).

FIGURE 8.2. House post carved by Calvin Hunt for the NW gallery in the Houston Museum of Natural Science. (Original photo: Dirk Van Tuerenhout.)

FIGURE 8.3. Entrance to the temporary exhibit on the Amazon, HMNS. (Original photo: Dirk Van Tuerenhout.)

8.1.2. Southwest

The Southwest gallery focuses primarily on Puebloan peoples. As with the Northwest Coast section, staff built on an existing relationship with Zuni Pueblo established during a previous exhibit project. In consultation with Zuni individuals, the exhibit team developed ideas, selected objects, and created text about the process of making pottery. The text was drawn directly from interviews with the artists. Zuni potter Milford Nahohai recommended pieces for addition to the museum's collection. Featured in the exhibit is pottery by Zuni artists Randy Nahohai, Anderson Peynetsa and Noreen Simplicio.

As part of an exploration of Pueblo architecture, museum staff was drawn to the idea of reconstructing a kiva from Sand Canyon Pueblo in Southwestern Colorado, a site excavated by Crow Canyon Archaeological Center. Crow Canyon has an active Native American Advisory Committee and museum representatives were invited to share exhibit plans with them. Staff initially wanted to include the actual artifacts that had been excavated

from the kiva but discussion with the Advisory Committee quickly established this was not an appropriate course of action because of the sacred nature of the objects.

The collective decision was made to make the display inside the kiva a statement from the Chair of the Crow Canyon Native American Advisory Committee explaining why no objects were included in this section of the exhibit. Peter Pino, Tribal Administrator for Zia Pueblo, wrote an eloquent and personal reflection on Pueblo ceremonial life. The kiva exhibit makes an express connection between contemporary Pueblo life and ancient Puebloan culture. Exhibit text acknowledges the importance of consultation, cultural sensitivity, and the ongoing sacred nature of objects long removed from their original context. While the recreated kiva is only a small part of a very large exhibit, it represented a big change in the interpretive process for the museum.

More time and greater financial resources would undoubtedly have allowed for additional consultation and even stronger Native representation in the exhibit. However, the accomplishment of the Hall of the Americas is that Native voices have a lasting presence in the Houston Museum of Natural Science.

8.1.3. More Connections

As the fourth largest city in the USA, Houston is home to more than 70 consulates of foreign countries. Temporary exhibits on topics related to foreign countries provide opportunities for collaboration. For example, the museum and the consulate general of Peru collaborated on programs related to the Machu Picchu exhibit in the Hall of the Americas. Peruvian folkloric dancers were present during the opening ceremonies of the exhibit and the museum was represented during Peru's national holiday celebrations held in Hermann Memorial Park. The Peruvian consulate and the museum worked together on a culinary event related to the Machu Picchu exhibit. The event, "Peruvian Rainforest Dinner," included not only Peruvian food and drinks but also music and dancers. While enjoying a good meal, the guests listened to presenters on the Native culture in Peru and how it has continued until today. Through exhibits and related activities like these, the museum continues to make the link between past and present, and does so in a variety of settings.

8.1.4. Programming Emphasized Cultural Awareness

In 1999, a new series of programs was initiated to educate the public using the Hall of the Americas. Dr. Dorothy Lippert (Choctaw), an archaeologist, was hired by Director of Education, Pam Wheat, to serve as education coordinator for the programs that introduced the public to archaeology and Native American cultures. These programs addressed many concerns that Indian people had about museum education and pointed to a new way of working together that resulted in presentation of accurate, non-stereotypical

information. The objectives for programming were to increase cultural awareness, present inquiry thought, and promote stewardship. Long-time museum supporter Dr. John P. McGovern underwrote the programs for 2 years. While some components of the effort were phased out after the initial grant, others such as the lecture series and educator workshops became self-supporting and continued.

8.1.5. Educator Workshops

Educator workshops enable teachers to use museum resources in class for the benefit of students who may or may not visit the building. By educating teachers, the museum can enhance learning for students for generations to come. Teachers will carry the message of cultural awareness into the classroom and incorporate it into lessons for a variety of subjects. In addition, the workshops encourage the local teachers to rely on the museum as an educational resource (Selig and Lanouette, 1983). ExxonMobil that actively sponsors science education underwrote educator workshops for 2 years. While the first year of monthly workshops were sparsely attended (6–10 teachers), the second and third year workshops had overflow crowds (50–75 teachers). Continuing education and career ladder credit was given for attending the workshops. Each workshop concluded with a feedback segment when teachers were asked to comment, verbally and written. The museum staff learned that teachers appreciated the new information and the prepared lessons that enabled them to teach the new concepts easily. They also asked for hands-on teaching materials that were developed by museum staff as Discovery Kits.

The Hall of the Americas workshops covered the different geographic regions as well as more specific topics such as construction of pre-Columbian musical instruments, rock art analysis, and contemporary Native America. The information in each workshop was designed to correlate with and enhance the exhibits in the Hall of the Americas. A workshop on Native American botany examined the different botanical references to be found throughout the Hall, from corn ears in an incomplete Navajo sand painting, to wooden boxes from the Northwest Coast to ceramic cacao beans from the Maya area. The geographic regional workshops focused on specific pieces in the exhibit; frequently introducing the skills required to produce artifacts such as a pine needle basket or a beaded rosette.

As the museum is a natural science museum rather than a history museum, the educational message focused on using the sciences to understand culture. Educator workshops were structured for teachers to learn how archaeology and anthropology illuminate the American past and present. Activities drawn from resource books such as *Intrigue of the Past* (Smith et al., 1996) and *Clues from the Past* (Wheat and Whorton, 1990) allowed teachers to experience lessons focused on inquiry that is the basis for archaeological work. The teachers were also introduced to archaeological skills such as ethnography,

site mapping, archeological analysis, and artifact replication. This helped the teachers to understand the process of deriving knowledge from archaeological practice.

A strong goal of the workshops was to impart the ethical aspects of archaeology. Texas currently does not have a law to protect unmarked burials on non-federal land, which comprises most of the state. Looting is a major problem for Texas archaeologists, along with desecration of rock art sites. The workshops addressed these issues and provided lessons for teachers to introduce ethics in the classroom.

An ethical consideration from a Native American point of view is to maintain and reinforce the connection between past and present. All too often, educator materials that focus on Native peoples frame information in a general, ethnographic presentation that denies Native Americans the right to be normal human beings, capable of change and adaptation. Each of the workshops introduced the contemporary Native community associated with the featured gallery from the Hall of the Americas. For example, the Maya workshop discussed the modern Maya communities and focused on Nobel Prize winner, Rigoberta Menchu (Figure 8.4). At other workshops, members of the local Indian community spoke about their own tribes—Navajo, Caddo, Cherokee, Apache, and Comanche. These presentations were intended to strike down any lingering images of "the vanishing Indians." The speakers each discussed his or her own background and through their presence in the museum illustrated these new partnerships with the Indian communities.

All of the Native American presenters expressed their pleasure at being invited to the museum to help teach. Many regularly make presentations to schools and groups in the area and are accustomed to doing this kind of work on a volunteer basis. Due to strong funding, the museum was able to compensate the guest teachers for their time. This elevated the work of these educators to a more professional level and indicated that the museum valued them for their expertise. Again, this enhanced the partnership with the Indian communities. Rather than the museum appearing to be the sole authority about the Native American past, the Hall of the Americas workshops integrated a variety of Native speakers and, through this, expanded the educational impact far beyond the exhibits.

8.1.6. Discovery Kits

As part of the outreach activities, the museum responded to requests and developed Discovery Kits for loan to educators. These are boxes of materials with instruction that are used in the classroom to educate about topics covered in the museum's galleries. These kits had input from different Indian groups. In many cases, the objects in the kits are fashioned by Native artists. The kits relate the same message as the other programs, correcting stereotypes and providing accurate and updated information about contemporary Native Americans.

FIGURE 8.4. Entry to Maya gallery HMNS showing façade of Hoccob Temple replica. (Original photo: Dirk Van Tuerenhout.)

8.1.7. Live in the Gallery

Another program that promoted contemporary Native American cultures was called "Live in the Gallery." Native American artists spent a weekend day in the Hall of the Americas performing or demonstrating their art. The artists were able to interact with the museum visitors and were not treated as part of the exhibit, but as expert teachers who could further the visitor's learning experience (Figure 8.5).

Many of the artists related directly to exhibit pieces in the galleries. For example, Ken Masters, a Cherokee potter, had his pottery making demonstration setup directly beside a museum display of Mississippian pottery. During his demonstration, he pointed to the case and discussed the differences and similarities between the ancient objects and his own work. Eldrena Douma, a storyteller, is the granddaughter of the Hopi potter, Nampeyo. The museum displays a bowl that was made by her aunt, Dextra Quotskuva. During her performance, she related stories to the animal figures that appear on the pots on display and urged listeners to examine her aunt's work.

Other artists who were featured include Cherokee storyteller Gregg Howard, Kiowa musician Phillip Bread, who gave a Native American Blues performance in the Hall and an Alabama–Coushatta drum group. One of the

FIGURE 8.5. Interactive screen in the SE gallery showing information on modern Cherokee tribes. (Original photo: Dirk Van Tuerenhout.)

museum's archaeologists, Jim Hughey, was the "Archaeologist in the Gallery" in October 2000. He displayed artifacts and informally discussed Texas archaeology with visitors to the Hall of the Americas. Louie LaRose, representing the Intertribal Bison Cooperative, shared with visitors how tribes today interact with bison. Poet and activist Otilia Sanchez, Yaqui, shared her writings and stories as a Native American advocate.

The presence of Native artists in the gallery forced the visitors to make the connection between objects on display, some of which were hundreds of years old, and an ongoing Native American tradition of art and craftsmanship. Visitors could learn from the artists about how methods and materials changed over the years. Through this program, Native American artistic traditions, like Native peoples, could therefore no longer be seen as static or unchanging, but vibrant and connected to a long history and exciting future.

8.1.8. Archaeology Lectures

A monthly lecture series for the Hall of the Americas brought archaeologists, some Native American, from all regions to discuss current research and issues. The series was a new offering to members of the museum community and took several months to garner an audience. The first few lectures only had 15–20 people in the audience. By the second year, each speaker gave two

lectures—one at noon and one at 7 PM. Each of these sessions generally had 80 people attending. In the initial year, a grant was necessary to pay expenses but by the second year fees covered expenses.

The lecturers on the topic of human arrival in the New World included Joe Powell, physical anthropologist, Michael Collins, archaeologist, Phil (Minton) Cash Cash, Nez Perce/Cayuse, archaeologist, and Roger EchoHawk, Pawnee, archaeologist (Echo-Hawk, 1993). This combination of speakers encouraged the audiences to acquire multiple perspectives on the topic. They learned that archaeological perspectives change with new discoveries, and that many Native American perspectives offer challenging new interpretations of archaeological knowledge.

8.1.8.1. Anthropology Symposium

The museum hosted an annual anthropology symposium as well. This symposium typically served as a platform to address issues related to Native American culture, past and present. It was held in the IMAX auditorium that seats 400. It was organized after an advisory committee laid the ground rules for topics and participation. It was funded annually by the Favrot Fund. A goal of this series was to offer anthropological dialogue for students from local colleges, especially community colleges where anthropologists are seldom on campus. Therefore, free tickets were given to professors to encourage attendance. General public and members paid for admission (Figure 8.6).

The first symposium was held on October 26, 2000 and centered on the concepts of power and cultures. Speakers included Charlene Teeters, Dr. Donald Frishmann, and Dr. Wade Davis. Ms. Teeters (Spokane Nation) shared her opposition to the continued stereotyping of American Indian culture in American society. Dr. Frischmann, Spanish and Latin American professor at Texas Christian University, presented on the current state of affairs of Native culture in Highland Chiapas. Dr. Davis, ethnobotanist and author of *One River* and *The Serpent and the Rainbow*, spoke about current Native American use of medicinal plants.

On October 18, 2001, the museum invited five speakers to address the issue of "First Americans: Peopling of the New World." The speakers all approached the same questions: when and how might the First Americans have arrived? The challenge to the speakers was not only to present answers to the questions using data from their own subfields of anthropology, but eventually also to try to explain the differences that arose between them. Dr. Bruce Bradley, archaeologist, presented his views on the arrival of early settlers from Europe, countering the more traditional view that all of the earliest Americans came across the Bering Land bridge with an Atlantic crossing. Dr. Johanna Nichols reviewed linguistic data and suggested that one had to consider a very early presence of human beings in the Americas if we were to explain the great linguistic variety that existed within the borders of this landmass. Dr. Ann Stone, genetic specialist, focused on the results of

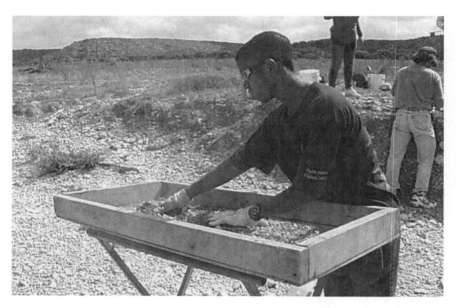

FIGURE 8.6. Students participating in XPedition sponsored by HMNS. (Original photo: Pam Wheat-Stranahan.)

her research, which does not, at this point, support a date as early as suggested by the linguistic data. Dr. Michael Collins, archaeologist, added a much appreciated Texas angle to the story by expanding on his experiences and results from excavations at the Gault site. Dr. Joe Watkins, Choctaw archaeologist, elaborated on the claim that American Indians "had always been around."

The format of the symposium allowed for a wrap-up session where the speakers could interact with each other as well as with the general public. It was very clear from these exchanges that there was great interest from all sides to come to a comprehensive understanding of the data and to try to explain the differences that still existed between them. The general public not only got a chance to ask some pointed questions, but also got the opportunity to see science in action and to realize that the issue of the archaeology of the earliest Americans is a complex one, and still escapes a definitive answer.

8.1.9. Heritage Day

In November 1999, the museum hosted the first Native American Heritage Day. November was selected because schools tend to focus on Native American culture at this time. While teaching in schools is often stereotypical, the museum worked to counter this, expanded the theme, and presented authentic information that students might not otherwise learn. Heritage Day

featured three main areas: a stage, activity centers for hands-on learning and demonstrations by Native American artists in the Hall of the Americas itself.

Native artists were invited to perform on stage near the entry to the museum. The invited guests included Gayle Ross, Cherokee storyteller, William Gutierrez, flute player and maker, Bayou City Indian Alliance, a local intertribal society who sent Native dancers, and Ballet Folklorico Azteca de Houston, who performs dances derived from Mexican cultures.

The activities that were presented each related to different galleries in the Hall of the Americas. They were selected to provide some new information about each area or to link a hands-on activity with the pieces on display. For example, in the activity that corresponded to the Andes gallery, participants tied feathers to create a feather textile. There are two such textiles on display, and it was hoped that by attempting to make such an item, visitors would gain new insight and respect for the ancient makers of the pieces on display.

Additionally, many members of the Indian community provided demonstrations or displays in the Hall of the Americas. Each individual or group was allowed to set up a display on a table in the hall and then speak with the museum visitors. This was a large-scale version of the monthly Live in the Gallery program.

Another example of such a Heritage Day was the one held on September 9, 2000. The theme of that day was "Native Americans and the Animal World." Tents were set up in front of the museum allowing displays game demonstrations, and basket weaving. The Cherokee Society in Houston participated with a "language table" where Cherokee animal names were discussed. Visitors were invited to enter the Hall of the Americas to enjoy additional Cherokee artifacts, genealogy information, and local Native American artists with their treasures. Other outdoor activities included dancing, music, storytelling, and more crafts. The event theme was linked to opening of the IMAX film "Wolves," about a Nez Perce Wolf Education Research Center in Idaho. Tribal member Levi Holt discussed their program.

Heritage Day provided the museum with media exposure and encouraged further interaction with the local Indian community. Many different groups participated and were made to feel that they could have a role in how the museum teaches about their cultures. The target audience, families with young children, responded to the event by fully participating in the various activities. The event was structured so that, even if a child had only been exposed to the most stereotypical information at school, Heritage Day events would open up other areas of thought about Native peoples.

8.2. Summary and Conclusions

The programs at the Houston Museum of Natural Science were undertaken with the goal of promoting archaeology as a way of contributing to our knowledge about the Native American past. However, a focus exclusively on

archaeology could reinforce the stereotype of Native cultures as being extinct or belonging to the past. It was important to balance this information with awareness about contemporary Indian peoples. So an equally important goal of the museum's education department was to educate visitors about the modern Native cultures. The programs that were undertaken promoted these two perspectives in a complementary fashion (Banks, 1994).

New directions have allowed the museum to become more closely involved with Indian communities whose history and cultures are presented in the exhibit halls. The Hall of the Americas program at the Houston Museum of Natural Science illustrated the changes in attitudes and awareness. The integration of archaeological perspectives and Native American knowledge can only help us more fully understand the history of the Americas.

References

Banks, J.A., 1994, *Multiethnic Education: Theory and Practice*. Third edition. Allyn and Bacon, Boston.

Berkhofer, R.F., 1978, *The White Man's Indian: Images of the American Indian, from Columbus to the Present*. Random House, New York.

Bieder, R.E., 1986, *Science Encounters the Indian, 1820–1880: the Early Years of American Ethnology*. University of Oklahoma Press, Norman.

Connolly, M., 2000, Who Paints the Past: Teaching Archaeology in a Multicultural World. In *The Archaeology Education Handbook*. AltaMira Press, New York.

Echo-Hawk, R., 1993, Working Together: Exploring Ancient Worlds. *Society for American Archaeology Bulletin* 11(4):5–6.

Hirschfelder, A., 1982, *American Indian Stereotypes in the World of Children: A Reader and Bibliography*. Scarecrow, New York.

Selig, R.O. and Lanouette, J., 1983, A New Approach to Teacher Training. *Museum News* 61(6):44–48.

Slapin, B. and Seale, D., 1998, *Through Indian Eyes: The Native Experience in Books for Children*. New Society Publishers, Philadelphia.

Smith, S.J., Moe, J.M., Letts, K.A., and Patterson D.M., 1996, *Intrigue of the Past: a Teacher's Activity Guide for Fourth Through Seventh Grades*. Bureau of Land Management, Anasazi Heritage Center, Dolores, CO.

Swidler, N., Downer, A.S., Anyon, R., and Dongoske, K.E., editors, 1997, *Native Americans and Archaeologists: Stepping Stones to Common Ground*. AltaMira Press, New York.

Wheat, P. and Whorton, B., 1990, *Clues from the Past: a Resource Book on Archeology*. Hendrick-Long Publishing Co., Dallas, TX.

9
Building Bridges Through Public Anthropology in the Haudenosaunee Homeland

Brooke Hansen and Jack Rossen

In this chapter, we discuss how, as a cultural anthropologist and archaeologist, we have moved toward a vision of public anthropology with partnerships of many kinds, centrally involving the Haudenosaunee (Iroquois) in the Finger Lakes region of central New York. The Haudenosaunee Confederacy is comprised of six nations, which include the Mohawk, Oneida, Onondaga, Cayuga, Seneca, and Tuscarora. Jack excavates contact and precontact Cayuga village sites, while Brooke has a special interest in Native health and healing. Our research and activism are conducted in a region with intense social and political complexity. It includes the Cayuga Indian Land Claim, a depressed state economy and collapsing tax base, heavy pressure from the governor for Native groups to take casinos, and an anti-Indian land claim group (called Upstate Citizens for Equality, or UCE). Our work involves a dynamic, evolving communication, and collaboration with local Native communities of the Haudenosaunee. It is a multifaceted approach that also includes joint public presentations, visiting secondary schools, acting as liaisons for Native art and artifact exhibits, and attending conferences and organizations (such as Cultural Survival) with Native colleagues.

Rather than developing a specific model for partnership with Native people in social activism and research, our public anthropology approach developed in response to one particular local ethnopolitical situation. The Cayugas are unique among the six Haudenosaunee nations because they were the only ones left without land after the tumult of the Revolutionary War and a series of dubious treaties and land sales. Much of our work has focused on a community organization called Strengthening Haudenosaunee American Relations through Education (SHARE) that we helped to develop. Since 2001, SHARE operated a 70-acre organic farm and house that was transferred to the Haudenosaunee in December 2005 as part of a land reparations plan we formulated to help them reestablish a presence in their ancestral homeland. Chief William Jacobs stated, "This is a wonderful thing for our people. It gives us a base and a place to call home where we can reestablish ourselves as Cayuga people" (Carter, 2005: 1A).

The many collaborative projects run at the SHARE farm included indigenous crop plantings, herb gardens, medicinal workshops, wild plant collecting, a seed saving program, and various public outreach initiatives. In this setting, our identities expanded from simply being a cultural anthropologist and archaeologist to being partners in a variety of public projects with Native and non-Native people in the region. This chapter presents an overview of our public anthropology with specific examples of our Native American community partnerships and the integral role of archaeology in providing a historical foundation for this work.

9.1. Public Anthropology in the Cayuga Homeland

Public anthropology demonstrates the ability of anthropology and anthropologists to effectively address problems beyond the discipline—illuminating the larger social issues of our time as well as encouraging broad, public conversations about them with the explicit goal of fostering social change. It affirms our responsibility, as scholars and citizens, to meaningfully contribute to communities beyond the academy—both local and global—that make the study of anthropology possible. (www.publicanthropology.org)

Public anthropology may be the latest catchword to describe an engaged, activist, and applied genre of the discipline, but it has been around since the inception of anthropology in various versions. Some of these might fall under the labels of activist anthropology, praxis, participatory action research, community based research, and on the most basic level, applied anthropology. In earlier days, the work of Margaret Mead exemplifies an anthropology that attempts to reach out to the public to make our research relevant to a wide audience, especially by publishing and speaking in popular magazines and venues. Mead received criticism for her orientation toward creating public dialogue (Ambrosino et al., 1981), and some shadows still hang over these genres of anthropology. Whatever label it falls under, this type of anthropology, geared to engaging local communities and fostering public outreach and discussion, best describes the work that we have been doing in the Cayuga homeland. It captures the essence of how anthropologists are trying to reshape their relationships with Native Americans and indigenous studies.

We are explicitly aware of the troubled history between anthropologists (especially archaeologists) and Native Americans and strive to develop forms of archaeology and cultural anthropology that are not hierarchical, but represent true dialogue and partnership. Our projects are works in progress and we have not reached our ultimate goals, (1) for cultural anthropology and ethnobotanical research to facilitate a revitalization of dietary and medicinal practices, and (2) for archaeology to represent a positive force through which Native people ponder their history alongside oral traditions and control the nature of archaeological research and the disposition of artifact collections. We also hope to reduce ethnic tensions in an area where stereotypes and

historical forgetfulness have produced misunderstanding and mistrust between non-Native and Native people.

As we began our journey into Haudenosaunee studies in the 1990s, it became clear that we had to address the intense local ethnopolitical conflicts between Native and non-Native peoples, most of which have centered on Indian land claims. This need was heightened by fact that we were not just working with Haudenosaunee people and learning about their history and culture, we also lived in and around the land claim, in essence, we were both local community members and anthropologists by virtue of our residence. For Brooke, this meant that in routine daily activities, such as picking up the mail from the local post office, racist discourses about Native people would be heard, such as a postal worker joking about how he would rent guns by the hour to local residents to shoot Indians if they tried to take back land through the Cayuga land claim. As an anthropologist, community member, and parent to a young child, it became clear to Brooke that education about Native people needed to quickly be brought out of the ivory tower and into local communities where ignorance about Native American treaties and law, coupled with widespread stereotypes about Indians as savages and drunks, were rampant.

Our local model of partnership and public interpretation of archaeology, and cultural anthropology in the region is based on several key issues. Primarily, the Cayuga Indian Land Claim, in the courts since 1980, has created an enormous amount of misunderstanding and apprehension on the part of local residents that led to the formation of groups like UCE that practice politically motivated historical revision. As a result of our observations, experiences, and consultations with Native leaders, we have tailored our public anthropology at archaeological sites, public talks, school visits, and exhibits to be contexts for dialogue to help dispel miseducation and explore these multifaceted issues. Specifically, our public interpretation first highlights the history of the Cayuga Nation, with its well-organized, sometimes occupationally specialized sixteenth- and seventeenth-century towns, villages and advanced agriculture and fruit tree horticulture.

One of the key events we often discuss that led to the Cayuga dispossession from their land was the Sullivan Campaign of 1779, a watershed historical event in central New York during which 43 villages, crop fields, and fruit tree orchards were burned and destroyed by the Continental Army (Cook, 2000[1887]). This complex event has not only been the focus of much historical revision, it has been rendered invisible by local school curriculums. Our efforts to raise awareness about the Sullivan Campaign helps local people understand that the Cayuga did not simply leave their territory 200 years ago, as is suggested by anti-Indian land claim adherents, but they were literally burned and chased out under the orders of General George Washington, known to the Haudenosaunee as "Town Destroyer" (Mintz, 1999: 4; Williams, 2005: ix). There are still some memories and oral stories about this time period that have been passed down among the Haudenosaunee, which we are collecting. This represents another productive collaboration in our work

between archaeology and cultural anthropology, revealing the relationship between the material culture and oral history of the Sullivan Campaign. For example, the archaeology reveals the complex economy of specialized villages and trade networks of food and materials, the growing pressures on Native people in the eighteenth-century that compromised these systems (forcing for example, the use of coal slag instead of chert for toolmaking), and after the Sullivan Campaign, the continued Cayuga presence in the heart of their homeland.

This integrative approach to research and public presentation of the past and present is designed to produce collaboration with Native people, facilitate communication and discussion of historical and contemporary issues, and ease local ethnopolitical tensions. We recognize archaeology and cultural anthropology as powerful forces that can either help or harm Native people. If collaborative partnerships that reflect local conditions are not developed, and if archaeologists and cultural anthropologists do not expand their identities to become activists, the forces of our discipline are unlikely to be positive for Native people.

9.2. Motivating Our Public Anthropology: UCE and the Cayuga Indian Land Claim

The local political climate is the significant compelling force for practicing public anthropology in the area. UCE is the most visible and vocal organization protesting the Cayuga land claim, which has been in the courts since 1980. UCE members erected a variety of signs throughout the Cayuga Lake region with slogans such as "Who will win, the farmer's heartbeat or the Indian's drumbeat," "Scalp the land claim, NRA Forever," "Entering Kosovo," and "We fought four wars for this land." UCE standardized this form of protest with a proliferation of professionally produced signs stating, "No Sovereign Nation, No Reservation." (Figure 9.1) It was the magnitude and intensity of this sign campaign that propelled us to deeply engage in public outreach in these communities to try and defray the mounting ethnopolitical conflict.

Members of UCE are farmers and business people living in the depressed economy of rural New York State. Sovereignty, taxes, and gaming are all complex issues, and this complexity is furthered by the fact that local residents are confused about the factions and subgroups of Cayuga from New York, Canada, and Oklahoma that all stake a claim in the region. The goals and ideologies of UCE are complex, but a few basics may be stated for the record. The term "equality" in their name is used as a euphemism for assimilation, in that this group wants all people living in the area, non-Native and Native, to have the same culture, religion, and be equal tax-paying citizens of the USA. They fear that an increased Native presence in the area and a land claim settlement will bring a lower tax base as reconstituted reservation lands and businesses come off tax rolls. They are also concerned about the potential consequences of gaming in the area. The Native people with whom we work

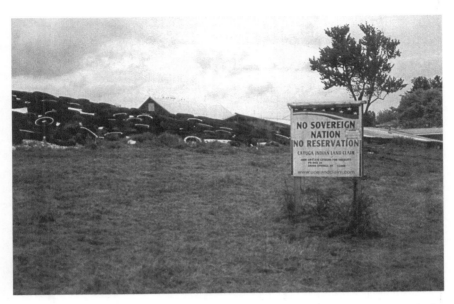

FIGURE 9.1. Anti-Indian land claim signs dot the landscape around Cayuga Lake. (Photo: Jack Rossen.)

view the group as being hostile to Native Americans and fear even driving through the area (Figure 9.2).

UCE should not simply be understood as a local expression of discontent against Cayuga and government, but should be placed within a larger framework of national and global cultural politics regarding the ongoing struggles of indigenous peoples to regain rights, land, identity, and culture (Turner, 1993; Pertusati, 1997; McIntosh, 2000; cf. Mackey, 2002). As Mackey has noted, based on her comparative studies, which include UCE,

...local governments and local residents often resist land rights being offered to indigenous groups in land claim areas. Significantly, their objections are often framed in "universal" human rights discourse. Indigenous land rights, they argue, violate *their* rights as local, regional and national citizens, and threaten their lands, communities and heritage. (2005: 14)

9.3. Historical Revision of the Cayuga and Their Homeland

The urgent need for collaborative anthropological and archaeological efforts with the Cayuga is highlighted by the prevalence of historical revisions that

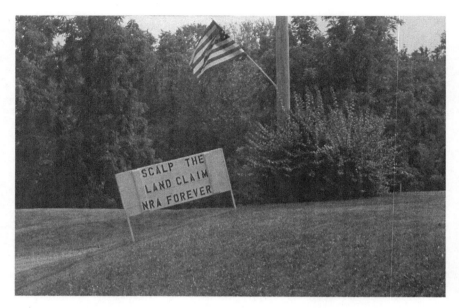

FIGURE 9.2. One of many signs in the local area reflecting resident opinions about the Cayuga land claim. (Photo: Brooke Hansen.)

denigrate and stereotype the Cayuga, and erase or disavow their long history and strong connection to their homeland.

In a section of the UCE website titled "A Cayuga Chronicle" (Hickman, n.d.), the Cayuga are characterized as a "Stone Age," and "warlike" people known for their "preoccupation with supernatural aggression and cruelty, sorcery, torture, and cannibalism." Also stated is that, "The Cayuga Indians came to the area of New York in the 1500s, a wandering nomadic tribe that traveled around the northeast, never having a permanent settlement" (UCE, n.d.), an assertion that few archaeologists would agree with. Despite ample evidence that the Cayuga had significant villages and cornfields in the area, a local historian wrote that when the first white settlers arrived in the heart of Cayuga territory (near current Aurora Village), they "found an empty wilderness" (Edmunds, 2000: 1). Historical markers placed throughout the area discuss the Sullivan Campaign "against the hostile aggressions" of the Cayuga (Ford, 2002) and glorify the destruction of the Native towns, villages, crop fields, and fruit tree orchards.

The local political climate, coupled with the extensive amount of historical revision, fueled the formation of the grassroots organization SHARE and our commitment to research and educate about more accurate depictions of the history, archaeology, and culture of the Cayuga people.

9.4. Responding to Local Ethnopolitical Conflict: The SHARE Project

In 1999, Julie and Jim Uticone, life-long residents in the Cayuga land claim area, began SHARE to promote friendship and mutual respect locally between non-Native and Native people. The Uticones were compelled to form SHARE as a response to the intensifying hostility, racism, and unrest enveloping the region as the Cayuga land claim case seemed to be coming to a climax. Bernadette "Birdie" Hill, Heron Clan Mother of the Cayuga Nation, was a significant source of inspiration for the formation of SHARE with her compelling stories of the dispossession of her people from their homeland and their desire to reconnect with their ancestral land (Tobin, 2002b). After the nascent SHARE group organized several events, including a peace circle, we met the Uticones and offered our anthropological and educational expertise, realizing the opportunity this provided to expand on the public outreach efforts we were already engaged in. Now equipped with resources such as institutional funds, student interns, and organizational skills, SHARE put out quarterly newsletters, held gatherings, organized Native American festivals (Bisignano, 2000; Plotnick, 2001), and visited local schools to discuss Native people and contemporary issues.

In 2001, we heard that a friend's organic farm was going up for sale near Union Springs in the claim area. The 70-acre farm is located adjacent to both Cayuga Castle, the largest Cayuga settlement site, and Great Gully, a place of great significance to the Cayuga (Tobin, 2002b). We pooled money, purchased the property, and the Cayuga farm project was born (Seldi, 2001; Thornley, 2001; Burdick, 2001a, b; Shaw 2001a, b). The ultimate goal is to repatriate the land to the Cayuga of New York, the only one of the Haudenosaunee tribes without a nation territory for their people to gather on. As we fundraised and worked on the details of the land repatriation, we operated the farm as an educational center and as a welcoming place for people of all kinds to reconnect with each other and the land (Figure 9.3). Given the very visible land claim protest signs in the area, we felt it was imperative to create this space for other voices and perspectives to be heard (Olson et al., 2001). Soon after acquiring the farm, some local residents began dropping by to express their discontent with the racist overtones of the anti-Indian land claim movement. We met a number of people, who were interested in learning more about the Cayuga and they were not adverse to a Cayuga return to the area. These occasions were not without controversy. The visit of the president of the local chamber of commerce to welcome SHARE was met with dismay by other chamber members, prompting her resignation (Long, 2001). We came to realize that even though UCE seemed to dominate the landscape and rhetoric about the claim, they could more accurately be portrayed as a vocal minority.

The SHARE farm enabled us to form many partnerships with Cayuga and Haudenosaunee people, who were interested in reconnecting with their

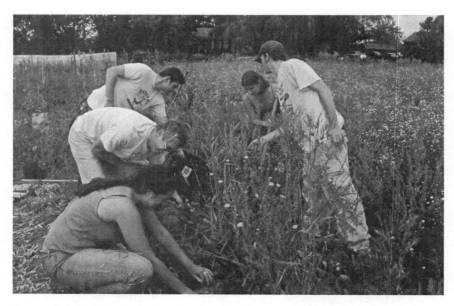

FIGURE 9.3. Jack Rossen and volunteers weeding crops at the SHARE farm. (Photo: Brooke Hansen.)

homelands and revitalizing cultural practices such as traditional agriculture and plant medicines. Immediately after the acquisition of the farm, Cayuga people did return to this small part of their homeland to plant the Three Sisters (corn, beans, and squash), harvest wild medicines and plant foods, conduct ceremonies and gather (Shaw, 2001d). To enhance these activities, Brooke developed the Haudenosaunee Medicinal Plant and Native Food Project, using her background in medical anthropology and ethnobotany. With grant support from Ithaca College, she created an educational medicinal herb garden as a space for both Native and non-Native people to learn about Haudenosaunee culture and ethnobotany (Keemer and Williams, 2003). The garden is in the shape of a great turtle in honor of the Sky Woman creation story in which the first woman on earth landed on the back of a turtle, which later became Turtle Island or North America. This collaborative project involved student interns and volunteers from Wells College, Ithaca College, and several other area colleges and high schools. Jeanne Shenandoah (Eel Clan, Onondaga), a local cultural midwife and herbalist, was the main consultant for the herb garden. Brooke organized workshops at the farm, led by Jeanne, where participants learned about Native crop revitalization, (corn, beans, squash, black ash, wild strawberry, etc.) and the cultural foundations of Native American herbalism. As part of these revitalization initiatives, we also have a Three Sisters garden at the farm, and we launched a Native seed saving program focusing on indigenous bean varieties.

Other cultural anthropologists have also been significantly involved with shaping the programs at the farm, most notably, Ernie Olson from nearby Wells College. Brooke, Ernie, and Jack organized and co-taught a class at the farmhouse on *Contemporary Native American Issues* that focused on *in situ* experiential and service learning. The money that Wells College paid us for teaching the class was used to fund outreach and pay farm bills. Students heard from many Native guest speakers and worked on projects related to eco-housing, nonprofit incorporation, fundraising, and educational outreach materials, in essence, we were teaching them the ropes of public anthropology (Figure 9.4). Ernie has also overseen various agricultural projects and integrated his colleagues and students from Wells College. In addition to assisting biology, physics, and ecology professors from Wells to set up projects for their classes at the SHARE farm, Ernie has also placed student interns and residents at the farm. This led to studies on chemical runoff from surrounding farms that are not organic, and the feasibility of harnessing wind power on the land (Cuppernell, 2004). These are issues of great concern to many Haudenosaunee people, whose culture and way of life are still very integrated with the environment. The organization embodying this philosophy, the Haudenosaunee Environmental Task Force, visited the farm on numerous occasions to explore and implement a variety of environmental programs (HETF, n.d.), such as planting black ash trees and purchasing a tractor.

FIGURE 9.4. Field school students Martin Smith and Nina Rogers sit with an exhibit of artifacts at a public festival. (Photo: Brooke Hansen.)

In addition to the outreach involving plant medicines and Native agriculture, we organized a number of other public events, festivals, and workshops at the farm to enhance our educational efforts at building bridges and addressing stereotypes and misconceptions about Native people. Jack organized workshops where people brought in Native artifacts from their farms for identification and discussion. These workshops also addressed issues such as the importance of archaeological site protection and the repatriation of human remains. This led to a request by a local museum to repatriate its human remains to the Cayuga people, which was conducted using the SHARE farm as an intermediary and temporary storage facility.

9.5. Archaeology of the Cayuga Lake Region

Jack's work at SHARE was an outgrowth of his archaeological research, which has focused on recapturing the history of the Cayuga presence in the area (Rossen, 2006). This work fits into the growing field known as indigenous archaeology, within which archaeologists actively collaborate and cooperate with Native people and work to reconceptualize archaeology as a positive force for Native people instead of the offensive force it has too often been (Anonymous, 1986; Swidler *et al.*, 1997; Watkins, 2000). The Haudenosaunee have had extremely negative recent experiences with an archaeologist who hoarded human remains in his basement, and with an archaeological field school run by a professor unknown to Native leaders and whose students were unaware they were working in a land claim area. In other areas of the country, Native people have become professional archaeologists and begun to actively research their ancient heritage (Jemison, 1997), but this has not yet occurred among the Cayuga.

The eastern Cayuga Lake shore area surrounding the SHARE farm is a landscape of hills, rolling farm fields, deep wooded gorges, and cliff lines. The region contains several of the largest historic Cayuga villages and towns, including the very largest of them all, *Goi-o-gouen*, or Cayuga Castle, described during its destruction in 1779 by Sergeant Major George Grant as having 50 well-built houses (Cook, 2000[1887]: 113). This region has received only sporadic attention from professional archaeologists. William Ritchie worked there in the 1940s, including his excavation of the Frontenac Island cemetery (Ritchie, 1945), where the exhumation of hundreds of burials that were scattered to several local and state museums continues to deeply offend the Haudenosaunee people with whom we work. Marian White briefly investigated the area from 1969 to 1971 (Niemczycki, 1984: 18–19), though most of her research was conducted in the Niagara frontier area of western New York (White, 1961, 1977).

Archaeologists are partly to blame for the historic revision that is locally practiced. First, the 30-year absence of professional archaeologists from this area is notable. There are other professionals working around Cayuga Lake

(Baugher and Quinn, 1995; Baugher and Clark, 1998; Allen, 1999; Levine, 2003), but not in this eastern shore heartland area. The absence of professional archaeologists promotes the notion that the area's pre-European history is trivial and unimportant. In contrast, the current presence of archaeologists and cultural anthropologists in the region promotes interest and generates contexts or places where dialogue occurs on both historical and contemporary Native American issues. Second, the professional archaeological literature on Haudenosaunee (Iroquois) origins and development is complex and contradictory. Dates in the literature for the origin of the Haudenosaunee Confederacy range from the 1100s (Mann and Fields, 1997) to 1400s (Fenton, 1998: 69) and 1600s (Kuhn and Sempkowski, 2001). Scholars supporting a late (even post-European contact) date for the formation of confederacy often do not cite, acknowledge, or address the detailed case that has been made for an earlier formation (Kuhn and Sempkowski, 2001; Funk and Kuhn, 2003). It should be noted that the Haudenosaunee themselves have always stated that their confederacy is nearly 1,000 years old (George-Kanentiio, 2000). The archaeological cultures immediately preceding the historic Haudenosaunee carry heuristic titles like Owasco, Point Peninsula, and Princess Point, names that separate them from the Haudenosaunee. Owasco (ca. AD 1000–1400) in particular is an interesting case, in that its architecture, pottery styles, and plant remains clearly link it to contemporary Haudenosaunee people. Recently, the unified concept of Owasco has come under attack by professional archaeologists, who are noting that the defining cultural traits such as corn, beans, and incised pottery styles all began at different times (Hart and Brumbach, 2003).

These discussions are presented in detail in archaeological journals, and an uninitiated reader may think them to be esoteric scholarly debates. However, because NAGPRA depends on cultural affiliation to repatriate human remains and associated artifacts to Native Americans, these debates carry significant consequences for Native people. Did Kuhn, then state archaeologist of New York, realize the consequences of his argument for a late formation of the Haudenosaunee Confederacy, which made it more difficult for Haudenosaunee people to regain artifacts from people who they deem to be their ancestors? Do these archaeologists realize how the confusion they have created on issues such as the formation date of the confederacy and the nature of Owasco have opened the door for antiland claim groups to minimize the Haudenosaunee past and the legitimacy of their claims to land and cultural objects?

9.6. Archaeology and Cultural Anthropology as Public Dialogue

Since 1999, Jack has conducted research, including four field schools, on Cayuga and Euro-American historic sites, with a focus on documenting what life was like in the poorly-understood eras before and after European contact

including the Sullivan Campaign. From discussions with Clan Mothers and other Native leaders, we learned that they are interested in a general picture of what the Cayuga Nation landscape and its settlements looked like prior to its destruction, as well as research that documents the pressures of Euro-American encroachment and Cayuga life after the Sullivan Campaign.

To gain this information, the excavation of trash middens and houses may sometimes be acceptable, as opposed to the excavation of ritual plazas and cemeteries, which are never acceptable.

We also learned how the Cayuga view archaeologists and academics in general, which emphasized the importance of preexcavation visits to sites by Clan Mothers. Basically, archaeologists are conduits for information. They themselves discover nothing, but the sites reveal themselves when the time is socially and politically correct. I once told a clan mother I believed I had found the location of a portion of the Cayuga village of Chonodote, known to the British and Americans as Peachtown. She replied that I had not found anything, but the site had chosen to reveal itself now. Similarly, Native people are unconcerned that Coreorgonel, the Tutelo village once located near present Ithaca, has not been located by archaeologists (Bauer and Quinn, 1995), because the time is not yet right for its revelation. Some site stories should be told, some should only be told when the time is right, and some site stories should never be told. Thus, when a Clan Mother is visiting a site, she is trying to determine whether or not the time is right for the story of that site to be revealed.

Archaeological research in a politically charged area with ethnic tensions provides both opportunities and dangers. We learned that every day in the field, a study site becomes a context for dialogue on historical and contemporary issues with both local people and Native Americans interested in their history. Excavating a longhouse in a backyard in Aurora Village underscored the depth and complexity of the Native presence and provided an opportunity to extend this dialogue to the local media (Shaw, 2002a, b). This longhouse led to a local realization that far from being an empty wilderness, there were probably Cayuga houses underneath many homes and backyards in this area that was once *Chonodote* or Peachtown (Cook, 2000[1887]). Perhaps, the most dramatic example of public archaeology were the excavations conducted at the Patrick Tavern on Main Street in Aurora. This was the first Euro-American building in the region (1793), an economic and political hub that symbolized the transition of the area from a Cayuga national center to a Euro-American expanding frontier. A constant stream of visitors to this highly visible site always led to discussions of the land claim, common misconceptions of Native history, and the historical reasons for the strong Cayuga attachment to the area.

9.7. Archaeology at Village X

Probably the biggest challenge for archaeological research is to present the past as integrated with contemporary sociopolitical issues, instead of as the esoteric study or treasure hunt of a disembodied past. To further

address the interests of the Cayuga in their homeland, specifically to counteract revisionist ideas of Cayugas without permanent settlements or strong attachments to the land, Jack sought out a site that could specifically help them recapture their lost history and validate their claim of the region as their homeland. Because of the 200-year lapse in Cayuga presence in the region, few Cayuga people have any understanding of where their villages were or what life was like. Therefore, in 2003 and 2005, Jack's research focused on a Cayuga village site called Village X to protect the site. Village X was an important settlement with a plaza and earthworks during the late 1500s and early 1600s. Before initial investigation, it was important for a Cayuga clan mother to visit the site and give her permission for excavation, which she did, conveying her perception that this was indeed a powerful site with a story to tell.

Excavation in both years was done as an archaeological field school, which included students from four colleges (Ithaca College, Wells College, Colgate University, and Mount Holyoke College). To increase the students' connection to modern-day cultural and political issues, the field school included activities at the SHARE farm such as meeting Native people, planting Haudenosaunee white corn in the Three Sisters garden, working in the herb garden, and learning about the organization's various projects. In the 2003 season, most of the crew lived at the SHARE farm house and helped plan and run a festival held there. Student field trips tied Village X to other Cayuga sites in the area to help students understand the landscape and complexity of the historic Cayuga Nation. Much discussion occurred at the field school about the Cayuga land claim, UCE, the many protest signs in the area (including the two that border the SHARE farm) (Shaw, 2001c), and the relationships between archaeology and contemporary Native people.

During the field seasons, members of the Cayuga and other Haudenosaunee nations visited the site as a way to reconnect with their ancestors and their past, which the students felt privileged to witness. In addition to spending time with Cayuga people, and even running the screens with them, students got to hear about what life is like for Cayuga people today, including a discussion from one visitor about what it is like to be a clan mother. Another Cayuga visitor to Village X site was a college student with a burgeoning interest in the history and archaeology of his people. During another visit, an Onondaga potter discussed the manufacture of pottery and showed her incised blackware pots that are incredibly similar to the recovered sherds (Figure 9.5).

9.8. Collaboration at Village X

In addition to the Native visitors, the students were intrigued by the steady influx of cultural anthropologists spending time at Village X, including Brooke and her students. The basis of much of our public anthropology stems

FIGURE 9.5. Ada Jacques (Onondaga, Turtle Clan) discusses pottery making with the archaeology field school students. (Photo: Jack Rossen.)

from our intradisciplinary collaboration between archaeology and cultural anthropology, and then branches out to many other relationships beyond. Since 2003, we have been working together on the archaeology in the Cayuga homeland. Jack's excavations at Village X produced significant evidence of healing activities, exemplified by a multitude of small grinding stones and pallets which could have been used for preparing medicinal plants and substances (such as ground antler, one of which was found in the excavations).

Brooke has been drawing upon ethnographic and botanical sources to compile Haudenosaunee plant medicine inventories in gorges adjacent to the site. There seems to be a large concentration of herbs used for female health issues (black cohosh, bloodroot, etc.), plants which are quite rare in other gully systems in the area, but seem to be plentiful around Village X, perhaps indicating that populations centuries back actively encouraged the propagation of these plants, or perhaps there is something unique in the geography of this particular gully system not found in other nearby locales. The idea that the gully next to Village X contained herb gardens is supported by an archaeological curiosity at the site. The deepest trash midden (almost 1m in depth) is located along a strip of the site edge adjacent to the gorge and herb area. In most archaeological contexts, when settlements are located next to cliffs, trash is thrown over the edge, resulting in little or no trash midden accumulation. The presence of an herb collecting or gardening area adjacent

to the cliff might explain why trash was piled up at the cliff edge rather than tossed.

In the summer 2005 field season, the plant inventories were expanded and botanical maps are being created for the site and the areas around it to explore whether or not the high concentrations of medicinal plants are there because Native people encouraged them, or if there are similar plant concentrations in comparative gully systems without Cayuga villages. This work has involved a number of students, local botanists, and Native American herbalists from Haudenosaunee nations. With only a handful of Haudenosaunee herbalists still practicing today, this information can be an important component of revitalizing plant medicine traditions, as we have undertaken at the SHARE farm.

The work we have done through SHARE and local archaeology has reaffirmed for us that the benefits of reaching out to Native people, community members, and anthropological colleagues are exponential. It has allowed us to strive for goals that are well beyond the usual intellectual agendas of anthropology. This is public anthropology in its essence, taking risks, developing partnerships, and acting as engaged local citizens to foster social change. This type of work requires a multitude of collaborative networks in order to achieve such lofty goals as combating racism and ignorance and reuniting a culture with their ancestral homeland.

9.9. Collaborative Networks

Our collaborations have taken many different configurations over the years and have included Native leaders and youth, college students, local schools, community members, nonprofit organizations such as Cultural Survival, health care personnel, and town and city officials. The purpose of these collaborations typically focuses on creating educational materials (such as newsletters and exhibits), organizing Native American festivals and events (such as the Peachtown Native American Festival and Education Day), hosting workshops (e.g., herbalism, local archaeology, etc.), and presenting in a multitude of settings from kindergarten classes to historical societies. One collaborative presentation we organized was for the *Iroquois Programs* at a local museum, the History Center of Tompkins County, and it was titled "Native American Herbal Healing Past and Present." We combined our interests in indigenous plant use, archaeological and ethnographic, and presented with two of our students, Kelly Keemer (Seneca) and Amanda Williams, who were interns for the development of the Turtle Island medicinal herb garden at the SHARE farm (Keemer and Williams, 2003). This was an opportunity to do public education about the prominent role and continued importance of plant medicines to Native people, and it also provided an opportunity to collaborate with and coach our students on presenting anthropological work in public settings.

The archaeological research led to collaboration on exhibits with local museums. One small museum in the land claim area (Frontenac Museum, Union Springs) had exhibits utilizing a turn of the century map marking Native groups in categories of savagery, barabarism, and civilization, along with a late 1800s photo labeled "the last Cayugas." One field school student, Sarah Knight, worked to organize the artifact collections and write new interpretive panels that present a dignified past, including the importance of repatriation (Barreiro, 1990; Jemison, 1997; George-Kanentiio, 1998) and the Haudenosaunee contributions to the US Constitution (Johansen, 1998) and the American feminist movement (Wagner, 2001). As the 2005 field season drew to a close, another field school student, Jessica Murray, finalized an exhibit at the History Center of Tompkins County that featured the importance of Native collaboration in archaeological research, using Village X as a case study. In these cases, Clan Mothers, Chiefs, and other Native leaders read and revised drafts of the exhibit texts.

We have emphasized throughout that our collaborative vision is flexible and open to new issues that are raised by our Native friends and colleagues. The 2005 field season led us to revisit the old issue of the curation and control of artifact collections (Williams, 1990). Cayuga leaders have not opposed the washing and analysis of artifacts from midden and house contexts, but that have clearly told us they do not want the artifact collections to go to a museum storage facility. This opened a dialogue on the topic that is ongoing. Some Native leaders have suggested that the materials be reburied, while others envision a Haudenosaunee-controlled collections facility that would allow young Native historians and archaeologists to study and learn from the materials. Still others have discussed keeping examples of certain artifacts for educational purposes and reburying the majority of materials on Indian-controlled land. We are unsure where this dialogue will lead, but we are sure that it is important to encourage the discussion and ultimately to facilitate whatever consensus emerges.

A shining moment in our public anthropology and collaborative endeavors occurred at the Northeastern Anthropological Association 42nd Annual Meeting in March of 2002. At that point in time, we had been working for several years with Haudenosaunee leaders on developing educational and agricultural projects at the SHARE farm and in local communities. We were diligently working on reshaping anthropology's relationship (at least our version of it) with local Native people and we were eager to share this with our anthropological colleagues. Appropriately, the theme of the 2002 meetings was *Anthropology—Building Bridges Across Disciplines* and we organized the plenary session "Exploring Common Ground Between Native Nations, Local Communities, and Anthropologists." We brought together Native elders, our students, and anthropology colleagues to present on our work together in the Finger Lakes regions of New York.

The audience heard about stereotypes and how to counter them from Freida Jacques, Turtle Clan Mother of the Onondaga Nation, a woman who

has been our long time consultant, collaborator, guide, and friend. Julie Uticone, president of SHARE and local hairdresser, copresented with Brooke and Bernadette "Birdie" Hill, the Heron Clan Mother of the Cayuga Nation (and inspiration for the SHARE farm project). Birdie's words of how her people were dispossessed and driven from their land, and her lifelong yearning to reunite with her homeland (which has been happening through the SHARE farm), brought the house down with a deep, respectful attentiveness from the audience, and a fair share of tears to accompany Birdie's moving story.

What struck us following the plenary session was not only the emotional response from the audience, but the many comments made to us by anthropologists about the importance of being present with our Native collaborators, who guide the work that we do. We were not only extremely pleased with the anthropological reception of our presentation, we also received an overwhelming response from the accompanying presentation we made at Cultural Survival (CS) headquarters in Cambridge, Massachusetts. This gave Birdie and other Native leaders a chance to explain firsthand to CS the struggles they are facing at their nations. This has led to continued bonds with CS, which has twice sent interns to work at the farm and featured Birdie and SHARE in their publications (Cultural Survival, 2003, 2005).

9.10. Conclusions

In June 2005, the Cayuga were shocked and devastated, as were we, by the dismissal of their 25 year-long land claim by the 2nd US Circuit Court of Appeals (Broach and Elliott-Engel, 2005; Rapp, 2005a). The rationales for the dismissal included the assertion that the tribes had delayed too long in seeking redress and the "longstanding distinctly non-Indian character of the area and its inhabitants" invalidated the claim, according to Justices Jose Cabranes and Rosemary Pooler (Rapp, 2005a: A5). UCE's reaction was swift, strong, and triumphant. Attorney William Dorr, who represents Cayuga and Seneca counties, stated "This is a complete victory, a complete vindication. The game is over. We win" (Associated Press, 2005). Martin Gold, lawyer for the Cayuga Nation, lamented "I don't see how any land claims can survive this decision" (Rapp, 2005a: A1). In the wake of this decision, we realize the SHARE farm becomes even more important as a land parcel and center for traditional Cayuga activities that is not subject to the shifting tides of the US legal system. The ruling also reaffirms our commitment to community involvement and continued education, especially because court justices have characterized the area as "distinctly non-Indian," an assertion that the archaeology and cultural anthropology directly contradict.

We offer a vision of partnership between academics, Native people and non-Native residents that is a work in progress. In many ways it was sparked

by living in an area with mounting ethnopolitical conflict and issues of miseducation, racism, and cultural disconnection. We deeply feel our responsibility as scholars and citizens to address and try to remedy these sociocultural issues using our privileged jobs as professors to create opportunities, dialogues, and community organizations. The discipline of anthropology in many ways has built itself upon the study of Native American cultures, even desecrating sacred human remains to do so, and it is high time that we make amends, both professionally and personally.

Our perspective on collaboration means creating for ourselves expanded identities that take us far beyond the classroom, campus, excavation sites, and laboratories. It requires us to connect and integrate the disparate worlds of Native and academic perspectives, connecting academic knowledge to contemporary issues and the concerns of Native people, while integrating cultural anthropology and archaeology. Our approach requires flexibility in developing evolving partnerships, with an openness to the constant influx of new ideas and issues that occur with changing cultural and political situations.

We have faced many challenges while practicing our version of an activist public anthropology, from political and tribal issues to financial ones. In recent years, the Cayuga have fissioned into different factions and made attempts to reunify and through all these shifts in leadership we have had to do our best to maintain good relations with all Cayuga people, a process which has not always been easy. One of the other major challenges has been financial. We were motivated by the magnitude of the issues and the immediacy of the need for intervention, in educating the local community and helping the Cayuga to reconnect with their land. We jumped into our endeavors with little time for external fundraising and faced the challenging prospect of appealing to grant sources to pay for Native American land repatriation, a long shot by our estimations.

We financed our SHARE programs creatively, using much of our own money, with some institutional help from our colleges, HETF, the Haudenosaunee Confederacy, and some local fundraising through festivals, workshops, and having student residents at the farm. We took on extra classes and consulting work to pay for these initiatives and the maintenance and improvements at the SHARE farm. Our advice to others embarking on similar pathways is to be creative in looking for funding, and be prepared to take some personal financial risks.

For 5 years, we operated the farm as an educational center, an advocating voice for Native people, and as a friendly place for people of all kinds to plant crops and reconnect with each other and the land (Olson et al., 2001). In December 2005, our goal was realized when the farm was transferred to the traditional Cayuga Nation (Rapp, 2005b; Carter, 2005; McNamara, 2006). Our Native friends have expressed interest in building a ceremonial longhouse and having community gardens and other environmental projects at the farm.

As for the archaeology, it is soon time to present the results to date to the Cayuga Counsel. We believe we have made some strides in raising awareness of the history of the Cayuga Nation, improved the public presentation of that history, worked toward protection of key sites, combated politically motivated historical revision, and provided support on local contemporary issues. The Cayuga Nation must decide anew if these benefits are worth the spiritual risks of excavating. What is the true test of collaboration and partnership? Should they decide against further archaeological research, the only option is to discontinue research on the Cayuga. Ultimately, we must be prepared to walk away when Native people view the archaeology as more dangerous and harmful than interesting and useful.

References

Allen, K.M.S., 1999, Considerations of Scale in Modeling Settlement Patterns Using GIS: An Iroquois Example. In *Practical Applications of GIS for Archaeologists: A Predictive Modeling Kit*, edited by R.J. Brandon, chapter 7. CRC, Taylor and Francis, London, UK.

Ambrosino, M., Peck, A., and Sakakeeny, W., 1981, *Margaret Mead, Taking Note*. Videorecording, Public Broadcasting Associates, Boston, MA.

Anonymous, 2003, *200 UCE Vehicles Protest at Cayuga Nation Store*. Syracuse Post-Standard, Sunday, November 23, p. B-1.

Anonymous, 1986, Theft from the Dead. In *Art from Ganondagan, the Village of Peace*. New York State Office of Parks, Recreation, and Historic Preservation, Bureau of Historic Sites, Waterford, NY, p. 8.

Associated Press, 2004, UCE: Impeach Pataki: Delay of Tax Collection on Indian Sales Prompts Call for Impeachment. *Auburn Citizen*, February 14, p. A1.

Associated Press, 2005, Land Claim Ruling Overturned. *The Citizen Online*, retrieved June 29, 2005, from www.auburnpub.com/articles/2005/06/28/news/breaking_ new...

Barreiro, J., 1990, Return of the Wampum. *Northeast Indian Quarterly*, Spring, pp. 8–20.

Baugher, S. and Clark, S., 1998, *An Archaeological Investigation of the Indian Fort Road Site, Trumansburg, New York*. Cornell University, Ithaca, NY.

Baugher, S. and Quinn, K., 1995, *An Archaeological Investigation of Inlet Valley, Ithaca, New York*. Town of Ithaca and Cornell University, Ithaca, NY.

Bisignano, A., 2000, Festival Promotes Love of Earth and its Different People. *Auburn Citizen*, October 1, p. A3.

Broach, L.H. and Elliott-Engel, A., 2005, Dealbreaker: Court Dismisses Cayugas' $248 million Judgment. *Auburn Citizen*, June 29, p. A1.

Burdick, K., 2001a, 70 acres Headed to Cayugas: College Professor Donates Springport Farm as Spiritual Link for Indian Nation. *Auburn Citizen*, May, pp. A1, A5.

Burdick, K., 2001b, Back to the Farm: SHARE Looks at Mohawk Project as Model. *Auburn Citizen*, May 10, p. A1.

Carter, D.L., 2005, Cayugas Buy 70 acres in Cayuga County for Homeland. *Ithaca Journal*, December 28, pp. 1A, 4A.

Cook, F., 2000 [1887], *Journals of the Military Expedition of Major General John Sullivan Against the Six Nations of Indians in 1779 with Records of Centennial Celebrations*. Heritage Books, Bowie, MD.

Cultural Survival, 2003, Cultural Survival Interns Volunteer for SHARE. http://www.cs.org/about/csnews/share.cfm, retrieved August 26, 2003.

Cultural Survival, 2005, Women the World Must Hear. Winter, 28(4): cover.

Cuppernell, E., 2004, *The Power of Wind: The Potential for Residential Wind Turbines in Union Springs, NY*. B.A. Thesis, Wells College, Aurora, NY.

Edmunds, S., 2000, *Aurora: Time Well Spent.*

Fenton, W.N., 1998, *The Great Law and the Longhouse: A Political History of the Iroquois Confederacy*. University of Oklahoma Press, Norman.

Fischer, J.R., 1997, *A Well-Executed Failure: the Sullivan Campaign Against the Iroquois, July–September 1779*. University of South Carolina Press, Columbia.

Flick, A.C., 1929, *The Sullivan–Clinton Campaign in 1779: Chronology and Selected Documents*. The University of the State of New York, Albany.

Ford, H.S., 2002, *Sure Signs: Stories Behind the Historical Markers of Central New York*. First Books Library, Bloomington, IN.

Funk, R.E. and Kuhn, R.D., 2003, Three Sixteenth Century Mohawk Iroquois Village Sites. *New York State Museum Bulletin* 503, Albany, NY.

George-Kanentiio, D., 1998, Healing Spirits Coming Home. *Syracuse Herald-American*, 15 November, p. D2.

George-Kanentiio, D., 2000, *Iroquois Culture and Commentary*. Clear Light Publishers, Santa Fe.

Halsey, F.W., 1901, *The Old New York Frontier*. Ira J. Friedman, Inc., Port Washington, NY.

Hart, J.P. and Brumbach, H.J., 2003, The Death of Owasco. *American Antiquity* 68(4):737–752.

Haudenosaunee Environmental Task Force (HETF) (n.d.) *Words That Come Before All Else*. Native North American Travelling College, Ontario.

Hickman, W. (n.d.) *A Cayuga Chronicle*. http://www.upstate-citizens.org/Cayuga Chronicles.htm

Jacobs, J., 2001, Onondagas Rebury Own: They Hold 'Dead Feast' for 47 Sets of Remains Returned. *Syracuse Herald-American*, August 19, pp. B1, B6.

Jemison, G.P., 1997, Who Owns the Past? In *Native Americans and Archaeologists: Stepping Stones to Common Ground*, edited by N. Swidler, K. Dongoske, R. Anyon, and A. Downer, pp. 57–63. Altamira Press, Walnut Creek, CA.

Johansen, B.E., 1998, *Debating Democracy: Native American Legacy of Freedom*. Clear Light Publishers, Sante Fe.

Keemer, K. and Williams, A., 2003, *Medicinal Herb Resource Guide: SHARE Farm, 2003*. SHARE, Union Springs, NY.

Kuhn, R.D. and Sempowski, M.L., 2001, A New Approach to Dating the League of the Iroquois. *American Antiquity* 66(2):301–314.

Levine, M.A., 2003, The Cayuga Lake Archaeology Project: Surveying Marginalized Landscapes in New York's Finger Lakes Region. *Archaeology of Eastern North America* 31:133–150.

Long, D., 2001, SHARE Flap Boils Over: Union Springs Chamber of Commerce President Resigns. *Auburn Citizen*, November 15, p. A1.

Lord, G.V.C., 1929, The Sullivan–Clinton Campaign: a Historical Pageant of Decision, Why the Republic Westward Grew. In *One Hundred Fiftieth Anniversary of the Sullivan–Clinton Campaign: Historical Programs and Dedication of Markers Along Route of March*. University of the State of New York, Albany.

Mackey, E., 2002, *The House of Difference: Cultural Politics and National Identity in Canada: Cultural Politics and National Identity in Canada*. University of Toronto Press, Toronto.

Mackey, E., 2005, Universal Rights in Conflict: 'Backlash' and 'Benevolent Resistance' to Indigenous Land Rights. *Anthropology Today* 21(2):14–21.

Mann, B.A., 2005, *George Washington's War on Native America*. Praeger Pub, Westport, CT.

Mann, B.A. and Fields, J.L., 1997, A Sign in the Sky: Dating the League of the Haudenosaunee. *American Indian Culture and Research Journal* 21(2): 105–163.

McIntosh, I.S., 2000, *Aboriginal Reconciliation and the Dreaming: Warramiri Yolngu and the Quest for Equality*. Allyn and Bacon, Boston, MA.

McNamara, J., 2006, Professor help Cayugas Regain Land. *Ithaca Times*, January 11, p. 5.

Mintz, M.M., 1999, *Seeds of Empire: the American Revolutionary Conquest of the Iroquois*. New York University Press, New York.

Niemczycki, M.A.P., 1984, *The Origin and Development of the Seneca and Cayuga Tribes of New York State*. Research Records No.17. Rochester Museum and Science Center, Rochester, NY.

Olson, B., Rossen, J., Olson, E., and SHARE, 2001, Helping the Cayuga Return to Their Homeland. *Anthropology News*, April, 42(4):19–20.

Pertusati, L., 1997, *In Defense of Mohawk Land: Ethnopolitical Conflict in Native North America*. State University of New York Press, Albany.

Peterman, S.E., 1999, Cayugas Wrong on Sovereignty. *Syracuse Herald American*, September 26, p. D3.

Plotnick, J., 2001, Indians Wait, Educate: Peachtown Festival Brings Native Cultures Together in Aurora. *Auburn Citizen*, September 23, pp. A1, A6.

Rapp, S., 2005a, Judges to Indians: You're Too Late to Reclaim Land. *Syracuse Post-Standard*, June 29, p. A1.

Rapp, S., 2005b, Cayugas Buy Farm for Cultural Homeland. *Syracuse Post-Standard*, December 28, pp. A-1, A-4.

Rapp, S., Hand, J., and Tobin, D., 2002, Cayuga Indian Decision Brings Mixed Reactions. *Syracuse Post-Standard*, March 12, p. A4.

Ritchie, W., 1945, *An Early Site in Cayuga County, New York: Type Component of the Frontenac Focus, Archaic Pattern*. Researches and Transactions of the New York State Archaeological Association 10, No. 1. Lewis Henry Morgan Chapter, Rochester.

Rossen, J., 2006, Research and Dialogue: New Vision Archaeology in the Cayuga Heartland of Central New York. In *Cross-Cultural Collaboration: Native Peoples and Archaeology in the Northeastern United States*, edited by J.E. Kerber, pp. 250–264. University of Nebraska Press, Lincoln, NB.

Seldi, P., 2001, On Native Ground: Community Group Purchases Land to give to the Cayuga Nation. *Ithaca Times*, May 16, p. 8.

Shaw, D.L., 2000, Claim Foes Take Message to Motorists: State Police Tell Protesters to Remove Slogan-Bearing Signs Lining a Seneca Falls Road. *Syracuse Post-Standard*, May 27, pp. B1, B5.

Shaw, D.L., 2000b, UCE Chapter Opens Storefront Office: Group Opposed to Native American Land Claims Picks Seneca Falls for Location. *Syracuse Post-Standard*, October 5, p. B5.

Shaw, D.L., 2001a, Group Buys Land for Cayugas: Springport Property Purchase Could Allow Tribe to Return to their Homeland, Group Says. *Syracuse Post-Standard*, May 3, p. A1.

Shaw, D.L., 2001b, SHARE Plans Visit to Mohawk Farm: Residents on the Land, in Montgomery County, Have a Goal of Self-Sufficiency. *Syracuse Post-Standard*, May 5, p. B1.

Shaw, D.L., 2001c, SHARE Gets Mixed Message: Neighbor's UCE Sign Puzzles Group at Farm Bought for Indians. *Syracuse Post-Standard*, August 18, p. B1.

Shaw, D.L., 2001d, SHARE Works Soil, Finances: Produce Sales, Volunteers Boost Farm for Native Americans. *Syracuse Post-Standard*, September 2, p. B1.

Shaw, D.L., 2002a, Cayugas' Award Reaffirmed by Judge. *Syracuse Post-Standard*, March 12, pp. A1, A4.

Shaw, D.L., 2002b, Longhouse in Backyard? Archaeologist Says Fire Pit Remains in Aurora Point That Way. *Syracuse Post-Standard*, June 16, pp. B1, B2.

Spiegelman, R., 2004, Fields of Fire: the Sullivan–Clinton Campaign, An Animated and Interaction Map-Set. DVD. Real View Media.

Stith, J., 2003a, Nation Business Protested: UCE Members Rally at New Cayuga Indian Gas Station. *Syracuse Post-Standard*, October, pp. B1, B2.

Stith, J., 2003b, Miles Apart on Cayugas: in Union Springs, a Protest; in Springport, a Festival. *Syracuse Post-Standard*, Sunday, June 15, pp. B1, B2.

Swidler, N., Dongoske, K.E., Anyon, R., and Downer, A.S., editors, 1997, *Native Americans and Archaeologists: Steeping Stones to Common Ground*. Altamira Press, Walnut Creek, CA.

Thornley, M., 2001, Returning Home: Anthropology Professors Aid Purchase of 70-acre Land Base for Cayuga Nation. *The Ithacan*, April 19, p. 1.

Tobin, D., 2002a, UCE Plans Nov 22 Protest. *Syracuse Post-Standard*, November 4, p. B1.

Tobin, D., 2002b, George Washington's Campaign of Terror. *Syracuse Post-Standard*, August 20, p. B1.

Turner, T., 1993, The Role of Indigenous People in the Environmental Crisis: the Example of the Kayapo of the Brazilian Amazon. *Perspectives in Biology and Medicine* 36(3):526–545.

Upstate Citizens for Equality (UCE) (n.d.) The Cayuga Indians and their Claim: Historic Perspective. www.upstate-citizens.org/cayugaclaim.htm

Wagner, S.R., 2001, *Sisters in Spirit: Haudenosaunee (Iroquois) Influences on Early American Feminists*. Book Pub. Co, Summertown, TN.

Watkins, J., 2000, *Indigenous Archaeology: American Indian Values and Scientific Practice*. Altamira Press, Walnut Creek, CA.

Wheeler, C., 2000, UCE Holds Second Rally. *Finger Lakes Sunday Times* (Geneva, NY), July 30, p. 1A.

White, M.E., 1961, Iroquois Culture History in the Niagara Frontier Area of New York State. *Anthropological Papers*, No. 16. Museum of Anthropology, University of Michigan, Ann Arbor, MI.

White, M.E., 1977, The Shelby Site Reexamined. In *Current Perspectives in Northeastern Archaeology: Essays in Honor of William A. Ritchie*, edited by R.E. Funk and C.F. Hayes, pp. 85–91. New York State Archaeological Association, Rochester and Albany, NY.

Williams, G., 2005, *Year of the Hangman: George Washington's Campaign Against the Iroquois*. Westholme Pub, Yardley, PA.

Williams, P., 1990, Reading Wampum Belts as Living Symbols. *Northeast Indian Quarterly*, Spring, pp. 31–35.

10
To Hold it in My Hand

Madeline Augustine, Christopher Turnbull, Patricia Allen,
and Pamela Ward

Dedication

As authors of this chapter we would like to acknowledge the many contributions
of Joseph Augustine (Figure 10.3) and to dedicate this work to his memory.
Without Joseph Augustine, Metepenagiag's past would never have met its present.

10.1. Introduction

The Metepenagiag Mi'kmaq Nation (formerly known as Red Bank) is
located at the junction of the Little Southwest Miramichi and the Northwest
Miramichi Rivers in northeastern New Brunswick, Canada. This chapter
provides a brief summary of the projects and relationships that have devel-
oped between two New Brunswick archaeologists, Christopher Turnbull and
Patricia Allen, and the Metepenagiag community. Metepenagiag perspectives
are given by Madeline Augustine and Pam Ward, individuals who have been
inspired by their heritage to play significant roles in the overall development
of their community. This chapter provides four separate perspectives on the
joint endeavors and partnerships between the Mi'kmaq and archaeologists.

A mutual story begins in 1972 when the late Joseph Michael
Augustine, then a Councilor and former Chief of Metepenagiag
Mi'kmaq First Nation, decided it was time to explore a childhood memory.
Mr. Augustine's discovery and reporting of a 2,500-year-old burial mound,
sacred to the Mi'kmaq, halted a menacing gravel mining operation, and intro-
duced his community to archaeology. While the mound was being explored
(1975–1977) Mr. Augustine found the Oxbow, a deeply stratified archaeologi-
cal site. Oxbow excavations (1978–1984) revealed the site was an intensively
and continuously occupied 3,000-year-old fishing village. Working together
for the past 30 years, the community and the two archaeologists have grown
and changed, each being as influenced by one as the other. Archaeological
surveys located over 60 additional pre-contact Metepenagiag sites. Other field
projects were initiated. Site reports, academic publications, films, public

literature, exhibits, and other community-based heritage projects have been accomplished. Both the Augustine Mound and the Oxbow site have been declared National Historic Sites for Canada. The community is currently developing a major cultural tourism attraction—*Metepenagiag Heritage Park*—to preserve and present Metepenagiag's outstanding cultural history.

It started with one man. Joseph Michael Augustine was born in Big Cove, New Brunswick in 1911. When he was a small boy his family moved to Red Bank, now Metepenagiag. Growing up in Metepanagiag, Joe spoke the Mi'kmaq language and learned many things about his heritage from his father John. As a teenager, Joe worked on log drives on the Restigouche River. A bit later he married Mary Metallic from the Mi'kmaq community at Listuguj. Joe brought his bride back to Metepenagiag to live and raise their family. Over the years Joe provided for Mary and their eight children by hunting, fishing, trapping, gardening, and guiding on the Miramichi River. He was a master basket maker and sold many kinds of ash baskets to supplement the family income.

Joseph Michael "Joe-Mike" Augustine was a community leader. He was Chief of the Metepenagiag Nation for two terms, 1952–1954 and 1956–1958, and Councilor from 1960 to 1964 and again from 1966 to 1972. In 1987, he received a *Certificate of Excellence* from the Hudson's Bay Company. That year Joe was judged to have harvested and prepared the highest quality beaver pelts of any trapper in Canada. In 1988, Joseph Michael Augustine was awarded New Brunswick's *Minister's Award for Heritage* in recognition of his discovery of the Augustine Mound and the Oxbow National Historic Sites (Figure 10.1).

In his hospital room just hours before his passing in 1995, Joseph viewed exerts from the documentary movie *Metepenagiag: Village of Thirty Centuries* (1996). He was moved by the Metepenagiag scenery and by the story, a story dedicated to his lifetime commitment to his community, his culture, and his heritage.

10.2. "When my father was a young boy . . ."

Madeline Augustine—Metepenagiag Mi'kmaq Elder, President of *Metepenagiag Heritage Park* and eldest daughter of the late Joseph Augustine (Figure 10.2).

"When my father was a young boy of 10, his father took him to all kinds of different places." There were two places in particular that he remembered the most. They were the Castor Brook and the Sugary. Each time they went there, they would pass by a mound where they would stop and make a pot of tea. Grandfather called this place a ceremonial ground. He would always tell my father the story of how the Indians of long ago used to dance around this mound. The mound was about 30 ft in diameter and 3 ft high. He told him about one Indian with a drum and how he would sit in the middle and others

FIGURE 10.1. The Little Southwest Miramichi River at Metepenagiag with the Oxbow National Historic site in the foreground. (Photo courtesy of Archaeological Services New Brunswick.)

would dance around the mound. This story was passed down to my Grandfather by word of mouth from generation to generation for 3,000 years. This story stayed in the back of my father's mind. Fifty years later he would come to realize how important these stories his father had told him were.

In 1971, while reading a National Geographic magazine, my father noticed a story about an Indian man from USA who had dug into a mound and discovered a burial ground. Father thought about the place across the river and, being the inquisitive and curious man he was, got his axe and shovel and headed to the mound that would later be named after him.

Upon arriving home he told me that he had found something very important. He placed some newspapers on the table and carefully took the bundle out of his pack. The first thing that I noticed was a 5 in. spear sticking out of the birch bark wrapping. Father then took a little sharp knife and he started piercing the bundle and then we saw what appeared to be gold!

"Dad we are rich," I said to my father. Turned out the *gold* was merely copper shavings from all the copper rings and beads in the bundle. However, it was then that I realized the importance of what my father had discovered. The next morning my father and I went very early to the mound. I saw where

FIGURE 10.2. Madeline Augustine (1975) was introduced to Metepenagiag archaeology shortly following her father's remarkable discoveries in the early 1970s. For over a decade Madeline devoted herself to numerous Metepenagiag archaeology and heritage related projects before earning a university degree in Health Care. Madeline Augustine, Elder, is President of Metepenagiag Heritage Park. (Photo Courtesy of Archaeological Services New Brunswick.)

he had dug a small hole. He started digging again in that same spot only this time he did not uncover artifacts, he uncovered human bones. I told father to stop digging. This was a very serious matter and we had to get archaeologists to come and see this and his other findings.

I wondered where we were going to find an archaeologist. I did not know if there was one in the province, but if there was such a person he would likely be in Fredericton. Fredericton is the capital of New Brunswick. If not, someone in Fredericton could surely help us.

My brother-in-law was attending the University of New Brunswick at the time. The University was in Fredericton. So, father and I headed to Fredericton with his findings. My brother-in-law told us that we should go to see Professor Paul Morrissy, an anthropologist at Saint Thomas University.

Professor Morrissy told father that what he had found was very significant and that the archaeologist, Dr. Chris Turnbull was away at the moment but he would definitely tell him about this when he returned. Not long after our trip to Fredericton, Dr. Chris Turnbull arrived in Red Bank. Father took him directly to the Mound. After examining it, Dr. Turnbull covered it up and went to speak to the then Chief Donald Ward. After their meeting the ball

started rolling and in 1975, after all the red tape and paperwork, the excavation began. How exciting!

My interest in our history was the main reason for my excitement. I had always wanted to work with archaeologists so I told my father that I would give anything to be able to be part of the excavation. However, since I did not have a university degree, I thought that I would not be eligible. Father wrote a letter to Dr. Turnbull on my behalf and to my surprise Dr. Turnbull agreed that I would work with him along with my brother Howard and my friend Yvonne Paul.

In 1996, after three long years in production, a movie—*Metepenagaig: the Village of Thirty Centuries*—was released. The movie had been coordinated by my nephew Noah Augustine. It is a 48-min long documentary and its main focus is Metepenagiag, its people and my father's discovery of the scared burial ground. His discovery of the 3,000-year-old Oxbow site is also featured in the movie.

Today, I am very happy to see how far we have come since 1972. I have worked side by side with my father since his discoveries at the Augustine Mound and the Oxbow sites. Throughout the excavations and until the time of his passing in 1996, we both dreamed that someday there would be a museum to display all the artifacts that had been found, and that Metepenagiag would be known for its rich culture and heritage. Now, some 30 years later, these dreams are becoming a reality.

10.3. "I will never forget the day I first met Joe Augustine . . ."

Dr. Chris Turnbull—Retired New Brunswick Provincial Archaeologist (1970–2002).

I will never forget the day I first meet Joe Augustine in the office of Paul Morrissy at St. Thomas University. Joe had brought in a big box filled with weird looking artifacts from a burial site he had just found across the river from his home. Having recently arrived in New Brunswick from western Canadian field research in 1970, this material was completely new to me: large spear points, knives, copper beads, organics, and a stone smoking pipe. The next Saturday I made my first visit to Red Bank with two graduate students. Joe took us over to the site; we drove in on an old woods road along the high banks across from the Oxbow. I could see Joe's diggings in the centre of a low earthen mound. The following year, with Joe's permission, we backfilled his excavations while discussions began about the future of the site.

Another factor entered into the picture during the spring of 1973. A good portion of the terrace that Joe had taken me over to get to the site the previous September, had just disappeared into an expanding gravel pit owned by the First Nation. Since Red Bank is located at the confluence of two rivers (the Little Southwest and Northwest), there have been tremendous fluvial

deposits made of high-grade aggregates. Gravel pits dot the region. Gravel test holes were perilously close to the mound itself! Without Joe's discovery, the whole area would have gone within a few short years as much archaeological material already had.

Colonialism, repression of indigenous societies, rural poverty, cultural assimilation: those concepts did not mean a lot to a young graduate student new to being a civil servant who stepped into the middle of a 500-year-old struggle for survival and justice. Because land claims have not been settled in Atlantic Canada, these struggles are essentially unfinished business on behalf of Canada. I was working for one of Her Majesty's Governments—albeit a provincial government. I would soon learn that survival skills among Aboriginal leaders included learning how not to be "handled" by government employees. However, we needed to follow procedures and negotiate agreements. We needed to strike a partnership and work together.

Bureaucracy had a habit of flitting civil servants in and out of First Nations. I think my first test was one of dedication. I had to simply keep at it until the community realized I was not going to go away. I am not demanding; I am not loud; I do not talk a lot, but I am persistent. Initially the reaction to me at the Band Hall was basically mutterings about the "bone-digger's back," each time I would show up for a meeting or drop in. It took 3 years before there was a certain level of comfort. What began as a discussion with the Metepenagiag Chiefs and Councils over the wish to excavate a single site in 1973 was to turn into the first of many years of joint effort over Metepenagiag Mi'kmaq Heritage.

In my job with the Province of New Brunswick I was free to develop the New Brunswick archaeology program as I saw fit. This even allowed us to work outside provincial jurisdiction on "federal" lands and develop face-to-face relations with First Nations' communities. Rather than having to deal with huge, seemingly insoluble issues we could deal effectively with local control over local resources and build-up a series of working relationships with First Nations.

In 1974, I got tacit agreement to proceed, funded by a contract from the (then) National Museum of Canada's Archaeological Survey of Canada. However, the artifacts were to be turned over to the National Museum in Ottawa as a part of the contract. I could not sign: I do not even remember if I brought this up with the Chief as I found it so unrealistic. I refused the contract.

In 1975, I applied through the University of New Brunswick for a Canada Council Research Grant to excavate the Augustine Mound. Then Chief Donald Ward had agreed to take a chance on our doing the work and said yes. This necessitated getting a permit from Indian Affairs to trespass on Indian Land supported by a Band Council Resolution on behalf of the Metepenagiag community. I believe this was the first ever Permit issued in Canada for archaeological research on Indian Land. One condition was that the human remains were to be re-interred in the Mound. This was a clear and

unequivocal statement of Red Bank's ownership over its archaeological heritage. I agreed.

The excavation crew was a mix from the community and from students at the University of New Brunswick and St. Thomas University. We functioned steadily over the next two summers, during some of the hottest weather I remember. It was in 1977 that Joe Augustine found the Oxbow site, a site just as important as Augustine for its own reasons. To fund work on this site we got a Canada Works grant that also funded the Red Bank History project. This project allowed us to do some oral history, record photos, and material culture. Looking back, one of my major regrets is that we did not do more ethno-history in parallel with archaeology.

The question of what to do with the cultural materials from the community had been an issue since Joe's discoveries. Tied to ownership were issues of curatorship, conservation, research, and respect. I remember the day in 1975, when the idea of a museum at Red Bank to house and display the Metepenagiag archaeological treasures came to mind and the chosen vehicle was Parks Canada. The first proposal was written in 1976 as a result of the nomination of the Augustine Mound to the National Historic Sites and Monuments Board of Canada. The application and approval of National Historic Site status for the Augustine Mound was a pivotal event, because it brought Parks Canada into the picture and, because the Historic Sites and Monuments Board of Canada made a strong recommendation to interpret the site to all Canadians. This was re-enforced a few years later with the successful application for the Oxbow site.

Parks Canada began work with Metepenagiag in the late 1970s: holding meetings, putting together briefs, drawing up preliminary plans, and supporting the research, including the technical report on Augustine Mound and funding for the McKinley site research (Turnbull, 1986) at the British Museum of Mankind. Archaeological Services New Brunswick opened a temporary exhibition in the community for two summers under agreement with Parks Canada that a future interpretation center would be forthcoming.

Unfortunately, Park Canada's demand, an unwavering one at the time, was that the land—Mi'kmaq reserve land—surrounding the Augustine Mound be transferred to their ownership. They would develop the site, but they had to *own* the land base. Such a paternalistic approach was unacceptable to Metepenagiag and created a lasting impression that is just now melting away. The agreement with Parks Canada fell into disarray.

Between the late 1970s and the late 1990s was a time of great turmoil over archaeology with the Aboriginal community in New Brunswick. While Augustine Research went into hibernation largely because of this political climate, Metepenagiag was in the eye of this hurricane because of our willing acceptance of Metepenagiag control over Metepenagiag affairs. The increasing friction between the Native community and archaeology was also a pale reflection of the increasing frictional issues of the place of Native societies within Canadian society.

For archaeology, however, it was a question of how to uncouple the discussion from archaeologists and couple it to the Native experience bound up in the making of those artifacts and sites. It required that archaeologists step back far enough to realize that in this time and in this place, the most important aspect of their work is with the community itself. Furthermore, it gets to the essence of archaeology's social contribution in the Canadian context—it culturally strengthens communities. Strong communities are a fundamental prerequisite to finding equitable and lasting living arrangements. That is why the development currently underway at Metepenagiag is about the people of the 3,000-year-old village of Metepenagiag, not about the Augustine Mound or the Oxbow site per se.

Metepenagiag recovered from the Parks Canada impasse of the early 1980s. We had to wait for Canada to change, to embrace its Aboriginal reality before Metepenagiag could be seriously considered once again. Parks Canada did change, particularly at the operations level and fully participated in many undertakings. New Brunswick also began to change. A number of initiatives were undertaken with Parks Canada, Archaeological Services New Brunswick, and Metepenagiag Mi'kmaq Nation that kept the relationship alive during these last 20 years. Some of these initiatives have included: static and traveling exhibitions, reburial, booklet, movie/video, provincial recognition for Joe Augustine's contribution to New Brunswick heritage, brochures, Park Canada studies on Aboriginal themes, a new development proposal, a feasibility study, and business plan.

Since the project started from within the First Nations community and control has remained with that community, a new kind of relationship has developed in which archaeology functions as a part of the living history and culture of the community of Metepenagiag. There are ups and downs, but we have found some space to work together in spite of the "insoluble" bigger issues that surround us all in Canada.

10.4. "I'd better work from this perspective"

Patricia M. Allen—Provincial Archaeologist/Manager, Archaeological Services Unit, Heritage Branch, New Brunswick Culture, and Sport Secretariat

When I read the editor's theme description for "*Past Meets Present*," I was very pleased to have been invited to participate. The theme spoke of a new found realization amongst many archaeologists that community involvement and public awareness projects can be beneficial not only to the discipline of archaeology but also to the public. I am pleased to say that this understanding is neither *new* to me nor my predecessor Chris Turnbull. As archaeologists, we have worked closely with the Metepenagiag Mi'kmaq First Nation for over three decades.

I first came to Metepenagiag as part of Chris Turnbull's Augustine Mound excavation team. An experienced field hand with past supervisory experience, in those early years I was occasionally put *in-charge* of related Red Bank archaeological surveys, salvage, and testing projects. I got to know the Mi'kmaq people, their river, and their land. I developed multiple Metepenagiag relationships, some work related, some not. For myself, this entire Metepenagiag experience, has enriched my personal life and guided my professional development.

In 1975, Metepenagiag had youth summer work projects available. However, cutting bush and painting fences was neither challenging nor rewarding for bright young minds. With the discoveries of Mr. Augustine an archaeology domino effect took hold. The Augustine Mound excavation led to surveys that led to testing projects, which in turn led to more excavations, all of which created some interesting jobs. Both Mi'kmaq students and mature learners easily latched unto field and laboratory archaeological techniques. By 1979, Metepenagiag had more archaeologically skilled hands than existed in the entirety of the rest of our province. University students joining the projects were frequently taught field techniques by experienced Metepenagiag people. Meanwhile, combining the land and drawing on Mr. Augustine's lifetime of knowledge, we soon discovered that Metepenagiag was totally covered with Mi'kmaq archaeological sites; so many in fact, that in certain places it was difficult to determine where one site began and another ended.

Over the years the archaeology work led to other cultural heritage-based projects and to public awareness initiatives that made Metepenagiag known regionally and nationally. All of the projects were approached as partnerships between archaeology and Metepenagiag. Money was always a problem but we did what we did with what we had or, with what we could find. We made use of every grant and employment program possible. If, as provincial employees we, the archaeologists, were not able to apply for specific monies due to jurisdictional regulations, the First Nation would apply. Regardless of where the money originated, Metepenagiag people were up front participating in and driving the discovery, recovery, recording, and presentation of their heritage.

I supervised my first field project in the Metepenagaig area in the spring of 1975. I was conducting salvage excavations at a large pre-contact village site located opposite Red Bank on the Northwest Miramichi River. My crew included several Mi'kmaq workers. At the Wilson site, my view of archaeology changed forever. I realized that the history I was digging up belonged to Madeline, to Howard and to Yvonne. It belonged to their families and to their community. It belonged to their Mi'kmaq ancestors. If I was going to be an archaeologist perhaps I had better work from this perspective. Later that same summer I was asked by the community to write one page on Metepenagiag history because the community was hosting the New Brunswick Indian Summer Games. This was my first experience in promoting *Metepenagiag* heritage.

In 1978 and 1979, I directed work at the Oxbow site, a Mi'kmaq riverside village, incredibly rich and deeply stratified. Radio-carbon dates revealed that this village had been the home of the Metepengaiag Mi'kmaq for nearly the last 3,000 years. The excavations proceeded with community crews of 20 or more. Crew members alternated between doing field work and guiding visitors around an archaeology Exhibit that we had mounted in a Red Bank school classroom. In 1983, still more sites were identified and tested. During a 1984 season at Oxbow I saw incredible community interest in what we were finding. People were not interested in reading a thick archaeological document of charts and tables, they just wanted to know what life was like in the past. I drafted a short article on what had been discovered, made a few copies and passed them along to the then Metepenagiag school principal and to other Miramichi region teachers. However, my efforts to find funding to print the little community history booklet were unsuccessful for several years.

In the early 1990s, the federal government, through the Department of Canadian Heritage, was sponsoring an *Access to Archaeology* program. I inquired on behalf of the community. The Metepenagiag booklet project was eligible! The community could apply. Chief Michael Ward signed the grant application. Together Councilor Anthony Haddad and I found various community members and teachers to review and edit the text. The monies arrived and we hired a Mi'kmaq artist, a photographer and a reputable publishing firm. Fine quality paper was donated by a local mill. Six months later we had 2,000 copies of a glossy little booklet entitled *Metepenagiag: New Brunswick's Oldest Village* (Allen, 1991).

The *Metepenagiag* book-launch turned into a community pride celebration. The grant allowed us to send free copies to all First Nations communities across Canada and to New Brunswick public and school libraries. The book's artwork, by the late Roger Simon, was impressive. One of his paintings was made into a poster. Others have since been used in various Red Bank related media presentations including films and web sites.

A few months before the booklet was printed, another opportunity to publicly announce the archaeological discoveries at Metepenagiag presented itself. New Brunswick is the only officially bi-lingual province in Canada and a third of our residents claim French as their first language. Government services, including education are provided in both languages. Larger regional centers have combined French schools and cultural facilities. At Miramichi City, only 15 miles from Metepenagiag, there is the French Center, Carrefour Beausoleil. This Center houses a fine gallery called GALARIE ARTcadienne.

GALARIE ARTcadienne had an unexpected opening in its 1992 winter schedule. Could Red Bank and Archaeological Services mount an exhibit of their archaeological findings for a 3-week period? Very quickly a rather remarkable photo and artifact exhibit came together. "*Objects From Our Miramichi Native Past*" was presented in French and English. It filled the

GALARIE ARTcadienne and the overall statement was impressive. The exhibit opened with a Mi'kmaq prayer, a sweet grass ceremony and words of welcome from Chief Michael Ward, the provincial Minister for Heritage and the Director of the Center. On the coldest night in January 1992, French, English and Mi'kmaq were warmed by the sweet grass and by the spiritual aura surrounding the artifacts. Over its 3-week showing, "*Objects From Our Miramichi Native Past*" registered large attendance numbers as French schools from across the province bussed by students. Young Acadians, proud of their own distinctive heritage, were introduced to their Mi'kmaq neighbors in a new light. While not text heavy, the selected photos and artifacts spoke eloquently of a unique, vibrant, and spiritually rich Mi'kmaq culture. In retrospect, I regret that the *Objects* exhibit was not produced in all three languages. A few years later, our next Metepenagiag exhibit was produced in three languages.

In 1997, New Brunswick's Regional Development Corporation, a government agency, partnered with the Canadian government to sponsor projects in Aboriginal Economic Development. In a bizarre arrangement, Aboriginal groups could not directly access this funding. With Metepenagiag community efforts underway to develop a major cultural heritage tourism product, Metepenagiag was anxious to produce a traveling exhibit. It could promote Metepenagiag heritage and simultaneously provide the community with a sampler product that could be used to offer visitors a taste of the potential of *Metepenagiag Heritage Park*. Archaeological Services could apply for the funds but we had to demonstrate a substantial monetary contribution. Provincial money was tight. I stripped another exhibit of its content, put a price tag on the good quality recycled hardware and offered it as our monetary contribution to the Metepenagiag exhibit application. The application was approved. With their own aboriginal tourism product this economic development project would represent the first step for Metepenagiag into the mainstream tourism industry.

A community elders group guided the exhibit content. A storyline was drafted. Metepenagiag elders translated the text and recorded the same in Mi'kmaq. A design was produced that fit our recycled hardware. On June 28th, 1997 the late Chief Michael Augustine unveiled "*Metepenagiag: Where Spirits Live,*" an art and artifact exhibition celebrating Metepenagiag's past and present (Figure 10.3). This exhibit traveled to over a dozen northeastern venues and was visited by people of all ages and from all walks of life. The exhibit was finally installed at Metepenagiag as the community's first cultural heritage tourism product.

More recently our Archaeological Services efforts have been driven by the desire to help Metepenagiag fulfill its dream of *Metepenagiag Heritage Park* (Figure 10.4). Archaeological Services will continue to participate in and push for the support and recognition of Metepenagiag heritage. The sites researched by Chris Turnbull and I, in partnership with the people of

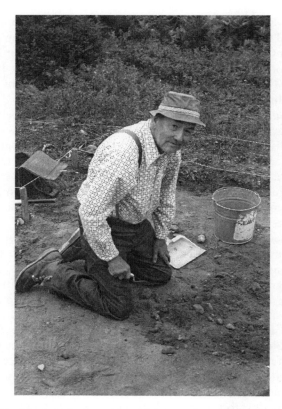

FIGURE 10.3. The late Joseph Augustine, Metepanagiag Elder, enjoyed exploring the heritage of his community through archaeology. His discoveries and his enthusiasm to have the past brought to the present resulted in the unique relationships that have grown between Metepanagiag and archaeologists. (Photo Courtesy of Archaeological Services New Brunswick.)

Metepenagiag, have added much to the understanding of the past history of the Miramichi region and the far northeast. However, the work has gone beyond the basic academic advancement of knowledge. The approaches taken to different projects over the years have always had valued-added components. Often projects were specifically focused to offer information to encourage broader public understanding and cultural awareness. In some cases, the archaeologists were mere participants in Metepenagiag driven initiatives but, we meshed well. When the *Metepenagaig Heritage Park* facility opens in 2006, it will have an environmentally controlled artifact storage space and an archaeology lab for resident or visiting researchers. Now, as archaeologists, where did we go wrong?

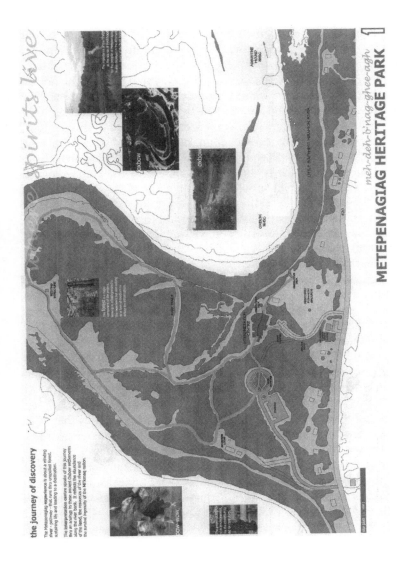

FIGURE 10.4. Conceptual plan for Metepenagiag Heritage Park, currently under construction and scheduled to open in spring 2007. (Photo courtesy of Metepenagiag Heritage Park Inc.)

10.5. Met—a—where and Arch—a—what?

Pamela Ward—Executive Director, Metepenagiag Heritage Park

I was 17 and had just graduated from high school. My summer job was to work alongside provincial archaeologists and other youth from my community at the Oxbow site. I was excited to be on the "pit" crew, the nickname given to all of the summer excavation groups because of the gravel pits that surround the area of The Augustine Mound and the Oxbow National Historic Sites. Finally, it was my turn to find some artifacts and be able to brag about the coolest summer job when I went away to college in the fall. In our community, 1984 would be the last summer of major excavations. The excavations at Augustine Mound and Oxbow began in 1975. Reflecting back now on the history of partnership between community and archaeology, working on these excavations provided an opportunity for my learning and growth as a youth, and as a Mi'kmaq community member from Metepenagiag. In my view the partnership to undertake the archaeological excavations was between: the Elder who shared the knowledge handed down to him about these special places in an effort to protect and preserve, the leadership of my community who had enough vision to learn more about our heritage and, the provincial government seeking to fulfill their mandate regarding cultural resources.

For many years, I could only listen to my older cousins and friends talk about their experiences on these pit crews. They would tell exciting stories about finding remnants of our Mi'kmaq culture; some that were radio-carbon dated to be 1,000 and 1,500 years old. They would also relate stories of our ancient village while digging into the earth just up the road from where our main community is today. Their lingo of the scientific methods of archaeology would interest and impress me. It was clear that they were not only earning a wage from a decent summer job but learning about themselves, what archaeology can tell us of the way our ancestors the Mi'kmaq of Metepenagiag lived many many years ago. Until that summer, I called myself a Native from Red Bank. After that summer, I began to say proudly that "I'm a Mi'kmaq (of the Algonquin language family) from Metepenagiag (traditional name for our community)." I was inspired to learn more.

As the youngest daughter of an Indian Chief, I had some understanding of my community and its history, but that summer wearing jeans and a sweatshirt in the blazing heat to protect myself from scratching bushes on our daily trek to the dig site, I learned a whole lot more about who I was, what I should be proud of and the precious heritage that I was holding in my hand—the heritage and history of my people, the Mi'kmaq. This new understanding that grew over the years would give me a stronger sense of self-confidence and pride to go forth and make a life for myself and become interested in the development of my community.

What I knew growing up was that my father and his fellow Chiefs, like leaders before and after them to present day, would constantly try to improve

the conditions of our communities known as reserves. They negotiated with the federal government, as they do today, principally through the Department of Northern and Indian Affairs, to respond to the social, economic, health, and basic living needs. They, on a nation to nation basis, faithfully negotiated within the longstanding treaty agreements between governments from generations before.

I remember when it finally clicked for me. One afternoon while standing in a pit so deep I could not see out of it, I had some charcoal in my hand from an ancient hearth some 1,500 years old. I imagined my ancestors building the fire there to cook their food and keep warm. The archaeologist told me that if I dug a bit more, I might find sturgeon bones. She said a 7 foot long sturgeon could provide for the community for a long time. What? I thought the Mi'kmaq lived on salmon because that's what we had for supper the night before. My father later told me that when the rivers changed, the sturgeon did not come here to spawn anymore and the salmon began to be the mainstay of the Mi'kmaq. I had a lot to learn. I was holding my heritage and history in my hand, these blackened inconspicuous indicators of a strong nation that once had its own structures for governance, and its own traditional means to deliver social, educational, and health services for its people.

I learned that Canada had not lived up to the treaty agreements signed by our ancestors to ensure our well-being and peaceful coexistence together. The years of colonization and assimilation that followed contact with European settlers some 500 years before, had resulted in extreme discrimination, both systemic and racial. There was a dramatic inequity in resource sharing. Ultimately the relegation to miniscule land bases and the lack of resources led to the marginalization of a once proud and thriving people.

Our community leaders over the years have also tried to improve relations with the local nonnative community who in my opinion, as a youth, were as unfamiliar with us as we were with them. The history and heritage they knew about us were never written or expressed by us and in most cases, were written from an ethnocentric viewpoint serving to portray us as uncivilized societies. There was no regard for our rich life ways and the many contributions of our ancestors. We felt we were treated unfairly by their ancestors and they had no true appreciation of our people and our community that was so ancient and enduring. I struggled to understand that they had no reliable mechanisms, institutions, or resources to even begin to understand our history and heritage in relation to their own ancestors settling in this land. In a Grade 8 social studies class in a New Brunswick high school, I had to read out loud for my fellow nonnative students that the Natives were savages. I looked at myself later that day not agreeing with what our course book had said.

With this type of history being taught to young impressionable youth, no wonder the relations between our cultures were strained. I realized that we had to become responsible for our own history and that we must play a lead role in influencing the best way to share it with our neighbors; that we would only respect our ancestors through the preservation, protection, and presen-

tation of the history and heritage of the Mi'kmaq of Metepenagiag. We also needed likeminded partners to do this.

The notion of creating the *Metepenagiag Heritage Park* (Figure 10.4), was first envisioned by Joe Augustine, the discoverer of the Augustine Mound and Oxbow National Historic Sites. He felt it was important to see the history and heritage that had been handed down to him by his father and grandfather meshed with the information gained from the years of archaeological excavations. He wanted a museum to tell the story of the ancient Mi'kmaq of Metepenagiag.

My predecessor, Joe's grandson had a feasibility study underway when I started work on the *Metepenagiag Heritage Park* project some 7 years ago. I had been employed in different areas of community development upto this point. I was well aware of the challenges faced by many First Nations in the areas of job creation, skills acquisition, and business development. Metepenagiag was no different. A development officer had to be creative and forward thinking about long-term sustainable economic development. Eco-tourism was a viable alternative for us. A book, a movie, and other public education resources were produced in partnership with other federal and provincial agencies and departments. Archaeologists were always the lead partners at the table helping to make these things happen with members of our community and others.

Like my ancestors, we have come to know that we need to reach out as a community to those around in peace and friendship so that all may benefit. The relationship between the Canadian government and all Aboriginals in this country is focused daily on a variety of levels. Aboriginal rights are tried and tested in all courts of the land and a greater relationship will be forged in some way. What ways we do not know, given the history, the law, and the lawmakers. What we do know is that we will be living here together for some time to come and we should work together, in partnership.

As my involvement grew in the *Metepenagiag Heritage Park* project, I began to view partnership in a specific way. Being responsible for bringing resources together and as a liaison for my community and other interested stakeholders, our community has been able to strike a number of partnerships that have resulted in various projects and initiatives working toward the creation of the *Metepenagiag Heritage Park*. Constant is the need to balance the western science of archaeology and the stories handed down from generation to generation in the on-going research and information gathering of our heritage and history. Partners at the table who respect the need for the Mi'kmaq story to be told by Mi'kmaq in a Mi'kmaq context have always been welcomed by our community.

Not only as a project manager, but as a mother of two daughters, I see my children work on elementary and high school projects using cultural resources that came from many years of such partnerships between community and archaeology. They are passing on the knowledge of our heritage and history to their non-Aboriginal school mates and teachers. When explaining

to them at an early age, I would simply say that neighbors should know their neighbors in order to be good neighbors. I am very proud each time myself or my children stand in front of a group of people and are able to provide insight and education on the shared history and heritage of the land where we all live today. These are inspiring forums that tell me I am in the right place doing the right thing with the right people for the right reasons. Coincidentally, it is also in such forums where more partnerships are conceived and pursued. When people have a deeper understanding of something important to them, they naturally want to pursue more knowledge of it and reach out to do it together.

10.6. Conclusion

In closing, having several years of experience working in the area of community development and especially with the development of a specific community driven initiative—the *Metepenagiag Heritage Park* scheduled to open in Spring of 2007—partnerships remain fundamental. WE have learned that partnerships are make or break based on the individuals involved in the process. It is the quality of the people involved in these partnerships that make the difference. Sometimes individuals and groups come together from a place of purpose, or they need to carry out a mandate or respond to a situation. However, what affects the process of partnership and takes it to another level is when the people who have been partners by purpose become champions by choice. It is this higher level in the process that not only yields results but builds stronger relationships, which can lead to unlimited benefits. It is this type of partnership that has existed within the context of the value of gathering and protecting cultural resources at Metepenagiag for as long as WE can remember.

References

Allen, P., 1991, *Metepenagiag: New Brunswick's Oldest Village.* Gooselane Publications, Fredericton, New Brunswick.

Beaubien, C. and Noah, A., 1996, *The Village of Thirty Centuries: A Story of a River, a People,... and Time.* Film produced by Beaver Creek Pictures in association with Northwest Passage Communications and the participation of Red Bank First Nation.

Turnbull, C.J., 1986, *The McKinley Collection: Another Middlesex Tradition Component from Red Bank, Northumberland County, New Brunswick.* Manuscripts in Archaeology, 17E, New Brunswick Department of Tourism, Recreation and Heritage.

Part 3
Universities

11
Outport Archaeology: Community Archaeology in Newfoundland

Peter E. Pope and Stephen F. Mills

11.1. Community Archaeology

Archaeologists are giving increased attention to the social context of their research, often in a self-conscious effort to involve non specialists in their work. The papers submitted to a recent special issue of *World Archaeology* suggest that Australasian archaeologists have been among the first to reflect seriously on the public context of archaeology (Marshall, 2002). Canadian archaeologists are also experimenting with a more community-oriented archaeology, particularly in the Arctic, where indigenous stake-holders have forced researchers to reappraise conventional approaches (Lea and Smardz, 2000; Rowley, 2002). In Canada's easternmost province of Newfoundland and Labrador (Figures 11.1 and 11.2), the situation is more complex. In our north, that is to say Labrador, the key issue is very much the ownership of the archaeological heritage, as elsewhere in arctic Canada (Figure 11.3). On the island of Newfoundland itself, community interest in archaeology is driven, to a great extent, by hopes of economic diversification. Several years ago, Memorial University's Archaeology Unit set up the Newfoundland Archaeological Heritage Outreach Program (NAHOP) in response to burgeoning community interest. This article reports our experience and suggests that the concept of "community archaeology" can be more broadly applied than it has been.

From the Newfoundland point of view, one of most important articles in the *World Archaeology* survey volume is a discussion of a project in the ancient port of Quseir, Egypt, which sets forth key aspects of community archaeology (Moser *et al.*, 2002: 229–242):

1. Communication with local organizations aimed at collaboration in the interpretation of regional history, with an emphasis on open interaction and plain language reports.
2. The interviewing of elders to recover local oral history.
3. The employment and training of local people with the aim of developing full time positions.

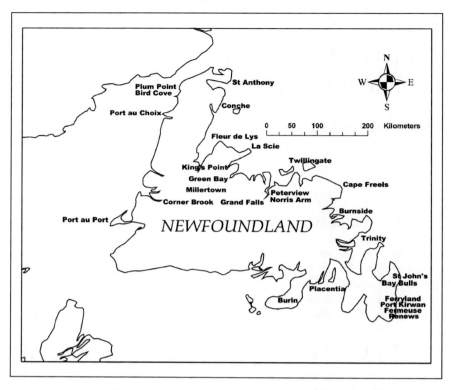

FIGURE 11.1. NAHOP registered communities on the island of Newfoundland.

4. Public presentation of research findings locally including:
 a. Creation of an accessible photographic and video archive.
 b. Development of educational resources, especially for young people.
5. Community control of heritage merchandising.

In what follows, we will take these commendable principles as identifying characteristics of community archaeology. We leave open the difficult question of whether "collaboration" merely implies informed consent or whether community archaeology requires a stricter standard for the negotiation of research aims (Greer *et al.*, 2002).

 If we consider the situations in which archaeologists actually apply such principles, it turns out that "community archaeology" is less extensive in practice than our abstract and neutral terminology might suggest. Most reported community archaeology projects involve postcolonial situations in which researchers of European descent are involved with indigenous communities or others, often people "of color," historically disenfranchised by the expansion of Europe. This is, for example, the social context of research

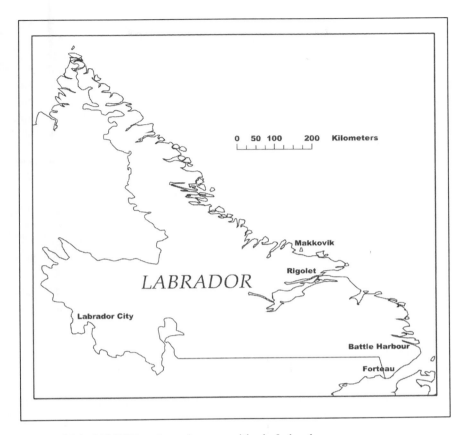

FIGURE 11.2. NAHOP registered communities in Labrador.

FIGURE 11.3. Test pitting at the site of the Eighteenth-century Fort Frederick, Placentia. (Photo courtesy of Blair Temple and Amanda Crompton.)

in the Canadian Arctic and of work done on Black Loyalist sites in Nova Scotia (Niven, 1994; Friesen, 2002). Such ethnic interaction is certainly part of community archaeology in Newfoundland and Labrador, especially when academic archaeologists work in Labrador, the northern, sparsely populated, continental part of the province. The work that Stephen Loring is doing on behalf of the Smithsonian Institution, in cooperation with Inuit and Innu (Montagnais) communities, is a fine example of community archaeology in this narrower sense (Loring, 1998; Loring and Ashini, 2000; Buckley and Hollingshurst, 2003).

The community archaeology approach is very much that mandated by the Canadian Archaeological Association (CAA), for dealing with Aboriginal sites (CAA, 2003). This statement of principles calls for archaeologists to recognize the cultural and spiritual links between Aboriginal peoples and the archaeological record, including particularly human remains, special places, and landscape features. Archaeologists are expected to respect the role of indigenous communities in management and interpretation of their heritage. Practically speaking this means archaeologists should do the following:

1. Encourage partnerships with Aboriginal communities in archaeological research, heritage management and education, based on shared knowledge and expertise.
2. Respect research protocols, developed in consultation with Aboriginals.
3. Support formal training programs in archaeology for Aboriginal people.
4. Support recruitment of Aboriginal people as professional archaeologists.
5. Respect protocols governing the investigation of human remains.
6. Respect the cultural significance of oral history and traditional knowledge.
7. Communicate research results in a timely and accessible manner.

There is an obvious overlap between the principles proposed by CAA for the investigation of Aboriginal sites in Canada and those principles we have taken to characterize community archaeology worldwide. These similarities are predictable, given that both sets of recommendations are essentially guidelines for professional behavior in the postcolonial context.

11.2. The Situation on the Island of Newfoundland

On the island of Newfoundland the situation is different. Here academic and contract archaeologists are working with projects sponsored by small-town community groups (Buckley and Gill, 2000; Pope, 2000; Mills, 2002; Mills, 2003a, b). The interactions between professional archaeologists, on the one hand, and the volunteers who typically make up local heritage committees are fraught with social and economic tensions but they are not, typically, inter-ethnic. Community archaeology in this somewhat wider sense has been going on in Newfoundland for some time, notably at Ferryland and Cupids (Canning and Pitt *et al.*, 1995; Tuck, 1996; Gilbert, 2000; Gilbert, 2003).

Following the collapse of cod stocks in the early 1990s and the subsequent moratorium on the cod fishery, federal/provincial funding was available for regional economic development. Small communities could find government funding to hire fishers and plant workers to work on archaeological projects. There are now several projects in Newfoundland that meet most of our criteria for community archaeology, not only at Cupids (Baccalieu Trail) and Ferryland (Colony of Avalon) but also at Fleur de Lys, and Placentia (Figure 11.1). Incipient or intermittent research that meets at least some of our criteria has also been carried out at Bird Cove, Burnside, Fermeuse, Port au Choix, Red Bay, Renews, and St. John's. In the last few years, the NAHOP has helped to facilitate community archaeology in the province.

11.3. The Newfoundland Archaeological Heritage Outreach Program

NAHOP itself does not sponsor archaeological projects, but rather assists projects sponsored by local community heritage groups. Although local sponsorship of archaeological research is an unusual model in North America, economic and political realities in Newfoundland and Labrador mean that archaeology is often driven by the social and economic interests of local communities, as much as by university research agendas or governmental cultural resource management considerations. This follows the collapse of northern cod stocks in the early 1990s and the imposition, in 1992, of a moratorium on fishing cod. With no foreseeable end either to the cod moratorium or to the continuing decline of Newfoundland's rural communities, archaeology here continues to be invested with hopes that go beyond purely academic or purely management considerations (Buckley and Gill, 2000). Communities grasp at any initiative that might aid economic survival. Meanwhile, as a traditional way of life disappears, people become more self-conscious about their own heritage and, to some degree, conscious of the cultural and social value of heritage, as a kind of rudder in a storm of rapid change. NAHOP is a positive response to this situation—designed to assist local projects with university expertise and to observe this new style of constructing the past.

Our program emerged in 1999, when Memorial University's Archaeology Unit responded to a national competition designed by the Social Science and Humanities Research Council (SSHRC), one of Canada's three national academic funding agencies. SSHRC had in mind a new kind of research program, the Community-University Research Alliance (CURA). This funding opportunity seemed tailor-made for archaeology in Newfoundland. Our initial CURA partners were the provincial Culture and Heritage Division, the Newfoundland Museum, and the Newfoundland Historical Society. As of June 2004, 36 community heritage groups from across the province were registered with the outreach program. Over the last few years, some of

NAHOP's client community groups have taken on key roles in our CURA. When invited by SSHRC to devise a completion strategy for the final 2 years of funding possible under CURA funding, we proposed an evolution of NAHOP to comprise six regional organizations, plus our key provincial partner, the Culture and Heritage Division. The regional organizations include five of the strongest community groups: Baccalieu Trail Heritage Corporation (which manages Cupids among other sites), the Colony of Avalon Foundation (Ferryland), the Placentia Area Historical Society, the Dorset Eskimo Quarry Committee (Fleur-de-Lys), and the Petit Nord Cultural and Natural Heritage Society (St. Anthony and area). Bringing Memorial University's Labrador Institute into the CURA seemed the best way to maintain contact with the widely dispersed projects in that part of the province. A seven-member consultative board, consisting of a representative of each agency plus the director, evaluates policies, within the framework for the completion phase approved by SSHRC. Peter Pope is the Director of NAHOP and Steve Mills is our coordinator.

The community organizations and archaeologists involved in the outreach program have their own specific research aims. We help these projects by providing access to information about archaeological artifacts and cultures, conservation, and site interpretation—but the keystone of our outreach is work placement of Memorial University archaeology students in field, lab, and exhibit situations. We also have our own research agenda, to record and assess the model of community-based archaeological site development that is emerging in Newfoundland and Labrador, through a multidisciplinary approach incorporating sociological and folklore studies. We hope to better understand the factors that drive the development of sites and of the various ways communities construct their past; we are engaged, that is, in meta-archaeology as well as in archaeology. NAHOP was initially designed, in 1999, to encourage and support best practices in archaeological research, in a transient economic context in which research initiatives were burgeoning. By 2004, as the tragedy of the fishery unfolds and as federal and provincial policies shift, community archaeology projects in the province are in decline, as accessible funding opportunities decrease. An important part of NAHOP's work, at this point, is to help our community partners plan for the unpleasant bump that accompanies the end of our program, in 2005. There remains plenty of work to do.

11.4. Program Activities

11.4.1. Student Fellowships, Assistantships, and Internships

From its inception, the Outreach Program offered different kinds of support to community-sponsored projects with very different track records. Some projects were already well-established. Ferryland's seventeenth-century

Colony of Avalon and the prehistoric research at the National Historic Park at Port au Choix, each directed by a senior member of Memorial University's Archaeology Unit, are long-standing projects under way since the early 1980s (Tuck, 1996; Buckley *et al.*, 2002; Renouf, 2002). NAHOP could best assist projects with such established academic links by offering fellowship support for graduate students. One such fellowship sponsored an intra-site study of remote sensing at a Dorset Paleoeskimo site near Port au Choix (Eastaugh, 2002). Another M.A. student delved into the seventeenth-century English West Country pottery trade by examining Somerset and Dorset ceramics excavated at Ferryland (Temple, 2004a). Graduate students working on community-sponsored projects continue to receive full or "top-up" fellowship support.

The Outreach Program awarded another fellowship in 2002 to a student in Memorial's Folklore department to conduct a study in the community of Placentia. The area was settled in the 1660s by the French, who were then forced to leave under the terms of the Treaty of Utrecht of 1713. Today's residents trace their ancestry to the English and Irish settlers who displaced the French. This study examines the relationship between official representations of Placentia's heritage by federal, provincial, and municipal governments, which often celebrate broad themes related to the French period, and the community's understanding of its past, which often emphasizes more recent events (Carroll, 2002). NAHOP also assisted the Placentia Historical Society in their efforts to develop a community-sponsored archaeological project, which since 2001 has been investigating the early French Basque *Vieux Fort* and some eighteenth-century English features (Crompton, 2003). The principal investigator was recently accepted into Memorial's new doctoral program in archaeology, with another NAHOP fellowship.

The Outreach Program aids community projects largely by hiring students to work for them. Student assistantships are, by far, our single largest budget item. Between 2000 and 2004, over 150 positions were funded for graduate and undergraduate students, to work on 22 community-sponsored archaeological projects throughout the province. (NAHOP does not provide assistance to contract archaeologists managing CRM projects.) As required by provincial regulations, the community-sponsored projects were directed by professional archaeologists and conservators, who are able to give Memorial's archaeology students further training in field and laboratory techniques. During the field season, between June and September, NAHOP-sponsored students improve their survey and excavations techniques, while others work in field labs, processing artifacts and practicing their field conservation techniques. Sites range from 4000-year-old Maritime Archaic Indian encampments to eighteenth-century taverns that once served migratory European fishermen.

Student assistantships are very important to community projects, as Memorial students complement local field crews. NAHOP support has sometimes been instrumental in the genesis of new projects and often in

sustaining less well-established local initiatives. Smaller community projects usually rely on government grants to hire local workers, displaced from traditional jobs in the fishery. These employees are usually not archaeologists, since such grants tend to exclude people from outside the area and, paradoxically, often impose conditions that restrict the employment of those who already have qualifications in the heritage sector. (These restrictions are part of a "labor market development" problem that NAHOP is trying to address.) Meanwhile, Memorial students bring with them some archaeological experience, even if simply classroom training or, at best, a field course. For some of the smaller community-sponsored projects, for example Placentia and Fleur-de-Lys, NAHOP students became a nucleus for the field crew, who could help investigators train other employees with no archaeological experience. The outreach program tries to assign students from particular regions to projects in their home area, but this has not been possible as often as we would like.

During the academic year, from September to April, NAHOP hires Memorial archaeology students for part-time work conserving, cataloguing and analyzing artifacts. Students thus have a chance to further develop their skills, which they can bring back, in turn, to community projects. These students work with faculty and staff researching material from the community-sponsored projects. Several former NAHOP-funded student research assistants have gone on to related postgraduate programs. For example, four former NAHOP students, who worked with Memorial's archaeological conservator Cathy Mathias, were recently accepted into the Archaeological Conservation Program at Sir Sanford Fleming College in Peterborough, Ontario.

In addition to sponsoring student assistantships, NAHOP has an internship program that has allowed recent graduates to develop their professional experience. Six internships, of about 20-weeks duration enabled graduates with a B.A., M.A., M.Litt, or a diploma in information technology to work on artifact studies, museum exhibits, publications, and video projects. A panel exhibit, prepared for the Port aux Basques Museum, explained a Dorset Paleoeskimo encampment at Cape Ray, a breathtaking point of land near the town, on the southwest corner of Newfoundland. A second panel exhibit, prepared for the Bird Cove Interpretation Centre, used maps and photographs to explain the achievements of Captain James Cook, the celebrated English naval officer whose cartographic career began in the 1760s and 1770s, making maps of Newfoundland and the Strait of Belle Isle. Another intern prepared an exhibit of seventeenth-century finds for the interpretation centre at Cupids (a Baccalieu Trail Corporation project). A fourth laid the groundwork for a future exhibit on ceramics in Newfoundland and Labrador over the last thousand years. (Seventeenth-century sites on the Avalon Peninsula have produced an impressive array of ceramics from Europe, New England, Asia, and even Africa.) Another intern used our GIS system to georeference historic map and military plans against modern base-data for the Placentia area, with the aim of pin-pointing possible

archaeological sites throughout the town, in particular the various military features in the Placentia area (Temple, 2004b).

In the past several years NAHOP has also sponsored a more academically oriented kind of internship, in the form of postdoctoral fellowships. In 2003, Lisa Hodgetts completed a postdoctoral study of thousands of faunal specimens from seventeenth-century domestic deposits at Ferryland, and was able to show that the early English colonists there had a surprisingly varied diet (Hodgetts, 2003). She is currently refining her research for publication. Her project created a permanent faunal reference collection for Memorial, with research benefits for archaeology in other Newfoundland regions as well. In 2003/2004, John Erwin examined Palaeoeskimo soapstone vessels in Newfoundland and Labrador. His analysis of vessel styles and functions was designed to test the hypothesis that Dorset Eskimo use of soapstone vessels transcended functional requirements for the production of heat and light. Their adaptive use of soapstone over millenia, despite functional alternatives, strongly suggests that it carried social and cultural meanings for the Dorset people (Erwin, 2004).

11.4.2. Dissemination

One of the major goals of the Outreach Program is dissemination of regional archaeological research, both outside the province and within it, to the community heritage groups who are working to establish their own research projects. To this end, NAHOP has supported the publication of resource material in various formats as well as sponsoring face to face discussions. Memorial students involved with community-sponsored archaeological projects and other community archaeologists have traveled, with NAHOP support, to present papers at conferences and workshops in Newfoundland, Nova Scotia, Ontario, and Rhode Island. For many, these were their first professional presentations. These trips gave our researchers the chance to meet archaeologists working on similar sites in North America and Europe, while at the same time helping to place Newfoundland and Labrador's community projects on the map, for the professional archaeological community. (We trust, too, that by featuring some of the most interesting archaeology being conducted at Memorial, these conference presentations will have long-term benefits for the university's archaeology program.)

From the outset we earmarked part of our budget to sponsor workshops. NAHOP itself has organized two to date. The first, "Working in Archaeology" brought community heritage volunteers and principal investigators together with archaeology students and the representatives of government funding agencies to discuss employment issues. Participants agreed that the problems currently surrounding labor market development in the heritage sector arise from the heavy reliance of community heritage projects on funding programs designed for other sectors. A second workshop on "Outport Archaeology" was an opportunity for principal investigators to present results

of community-sponsored projects. We plan a final workshop to discuss the challenges that will arise as government policies shift and as NAHOP winds down.

The Outreach Program has also assisted another series of workshops, which grew out of a conference in 2000, organized by community organizations in La Scie, Baie Verte, and Fleur-de-Lys on the Baie Verte Peninsula, to promote the history of Newfoundland's long-forgotten French Shore. From about 1504, Breton, Basque, and Norman fishers exploited Newfoundland's rich fishing grounds and maintained fishing stations until France relinquished its fishing rights in 1904, retaining only an offshore banks fishery based at St Pierre and Miquelon, off our south coast. By sponsoring conference attendance, NAHOP was able to bring heritage groups from various parts of the province together to form a French Shores Working Group, to promote research on the history of the French in Newfoundland. Our timing was good, as this interest dovetails into a larger Canadian celebration of the 300th anniversary of the founding of Acadia, in 2004. Local groups organized follow-up conferences, at Placentia in 2001, at St. Anthony in 2003, and in Baie Verte again in 2004. The outreach program supported these with travel funding for community representatives and speakers. The communities involved with the French Shores Working Group have succeeded in generating a renewed interest in the French Shore among Newfoundland archivists, historians, and archaeologists. Results are already evident at the Vieux Fort in Placentia. Meanwhile, M.A.P. Renouf and Peter Pope have begun survey work and testing for French materials at Port au Choix and on the Petit Nord, the old French fishing zone on the Atlantic side of the Great Northern Peninsula (Renouf et al., 2004). We are also supporting basic bibliographic research in the province as well as archival research on microfilmed colonial documents available in Canada and research in France on maps and plans of early fishing establishments (Ardley, 2001; Hiller, 2001; Pope, 2003b; Tompkins, 2003).

Over the past 3 years, NAHOP has supported public dissemination of research. For local heritage groups trying to communicate local historic resources to educators and government officials, one of the most effective forms of publication has turned out to be "Heritage Resource Inventory" poster maps. These wall-sized color posters are based on archival research, oral tradition, and archaeological survey. Memorial archaeologist M.A.P. Renouf and geographer Trevor Bell developed these heritage inventory posters to summarize the results of their research on the coves and bays of the Great Northern Peninsula (Bell et al., 2000, 2001; Bell et al., 2002). NAHOP hopes to develop similar poster inventories for the Petit Nord region, south of St. Anthony, for the Baccalieu Trail region, between Conception and Trinity Bays, and for the South Avalon region around Ferryland. One of Memorial's doctoral candidates is now using a student assistantship to assemble the base maps needed for a GIS database of the South Avalon and the Petit Nord. One of the challenges we have not quite

solved is how to produce a smaller version of these large presentation-quality posters at a price low enough for general distribution.

In collaboration with the Heritage Outreach Project (an allied Memorial University project), NAHOP produced *Heritage Outreach Guidelines* for community groups interested in archaeological projects (Simms *et al.*, 2001). This instructional workbook explains archaeological resources, the role and responsibilities of archaeologists and conservators, and even offers suggestions on organizing a local heritage committee. The appendices include a glossary, provincial legislation, and international charters dealing with the protection and management of archaeological heritage. Every heritage group registered with the outreach program is provided with one of these guides. Since the basic organizational principals of archaeology are similar almost everywhere, we have also been able to sell these guides at conferences.

NAHOP has produced four videos. The first, *Outport Archaeology*, is a touching profile of several rural communities involved in archaeological projects (Buckley and Gill, 2000). This video highlights heart-felt local hopes that archaeological interpretation promotes cultural tourism. Each of these "outports" has fascinating archaeological resources that could be developed to offer an economic boost in communities distressed by the moratorium on cod and the resulting outward migration that, in turn, threatens a centuries-old way of life. The video was aimed primarily at community heritage groups themselves, to help them understand some of the common problems facing projects across the province. It not only proved popular with its intended audience but also won a CAA award for public communication. Our second video, *Working in Archaeology*, was a brief synopsis of the NAHOP workshop on employment issues, prepared as a summary for government agencies (Buckley and O'Leary, 2001). Our third video, *Bound for Avalon*, featured five archaeologists working on community-based research on early European settlement in Newfoundland (Buckley *et al.*, 2002). This video was intended as a popular summary of research and is currently being used in several interpretation centers. Our fourth video documents the involvement of Labrador Aboriginal communities in archaeological investigation of their heritage. It is intended to present best practices to students, community partners, and professional archaeologists. These videos were all joint productions with Memorial University's School of Continuing Education video unit DELT (Distance Education and Learning Technologies) and would not have been possible without substantial financial assistance from several provincial government departments.

Another dissemination project is the reproduction of theses and dissertations by Memorial students, in a series of seven thematic CDs, *Studies in Newfoundland Archaeology*, prepared by intern Jeannie Howse (Howse, 2001–2003). An eighth CD volume, on Maritime Archaic Indians, the first inhabitants of our part of North America, was completed in 2004. The theses, spanning some 8,500 years of Newfoundland and Labrador culture, are reproduced digitally in Adobe Acrobat format. These clear, accessible,

user-friendly disks have been well-received at archaeological conferences in Canada and New England, where they have been sold at a price that enables us to recover costs of reproduction.

NAHOP's latest dissemination strategy is publication of material culture identification guides in booklet format, aimed primarily at local researchers. The first guide explains the reworking of European metals by the Beothuk, the Aboriginal inhabitants of Newfoundland at the time of European contact c.1500 (McLean, 2003). Sadly, the last known Beothuk died in 1829 and these people are therefore best known from their archaeological remains. Laurie McLean's *Guide to Identifying Beothuk Iron* will be useful not only to those studying the Beothuk locally but also to researchers elsewhere, interested in the process of cultural contact. Our second material culture guide is John Wicks' *Identifying Glass Bottles,* a well-illustrated dating aid for European and North American bottles manufactured between 1650 and 1920 (Wicks, 2003). Like our videos and thesis CD volumes, these guides sell well at SHA and CHEHA conference bookrooms.

NAHOP has also helped support two journals produced by Memorial researchers. *Avalon Chronicles,* edited by Memorial archaeologists James Tuck and Barry Gaulton for the Colony of Avalon Foundation, is dedicated to the historical archaeology of Newfoundland and Labrador, in the context of eastern North America. Another Memorial archaeologist, Lisa Rankin, is preparing the inaugural volume of a second journal, *North Atlantic Prehistory*. Both journals feature the work of Memorial researchers and graduate students. NAHOP has also assisted the peer-reviewed journal *Newfoundland Studies* to publish two special issues on early modern Newfoundland.

11.4.3. Other Outreach Activities

The outreach program has furthered community archaeology in the province in a number of other ways. At a concrete level, NAHOP Coordinator Mills surveyed the eighteenth-century Moravian site of Hoffnungsthal for an Inuit heritage group in Makkovik, Labrador, and he has spent several field seasons researching an early modern site at Renews (Mills and Cary, 2000; Mills, 2003c). Program Director Pope has relied on NAHOP assistants and interns for his field work on the early St John's Waterfront and in the early settlements that surround Fermeuse Bay (Figures 11.4 and 11.5) (Pope, 2003a, 2004a). In the summer of 2004, the Quebec-Labrador Foundation and NAHOP jointly assisted the French Shore Historical Society in a survey of migratory French fishing stations near the communities of Conche and Croque. At a more general level, NAHOP's director and its coordinator contribute to the consultative role that Memorial University archaeologists have traditionally had with the provincial Culture and Heritage Division. Mills serves on the board of the Association of Heritage Industries, a provincial organization

FIGURE 11.4. Memorial University undergraduate students Janine Williams and Tomas Brosnan record waterfront graffiti at Blacksmith, in Fermeuse Bay, Newfoundland. The community of Port Kirwan can be seen in the background. (Photo courtesy of Peter Pope.)

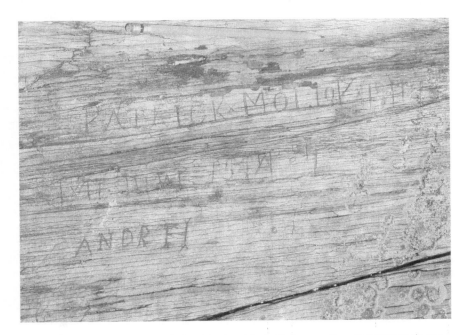

FIGURE 11.5. Waterfront graffiti at Blacksmith, in Fermeuse Bay: "PATRICK*MOL-LOY*1817 . . . ANDR H". (Photo courtesy of Peter Pope.)

that helps develop cultural policy for Newfoundland and Labrador. Meanwhile, Pope is pursuing links with Irish researchers who have parallel interests in the archaeological construction of the past (Cooney, 2003; Pope, 2004b).

11.5. Conclusions

With research leadership after 2005 in view, NAHOP's current completion phase emphasizes the development of cooperative regional expertise, research links with Memorial University that facilitate ongoing outreach, and a resolution of bureaucratic impediments to labor market development in the heritage sector. Memorial's Archaeology Unit has a long-term record of collaboration with community organizations in research and appropriate site development, dating back at least to James Tuck's research on a sixteenth-century Basque whaling station in Red Bay, Labrador, in the 1980s (Tuck and Grenier, 1989). During NAHOP's completion phase we are working closely with community partners who have established links to Memorial and we hope to strengthen these links.

In the course of our outreach program, it has become apparent that community heritage projects that take a regional approach have advantages both from the research point of view and in public interpretation. There is no one model for cooperation. Some regions, like The Baccalieu Trail, have a single heritage corporation. In other regions a strong well-developed project, like the Colony of Avalon, has inspired smaller research projects in neighboring communities. On the Great Northern Peninsula, the Petit Nord Heritage Society and Renouf's Port au Choix project have taken a lead in assembling basic documentary research and initiating archaeological survey. We do not expect regional partners to shoulder the expense of conducting archaeological projects across their region (if that is not their policy), but rather to facilitate regional research by other communities when possible. We are hoping, in other words, to promote the development of regional expertise.

Labor market development has become a key issue for our program. An unfortunate result of erratic heritage sector funding has been the creation of barriers that prevent young people from gaining work experience in the heritage field. One of the most insidious of these is that students are sometimes excluded from participation in projects, because the supporting agency has defined prospective employees in such a way as to include only those requiring retraining. These projects need skills and would provide students with valuable experience. A fixation on local job creation is proving costly in terms of the development of regional skills. The workshop and video *Working in Archaeology* were our first efforts to raise this question. In a productive meeting in 2001 with the provincial Minister of Tourism, Culture, and Recreation at the time, we were heartened that he recognized how important it is that

a program of student field placements continue beyond NAHOP's mandate and we intend to continue to lobby provincial and federal agencies to this end.

Anyone who has worked in community archaeology knows that community involvement in research can have profound effects. The development of fresh research on Newfoundland's French Shore is an excellent example of a research direction in which community groups have led and academic researchers are following. In this and in many other projects, Newfoundland's archaeologists are, in a sense, applying principles usually recommended for cooperation with Aboriginal groups, to archaeology in all community contexts. And why not? Should not archaeologists always collaborate, if possible, with local organizations in the interpretation of regional history? If plain language reports are a good idea in the postcolonial context why not in other contexts too? Will not researchers inevitably benefit from local oral history? Do not local people always have a claim on employment and training when archaeological projects impinge on their way of life? Should not research findings always be reported locally and are not photographic and video archives educational resources for young people always a good idea? Who else has a better claim on heritage merchandizing than local community groups?

The application of these principles is not simple. The members of a community, like academics, have ideas about the past—some of which may turn out to be true and some of which may turn out to be false. Archaeological researchers and community groups have distinguishable interests: the former oriented to the pursuit of knowledge within the framework of the historical sciences, the latter oriented to economic and social development. These interests overlap in the domain we have come to call "heritage" (Lowenthal, 1998). To the extent that researchers remain interested in history, and not simply in heritage (the industry that feeds on history) we have to remain interested in the plausibility of claims about the past, whether or not they will be directly useful for heritage interpretation and whether or not they indirectly promote economic and social development. Archaeologists and community organizations have different agendas and only the naive will suppose that pious support for the principles of community archaeology will somehow reconcile these in every case.

Learning to work with community groups is something like learning to sail. They are a force to be reckoned with: where you end up depends both on where you want to go and on which way the wind is blowing. This is not intended as disrespect for community organizations. They might surely take the symmetrical view that learning to work with archaeologists is also something like learning to sail and that where communities end up is not merely the result of the course they lay out but also on the direction of the academic wind. This interaction is something much more complicated than negotiation. At its best everyone arrives safely where they need to be, although the trip is almost guaranteed to be more complicated than anyone might have reasonably foreseen.

References

Ardley, S., 2001, French Cod Fishery in Newfoundland: An Annotated Bibliography. Report for French Shores Working Group, on file, NAHOP, 22 pp.

Bell, T., Renouf, M.A.P., and Pottle, C., 2000. Heritage Inventory: Humans on the Landscape. Boat Harbour to Goose Cove, Great Northern Peninsula, Newfoundland. St John's: NAHOP. Color poster, 100 × 150 cm, for L'Anse aux Meadows and Area Economic Development Committee.

Bell, T., Renouf, M.A.P., and Pottle, C., 2001. Heritage Inventory: Humans on the Landscape. Eddies Cove West to Eddies Cove, Great Northern Peninsula, Newfoundland. St John's, NAHOP. (Color poster, 100 × 150 cm, for St. Barbe Development Association).

Bell, T., Renouf, M.A.P., Hull, S., and Crompton, A., 2002, Stage 2 Heritage Inventory: Humans on the Landscape. Boat Harbour to Goose Cove, Great Northern Peninsula, Newfoundland. St John's: NAHOP (Color poster, 100 × 150 cm, for Petit Nord Cultural and Natural Heritage Society).

Buckley, R. and Gill, P., 2000, *Outport Archaeology*. Video, 25 mins. Memorial University, DELT and NAHOP, St John's.

Buckley, R. and O'Leary, K., 2002, *Working in Archaeology*. Video, 8 mins. Memorial University, DELT and NAHOP, St John's.

Buckley, R., Pope, P., and Hollingshurst, F., 2002. *Bound for Avalon*. Video, 22 mins. Memorial University, DELT and NAHOP, St John's.

Buckley, R. and Hollingshurst, F., 2003. *Archaeology and Traditional Knowledge in Labrador*. Video, 27 min. Memorial University, NAHOP and DELT, St John's.

Canadian Archaeological Association, 2003. *Statement of Principles for Ethical Conduct Pertaining to Aboriginal Peoples*. Internet site: www.canadianarchaeology. com/ethical.lasso

Canning and Pitt Associates, Fredrick Hann Associates, Past Present Consulting, BFL Consultants, Sheila Gillard Studio 1995, The Colony of Avalon master plan. Report on file, Provincial Archaeology Office, St. John's.

Carroll, P., 2002. *The Past in the Present: Oral History, Material Culture, and Self-identity in Placentia, Newfoundland*. MA thesis proposal, Department of Folklore, Memorial University.

Cooney, G., 2003, The Development of Community Archaeology in Newfoundland: Potential Applications for the Integration of Archaeological Research and Community Development in Ireland. Report for the Ireland–Newfoundland Partnership, on file Archaeology Unit, Memorial University.

Crompton, A., 2003, Excavating Plaisance: the "Ancient French Capital" in Placentia, Newfoundland, Canada. Paper presented to the Society for Historical Archaeology, Providence RI.

Eastaugh, E., 2002, The Dorset Palaeoeskimo Site at Point Riche, Newfoundland: An Intra-site Analysis. MA thesis, Memorial University (Anthropology). In: *Studies in Newfoundland Archaeology*, vol. 7, CD. NAHOP, St. John's.

Erwin, J., 2004, Prehistoric Soapstone Vessel use in Newfoundland and Labrador. Report on file, Archaeology Unit, Memorial University.

Gilbert, W., 2000, Finding Cupers Cove: Archaeological Excavations at Cupids 1995–1999. Report to Baccalieu Trail Heritage Corporation, on file Provincial Archaeology Office, St. John's.

Gilbert, W., 2003, Archaeology on the Baccalieu Trail: a Regional Perspective on the Cupids Colony. Paper presented to the Society for Historical Archaeology, Providence, RI.

Greer, S., Harrison, R., and McIntyre-Tamwoy, S., 2002, Community-based Archaeology in Australia. *World Archaeology* 34(2):265–287.

Friesen, T.M., 2002, Analogues at Iqaluktuuq: the Social Context of Archaeological Inference in Nunavut, Arctic Canada. *World Archaeology* 34(2):330–345.

Hiller, J., 2001, The French Fishery on the Petit Nord. Report for French Shores Working Group, on file, NAHOP. 33 pp.

Hodgetts, L., 2003, Seventeenth-Century English Colonial Diet at Ferryland, Newfoundland. Preliminary Report for NAHOP, on file Archaeology Unit, Memorial University.

Howse, J., comp (2001–3), Studies in Newfoundland Archaeology: Theses on the Archaeology of Newfoundland and Labrador. CDs. 7 vols. NAHOP, St. John's: vol 1. *17th-century Planters' Houses* (Stephen F. Mills, 2000; Douglas A. Nixon, 1999; Amanda J. Crompton, 2001); vol 2. *17th and 18th century Material Culture* (Peter E. Pope, 1986; Eleanor Stoddart, 2000; John Wicks, 1999); vol 3. *Technological Studies in Ferryland* (Matthew Carter, 1997; Barry Gaulton, 1997; Rick Gaulton, 2001); vol. 4. *Beothuks* (G. William Gilbert, 2002; R.J. LeBlanc, 1973; Laurie A. MacLean, 1989; Gerald Penney, 1984; Fred Schwartz, 1984; and 3 articles by R.K. Pastore); vol 5. *Recent Indians (Beothuks and their Predecessors)* (Paul C. Carignan 1973; Janet E. Chute 1976; Timothy L. Rast, 1999; David N. Simpson, 1986; Michael A. Teal, 2001); vol 6. *Groswater PaleoEskimo* (Reginald Auger, 1984; Brenda L. Kennett, 1990; Sylvie LeBlanc, 1996; Patricia Wells, 2002); vol 7. *Dorset PaleoEskimo* (Edward J.H. Eastaugh, 2002; John Erwin, 1995, Lisa Mae Fogh, 1998, Carol Frances Krol, 1986, Maribeth S. Murray, 1992; Douglas Taylor Robbins, 1985; Anna Irena Sawicki, 1983).

Lea, J. and Smardz, K.E., 2000, Public Archaeology in Canada. *Antiquity* 74:141–146.

Loring, S., 1998, Stubborn Independence: an Essay on the Innu and Archaeology. In *Bringing Back the Past, Historical Perspectives on Canadian Archaeology* edited by J.S. Pamela and D. Mitchell, pp. 259–276. Archaeological Survey of Canada, Mercury Series, Paper 158.

Loring, S. and Ashini, D., 2000, Past and Future Pathways: Innu Cultural Heritage in the Twenty-first Century. In *Indigenous Cultures in an Interconnected World*, edited by C. Smith and K.W. Graeme. UBC Press, Vancouver, 167–189.

Lowenthal, D., 1998, *The Heritage Crusade and the Spoils of History*. Cambridge University Press, Cambridge, UK.

Marshall, Y., 2002,What is Community Archaeology? *World Archaeology* 34(2): 211–219.

McLean, L., 2003, *A Guide to Beothuk Iron*. NAHOP Artifact Studies 2. Archaeology Unit, Memorial University, St. John's.

Mills, S., 2002, Helping Preserve our Past: Archaeological Outreach in Newfoundland and Labrador. Paper Presented to the International Committee on Archaeological Heritage Management at the Canadian Archaeological Association, Ottawa, ON.

Mills, S., 2003a. Community Archaeology in Newfoundland and Labrador. Paper Presented to Council for Northeast Historical Archaeology, Lowell, MA.

Mills, S., 2003b. Community-based Archaeology in Renews, Newfoundland. Paper Presented to the Society for Historical Archaeology, Providence RI.

Mills, S., 2003c. Archaeology at Renews, Newfoundland 2001–2002. *Avalon Chronicles* 7(2002):83–105.

Mills, S. and Cary, H., 2000, A Glimpse at Hoffnungsthal: the First Moravian Mission in Labrador. *Avalon Chronicles* 5:101–112.

Moser, S., Glazier, D., Phillips, J.E., Lamya Nasser el Nemr, Mohammed Saleh Mousa, Rascha Nasr Aiesh, Susan, R., Ancrew, C., and Michael, S., 2002.

Transforming Archaeology Through Practice: Strategies for Collaborative Archaeology and the Community Archaeology Project at Quseir, Eqypt. *World Archaeology* 34(2):220–248.

Niven, L., 1994, *Birchtown Archaeological Survey (1993): the Black Loyalist Settlement of Shelburne County, Nova Scotia, Canada.* Roseway Publishing, Lockeport, NS.

Pope, P.E., 2000, Outport Archaeology: Community-sponsored Excavation in Newfoundland. Paper presented to Canadian Archaeological Association, Ottawa. On line at http://collection.nlc-bnc.ca/100/200/300/ont_archaeol_soc/annual_meeting_caa/33rd/pope.pdf

Pope, P.E., 2003a, Fermeuse Area Survey, 2002. Report on file, Provincial Archaeology Office, St. John's.

Pope, P.E., 2003b, Le Petit Nord du XVIIe siècle: une Description Inédite de la Pêche Française Transatlantique. *Annales de Fécamp* 10:13–18.

Pope, P.E., 2004a, The Waterfront Archaeology of Early Modern St John's, Newfoundland. In *Close Encounters: Sea- and Riverborne Trade, ports and hinterlands, ship construction and navigation (antiquity, middle ages, modern times)* edited by M. Pasquinucci and T. Weski. BAR, Oxford, International Series 1283, 179–190.

Pope, P.E., 2004b, Outport Archaeology in Newfoundland: Reconstructing the Past. Identity, Memory and the Material World. Symposium, Humanities Institute of Ireland, University College, Dublin.

Renouf, M.A.P., 2002, Archaeology at Port au Choix: 1990–1992 Excavations. *Occasional Papers in Northeastern Archaeology, 12.* Copetown Press, St. John's.

Renouf, M.A.P., Wells, P.J., Pope, P.E., and Pickavance, R., 2004, Report of the 2003 Field Season at port au Choix, Conche and Englee. Report on file, Parks Canada, Heritage Resources Branch, Halifax, and Provincial Archaeology Office, St. John's.

Rowley, S., 2002, Inuit Participation in the Archaeology of Nunavut: a Historical Overview. In *Honoring our Elders, a History of Eastern Arctic Archaeology* edited by W.W. Fitzhugh, S. Loring, D. Odess, pp. 261–272. Arctic Studies Center, Smithsonian Institution, Washington.

Simms, P., Pope P., Mills, S., and Maynard, L., 2001, *Organizing Community Archaeological Projects in Newfoundland and Labrador: Heritage Outreach Guidelines.* 104 pp.+appendices. Memorial University Archaeology Unit, Heritage Outreach Project and NAHOP, St. John's.

Temple, B., 2004a, *Somerset and Dorset Ceramics from Seventeenth-century Ferryland, Newfoundland.* MA thesis, Department of Anthropology, Memorial University.

Temple, B., 2004b, Placentia Historic Map GIS Project. Report on file, Archaeology Unit, Memorial University.

Tompkins, E., 2003, Bibliothèque Nationale: Département des Cartes et Plans, Service Hydrographique de la Marine: portfeuilles 128, 129, 130. Archives Nationales, Département des Cartes et Plans, Paris: maps. Service Historique de la Marine, Vincennes, Paris: maps; Hydrographic charts. Reports on file, Archaeology Unit, Memorial University.

Tuck, J.A., 1996, Archaeology at Ferryland, Newfoundland 1936–1995. *Avalon Chronicles* 1:21–42.

Tuck, J.A. and Grenier, R., 1989, *Red Bay, Labrador: World whaling capital A.D. 1550–1600.* St. John's: Atlantic Archaeology.

Wicks, J., 2003, *Identifying Glass Bottles.* NAHOP Artifact Studies 2. Archaeology Unit, Memorial University, St. John's.

12
Service-Learning: Partnering with the Public as a Component of College Archaeology Courses

Sherene Baugher

12.1. Introduction

"Service-learning," is the higher education reform movement to connect community service to academic courses. Since the 1960s, it has involved summer internships (both paid and unpaid), course credit internships, placing students in government agencies for a semester, experiential education, field-study courses, urban semesters involving students in diverse anti-poverty programs, and has even included international study programs. In the 1960s, with the establishment of the Peace Corps and VISTA, universities became interested in providing opportunities for students to gain "real world" experiences by working in communities through internship programs. In 1971, the National Center for Service-Learning was established to help promote community outreach and one of the efforts was to help high school and college administrations evaluate ways to offer credit for service-learning experiences (Bounous, 1997: 5). In the 1970s, there was federal funding for students to engage in community internship as part of the anti-poverty programs. In the 1980s, the Reagan administration cut federal funding for paid anti-poverty program internships, and community service moved to a model where the work was connected to academic courses (Lounsbury and Routt, 2000: 28). The *National Community Service Act of 1993*, signed by President William Jefferson Clinton, further strengthened these academic initiatives for public outreach. Today, the term "service-learning" is "typically used to refer to a course-based, credit-bearing educational experience where students participate in organized service that meets community needs, and reflect on the service to gain further understanding of course content, a broader appreciation of the discipline, and an enhanced sense of civic responsibility" (Lounsbury and Routt, 2000: 27). Often these service-learning courses are offered in departments of sociology, education, planning, political science, government, labor relations, but usually archaeology courses are notably absent. However, archaeology courses could integrate community service simply as a module within the courses.

This chapter discusses how "partnering with the public" can be integrated into college archaeology courses by way of service-learning. The examples come from 15 years of archaeological service-learning courses at Cornell University. This ongoing endeavor has resulted in public programs as well as diverse interdisciplinary research.

12.2. Archaeology and Community Service

The archaeological professional has a commitment to public outreach. Public education committees that promote outreach are now permanent committees of the Society for Historical Archaeology (SHA) and the Society for American Archaeology (SAA). Successful public education endeavors are highlighted in both societies' newsletters. Lynott and Wylie's *Ethics in American Archaeology* (2000) stresses the need for public education and outreach efforts. Ellen Herscher and Francis McManamon (2000) note some of the innovative outreach work has included archaeology programs on the Learning Channel and some state efforts to highlight archaeology month. The Society for American Archaeology book, *Archaeologists and Local Communities: Partners in Exploring the Past* (Derry and Malloy, 2003) provides various case studies of archaeologists working with community partners. These outreach efforts were often undertaken by archaeologists in government agencies, museums, and cultural resource management firms. Archaeologists in colleges and universities have committed their own time (separate from their teaching) to public outreach. Faculty members can also incorporate community service into their teaching by way of service-learning.

Service-learning does not have to be the focus of an entire course; it can be a component of a course. The techniques and values of civic engagement can be integrated as components of many courses and not marginalized by being placed in a single-focused course. A summer field program can be an appropriate course for engaging the public. Opening up archaeological sites to tours or visits has been shown to be an effective form of outreach (Jameson, 1997). In fact, involving a community in an excavation can encourage community pride and the protection and preservation of a site (Versaggi, this volume).

Service-learning can involve research. In fact, good outreach should involve research. One of the ways to integrate research into service-learning is to involve the community into the research project. University-based social scientists, especially sociologists, sometimes conduct what is referred to as "participatory action research," also known as "PAR." In participatory action research community members become partners with academics, and the goals and focus of research are decided jointly. This idea of a partnership with non archaeologists may be the biggest barrier preventing archaeologists becoming involved in service-learning. Traditionally archaeology is a hierarchical system with top down management. To suggest that

non archaeologists should in any way be involved in setting a research agenda is to suggest giving up some power and control. Some archaeologists may fear that sharing "control" would just make the archaeologist a technician who is working for the client a/k/a/ the community. However, partnership implies that both groups bring ideas and perspectives to the table and there is the belief (shared by the partners) that the joint endeavor is better because of the multiple voices. These joint projects have the potential to be richer and more detailed than a solely academic-focused effort. Community members may also assist in the research rather than just being the subject of the research, and they may suggest research that was not the initial priority of the social scientist. Another very positive benefit of PAR and service-learning is that community members often become involved in their own community history and participate in oral history projects (Baugher, 2000). They also become grass root supporters of archaeology and historic preservation. The rest of this chapter is devoted to providing examples of engaging the public by including service-learning into archaeological courses.

12.3. An Archaeological Model for Service-Learning and Community Outreach

This chapter's suggested model for archaeological-based service-learning is based on 15 years of undertaking service-learning projects at Cornell University. Since 1992, I have tried different approaches and tested new techniques and discussed with students and community members what components of service-learning they like and do not like. I have analyzed these different experiments in service-learning to develop an archaeological model and tested it at various sites.

In many colleges and universities throughout the country, service-learning courses are one semester in duration and the whole course is focused on a single community service project that can be completed within the limits of one semester. However, service-learning does not have to be a single course entirely devoted to service-learning. By embedding service-learning as components of regular academic courses, faculty can undertake more complex projects that are multi-semester and develop more in-depth ties to the community. Often by the end of a one semester project, the students, faculty members, and community members realize what they could and perhaps should have done but there is no time to implement change since the project is over. With a two or three semester involvement in a community there is time to develop a deeper understanding of the community and to accomplish a more detailed and complex project.

The model suggested in this chapter involves integrating service-learning as a component of three courses and the project is spread out over three semesters: Spring course involving documentary research; Fall class (or summer

field school) on field excavation; and Spring class involving laboratory work in archaeology. I found that a three-semester model worked to initiate a project: a spring semester course in which the background research can be completed; a fall semester archaeological field class to undertake excavations (this could also be a summer field school); and a spring semester laboratory class to analyze the results of the fall or summer semester's excavation. This model allows adequate time for a project to be developed, changed, and implemented. It also enables the community group to become more familiar with the professor and the Cornell students. The community members and the academics have the time to develop a better understanding of each other and be able to reach mutual goals. The most important component is an enthusiasm by the faculty, students, and community members to work together toward common goals.

This three-semester model worked out to start a project, but I found that the commitment to the community required being involved beyond the year and a half time frame. The community relations and trust grew and developed over time. I found that I repeated the field and lab sequence for additional years not only to obtain more detailed research but to develop closer ties with the community. Later in this chapter, I discuss my three specific multi-year community projects.

I believe that community service has to be voluntary. By embedding service-learning as a component of a course, all students can be exposed to the ideas of public outreach and community partnerships but all students do not have to be actively engaged in service-learning. In my courses, students can become actively involved with a community if they chose to. Students are provided with different ways to excel in the course and arrive at the same grade with or without direct contact with community members. For example, some students can opt to interview community members for an oral history project, whereas others can choose to undertake archival research on newspapers or census records without working with any community members. In the end, the work of the whole class benefits specific communities but there is no requirement for individual students to become engaged in interactions with individual community members.

12.4. Designs for Archeological Courses in Service-Learning

Three different courses compose the suggested archaeological service-learning sequence. Students can take one, two, or all three of the following courses: documentation including interviews and oral history, excavation, and laboratory work. The work can be spread over a year and a half or for colleges with a tri-semester sequence; it can be accomplished within one year. The initial goals of any joint project and joint research should be worked out between the faculty member(s) and the community members before the start

of the first phase of the work. As the work progresses goals and objectives are probably revised.

12.4.1. Course 1: Documentation Including Interviews and Oral History

Documentary research can be integrated into diverse courses in lieu of a traditional research term paper. I have invited community members to my class to talk to the students about their community and why they want us to be involved in archaeological research and what are their goals in the joint research. Interestingly, the students were more motivated to undertake the documentary research because it was not just an academic exercise; it was research that mattered to and was valued by the community members.

In our teaching we emphasize to our students that all archaeological fieldwork should be preceded with thorough documentary research. As part of the preparation for the documentation project, students need to be trained in undertaking primary source research using historic maps, deeds, mortgages, wills, census records, city directories, and newspapers. Students can divide up into teams to undertake a documentary study on a specific parcel of land (similar to Phase I site study in Cultural Resource Management projects). I found that this documentary research worked best in a graduate class or in a 500 level course that combined seniors with graduate students. In obtaining information on a community over time, undergraduates enjoyed being assigned a specific time frame (a 1-year interval) to gather data from weekly or monthly newspaper records. The work on a community often expanded the students' interests. Many of the students, while they were searching historic newspapers for information on families and a particular community, became fascinated with the nineteenth-century product advertisements that led to useful class discussions about consumer behavior and artifacts archaeologist might find at sites. Students also liked the challenge of tracing a particular family through census records and city directories and it opened up discussions about nineteenth-century job opportunities, economic status, gender roles, urban versus rural lifestyles, and the social and economic roles of servants and boarders within a household.

Oral history work was undertaken by some students who wanted to work closer with community members. I provided training sessions in undertaking oral history and had the students read and discuss relevant books such as Sommer and Quinlan's (2002) *Oral History Manual*. The community members who volunteered to be interviewed were interested in having copies of the tapes. We produced both video and audio tapes. The university kept a copy and also provided copies to the person being interviewed. If the larger community group requested tapes, we provided them with tapes as well. Volunteers said that their families especially enjoyed seeing the video interviews and that grandchildren enjoyed hearing their grandparents "talk about the old days." A totally unforeseen outcome was that some students became

interested in recording their own family histories after the course was over. Years later I have had students send me notes telling me they were compiling oral history interviews with their grandparents.

12.4.2. Class 2: Excavation

This can be either a summer or fall field class, so that the lab class can be in the spring. I have used fall field classes with work undertaken on Friday afternoons, and all day Saturday during September, October, and early November. The excavation has academic research goals just like any traditional project. In our projects we also have research goals that are of value to the community and we have a public outreach component. In the field class the students learn the same techniques and methodologies as in traditional field schools (Figure 12.1).

At Cornell, the students are from a variety of academic majors, but the majority are from the fields of archaeology, city planning, historic preservation, landscape architecture, and natural resources, fields that require professionals who can evaluate the significance of archaeological sites and burial grounds when making planning, design, and policy decisions. For many of these majors, interaction with the public will be part of their work as professionals, so there was an interest (by many students) in being involved in a course that had an outreach component.

We discuss both in class and in the field the importance and value in sharing our knowledge and our discoveries with the public and how the field of archae-

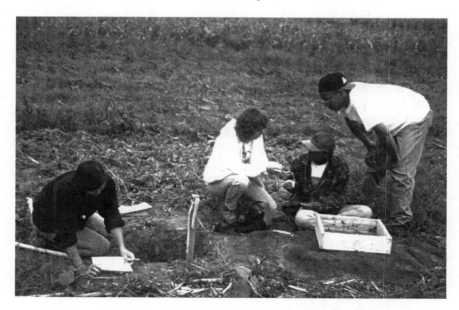

FIGURE 12.1. Sherene Baugher discusses artifacts and shovel testing methodology with students (Photo: Thomas Volman).

ology is changing. Every fall we have at least one "open house" day where the public can tour the site. Members of various Central New York Chapters of both the Archaeological Institute of America and the New York State Archaeological Association visit our site on open house days. In addition, the general adult public reads about our projects in the newspaper and visits our sites on the open house days (Figure 12.2). We also encourage group tours on non-open house days, and have hosted Cub Scouts, church youth groups, school groups, home schooling families, and a youth group from the Oneida Indian Nation (the reservation is 2 hours from Ithaca). In 2005, when the New York State Finger Lake Parks advertised our open house days on our archaeological work at Robert H. Treman State Park we had visitors coming as far away as Buffalo, New York (3 hour drive from Ithaca).

Students can volunteer to give tours explaining their work to tourists. Since the outreach is voluntary, some students are very enthusiastic and others would prefer to be more removed from any involvement with the public. Student attendance for the open house days is not mandatory, so students who were not interested in public outreach did not have to participate. Those

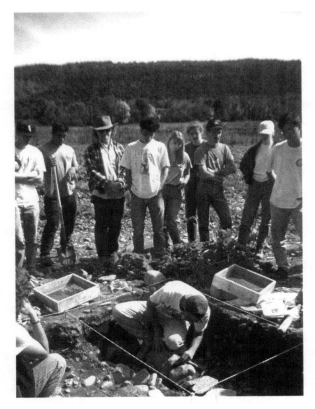

FIGURE 12.2. Members of the public visit the Inlet Valley excavation during "Open House" days.

who did not participate would put in an equal amount of time (on other days) on general field work, therefore assuring that all course work involved an equal investment of student time. Interestingly, over the years more and more students want to be involved in outreach. Some shy students surprisingly discovered that they enjoyed answering questions about their work and showing people artifacts that they had unearthed. Some community members were also able to share with students their insights regarding our outbuildings and features.

12.4.3. Class 3: Laboratory Work

A spring laboratory class involves teaching students to clean, identify, date, and catalog artifacts. The end result of the class is a collection catalog of all the artifacts from our fall fieldwork. Copies of the collection catalog are sent to the community and to appropriate government agencies including the State Historic Preservation Office. Students also attend lectures and discussions. Once students have learned how to identify artifacts they also have class discussions on how archaeologists use material culture to understand past lifestyles and consumer behavior. Required texts include books such as Orser's *Images of the Recent Past* and books that use artifacts to interpret a community's history such as Cantwell and Wall's *Unearthing Gotham*. The community component of this course is that community members come to the lab classes and discuss the artifacts with the students. For example, when the students were working on a farm site, they enjoyed talking with the local farm families because the families could easily identify the "mystery" metal objects that were fragments of farm implements.

12.5. The Archaeological Service-Learning Projects

Since 1992, Cornell students have worked on three service-learning projects all within 20 miles of the Cornell campus. They were: Indian Fort Road 1992 and 1996–1997; Inlet Valley 1993–1996; and Enfield Falls 1998–present.

12.5.1. Indian Fort Road Project

Our first major effort was the "Indian Fort Road Project." I was contacted by the property owners, John and Lisa Cowden, because they were going to renovate a barn on their property and wanted to make sure that the work did not impact any archaeological remains. Their construction did not require any special permits or government funds and did not trigger any legally mandated archaeological surveys. The Cowdens knew that their property was on the site of a Cayuga Indian village, ca. 1500s and they wanted all the archaeological work to be coordinated with Cayuga Indian Chief Frank Bonamie. The major concern was to protect and preserve any Native American burial

grounds. As it turned out, there were no intact Cayuga or historic period deposits in the proposed construction area. Four years later we returned to the site to excavate in a protected area in the woods near the barn and found the remains of a Cayuga Indian village (the American Indian component of this project is discussed subsequently along with the work of the Native American community at the "Inlet Valley Project.")

12.5.2. Inlet Valley Project

The "Inlet Valley Project" involved 4 years of work. The 200 acre parcel involved work on three separate sites, which were: a Tutelo Indian village, eighteenth century; a temporary American Indian settlement, ca. AD 700; and the site of an early nineteenth-century farmstead, "The Fisher Farm," ca. 1820–1867.

In the Inlet Valley project we had a joint team of students from Cornell and Ithaca College. Archaeology Professors Michael Malpass and Chris Poole from Ithaca College joined me in working closely with the Native American community, the Town of Ithaca, and landowners. At Inlet Valley we thought we might uncover the Tutelo village known as Coreorgonel (translation: where we keep the pipe of peace). The Tutelo Indians were a Siouan-speaking tribe from Virginia, who fled their homeland and sought refuge among the Cayuga Indians (one of the six nations of the Iroquois Confederacy) in New York (Mooney, 1894: 50–51). In the mid-1700s, the Cayugas provided land and protection for the Tutelos and adopted, rather than absorbed, them (Speck, 1938: 7). Twenty-five houses, farm fields, and orchards of the politically neutral Tutelo village of Coreorgonel were destroyed in 1779 by an American military expedition under the direction of Patriot General John Sullivan (Dixon, 2002: 74). The Tutelos fled to Canada, and after the war some remained on Six Nations Reserve in Ontario living with the Cayugas.

Both the Indian Fort Road project and the Inlet Valley project were endangered sites that did not trigger an environmental review. We were contacted by property owners (Indian Fort Road) and concerned governmental officials (Inlet Valley) because they wanted to be sure that no important sites would be adversely impacted by development. In both cases, we worked with local Native American leaders and property owners (and in the case of Inlet Valley with municipal planners) before the fieldwork started. We all agreed that we would not excavate any burial grounds. If any burials were accidentally discovered, work would be stopped immediately and the appropriate religious and political American Indian leaders would be contacted. Our mutual goal was to protect and preserve, not to excavate, sacred sites and burial grounds (Baugher and Frantz, 1997; Baugher and Clark, 1998).

Students on both projects were aware that their archaeological work involved them in one of the major ethical debates in archaeology today—the debate over the preservation of Native American cemeteries. Part of the

debate focuses on whether Native Americans should have a voice in what happens to their burial grounds or should these sites continue to be laboratories for archaeologists and physical anthropologists without Native American permission (Swidler *et al.*, 1997). Students heard classroom lectures on this subject as well as participating in field discussions and reading assigned material. Since my colleagues and I support the preservation of American Indian burial grounds, Native American advisors were kept abreast of developments and occasionally visited the site. Just as significantly, there were both Native American graduate and undergraduate students working on the sites (Figure 12.3). Because Native American students were working side by side with non-Native Americans, the protection and preservation of burial grounds became a very real issue, not an abstract scientific topic. Students who initially supported the scientific excavation of cemeteries came to support Native Americans right to protect their ancestors' remains.

The Inlet valley site had also been a Euro-American farm in the nineteenth century. It was one of the most productive farms in the Town of Ithaca. As we excavated the farm site students were interested in learning about the

FIGURE 12.3. Native American student Susan Pacek (right) helps screen artifacts at the Indian Fort Road site.

nineteenth-century agricultural revolution and the use of scientific techniques in nineteenth-century farming. In fact we found examples of elaborate farm drains, some over 400 ft long. It was especially helpful when farmers came to the site and discussed how they dealt with drainage problems in the early twentieth century and even how techniques changed in the 1950s and 1970s.

12.5.3. Enfield Falls Project

Enfield Falls is the project that has consumed most of our time; we have been working here steadily since 1998. It is also the project involving the most outreach work. Today, when you visit Robert H. Treman State Park, you will see a beautiful "natural" environment that has attracted visitors for generations. The spectacular waterfalls, a beautiful gorge, and diverse floral and fauna have been enhanced with charming stone bridges, trails, and pathways. Some of these were built in the 1920s by the park staff but most were constructed by Civilian Conservation Corporation (CCC) workers in the 1930s. For tourists picnicking or camping at the park, there are very few clues that this park is both a natural and an historic landscape. Buried only a foot beneath this gorgeous natural landscape is a nineteenth-century historic landscape— a vibrant hamlet existing underneath the picnic grounds of what is now Upper Robert H. Treman State Park (Figure 12.4).

FIGURE 12.4. Members of the Friends of Robert H. Treman State Park take a tour of the excavation given by archaeology graduate student Yasha Rodriguez (center).

Enfield Falls was a hamlet within the Town of Enfield in Tompkins County, New York. The hamlet housed a grist mill, saw mills, a general store, a hotel, a tannery, other craft shops, and homes. Unlike other rural hamlets, Enfield Falls had beautiful gorges and breathtaking water falls, which enabled it to have a small tourist industry complete with a resort hotel built in the 1830s. In the 1920s and 1930s, most of the buildings in the hamlet of Enfield Falls were razed in order to create Upper Robert H. Treman State Park. However, two historic structures, the gristmill and the miller's cottage, survive as reminders of the site's former history. Both the Mill and the Miller's Cottage are on the State and National Register of Historic Places. The Mill serves as a mill museum and the Miller's house is now the home for park staff.

However, not everyone had forgotten the extent of this hamlet. The descendants of residents of Enfield Falls still live in Tompkins County. Some belong to a nonprofit organization called "The Friends of Robert H. Treman State Park" (The Friends), which records both the history of the park and the former hamlet of Enfield Falls. "The Friends" organization works closely and cooperatively with park staff and has taken on projects that cannot be accomplished within the limited park budget. The Friends have given numerous tours of the mill, produced a pamphlet on the history of the hamlet, and provided public lectures. The Friends and park staff learned of my work with the Town of Ithaca and the Native American community and wanted to develop a partnership at Robert H. Treman State Park. Our joint project (Cornell University, Friends, and Park Staff) is called "Rediscovering Enfield Falls" and has multiple goals: documentary research, oral history, and archaeological fieldwork to determine what material survived the transformation of the hamlet into a public park. My fieldwork revealed foundations of homes, shops, and outbuildings from the nineteenth century, along with intact deposits in yards, nineteenth-century pathways, and other features (Baugher et al., 2005). These deposits were preserved when the park staff and the CCC covered the foundations and yard deposits by raising the ground level. The Friends goal (and also the Park's goal) was to let tourists know about the history of this community situated within a ruggedly beautiful natural setting. The Friends wanted tours of the site, temporary exhibits, and public lectures. Our joint outreach grew to involve a permanent archaeological exhibit within the historic mill, permanent outdoor archaeological exhibits, and an archaeological component in the new visitor orientation film for the park.

12.6. Academic Research and the Three Service-Learning Projects

Service-learning is outreach work but in archaeology it can and should involve research. Because all of our service-learning projects were on important sites, there was a professional responsibility to produce reports beyond the collection catalogs produced in the laboratory class. Some students have

completed senior theses and master's theses undertaking further research on these sites (Clark, 1998; Costura, 2002; Kelly, 2002). Technical site reports (similar to Phase 2 and Phase 3 Cultural Resource Management reports) were compiled with both graduate students and seniors who wanted to undertake more detailed research in historical archaeology (Baugher and Quinn, 1995, 1996a,b; Baugher and Clarke 1998; Baugher et al., 2005). These site reports were provided to the Friends, property owners, interested community members, Native American leaders, town and county agencies, and the New York State Historic Preservation Office. In addition, presentations on the research of these sites at conferences have been given on an yearly basis for the Council for Northeast Historical Archaeology and for the New York State Archaeological Association.

Service-learning can and does impact positively the research by both students and academics. Scholars would find that service-learning can open up new doors within their own research. Some of our service-learning projects have led me into new areas of research, such as farmstead archaeology and that has resulted in academic publications (Baugher, 2002; Baugher and Klein, 2002).

Complex ethical issues involving burial sites and the preservation of sacred sites became clearer to all of us working with Native Americans. This has also led me to more activism. For example, I was asked to become the pro-bono archaeologist for the Onondaga Nation near Syracuse, New York. I serve as a liaison, working with the attorney for the Nation, between the Onondaga Nation and the New York State Historic Preservation Office. I have also undertaken more research and writing on the preservation of sacred sites (Baugher, 1998, 2005).

12.7. Funding

My service-learning work started with a very modest budget. When I arrived at Cornell, Cornell's Archaeology Program had only two shovels, two trowels, and two screens in Ithaca. All other supplies were permanently at overseas sites because Cornell's archaeology work has been in South America, Honduras, the Mediterranean, and the Near East. Fortunately, Cornell is a member of the Campus Compact, a group of Northeast colleges and universities that support community outreach work and service-learning. In 1992, I received a Cornell Faculty-Fellows-In-Service grant from the Public Service Center for $2,000 for my first semester of archaeological fieldwork. This money enabled me to purchase some inexpensive equipment for a field class in archaeology. Our projects have subsequently received grants from the New York State Preservation League and the Jacob and Hedwig Hirsch Fund for Archaeology at Cornell for archaeological equipment. The cost of running an excavation was shared by diverse departments who shared costs to pay for vans to transport students to the archaeological sites and for teaching assistants. Over the years we have been able to replace inexpensive "start up"

equipment with more durable, higher quality material. During the Inlet Valley project, the Town of Ithaca's Planning Department provided funding for two graduate research assistants as Town interns in 1993 and one assistant in succeeding years through June 1996. The assistant planner George Frantz acted as liaison between the Inlet Valley project and the landowners/developers. He also provided mapping and surveying services. The Town of Ithaca's Highway Department provided heavy excavating equipment and operators.

During the Enfield Falls project, the staff at Robert Treman State Park provided use of storage space for our equipment, and at the end of every field season they backfilled our site. In terms of our permanent outdoor archaeological exhibit, the New York State Parks Finger Lakes Office has provided us with the granite pavers and gravel for outlining the foundations of two of the historic buildings (the original foundations are buried a foot below grade). They also provided all the topsoil needed to improve the landscape surrounding the site. They also purchased the equipment needed for a visitor orientation film and paid for all the lighting needed for the exhibit cases. The Cornell Council for the Arts and The Jacob and Hedwig Hirsch fund at Cornell provided grants for the archaeological exhibit cases and for the cost of the archaeological signage within the historic mill.

12.8. Lessons Learned

For the faculty member there must be more than one semester involvement in service-learning. Credibility is something that is built up slowly over time. It is naïve to think that a community will open up and be supportive if only one field season is committed to the project with only vague statements about follow-up sessions. Oral history, community history, and work with descendants provide new insights, additional voices, and additional perspectives to projects. However, these do not happen overnight—the archaeologist needs to invest considerable time in order for community partnerships to work.

12.9. Conclusions

Service-learning is an effective way to introduce the values of outreach and community service to our students. It allows students to "partner with the public" but within the context of an academic course. It provides opportunities for students to work with people from different professional backgrounds, such as town planners, and different ethnic groups, such as Native Americans. It can also provide opportunities for students to understand complex ethical issues, such as Native American reburial and repatriation, by hearing diverse points of view outside the context of a college lecture. In the end, students realize that research and outreach can be combined.

Service-learning should become part of the curriculum in archaeology so that the public's real interests are considered in tandem with what we, as archaeologists, view as important. As a result of working with communities we move beyond the academic status quo and gain a richer interpretation and understanding of our diverse history.

References

Baugher, S., 1998, Who Determines the Significance of American Indian Sacred Sites and Burial Grounds? In *Preservation of What, for Whom? A Critical Look at Historical Significance*, edited by M. Tomlan, pp. 97–108. National Council for Preservation Education, Ithaca, New York.

Baugher, S., 2000, Service-learning and Community History: Archaeological Excavation, Historical Documentation, and Oral History. In *Working Paper Series on Service-learning*, vol. III, edited by T.A.O'Connor and L.J. Vargas-Mendez, pp. 7–12. Public Service Center, Cornell University, Ithaca, New York.

Baugher, S., 2002, What is It? Archaeological Evidence of Nineteenth-Century Agricultural Drainage Systems. *Northeast Historical Archaeology* 30–31: 23–40.

Baugher, S., 2005, Sacredness, Sensitivity, and Significance: The Controversy Over Native American Sacred Sites. In *Heritage of Value, Archaeology of Renown: Reshaping Archaeological Assessment and Significance*, edited by C. Mathers, T. Darvill and B. Little, pp. 248–275. University Press of Florida, Gainesville.

Baugher, S. and Clark, S., 1998, *An Archaeological Excavation of a Cayuga Indian Village: The Indian Fort Road Site, Trumansburg, New York*. Cornell University, Report submitted to NYS Office of Parks, Recreation and Historic Preservation.

Baugher, S. and Frantz, G., 1997, A Service-learning Model in Archaeology: A Partnership Between University Archaeologists, Municipal Planners, and Native Americans. In *Working Paper Series on Service-learning*, vol. I, edited by R.M. Bounous, pp. 19–28. Public Service Center, Cornell University, Ithaca, New York.

Baugher, S. and Klein, T., editors, 2002, Archaeology of Nineteenth-Century Farmsteads in Northeastern Canada and the United States. Thematic issue of *Northeast Historical Archaeology*, vol. 30–31.

Baugher, S. and Quinn, K., 1995, *An Archaeological Investigation of Inlet Valley, Ithaca, New York*. Town of Ithaca Planning Department and Cornell University, Report submitted to NYS Office of Parks, Recreation and Historic Preservation.

Baugher, S. and Quinn, K., 1996a, *An Archaeological Investigation of Eddyhill Farm Industrial Parcel, Inlet Valley, Ithaca, New York*. Town of Ithaca Planning Department and Cornell University, Report submitted to NYS Office of Parks, Recreation and Historic Preservation.

Baugher, S. and Quinn, K., 1996b, *A Phase Two Archaeological Investigation of Inlet Valley, Ithaca, New York*. Town of Ithaca Planning Department and Cornell University, Report submitted to NYS Office of Parks, Recreation and Historic Preservation.

Baugher, S., Costura, D., Costura, M. and Schryver, J., 2005, *Preliminary Archaeological Investigation of Enfield Falls at Robert H. Treman State Park, New York*. Cornell University, Report submitted to NYS Office of Parks, Recreation and Historic Preservation.

Bounos, R.M., 1997, Introduction. In *Working Paper Series on Service-learning*, vol. I, edited by R.M. Bounous, pp. 5–8. Public Service Center, Cornell University, Ithaca, New York.

Cantwell, A. and Wall, D., 2001, *Unearthing Gotham: The Archaeology of New York City*. Yale University Press, New Haven, Connecticut.

Clark, S., 1998, *Senior Honors Thesis, Archaeology Program*. Cornell University

Costura, D., 2002, *An Interpretive Design For The Archaeological Excavation of Enfield Falls at Robert H. Treman State Park*. MLA Thesis, Department of Landscape Architecture, Cornell University.

Derry, L. and Malloy, M., editors, 2003, *Archaeologist and Local Communities: Partners in Exploring The Past*. Society for American Archaeology, Washington, D.C.

Dixon, H., 2002, A Saponi by any Other Name is Still a Siouan. *American Indian Culture and Resource Journal* 26(3): 65–84.

Heath, M.A., 1997, Successfully Integrating the Public into Research: Crow Canyon Archaeological Center. In *Presenting Archaeology to the Public: Digging for Truths*, edited by J.H. Jameson, Jr., pp. 65–72. AltaMira Press, Walnut Creek, California.

Herscher, E. and McManamon, F.P., 2000, Public Education and Outreach: The Obligation to Educate. In *Ethics in American Archaeology*, revised second edition, edited by M.J. Lynott and A. Wylie, pp. 49–51. Society for American Archaeology, Washington, D.C.

Kelly, S., 2002, *Senior Honors Thesis. Archaeology Program*. Cornell University.

Jameson, J.H., Jr., editor, 1997, *Presenting Archaeology to the Public: Digging For Truths*. AltaMira Press, Walnut Creek, California.

Lounsbury, M. and Routt, D., 2000, Negotiating Course Boundaries: Service-learning as Critical Engagement. In *Working Paper Series on Service-learning*, vol. III, edited by T.A. O'Connor and L.J. Vargas-Mendez, pp. 27–33. Public Service Center, Cornell University, Ithaca, New York.

Lynott, M.J. and Wylie, A., editors, 2000, *Ethics in American Archaeology,* revised Second edition. Society for American Archaeology, Washington, D.C.

Mooney, J., 1894, The Siouan Tribes of the East. *Bureau of Ethnology Bulletin*, vol. 22. Smithsonian Institution Press, Washington, D.C.

Orser, C.E., Jr., 1996, *Images of the Recent Past: Readings in Historical Archaeology*. AltaMira Press, Walnut Creek, California.

Sommer, B.W. and Quinlan, M.K., 2002, *The Oral History Manual*. AltaMira Press, Walnut Creek, California.

Speck, F.G., 1938, The Question of Matrilineal Descent in the Southeastern Siouan Area. *American Anthropologist* 40(1): 1–12

Swidler, N., Dongoske, K.E., Anyon, R. and Downer, A.S., editors, 1997, *Native Americans and Archaeologists: Stepping Stones to Common Ground*. AltaMira Press, Walnut Creek, California.

13
Partners in Preservation: The Binghamton University Community Archaeology Program

Nina M. Versaggi

13.1. Introduction

We often hear the statement that one of the greatest threats to the archaeological record is an uninformed and disengaged public (Davis, 1997: 85; Hoffman, 1997: 73; T. Price et al., 2000; K. Hoffman et al., 2002: 215). This statement derives from the fact that most archaeological research in the USA is publicly funded through legislative mandates that seek to identify and preserve significant aspects of the past for the public good. In fact, the premise on which historic preservation is based clearly states that the collection and protection of information about the past is in the public interest (http://www.cr.nps.gov/local-law/FHPL_HistPrsrvt.pdf). Preservation legislation on both the federal and state levels has established a role for archaeologists as stewards of the past, agents on the ground who discover, interpret, and protect pieces of our collective cultural heritage.

The phrase, "in the public interest," is a broad concept, open for varied interpretation. First-line beneficiaries of these legislative mandates tend to be archaeologists, historians, and architectural historians who are presented with opportunities to conduct research deemed to be important to the interpretation of the past. As many of us have already concluded, what archaeologists perceive as important is not always the same as the significance attached to the past by others. We have all come to realize that there are diverse types of "public values" people attach to the preservation of sites, among them the value to descendent communities and cultural descendants, the value to the educational community, and the value to general community constituents.

The Public Archaeology Facility (PAF) is a research center on the campus of Binghamton University, one of the four state universities in New York. In 1996, PAF formed the Community Archaeology Program (CAP), an umbrella for the many presentations done throughout the year. CAP is based on the premise that the public has more than a passing interest in the research conducted by archaeologists, and the program provides a way for constituents to become stakeholders. The CAP umbrella still covers traditional slide

presentations, site/lab tours, visits to local schools, and a traveling exhibit. In addition, CAP offers a supervised field opportunity for community members (children and adults) to build "sweat equity" in a local site and contribute to the research and interpretive process. CAP also provides an opportunity for graduate students to receive training in the philosophy and practice of meaningful community outreach. This paper will detail the CAP program and discuss the principles we have formulated that guide our partnership with the public in the research, interpretation, and preservation of the cultural heritage in our local communities.

13.2. Values and Archaeology

Generally speaking, people tend to be advocates for causes that they understand. Individuals and groups attach value to items and issues with which they can empathize on a personal or professional level. Archaeology and historic preservation are no exception (Davis, 1997: 85; Jameson, 1997: 17). Archaeologists and other professionals who share information with the public about the importance of preservation, engage a diverse constituency in the stewardship of the archaeological record. This responsibility is so important that the Society for American Archaeology acknowledged the need for public interpretation and outreach in two of their eight principles of archaeological ethics (Lynott and Wylie, 1995). However, we often assume that all people will view the importance of the past in the same manner as professional archaeologists, who are well-schooled in assessing the significance of archaeological sites and historic properties through the eyes of researchers. We can all share examples of the many times a member of a local community has confronted us with the questions, "Why are you doing this? Why is it important to me? Why should my tax dollars pay for it? What do I get out of it?" The research conducted by archaeologists does not always make sense to people who have a more personal connection to our study area, or who lack an obvious connection. The perceived "value" of traces of the past can be expected to vary depending on the views and agendas of the involved parties. It is incumbent on the front-line researchers to give coherent answers to these questions. For instance, descendent communities, associated ethnic communities, and members of historically intact neighborhoods may all value the past in different ways and for diverse reasons. Archaeological study is enriched when informed by these different views. However, archaeologists need to translate the data we acquire from sites into formats that have meaning to local communities. Access and participation in the process of discovery and interpretation create the opportunity for a rich dialogue about the past, and encourage passive constituents in a community to become shareholders, or part "owners" of the past to which they are linked.

The public's perception of the "value" they receive from archaeological research and historic preservation is directly dependent on how well

archaeologists communicate those benefits to the general public, and to the specific communities within which we live and work. The public's interest in this research has been demonstrated by the popularity of media presentations involving archaeology. A Harris Poll commissioned by the Society for American Archaeology in 2000 has also demonstrated this interest. This snapshot in time showed that 96% of those surveyed supported protecting important historic sites; 80% agreed with using public funds to accomplish this protection; and 60% believed in the value to society of archaeological research and education (http://www.saa.org/pubrel/publicEd-poll.html; Lynott and Wylie, 1995). Many archaeologists across the country have worked hard to earn this level of support, but times change, and support can erode overnight, as can the very legislation on which we depend for identifying and protecting sites of national and regional significance. It is incumbent upon archaeologists to continually renew their efforts to inform and engage the public.

Informing the public has become an enjoyable and rewarding task for those archaeologists who have mastered the art of interpreting our research in exciting ways for nonarchaeologists. Slide presentations, site tours, and exhibits are becoming more and more common means of sharing our results with the communities in which we work. However, engaging the public as partners in preservation is much more difficult. It is the difference between a monologue about the past (i.e., archaeologists telling a story based on their research), and an active dialogue (i.e., public participation in research and the interpretation of results). While both are perfectly acceptable means of reaching out and informing the community at large, it is the dialogue that makes archaeology truly accessible to the public, and actively engages people in the whole concept of preserving and protecting the past (Davis, 1997: 85). As Teresa Hoffman noted (1997: 73), access to the past fosters "appreciation of, respect for, and increased activism on behalf of our irreplaceable heritage." By providing the means for nonarchaeologists to play a more active role in accessing the past, we stand to learn a valuable lesson: the past is important to others for reasons well beyond the research we so fervently practice (K. Hoffman et al., 2002: 221). In addition, we also learn that the public is interested in our research and can contribute to our results.

13.3. Community Outreach at Binghamton University

PAF sponsors most of the community outreach and interpretation projects at Binghamton University (SUNY) related to archaeology. PAF is organized around three main missions: the training of archaeologists within a Cultural Resource Management (CRM) framework, the conduct of innovative research on the prehistory and history of the Northeastern USA, and the sharing of our results with the communities in which we work. As our name implies, we are serious about "public archaeology"—our staff has been

FIGURE 13.1. CAP *Time and Tradition* exhibit on the archaeological history of central New York State. (Photo: N.M. Versaggi.)

offering lectures and site tours since the late 1970s. Recently, we have added an eight-panel traveling exhibit, *Time and Tradition* (Figure 13.1), which chronicles the archaeological history of New York State. Much of our practice of community outreach has changed through the years as we realized the diversity of our audiences, how our goals may have differed from what our communities hoped to gain, and how our research could be incorporated into our community programs. We realized that three types of audiences attended our programs: people interested in a "live performance" by a local archaeologist purely for entertainment; those seeking to advance their knowledge about the past; and those who wanted to experience first-hand the process of discovering and interpreting the past. Our CAP gradually developed from these lessons learned.

13.4. The Community Archaeology Program

Archaeology is inherently interesting to a large cross-section of the population. As Smardz (1997: 103) argued, "It is the excitement and romance of archaeological discovery that makes people think archaeology is worth doing and learning about." Our programs are usually well-attended but we wondered if our slide lectures and site tours were just "teasing" our audiences about the excitement of uncovering the lives of people from hundreds and

thousands of years ago. When asked, "Can we join you?" our answers were, "Sorry, we do not have opportunities for untrained people to participate in our excavations." The cumulative effect of these negative responses soon made us realize that we were satisfying only a portion of the audiences who attended CAP presentations. We were failing to reach out to those who requested more direct ways to connect to the past through participation. This propelled us to rethink our approaches to community programs, and formulate a different way to involve a broader range of "the public" in our projects. Rather than viewing the public solely as a passive audience seeking entertainment and education, we shifted our focus to one where community members participated in the process of discovery, research, advocacy, and preservation. As with many inventive processes, happenstance played a major role in the formulation of CAP.

13.5. SPARK

At about the same time as our "enlightenment," we were asked to partner with a local school district, which was searching for innovative ways to challenge their district-wide elementary program called SPARK. The word is not an acronym; it denotes a mission to identify highly motivated students who could benefit from an enrichment program that supplemented the existing curriculum for all elementary students in the district. SPARK provides students with creative problem-solving lessons developed to compliment the classroom curriculum. In New York State, the Social Studies curriculum for the sixth grade includes study of the distant past as well as the more recent past. Archaeology fits well in this framework, and a field trip to the University archaeology labs offered the perfect opportunity for adding that extra "spark" to the classroom lesson plans. This opportunity also provided us with the spark that we needed to start implementing an outreach program that was more dynamic and engaging.

This partnership has become an annual collaboration, and we are approaching our fifteenth anniversary. The SPARK program includes several components, some of which are passive entertainment (e.g., a slide presentation showing archaeologists at work, making discoveries, and interpretations with people illustrations). An educational component sends the classes to labs where faunal assemblages are presented as avenues for understanding diet, seasonality, and land use. Another lab venue shows archaeologists washing and cataloging artifacts, floating and sorting the organic remains from soil samples, and drafting maps. A more hands-on, engaging component involves a "guess the mystery artifact" task that challenges students to classify and interpret unusual artifacts from the prehistoric and historic past. Prior to each of these visits, CAP instructors collaborate with teachers on what elements to highlight in our program that would best enhance the concepts taught in the classroom. The program was so successful that we were

asked to participate in a statewide Imagination Celebration that centered on archaeology as an avenue for enriched learning. Our most significant innovation, however, was when we were asked by excited students, "How can we do more of this?" we were able to answer, "We have a summer program that will allow you to participate in archaeology in the field and lab." Thus was born our summer CAP program, which started with a children's (ages 9–13) section, expanded to include a teacher's session, and is currently enrolling children, teachers, and the general public.

CAP for Kids incorporated many of the elements used in the SPARK visits, but expanded and diversified them. The summer program involves a session of four half-days. We knew from our collaboration with teachers, that the attention span for this age group would sharply drop while the potential for boredom would rise if full-day sessions were used. The exception was day four, which focused on a field trip to a site of historical interest and to an active archaeological site. When the participants are on-site, there is one professional archaeologist assigned to every three to four students. Each group of students mans a soil screening station, monitored by a professional archaeologist and/or recent graduate of Binghamton University's undergraduate field school. In fact, the CAP Kids field trip visits the archaeological site that serves as the field laboratory for our field school each year (Figure 13.2).

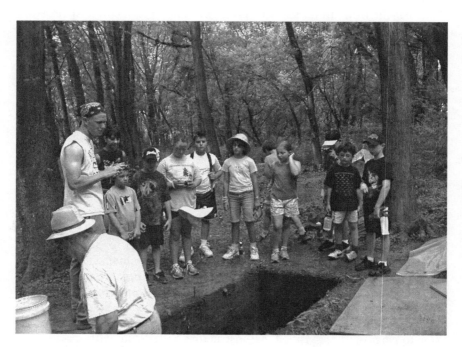

FIGURE 13.2. Children from CAP receive an introduction to the Castle Gardens site before joining screening stations. (Photo: D. Tuttle.)

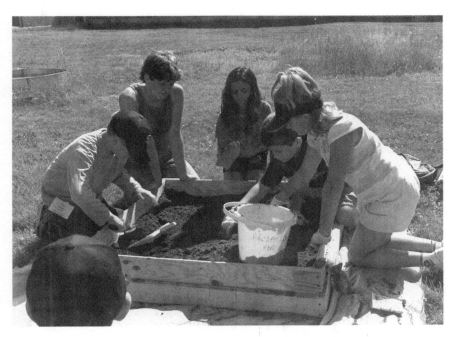

FIGURE 13.3. Children participate in a "mock" excavation on the Binghamton University campus. (Photo: D. Tuttle.)

This provides research continuity as well as an opportunity to train graduate and undergraduate students in an aspect of community outreach. The other three days of the CAP program occur on campus, with each day focusing on a learning theme. For instance, one day centers on the concept of discovery. Instructors create a mock excavation of an archaeological site within wooden frames placed in an outside courtyard on campus (Figures 13.3 and 13.4). Artifacts from the PAF teaching collection, as well as constructed "features," and a sprinkling of modern faunal and botanical remains wait for discovery within the soil matrix. Another day revolves around the theme of analysis. Students take the maps of their discoveries, the artifacts found, and the features uncovered and learn how archaeologists conduct the process of pulling information from those components. Measurement, classification, and interpretation are parts of this process. Students also learn to do their own flotation of soil samples taken from "features" found within the mock excavation. The theme of interpretation involves linking all the results of the analysis and visualizing a picture of what the mock excavation represents. This task is facilitated by a visit to the computer lab, where several interactive web sites allow the students to see how others interpret the past. When the class arrives at the "real" excavation on their final day, they possess many of the discovery, classification, and interpretation skills needed to enthusiastically, but

FIGURE 13.4. Children screen dirt from the mock excavation on the Binghamton University campus. (Photo: D. Tuttle.)

respectfully, participate in the process of discovery. For the on-campus half-day classes, three instructors/supervisors are assigned to each group of 20 students (each class is capped at 20). A workbook, authored by the CAP instructors, is used to provide students with reinforcement of the concepts taught. At the beginning of the next school year, teachers tell us that many of our student participants bring the lessons learned into the classroom, which provides an additional means of reinforcing the standard social studies curriculum. Often, we set up our mobile exhibit at participating schools as a follow-up that provides a visually appealing medium for discussing social science concepts and reinforcing lessons learned over the summer.

CAP for teachers and the general public built on the successful children's program and a volunteer weekend conducted at a threatened prehistoric site in the Chemung Valley of New York. In 1994, PAF sponsored the community volunteer weekend to help archaeologists finish the last phase of excavation at a site that would be mined imminently for topsoil. The Thomas/Luckey site served as the BU undergraduate field school site for 5 years

(Knapp, 1996; Miroff, 1997, 2002). The goal was to execute a state-approved data recovery plan that would "clear" one section of the site each year for mining in the following months. What started as an artifact-poor Late Woodland occupation soon became a feature-rich village site with longhouses, storage and pits, and hearths. The six-week field school and PAF labor were insufficient for the final push to complete the first season's investigations. The volunteer weekend invited interested members of the University community to assist with the final excavations. We were overwhelmed with the response from potential volunteers and the enthusiasm expressed for the research we were conducting on this significant site. We were also richly rewarded when many volunteers stated that they were unaware of these hidden sites and the exciting information they contained on their region's cultural heritage. Several participants expressed an interest in helping to advocate for preservation at other important sites, and asked for more opportunities to participate.

The next summer, we instituted a summer CAP program for teachers and the general public. The adult CAP program provided participants with one day of lectures and demonstrations in preparation for three days in the field. Again, the field investigations occurred at the same site that served as our undergraduate field school. The reason for this was both operational and philosophical. The program needed a closely supervised field opportunity (one professional archaeologist monitors each excavation unit) that was linked to either a threatened site or an ongoing research project. The field school site answered both of these needs. Participants learned about our research design, and saw the analysis and professional reports generated by each field season. This lesson demonstrated the ethical principle that archaeology is not just about digging up artifacts, but is an important component of the preservation process. Excavation preserves data for current and future analysis when sites are threatened, and shares that data with peer audiences and the public through professionally written documents. Second, CAP is based on the premise that the public has more than a casual interest in the research conducted by archaeologists. While some people are satisfied with slides of artifacts and archaeologists at work, many are eager to learn more about the process of archaeology: guiding principles and theories, methods, and ways to interpret data. In many communities, nonarchaeologists are more than passive constituents; they are active stakeholders in local preservation issues. CAP, in turn, offers more than the transfer of information from archaeologist to nonarchaeologist. Instead, the program provides a way for constituents to become stakeholders, and for stakeholders to experience the hands-on process of archaeology in their communities. Many stakeholders accumulate the tools needed to become advocates, either for archaeology or other causes important to them that can also be served by preservation. By building "sweat equity" in a local site of importance, individuals become stakeholders and individual partners in advocacy for the many issues of significance to local communities. Some of these issues could include the remembrance of lost communities, the development of heritage tourism,

the building of pride in a local community, and the acknowledgement of Native American traditional territories.

Developing partners for preservation is a process that does not happen overnight and may not come to fruition on every project. For us, there have been two notable situations where the CAP program has resulted in significant preservation results. The first was for a Cultural Resource Management project that served as an additional field visit for the CAP program. During the final phase of data recovery (just prior to the start of construction), CAP visited the Broome Tech site in the Town of Dickinson in Broome County, New York. This multicomponent site was yielding layers of artifacts and features that had the potential to completely revise the prehistoric sequence in the region. Some of the CAP participants lobbied local officials for preservation of a piece of the site as "green space." When the developers saw the public interest in preservation, they worked with local officials to revise a parking ordinance to allow a smaller parking space width at the proposed mall. This change decreased the acreage needed for parking and freed up a sensitive area of the site so that it could be designated as part of the required green space for the parcel.

The second example of CAP's influence on public interest and preservation occurred at the Castle Gardens site, (Figure 13.5) another multicomponent occupation within the Town of Vestal, Broome County, New York. A unique Late Archaic projectile point, Vestal Corner-Notched, was first identified at Castle Gardens in the 1960s and this artifact carries the name of the town in which it was first recorded (Ritchie, 1961: 130; Funk, 1998: 557–578). This site is tucked away on a small piece of floodplain amidst numerous strip malls along a busy local highway. Castle Gardens is the name assigned to the adjacent housing development constructed in the 1940s and 1950s. The site has served as our undergraduate field school and CAP field project for the past two years. After one year, PAF staff presented a New York State archaeology month presentation on our excavations. Similar presentations usually have about 30–50 local attendees; an overflow crowd of almost 100 people attended the Castle Gardens program. Among those in the audience were original homeowners in the housing development, and other town residents. Many of these people are weary of the constant rate of commercial development, which has steadily compromised neighborhood after neighborhood. Also in attendance were town officials and members of the local historical society. Based on comments after the presentation, we would like to believe that this project has provided local residents with a renewed pride in their town and neighborhood. There was an enthusiasm for locating and protecting similar sites in the town. Some residents expressed an interest in exploring ways to create a town ordinance that would assist with identifying and preserving other sites and structures of historical interest in this locality. While this ordinance has not come to fruition yet, sensitivity to preservation issues has been elevated to a much higher level in this municipality. Community members were thrilled when *Archaeology Magazine,* a publication of the

FIGURE 13.5. Adult CAP participants screen soil with their supervising archaeologist. (Photo: N.M. Versaggi.)

Archaeological Conservancy, included an article on Castle Gardens (Dickinson, 2005), and when the site was featured on New York State's Archaeology Season poster ("Education and Archaeology in New York State"). We have completed our final research season at the Castle Gardens site, and we will present additional community programs after completion of analysis and professional and popular reports. There is high optimism that positive trends will continue.

13.6. Conclusions

It is the ethical responsibility of archaeologists to conduct all treatment and management of archaeological sites in a spirit of stewardship, recognizing the potential for the multiple public values that can be associated with these sites. In addition, archaeologists have a responsibility to interpret their research in such a way that it is understandable and accessible to the public. I would argue that it is also the responsibility of the "stewards of the past" to engage the public in the process of discovery, evaluation, and preservation. This engagement creates an informed public, and transforms general constituents into stakeholders armed with information that allows them to evaluate what is significant to them and their communities.

Our experiences interacting with various cross-sections of communities have taught us valuable lessons over the years. One is to continually

acknowledge that the value assigned to archaeology by archaeologists is often very different from that of the constituents and shareholders connected to our local communities. The second is that our programs need to be layered in such a way to provide entertainment for those who form a "passive" audience, education for those seeking to understand more about the past, and active participation for those who want to be more engaged partners in the whole process of archaeology and preservation.

There are also basic operational lessons. For instance, funding is always an issue. Several attempts to secure community and national grants for CAP were not successful. Instead, we rely on a modest "tuition" charged to each participant, along with the willingness of CAP instructors to volunteer some of their time. PAF supplements the tuition charged so that CAP instructors are paid not only for the contact time with participants, but for part of the preparation time. In addition, PAF archaeologists assume the responsibility of closing the site for the season after CAP ends. Community outreach projects that involve children and hands-on participation (both for adults and children) require intensive supervision. For instance, when our adult program is in the field, there is one supervising archaeologist (Figure 13.5) per excavation unit; two to three CAP participants are assigned to each unit. For the children's program, we designate one instructor and one assistant for every ten students enrolled. Additional assistant instructors are added for the next ten enrollees. Since the children's program involves more on-campus activities and less field time than the adult program, fewer supervisors are needed. The CAP Kids field visit to the archaeological site overlaps with our adult CAP program, so there is abundant supervision for this sensitive part of the program. Programs that involve this level of professional supervision are expensive, and we would not be able to continue operation with a fully paid staff. CAP began as an all-volunteer effort, and we continue to rely on some degree of time donation as part of the program.

However, we hope that this donation of time has its own benefits. For us, it is truly a pleasure working with enthusiastic children and with our adult members who offer so much back to us. Each graduate of the adult CAP program (13 years and older) is welcomed back the following year (free of charge) to participate in our next project. They, in turn, serve as mentors to our new batch of "students." Some of our CAP graduates have gone on to become regular volunteers with PAF, while others have decided to pursue archaeology majors in college. We also have amassed a corps of potential volunteers that now numbers about 20 individuals. Recently, CAP volunteers assisted professional archaeologists with a major urban excavation in Binghamton that uncovered more historic and prehistoric features than anticipated. These volunteers have obtained sufficient field experience to allow them to work alongside our professional staff with minimal supervision. Three of our CAP graduates have completed undergraduate degrees in Anthropology and now work at PAF. As we organize future research projects

outside of our CRM contracts, we know that we have the potential to staff such projects with dedicated avocational archaeologists in the making.

CAP has also provided our undergraduate and graduate student assistants with valuable experience in community outreach, an aspect of the discipline of archaeology that is rarely taught in formal classroom settings. At Binghamton University, we have seen a notable increase in applicants to our graduate program in archaeology who express an interest in community outreach. Some of our graduate classes are incorporating components and assignments that address this emerging interest within the discipline.

We have assumed the philosophical stance that it is incumbent on archaeologists not only to share archaeological results with individual communities, but also to forge partnerships with individuals and groups with a passion for the past through community-based outreach programs. The basic premise is that the past is not "owned" by a few, but should be made accessible to many. Accessibility provides communities with the tools to interpret the past in ways that are meaningful to the communities in which they reside and represent. As Heath (1997: 65) explains, archaeology offers local communities an exciting and unique way to "capture their pasts." The best way to make the past accessible is through projects that involve communities and individuals in archaeological research. In this way, we will continue to forge partnerships in preservation.

Acknowledgements. I would like to thank Sherene Baugher and John Jameson for inviting me to participate in this volume. Timothy Knapp, Laurie Miroff, and Mary Price were the co-founders of our CAP program. Without their dedication to the project, CAP would not exist. Later, Lynda Carroll, Justin Miller, and many graduate students staffed our presentations and summer classes. They all contributed to the growth and success of CAP. The teachers of the Union-Endicott School District's SPARK program provided important input for the CAP Kids project. Finally, many thanks to the scores of CAP graduates who return each year to help with our research projects. They demonstrate the success of the programs.

References

Davis, K., 1997, Sites without Sights: Interpreting Closed Excavations. In *Presenting Archaeology to the Public,* edited by J.H. Jameson Jr., pp. 84–98. AltaMira Press, Walnut Creek.

Dickinson, R., 2005, Confronting a Conundrum: Can Technological Advances Help Archaeologists Solve a 40-year Old Mystery? *American Archaeology* 9(3):31–35.

Funk, R.E., 1998, *Archaeological Investigations in the Upper Susquehanna Valley of New York State,* vol. 2. Persimmon Press Monographs in Archaeology, Buffalo, NY.

Heath, M.A., 1997, Successfully Integrating the Public into Research: Crow Canyon Archaeological Center. In *Presenting Archaeology to the Public*, edited by J.H. Jameson, Jr., pp. 65–72. AltaMira Press, Walnut Creek, CA.

Hoffman, K.S., Ballo, G.R. and Austin, R.J., 2002, The Past in Service to the Present: Some Concluding Thoughts. In *Thinking About Significance*, edited by R.J. Austin, K.S. Hoffman and G.R. Ballo, pp. 215–222. Papers and proceedings of the Florida Archaeological Council, Inc. Special Publication Series No. 1. Riverview, Florida.

Hoffman, T., 1997, The Role of Public Participation: Arizona's Public Archaeology Program. In *Presenting Archaeology to the Public*, edited by J.H. Jameson. Jr., pp. 73–83. AltaMira Press, Walnut Creek.

Jameson, J.H., Jr., 1997, *Presenting Archaeology to the Public*. AltaMira Press, Walnut Creek, CA.

Knapp, T.D., 1996, *Stage 3 Data Recovery Thomas/Luckey Site (SUBi-888), Town of Ashland, Chemung County, New York*. Submitted to New York State Office of Parks, Recreation, and Historic Preservation. Public Archaeology Facility, Binghamton University, Binghamton, NY.

Lynott, M.J. and Wylie, A., editors, 1995, Stewardship: the Central Principle of Archaeological Ethics. In *Ethics in American Archaeology, Challenges for the 1990s*, pp. 28–32. Special Report, Society for American Archaeology. Allen Press, Lawrence, KS.

Miroff, L.E., 1997, *Thomas/Luckey Site (SUBi-888), 1996 SUNY-Binghamton Field School Report, Town of Ashland, Chemung County, New York*. Submitted to New York State Office of Parks, Recreation, and Historic Preservation. Public Archaeology Facility, State University of New York, Binghamton.

Miroff, L.E., 2002, *Building a Village One Household at a Time: Patterning at the Thomas/Luckey Site, New York*. Unpublished doctoral dissertation, Anthropology Department, Binghamton University, University Microfilms, Ann Arbor, MI.

Price, M., Knapp, T.D., Miroff, L.E., Rafferty, S. and Versaggi, N.M., 2000, Creating Steward's of the Past: Binghamton University's Community Archaeology Program. Paper presented at the 65th Annual Meeting of the Society for American Archaeology, Philadelphia, PA.

Ritchie, W.A., 1961, *A Typology and Nomenclature of New York Projectile Points*. New York State Museum and Science Service Bulletin, No. 384. Albany, NY.

Smardz, K.E., 1997, The Past Through Tomorrow: Interpreting Toronto's Heritage to a Multicultural Public. In *Presenting Archaeology to the Public*, edited by J.H. Jameson, Jr., pp. 101–113. AltaMira Press, Walnut Creek, CA.

14
Archaeology to the Lay Public in Brazil: Three Experiences

Pedro Paulo A. Funari, Nanci Vieira de Oliveira,
and Elizabete Tamanini

14.1. Introduction

In Latin America, there is a lack of dialogue and cooperation between archaeologists and the lay public (cf. Gnecco, 1995), though there is a growing body of evidence that this is changing, with an increasing number of archaeologists ready to engage in active community action (cf. Noelli, 1994, 1995, 1996a,b,c; Funari, 2001). For several decades, archaeologists have not been concerned with a wider audience and often a technical jargon has made it difficult for nonarchaeologists to be able to understand archaeological publications. However, several archaeologists now regard public archaeology, particularly addressing the lay public, as an essential part of their social responsibility (Mazel and Stewart, 1987: 169). Furthermore, archaeology can play a meaningful role in showing diversity, showing poverty in the past, celebrating ordinary architecture, walls that are dirty rather than clean. This way, ordinary people can recognize themselves in the archaeological discourse, using thus the past to create alternative texts for the present (Hall, 1994: 182). Public archaeology is understood in this chapter as all the public aspects of archaeology, including such topics as archaeological policies, education, politics, religion, ethnicity and archaeology, public involvement in archaeology (Ascherson, 1999). The contextual epistemological approach, since the 1980s, has opened the way for a growing interest in archaeological theory and practice for the interaction with ordinary people and communities (Funari et al., 2005). There are a variety of lay public audiences and this paper attempts to address this diversity by presenting three different experiences from Brazil (for an overview of the subject, cf. Funari, 2004).

Brazil is a vast country, as big as the lower contiguous continental US and so we have chosen three different areas and a variety of lay audiences. We deal with an ethnic/political movement and the media in the case of a seventeenth-century runaway slave settlement, with squatters and school children physically close to prehistoric shell middens and with the relatives of missing people excavated by the archaeologist in clandestine cemeteries.

Though each case study is unique, there are common threads that serve to aid archaeologists in dealing with lay audiences.

14.2. The Audiences Interested in the Archaeology of Runaway Settlers, or Maroons

In the beginning of the seventeenth century a large runaway polity was established in the backlands of northeastern Brazil, enduring over the whole of the seventeenth century (Figures 14.1 and 14.2). It became known as Palmares, or the land of the Palm trees, in Portuguese (Orser, 1996, with earlier references in English). The inhabitants themselves referred to the polity as "Angola Janga" (Little Angola). This enduring freedom experience lasted until 1694, when slave-hunters destroyed the maroon (Funari, 1999a, with earlier references in English). Archaeological field research conducted in 1992 and 1993 by a joint American and Brazilian team identified the largest settlement, the capital of the polity, where 14 sites were located (Funari, 1991; Orser, 1992, 1993). Black movement activists had used this settlement since the 1970s, when they proposed the 20th of November, the day the last leader of the maroon, Zumbi, was killed, as a Black awareness day (Funari, 1996a). The top of the hill where the settlers had chosen to construct their capital, produced a lot of surface material, enabling the Black Movement to identify it as a powerful symbol of Black fight against oppression. Although the site, known as Serra da Barriga (or Potbelly hill), was a powerful symbol

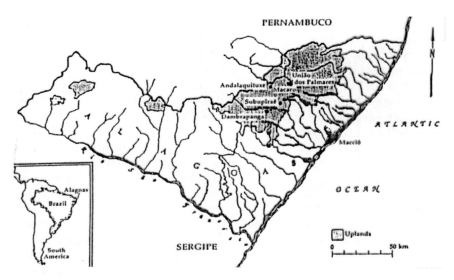

FIGURE 14.1. Map of Palmares in the state of Alagoas, Brazil. (After Funari, 1999a: 312.)

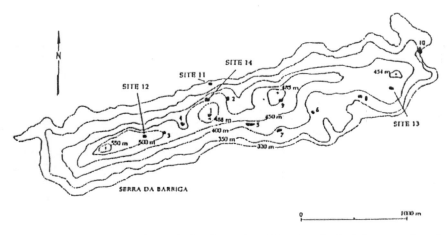

FIGURE 14.2. Map of the Serra da Barriga, where 14 archaeological sites were found. (After Funari, 1999b: 318.)

before recognizing the value of the material record, the material evidence produced a much wider discussion of the site and its importance (Figure 14.2). However, local authorities and Black activists, unaware of the possible damage to the archaeological evidence, sponsored festivals on the top of the hill (Funari, 1996b). To facilitate access to the hill and to accommodate visitors they permitted a small road to be built as well as a leveling of the ground, destroying important archaeological evidence (Orser and Funari, 1992). Prior to the 1990s, no previous archaeological fieldwork was carried out and there was thus a lack of concern on the part of the archaeological establishment (Funari 1995a, 1997).

The archaeological research took place in close contact with both the local community and the Black movement (Funari, 1994). The results were impressive, as several books and papers were published for a professional audience (cf. list in Funari, 1996c) and the repercussions in the press and media in general were quite large. The archaeological work was used on the cover of publications like "Super-Interessante," a popular news magazine to youngsters, twice, in 1993 and 1995 (Ladeira and Affini, 1993). To quote the news magazine heading (Arnt and Bonalume, 1995: 30): "The voice of runaway slaves springs from the earth." The main newspapers, like *Folha de São Paulo* and *O Estado de São Paulo* reported on the excavations and even such magazines as "Família Cristã" (Christian Family, a Catholic monthly) published on the archaeological work (e.g., Bonalume, 1995; Cipola, 1995; Fagan, 1993; Keys, 1993; Felinto, 1994; Mayrink, 1995; Pereira, 1992; Piglione, 1995). The result of all this publicity was that for the first time school textbooks introduced references to the maroon and to the archaeological evidence from the polity. For the first time, school textbooks referred to a historical archaeological site and it

was also the first time slave resistance has been emphasized. Scott Allen continued fieldwork in 1996–1997, including students from the local University (UFAL), and mounted several exhibitions in União dos Palmares, where the site is located, and Maceió, the capital of the state of Alagoas. Allen has also given numerous on-site talks to busloads of school children and the occasional tourist (Allen, 1999, personal communication).

The evidence from the runaway sites has shown that the pottery used by the maroon people was of European, native Brazilian and mixed styles (Orser, 1994, 1996; Funari, 1995b, 1998; Allen, 1999, personal communication). The news that the runaway polity had such a variety of pottery wares caused mixed reactions in different lay audiences. Within the Black movement there were two opposing views. For some activists, the maroon is a symbol of African resistance to white oppression and they considered that the presence of Native and European wares could put the Africanness of the polity into question. Others argued that the runaway settlement was a safe haven not only for Africans enslaved on the plantations but also for Indians enslaved by the same masters and indeed also for all those persecuted by the authorities. This includes the Muslims, the Jews, women accused of being witches and other excluded people. Furthermore, the polity should also have interacted with natives in the west and with settlers in the coast, in order to survive, and thus the evidence of mixed features and cultural interaction was thus interpreted as only too natural (Funari and Carvalho, 2005).

If within the Black movement there was some controversy, the media was excited by the archaeological work and dealt with the data in a mixed way. Most articles emphasized that the polity was a safe haven and also suggested that it could even serve as a model for a nonexploitative society in the past, enabling people of different backgrounds to live together in peace (e.g., Arnt and Bonalume, 1995). Conversely, others considered the evidence as an indication that the maroon was not really African and suggested that they were reproducing the exploitation of the colonial society within their settlement (e.g., Moon, 1991). Clearly the archaeological work has been interpreted differently not so much because of the evidence but because different interpretive models were being used. Those preferring to see the maroon as an African homogeneous entity tended to reject the data while those accepting them were prone to look for a heterogeneous and open society fighting against oppression (an in-depth report of these issues is presently being prepared by Scott Allen). For the archaeologists it was important to give voice to different interpretations, especially by those activists who fight discrimination today. The experience has shown that:

1. To work with social activists is possible and does not mean that there must be a consensus, for there are multiple ways of interpreting the past and putting it into use in the present; and
2. The use of the archaeological "news" by the media is also dictated by their own concerns and the archaeologists have little control over it.

Another lay public reached by this archaeological project is school children, the readers of school textbooks. History textbooks used by children in the primary and secondary schools rarely refer to any kind of archaeological evidence. When they do so they deal with prehistoric sites and with foreign, mostly ancient Great Civilizations of the past. The archaeological evidence from Palmares and the resulting attention by the media led to the introduction of issues relating to the new material. Traditionally, the subject had either been ignored or shown as evidence of an ill-fated Negro rebellion, which ought to be curbed. In the words of a leading historian, Evaldo Cabral de Melo (in Leite, 1996; details in Funari, 1996c): "The destruction of Palmares was necessary, because it was a Black state." Archaeological data and the ensuing discussion about the character of the polity reached ordinary school children and challenged the prevailing racist views on the maroon.

14.3. Lay Public: The Community and Archaeologists

Communities are not homogeneous. Recent anthropological discussion of community life stresses the varied and fluid character of any community (Funari, 2003). In Brazil, as in other developing countries, social imbalances are huge and poor communities, particularly in big cities, are caught in the midst of a struggle between drug dealers and the police. It is not uncommon to find policemen in the shadowy world in-between the law and crime. In this context, archaeologists are also in a complex situation, aiming at working with local communities, but also aware of the inner contradictions permeating them. The next two cases refer to the contradictions facing archaeologists working with two different publics. Let us start with the case of poor communities.

An experience from the south of the country serves as an example of an innovative approach. In Joinville, an industrial city, there are several shell middens and there is also a unique Shell Midden Museum. Some of these human-made middens are now in areas occupied by squatters. Poor people inhabit the slums around shell middens and there has been an active program by museum staff to work *with* this community in order that people have the opportunity to learn about the shell middens. Especially children, when introduced to these archaeological sites, soon develop an affectionate relationship with them and this educational approach produces interaction with adults (Figures 14.3 and 14.4). Town council Bills protecting shell middens are only effective when the people themselves are actively involved in protecting the sites (Figure 14.4). This grass-roots approach produces immediate results and it is even possible to argue that the authorities, another important lay public, are themselves more sensitive to archaeological action and heritage protection precisely because of people's concern with *their* archaeological assets (Tamanini, 1994, 1999).

FIGURE 14.3. School children at Rio Comprido sambaqui, Joinville, Brazil. The houses of city inhabitants are very close to the archaeological site and the children come from quarter schools.

FIGURE 14.4. School children at Joinville walking to Rio Comprido sambaqui for a learning activity.

At Vila Paranaense (Bairro Boa Vista, Joinville), a shell midden known as Espinheiros Dois, is surrounded by a large community and in 1991 the Museum staff began a public archaeology program, aiming at putting together scholars, museum officials, local activists and ordinary people in general. This experience was expanded to another shell midden, Rio Comprido in 1993 (Figure 14.5). In both places, the squatters live in areas with poor sanitation and lack of facilities, so that the environmental damages are widespread. The strategy used to develop a public archaeology partnership with community was to try and find out the different interests of the community in relation to the archaeological remains. It became clear that the shell midden was imbedded in a net of social activities, such as festivals and its use as a dump. The way to interact with the community was to take part in activities sponsored by schools, church and community institutions. A proposed curriculum that embraced the reality of children's lives (Collicott, 1990: 109) and participatory decision-making mechanisms brought together community and school leaders and archaeologists (La Belle 1986: 212). "School, community and cultural heritage: the experience of environmental education," this was the learning motto adopted by the school, community and archaeologists working together. Public archaeology implied training teachers, preparing didactic material, school festivals, debates and other activities. This critical pedagogy, concerned with student and community experience, takes the problems and needs of the people themselves as its starting point (Giroux and McLaren, 1986: 234).

FIGURE 14.5. Children take notes and then discuss archaeological heritage with mates, friends and at home.

The main challenge was to empower the community, taking into account the variety of interests and even its inner contradictions. There were people with different ethnic backgrounds, different religion denominations, and different political affiliations, all of this permeated by the always-present police/outlaws tensions. The first move was to recognize diversity and to enable different people to interpret shell middens their own way and to set up activities on their own terms. Different social actors thus appropriated the middens, interpreted as public parks, some taking them as important Indian heritage, others as proof of the universal deluge, others still as a nuisance. The majority though changed their minds in the process of inter-action with archaeology and thinks anew the shell middens. The results were impressive, as the community perceived shell middens as part of their own heritage, not as a dump for garbage, as previously (Tamanini and Oliveira, 1997).

14.4. Archaeologists and Lay Public Feelings

During the military dictatorship between 1964 and 1985, many missing people were executed and buried in mass graves in different places of the country. There are as yet very few initiatives to recover the remains of those who were buried in those graves and this is so for various reasons, not least the feeling that oblivion is better that remembrance. However, for the rela-tives of victims, what they demand is precisely the identification of people, in order to enable them to at least properly bury their dear relatives.

In Rio de Janeiro there has been an archaeologist (Nanci Vieira Oliveira) involved with the excavation and identification of people buried in one such mass grave. In 1991, the human rights group "Never Again Torture" and the Doctors Association in Rio de Janeiro, with the support from the Argentinean Forensic Anthropology Team, was interested in identifying 14 corpses of missing people. Nanci Oliveira took charge of search for their remains and was able to find a mass grave with some 3000 bodies at the Ricardo de Albuquerque Cemetery. This mass grave was some 25-m long and 1.5 m large and the bodies were dismembered, so that the bones were mixed up. The wet soil contributed to the further deterioration of the bones, mak-ing it difficult to identify individuals through skull features. The working conditions were also particularly difficult, as the archaeologist had to bring the bones to the police before being allowed to bring the material to be stud-ied in the laboratory. Furthermore, the archaeological lab was in the Rio de Janeiro State University, where Oliveira worked but the human rights activists and the family of the victims asked the study to be carried out else-where, as the main suspect of signing false death medical documents was a leading Faculty of Medicine lecturer at that University. For the relatives, this very special lay public, it was not enough to recognize the expertise of the archaeologist in charge of the work, for there was a strong sentiment that "the identification should not take place in the same university where the

suspected doctor worked," as if this could in any way alter the result of the study. These fears are for the cold archaeologist simply irrational, but how could one not understand the feelings of these relatives? Irrespective of those concerns though, for legal reasons, the analysis went on in the university laboratory and the access of relatives, even though allowed, was not enough to alay their concerns about the archaeological study.

There were two properly forensic aspects of the archaeological work that interested this very specific lay public: the identification of individuals and the establishment of the way each individual was killed. The identification of individuals can be more or less a technical task, although even here it was often necessary to work with the relatives to sort out the details possibly identifying an individual. Much more chilling though was to establish the details of the murder, *when the archaeologist is working with living relatives.* We archaeologists are used to excavating cemeteries and even sometimes-mass graves from a distant reality. It is an odd experience to interact with suffering people. How to deal with the details of shot perforations, when the interlocutor is the widow of a victim? How to try to reconstruct dismembered bodies with the help, for the identification of bones, of the children of a victim? These bones embody the very contradictions of a dark period of the recent past and stir thus strong emotions, even today, or, as put J. Hermann (1981: 27), "archaeological monuments embody the contractions of their historical contexts." In the end, the conditions of preservation of the bones did not allow the identification of the missing people. Of course, the fears of the relatives were proven right, as not a single identification was possible. Even if the evidence was insufficient and defective, as it indeed was, the whole political context, and the subjective feelings of relatives, contributed to their uncomfort with the results. The archeologists were put in an impossible situation: the evidence was not conclusive, but they acknowledged the obvious frustrations and doubts of sore relatives.

14.5. Conclusions

The three examples in this paper point to the variety of situations confronting the archaeologist dealing with the lay public. There are in reality several different lay audiences, each with its own features. We could distinguish at least six audiences dealt with in the three case studies:

1. Activists;
2. Media;
3. School textbook readers;
4. Ordinary people in the community;
5. Community school children;
6. Relatives of victims.

However, each of these can also be split, according to their different interests and outlooks. Activists, in this case Black activists fighting racism and discrimination,

are divided between those who prefer to stress integration and those who stress difference. The media is even more split, as archaeology is in general considered interesting in so far as it stirs the attention of the public. Selling a piece is more important than the truthfulness of the information and sometimes the media deals with archaeology as mere entertainment. The archaeologist is also pushed into difficult ethical choices, for the archaeologist must publicize his or her work but in doing so he or she risks being misunderstood and misreported. Even more than that, there is a temptation to produce spectacular evidence and/or interpretation just to satisfy the media interest (Funari, 1999b). To work with the community is probably the most important commitment by the archaeologist but again it can include a wide variety of conflicting interests. Poor squatters do not share the same values of the middle classes, may be less prone to consider the long-term benefits of the scientific endeavor and may even, in some cases, be controlled by drug dealers. Equally difficult challenges face the well-intentioned archaeologist dealing at the same time with the relatives of victims and with the perpetrators of those crimes. All these lay audiences, in their wide range of interests and mixed features, constitute a challenge to Brazilian archaeologists. It is easier to ignore the lay public and stay inside our labs or research units but this is an illusory move, for in the end it is the lay public, an informed and critical one for that matter that is the ultimate reason for our archaeological work.

Acknowledgments. We would like to thank John Jameson and Pierre Desrosiers for inviting us to take part in the session on "Giving the Public its Due: New Horizons in the Public Interpretation of Archaeology" at the SHA Meeting in Québec, in January 2000. We are also grateful to the following colleagues who helped us in different ways: Scott Allen, Cristóbal Gnecco, Martin Hall, John Jameson, Francisco Silva Noelli, Mário Sérgio Celski de Oliveira, Charles E. Orser, Jr. The ideas expressed here are our own, for which we alone are therefore responsible. We must mention also the institutional support from the Brazilian National Research Council (CNPq), the São Paulo State Science Foundation (FAPESP), CAPES and the Núcleo de Estudos Estratégicos (NEE/UNICAMP).

References

Arnt, R. and Bonalume, R. 1995, A Cara de Zumbi. *Superinteressante*, Novembro, 30–42. São Paulo, Brazil.
Ascherson, N., 1999, Call for Papers. *Public Archaeology*. Journal published by James & James and the Institute of Archaeology, London, UK.
Bonalume, N. and Ricardo, 1995, O Pequeno Brasil de Palmares (The Little Brazil that was Palmares). *Folha de São Paulo*, 4 July, 5:16.
Cipola, A., 1995, Máquina Destrói Vestígios De Quilombo. *Folha de São Paulo*, 11 November, 3–3. São Paulo, Brazil.
Collicott, S.L., 1990, What History Should We Teach in Primary Schools? *History Workshop* 29:107–110.

Fagan, B., 1993, Brian Fagan, Brazil's Little Angola. *Archaeology*, July/August, 46:14–19.
Felinto, M., 1994, Palmares. Folha de São Paulo, Mais!. 12 November: 3. São Paulo, Brazil.
Funari, P.P.A., 1991, A arqueologia e a Cultura Africana nas Américas. *Estudos Ibero-Americanos* 17(2):61–71.
Funari, P.P.A., 1994, La cultura material y la arqueología en el estudio de la cultura africana en las Américas. *América Negra* 8:33–47.
Funari, P.P.A., 1995a, Mixed Features of Archaeological Theory in Brazil. In *Theory in Archaeology, a World Perspective*, edited by P.J. Ucko, pp. 236–250. Routledge, London, UK.
Funari, P.P.A., 1995b, The Archaeology of Palmares and its Contribution to the Understanding of the History of African-American Culture. *Historical Archaeology in Latin America* 7:1–41.
Funari, P.P.A., 1996a, República de Palmares" e a Arqueologia da Serra da Barriga. *Revista USP* 28:6–13.
Funari, P.P.A., 1996b, Archaeological Theory in Brazil: Ethnicity and Politics at Stake. *Historical Archaeology in Latin America* 12:1–13.
Funari, P.P.A., 1996c, Novas perspectivas abertas pela Arqueologia na Serra da Barriga. In *Negras Imagens* edited by Lilia Moritz Schwarcz and Letícia Vidor de Sousa Reis, pp. 139–151; 228–230. Edusp/Estação Ciência, São Paulo, Brazil.
Funari, P.P.A., 1997, Archaeology, History, and Historical Archaeology in South América. International Journal of Historical Archaeology 1(3):189–206.
Funari, P.P.A., 1998, A Arqueologia de Palmares. Sua contribuição para o conhecimento da História da cultura afro-americana. *Studia Africana, Barcelona* 9:175–188.
Funari, P.P.A., 1999a, Maroon, Race and Gender: Palmares Material Culture and Social Relations in a Runaway Settlement. In *Historical Archaeology: Back from the Edge*, edited by P.P.A. Funari, M. Hall and S. Jones , pp. 308–327. Routledge, London.
Funari, P.P.A.,1999b, Brazilian Archaeology, A Reappraisal. In *Archaeology in Latin America*, edited by G. Politis and B. Alberti, pp. 17–37. Routledge, London, UK.
Funari, P.P.A., 2001, Public Archaeology from a Latin American Perspective. *Public Archaeology* 1:239–243.
Funari, P.P.A., 2003, Conflict and Interpretation of Palmares, a Brazilian Runaway Polity. *Historical Archaeology* 37(3):81–92.
Funari, P.P.A., 2004, Public Archaeology in Brazil, In: *Public Archaeology*, edited by N. Merriman. Routledge, London and New York, 2002-210, ISBN 0 415 25888 x (hbk) 0 415 25889 8 (pbk).
Funari, P.P.A. and de Carvalho, A.V., 2005, *Palmares, ontem e hoje*. Jorge Zahar Editor, Rio de Janeiro.
Funari, P.P.A. and Orser, C.E., Jr., 1991, Pesquisa arqueológica inicial em Palmares. *Estudos Ibero-Americanos* 18(2):53–69.
Funari, P.P.A., Zarankin, A. and Stovel, E., editors, 2005, *Global Archaeological Theory, Contextual Voices and Contemporary Thoughts*. Kluwer/Plenum, New York.
Giroux, H.A. and McLaren, P., 1986, Teacher Education and the Politics of Engagement: The Case for Democratic Schooling. *Harvard Educational Review* 56:213–238.
Gnecco, C., 1995, Praxis científica en la prehistoria: notas para una historia social de la Arqueología colombiana. *Revista Española de Antropología Americana* 25:9–22.
Hall, M., 1994, The Veil of Popular History: Archaeology and Politics in Urban Cape Town. In *Social Construction of the Past, Representation as Power*, edited by G.C. Bond and A. Gilliam, pp. 167–184. Routledge, London, UK.

Hermann, J., 1981, Archäologische Denkmäler und ihre Rolle für Geschichstbild und Landeskultur. In *Archäologische Denkmale und Umweltgestaltung*, edited by J. Hermann, pp. 5–34. Akademie Verlag, Berlin,Germany.

Keys, D., 1993, South America's Lost African Kingdom. *The Independent*, Tuesday 19 October, Miscellany, p. 27.

La Belle, T.J., 1986, From Consciousness Raising to Popular Education in Latin America and the Caribbean. *Comparative Educational Review* 31:201–217.

Ladeira, C. and Affini, M., 1993, Palmares: cem anos de sonho. *Superinteressante*, September, 38–43. São Paulo, Brazil.

Leite, P.M., 1996, No túnel da História. *Veja*, 31 January, 102–104. São Paulo, Brazil.

Mayrink, J.M. 1995, Os quilombos. *Família Cristã*, November 1995, 16–19. São Paulo, Brazil.

Mazel, A.D. and Stewart, P.M., 1987, Meddling with the Mind: The Treatment of San Hunter-gatherers and the Origin of South Africa's Black Population in Recent South African School History Textbooks. *South African Archaeological Bulletin* 42:166–170.

Moon, P. 1991, Casa-grande negra. *Isto É*, 1284, 11 May, 70–71. São Paulo, Brazil.

Noelli, F.S., 1994, Indígenas e áreas de conservação: a polêmica continua. *Boletim Agir Azul* 9:4.

Noelli, F.S., 1995, Os indígenas do sul do Brasil podem contribuir para a recomposição ambiental? *Boletim Agir Azul* 10:4.

Noelli, F.S., 1996a, Os Jê do Brasil meridional e a Antigüidade da agricultura: elementos da Lingüística, Arqueologia e Etnografia. *Estudos Ibero-Americanos* 22(1):13–25

Noelli, F.S., 1996b, A ocupação do espaço na terra indígena Apucarana-Paraná: elementos para uma reflexão interdisciplinar. *Revista do CEPA* 20(24):27–36.

Noelli, F.S. 1996c, Buscando alternativas aos problemas das áreas indígenas do RS: resposta a um ambientalismo anti-holístico. *Boletim Agir Azul* 12:4.

Orser, C.E., Jr., 1992, *In Search of Zumbi*. Illinois State University, Normal, US.

Orser, C.E., Jr., 1993, *In Search of Zumbi, 1993 season*. Illinois State University, Normal, US.

Orser, C.E., Jr., 1994, Toward a Global Historical Archaeology: An Example from Brazil. *Historical Archaeology* 28(1):5–22.

Orser, C.E., Jr., 1996, *A Historical Archaeology of the Modern World*. Plenum Press, New York.

Orser, C.E., and Funari, P.P.A., 1992, Pesquisa arqueológica inicial em Palmares. *Estudós Ibero-Americanos* 18(2):53–69.

Pereira, P., 1992, Arqueologia tenta desvendar vida em Palmares. *O Estado de São Paulo*, 25 June, A28.

Piglione, C., 1995, Quilombo de Palmares era multiétnico. *Jornal da Unicamp*, October, 8. Campinas, Brazil.

Tamanini, E., 1994, Museu Arqueológico de Sambaqui: um olhar necessário. Campinas, Master's thesis, Department of Education, Campinas State University, Brazil.

Tamanini, E., 1999, Museu, Arqueologia e o Público: um olhar necessário. In *Cultura Material e Arqueologia Histórica IFCH-UNICAMP*, edited by P.P.A. Funari, pp. 179–220. Campinas, Brazil.

Tamanini, E. and Oliveira, M.S.C., 1997, A Cidade e o Patrimônio: Reflexões sobre a Preservação de Sítios Arqueológicos em Joinville. Joinville. Manuscript, Museu de Sambaqui de Joinville, Joinville, Brazil.

Part 4
Public Schools

Part 5
Public Health

15

Archaeology for Education Needs: An Archaeologist and an Educator Discuss Archaeology in the Baltimore County Public Schools

Patrice L. Jeppson and George Brauer

Public Outreach in archaeology generally operates with a disciplinary lens calling for stewardship—namely the preservation of archaeological sites through enhanced public awareness. This disciplinary-based goal, while important and relevant, represents the minimum role that archaeology can play in formal school education. An alternative approach for school outreach advocates the use of archaeology *for education's needs*. Notably, this approach is in keeping with how educators are already using archaeology as part of their instruction. The key to this kind of civically engaged school outreach rests with the professional educator who can successfully translate archaeological research into a useful format for educational needs. The rich potential of this approach is demonstrated by the Baltimore County Public Schools program of archaeology education. In this District-wide program, now in its 20th year, the discipline of archaeology is an integral part of the essential curriculum used in both primary and secondary grades.

Here, the creator and Director of this education program (Social Studies Curriculum Specialist George Brauer) and one of the program's archaeology collaborators (Patrice L. Jeppson) discuss the value of the *archaeology as education* approach. In doing so, they draw upon one portion of the extensive Baltimore County Public Schools program as an example—the archaeology-infused, *Grade 3 Integrated Social Studies/Science Curriculum*. In sharing their thoughts as well as the goals and concepts of this educational programing, these collaborators advocate that an *archaeology for education* approach is one means for "improving communities through archaeology so as to improve archaeology through communities" (Jeppson 2000, 2001, 2002).

15.1. Introductory Comments by Archaeologist Collaborator Patrice L. Jeppson

In the mid-1990s, the *Culture Wars* in America were taking a toll on arenas of specific and tangential importance to archaeology. The actions of the 104th Congress (lead by Newt Gingrich) had shepherded in many changes.

231

The research climate was chilled due to the slicing of the NEH budget. There was a significant reduction and even partial elimination of congressional appropriations for many federal agency historical offices, which was resulting in the eradication of many cultural resource jobs. Regardless of the fact that there were ever-increasing visitor numbers, Congress crippled the funding for our national museums, including those interpreting cultural history. Meanwhile, out in the hinterland, federal and state agency preservation officials (particularly in the western states) were encountering incidents of non-compliance, deliberate civilian obstruction, and, on occasion, physical threats as they went about their charge. I felt that Public Archaeology offered an important opportunity to advance a "value cultural resources" position within this cultural climate. I sought an interpretive archaeology position that could address public sentiment toward history and historical resources that operated at a grass roots level.

I found one such opportunity in a program run by George Brauer, Director of the Center for Archaeology in the Baltimore County Public Schools [CFA/BCPS]. His program of archaeology education operates in the 22nd largest US public school district with 160 schools, 5,000 teachers, and 109,500 students in grades K-12. (For overviews of this program see Brauer, 1995, 1999, 2000, 2004; Jeppson, 2000; Jeppson and Brauer 2000, 2003; and the CFA/BCPS web page archived at www.p-j.net/pjeppson/or). What follows here reports some of what I learned at the Center for Archaeology/BCPS between 1998 and 2002 while co-supervising field practicums, co-presenting classroom-based programing, and co-writing archaeology-enriched curriculum exercises.

What is discussed here involves revelations that may be quite obvious to some but these observations share some of what I think the Baltimore County Public Schools has to teach archaeologists as they attempt in their interpretation efforts to "Give The Public Its Due" (Jameson, 2000: 71). The *archaeology as education* example offered here argues for an engaged approach to public outreach that emphasizes social commitment rather than strictly professional needs alone (Pyburn and Wilk, 1995; Jeppson 1997, 2000, 2001, 2003, 2004a, b, [2007]; Downum and Price, 1999; Watkins *et al.*, 2000; Zimmerman, 2000).

15.2. Introductory Comments by Social Studies Curriculum Specialist George Brauer

I am a teacher and an avocational archaeologist with a passion for both education and archaeology. I have 35 years of avocational experience (totaling more than a decade's worth of full time research and cultural resources-based fieldwork) and I have been a professional educator for four decades—serving initially as a classroom teacher, later as a Department Chair, and now as a Social Studies Specialist in the District's Department of Curriculum and

Instruction. In my school district, I carry the *formal title* of Teacher Archaeologist.

While archaeologists have been busy exploring how archaeological knowledge might best be conveyed to a wider audience, I have spent 30 years specifically exploring ways that archaeological methods and theories might enhance the quality of Social Studies curriculum at the secondary and elementary school levels. This interest led to the development of the Baltimore County Public Schools' sequential archaeology curriculum (which builds each year upon the previous year's knowledge) and to the establishment of the BCPS Center for Archaeology, which is a facility providing educational support services for the archaeology instruction within the curriculum (Brauer 1995, 1999, 2000, 2004; Jeppson and Brauer 2003; www.p-j.net/pjeppson/or). The archaeology program's primary goals are to promote in students an appreciation for the value and complexity of historical and archaeological research, to help students develop mechanisms for critical analysis, to raise their historical consciousness, and to have them better understand the responsibility they have for the stewardship of the world's nonrenewable cultural resources. The motivation behind our program is to provide students with the knowledge and skills needed to live as productive members of society and to provide our District's social studies teachers with the means for doing this job.

At the same time, I am also keenly aware that this educational instruction can serve a benefit for archaeology (even though that is not our program's primary purpose). Educating students about archaeology as part of the life learning experience is an effective and too often overlooked means of bringing the public "on board" as archaeological stewards. As the English archaeology educator Peter Stone has said, "if access to the evidence of archaeology is not available to all, through its inclusion in formal and informal educational programs, then society runs the risk of the interpretation of archaeological evidence being biased... Time is of the essence here, as the failure to include archaeological interpretation in curricula can be argued to have contributed to the lack of understanding on the part of the general public, with regard to the archaeological-cum-educational-cum-political importance of sites" (Stone, 1997: 27).

The BCPS program of archaeology instruction is popular with students, their parents, and with our teachers. Our efforts have received professional education peer review recognition including the *National Council for the Social Studies* 1995 Curriculum Award, the *Maryland Council for the Social Studies* 1994 Curriculum Award, and the *National Association of Gifted Children* 2001 Curriculum Study Award. We have been awarded grants by the *Maryland Historic Trust*, the *National Science Foundation*, the *National Council for the Social Studies*, and by several private corporations. The archaeology community has also recognized these education efforts with their *Archaeological Society of Maryland* 1999 Patricia Seitz Memorial Teacher of the Year "Certificate of Excellence" and the *Society for American Archaeology* 2001 Excellence in Public Education Award.

15.3. *Archaeologist Jeppson*: Going Beyond Archaeology's Needs to Meet the Needs of Others— in this case, the Community of Schools

While generally aware of the potential that archaeology offers education as a resource, archaeologists for the most part have taken advantage of educational openings to proselytize about archaeology's needs. The actions of most public archaeologists, whether dealing with schools or archaeology's other "publics," remain inward-directed (discipline-based). Regardless of how one labels or defines the activity, or whatever methods were employed to effect differing levels of engagement with the public—be it *Archaeological Outreach* (presenting to others insights gained while serving as keepers of the public trust), *Public Archaeology* (sharing methods used in interpreting the past so as to empower others in knowledge production), or *Archaeological Education* (tailoring pedagogical techniques for educational institutions to meet their curricular goals)—moreover these efforts are enacted through a disciplinary lens calling for stewardship or "preservation through enhanced public awareness." In this vein, a cadre of dedicated archaeologists successfully accomplishes a great deal in protecting archaeology sites from vandalism and looting. Even so, an additional Public Archaeology approach seems warranted "because our public archaeology often doesn't connect to the daily lives of our publics when archaeology's needs form the primary focus" (Jeppson, 2000, 2001). While very relevant and important, these endeavors do not necessarily operate with an understanding of the benefits that await archaeology as a result of working with others to meet *their* needs.

A useful analogy to highlight this difference between discipline-based goals and a civically engaged form of Public Archaeology is found in those horse-drawn carriages conveying tourists around places like historic Charleston, Philadelphia, or in New York City's Central Park. The disciplinary lens archaeologists are operating under public practice functions much like the blinders that are put on carriage horses in order to direct their vision and therefore their performance. The blinkered archaeologist trudges around the streets (among the public) heading always toward the trough at the end of the day—the goal of preservation of sites and an inculcation in the public of the importance of the past. Meanwhile, immediately out of view, there are crises occurring: cars crashing (funding cuts), buses careening around corners (job elimination), and pedestrians coming up alongside on the sidewalk (non-compliance with legislative acts). One useful approach might therefore be to "take off our disciplinary blinkers and instead spread our wonderful and interesting 'hay' all around for others to eat *now* so that they will be more likely to join us later at the trough of preservation needs" (Jeppson, 2000). This approach to outreach advocates another way of "looking at" what so many of us are doing. It argues that increasing public awareness about preservation issues, broadening historical interpretation, and inculcating an appreciation

for the past might be more successfully addressed under a strategy where archaeology operates not for archaeology's needs but alternatively, when archaeology's needs meet the needs of the public.

15.4. *Educator Brauer*: The Problems and Potentials for Archaeology in Schools

An *archaeology for education* approach is already acted on by educators. The possibilities are not immediately evident, however, to most archaeologists (even publicly directed archaeologists) who often exhibit a reluctance to become engaged with the community of schools. In part, this reluctance is no doubt inevitable given the money and time constraints related to archaeological research. This is particularly so within the fast-paced world of cultural resources management where site-specific research does not easily correspond to curriculum content and there is little lead time to match onsite outreach opportunities with nearby school needs. However, among many archaeologists there is also a misguided fear that teaching about archaeology will inspire students to dig on their own (Jeppson and Brauer, 2003). This concern, which seems reasonable on the surface, overlooks the fact that students study archaeology in school as a way to become prepared, informed, members of society, not to "rob sites." Additionally, it misses the point that archaeology already exists within the scope of Social Studies education, one of the major content areas of learning taught in Kindergarten through 12th-grade education (See National Council for the Social Studies [NCSS], 1992; Jeppson, 2002, 2003, 2004a, b [2007]). Indeed, by definition, the primary purpose of Social Studies education is to "help young people develop the ability to make informed and reasoned decisions for the public good as citizens of a culturally diverse, democratic society in an interdependent world" (NCSS 1992: <http:www.ncss.org/about/background.html>) and archaeology is already being used as a means to accomplish this aim in classrooms across the nation.

15.5. *Archaeologist Jeppson*: Archaeology in Schools Makes Good Sense All Around

With archaeology utilized for education needs, young people are more likely to grow up and vote for, and contribute toward, archaeology's needs. It should be remembered that while formal school education constitutes just one audience within Public Archaeology outreach, ALL members of archaeology's other varied audiences or publics (heritage tourism, developers, legislators, Native Americans, descendant communities, etc.) at one time also comprise part of the formal school audience. Formal school education, with its 53 million public school students K-12, and its 2.3 million public school teachers, will always constitute archaeology's largest and most inclusive

(complete, extensive) audience (National Center for Education Statistics, *Enrollment in grades K-8 and 9–12 of elementary and secondary schools, by control of institution, with projections: Fall 1985 to Fall 2010*: Table 1, 2000). Looked at this way alone (numerically), formal school outreach warrants substantial interest and dedication of resources by archaeologists.

However, archaeologists should make the effort to become involved with schools for a more fundamental reason. Formal school education is one of our society's main means of intergenerational transmission of culture (Levinson, 1999, Jeppson, 2000, 2001, 2003, 2004a, b [2007]). School education structures everyday beliefs, values, and expectations for most citizens and it serves to organize public debate around a number of key issues. By embracing this realm of cultural production and reproduction we can help open up a greater space for archaeology's participation in public debate. In advertising and attempting to inculcate their message with the school audience, archaeologists operating with a stewardship agenda do recognize and sometimes embrace schools as a site of cultural values and beliefs transmission—again, for archaeology's needs. However, associated education needs are often embraced less effectively with the result that the archaeology stewardship agenda can actually be impeded.

This is seen when archaeology outreach ties archaeology methods and results to critical thinking and or other educational skills—but for the purpose of teaching *archaeology* rather than required (taught) subjects. A more effective approach is one that merges archaeology outreach with instruction needs, for example, using archaeological site stratigraphy to teach Lyell's principle in a geography class, using a site map to teach basic map skills such as cardinal directions or axes, or using archaeological evidence as an example of a primary resource in a history exercise. Offering archaeology in a useful form for classroom needs creates a conduit through which an associated site preservation message can be conveyed.

15.6. *Educator Brauer*: Archaeology for Education's Needs Helps to Foster Collaboration

Archaeologists undertaking school outreach often overlook collaborating with educators whom they perceive as part of "the audience" as opposed to as a potential "partner." They thus fail to capitalize on the strengths of these other professionals. This is a shame because good outreach materials do not automatically follow as a by-product of good archaeology. Collaboration between educators and archaeologists is needed to stem a growing tide of materials that are less useful for implementation in schools due to excessive jargon or to content that is only marginally suited to curricular needs.

The need for collaboration is known to publicly active archaeologists who concentrate in archaeology outreach to schools (among others, Stone and MacKenzie, 1990; Jameson *et al.*, 2000; Smardz and Smith, 2000) and there

are several very fine examples of materials produced in collaboration with educators (among others, Smith *et al.*, 1992; Jameson *et al.*, this volume). Now that public interpretation is becoming more generally recognized as an essential component of both CRM and academic archaeology, archaeologists around the country are starting to incorporate outreach to schools as part of their practice. Thus, highlighting the need for, and the potential of, collaboration with educators becomes all the more critical. Unfortunately, the archaeology profession's inclination to value insider evaluations of education-directed materials hinders progress otherwise made in this area (Goldstein, 1998). Assessments of educational resources by archaeologists may meet archaeology standards but they often overlook education priorities and concerns. This has implications for the educator receptiveness to archaeologist-recommended readings, lesson plans, or web pages.

15.7. *Archaeologist Jeppson*: The Cultural and Disciplinary Factors Influencing Collaboration

It is odd that archaeologists do not automatically collaborate with education professionals but instead so often attempt educational programing themselves. This kind of usurping of another professional area of expertise is not something that happens elsewhere in our field. We "routinely send the human remains we recover to the osteologist, the animal bone evidence to a faunal specialist, and decomposing leather to the conservator" (Jeppson, 2000). Yet we do not routinely collaborate with educators but rather try to be both archaeologist and educator, often compromising one effort while failing at the other. As George Brauer has stated to me, "archaeologists excavate with great precision and then are not as precise in their efforts to publicly interpret finds." The implications of our actions are serious. The goals of increasing public awareness about preservation issues and of inculcating appreciation for the past are impeded. At best, precious resources and time are depleted while we "reinvent the wheel." In truth, archaeologists generally know little about the "transfer of information as practice" (except, perhaps in college level training). The transfer of knowledge within the formal education sector (K-12th grade) is not our forte—and, it can be argued, it is not our job. Not only are we unschooled in appropriate instructional strategies (e.g., everything from selecting age appropriate vernacular to accommodating the developmental stages of learning), we are outside the *culture of education* and hence unaware of how, when, and where, teaching plans become formulated, approved, and implemented. There is an entire field of research with understandings, methods, methodology, and philosophies dedicated to this practice that we archaeologists regularly overlook or ignore when attempting to share our world within the formal education sphere. Perhaps it is because American society does not adequately value its educators that we in our profession (as part of American culture) neither

recognize nor appreciate this expertise (Jeppson, 2000, 2003, 2004a, b [2007]). When archaeologists undertake lesson plan development on their own they are not just practicing outside their field of preparation but also, effectively, practicing education without a license.

15.8. *Educator Brauer*: Collaborations Determine Curricular versus Extra-Curricular Impact

A lack of collaboration with educational professionals is one reason for the production of archaeology outreach materials that are *extra-curricular* or outside (beside) the main course of study offered in schools. With the instructional burden teachers carry today as a result of the focus on state testing for standards, archaeology, when implemented as an extra-curricular activity, often just gets set aside. As such, the lack of collaboration can hamper even archaeology's stewardship agenda. Through collaboration, the production of less relevant educational resources can be avoided. Curriculum-based archaeology programing offers archaeology for education's needs that better assures that educational outreach is beneficial for archaeology's stewardship's needs. When presented and received within the context of core instruction, any associated preservation messages are encountered and absorbed alongside.

15.9. *Archaeologist Jeppson*: The Baltimore County Public Schools Program of Archaeology

The Baltimore County Public Schools program is an example of the strengths and possibilities for a curriculum-based program of archaeology. The archaeology programing in the Baltimore County Public Schools falls within the *Essential Curriculum*, the nonnegotiable program of study that the district's 5,000 teachers are expected to teach and its 109,500 students are expected to learn. A Social Studies Curriculum Specialist (co-author George Brauer), with the help of the Center for Archaeology staff (including, among others, myself [co-author archaeologist Patrice L. Jeppson]), produce readings and exercises using educator-evaluated professional archaeological research, commercially available materials, and primary data recovered by students at a Center run site (See bibliography of educational materials produced by the BCPS/CFA at http://www.p-j.net/pjeppson/or/tv.htm). Archaeology-enriched primary content materials, extension and supplemental activities, and assessment activities are integrated into a second grade literature unit, a third grade social studies unit, a fourth grade Maryland History lesson, sixth grade and seventh grade World Culture courses, a high school US History course, and a semester long archaeology elective course. This

extensive program of archaeology education, which is discussed elsewhere in detail (in particular see Jeppson and Brauer, 2003 and also at the Center for Archaeology/BCPS web page www.p-j.net/pjeppson/or.htm) will be demonstrated here using the third grade programing example.

15.10. *Educator Brauer*: Archaeology in the BCPS Third-Grade Program, 1987–2005

The archaeology content used in the third grade program, like the rest of the BCPS archaeology program, first finds its way into a usable form for education needs and then makes its way into the hands of teachers. The third grade social studies curriculum, *Integrated Science/Social Studies Guide for Grade 3: Exploring Environments, Baltimore and Beyond* (BCPS Office of Social Studies, 1993; CFA/BCPS, 2000a–c), shepherds approximately 7,500 eight, nine, and ten year olds into the study of archaeology each year. These Grade-3 students learn archaeology terms and concepts in a unit dealing with the local community and/or Ancient Greece. This introductory knowledge sets the stage for subsequent learning; substantive archaeology research is integrated into instructional exercises assigned as part of coursework in higher grades.

The archaeology infused, Science/Social Studies course guide provides the District's third grade teachers with meaningful instructional connections for teaching students that reflect current education research related to teaching strategies and effective curriculum. Meaningful student tasks (teaching ideals) are modeled throughout the course guide and these support education initiatives mandated by Baltimore County Public Schools and the Maryland State Department of Education. The archaeology-infused activities in the guide offer a variety of suggestions for student products (assignments) and include various instructional strategies to meet diverse student needs (e.g., gifted students or students with special needs). As with other areas of the course guide, the archaeology-derived units include learning objectives (Stated Learning Goals), useful background information, and teacher instructions, as well as a literature component developed around the Maryland State Department of Education *Outcomes*, or education standards.

The teacher instructions for the archaeology component of the guide include teaching models that direct the students toward Maryland State Department of Education goals. These suggestions for instruction include sequentially developed learning tasks, each of which begins with an activity that enables the students to gain knowledge and construct meaning. This is followed by a set of activities that progress through the steps of organizing information, extending and refining knowledge, and, finally, making thoughtful application of knowledge. The archaeology activities are written in a standardized lesson plan format helping to make the skills of the archaeologist, and the information gained through their practice, of use to teachers. This formatting breaks down archaeology's research methods and

results into their various components and links these clearly and directly to the instructional skills the teacher is using. This means, for example, making obvious "where" and "how" portions of a specific archaeology activity meet such instructional goals as establishing an orderly pattern to student thought from concrete to abstract principals, developing visual perception, requiring adding and subtracting of numbers, and practice at making estimations.

Supporting the third grade archaeology unit is a curriculum-matched television program, *The Adventures of Indiana Joe and the Secret of Oregon Ridge,* which is produced by the School District's cable television station (CFA/BCPS, 2000d). This instructional program reviews information taught as part of the archaeology unit (Figure 15.1). The program includes a short drama skit and then a "live" or taped class interaction component where students from selected schools interact with the Center for Archaeology Director (Social Studies Curriculum Specialist George Brauer) Indiana Joe through a telephone link-up. The program is broadcast repeatedly (for several weeks) during the period of the school year that the archaeology enriched

FIGURE 15.1. Baltimore County Public Schools cable television program schedule. *Inset*: Broadcast *still* showing Center for Archaeology Director George Brauer (*left*) instructing treasure-hunter Indiana Joe (*right*)—and the Grade 3 classrooms tuned in—about how the value of artifacts lies in what they can teach about the past. (Courtesy, Baltimore County Public Schools, Towson, Maryland.)

sections of the Community History or Ancient Egypt unit is taught. This program has received a local, Emmy-type, award. This remote, instructional-supporting program reinforces the idea that archaeology is not a treasure seeking venture but rather a process for learning about the past: Indiana Joe is "set straight" by the Center's Director, George Brauer and the students about how artifacts are valuable *as sources of information.*

Periodically over the years, when time and field conditions have allowed, an excavation experience on a simulated site has also been offered as a third grade supplemental exercise. To date, close to 350 students have participated in this option. The 20 × 20 ft manufactured site used for this exercise has both a historic and prehistoric component with reproduction and twenty-first century artifacts standing in for specific architectural features and various food-related activities. Site interpretation through gathered data and hypotheses making (not artifact discovery) is the educational objective of this exercise (Figure 15.2).

A main support resource offered for the third grade unit is the School Visitation (Out-Reach) Program. This enrichment learning opportunity involves approximately 800 students annually in predominately Title 1 Category schools (i.e., schools with an economically disadvantaged student population receiving supplemental Federal education assistance). Staff from the Center for Archaeology present this program as a way to help students succeed in the regular school program, meet the high standards of the

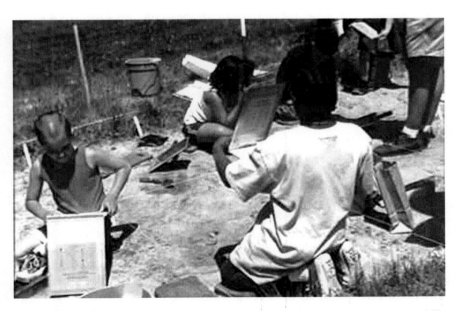

FIGURE 15.2. Third Graders learn about spatial perception and practice map skills used in annual standardized testing while taking field notes at a simulated site with prehistoric and historic components. Center for Archaeology/Baltimore County Public Schools, Towson, Maryland. (Photo by P. L. Jeppson, 2000.)

Maryland State School Performance Program (the annual state standardized test), and improve achievement in both basic and advanced skills. Archaeology is used to capture the interests of these students as a means to educate them (CFA/BCPS, 1997, 1999, 2000a–d). In the first half of this program's presentation, the curriculum content is reviewed in a verbal interactive *extension exercise* where student thinking is stretched and strengthened as a presenter asks questions that build upon one another. A site map is used to review map reading skills, which the State Standards test for annually. During the second half of the program, the students conduct a hands-on learning activity performing an artifact analysis. Working first individually and then in groups, the students gather data through direct observation of real objects, form hypotheses, and draw conclusions. The artifact analysis provides students with practice in several "tested for" taught skills including measuring with rulers, estimating (e.g., the weight of their objects), and practice with shapes.

To facilitate the third grade archaeology curriculum, the Center for Archaeology/Baltimore County Public Schools developed an in-service program for third grade teachers presented at the Center's project site of Oregon Ridge (details of this field research project are discussed elsewhere in greater depth in Jeppson and Brauer, 2003). In this in-service program, archaeology serves fundamentally as the *content base* for learning improved, social studies instructional strategies. Archaeology is, in other words, of secondary importance to the in-service course objective of continuing education training for District Staff. The teachers have an experience conducting excavation or lab work each morning under the supervision of the Center for Archaeology staff while the afternoons are spent identifying and examining the *specific* social studies skills used during various archaeological tasks. The teachers return to their schools as Archaeology Content Leaders who share their knowledge by mentoring their Department colleagues. These teachers also bring first-hand experience and enthusiasm back to their classes (Figure 15.3).

15.11. *Archaeologist Jeppson*: Archaeology is Embedded Into the Social Studies Curriculum

The BCPS program of archaeology instruction teaches everything from reading to spatial relationships. Archaeology methods and results are used in instructing subject content and critical education skills relevant to *taught* (i.e., required) social studies topics (i.e., history, geography, etc.) as well as math and reading. This educational instruction (using archaeology as a means to an educational end) is possible because the Office of Social Studies integrates archaeology content into the instructional materials the teachers use. Being core curriculum-based, the archaeology has access to pre-established networks for communication, influence, guidance, and direction allowing multiple archaeology products to be used for a number of educational purposes. Teachers use the archaeology enriched curriculum because it represents more

Center for Archaeology

Skill Check

Directions: At the conclusion of each session check the instructional
skills you used throughout the day.

Skill List	Mon.	Tues.	Wed.	Thurs.	Fri.
Problem-solving					
Predicting					
Generalizing					
Explaining					
Assessing					
Analyzing					
Interpreting					
Estimating					
Comparing					
Contrasting					
Identifying					
Summarizing					
Graphing					
Measuring					
Surveying					
Illustrating					
Revising					
Describing					
Justifying					
Categorizing					
Organizing Information					
Recording Data					
Applying Knowledge					
Drawing Conclusions					
Formulating Hypotheses					
Others					

FIGURE 15.3. As part of *In-Service* training, teachers identify Social Studies skills utilized during archaeological fieldwork. (Courtesy, Office of Social Studies, Baltimore County Public Schools, Towson, Maryland.)

than extra-curricular, add-on, frill activities. The archaeology is basic to the goals and mission of their job. This is archaeology's use for education's needs. Being positioned within the curriculum means that archaeology is less likely to be perceived by the students and teachers as only as a luxury but instead will be recognized as a basic component of life and learning experience. It is this understanding, in turn, that holds significant promise for encouraging within the student an appreciation and responsibility for the resources of the past.

15.12. *Educator Brauer*: An Educators' Perspective on Archaeology and Education

When the Baltimore County Center for Archaeology began operations in 1984, it was rare to find a professional archaeologist willing to engage the public in archaeology. Gradually the horizon began to open, and archaeology has recently seen a dramatic increase in such activity as exemplified in many local, regional, and national programs. It is gratifying to see so many archaeologists presenting programs at educationally oriented conventions in recent years. Today all major archaeological associations and most museums have some form of public archaeology outreach component in their programing. If archaeology is to thrive, the encouragement of "public" interest and participation is vital. Ultimately, the public pays the piper and the public's right to influence the tune has to be acknowledged.

John Jameson has observed that educational programs are most effective when specialists from interdisciplinary teams design and implement programs for the public (Jameson, 2000). I have been fortunate to participate in and/or observe several successful programs: Flowerdew Hundred in Virginia with the late Jim Deetz, Crow Canyon in Colorado with then educational director Pam Wheat, The Hermitage in Tennessee with Larry McKee, and Archaeology in Annapolis with Parker Potter. Unfortunately, I have also been witness to public archaeology programs that could have been dramatically more effective had a skilled educator been consulted.

More importantly, I would like to promote the idea of partnerships between professional archaeologists and educators. If you desire to reach out to a receptive and enthusiastic audience, then reach out to educators. There is probably one volunteering in one of your activities. What can educators bring to an alliance? Educators offer skills in planning, organization, and student management. They can translate information to their students and through their knowledge of learning behaviors help you identify the capabilities students might have for active involvement. Not only will you influence students but you will reach their parents, family members, and friends in a ripple affect. All public schools nationwide have curriculum that could be invigorated with archaeology. While elementary students or even most high school seniors are not likely to contemplate the merits of a post-structuralist paradigm, a "brains-on" and "hands-on" involvement in the process of archaeology can deepen their appreciation for the value and complexity of historical and archaeological research. In turn, teachers see the tremendous instructional potential in the wealth of archaeological methodologies and content. Archaeological research offers a sense of mystery and excitement that works well to stimulate student interest in things historical.

In many ways the agendas of the Education and Archaeological professional communities are compatible. Both have assumed certain responsibilities to learn about, protect, and preserve the cultural resources of the human past. Alliances with educators and schools, whether public or private, offer a wide

spectrum of possibilities to expand upon the archaeological mandate to dis-seminate archaeological information. Both are uniquely qualified to interpret the past and both have a social and ethical obligation to engage the public in their work. When materials or programs are available, or can be created, which allow the incorporation of archaeological information into classroom or field trip activities, both education and archaeological goals can be advanced.

Some may caution that in today's educational climate with its demands for curriculum standardization, comprehensive assessment, and funding accountability that schools may not be amenable to revising their essential curriculum to include archaeology. My experience as a curriculum specialist tells me that nothing could be further from the truth. Teachers and curriculum writers are on a perpetual quest, seeking ways to motivate and engage students and to energize their curriculum. In the opinion of many of my education colleagues, no curricular innovation has more potential for meeting these needs than does the field of archaeology with its hands-on elegance and profound demand for imaginative, reflective, and creative thinking. Obtaining a more central role for archaeology as a part of teacher instruction and student learning is possible. It can and should be done.

15.13. *Archaeologist Jeppson*: Archaeology Outreach as Civic Action

Currently within education there is an unprecedented magnitude of change being brought about by the classroom standards movement. In 1995, 13 states had State Academic standards in place. By 1999, 45 had them (Chase, 1999). Some have seen this movement as spelling doomsday for the archaeologist who wants to approach teachers distracted by constricting budgets and greater demands for test scores and who are thus not open to a new subject or to revising their curriculum. But just the opposite is true. With the onset of standards, curriculum programs are being written (many schools never had them) or re-written to meet state standards. There is actually now an opportunity to bring archaeology to the formal education table. Archaeologists just need to get in the door and offer to collaborate.

That is what we should do—Collaborate. We are not K-12th grade teachers. Our job is archaeology. When we do attempt to wear two hats our archaeology suffers (our limited resources are compromised) while we inadequately perform another profession's role. Archaeologists can contribute content that educators can use to make kids think and that is what we should be trying to do. Going beyond disciplinary needs (Stewardship) to meet education's needs presents us with an opportunity for integrating intellectual practice with social life as "citizen archaeologist." This approach to public archaeology holds that we should participate archaeologically in society as active citizens—meaning that "we can connect to the daily lives of people and give them information they need and can use" (Jeppson, 2000, 2003, 2004a, b [2007]). In a civic

archaeology approach, our publics are viewed as constituents rather then clients, students, or mere audiences to be entertained. This is a form of practice where responsibility to the public is based not on archaeology's needs "but on archaeology's needs to meet the needs of the public" (Jeppson, 1997: 66). This motivation is entirely opposite of the way most public archaeology is conducted. However, by relating archaeology to the world in this directed fashion it can operate as one small piece of contemporary culture that filters through and has an effect upon multiple areas of life.

Acknowledgments. Educator Brauer: An earlier version of this commentary was presented at the 2000 meeting of the Society for Historical and Underwater Archaeology, Quebec City, Canada. I would like to thank former Staff Archaeologist and Program Assistant Patrice L. Jeppson for her past and present contributions to the success of the Center for Archaeology and for her helpful comments on this paper. Thanks also go to past Staff Archaeologist and Program Assistant Karen Lind Brauer for her assistance. *Archaeologist Jeppson*: An earlier version of my commentary was presented in a paper at the 2000 meeting of the Society for Historical and Underwater Archaeology, Quebec City, Canada. George Brauer, developer and Director of the Center for Archaeology/Baltimore County Public Schools, devised the educational strategies discussed here. I am grateful to him for his patience while instructing me in the practical matters of educating others. Materials pertinent to the Center's program belong to the BCPS Division of Educational Support Services/Department of Social Studies/Office of Curriculum and Instruction. I thank Jed Levin for the helpful comments he provided on an earlier draft and Karen Lind Brauer for assistance with this final draft.

References

Baltimore County Public Schools, Office of Social Studies (OSS/BCPS), 1993, *Exploring Environments, Baltimore and Beyond: Integrated Science/Social Studies Guide for Grade 3*. Educational Support Services, Office of Social Studies, Baltimore County Public Schools, Towson, MD.

Brauer, G.H., 1995, Archaeology as Social Studies Content in the Baltimore County Public Schools. Presentation at the 75th National Council for the Social Studies Conference, Phoenix, AZ.

Brauer, G.H., 1999, Archaeology in the Social Studies Curriculum. Presentation at the 79th National Council of the Social Studies Conference, Los Angeles.

Brauer, G.H., 2000, Public Archaeology at Oregon Ridge: "It Can be Done." Paper Presented at the 33rd Conference on Historical and Underwater Archaeology, Quebec City, Canada.

Brauer, G.H., 2004, Archaeology and Critical Thinking. Pre-Conference Clinic Presented at the 84th National Council for the Social Studies Conference, Baltimore, MD.

Center for Archaeology/Baltimore County Public Schools (CFA/BCPS), 1997, *Using Clues from the Past: Performance Assessment Activity, Grade 3 Social Studies*, Revised from 1996 edition. Educational Support Services, Office of Social Studies, Baltimore County Public Schools, Towson, MD.

Center for Archaeology/Baltimore County Public Schools (CFA/BCPS), 1999, *Pre-Visit Student Activity Packet for Grade 3 Social Studies Archaeology Unit.*

Educational Support Services, Office of Social Studies, Baltimore County Public Schools, Towson, MD.

Center for Archaeology/Baltimore County Public Schools (CFA/BCPS), 2000a, *Student Activity Packet for Third Grade Social Studies Archaeology Units*, Expanded and Revised from 1996 edition. Educational Support Services, Office of Social Studies, Baltimore County Public Schools, Towson, MD.

Center for Archaeology/Baltimore County Public Schools (CFA/BCPS), 2000b, *Archaeology: Search for the Past, Student Workbook*, Expanded and Revised from 1996 edition. Educational Support Services, Office of Social Studies, Baltimore County Public Schools, Towson, MD.

Center for Archaeology/Baltimore County Public Schools (CFA/BCPS), (2000c), *Tools of the Archaeologist. Third Grade Social Studies Archaeology Units Workbook.* Educational Support Services, Office of Social Studies, Baltimore County Public Schools, Towson, MD.

Center for Archaeology/Baltimore County Public Schools (CFA/BCPS), 2000d, *The Adventures of Indian Joe and the Secret of Oregon Ridge.* Baltimore County Public Schools Education Channel Broadcast Video. Baltimore County Public Schools, Towson, MD.

Chase, B., 1999, An Academic Boost: CEO's and Governors Support Standards from Classroom Up. National Education Association Paid Editorial, *The Washington Post*, Opinion, B2.

Derry, L. and Malloy, M. editors, 2003, *Archaeologists and Local Communities: Partners in Exploring the Past.* Society for American Archaeology Press, Washington, DC.

Downum, C.E. and Price, L.J., 1999, Applied Archaeology. *Human Organization* 58(3): 226–239.

Goldstein, L., 1998, Editor's Corner. *American Antiquity* 63(4):529–530.

Jameson, J.H., Jr., 2000, Abstract: Giving the Public It's Due: New Horizons in the Public Interpretation of Archaeology. In *Program: 33rd Conference on Historical and Underwater Archaeology,* edited by R. Auger and W. Mos. Society for Historical Archaeology, Quebec City.

Jameson, J.H., Jr., Conrad, N., and Van Voorhies, C., 2000, A Colonial Classroom: Fort Frederica National Monument. Paper Presented at the 33rd Conference on Historical and Underwater Archaeology, Quebec City, Canada.

Jeppson, P.L., 1997, "Leveling the Playing Field" in the Contested Territory of the South African Past: a "Public" versus a "People's" Form of Historical Archaeology Outreach. In *The Realm of Politics: Prospects for Public Participation in African–American and Plantation Archaeology,* edited by C. McDavid and D. Babson. *Historical Archaeology* 31(3):5–83.

Jeppson, P.L., 2000, Lessons Learned During a Year of Archaeology in the Baltimore County Public Schools. Paper presented at the 33rd Conference on Historical and Underwater Archaeology, Quebec City, Canada.

Jeppson, P.L., 2001, Pitfalls, Pratfalls, and Pragmatism in Public Archaeology. Paper presented at the Theoretical Archaeology Group Conference, Dublin, Ireland.

Jeppson, P.L., 2002, Introduction. "Reach America": Looking to the Future of Archaeology and the Public Schools. Panel Discussion Presented at the 35th Conference on Historical and Underwater Archaeology, Mobile.

Jeppson, P.L., 2003, Archaeology in the Public Interest: Applied Historical Archaeology in a South African Museum Educational Exhibit. Archaeology into the New Millennium: Public or Perish. *Proceedings of the Chacmool Conference,* University of Calgary, 1995, pp. 213–231.

Jeppson, P.L., 2004a, Pitfalls, Pratfalls and Pragmatism in Public Archaeology: A Case Study. In *Interpretation for Archeologists: A Guide to Increasing Knowledge, Skills, and Abilities, Archeology and Ethnography Program*, edited by T.S. Moyer, H.A. Hembrey, and B.J. Little. National Park Service, Washington, DC; http://www.cr.nps.gov/aad/ifora/ and http://www.cr.nps.gov/aad/IforA/respon3.htm.

Jeppson, P.L., 2004b, Doing Our Homework: Rethinking the Goals and Responsibilities of Archaeology Outreach to Schools. Paper presented at the Conference on Historical and Underwater Archaeology, St. Louis, MO.

Jeppson, P.L. [2007] Doing Our Homework: Reconsidering What Archaeology Has to offer the Community of Schools. In *Changing the World with Archaeology: Activist Archaeology*, edited by J. Stottman University of Florida Press.

Jeppson, P.L. and Brauer, G., 2003, "Hey, Did You Hear About the Teacher Who Took the Class Out to Dig a Site?": Some Common Misconceptions About Archaeology in Schools. In *Archaeologists and Local Communities: Partners in Exploring the Past*, edited by L. Derry and M. Malloy, pp. 77–96. Society for American Archaeology Press. Washington, DC.

Jeppson, P.L., Brauer, G. and Levin, J., 2000, Center for Archaeology/Baltimore County Public Schools [CFA/BCPS], web page archived at <www.p-j.net/pjeppson/or>

Levinson, B.A., 1999, Resituating the Place of Educational Discourse in Anthropology. *American Anthropology* 101(3): 594–604.

National Council for the Social Studies (NCSS), 1992, Expectations of Excellence: Curriculum Standards for Social Studies. <http:www.ncss.org/about/background.html>, Washington, D.C.

National Center of Education Statistics (NCES), 2000, Projection of Education Statistics to 2010. National Council for Education Statistics, Washington, DC.

Pyburn, K.A. and Wilk, R.R., 1995, Responsible Archaeology is Applied Anthropology. In *Ethics in American Archaeology: Challenges for the 1990's*, edited by Mark J. Lynott and Alison Wylie, pp. 71–76. Special Report. Society for American Archaeology, Washington, DC.

Smardz, K. and Smith, S.J., editors, 2000, *The Archaeology Education Handbook: Sharing the Past with Kids*. The Society for American Archaeology Press, Washington, DC, and Alta Mira Press, Walnut Creek CA.

Smith, S.J., Moe, J., Letts, K. and Paterson, D., 1992, *Intrigue of the Past: Investigating Archaeology, a Teacher's Activity Guide for Fourth Through Seventh Grades*. Bureau of Land Management, Salt Lake City.

Stone, P.G., 1997, Presenting the Past: a Framework for Discussion. In *Presenting Archaeology to the Public: Digging for Truths*, edited by Jameson, J.H., Jr., pp. 23–34. Altamira Press, Walnut Creek, CA.

Stone, P.G. and MacKenzie, R., editors, 1990, *The Excluded Past: Archaeology in Education*. Unwin Hyman, Routledge, London.

Watkins, J., Anne Pyburn, K. and Cressey, P., 2000, Community Relations: What the Practicing Archaeologist Needs to Know to Work Effectively with Local Communities. In *Teaching Archaeology in the Twenty-first Century*, edited by S. Bender and G. Smith, pp. 73–82. Society for American Archaeology Press, Washington, DC.

Zimmerman, L., 2000, Regaining Our Nerve: Ethics, Values, and the Transformation of Archaeology. In *Ethics in American archaeology*, edited by M.J. Lynott and A. Wylie, pp. 71–74. Second revision. Society for American Archaeology Press, Washington, DC.

16
Audience, Situation, Style: Strategies for Formal and Informal Archaeological Outreach Programs

Carol J. Ellick

16.1. Introduction

Archaeologists are often contacted by teachers looking for a one-hour presentation on archaeology or cultural history. The presentation request can be for an introduction to a new topic area, for inspiration during the study process, or as the culmination of a unit. Many archaeologists, while comfortable with their knowledge on the topic and their competence in the field, would rather share an excavation unit with a scorpion than to face a classroom of expectant 10 year olds. If the reluctance is based on a lack of training or experience with communication, then the comfort-level can be raised. This chapter provides some practical and tested strategies for the presentation of archaeological and historical information to children.

Situations using archaeology as the method for telling children about the past include both formal, classroom-style and informal, museum-style learning environments. In formal learning environments, children are a captive audience, and information may be transferred to the group as a whole. While personal contact may last only an hour, pre-visit and post-visit materials can extend the learning experience.

Events such as "archaeology days" at a museum or park are another environment for telling children about the past. These situations are unstructured and informal. The audience represents a diverse population. The number of individuals attending an event is difficult to predict. Materials and methodologies may need to be created to reach children of all ages. In the informal environment, the audience comes and goes at its own pace. Contact varies from individual to individual. Visitors attending these types of events arrive with no common base of knowledge. Unlike the captive audience of the formal classroom, this audience is in attendance as an interested public.

Although quite different, each of these situations offers the potential for reaching children. Key to each situation is preparation and a defined structure. This chapter discusses basic strategies for increasing the chance of knowledge acquisition and retention for both captive and non-captive audiences. Case studies include: (1) the presentation of information; (2) presentation

preparation; (3) utilization of educational techniques; (4) concepts conveyed; and (5) application of the strategy in lesson plan format including materials, setting the stage, process, and closure.

16.2. Captive Audience and the Formal Learning Environment

The school classroom is representative of a formal learning environment. Children within the formal learning environment are united by a specific set of common traits such as age, skill-level, or interest in the subject matter.

16.2.1. Relating Archaeological Education to State-based Educational Standards

In the United States, archaeology is not a required subject for graduation from high school. The incorporation of archaeology in the kindergarten through twelfth grade classroom is generally as a thematic unit for teaching the required subjects and meeting the individual state department of education standards, benchmarks for learning, and performance objectives. The state standards requiring the study of state history is generally required in either fourth or fifth grade and again in seventh or eighth grade. The New Mexico state Social Studies strand for history, Content Standard I states that students must be "able to identify important people and events in order to analyze significant patterns, relationships, themes, ideas, beliefs, and turning points in New Mexico, United States, and world history in order to understand the complexity of the human experience." Kindergarten through fourth grade Benchmark I-A is specifically focused on New Mexico history. It requires that students must be able to "describe how contemporary and historical people and events have influenced New Mexico communities and regions." Within each benchmark, specific performance standards target the required achievement or skill to be acquired within each grade. In fourth grade, Performance Standard 1 requires that students be able to, "Identify important issues, events, and individuals from New Mexico pre-history to the present." The only way to get to prehistoric or "pre-contact history" is through the use of archaeological data.

16.2.2. Presentation of Information

Presentations within the formal classroom context are generally limited to a single class period or block lasting less than an hour's time. Despite time restrictions, a great deal of information on archaeological method and theory and cultural history can be covered. Successful incorporation of simple educational concepts such as relating new information to student background, appealing to all learning-styles, and open-ended questioning can

increase class participation and ultimately increase knowledge acquisition and retention.

16.2.3. Presentation Preparation

You receive a request. "Our class is studying dinosaurs. We would like an archaeologist to come and visit." Your mind whirls. You say to yourself and not the teacher: "We don't do dinosaurs." You say to the teacher: "Archaeologists and paleontologists, the scientists who study dinosaurs, conduct their fieldwork using similar methodologies. Archaeology, however, studies only the materials related to human beings. Dinosaurs walked this planet long before people." This phrasing relates the studied subject and gives the teacher a graceful way out, if desired. Sometimes, though, they will like that connection and still arrange for the class visit.

Requesting information regarding the audience, materials, time limit, and location will help in the preparation process. A form can be designed that lists information directly related to the visit. Questions relating to audience should include requests for details regarding age or grade-level, group size, and if there are any children with special needs. How many classes will be present at once? Some teachers like to have "all fourth grades" attend. Others would prefer individual presentations to each group. Be clear on the time limits. The length of time of a class period or block varies from school to school. Time limits should also be considered in relationship to the attention span of the audience. What audio-visual resources are available in the building and what will need to be brought at the time of the visit?

The form serves a purpose beyond getting instructions to the venue and presentation preparation. Maintaining a file of requests provides statistical data potentially useful in tracking classroom visits. It also provides a ready-made list of educators interested in archaeological education who can be contacted for workshops, testing materials, or other outreach projects. An example of a group presentation request form follows (Figure 16.1).

16.3. Utilizing Educational Techniques

A guest speaker is selected for his or her expertise in the subject matter. In most cases, the requested presentation relates to the subject matter being covered that term. Presentations may be solicited as an introduction to the topic or as information sharing during a research phase, more often if comes as closure to the unit.

Students come to the presentation with a common base of knowledge. By relating the new information to the base of knowledge, students will better be able to move toward higher levels of skill acquisition and knowledge. The educational strategies utilized must be age-appropriate. Younger students have a more limited base of experience than older children. Correlations are

Date of Contact:	Presentation Date:	Time: _____ to _____	
Contact Person:			
Name of Group:			
Address:			
Directions to location:			
Phone:	FAX:	Email:	
Group Size:	Age Range:	Room set up:	
Focus of presentation:			
Current area of study:			
Special instructions, needs, guidelines:			
MATERIALS CHECKLIST:	BRING	PROVIDED	
flip chart and markers			
dry erase board and markers			
artifacts and tool kit			
information packet			
table for props			

FIGURE 16.1. Group presentation request form.

drawn to home, family, and neighborhood. Older children have a broader experience base. Their experience extends to multiple communities, the town or city, and potentially beyond. Relating complex concepts such as artifact distribution patterns and social structure to household items, rooms, yards, and neighborhood links known places to new information.

The classroom contains auditory, visual, and tactile learners. Most children are fairly balanced in their learning-styles, acquiring knowledge through each method. There are, however, children who have processing deficits. If the teaching-style does not mesh with their learning-style, the student will be less likely to process the information. Although easiest for the presenter, a strictly oral presentation appeals to only the auditory learner. The use of a flipchart or a blackboard will appeal to the visual learner. Jot down vocabulary and sketch artifacts and features. The use of words and pictures will appeal to both the text-based and graphic learners. Show

FIGURE 16.2. A high school student examines a piece of pottery that is being passed around the classroom.

examples of tools, maps, and artifacts. Distribute objects that can be touched, but be prepared for the time that will be required to interact with the objects and bring the group back to the discussion (Figure 16.2). To see it, touch it, and do it is to learn it.

Open-ended questions allow the students to participate in the process. The open-ended question initiates discussion and does not end with a "yes" or "no" answer. Questions starting with "Do you . . . ?" "How many . . . ?" "Have you . . . ?" provide a technique for gathering general information and quickly moving people along; but do not encourage any high-level thinking on the part of the student. Open-ended questions that require thought lead to the synthesis of information. "What are the basic human needs?" can lead to a discussion on satisfying those needs, which leads to a discussion of culture, which leads to a discussion about how "culture" is described by material remains, and the archaeological process. Ask questions and provide wait time. Allow the information time to connect in the students' minds. Encourage involvement by all, by alternating between the front of the audience and the back, side to side, and between boys and girls. Become a moving object as you ask questions and interact with the class through eye contact and body language. You are the storyteller, the narrator of the past.

Interactive techniques can lead students to the basic archaeological concepts and a preservation ethic.

16.3.1. Concepts

Structure questions that lead to multiple concepts. Interactive and visual teaching techniques are especially useful in conveying large sums of new information in a short period of time. Write the question on the blackboard, flip chart, or whiteboard (Table 16.1).

TABLE 16.1. Questions, concepts, terms and vocabulary.

Questions	Concepts	Terms and vocabulary
What is archaeology?	The study of people through the materials they leave behind.	Archaeological site Archaeology Artifact Context
	Removing artifacts from context without proper documentation destroys information.	Feature Scientific inquiry
What is culture?	Culture is the shared set of beliefs, behaviors, and actions, which differentiates one group from another.	Attribute Basic human needs Classification Culture Site structure
	Interpretation of culture in an archaeological context relies on material remains.	
Where did people live?	People select habitation areas based on the availability of resources.	Ecosystem Life-zone Riparian woodland Seasonal-round Sedentary
What are the steps of the archaeological process?	Archaeology is more than excavation.	Archaeological survey Analysis Context
	The site is excavated but the information is preserved.	Excavation Testing Preservation Processing laboratory

16.4. Application of a Strategy

The following example illustrates one strategy for the presentation of information on the archaeological process and cultural history within the formal learning environment. It uses teaching-styles that appeal to visual, auditory, and tactile learners.

16.4.1. Teaching Site Formation and the Archaeological Process

16.4.1.1. Materials

Blackboard, chalk, floor space that can be viewed by everyone, artifacts or replicas representing distinct activity areas of a site (pot sherds; grinding stone and hand stone; beans and corn; hammer stone, leather, antler tine, flakes, core, biface, and projectile point; basketry, bone awl, cordage, cotton, and a spindle whorl) from a distinct time period.

16.4.1.2. Setting the Stage

Begin with an interactive process, soliciting answers from the students—"If I walked into your room could I tell that you were a boy or a girl? What might be in the room that would tell me that you liked sports? Could I tell if you shared that room with a brother or a sister? How would I know what grade you were in?"

"Each house has specific spaces for specific activities. By observing the materials in those spaces and the patterns of materials throughout the house, yard, and neighborhood, we can tell a lot about the people who live there."

Tell a story, make it human—Gently toss a hammer stone, feeling the weight of it and letting if find its comfortable place in your hand. "How many of you have gone camping and forgotten the hammer or mallet that you use to pound the tent stakes? What did you use instead? By picking up a rock and using it, it has become an artifact, something made or used by people." Pass artifacts to be touched and write down the terms.

16.4.1.3. Process

Talk to students about the artifacts as you lay out a series of activity areas in a semicircle in front of you (Figure 16.3). Describe the item, how it is used, and the material from which it has been made. Define use areas as the kitchen

FIGURE 16.3. The presenter explains the site as it develops. (Photo taken by Robin Batty.)

and storage area (pot sherds, ground stone, beans, and corn), tool-making area (hammer stone, leather, antler tine, flakes, core, biface, and projectile point), spinning and weaving area (basketry, cordage, cotton, bone, awl, and a spindle whorl).

"It is 1,000 years ago in southern Arizona. A culture that archaeologists call the Hohokam live here. They were among the first farmers in North America. Archaeological sites containing households and activity areas show patterns of their lives. Broken pottery and grinding stones are located in the "kitchen" area. Hammer stones, leather, an antler tine, hunting points and debitage litter the stone tool making area. Basketry materials, a bone awl, cordage, cotton, and a spindle whorl indicate a spinning and weaving area. People live in this place for 10 years, then as resources become scarce, the site is abandoned as people move on."

"Time passes, the elements, wind, rain, heat and cold have an effect on the material remains. What rots?" Allow students the time to look at the materials. As they identify the organic materials—cordage, basketry, wooden stick from the spindle whorl, cotton, bone, leather, and antler—remove each from the site (Figure 16.4).

"Time moves up to about 1975. Someone is walking in the desert and comes across a scatter of artifacts. Fascinated, he removes the hunting points, decorated ceramics and the spindle whorl." Act out the looting of the site you narrate, "Oh, an arrowhead, I always wanted to find an arrowhead. And, isn't this pretty. I bet I could make a necklace out of this for my sister." The grinding stone and hammer stones get called rocks and moved out of context. All diagnostic artifacts are pocketed.

FIGURE 16.4. Site patterning and activity areas.

"Time moves up to 2000. It has just been announced that the county is going to build a road. They hire an archaeologist to survey the area prior to disturbing the ground." Walk across the classroom and stop when the site is encountered. The archaeologist interprets the site. "We have encountered an interesting archaeological site. The site is spread out. There is not much patterning, so we are unable to distinguish activity areas. The pottery is all plain. The people must not have had any time for special activities like decorating pottery. There are no hunting points, so the people must have been vegetarians."

We have not told the students that removing artifacts from context removes information. They have witnessed it and can be the ones to tell you that the story was altered when artifacts were moved and removed. At this point, it can be pointed out that the removal of the artifact causes the loss of more than the artifacts themselves. When the organic materials rotted and the spindle whorl was taken, it removed all of the indications that cotton was grown and spun. The archaeologist would no longer know where to take the pollen samples.

16.4.1.4. Closure

Ask students if the interpretation of the site was an accurate description of the occupation and activities. If not, what were the problems? Conclude the presentation with a short discussion on laws. Ask students for ideas for taking the image of the artifact without removing it from the site. Most will say "take a photo," "draw a picture." Recommend picking up the artifact, touching it, think of a story that might describe how it came to be or how it landed where it was found. The story can be written down or simply remembered. The artifact can be put back where it was found. Conclude the discussion with, "Where do archaeologists work?" "If you encountered an archaeological site what would you do?" "How would you find an archaeologist to take out to the site so that it can be recorded?" Let students tell you "The phonebook."

16.5. Non-Captive Audience and the Informal Learning Environment

Events represent one type of informal learning environment. Events may be strictly designed as an archaeological outreach effort, or they may include archaeological information as one aspect of the program. The activities may be held in structured or unstructured locations. Structured locations are places designed to move people through them. They include places that attract children and families and maintain regular children's programs and events such as museums and community centers. Informal learning environments include those not usually oriented to children's activities or in a location set up for a one time event, like in a park under a canopy. They may be once a year offering that travels to a different location each year. They draw the public to them as opposed to taking the event to the place that already draws the public.

In either case, the activities must be designed such that they can be led by volunteers with a minimum of training. The target audience is not only the children, but the entire family. Taking the event to a place with a built-in audience increases the likelihood of a high rate of attendance. Children attending events within the informal learning environment are united by interest, although the interest may be on the part of the adult, not the child. Those attending range in age, skill level, and interest in the subject matter.

16.5.1. Presentation of Information

The presentation of information within an informal context invites alternative strategies. The composition of the audience varies as does the length of visitor contact. Children are in attendance with their parents or guardians. Their attention must be directed through concrete activities in this environment as activities will draw their focus. The ability to transfer verbal information is limited, unless the event is a slide-show or lecture. Generally, verbal information is limited to conversations with individuals, as opposed to groups. People move through the event, try hands-on activities, read as they pick up papers, look at displays, and move on.

16.5.2. Presentation Preparation

Pre-event preparation is key to a successful process. Events take place in a variety of locations, potentially without access to resources. Complete reliance is made on the materials transported to the scene. If the event is outside, a ball of string, scissors, tape, and a pile of river cobbles transported with the event materials may save the day, if the wind picks up. Preparation of materials for ease of use is also essential. Set up the hands-on activity materials so they are ready for the child. In the case of cordage bracelets, double the raffia and tie the knot ahead of time. This will allow children to focus on the twining instead of getting set up for it (Figure 16.5). It also allows volunteers to focus their energies on the actual activity instead of time-consuming preparation that can result in a line of children waiting for their turn.

When practical, meet with the volunteers ahead of the event. Teach them the activities and explain the logic as well as the process. Demonstrate the activities and allow time for the volunteers to engage in the activities themselves. Reinforce the learning objectives of each activity so that the volunteer may transfer the information to visitors. Create verbal and visual instructions and examples for each activity.

16.5.3. Group Presentation Request Form

The group presentation request form is well suited to tracking information for the informal learning situation as well as the formal, although the checklist for materials may need expanding based on the circumstances.

FIGURE 16.5. Volunteers instruct children and adults at the Cordage Site.

Alternatively, a second checklist for supplies—what to bring, what is provided, others supplying materials—may be necessary. Creating it as a check list instead of just materials list may help ensure that nothing is forgotten. Copying the forms for the event presentations on an off-white or colored paper will help organization with a visual clue if records for all presentations are kept in the same file or notebook.

16.5.4. Utilizing Educational Techniques

The audience is an unknown. Even in a situation where preregistration is possible, there is no way to know the ages, abilities, backgrounds, and learning styles. It is therefore, all the more important is to incorporate the full-range of teaching styles.

Linking to a common background can be done as an introduction on the handout. Relating archaeological investigation to observing a room in a house and inferring use offers an immediate recognizable link to a very basic common background.

Create text-based and visual examples of each activity. This in combination with the volunteers demonstrating and assisting with the activities satisfies the needs of the visual, tactile, and auditory learners. Activities should have

alternatives. Making cordage requires fine motor skills and abstract thinking that are not well developed in younger children. Creating alternative methods of achieving the goal will keep frustration levels low.

Discussions linking the activity to the information on culture and the archaeological process will help move the activity from simply a "craft project" to an archaeological education experience. Open-ended questioning techniques can be used with individuals or with a group of visitors.

16.5.5. Concepts

Archaeological, culture, and preservation concepts are presented through the connection of the hands-on activities and the handout. The handout begins by relating new information to a familiar background. Each activity is presented as an archaeological site on a tour—the pottery village site, the cordage site, the pictograph wall site. The following information provides an example of the concepts presented on the cordage site.

> People have been making cordage ever since they needed to tie things together. Different materials are used to make cordage, depending on the purpose of the string or rope. Cordage can be thousands of years old! It is rare to find cordage and other organic materials in sites. Sometimes, these materials are found in dry caves. Cotton, corn, yucca cordage, and other organic materials are very fragile. People who study these materials wear cotton gloves to protect objects from the oils in our skin.

In addition to the specific information on material remains and site types, a final paragraph provides visitors with a preservation message. It gives them the resources to assist with preservation, even children.

> Help Protect the Past! Guard It and Keep It Safe!
> If you find an artifact when you are out walking, leave it where you found it and bring the archaeologist to the artifact. Don't know an archaeologist? Check the Yellow Pages! Or, you can contact the state archaeologist at the State Historic Preservation Office.

16.6. Application of a Strategy

The following example illustrates one strategy for the presentation of information within the informal learning environment. The event offered four specific hands on activity areas and a 28-min video on the archaeological process. The event was designed for children of all ages. Nearly 200 children attended the four-hour event.

16.6.1. Albuquerque Archaeology Day

In 2002, the City of Albuquerque, New Mexico, sponsored a series of public events relating to archaeology. While most events did not exclude children, only one was structured specifically for children and families. The

event took place at the New Mexico Museum of Natural History. Advertisement was made in the museum newsletter and in local papers, but most visitors just "happened by." The success of the event in terms of number of people was based on hosting it in a location with a ready-made audience.

16.6.1.1. Materials

Necessary materials were provided by the event organizers through a grant, the museum, and multiple donors. The museum provided large items such as tables and chairs plus craft materials from their education department—scissors, colored washable markers, floor mats, and signs directing people to the activity areas. The grant provided funding for the activities—brown butcher paper, paper bags, water-based paint, masking tape, packing tape, plastic blue beads, raffia, zip-lock sandwich-sized plastic bags, spray bottles, stamps and stamp pads, name tags, and caution tape. The archaeological and historic preservation organizations donated materials that were included in the goodie bags—pencils, archaeology coloring books, balloons, magazines, county maps showing historic places of interest, and "Archaeology: It isn't dinosaurs!" magnets.

Preparations were necessary for each of the four activities: pot puzzles had to be designed and produced on white card stock; raffia had to be measured, cut to size, and pre-knotted; instructions had to be printed and copied; and goodie bags had to be stuffed with handouts. On the day of the event, a "rock wall" and "boulders" had to be cut to size and taped to the wall; and the atl–atl area had to be taped off with caution tape.

16.6.1.2. Setting the Stage

Dress like an archaeologist (Figure 16.6). If you do not have a set of khakis and a pith helmet, the standard jeans, t-shirt, baseball cap, trowel in pocket, plumb bob and tape measure hanging from belt, clipboard in hand will do. Greet people as they enter the building. Welcome them to the archaeology day and distribute copies of the information page and the site map to the children and interested adults.

16.6.1.3. Process

The lobby was set up with discrete but visible activity areas. Each station was created using two tables. Two volunteers supervised each activity. Supplies were placed around the tables and restocked as they were used. Individuals wanting to participate in the activities could follow the written directions or receive assistance from volunteers. In addition to the materials required for each activity, each station had a set of stamps and stamp pads. As children visited a site and completed the activities, they were encouraged to stamp their trail map.

The first "site" encountered as people entered the museum was the Pictograph Wall Site (Figure 16.7). The wall was created with three pieces of

FIGURE 16.6. Dress like an archaeologist. (Photo taken by Terry H. Klein.)

brown butcher or package wrapping paper measuring 3 ft wide and approxi-
mately 10 ft long, laid edge to edge so that the wall was approximately 9 ft
high and 10 ft long. Boulders were created from paper bags and grass was
made from raffia. Visitors were able to leave their hand print on the wall
using a mixture of tempera paint and water applied with a spray bottle.
(Visitors also placed their hand print on a paper bag containing the goodies).

At the Pottery Village Site, children colored pages illustrating pots of local
designs. Each page had information about the pot and the culture that made
it. After coloring, children could cut the pot out and make a puzzle (Figure
16.8). Some kids kept their drawings whole.

Children used twining methods to create cordage bracelets. The raffia (a
natural plant fiber from palm trees) was prepared ahead of time, doubled
over and knotted, and ready for the children to start their bracelet.

The hunting site was located outside of the museum. A corridor between
the building and the parking lot was cordoned off as the atl-atl alley. A card-
board target the shape of a buffalo was set up at the far end of the corridor.
Children were instructed on the use of the atl-atl, (a throwing stick) and the
spear by an experience volunteer.

Safety was taken into consideration with all activities, inside and out.
There was plenty of supervision by the enthusiastic volunteers at each activity

FIGURE 16.7. A young boy leaves his hand print on the pictograph wall.

station with additional volunteers walking throughout the area offering assistance when needed.

16.6.1.4. Closure

Each child took with them their completed projects, the informational handout, the trail maps with the stamps, and a bag of archaeology and preservation oriented gifts, all of which was contained in the paper bag with their hand print. They also took with them a sense of wonder and questions for the future. The experience does not end when they walk out the door.

16.7. Conclusions

Opportunities for the presentation of information on archaeology, cultural history, and preservation are available in both formal and informal learning environments. The formal learning environment of the school classroom offers the presenter a cohesive captive audience and an instructor who can fill in the presenter on details relating to the group being addressed. The

FIGURE 16.8. Displaying a finished pot.

informal learning environment presents unknowns. Even without knowing the group size, age range, and learning-styles of the group, an event can be created using hands-on activities and activity stations that will appeal to all learners. Utilizing educational techniques such as tying new information to previous knowledge, appealing to all learning-styles, and using open-ended questioning techniques not only increases the amount of new information that can be transferred but also increases the potential for knowledge retention on the part of the learner. "Telling" children about the past means involving them in the learning process.

17
Adventures in Archaeology at the Ontario Heritage Trust

Dena Doroszenko

17.1. Introduction

To generalize, public archaeology can be defined as archaeology as presented to the public, participated in or by the public, and in a broader definition, archaeology conducted utilizing public funds (i.e., taxpayer dollars). Access to archaeological resources can be used to fulfill knowledge and belief needs for all peoples or groups. The techniques and approaches utilized to accomplish these programs in Ontario include excavation projects, field schools, school group day programs, summer day camps, public lectures, site tours, and public awareness programs often offered in the context of a museum and/or more recently by archaeological societies.

Archaeology in Ontario, as regulated by the *Ontario Heritage Act* of 1974, and the Ontario Ministry of Culture, ensures preservation and protection of archaeological sites across Ontario and the licensing of archaeologists within the province. Archaeological investigations in Ontario are carried out by a variety of dedicated people, who range from academic researchers and professional consultants, to avocational archaeologists who go out on weekends to study sites. Regardless of the person or persons involved, archaeological investigations in Ontario are undertaken by people, who are licensed by the province and who report their findings to the province so that the information resulting from their endeavors will not be lost. Ontario now has a thriving community of professional archaeologists, who assist in addressing the impact of development on archaeological resources. To undertake any kind of archaeological fieldwork in Ontario, the *Ontario Heritage Act* [Part VI, Section 48(1)] requires that a person hold a valid archaeological license, issued by the Province of Ontario. These licenses are not transferable, are valid for 3 years from the year of issue, and given that report requirements are met on an annual basis, are issued according to three categories: professional, researcher, or avocational. The ministry also provides licenses to divers who wish to dive a shipwreck for conservation purposes (as opposed to a sports or recreational dive). Having a license puts some obligations on the license holder. He or she must report on research findings to the province

[section 65(1)] in accordance with reporting requirements stipulated in the *Act* and ministry guidelines. License holders are also required to report all new sites found during the fieldwork. New sites that are found are added to the Archaeological Sites Database held by the Ministry of Culture. In this way, a person or persons interested in providing public archaeology programs are now required, by law, to be licensed and report on the work conducted under that license.

In this chapter, an overview of the development of public archaeology in Ontario is discussed prior to a discussion on the growth of public archaeology on Trust properties.

17.2. The Development of Public Archaeology by Private Organizations in Ontario

While the Government of Ontario undertook the regulation of archaeological activities in the province, the concept of public archaeology had already been present within the profession itself for decades. Academic archaeologists utilized students in large-scale excavations during the 1960s and in the 1950s; an organization was founded on the basis of providing access to Ontario archaeology to nonspecialists.

The Ontario Archaeological Society (OAS), was founded just over 50 years ago, and has always been quite active in excavating sites and promoting archaeological interests to the public. In October 2000, the OAS moved into new headquarters within a Community Center in Richmond Hill, Ontario. The partnership came about as the town was looking for a steward/custodian for the McGaw site, an Iroquoian site, dating to circa 1400–1450 AD. In partnership with the Town of Richmond Hill, this center provided the OAS with a much higher profile than they have had in past years and as a result, they were actively involved in developing public programs, which include programming for the residents of the town and programming for OAS members. At the end of 2003, a number of successful programs were offered: March Break programs, spring-summer 9-week introduction to archaeology programs, adult learning vacation programs, and archaeology camp programs for kids. Unfortunately, due to funding constraints, the partnership with the Town of Richmond Hill has ended as of late 2003. While an innovative and successful 3-year venture, sustaining a broad based public archaeology initiative was financially constraining for the OAS. With a new office located in the historic Jesse Ashbridge House in the City of Toronto, the OAS held in September 2004, a highly successful Archaeology Day program with activities geared toward fulfilling their mandate on providing access to the archaeological history of the province to the public. These included displays, an archaeology book sale and activity areas for children and booths about paleo-botany, ceramic reconstruction and flint-knapping demonstrations.

The OAS also has chapters across Ontario, several of which are active in the field, providing their members with dig opportunities and/or working

with other partners to establish public archeology programs. As an example, the Ottawa Chapter of the OAS has worked with Bonnechère Provincial Park in eastern Ontario and has had a long history offering public dig opportunities in their geographic area.

The Cataraqui Archaeological Research Foundation & Centre in Kingston (CARF), Ontario was founded in 1984, and has played a major role in heightening the public's interest in local archaeology. The mandate of the Cataraqui Archaeological Research Foundation focuses on education and research, and they have a strong commitment to providing educational programs for all ages and skill levels. Excavations they have conducted whether through their consulting arm in culture resource management projects, public archaeology programs, and since 1998, the summer day camp programs in archaeology, CARF has been visible and popular in the city. With an excellent museum component attached to their headquarters, they offer a variety of programs for the educational system in their community.

Through such activities as presentations to historical and other interested organizations, half- and full-day programs for students visiting from local schools, resource kits for elementary school teachers, and the week-long summer camp, "*Can You Dig It?*" CARF works responsibly to raise the level of archaeological awareness in Eastern Ontario. "*Can You Dig It?*" is a week-long interactive archaeology program. Offered in conjunction with Kingston area museums, "*Can You Dig It*" is run for two age groups, 8–12 and 13–17; due to the nature of archaeological activities and the importance of the recovered information, an instructor to student ratio of at least 1:5 is maintained.

They also offer a half-day workshop entitled "*What Happens After the Dig?*" in which participants learn about the processing and interpretation of artifacts.

The Foundation for Public Archaeology was active during the early to mid 1980s and has been dormant since the late 1980s. Several day programs for school groups were offered at the Front Street Site in 1984 in Toronto, the Roland Burr House in Richmond Hill in 1985, and at Montgomery's Inn in Etobicoke in 1985 and 1986.

In 1985, the Toronto Board of Education was granted $250,000 by the provincial government for the design and implementation of an educational facility—the Archaeological Resource Centre (ARC). Hands-on programs were operated by the ARC between 1985 and 1994 resulting in a large-scale and highly successful public awareness program for the purpose of educating over 200,000 youth and adults in the conservation of Toronto's past (For more details see Smardz, 1997). With full-time staff, the ARC offered day programs for school groups, night programs for adults, and a high school field school every summer. These were their primary programming efforts. The day programs offered were full-day programs and half-day programs for classes. The school groups and field school occurred on archaeological sites over the years including those found on Board of Education property, e.g., Ryerson School, Thornton Blackburn site and the Leslieville School site, as well as other properties such as the Ashbridge Estate and the Half-Way

House on Kingston Road. Unfortunately, in 1994, the program ended due to fiscal restraint within the Board of Education.

The London Museum of Archaeology has offered innovative programming since its founding. This museum is a nonprofit research centre and data base resource for studies in Ontario Archaeology. The museum houses over 2.5 million artifacts for analysis and maintains a public gallery for the interpretation of the 11,000 year occupation of Southwestern Ontario. Adjacent to the museum is the Lawson Provincial Heritage and Archaeological Dig Site. Identified as an area occupied by Iroquoians circa 1475–1500 AD., the excavated portion of the village hosts reconstructions of the palisade, earthworks and one of nine fully excavated longhouses. The museum and reconstructed site are open to the public. For several years they have operated a core program that gives students experience with particular topics related to the Ontario Education Curriculum including Archaeology in Ontario, Aboriginal Ontario, Native Plants and the Environment, Historical and Cultural Topic Workshops, Craft Workshops and a summer day camp on a prehistoric site adjacent to the museum. These camp programs include weeks devoted to Paleontology, Native Archaeology, and Pioneer Archaeology. Outreach and Teacher's resource services are also available. These have been highly successful programs.

The Royal Ontario Museum (ROM) also offers day camp programs, primarily run and operated within the museum facility itself. In 1998 and 1999, a partnership with the ROM and the Ontario Heritage Trust resulted in hands-on archaeology activities being provided for their camp programs on an actual site.

Consulting companies have also undertaken a number of public archaeology programs. These have included everything from simply being "in the public's eye" to human-interest articles in newspapers and television. Archaeological Services Incorporated, in 1999, conducted public programs at an historic site in Niagara-on-the-Lake, the Butler Site, which resulted in a local group banding together and working towards purchasing the site from the developer in order to ensure its preservation and commemoration.

Many of the above noted institutions also have active web sites, which offer web visitors an over-view of their programs, their activities, a virtual museum in some cases and often, summaries on the archaeology of Ontario or specific regions.

17.3. Our Program: The Ontario Heritage Trust and Public Archaeology

As Archaeologist for the Ontario Heritage Trust (OHT), an agency of the Government of Ontario, I work within the context of a public trust. Established in 1967, the Ontario Heritage Trust was modeled in part after

England's National Trust. The mandate of the OHT is to identify, preserve, protect and promote Ontario's built, cultural and natural heritage. As such, it holds a portfolio of 170 properties that have been identified as provincially significant because of their architectural, historical, natural, cultural, or archaeological features. There are 24 built heritage sites throughout Ontario, comprising a built portfolio which include 58 buildings. Eleven of these sites are designated National Historic Sites. The historic buildings span a full range of size and use, from community museums such as the Mather Walls House, Keewatin and Fulford Place, Brockville, to the Ontario Heritage Centre and the Elgin & Winter Garden Theatre Centre in Toronto. The properties have local operating partners or are operated directly by the Trust to include revenue-generating businesses as a demonstration of the successful adaptive reuse of heritage buildings. The Trust owns 146 natural heritage sites throughout Ontario totaling 13,882 acres. These environmentally sensitive or unique lands include Niagara Escarpment lands, farmland, wetlands, moraine topography, undisturbed forests, islands, and other natural areas representative of the Ontario landscape. Land management of these and other natural heritage properties is undertaken through local, provincial and federal custodial partnerships.

The Trust's mandate has also enabled the agency to facilitate research into Ontario's past. This included a grant program not only for archaeology but also architectural & historic studies and natural heritage projects. Over a 17 year period (from 1978 to 1995) the Trust flowed more than $1,000,000.00 in grants to support archaeological research in Ontario. Grants supported archaeological surveys, fieldwork (by professionals and graduate students), collection analyses, scientific analyses and public projects. One such program was the Nestor Falls site, in northwestern Ontario, south of Kenora. The program, run in the late 1980s, was called "Who Passed This Way," which included a component each summer of introducing First Nation's students to the archaeology of their past (Bruyere, 1990)—a program that has also been conducted to a limited degree in other parts of the province, most notably, in southwestern Ontario. A number of other public archaeology initiatives were funded by the Trust over the years including book projects, such as "Snake Hill" and "Death at Snake Hill"—books related to the archaeology of a War of 1812 cemetery (Pfeiffer and Williamson, 1991; Litt et al., 1993).

Archaeology has been conducted on Trust properties since 1974. To date, 45 properties have been archaeologically investigated in regards to assessments, mitigation, research and monitoring. In addition, another 32 natural heritage properties have had Stage 1 Assessment work. The Bruce Trail properties are a future project (there are currently 102 of these with more being acquired every year). As a result, the OHT holds an archaeological collection now numbering over 600,000 artifacts. The collection includes prehistoric and eighteenth through twentieth century artifacts. As with the cultural collections, selected archaeological artifacts are conserved and exhibited: all others are

catalogued and stored to ensure their preservation for future study as required by provincial statute.

Since 1987, the Trust has been involved in either partnering with other institutions, usually educational, to conduct public programs, or it has developed its own. For example, day programs for school groups have been directly offered by the Trust at Barnum House in Grafton, Ontario in 1990 and 1991, and the Homewood museum, near Brockville in 2000 (Figures 17.1 and 17.2). Partnerships have taken place with the Archaeological Resource Center of the Toronto Board of Education at the Ashbridge Estate in 1987 and 1988, where approximately 6,000 youth learned about the history and archaeology of that property. Other partnerships that have been established include the University of Toronto and the ROM between 1998 and 2003. Beginning in the spring of 1998, the University of Toronto ran a field school each spring at the Ashbridge property until the summer of 2000. In the summer months of 1998 and 1999, day campers came to another area of the site to participate in day programs that offered hands-on archaeology. In 2002 and 2003, the University of Toronto ran field schools at the Scotsdale Farm property in Georgetown, Ontario. The focus of this work was a sixteenth century Iroquoian village site.

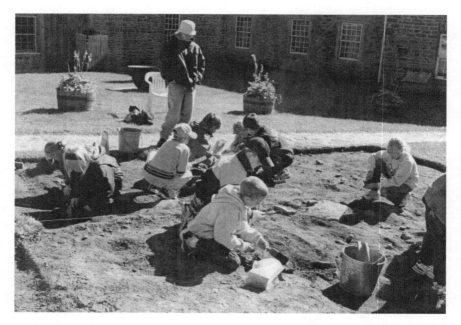

FIGURE 17.1. Homewood archaeology in 2000. Photo credit: Ontario Heritage Trust

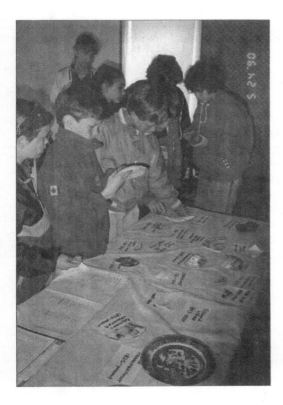

FIGURE 17.2. Barnum House artifact workshop in progress in 1990. Photo credit: Ontario Heritage Trust

17.4. OHT Program Descriptions

17.4.1. School Day Programs

On several properties as noted above, the Trust has conducted half-day and full-day programs for school groups ranging from Grade 4 to Grade 8 and the occasional secondary school program. These programs were most successful on sites which had an immediate resource to enhance the connection between an archaeological site and the historic building—in other words, a house with furnishings. The historical background on the two sites and the general nature of the school programs will be provided first, and then the specific details on the operation and supervision of the school programs will be given.

Barnum House, located near Grafton, Ontario was built circa 1820 by Eliakim Barnum. Barnum House is without doubt one of the finest houses to survive from the early years of settlement in Ontario. Eliakim Barnum was a Vermont native who immigrated to Upper Canada, and prospered here through investments in milling and distilling as well as property development. In 1982, the Ontario Heritage Trust acquired the house and property and launched a restoration and interpretive research program for the house.

Archaeological research was conducted in the summers of 1982 and 1986 by Gary Warrick and in 1987, 1989, 1990 by Dena Doroszenko and Doroszenko and Sherman in 1991.

During the restoration of the exterior of the house in 1989, archaeological monitoring was conducted of the below ground work. It was noted that in addition to artifacts being recovered, archaeological deposits related to the demolition and fire of the earlier Norris house were encountered right up against the foundation of the existing house along the entire southern elevation. This reenforced the interpretation that Barnum House was built on the site of the earlier Norris House, utilizing the Norris House foundations. Furthermore, the east wing foundation implies that the Norris House was possibly larger than the existing Barnum House. Within the deposits were large quantities of fire-hardened nails and melted window glass.

As a result of the richness of the site and the documented stratigraphy around various sides of the house, a project in 1990 was developed to enhance the archaeological investigations, a public educational archaeology program offered to local schools. Over a 5-week period in the spring of 1990, approximately 300 students, primarily grades 7 and 8 from the City of Port Hope, Towns of Cobourg and Colborne, came to the site for full-day or half-day archaeology programs. Class size varied from approximately 20 children to as high as 31. Only one class at a time was permitted per program. The area of excavation was the woodshed to the rear of the house and the research design was focused on determining the extent of the fire debris area surrounding the house and an examination of the woodshed structure. Capital work was to begin in the fall, which would necessitate full documentation of the woodshed foundations before their removal for construction of a new wing on the original footprint of the woodshed. The school groups were utilized to facilitate large-scale excavation of this area and to provide the community with the opportunity to 'touch the past'. While the school groups were on site, the focus of excavation was the large area to the rear of the house. When the school groups were not present or not booked for particular days, the field crew was continuing excavation in the woodshed area or excavating units at the front of the house. The rear area had substantial fill on top of the more sensitive fire deposits and this was determined to be an appropriate location for educational programming. The school groups excavated only in the fill layers and once the fire deposits appeared, the students were moved over to other units to continue excavating the fill deposits. Class after class, and in particular, the teachers, exclaimed how valuable they found hands-on programs in archaeology. The ability to touch the past fostered an appreciation for the history of their community beyond the classroom.

Homewood is another OHT property located just east of the Village of Maitland, in eastern Ontario on the St. Lawrence River. Dr. Solomon Jones was born in Connecticut in 1756. The family moved to Fort Edward, New York early in his life and he took his first medical training at Albany. They were a prosperous family, involved in farming, milling, land speculation and local government.

When the American Revolution began, Solomon served as Surgeon's Mate in Jessup's Corps and at this time, completed his medical training in Montreal. At the end of the war, he left to take up land in Augusta Township in the first wave of Loyalist resettlement. He was accompanied by his wife and his mother. Three of his brothers, John, David and Daniel Jones also settled in the area.

Solomon's first grant of land was Lot 17 and the east half of Lot 18 in the First Concession. His final choice for settling down was Lot 22 and the east half of Lot 23, Concession 1, August Township. His first home was a log cabin located closer to the St. Lawrence than Homewood. The family lived in this dwelling for 15 years. During this time, Dr. Jones established his medical practice in the community. He was the only doctor between Cornwall and Kingston from 1785 to 1800. The family oral history tells of the time that there was a surprise social visit to their home by Chief Joseph Brant, accompanied by 500 of his warriors as they traveled westward (Brant had apparently been a friend of Solomon's in-laws, the Tunnicliffes).

Excavations on the property took place in 1979 by Rita Michaels (1980), 1993, 1999, 2000 and 2002 by Dena Doroszenko. The year 2000 project was designed purposefully for school programs. The area selected for excavation was the location of a number of outbuildings: a smokehouse, privy and ash pit. The students excavated the topsoil and recent fill layers over this area. Again, large-scale excavation allowed plenty of room for excavators to work. The project ran for 3 weeks and approximately 300 children (Grades 6–8) from the City of Brockville to the Town of Prescott participated in the program.

17.5. Excavation Procedures

In the above two cases (Barnum House and Homewood), the programs included a tour of the house in order to provide a context for the finds the children would discover that day. Full-day programs worked best due to the length of time the classes would experience on site. Tours generally took approximately one hour, at times a slide lecture about historic archaeology was first given to the entire class, after which, the class was split into two groups. The first group would have a tour of the house museum and then take part in artifact workshops, while the second group went immediately outside to begin their hands-on digging experience. The amount of time an individual child would spend in the field would be a maximum of 2 h during the day. The supervisor to child ratio was 1 to 5 maximum, and when a class of 25 was split, in the field this often resulted in a 1 to 3 ratio providing each student with individual attention. The children experienced all of the basic aspects of fieldwork which included: troweling, sifting soil, recording the position of artifacts within a unit, learning how to Munsell a soil color and how to tell the different types of soil. In addition, artifacts uncovered were identified and discussed with the children.

These programs were on active sites. Beyond the work with the school children, professional archaeologists identified, dated, catalogued, and

analyzed the material. Professional reports were submitted for each project under the requirements of the Ontario Heritage Act's statutory regulations (Doroszenko, 2002, 2003; Doroszenko and Sherman, 1991).

After numerous tries at full-day or half-day programs for school classes, it has become evident that this is the most expensive program to deliver; yet on the other hand, these programs experience the most exposure to a community population. The primary reason for problems with these types of programs is the difficulty in recovering the costs of the program. To charge the real cost of delivering a day program would be beyond the means of most families given the small fees generally charged for field trips for school groups. Therefore, either the institution or agency delivering programs of this type recognizes this from the onset, or one of two approaches need to be considered. First, charge a more realistic fee and gauge the number of bookings to be indicative of the programs' success in the community regardless of the fee structure or; Second, find a corporate sponsor or obtain a grant to subsidize the necessary expenditures for the delivery of the educational program and subsequently charge a small fee for the program.

The Ontario Heritage Trust has examined what has been successful over the years and determined that summer day camp programs are more cost recoverable than school programs and provide children with exposure over a longer period of time to the philosophy of conservation and preservation that is inherent in our mandate as a heritage organization.

17.5.1. Summer Day Camp Programs

In discussion with other providers of public archaeology programs in Ontario, summer day camp programs appear to be the most successful activity with a number of organizations across Ontario as of 2004. These programs enable realistic cost recovery and sustained periods of activity that provide the participants with a glimpse of the archaeological profession.

Beginning in 2002, the Trust undertook a partnership with the City of Toronto at their jointly owned property, the Spadina museum. (Figures 17.3 and 17.4)

Dr. Baldwin's new country home, probably finished in 1818, was named Spadina, derived from an Indian term Ishapadeena, meaning a hill or a sudden rise in the land (Thompson, 1975: 81). In 1835, the first Spadina burned down to the ground under unknown circumstances. Construction of a new house on the site was apparently delayed for one year while Dr. Baldwin completed the building of his large house in town. The second Spadina was completed by the end of 1836. In 1866, the property now consisting of 80 acres between Davenport Road and St. Clair Avenue was purchased by James Austin.

James Austin and his family immigrated to York in 1829. Young James Austin was apprenticed to the printing establishment of William Lyon MacKenzie for four and a half years, while the rest of his family moved to a farm in the Township of Trafalgar. On his return, he went into the wholesale grocery business with Patrick Foy in 1843. James Austin was, in later years, a

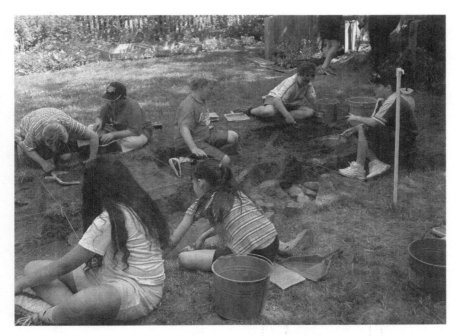

FIGURE 17.3. Summer day camp program at the Spadina Museum in 2003. Photo credit: Ontario Heritage Trust

prominent member of Toronto's business community. In 1844, James Austin married Susan Bright and they had over the years, five children. Having purchased Spadina in 1866, James Austin decided to make a number of changes. He demolished the 1836 Spadina and began construction of a much larger house on the same site, using the same foundations. In 1897, James Austin died, leaving the Spadina property to his youngest son, Albert William Austin. It was under Albert's tenure that a great deal of building activity took place at Spadina in the form of additions to the 1866 structure.

In 1982 and again in 1983, major archaeological investigations took place at the Spadina property by professional archaeologists. Conducted under the auspices of the then Toronto Historical Board, this work investigated several areas in the first season including the south basement; the Baldwin Cottage area and the east side of the house (Doroszenko, 1983). In 1983, the field season concentrated again on the south basement and outside, in the garden and orchard areas (Doroszenko, 1984). A third season occurred in 1988 and concentrated on other areas in the basement of the house (Cataraqui Archaeological Research Foundation, 1988).

In the summers of 2002, 2003, and 2004, two week summer day camp programs in archaeology were offered jointly by the OHT and the City of Toronto. These programs were fully booked and had waiting lists. In 2002, the programs were offered to children aged 8–12. In 2003, the age group was

276 Dena Doroszenko

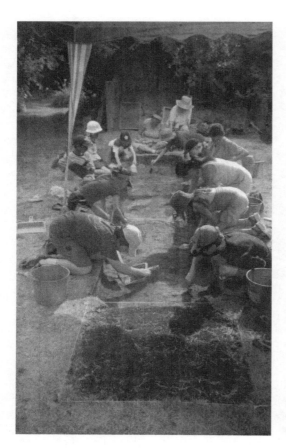

FIGURE 17.4. 2005 Spadina
Museum summer day camp in
the field. Photo credit: Ontario
Heritage Museum

narrowed to ages 10–13. In financial terms, with two summer students (field
school trained undergraduate university students) provided through federal
and provincial employment programs, the revenue from each week of the pro-
gram allowed for two professional archaeological staff to be hired to assist in
the supervision of the program. The gross revenue was divided between the two
organizations with a larger portion allocated to the OHT due to the higher
staffing requirements. The field costs of the project were cost recoverable as a
result.

The area selected for excavation was to the rear of the chauffeur's residence
and garage. This was an area not previously tested to any great extent. The
stratigraphy of this area was straightforward, due to testing in 2001, and
demonstrated at that time that artifacts were present in this area. Added to
the fact that the area was somewhat separated from the house museum, the
area was ideal for public programming.

The ability to sustain the interest of young children while digging can be
quite challenging. A variety of activities are necessary in order to keep the

children intellectually stimulated and ensure they don't become bored or feel the camp program is too much like school. The camp has a maximum number of 15 children per week (with a ratio of 3 to 4 children per adult). The program begins with a tour of the property, followed by a video about the family who lived in the house and then a tour of the historic house museum. After this, each day is spent in the field, learning the basics, on a gradual basis. The entire group is split into a "Baldwin" group and an "Austin" group. They stay in their groups every day and rotate from excavating to activities every half day. For example, on Tuesday mornings, the Baldwins begin excavating in the morning and after snack time, they undertake activities that include short workshops about family genealogy, stratigraphy, putting things back together from artifacts to the site, washing and labeling artifacts, drawing artifacts, and even painting a banner for the group on the last day. The Austins undertake the scheduled activity first and after snack time are in the field. Every child excavates in the field for no longer than 2.5 h/day. In 2003, a visit and tour of the City of Toronto Archives was incorporated in the program down the hill from the museum. This also allowed a short walking tour of the neighborhood to occur. The main thrust of each week program is to try and give the children an understanding of 'context' and how important that concept is to archaeology. We attempt to give them a view of their world through the eyes of a building that has been in the landscape for several generations. The emphasis through the fieldwork and particularly artifact discussions is "change" and the comparison of life today to the experience of the past. What has also become important is to recognize that "camp" needs to incorporate "fun." This has developed, as of 2004, by inserting short breaks during the day, usually right before lunch and at the end of the day before they are picked up by their parents, and allowing the children to play games. These games also often include aspects that are relevant to archaeology. For example, one game played is known as the Stalking Game and involved the children being designated as "game" or "hunters." The designated game individuals are blindfolded and learn to listen for the hunters who must slowly stalk them and tag the game without being discovered. Another game is the "Deer Hunt" which involves a team of deer and a team of hunters. The object of this game is to learn how to strategize as a team and how to get the deer to herd through a deer run. Needless to say, these two games have become popular because they involve activities which are fun.

17.6. Conclusion

To conclude, by offering dynamic and innovative programming, institutions in Ontario, such as the Ontario Heritage Trust, are forging into the twenty-first century with an awareness and public education mandate much stronger than ever before. As archaeologists continue to identify, research and preserve sites,

public outreach programs are becoming a responsibility that can not be ignored whenever archaeological investigations are taking place within reach of a community. In order for the public to understand the importance of archaeological preservation and protection, this should be a priority for all those involved. The challenges faced by the profession are how to balance the demand versus the cost of delivering public programs. We all own the past and archaeologists have the ability to include the general public in their projects.

References

Bruyere, S., 1990, Who Passed this Way? Archaeology at the Falls. Unpublished manuscript. Ontario Heritage Foundation (OHF), Toronto, Ontario.

Cataraqui Archaeological Research Foundation, 1988, The Spadina Archaeology Project 1988. Unpublished manuscript on file with Ontario Heritage Foundation, Toronto, Ontario.

Doroszenko, D., 1983, *Spadina House Archaeological Research Report: 1982 Field Season*. Report on file with the Ministry of Culture, OHF and the Toronto Historical Board, Toronto, Ontario.

Doroszenko, D., 1984, *Spadina Archaeological Research Report: 1983 Field Season*. Report on file with Ministry of Culture, OHF and the Toronto Historical Board, Toronto, Ontario.

Doroszenko, D., 1987, *Conservation Activities on Ontario Heritage Foundation Properties:* 1987, Toronto, Ontario.

Doroszenko, D., 1989, *Conservation Activities on Ontario Heritage Foundation Properties: 1989*. Toronto, Ontario.

Doroszenko, D., and Sherman, E.M., 1991, *Barnum Carriage House: Public Archaeology Project, 1991*. Unpublished manuscript on file with the Ontario Heritage Foundation and the Barnum House Museum, Toronto, Ontario.

Doroszenko, D., 2002, *Barnum House Archaeology 1990*. Unpublished Manuscript. Ontario Heritage Foundation, Toronto, Ontario.

Doroszenko, D., 2002, *Homewood Archaeology 1993 Field Season*. Unpublished Manuscript. Ontario Heritage Foundation, Toronto, Ontario.

Doroszenko, D., (2003) 2000 *Archaeological Investigations at Homewood, Brockville, Ontario*. Unpublished Manuscript. Ontario Heritage Foundation, Toronto, Ontario.

Litt, P., Williamson, R.F., and Whitehorne, J.W.A., 1993, *Death at Snake Hill: Scenes from a War of 1812 Cemetery*. Ontario Heritage Foundation, Local History Series No. 3. Dundurn Press, Toronto, Oxford.

Michael, R., 1980, Homewood Archaeology (rev). Unpublished manuscript. Ontario Heritage Foundation, Toronto, Ontario.

Pfeiffer, S. and Williamson, R.F., 1991, *Snake Hill: An Investigation of a Military Cemetery from the War of 1812*. Dundurn Press, Toronto, Oxford.

Smardz, K., 1997, The Past Through Tomorrow: Interpreting Toronto's Heritage to a Multicultural Public. In *Presenting archaeology to the public: digging for truths*, edited by J.H. Jameson Jr., pp. 101–113. Altamira Press, Walnut Creek, CA.

Thompson, A.S., 1975, *Spadina: a Story of Old Toronto*. Pagurian Press Ltd., Toronto.

Warrick, G., 1982, *Archaeology of the Barnum House, Grafton, Ontario: 1982 Investigations*. Manuscript on file with the Ontario Heritage Foundation, Toronto, Oxford.

Warrick, G., 1986, *Barnum House Archaeology: 1986 Investigations*. Manuscript on file with the Ontario Heritage Foundation, Toronto, Oxford.

18
Excavating the Past: 20 Years of Archaeology with Long Island, NY Students

Gaynell Stone

18.1. Introduction

During the last twenty years, thousands of Long Island students have been introduced to the principles and practice of archaeology, albeit during the regular public school programs in the museum education programs sponsored by the Suffolk County Archaeological Association (SCAA). Began almost accidentally, with only modest support from the SCAA, the quality of the day-long programs has attracted an ever-growing demand. We offer outdoor programs on Native Life and on Colonial Life during the spring, summer, and fall, and during the winter months additional workshops are provided in schools and libraries. This chapter will discuss the development and growth of our program and its outreach work for elementary, middle, and high schools on Long Island.

18.2. Background

In the early 1980s, while a graduate student in the Anthropology Department at Stony Brook University, I discovered that most local histories began with the English colonists—even giving little attention to the earlier "Dutch" inhabitants (all of the many multicultural peoples who were not English). The extensive prehistory of the Island was largely ignored or glancingly acknowledged. Avocational archaeologist's reports were scattered in various newsletters and journals, many obscure. Aside from Harrington's and Saville's ca.1920s' excavation of Shinnecock and Montaukett sites, the post-WWII reports of Ralph Solecki on Ft. Corchaug and other sites, Carlyle Smith's overview of Long Island coastal archaeology, Ritchie's Orient Culture research, Bert Salwen's site reports, and Ron Wyatt's study of the Archaic on Long Island, there were few professional archaeology reports (Saville, 1920; Harrington, 1924; Smith, 1950; Solecki, 1950; Ritchie, 1965; Salwen, 1968; Wyatt, 1977).

Interested citizens had no accessible accurate information to refer to on their region. Concurrently, I was developing and teaching courses on regional

culture history (Long Island Native Americans, Archaeology, Cultural Geography, Multicultural History, etc.) in Stony Brook University's graduate program for teachers, and for the Suffolk County Organization for the Promotion of Education, a regional teaching training institute. Teachers of gifted students approached me with the problem that their elementary students loved archaeology, but that the teachers could "fake" it—read and talk about it—only so long. The students hungered to excavate; could I set up a properly supervised "dig" for their students? So, almost accidentally, our archaeology program began in 1983 and continues to grow every year.

Earlier, in the mid-1970s, some of the faculty and graduate students of the Anthropology Department had founded the SCAA as a voice to preserve archaeological sites, which were rapidly disappearing with the frenetic development of the time. Dr. Phil Weigand, then chair of the Anthropology Department, was very supportive of this and later founded the Long Island Archaeology Project as a contract archaeology entity (Cultural Resources Management) within the department. As the secretary of the SCAA, I sent scores of letters to all levels of government apprising them of their archaeological record and the responsibility to survey, test, and possibly excavate or mitigate sites. It was a daunting educational effort—which still goes on —as most agencies didn't really want to know about this responsibility. The State Environmental Quality Review Act (SEQRA) law provided a legal requirement that helped, but emphasized environmental review more than archaeological assessment, and its requirements didn't cover most of the development on the Island.

To address the lack of information on regional culture history for the public (and officials, who were usually astounded at their area's archaeological resources), SCAA began a series of volumes, which began with current professional commentary on reprinted early articles and later included the contemporary body of professional archaeology as it developed (Stone, 1975, 1976, 1978, 1980, 1983, 1993, 2006; Stone and Ottusch-Kianka, 1985; Truex, 1982). There are nine volumes in this series, *Readings in Long Island Archaeology & Ethnohistory*. Librarians tell us they are the most stolen books in the library—now all put in the reference section to protect them. These reference volumes have provided the scholarly data used by academic and CRM archaeologists. These volumes also provide the background information needed to produce curriculum materials and posters for the museum education programs we have developed, for museum exhibit catalogs, and the documentary films we are currently making (Truex and Stone, 1985, Stone, 1985, 1988, 1991a, b, 1992, 2007, Martin et al., 1985).

The SCAA's archaeology-based education programs could not have been developed without this research base. It is the major museum education program in the area that is based on scholarly research. SCAA's educational purpose is fulfilled by the museum program as well as our three times yearly Newsletter, which is sent to County public libraries, historical societies,

museums, regional archaeologists, and Town Historian's offices. Our preservation mandate is carried out by advising and consulting with local government planning and other departments.

18.3. The First Program

The SCAA Board had been meeting at Hoyt Farm Park in Commack, Town of Smithtown, in Suffolk County which was known to have prehistoric and historic cultural resources. The staff at Hoyt Farm Park has much oral history information, photographs, a Hoyt painting of a former Dutch gambrel roof barn, and an Edward Lange ca.1890s' watercolor of the farmstead, which showed how differently the site had been used over time. In addition, the Farm Diary kept by Mr. Hoyt tells what they were growing if not always where.

Bob Giffen, manager of the Park and a naturalist, had helped excavate a Connetquot River Native American fish smoking site with Walter Saxon, then an archaeologist of the Garvies Point Museum & Preserve, the geology and archaeology museum of neighboring Nassau County. So, Giffen was receptive to our laying out a couple of 5 ft squares to provide a full school day "excavation experience" for the fourth to sixth grade gifted students. Thus, almost accidentally, our program began. We in SCAA realized that if we wanted the future voters of the area to be aware of our invisible archaeological resources and be preservation minded, we needed to work with students. With our graduate student board members and colleagues, we had part-time staff to carry out our program.

There seemed no point in using a "planted square" (one created by us) to introduce students to archaeology when there was so much about the farm that Giffen would like to know. For example, we created squares under a porch roof over the entry to our barn museum (to be able to excavate in inclement weather), expecting to find nothing. To our surprise, we found lost farm tools, brick features, and building debris.

An elderly man who had planted the trees when he was young said they dug up "arrowheads" every time they dug a hole; he had a "quart" (jar) of them. Visitors to the park trails have found more projectile points than we have in all our squares. We knew we would not excavate a sensitive site with students if we located one, which we have not found to date. Most of our work has been on twentieth century sheet scatter and occasional refuse deposits.

Shovel tests to sterile soil (usually less than 60 cm) found highly variable soil composition with large amounts of clay. Stratigraphy can be better ascertained from the excavation squares, some of which are always open for the program, since the students work very slowly and remove very little soil in their ca. 20-min turn in the squares during the school day programs.

We began this on-going program in 1983 at Hoyt Farm Park, which came to be called "Native Life & Archaeology." Teachers from dozens of school districts appreciated it so much and asked if we had more; from this came the

development of our second program, "Colonial Life & Technology," six years later at the Blydenburgh County Park (approximately 2 miles away, also in Smithtown Town), which has a gristmill and mill remains complex dating from 1798. These archaeological educational programs operate mostly in good weather—mid-September to mid-December, mid-March through June, following the school calendar.

In 1996 both Nassau and Suffolk County Boards of Cooperative Educational Services, Gifted and Talented and Enrichment programs, requested that we initiate archaeological field schools for their students in July. Nassau BOCES booked one week full-day field school and Suffolk BOCES chose two weeks of half days; elementary through high school students come from dozens of school districts in both counties. Some students come back year after year to Blydenburgh County Park to further study its cultural remains.

Since "local studies" are required in the fourth or fifth grade New York State curriculum, and Native Americans (or other cultures) are studied in second, fourth, and seventh grade, all of these grades have attended our program, the fourth graders mostly. Despite our bias that second graders would be too young, we have found them to be very serious and attentive; of course, we modify activities to suit their level of development. Tonia Deetz Rock (2002, personal communication) found the same unexpected results in her extensive work with second graders. The summer field schools usually include middle and high school students, as their schedules make it difficult to attend the school day program. Also the BOCES programs recruit the students, over which we have no control. But, we group students by age/grade level during the program, as they rotate through the various activities, so this is not a great problem.

18.4. Changes Over Time

The programs have had many permutations over the years as we experimented and evolved. The first sessions at Hoyt Farm Park (before we had the extensive previsit materials we have today) consisted of introductory sessions with the students on why and how to do archaeology, as well as types of artifacts so they would recognize what they were finding. Then we trundled down the trails with all our equipment to the forest plot, where we shovel tested and opened some areas to excavation. Few Native American artifacts have been found, negating the hypothesis that there would be a presence there due to proximity to the vernal pond. Currently we are excavating around the remains of a workshop, whose post underpinnings are still in place. A spot where a nineteenth century barn once stood is another area we can explore in future. The students never seem perturbed that we are finding historic period artifacts rather than Native American ones. They are excited about anything they find, and we relate the artifact to the on-going history of the site.

What started out as a program with a major focus on archaeological excavation changed to a program where students learn about Long Island

history and culture through archaeological discoveries made by professionals and themselves. Today, student excavation accounts for only a 20–30-min component for each group out of the full-day program. The excavation experience demonstrates how archaeologists work and that it is a very careful and meticulous process. Students enjoy the process and realize that archaeological work is not what is depicted in the movies. The rest of the program (which is described later in this chapter) shows students what we have learned *from* archaeology. Our program has changed through time with input from the educational community.

18.5. Input from the Community

As word spread on the educational grapevine about this wonderful new experience for students, an administrator from a local Suffolk Board of Cooperative Educational Services (a liaison group between local schools and the New York State Education Department) wanted to take over the program. That would mean loss of archaeological oversight, as they would have their teachers run it. Fortunately, an advisory board of school principals and superintendents supportive of our endeavor advised against this, so we archaeologists could continue to develop the program. The innovative Shoreham-Wading River School District, from Superintendent Dr. Richard Doremus, to Elementary Education Director Dr. J. Kenneth Gorman, to an exceptional group of fourth grade teachers, especially Peggy Waide and Linda Harris, participated and consulted in the development of our programs, which are unique for the Metropolitan area of New York City. The National Museum of the American Indian, Heye Center in New York City, has recommended our programs as exemplary.

However, the board advised us to structure the program so that a full bus of students (2 or 3 classes) could be accommodated at one time (buses are expensive; a half-full bus even more so); that the program run a full day (ca. 10 A.M. to 2 P.M., fitting within the usual school day); and that we mesh better with the school curriculum. This advice has shaped our programs in which archaeology is embedded within topical experiences (Native Life and Colonial Life) that correlate with and enhance the school curriculum. If our program was entirely archaeology, there would be very few participants, as many schools cannot take a field trip unless it meets a substantial part of the State Learning Standards. Our program meets over 90% of these standards, since its topics and archaeology are so multidisciplinary.

We secured partial grant funding for the production of the posters, which are part of the postvisit materials, in cooperation with BOCES and the New York State Council for the Arts; for development of our hands-on museum interpreting Long Island Native Life from the New York Council for the Humanities and the Center for Excellence & Innovation at Stony Brook University. We have collaborated with SCOPE for teacher workshops utilizing

our site, activities, and materials, as well as museum exhibits based on our research. Our previsit booklet, *A Way of Life: Prehistoric Native Americans of Long Island—Paleo, Archaic, Woodland, 12,000 to 3,000 Years Ago*, exemplifies the cooperation of regional scholars, museum archaeologists, historical societies, the then Museum of the American Indian, teachers, SCAA officers, Shoreham-Wading River School District teachers, and SCOPE officials. Its publication has been funded by the Suffolk County Office of Cultural Affairs and the New York Community Trust (Westchester).

18.6. A Typical Day—Program of Native American Culture History

Prior to coming to our program, we send teachers our 50 page introductory activity packet (Martin, 1986) on how and why we do archaeology, how Native people got to Long Island, how we know how they lived, etc. and our 14 page booklet, *A Way of Life.* by James Truex and Gaynell Stone (1985). By the time students arrive they have some expectation of what they will be learning and experiencing during the day. This is written on a 4th–6th grade level (although many adults don't see it as a *child's* booklet) and is heavily illustrated.

Students coming to Native Life & Archaeology spend the day rotating among three stations: each 1/3 of the total students rotate among—(1) the hands-on museum with large murals of Long Island Native American lifeways through time and how it changed with the environment, and a demonstration square to show how to excavate ("trowel" not dig), plus excavating at the current archaeological squares for ca. 20–30 min to show how we have learned about prehistoric Native life; (2) an ethnobotany walk on the trails with fire making and shelter building to show how Native people made a good living from the forest; and (3) experiencing primal culture by cooking (corn cakes and vegetable soup) around a sheltered hearth and pounding corn in a mortar; they also visit the bark-covered wigwam to experience Native American shelter, and sit on bear and deer skins to drill pieces of slate with a replica flint drill to make a pendant to wear home. Faces are painted with red and yellow ochre, much of it found on the site, and Native American technology items are viewed.

Every part of the program is related to the rest of it: a burl, like the burl they see on a tree trunk on the trail, is transformed by fire technology into a wood bowl in which we demonstrate rock boiling (faster than a microwave!). The drill they use is the same as an artifact in the museum; all the cooking utensils are made of natural materials. On the trail they make fire with a bow drill, the origin of the fire they cook over. They see and use skins of animals they have never seen in real life; they experience how a wigwam is constructed and lived in. They use replica artifacts that we know about only because the original was once excavated—the point of the archaeology experience.

During the *Powaw* (now Pow Wow) at the end of the day, students hear traditional regional Native American music, accompany it with authentic musical instruments, eat the food they have cooked, and accompany a song the staff acts out. Students and teachers go home tired and inspired.

The "Please Touch" museum, in a recycled rough wood-paneled barn, is used to transport the students from their twenty-first century life to a culture of thousands of years ago. Each mural is surrounded by the artifacts, eco-facts, and animal skins and bones of its time period. Even a child who could not read could see what was happening. The hunting technology of each period hangs over its mural; the projectile points of each period are displayed on tree trunk bases, as are all skins, artifacts, etc.

The Paleo-Indian period mural depicts a tundra environment with a spear overhead. The Archaic Period mural shows the change in environment, with trees from which to make a bark wigwam and a dugout canoe with the hunting dart and atlatl overhead. The Late Archaic or Transitional Period mural depicts the drama of a burial of the Orient Burial Cult on Long Island, with leather clothing and a turkey feather rain cloak nearby. Models of round and oval wigwams and a long house show the different types of shelter used on the Island; these are next to a 10-ft diameter mat-covered wigwam with a cattail mat in process of weaving. The Woodland Period mural shows all the varied village activities of that time with a bow and arrow overhead. Whale ribs and vertebrae indicating whaling, a digging stick and scapula hoe indicating horticulture, and clay pots are below.

The Contact Period mural shows Fort Corchaug, one of the seven known European-inspired Native American forts built on Long Island for trade and protection, with strings of wampum and trade beads below illustrating this contact of Europeans and Native Americans as well as a brass tipped arrow overhead. An authentic replica dugout canoe below holds the new material culture: copper pots, woven duffel cloth, glazed Dutch ceramics, etc. The staff also notes the invisible things that came with the Europeans—the diseases that decimated the local Native American population.

A mural bristling with images of Historic Period Native American life— from shamans to Christianity, wigwams to vernacular houses, shore to ocean whaling, skin clothing to European textile clothes, Natives Americans as soldiers in American wars, etc. completes the mural story. In process is a mobile of photographs of current local Native Americans, possibly neighbors or ancestors of some of the students, to show they are still here.

A mock waist-high 1-m square, with stratigraphy on the side walls and the many types of artifacts that may be found in the various layers of soil, bridges the museum to the outdoor archaeological squares and is used to demonstrate how to scrape, not dig, at the archaeological site. This rich visual, sensory, and material environment provides all the answers needed for the State test on Native American life, for which teachers are very grateful. Students retain information in this fashion much better than reading a printed page.

18.7. The Excavation Experience for the School Day Program

Three 2-m squares are used for larger groups closer to 20 students and two for smaller groups, with one staff member for each square, about a 1:5–7 ratio. To ready the squares for the student archaeologists, staff groom it and take depth measurements each morning. The students are intently supervised as they carefully scrape the soil; those who cannot do so carefully with a trowel are given a brush to work with or asked to step out of the square and observe. Some of the students of each square may be washing artifacts they found or assisting with sifting. All students in a square stop working when an artifact is found so they may observe or participate in measuring in the artifact to maintain horizontal and vertical control—and to reiterate the importance of record keeping. The student who finds the artifact enters the data into the square Record Sheet and traces it on the back (so we can tell one piece of glass, etc. from another in the field). Artifacts are different types of glass, nails, coal, some tools and ironware, and limited ceramics at Hoyt; more ceramics are found at the Blydenburgh site, as well as a few doll parts and other such esoteric nineteenth and twentieth century objects.

Since these teaching sites are so shallow, less than 60 cm, the students usually excavate to sterile soil; staff do the last bit if necessary, which seldom has artifacts. Staff catalog and clean the artifacts each day, summer field school staff and students process the artifacts, the Archaeology Manager enters them into the Access database, and I do a report (photographs of artifacts and analysis) for sites each year. Cases of the artifacts found enrich Blydenburgh's interpretation room. The Hoyt House Museum is seldom open, due to staff shortages, but cases of some of the artifacts excavated also enhance it.

Parent chaperones (required by school districts at one for each ten students and by us for supervisory purposes) often assist with the sifting and other tasks that may be needed. At the close of the period, each square group shows its findings to the others so all will know the breadth of what is being found and what it may mean. They have learned that archaeology is hard, careful work with lots of record keeping. Many seem to realize that doing this is why they have been doing all that math and writing in school! They also have experienced a different culture and time period and "archaeology as discovery" as best one can in a twenty-first century park setting. At the end of the day staff map soil color changes; in actuality, very little soil is removed each day.

18.8. Postvisit Education

Postvisit materials are given in a sequence each year—first, a colorful poster, *After Your Visit*, suggesting many follow-up activities, illustrated by Peggy Waide's students early in the program (Martin, 1986); second, the *Native Technology* poster showing how all technology evolved from flint knapping

through to today's power tools (Stone, 1988); third, the *Native Long Island* map illustrating many known Native place names on the Island, important sites, pictographs, artifacts, developed to counter the often repeated myth of "13 tribes on Long Island" (Stone, 1991b, 1985); fourth, the Montaukett exhibit catalog (Stone, 1991b); fifth, the exhibit catalog on "Women's Work: Native and African Women of Long Island" (Stone, 1992); sixth, *Study Pictures of Coastal Native Life* taken from White's pre-1598 drawings (Stone, 1985). For succeeding years we have a series of activity sheets based on Native artifacts found on the Island (taken from our reference volumes). For very young children (who do not excavate) we have an *Animal Tracks* poster and activity sheet, since they have done animal tracks at the site.

We have teachers still coming almost since we began; after a few years they can turn their classroom into a museum by displaying these materials. Students write us letters on many aspects of the program, sometimes send queries for us to answer, and once in a while send a mural they have made based on their experience in the program. Many teachers tell us or call spontaneously to thank us for the "best field trip we have ever been on." Ratings of this trip by students and faculty who book through the BOCES are uniformly "Excellent" or "Very Good."

18.9. Historical Archaeology and Our Multieducational Experience

Fall is "Native American time," so we are largely booked for fall by midsummer. Some schools also book our Colonial Life program (which also includes archaeology for larger groups in order to keep group size manageable) at Blydenburgh County Park only a few miles away in the fall also. But, following the school curriculum, winter and spring are "Colonial time." We are completely booked for the spring Colonial Life program before the year's end. Colonial Life mirrors the structure of Native Life (which exemplifies Long Island before the Europeans), but shows what happened after Europeans brought their metal economy.

18.10. Previsit and Postvisit Materials and Workshops

For the school year program, extensive previsit materials include information on the site and the history of the Hoyt-Wicks house, and on waterpower, mills, and the site for Blydenburgh. Segments on learning a trade (which we do in the Colonial program), on crafts, on the Principles of Simple Machines (required in fourth grade science), on how and why we do archaeology, and on early Long Island's multicultural history not in the textbooks are included. Postvisit materials include many activities, such as assembling a house, archaeology in the classroom, preserving food, games of the period, and much more.

FIGURE 18.1. In-school archae-
ology workshop probe box in
action.

We also provide in-school workshops on Native Life, Colonial Life, and
Archaeology for those who cannot come to our site. We have extensive
authentic and replica artifacts for each topic so that students can get a
sense of the period and the craft. Some previsit materials are also provided
for the workshops. The Archaeology Workshop includes excavating artifacts
from a replica dirt "square," mapping artifacts in a 2-m square outlined with
tape on the floor, placing prehistoric and historic artifacts in the correct time
period in a 3-level Plexiglas "square" representing stratigraphy, and a Probe
Box to demonstrate how archaeologists can probe the ground to find sub-
merged remains (Figure 18.1).

18.11. The Colonial Program Day

The full-day program is divided into the following sequences:
Hands-on Technology—instead of stone tools and primal technology, stu-
dents experience the Colonial metal economy by blacksmithing (each one
makes an S hook to take home to surprised parents); working with antique
tools in a re-created nineteenth century child-size workshop where they saw,

plane, drill, and make shingles; learning the background of textile production by carding, spinning, and weaving; cooking in a kitchen with a cast-iron stove—peeling apples with a modern apple peeler exemplifying the Principles of Simple Machines, chopping them for Dutch apple pancakes, cutting up vegetables for soup, churning cream to make butter, grinding grain to make the pancakes, making applesauce and cider from the apples, etc. At the end of the day, a Frolic is held, with traditional music and musical instruments to play, eating the pancakes, butter, and applesauce, and drinking the cider they've made. The dishes we use are replicas of the same fragments we've excavated—Chinese porcelain, mocha ware (annular ware), transfer-printed whiteware, redware, feather-edged creamware, majolica, etc. So the students, teachers, and parents can see how the site's archaeology helps tell a more complete story of its use through time.

All activities exemplify the ingenuity and invention of the early settlers. The Blydenburghs were early Hollanders from New York City, which counters the local myth of "everyone was English." The Principles of Simple Machines, studied in fourth or fifth grade science, are evident in every activity and tool the students' use. The interconnectedness between the carpenter and blacksmith to create the tools needed to turn logs into timbers for building and tools for every task is evident. A quarter-size model of the corner of a post-and-beam structure (courtesy of skilled artisan David Thompson) in the carpenter shop illustrates the cooperation required of the settlers to build shelter and survive, and illustrates the framing of the original Blydenburgh house. These same principles are also implicit in the Native Life program.

Archaeology—the archaeology findings from the site show the students how the settlers lived here and how we can analyze the artifacts to tell more about them. Edward Johannemann and Laurie Schroeder did a survey of the site in the 1970s, which revealed structures not now there, as do historic photographs (Johannemann and Schroeder, 1979). The archaeology we have done at the site has contributed greatly to the interpretation of this farmstead and nineteenth and twentieth century industrial complex. We have concentrated on testing and excavating work yard portions of the farmstead (Figure 18.2).

The historical and genealogical account of the family is spare until one can see what dishes they used; the bullets indicating their hunting proclivities; the oarlock illustrating their rowboats on the lake, Stump Pond, created by their milldam; clay pipes showing someone was smoking; what dishes and other objects they used through time.

Excavation—in the day program, was first done in the work yard behind the house, with many household artifacts found as well as a round brick feature with heavy stone edging on top, which appears to have been a well. It was excavated only during the summer field schools, so it went slowly. One year our regional news TV channel filmed segments of the students excavating the site from 6:00 to 10:00 AM between newsbreaks (Figure 18.3). Excavation of

FIGURE 18.2. Test pitting at the Blydenburgh County Park summer archaeological field school.

this productive back yard was stopped suddenly by the County Parks Historical Services because the back cellar wall needed to be reinforced. Staff and students performed salvage archaeology in the original builder's trench along the length of the wall to save what information we could. Our excavation there supports the intention of Section 106 of the National Historic Preservation Act, as this area now must be graded to direct water away from the foundation of this National Register site.

Our excavation was then moved to the rear of our program's carpenter's shop (a former workshop), where the ground level of the dirt was so high that it was destroying the bottom row of shingles and foundation. This excavation, still continuing, has found a surprising number of nineteenth and twentieth century tools lost by workers over the years, and the dirt level has been lowered to protect the shingles. The 2003 field school shovel testing located a trash midden there, which continues to be excavated. Shovel testing is largely done by the summer field schools, not the day programs, unless an archaeology-oriented group wants more facets of archaeology.

The Summer Field Schools—for gifted students have test pitted to sterile soil, usually 45 cm, at 1-m intervals, more than half the former farm yard

FIGURE 18.3. Regional TV News 12 filming students excavating.

to the east of the Blydenburgh-Weld house. In the field schools, one for Nassau County gifted students full day for five days, and one for the enrichment of Suffolk County students (both grades 4 through 12) half days for eight days, we try to have the students carry out all aspects of archaeology. The groups each summer have averaged about 15 for Nassau and 10 for Suffolk. The programs are staffed accordingly, with one staff member for about each 5–8 students, divided into different age/grade groups.

Preparation for Digging—involves a field trip to the local library to show how we "dig" in the archives before we dig in the soil, and to the historical society to see the many historic photos of the site in the twentieth century and of the area (Figure 18.4).We go to the cemetery to see the many Blydenburgh gravestones and make rubbings of some to connect to the family genealogy and how it relates to our findings (Figure 18.5).The students begin to see that the empty lawns of today's park belie the dense collection of farm buildings that once were there. The historic photographs, faint surface traces of barns (which they map with flags during a surface survey activity), some resistivity testing, and the shovel test pits and excavations are beginning to recreate this past landscape.

The Typical Day—consists of the students excavating and shovel testing in the cooler morning hours. We no longer shovel test in advance since we know what we are likely to find. Shovel testing has guided where the excavation squares were opened. The students' favorite activity is shovel testing; they open the test pit with a shovel and trowels and further excavate it with the

FIGURE 18.4. "Excavating" information at the library.

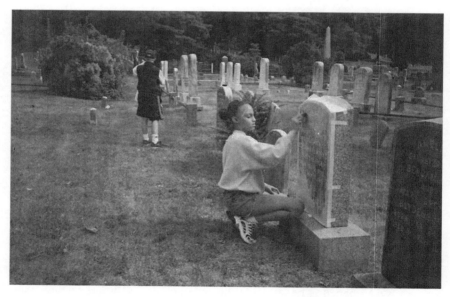

FIGURE 18.5. Getting Blydenburgh family information in the cemetery.

most efficient tool we have found—a largish quahog clam shell. They dig by 15 cm arbitrary levels (unless the situation calls for less), recording natural soil levels as they reveal them, as we have a limited stratigraphy usually involving only two layers below the topsoil. The students screen the soil and record on the Shovel Test form what they find by soil color and artifacts. Photographs are taken of *in situ* notable artifacts (also done in the two meter excavation squares). Soil is saved from a sampling of shovel tests for flotation in the hotter part of the day (water play!).

They also wash the artifacts and later count and categorize them by type in order to create a pie chart of what was found in the shovel tests. The map of the shovel tests by percentage of artifact types found is very useful for getting a sense of what was going on in that area. For example, one cluster of brick sherds was further investigated and found to be a small cistern, apparently located at the corner of a small (Dutch?) barn which burned 30 years ago, known from a family painting.

The same sequence is followed for excavation in the 2 m squares: all artifacts are measured using standard reporting forms, all soil is sifted through 1/4 in. mesh screens, and some soil is saved for flotation. Further shovel tests are made when the square appears sterile to double check, photographs are made as needed, and profiles are drawn before back filling. Some talented older students may work on the profiles, but usually it's talented staff. A map of the Blydenburgh house, measured and drawn by high school students (later tied into the landscape by a professional surveyor) amazes adults, who find it hard to believe it was done by students. The surveyor has laid out lines, which we utilize in creating the shovel test transects.

Their favorite activity during the hotter period of the day is reconstructing broken ceramics (replica items previously broken through use and brought in as a teaching tool); others are seeing films on archaeology during inclement weather, writing in their journals, organizing documents of the Blydenburghs, and many other activities. After lunch on the full days and later morning in the half days, a different craft specialist each day directs the students in blacksmithing, carpentering and assembling the post and beam house model, textiles and weaving, and, on the last day, cooking—making hand-cranked ice cream and lemonade from scratch—novelties in this high-tech age. Each activity uses artifacts showing the progression of that technology through time—colonial wood lemon squeezers to Victorian glass reamers to modern levered ones. These are also related to the archaeology of the site when possible.

18.12. Conclusion

Conducting such extensive programs as these for over 12,000 students a year requires many staff members—usually 20–25—who all work part time at one or both sites the seven months we are in session. Staff consist of retired teachers and other retirees, graduate students, and "stay at home moms," who

find this an ideal way to use their skills but still be home when their children are. They work from 1–5 days a week, as fits their schedule; I am the only full time staff, with part-time bookkeeping and computer work back up. New staff receive three paid days of training at each station where they choose to work, and all are encouraged to train for multiple stations. Those who supervise the archaeology are required to read an *Introduction to Archaeology* text (if they haven't already had a course) and urged to take a local college field school, which many do. We have site managers at each site, who receive a fee commensurate with substitute teacher pay. The day's fee for staff is higher than the high local hourly rates for roughly a 5 hour day. We have no staff volunteers because we need five to seven staff at Native Life and five to nine (depending on group size) at Colonial Life, which we need to rely on.

The authenticity of our sites, artifacts, and activities for which we are known does not come cheap. We have tens of thousands of dollars invested in our wigwams, hearth shelter, and museum at Hoyt Farm Park and many thousands more to create a textile workshop, kitchen with colonial implements, blacksmith shop, and carpentry shop at Blydenburgh Park. This has been amassed gradually over the years as the programs developed and expanded, mostly paid by fees from the program, since we have no municipal funding, are charged a fee to use the Hoyt Farm site, and provide services which equal a fee at Blydenburgh Park. The up side is that we have not had a drop in attendance when the economy and/or school budgets have decreased. Although this is the most expensive museum education program in the area (and only day-long one), at approximately $15.00 a student for the day, we don't make much of a "profit." Any funds over program costs go toward our on-going publications program (now finishing our ninth volume) and documentary films (Stone, 2007a).

This program could only happen because of the volunteer commitment and energy of people who appreciate archaeology and believe children deserve excellent programs, the talents of many—especially Wendy Martin and Chris Donovan, formerly of the Hoyt Farm staff—and many others. Also needed is a nonprofit group to back the project and to provide access to grants, as well as cooperative relationships with other local institutions. It is essential that an archaeologist lead the program to maintain quality; experience in learning theory and child development is very helpful.

Also important is basing the program on scholarly research, not just local stories or myths. "Authenticity," now a focus of seventh grade education, is also important, but it is expensive; for a Native American culture program, a nail in a dowel rod for a "drilling experience" just doesn't do it compared to a replica flint drill. Children crave hands-on experiences and learn best from sensory activities—in short supply in today's test-driven school environment—which an archaeology-based program can certainly supply. Judging from our experience, this should be possible in many places—encouraging inquisitive children who will hopefully be the preservation-minded citizens supporting archaeology in the future.

References

Harrington, M.A., 1924, *Exploration of an Ancient Burial Ground and Village Site Near Port Washington, Long Island.* Museum of the American Indian, Heye Foundation. Reprinted in *The Second Coastal Archaeology Reader: 1900 to the Present,* by Truex J., editor, 1982. Suffolk County Archaeological Association., Stony Brook, NY, pp. 83–89.

Johannemann, E., Schroeder, L., 1979, *Cultural Resources Survey of Blydenburgh County Park. Mss. on File with Historic Services.* Suffolk County Parks Department, West Sayville, NY.

Martin, W., 1986, *After Your Visit,* poster for the *"Native Life & Archaeology"* program, Hoyt Farm Park. Suffolk County Archaeological Association., Stony Brook, NY.

Martin, W., Stone, G., Donovan, C., 1985, *"Native Life & Archaeology booklet".* Suffolk County Archaeological Association., Stony Brook, New York.

Ritchie, W.A., 1965, The Story Brook Site and its Relation to Archaic and Transitional Cultures on Long Island, 1959. New York State Museum and Science Service, Bulletin 367.

Salwen, B., 1968, *"Muskeeta Cove 2, A Stratified Woodland Site on Long Island",* Society for American Archaeology, 33(3):322–340. Reprinted in, *The Second Coastal Archaeology Reader: 1900 to the Present,* by Truex J., editor 1982. Suffolk County Archaeological Association, Stony Brook, NY, pp. 153–160.

Saville, F., 1920, *"A Montauk Cemetery at Easthampton, Long Island",* Museum of the American Indian: Heye Foundation. *Indian Notes and Monographs,* vol. II: 3. Reprinted in, *The History and Archaeology of the Montauk,* vol. III. second edition. *Readings in Long Island Archaeology and Ethnohistory,* by Stone G., editor, 1993. Suffolk County Archaeological Association, Stony Brook, NY, pp. 615–628.

Smith, C., 1950, *The Archaeology of Coastal New York.* American Museum of Natural History. *Anthropological Papers,* vol. 43, Pt. 2. New York.

Solecki, R., 1950, *The Archaeological Position of Historic Fort Corchaug, L.I. and Its Relation to Contemporary Forts,* Bulletin, No. 24. Archaeological Society of Connecticut, New Haven, CT, pp. 3–40.

Stone, G., editor, 1977, *Early Papers in Long Island Archaeology,* vol. I. *Readings in Long Island Archaeology & Ethnohistory.* Suffolk County Archaeological Association, Stony Brook, NY.

Stone, G., editor, 1978, *The Coastal Archaeology Reader,* vol. II. *Readings in Long Island Archaeology and Ethnohistory.* Suffolk County Archaeological Association, Stony Brook, NY.

Stone, G., editor, 1979, *History and Archaeology of the Montauk,* vol. III. *Readings in Long Island Archaeology & Ethnohistory.* Suffolk County Archaeological Association, Stony Brook, NY.

Stone, G., editor, 1981, *Languages and Lore of the Long Island Indians,* vol. IV. *Readings in Long Island Archaeology and Ethnohistory.* Suffolk County Archaeological Association, Stony Brook, NY.

Stone, G., editor, 1983, *The Shinnecock: A Culture History,* vol. VI. *Readings in Long Island Archaeology and Ethnohistory.* Suffolk County Archaeological Association, Stony Brook, NY.

Stone, G., editor, 1985, *Coastal Native Life.* Study Pictures. Suffolk County Archaeological Association, Stony Brook, NY.

298 Gaynell Stone

Stone, G., editor, 1988, *A Native Technology Poster*. Suffolk County Archaeological Association, Stony Brook, NY.

Stone, G., editor, 1991a, *"Native Long Island"* poster. Suffolk County Archaeological Association, Stony Brook, NY.

Stone, G., editor, 1991b, *"The Montauk: Native Americans of Eastern Long Island"*. Exhibit catalogue. Guild Hall Museum, East Hampton, NY.

Stone, G., editor, 1992, *"Women's Work: Native and African-Americans of Long Island"*. Exhibit Catalogue. Westhampton Free Library and Writers' Festival, Westhampton Beach, NY.

Stone, G., editor, 1993, *The History and Archaeology of the Montauk*, vol. III , second edition. *Readings in Long Island Archaeology and Ethnohistory*. Suffolk County Archaeological Association, Stony Brook, NY.

Stone, G., editor, 2007a, *Native Forts of the Long Island Sound Area*, vol. VIII. *Readings in Long Island Archaeology and Ethnohistory*. Suffolk County Archaeological Association., Stony Brook, NY (In preparation).

Stone, G., editor, 2007b, *The Sugar Connection: Holland, Barbados, Shelter Island*. Documentary Film, Suffolk County Archaeological Association., Stony Brook, NY.

Stone, G., Kianka, D.O., editors, 1985, The Historical Archaeology of Long Island: part 1 – The Sites, vol. VII. *Readings in Long Island Archaeology and Ethnohistory*. Suffolk County Archaeological Association, Stony Brook, NY.

Truex, J., editor, 1982, *The Coastal Archaeology Reader: 1900 to the Present*, vol. V in the series. *Readings in Long Island Archaeology and Ethnohistory*. Suffolk County Archaeological Association, Stony Brook, NY.

Truex, J., Stone, G., 1985, *A Way of Life: Prehistoric Natives of Long Island*. Suffolk County Archaeological Association, Stony Brook, NY.

Wyatt, R.J., 1977, The archaic on Long Island. *Annals of the New York academy of medicine*, vol. 288, pp. 400–410. Reprinted in *The Second Coastal Archaeology Reader: 1900 to the Present*, by James Truex, editor, 1982. Suffolk County Archaeological Association., Stony Brook, NY, pp. 70–72.

19
Transportation Collections: On the Road to Public Education

Ann-Eliza H. Lewis

19.1. Introduction

Boxes stacked on boxes, long aisles lined with endless shelves of artifacts. These are familiar sites to many archaeologists who look wistfully at the latent educational potential of archaeological collections. Stored in these boxes and drawers are many compelling stories—stories of history and prehistory that the public craves. But who has the time to tell them? Few archaeologists find the time to conduct the level of analysis they might want to do never mind the seemingly "extra" work of a public education program. Public education, however, should never be considered "extra," especially on projects carried out under the National Historic Preservation Act (NHPA). It is easy to get so caught up in following the details of section 106 of NHPA that one forgets Section 1 of the same act, which states that the purpose of the act is to enrich public life. The NHPA was passed, in part, because "the preservation of [our] irreplaceable heritage is in the public interest so that its vital legacy of cultural, educational, aesthetic, inspirational, economic, and energy benefits will be maintained and enriched for future generations of Americans," and because then current preservation programs were considered inadequate "to ensure future generations a genuine opportunity to appreciate and enjoy the rich heritage of our Nation," (NHPA Sec 1(b)4–5). When sitting in storage, however, this "rich heritage" is available only to the people who happen to pass through the storage room. Most archaeologists agree that not all Cultural Resource Management (CRM) projects produce results that are worth sharing, but when there are interesting results, we have a professional responsibility to share them with the general public. However, finding the time and resources is a challenge. It is unfortunate that there is little or no dedicated funding to fulfill this aspect of one of the corner stones of the national preservation program. The Massachusetts Historical Commission (MHC) has addressed the problem partially by incorporating public education into the daily activities of their curation facility. Curation is another critically under funded program, but bringing public education into the curation facility has helped both programs.

Public programing began in earnest at the MHC when the collections from the Central Artery/Third Harbor Tunnel project (better know as Boston's Big Dig) were delivered to the MHC for permanent curation. The Big Dig, the largest highway construction project in the world, is a good example of how public education can happen with limited resources and within the context of section 106 or other CRM projects. The ongoing Big Dig education program works because two crucial elements are present. First, the integrity and significance of some of the identified sites were astonishing for an urban core and produced some very exciting discoveries. Second, since the completion of the excavation phase, the MHC has made it a priority to provide local schools and the general public with access to the results of the archaeology through a program of exhibits, school curricula, and public programs. This institutional support continues despite an uneven history of funding for the program. A summary of the core elements of the program follows accompanied by some remarks on how we completed the programs within our limited budget.

19.2. The Big Dig

Today the Big Dig is nearing completion; but the $14 billion dollar project has had its ups, downs, and controversies. It is a project regarding which Bostonians and Massachusetts residents have been divided and few believed would ever be completed. Planning began in earnest in the 1970s, but only in the last few years have cars begun to travel the core elements of the highway. The basic components of the Big Dig include replacing the elevated I-93 (Figure 19.1), the major north/south artery through the heart of downtown, with a state-of-the-art tunnel; extending I-90 (the Massachusetts Turnpike) to Logan International Airport via a new tunnel under Boston Harbor (the Ted Williams Tunnel); building a new bridge over the Charles River; replacing the connector to the Tobin Bridge in Charlestown, finding a suitable location to place the clays excavated for the tunnel; and the removal of the 1950s-era elevated highway structure. Further complicating the project was the necessity that traffic continue to flow on the existing elevated highway while the tunnel was dug directly below. Needless to say this project has caused considerable disruption in Boston's daily traffic for the last decade. There are few people who have no opinion regarding the project. This type of high profile project provided an excellent opportunity to increase the audience for archaeology in Massachusetts.

The archaeology has been one consistently positive aspect of the project. For archaeologists the Big Dig provided a rare opportunity to look across the city for surviving archaeological sites, including a detailed look at one of the Boston Harbor Islands. Archaeologists examined from north to south the entire city from Charlestown to South Boston and out into Boston Harbor. While much of Boston is built on landfill, the new highway passes through

FIGURE 19.1. Boston before the Big Dig with traffic clogging the elevated highway. (Courtesy of the Massachusetts Historical Commission, Office of the Secretary of the Commonwealth)

some of the oldest parts of the landmass making it possible that early sites would be discovered within the project area. The time frame of the research project has been quite long. The earliest survey reports were submitted in the late 1970s. Data Recoveries followed in Charlestown in the mid-1980s. Later in the 1980s the archaeology began for the downtown, South Boston, and the Harbor Islands sections, with the final data recoveries being completed in 1994. The collections came to the MHC for curation in 1997. (Selected reports and articles include Elia and Seasholes, 1989; Elia et al., 1989; Gallagher and Ritchie, 1992; Cheek, 1998b, Cook, 1998; Cook and Balicki, 1998; Heck and Balicki, 1998; Cheek and Balicki, 2000).

The archaeologists were pleased at the surprising amount of undisturbed sites that survived nearly 400 years of intense urban development. Intact archaeological deposits were uncovered that included early Native American settlements and campsites, a seventeenth- and eighteenth-century tavern (Figure 19.2), a sealed seventeenth-century privy, an eighteenth-century metalsmith's home and workshop, a nineteenth-century glass factory, and a mill pond that revealed information on the processes of making land in town. The results included a significant collection of artifacts and personal stories that would engage just about any history lover. There were other stories too, ones that appeal to broader less-history savvy audiences—an abused wife who successfully sued for divorce in 1671, the oldest bowling ball in North America (For a summary of the sites see Lewis, 1999).

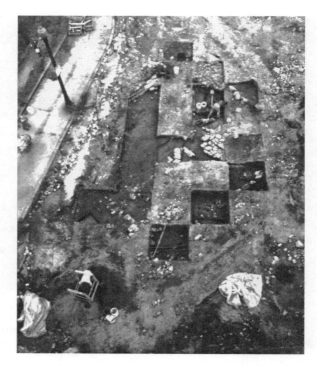

FIGURE 19.2. Excavations underway in the City Square Archaeological District in Charlestown, location of the Three Cranes Tavern Site and Governor John Winthrop's first home. (Courtesy of the Massachusetts Historical Commission, Office of the Secretary of the Commonwealth)

19.3. The MHC

The MHC is both the State Historic Preservation Office and the Office of the State Archaeologist. In these capacities the MHC oversees section 106 review in the Commonwealth. The MHC is also the home of the Archaeological Curation Center, which curates state-owned collections. In Massachusetts the State Archaeologist oversees the disposition of collections that result from excavations conducted under permit and encourages public access to archaeological collections through educational programs and exhibits (M.G.L. Ch. 9 ss.26–27C). Upon completion of the final reports, the collections were moved to their storage facilities. At this point the collections could have started their long shelf life, permanently curated and at risk of being forgotten. Instead, the State Archaeologist and the Secretary of the Commonwealth (under whose jurisdiction the MHC falls), lobbied for funding to support the previously unfunded curation center. For 2 years the MHC received line item funding in the state budget for the program. Although now deleted from the state budget, those 2 years of funding

allowed the groundwork to be laid for an ongoing archaeological education program. There is no longer a dedicated funding source for the archaeology education program. The MHC has, however, managed to incorporate one staff position and one contract position into its regular budget to keep the program running on a minimal level.

19.4. Program Components

The public education program is a multicomponent one designed to reach adult and student audiences. It includes a classroom curriculum, exhibits, and publications. What follows in this chapter is a summary of the MHC's Big Dig education program that provides information on how we accomplished a variety of different projects. When the MHC first received state funding for the curation of collections seven archaeologists were contracted for 6 months to work on archaeological collections primarily from major transportation projects including the Big Dig, but also large highways such as Interstate 495, and subway extensions. The following fiscal year four archaeologists returned to continue the curation and education programs. For the last several years two archaeologists have staffed the curation center.

19.4.1. Curricula

One of the first education projects we developed was a curriculum for classroom use that would introduce students to both general archaeological thinking as well as to the results of the Big Dig archaeology project. We began by conducting a survey of local teachers to assess the interest in a classroom guide and to ask their advice as to the best grade level and topics. Many responded with helpful comments. The result was a six-lesson curriculum for grades 5 through 8. The first two lessons introduce concepts such as stratigraphy and basic archaeological reasoning. Each of the next three lessons has a dual focus. Each presents the results of excavations at one Big Dig site while also introducing a specialized aspect of archaeological study. The chapter on Katherine Nanny Naylor's seventeenth-century privy, for example, portrays life in Puritan Boston and also introduces students to some of the scientific studies routinely used in archaeology. The privy was rich in organic remains, including nearly a quarter of a million seeds and significant pollen from which to develop a discussion of diet. The lesson also introduces macroscopic remains as further evidence illustrative of Puritan life. Recovered eggs of whipworm and roundworm augment our knowledge of health and hygiene in early Boston and add dimension to a discussion opened by a bone lice comb. Another lesson introduces the use of historical documents while explaining the glass industry in nineteenth-century South Boston. The final lesson in the packet asks students to summarize their knowledge of the archaeology of the Big Dig in one of a number of ways including poster exhibits, short stories, or other creative reports.

Each lesson plan includes a background essay for the teacher's own use, detailed exercises including worksheets as necessary and reproducible illustrations, which can be used to make transparencies. The curriculum was produced entirely in-house using images and documentation from the collection. It is extensively illustrated with black and white photos and line drawings. We designed it to be reproduced in-house at our copy center, thus avoiding expensive printing. The curriculum packets are distributed unbound, three-hole punched, and shrink-wrapped. This makes it easy for the teachers to copy the activities and other components of the plan for future classes. While not as glitzy as many available curricula, we are able to produce and reproduce these packets on demand and can distribute them free. Several thousand copies of this program have been distributed to schools across Massachusetts.

During the curriculum's review period the Massachusetts Department of Education introduced their Curriculum Frameworks for History and Social Studies (MA DOE, 2003) in preparation for a new statewide, mandatory, student achievement test. We spent considerable time making sure our work addressed the curriculum frameworks and identifying the appropriate target grade level for widest adoption of the lessons. Teachers reviewed the curriculum to make sure we kept on track to provide a useful product. Because the curriculum frameworks do not specifically include archaeology, we created a table in the final draft of the curriculum's introduction that listed specific learning objectives copied verbatim from the frameworks and next to each explained how an activity satisfied that learning objective. This achieved two goals. It helped teachers understand that archaeology did not need to be a separate unit, but could be incorporated into regular social studies instruction including history, geography, anthropology, and economics. It also helped teachers with their supervisors. Teachers told us that the chart could easily be presented to their supervisors if they were asked why they were teaching this seemingly "extra" activity instead of focusing on the frameworks.

Working within the frameworks has been challenging. In the time since the curriculum was written, the frameworks have been revised twice and as statewide testing becomes increasingly important and high-stakes in Massachusetts, teaching to the test is more common. Because archaeology is not specifically written into the requirements, many teachers are hesitant to incorporate it into the classroom. We continue to spend time explaining how archaeology fits the frameworks even though the word archaeology may not appear. This is a topic we address in particular detail in teacher-training workshops.

19.4.2. Teacher (and Archaeologist) Training

In addition to including teachers in the planning and review of our student programs, we offer occasional professional development opportunities for teachers. Although the professional development programs have had

different formats they all have shared the same combination of goals. On one hand we want to supply teachers with the tools they need to incorporate archaeology into their regular classroom activities thereby enlisting them to help raise the next generation as an "archaeologically aware" one. On the other hand, we hope that teachers will help us develop future education programs by sharing their expertise as educators.

We do not teach teachers how to excavate a site; instead we teach from the standpoint that "real" archaeology begins *after* a dig when the interpretation of the site and artifacts takes place. This changes archaeology from the "fun digging activity" that so many education programs seem to make it out to be and places it firmly in the category of "a way to study and learn about the past." It is troubling that archaeology is often used as a way to give students a break from study. Archaeology is fun, but why can't it be fun *and* an integral part of all serious study of the past?

In most cases the Big Dig archaeology program plays a smaller part in this aspect of our education program. The program usually begins with a tour of the exhibit *Archaeology of the Central Artery: Highway to the Past* (discussed below). The tour focuses on how archaeology both confirms and challenges the traditional school presentation of Boston and Massachusetts history. Throughout the tour we highlight elements of the results of the excavation that articulate specifically with the Massachusetts curriculum frameworks; we also point out the interdisciplinary nature of archaeology in order to accommodate the wide variety of teachers that attend. (In our last program we had most grades levels represented and we had science, history, and art teachers to accommodate. When we plan the details of each program we often wait until we know our enrollment and try to address the particular needs of each teacher type.)

The Big Dig is our hook from which we segue into a discussion of how archaeologists interpret the past from material remains and how this can be a valuable addition to their classroom. Teachers do not like lectures so the format of all of our programs is interactive and hands-on. We enjoy modeling the classroom activities for the teachers, and they always enjoy doing the projects that we are recommending for their classes. To break the ice we often begin with a classic archaeological classroom exercise including giving everyone a penny and asking them to call out things we can "know" about the culture that produced them or passing around lunch bags full of items collected around the lab or my house to small groups of teachers and asking them to interpret the site and the people who left them behind.

With the ice broken we next provide some version of a very condensed archaeology 101 class. If possible we arrange for a visit to a working archaeology lab. Most recently we visited the lab at the Fiske Center for Archaeological Research at the University of Massachusetts, Boston. Two activities that are very popular are lesson planning and archaeological ethics. We always allow at least an hour for small groups to work together to develop lessons to use in their class followed by a discussion where I can critique the

archaeological soundness of the activity as well as provide suggestions. The other teachers provide constructive criticism on the educational soundness. This open forum often brings up a number of issues regarding running mock and actual digs and provides a good lead into the archaeological ethics activity that follows. Again working in small groups, each group works through a copy of an archaeological dilemma taken from the SAA Sampler (SAA, 1995) or from Alexandria Archaeology's website (http://oha.ci.alexandria.va. us/archaeology/ar-programs-activities-1.html). This activity is always enlightening for the teachers as well as the archaeologists. It is a critically important element of the program because although we are genuinely committed to archaeology education we also want to make sure that teachers understand some of the issues surrounding archaeological excavations and the nuances of collecting. We also want to make sure they know that it is not appropriate for them to run a dig on their own or to dig up their school yard, which in most cases in Massachusetts is illegal without a permit from the State Archaeologist.

We are quite open with the teachers that we need to learn from them. We are not trained as educators so we share our archaeological expertise and they share their needs and concerns as well as providing information on what is or is not practical and/or useful for their classroom. They have provided valuable insight into how to teach kids and on how to develop useful effective programs that they will use in the future. Anyone beginning a program can contact their local social studies council or state department of education to be put in touch with teachers. Understanding how kids learn and what they are capable of at different grade levels is critical to creating successful programs for teachers and students (see Geraci, 2000; Johnson, 2000 for details on how students learn).

At one time our teacher-training program was offered jointly with a program offered with our sister agency, the Massachusetts Archives. This program focused on training teachers to properly use and identify primary sources and then to learn how to teach using primary sources. Archaeology was incorporated as an important primary source to consider. This was a nice way to present archaeology because rather than singling archaeology out as a unique or special activity, it was presented as just another way to learn about the past that should always be considered. This helped to combat the tendency of teachers to want to include archaeology as a fun, less serious classroom activity. Because primary sources are an important focus of the state curriculum frameworks, we often return to this format for teaching archaeology. The only "drawback" in this partnership was that archaeology so intrigued the teachers that most discussion reverted to archaeology—frustrating the archivists.

During our teacher-training programs we always offer the opportunity for teachers to learn more about MHC's other resources including the National Register's Teaching with Historic Places Program, which has several Massachusetts-based lessons, and the Inventory of Historic and Archaeological

Assets of the Commonwealth. Teachers are particularly fascinated with the inventory and could often be found during free time delving into their town's files looking for interesting ideas for their history classes.

Other than staff time, teacher-training programs are not expensive to run. When we have a budget, we might spend it on coffee and snacks, but rarely do we need to buy any specialized items. We have spent some time and money building a library of archaeology education materials for teachers to browse during scheduled research times. We have found it important to offer professional development points (PDPs) to teachers who enroll in our classes. At times we have also offered college credit through the University of Massachusetts, Boston, but this adds a considerable number of administrative tasks as well as tuition payments for our otherwise free programs. Massachusetts teachers must earn PDPs and college credits to maintain their certification; providing PDPs is an extra incentive to encourage teachers to attend. We have offered the classes on Saturdays and weekdays and during both vacation and school times and still have not decided what is best. Asking teachers usually ends with as many different answers as teachers asked.

19.4.3. Exhibits and Field Trip Programs

During the first year after the collection arrived at the MHC two exhibit programs began. First a traveling exhibit program. Two different traveling exhibits were created "Women in Colonial Boston," which told the stories of the lives of three enterprising women: an eighteenth-century tavern owner, the eighteenth-century owner of the first stoneware pottery in the northeast, and the story of Katherine Nanny Naylor whose seventeenth-century privy provided an amazing and detailed portrait of daily life in Puritan Boston. The second exhibit, "Industry Must Prosper," focused on three Boston industries: redware manufacture, glass manufacture, and pewtersmithing. The staff of collections assistants designed the content and built the frames for these panel exhibits. The Secretary of the Commonwealth's Office has a full-time graphic designer on staff to help with design of all of our materials, which saves considerable money. The one significant expense of these exhibits was the printing. At the time, our office did not have a large format printer so the panels of the exhibit were printed, mounted, and laminated for easy cleaning by a professional print shop. In retrospect it may have been more cost-effective and certainly more convenient to buy pre-fabricated exhibit frames that pack away easily for transport. Building our own portable frames, however, has provided satisfactory, economicalm, and durable results (Figure 19.3).

The exhibits were designed to travel without artifacts to places that did not have the security to accept artifact loans. The exhibits' first tour was through the Boston Public Library system and its many branches. First priority was to send the exhibits to branch libraries in the Boston neighborhoods that were impacted most directly by the construction. The exhibits spent 2 years touring the libraries. Because these exhibits do not have artifacts, they are

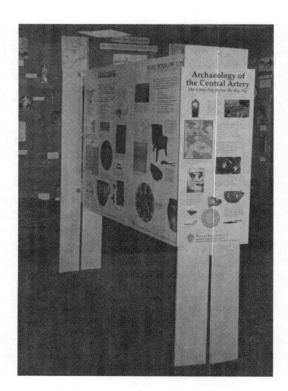

FIGURE 19.3. MHC's Traveling
exhibit (Photo: Ann-Eliza
Lewis)

well suited to be displayed at many different types of venues. Today the
exhibits remain available, free of charge, to local historical societies, muse-
ums, and classrooms to borrow. We have also been invited occasionally to
bring them to unique locations such as a display booth at the Lowell Folk
Festival.

Despite the success of the traveling exhibit panels, we wanted to show
people the artifacts themselves. To test the interest level for an artifact
exhibit, the MHC installed a small exhibit in the lobby of the State Archives
Building for Massachusetts Archaeology Week 1998. The main visitors to
this lobby gallery are visitors to the MHC and the Massachusetts Archives.
While the exhibit received favorable reviews from general audiences, the real
interest came from schoolteachers who began asking to schedule field trips
to the lobby! (Figure 19.4) This led to the quick production of an activity
booklet for teachers to use to stretch out a field trip.

With teacher interest apparent, the MHC decided to pursue developing a
larger exhibit in the Commonwealth Museum, which is a small museum
devoted to Massachusetts history located in the same building. The
Commonwealth Museum is the only state history museum in Massachusetts
and normally has changing exhibits. The Big Dig exhibit opened in 1999 with

FIGURE 19.4. Under the Asphalt, an exhibit in the lobby of the Massachusetts Archives building on Columbia Point (Photo: Ann-Eliza Lewis)

an intended 6-month run. In 2006, the exhibit remained open in part because of the ongoing teacher demand for access to the collections. The exhibit remained open through the 2006 school year.

Like our other programs the exhibit was designed and installed entirely by the staff of the archaeology lab with the help of our in-house graphic designer. Financially, the exhibit creation was a collaborative effort. The MHC and the museum each had limited funds, but provided what they could. The museum, for example bought cases for the artifacts on the condition that they be designed to later hold documents from the state archives. The MHC shouldered most of the finances from the line item funding that was temporarily available, this covered staff, exhibit supplies, printing, and rights and reproduction fees for images displayed in the exhibit. Most of the text and images were produced in-house. One of the best purchases made in preparation for the exhibit was a good-quality, wide carriage, color ink jet printer, and a flatbed scanner that could scan slides and negatives as well as flat art. While a substantial investment in equipment, it significantly cut the amount of printing we had done by a professional shop and has continued to prove invaluable as our programing has expanded.

Marketing the exhibit as a field trip destination was begun immediately and the turnout far surpassed our expectations. In the first year about 4,000 students visited the exhibit. For a museum that rarely had more than a few

100 student visitors each year this was a significant increase. The exhibit has maintained high numbers of visitation now averaging closer to 6,000 students per academic year.

Running a successful field trip program takes considerable effort. When we began field trips to the Commonwealth Museum the museum had no education staff. Lab staff therefore was taken away from curatorial tasks to teach the students—bringing lab work to a virtual halt. Over the last 2 years we have switched to having museum docents, trained by lab staff, lead the tours. There have been a number of compromises with this change. However, with no dedicated funding at this time, it has been good to return our now significantly reduced staff to the lab to continue the lab's curatorial duties as well as work on new program development.

The field trip activities are highly structured to guarantee that the students see the majority of the exhibit and learn more about archaeology. The programs were developed through informal consultation with teachers who provided critically important information on age appropriate, inquiry-based activities. While the archaeology lab was running the tours, evaluations were sent to teachers after every visit. These provided valuable feedback that helped us refine the program to suit the needs of the teachers and their classes. Today, we have two main programs one for elementary grades and one for junior and senior high school students. The activity packets are created in-house for easy updating and copying.

All tours begin with a brief introduction to archaeology and the Big Dig. For older students we offer our "experts" program. This consists of breaking the students up into small groups and asking each group to become "experts" on one of the sites. After about 15 minutes of examining the sites, the class takes a tour of the museum with each expert group leading the tour of their site. Each group is given a handout with questions to answer that they may use to guide the creation of their tours. We let students choose how to present their tours and have seen everything from tours written in verse, to raps, to more traditional tours. Younger students receive an activity packet that includes scavenger hunts, stratigraphy and other exercises, and a variety of other activities that can be done when the kids return to their classrooms (Figure 19.5). Teachers are offered the opportunity to grade tours and to collect activity packets. Teachers may also make special requests for career day information or other activities.

An important part of our interaction with teachers is the confirmation call. Before each visit the tour leader calls the scheduling teacher to confirm the visit and talk about the program. We ask about special needs of the kids and try to get a feel for the class. We find that in talking to the teachers we can often provide a program better geared to the specific needs of the class. Before their field trip, every class receives a curriculum and a booklet on the archaeology of the Big Dig. We hope teachers will do some pre-visit instruction. It is rare that a teacher completes the entire curriculum before coming, but many do one or two of the activities in the curriculum.

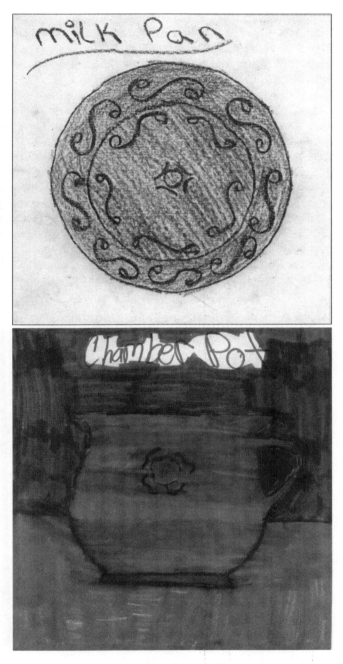

FIGURE 19.5. (a) A crayon drawing of a redware milk pan sent as part of a thank you note from a class that visited the museum. (b) Drawing of a chamber pot sent in a thank you note from class. (Photo: Ann-Eliza Lewis)

The one regular criticism we receive is that the kids do not get to touch the artifacts. I do not know why people assume they can touch archaeological artifacts when they are not allowed to touch most history museum's collections. To satisfy this desire we have added some hands-on activities such as giant magnetic jigsaw puzzles of artifacts (Figure 19.6).

In addition to these rather traditional exhibit venues, we have also had an opportunity to reach out more broadly with some less traditional exhibits—perhaps better termed promotions because the goal was to bring people to the Commonwealth Museum for a more in-depth look. One was a kiosk displayed outside of the Edward A. LeLacheur Park stadium (in Lowell, MA) on Big Dig Night at the Lowell Spinners—a single A baseball team. Along side a Big Dig backhoe, we had a three-sided display and a table with flyers on Big Dig archaeology; archaeologists were available before the game to answer questions from the public. Another fun promotion included large-scale banners displayed at a recent home show in Boston (Figure 19.7). Unfortunately there is no way to track whether these promotions brought more visitors to see the archaeology exhibit, but at the very least they let more people know that archaeology was part of the Big Dig.

FIGURE 19.6. Students assembling a giant magnetic jigsaw puzzle of an 18th-century washbasin. (Photo: T.C. Fitzgerald)

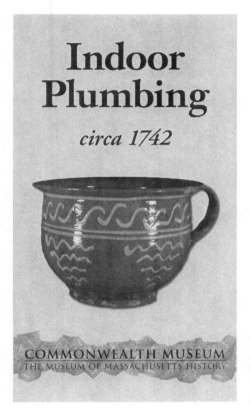

FIGURE 19.7. One of 6 banners that hung at a home show at Boston's World Trade Center. (Photo: Ann-Eliza Lewis)

19.4.4. Publications

Short books are an increasingly popular way to provide the public with information regarding archaeological projects and the Big Dig is no exception (e.g., Caltran, 1993; Henderson *et al.*, 1995; UV CAP, 2003). Ideally funding for a publication would be included as part of the mitigation plan. The archaeologists who conducted the Big Dig excavations wrote three good popular reports (McHargue *et al.*, 1994; McHargue, 1996, 2000). Each was informative, well illustrated, printed economically, and contained summaries of the project as well as supplementary information on archaeology in general. They suffered, however, from small print runs and limited distribution. Printing and distribution are the most expensive parts of a publication program; funding both, especially money for envelopes and postage, is critically important.

The MHC published a more widely distributed booklet on Big Dig archaeology in 1999 (Lewis, 1999). This short, full-color booklet was made possible by a substantial private donation from the Gillette Company. Their support

FIGURE 19.8. The Cover of Highway to the Past: The Archaeology of Boston's Big Dig. (Courtesy of the Massachusetts Historical Commission, Office of the Secretary of the Commonwealth)

paid for the production and distribution of 10,000 copies. The donation included sufficient funds to mail the book and in fact the donation required that we send a copy of the book to every school and public library in Massachusetts. MHC archaeologists wrote and edited the text. Production of the booklets again was made considerably more simple and economical by using the Secretary's in-house graphics team. MHC paid for a second printing of the book in 2002 and as of today about 16,000 copies have been distributed free of charge throughout the country (Figue 19.8).

19.5. Content

I have spent little time talking directly about content, but content and presentation are critical to the success of our public programs. I cannot count the number of times I have asked "is this something only an archaeologist could love?" This is my way of reminding myself that our audience is the general public. Storytelling is an important element of archaeology and critical to public programs. A recent essay by *Archaeology Magazine*'s editor, Peter Young, illustrated the importance of developing a good story for the public

(Young, 2003). Developing an exhibit, public lecture, or lesson plan requires similar care. There are many aspects to making the story successful. One is relevance; this is particularly true for kids. If the answer is "yes" when I ask "is this something only an archaeologist could love?" then I have to figure out why I thought the public might want to know this and then figure out a way to tell it. Some stories in the Big Dig collection tell themselves (see Cook, 1998) such as the much told story of Katherine Nanny Naylor, a wealthy widow who, in 1671, successfully sued her second husband for divorce citing abuse and adultery. At that same site archaeologists conducted extensive scientific studies that add critical insight into the study of seventeenth-century life in Boston. Simply reporting the results of archaeoentomology, palynology, and parasitology rarely captures the imagination of adult audiences never mind kids. However, talk about having ringworm or whipworm or having weevil-infested flour and things begin to get interesting. Telling stories about archaeological research is not a new idea, but it is not something we do on a regular basis. It takes some practice to learn how to tell a good story.

Finding story elements to which a child can relate will help them connect with the past. For example one of our museum activities for young children asks them to look at a seventeenth-century child's shoe and then to draw their own. The kids talk about how the shoes differ and describe which of their current daily activities would be affected if they had to wear shoes like the one on display. Other handles for kids and or adults have been cod fishing, bowling, tavern behavior, and fashion. Additionally helpful has been having names of real people from the past that lived at these sites. Broken bits seem just a little more important when you can say "That stoneware jug was made at a pottery owned by Grace Parker; it was found at the Three Crane's Tavern, which was owned by the same family, the Longs, for more than 150 years."

We also ask what we want our audience to learn in each program. In all cases our long-term goal is to raise awareness of archaeology in Massachusetts and build a knowledgeable and supportive public. To that end, the specific message of each program needs to be engaging and informative. For example, when we were designing the exhibit on the archaeology of the Big Dig for the Commonwealth Museum we were torn over whether we were telling the story of the archaeological project or the story of the results of the project. It may seem picky, but with limited space and limited attention spans it became critical to decide what was more important and we eventually settled on the latter. While many aspects of the archaeology were interesting, it was the resulting interpretation that was most relevant for the general public.

19.6. Conclusion

Running public education programs is time consuming, and time is the greatest expense. We have been lucky to have limited and sporadic funding, but overall have managed to run the program on a relative shoestring. The return

has been excellent. Our field trip program has reached more than 18,000 school kids. We have mailed at least 16,000 *Highway to the Past* booklets and several thousand copies of the middle school curriculum. While we do not have a way of tracking the number of adults we have reached or to measure the effects of our efforts, we have no doubt managed to begin to tell the story of archaeology in Massachusetts.

The future is bright for archaeology education at the MHC. The Big Dig has been a great stepping-stone to a full-scale education program that will expand beyond this one CRM project. Although funding remains scarce there are more programs planned. One source of funding is a grant from the Massachusetts Highway Department through the FHWA's ISTEA/TEA-21 grant program. The MHC has received grants for collections work and for future education programs. The education portion will fund programs that take the Big Dig education program "on the road" through better curricula, an educational CD-ROM, a website, and more traveling exhibits. These grants will also provide support to produce short booklets on the results of some of the other interesting excavations completed before other Massachusetts transportation projects.

The public education program at MHC has done more than simply keep Big Dig archaeology in the public eye. It has led to continued financial support and a more priceless item—public awareness of archaeology in general. It has also helped to bring the section 106 process full circle. We are often so caught up in following the letter of the law that we forget the spirit of the laws that govern CRM archaeology. Making public education a regular part of all public archaeology programs will satisfy both the letter and the spirit.

Acknowledgments: The success of the public education programs is due to the support and hard work of a number of individuals including Secretary of the Commonwealth, William F. Galvin, State Archaeologist and SHPO Brona Simon, and the former SHPOs of Massachusetts, Judith McDonough and Cara H. Metz. Many talented archaeologists have worked in the MHC's Archaeology Lab and contributed to the programs described here: Christa Beranek, Jeff Carovillano, Margo Muhl Davis, Freddie Dimmick, Harley Erickson, Alicia Paresi Friedman, Elizabeth Kiniry, Rita Reinke, Leith Smith, and Carolyn White. A number of teachers have provided regular input into our programs, but one in particular, Marc Nachowitz of Leominster High School, has provided consistently solid advice and encouragement. The excavations were carried out by a number of firms including Harvard University's Institute for Conservation Archaeology, The Public Archaeology Lab., Inc., Boston University's Office of Public Archaeology, Timelines, Inc., and John Milner Associates. Today, the University of Massachusetts, Boston, holds the contract for contingency work.

References

Bower, B.A., 1998, The Central Artery/Tunnel Project Preservation Program. Perspectives on the Archaeology of Colonial Boston: the Archaeology of the Central Artery/Tunnel Project, Boston, Massachusetts. *Historical Archaeology* 32(3):11–18.

Cheek, C.D., 1998a, Introduction. Perspectives on the Archaeology of Colonial Boston: the Archaeology of the Central Artery/Tunnel Project, Boston, Massachusetts. *Historical Archaeology* 32(3):1–10.

Cheek, C.D., editor, 1998b, Perspectives on the Archaeology of Colonial Boston: the Archaeology of the Central Artery/Tunnel Project, Boston, Massachusetts. *Historical Archaeology* 32(3).

Cheek, C.D. and Balicki, J., 2000, Archaeological Data Recovery: the Mill Pond Site (Bos-HA-14), Boston, Massachusetts, 3 vols.

Cook, L.J., 1998, Katherine Nanny, Alias Naylor: a Life in Puritan Boston. *Historical Archaeology* 32(1):15–19.

Cook, L.J. and Balicki, J., 1998, Archaeological Data Recovery: the Paddy's Alley and Cross Street Back Lot Sites (BOS-HA-12/13), Boston, Massachusetts, 4 vols.

Elia, R.J. and Seasholes, N., 1989, Phase I Archaeological Investigations of the Central Artery/Third Harbor Tunnel Project, Boston, Massachusetts. Report of Investigations 78. Prepared by Office of Public Archaeology, Boston, Massachusetts.

Elia, R.J., Landon, D.B., and Seasholes, N.S., 1989, Phase II Archaeological Investigations of the Central Artery/Third Harbor Tunnel Project, Boston, Massachusetts. Report of Investigations 81. Prepared by Office of Public Archaeology, Boston, Massachusetts.

Environmental Division, California Division of Transportation, 1993, Historic Preservation and CALTRANS Archaeology. Caltrans, Sacramento.

Gallagher, J. and Ritchie, D., 1992, Archaeological Data Recovery, Synthesis volume, Central Artery North Reconstruction Project, Charlestown, Massachusetts (Volume VIII Public Archaeology Laboratory, Pawtucket, RI).

Geraci, V.W., 2000, Learning and Teaching Styles: Reaching All Students. In *The Archaeology Education Handbook: Sharing the Past with Kids*, edited by K. Smardz and S.J. Smith, pp. 91–100. Altamira Press, Walnut Creek.

Heck, D.B. and Balicki, J.F., 1998, Katherine Naylor's "House of Office": a Seventeenth-Century Privy. *Historical Archaeology* 32(3):24–37.

Henderson, K., Taylor, T., and Hutiral, J., 1995, *Layers of History: the Archaeology of Heritage square*. Pueblo Grande Museum & Northland Research, Inc., Pheonix.

Johnson, E.J., 2000, Cognitive and Moral Development for Children: Implications for Archaeology Education. In *The Archaeology Education Handbook: Sharing the Past with Kids*, edited by K. Smardz and S.J. Smith, pp. 72–90. Altamira Press, Walnut Creek.

Lewis, A.H., editor, 1999, *Highway to the Past: the Archaeology of Boston's Big Dig*. Massachusetts Historical Commission, Boston.

Massachusetts Department of Education, 2003, Massachusetts History and Social Science Curriculum. MA DOE, Boston, available at www.doe.mass.edu/frameworks/hss/final.pdf.

McHargue, G., Fleming, J., Mrozowski, S.A., Cox, D.C., Rainey, M.L., Miller, B.P., Doucette, D., and Richardi, D., 1994, Redware and Redcoats: a Popular Report on the Archaeology Performed in Charlestown, Massachusetts, for the central artery North Reconstruction Project.

McHargue, G., 1996, *Seashells, Seashells, by the Seashore, the Story of the Spectacle Island Archaeological site*. Timelines, Inc., Littleton.

McHargue, G., 2000, *Piety and Profit: Three Archaeological Sites from Boston's Past*. Timelines, Inc., Littleton.

Society for American archaeology, 1995, *Teaching Archaeology: a Sampler for Grades 3 to 12*. Society for American Archaeology, Washington, DC.

University of Vermont Consulting Archaeology Program, 2003, *An Introduction to Vermont Archaeology: Native American Archaeological Sites and the Chittenden County Circumferential Highway*. University of Vermont Consulting Archaeology Program, Burlington.

Young, P., 2003, The Archaeologist as Storyteller: How to Get the Public to Care About What You Do. *SAA Archaeological Record* 3(1):7–10.

Part 5
Public Agencies and Professional Organizations

20
Protect and Present—Parks Canada and Public Archaeology in Atlantic Canada

Denise Hansen and Jonathan Fowler

20.1. Introduction

Atlantic Canada's rich and complex history is written everywhere upon its varied landscapes, from the geological wonders of Gros Morne to the Acadian dyke lands of Grand-Pré. The federal Parks Canada Agency is mandated to protect and present nationally significant examples of Canada's natural and cultural heritage. A diverse family of protected areas, the Parks Canada system encompasses national parks, which represent significant Canadian landscapes, national marine conservation areas, and national historic sites, which commemorate our county's cultural evolution. Despite its small size relative to the rest of the country, Canada's Atlantic region (Figure 20.1) contains seven national parks and Parks Canada administers 37 national historic sites. These historic sites and national parks reflect the full range of human activity spanning 11,000 years, each one commemorating a specific aspect of Canada's national story. Archaeology is a major component of the agency's operations in the Atlantic region, and often plays a critical role in cultural resource management (CRM) as well as research. In addition to conducting excavations, archaeological staff, who are based at the Atlantic Service Centre in Halifax, the Underwater Archaelogy and Material Culture Research Units in Ottawa and at the Fortress of Louisbourg National Historic Site of Canada in Cape Breton, conduct inventories, monitor and protect the integrity of heritage resources, and maintain Atlantic collections. They play an advisory role in site management planning, as well as assisting in the development of and adherence to statements of commemorative intent, which serve essentially as mission statements for the sites. Of particular interest to us here, archaeological staff also help interpret data for exhibit and develop outreach activities for the general public and for students. This article describes the successes and challenges attending Parks Canada's public archaeology programs in Atlantic Canada and highlights the importance of multidisciplinary partnerships to the success of these programs.

Recognizing the fundamental importance of public interpretation to archaeology generally, and to Parks Canada's mandate in particular, Parks

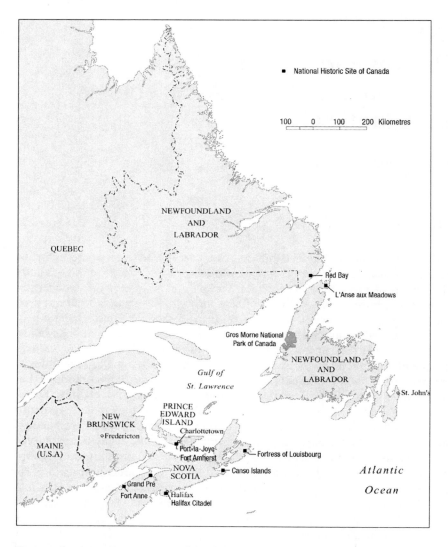

FIGURE 20.1. Map of Atlantic Canada locating select national parks and national historic sites of Canada featured in this article (map courtesy of Parks Canada).

Canada archaeology staff are routinely engaged in the interpretive process. By interpretation, we are referring to "a communication process designed to reveal meanings and relationships of our cultural and natural heritage to the public (visitors) through first-hand experiences with objects, artifact, landscapes, or sites" (Interpretation Canada, 1976). Our approach to interpretation is characterized by a high degree of multidisciplinary interaction, with archaeology staff collaborating on teams planning exhibits, publications, and

educational programs and products. Given the high level of public visibility attending archaeological work in a national historic site or national park, however, it is not surprising that our interpretive efforts often begin only a few feet from the pit.

20.2. In the Field—Beyond "Sex Appeal"

Archaeology has long been a discipline with "sex appeal." While archaeologists may welcome the opportunity to provide visitors with a positive, educational experience, cultural resources are not always best managed when we simply harness archaeology to tourism. Responsibility dictates that legitimate research questions and CRM concerns must provide the motive when we break ground. Having said that, archaeological work at national historic sites and national parks in the Atlantic Region is often conducted in full view of the visiting public and, given the severity of our winter season, frequently during the warmer months and the busiest tourist season. The quality of the resulting dynamic depends to a very large degree upon the archaeologist's attitude and preparation. One recent example of a highly visible archaeological excavation illustrates the joys and challenges of digging under the watchful eyes of an inquisitive public.

Since 2001, Parks Canada, Saint Mary's University, and the Société Promotion Grand-Pré have collaborated on an annual archaeological field school project at Grand-Pré National Historic Site of Canada. Situated in the heart of a pre-Deportation Acadian community dating to 1682–1755, Grand-Pré National Historic Site commemorates the Deportation and the national significance of this centre of Acadian activity, as well as the enduring importance of this particular locale to the Acadian people. The project's goal is to identify and explore elements of the pre-Deportation Acadian community, particularly the original parish church, a symbolic focal point at the site. Although protected since the early twentieth century and subject to periodic archaeological investigation since the 1970s, no tangible evidence of the original church has yet been found.

The multidisciplinary partnership at the heart of the Grand-Pré Archaeological Field School Project sprang to life quite by accident, yet it has nonetheless powered an important research program and learning experience despite a persistent climate of budgetary constraint. Jonathan Fowler conducted background research on the location of the church and the priest's house as a volunteer during the late 1990s, with the active support of Donna Doucet, Executive Director of the Société Promotion Grand-Pré, the Acadian group that co-manages Grand-Pré National Historic Site with Parks Canada. In 1999, Doucet and Fowler organized a small conference for researchers working on Acadian history, during which time Fowler met retired Nova Scotia businessman and geophysicist Duncan McNeill. In 1987–1988, McNeill's geophysical work at Port-la-Joye–Fort Amherst National

Historic Site of Canada, Prince Edward Island, with Parks Canada archaeologist Rob Ferguson led to the discovery of the Haché-Gallant site, an Acadian dwelling dating to the early eighteenth century. Intrigued by Fowler's research, McNeill offered to employ the Geonics EM-38B, an electromagnetic conductivity and susceptibility instrument, to two areas of high archaeological potential within the park grounds. The results confirmed the existence of large geophysical anomalies, giving credence to Fowler's initial speculations and further intriguing archaeological staff at Parks Canada. Meanwhile, Saint Mary's University in Halifax approached Fowler to teach an undergraduate archaeological field school course. The timing was perfect. With a small budget, equipment, lab facilities and human resource support supplied by Parks Canada, work commenced in May 2001, and has continued every summer since. After three successful seasons on a very limited budget, when portions of a pre-Deportation-era Acadian building were located and explored, the project received substantial federal funding for the 2004 season. Yet it was the multidisciplinary nature of the partnership, involving a volunteer geophysicist, university administrators and students, archaeologists, Parks Canada staff, teachers, and community groups, not to mention the active interest in engaging the visiting public, which had carried the project successfully up to this point.

Having worked and toured many archaeological sites, we have seen directors take a variety of stances with respect to visitors. At either extreme, archaeologists may be found on the one hand engaging visitors in trench repartee, occasionally bringing them into the pit, or on the other remaining mute and remote. While the decision over which model to practice—affable host, curmudgeonly monk, or something in between—is often influenced as much by time constraint as personal preference, it has always been our position that public interest in archaeology should and must be actively cultivated. An archaeologically piqued public is a welcomed ally on the critical heritage advocacy and funding fronts, and if enlightened self-interest were not enough, one might take a moment to consider whose history we are digging in the first place. It is archaeology's intimate fixation with the stuff of daily life that renders it a democratic discipline, perhaps the best source available for a people's history. Therefore, to the extent that one can do so without imperiling our research objectives or the integrity of the resource, robust efforts should be made to engage with the visitor: to interpret and to invite speculation. To these ends, Parks Canada is committed to integrating archaeology in the visitor experience as part of our mandate to educate the public.

On site, one of the easiest and most practical ways to begin the dialogue with the public and communicate basic messages is through temporary signage. Signage positioned in open and, if possible, shaded areas along access routes to the site provides answers to the most elementary and most common questions we encounter ("Who are you, what are you looking for, what have you found?"), establishing context and providing an opportunity for higher-level interaction at the excavation site itself. It has been our experience that visitor

interaction with signage is highly variable, and some visitors will avoid the signs regardless of position. Perhaps the best recent example of public resistance to signage comes from a failed exercise in human traffic control at Grand-Pré National Historic Site, where maintenance personnel aptly placed a "No Exit" sign in a heavily traveled portion of the site containing an early colonial ceme-tery. Several passers-by asked one archaeologist working immediately beneath the sign if they could exit this way. Nonetheless, we have found the overall effect of signage to be a reduction in the routine process of responding to the same three or four elementary questions on a recurring basis. Signage construction materials vary greatly with expense, but a great deal can be communicated through a low-tech approach. Colleagues of ours have had great success mounting an 8.5 in. × 11 in. board on a wooden stake and placing a hinged piece of plexiglass over top. This provides both rudimentary weatherproofing and flexibility for changing interpretive text. The often-windy conditions at Grand-Pré National Historic Site required a much heavier, laminated sandwich board to provide an introductory message in both of Canada's official lan-guages.

Depending on the volume of visitor traffic and the resultant disruption of work, designating a crewmember as a public liaison (Figure 20.2) on a

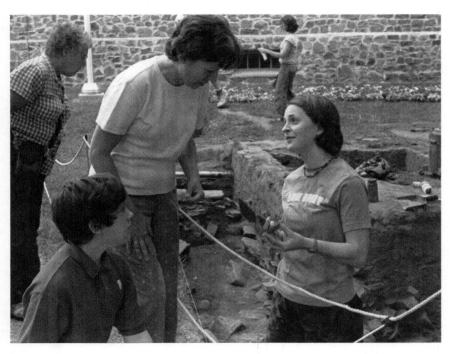

FIGURE 20.2. Site assistant Emilie Gilbert with the visiting public, Grand-Pré National Historic Site of Canada archaeological field school, summer 2004 (courtesy of Parks Canada, photograph by Jacolyn Daniluck).

rotating basis may be a practical use of human resources. Although crew guides may require a crash course in public relations, particularly if they are not naturally comfortable in front of groups, their direct participation has the benefit of personally bridging the gulf between professional archaeology and the public. In exchange for a more intimate visiting experience, the public provides us with a wealth of information about their understanding of our work. In our view, therefore, this exchange is valuable not only for what we can offer, but also for the perspectives we receive in return. At staffed national historic sites and national parks, on-site interpreters frequently undertake some of this duty, but even this approach places some demands on the archaeologist's limited time, as open and frequent communication with the interpreters is necessary to ensure that interpretive messages are accurate and current.

The Congrès mondial acadien, hosted by Nova Scotia in the summer of 2004, brought tens of thousands of Acadian visitors to the province to celebrate their roots. Grand-Pré National Historic Site was a major attraction, and the events surrounding the Congrès provided the Grand-Pré Archaeological Field School with an excellent opportunity to reach out to the public. A 15-min "excavation update" was presented to the visitors each morning and visitors were encouraged to tour the excavation units to see how work was progressing. One Saturday was set aside for three illustrated talks on archaeological themes. One of the most popular activities was the "Archaeologist for a Day" program, sponsored by the Société Promotion Grand-Pré, which allowed one member of the public to join the excavation team each workday. Any concerns that this program might be under-subscribed were put to rest when a journalist from the Canadian Broadcasting Corporation spent a day on-site as a volunteer archaeologist and recorded an engaging and good-humored radio news story. Participation was guaranteed once we had found a means to tap the public on the shoulder.

The role of news media in archaeology is a vast topic, but our experience in Atlantic Canada has convinced us that the media are an excellent and very useful, if sometimes unpredictable, means of extending our voices beyond the confines of our discipline. The amplification does not come without costs. The presence of media on-site creates an instant human resource demand in order to properly frame up the site's historical context and significance as well as conduct interviews. Composing and circulating press releases in advance, as well as booking visits during low-intensity times such as lunch hours are two ways to mitigate this impact. Another issue relates to the abdication of editorial control one experiences when relying on the press. This came home to Jonathan Fowler a couple of years ago when, following a 15-min interview with a local newspaper reporter scribbling busily beside him, he later found this conversation reduced to a very abstract comment about brick fragments. Was he unthinkingly speaking a foreign tongue of specialized terminology? This experience encourages us to consider the contexts in which the public frames the information we provide. Subsequent

experience has demonstrated that many people in the news media are open to some guidance in terms of identifying, if not exactly shaping, some of the more salient messages archaeologists are seeking to communicate. Usually it is the human-interest angle that the media are trying to capture rather than any of our more idiosyncratic fascinations with the sites we dig, but we have come to hold the view that one has to open the dialog someplace. A final interesting revelation came after spending a day and a half taping a documentary segment for The Discovery Channel, highlighting Duncan McNeill's geophysical work at Grand-Pré. This effort was subsequently distilled into approximately 8 minutes of broadcast footage. Since those 8 minutes were broadcast several times nationally, however, we concluded that it was time well spent.

20.3. Telling the Story—Exhibits and Interpretive Signage

Exhibits offer an important channel for communicating messages to the public, and a great deal of multidisciplinary planning goes into the creation of Parks Canada's exhibits. The purpose of our exhibits is to present significant elements of the site's story through a variety of media in an engaging, interactive way, making the subject "come to life through active visitor involvement and extreme relevance to everyday life" (Veverka, 1998: 125). With reference to archaeology, we strive to achieve this goal through a variety of methods that situate evidence of past cultural activity in a meaningful, lived context.

Several national historic sites in Atlantic Canada include what is perhaps the ultimate archaeological exhibit—reconstructions of period buildings on or near the excavated site, their present built reality based heavily on the results of interdisciplinary research. The Fortress of Louisbourg National Historic Site in Cape Breton, Nova Scotia is the best-known example, with one-quarter of the eighteenth-century French fortress faithfully reconstructed on the original site and interpreted by costumed animators. The renowned Norse World Heritage Site of L'Anse aux Meadows in the province of Newfoundland and Labrador includes four reconstructed sod buildings. Unlike the buildings at Louisbourg, the L'Anse aux Meadows reconstructions are located near, rather than on, the actual archaeological site. This represents a shift in reconstruction philosophy from the approach at Louisbourg, reflective of a more cautious approach to the protection and evolution of the cultural resource. In a departure from past practice, reconstructions are now rarely approved for national historic sites. Bruce Fry discusses the issue in a recent article, stating that the "whole concept of reconstruction is now much less acceptable to the heritage community than it was when the Louisbourg project was first proposed and is discouraged in the current CRM policy" (Fry, 2004: 212).

The Canso Islands National Historic Site, located on the eastern tip of mainland Nova Scotia, was an important cod fishing base developed first in

the sixteenth century by the French and subsequently, during the first half of the eighteenth century, by the British. Parks Canada conducted extensive archaeological excavations there on Grassy Island, the location of a New England based fishing and trading community. Interpretation on the island and at the visitor centre located on the mainland is a stellar example of what can be accomplished without the benefit of reconstruction, and much of our understanding of eighteenth-century daily life at Canso has been gleaned from the dual disciplines of archaeological and historical research.

A multidisciplinary team of Parks Canada specialists, led by Halifax-based (Heritage Presentation) Interpretation Specialist Bruce Rickett, planned and produced an interpretive display in the visitor centre that showcases "peopled" dioramas (Figure 20.3) that provide visual snapshots of colonial life on Grassy Island. Artifacts displayed in nearby cases are reproduced in their proper cultural setting within the dioramas. The exhibit also includes an introductory video and scale model of the eighteenth-century town. Visitors, who travel by boat to the island, may take a self-guided tour or be accompanied by a guide. Visually rich interpretive signage (Figure 20.4) has been placed at each stabilized archaeological site on the island, with an archaeologist and historian featured on the signs as characters providing the information.

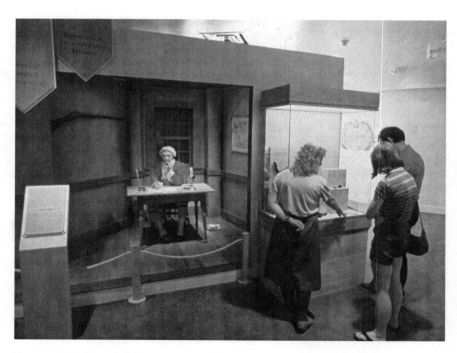

FIGURE 20.3. "Peopled" dioramas provide visual snapshots of colonial life on Grassy Island (courtesy of Parks Canada).

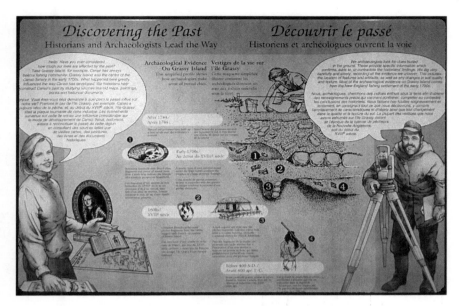

FIGURE 20.4. Outdoor interpretive signage, Canso Islands National Historic Site of Canada (courtesy of Parks Canada, illustrations by Terry MacDonald).

The eighteenth-century structures themselves are not reconstructed, but their outlines are defined with stone to enhance visibility. Visitors seem to get the message without the benefit of reconstruction. A Parks Canada Visitor Satisfaction Survey has indicated that visitors came away with a strong understanding of the national historical importance of the site, accomplished without any reconstruction. At least 90% of visitors understood three stories with strong archaeological themes, including the "harsh living conditions for a lowly soldier"; "the remains of the merchant dwellings" and the "richness of the Canso fisheries in 1600s" (Parks Canada, 2000). Indeed, we wonder if the subliminal experience of journeying to an island dotted with windswept ruins might not actually enhance the visitor's sense of place and of time depth in ways that a reconstruction does not. In this case, less may be more.

Parks Canada exhibits strive to contextualize material culture and historical events rather than simply present them. For example, in *Warden of the North*, an introductory exhibit at the Halifax Citadel National Historic Site, excavated eighteenth-century tableware artifacts are presented as they would have been used in daily life, set on a period-style table in a room (Figure 20.5) with a 1700s image of Halifax used as a backdrop behind a window. In the recently opened (2003) interpretation center at Grand-Pré National Historic Site, a wooden sluice, the keystone of Acadian salt-marsh reclamation technology, is displayed, not in a glass case, but in a full-scale diorama, which clearly demonstrates how the object functioned in its proper setting.

FIGURE 20.5. Excavated eighteenth-century tableware artifacts are presented as they would have been used in daily life, set on a period-style table (courtesy of Parks Canada, photograph by Diana Church).

Built into the diorama is also a monitor that allows visitors to view a 4-min video explaining how the Acadian dyking process worked. Beside the diorama, a scaled landscape model provides visitors with an eagle's view of a colonial landscape, further situating the sluice in a broader context and clearly demonstrating its relationship to other elements of the cultural and natural setting. Across the hall from this exhibit, the new multimedia theatre elaborates on this philosophy. Modeled to resemble the interior of a ship's hold, the theatre, which runs a 20-min film about the eighteenth-century Deportation of the Acadians, was designed to make the visitor's experience of the past affective as well as cognitive. Architecture is employed to "frame the viewer within the image" with the intention of making visitors feel that they are part of the experience rather than simply passive onlookers.

In the world of effective interpretation, a picture does indeed "speak a thousand words." Period genre paintings depicting appropriate material culture are often used in Parks Canada exhibits to evoke feeling and to place artifacts in their proper setting. Original artwork is frequently commissioned with archaeological artifacts found at the site incorporated into the image.

For example, artist Terry MacDonald included images of an excavated smoking pipe, ceramic drinking costrel and Venetian-style wine glass in his detailed rendering of a seventeenth-century French family scene (Figure 20.6) exhibited at Fort Anne National Historic Site in Annapolis Royal, Nova Scotia. Creation of any new exhibit or publication artwork almost always involves a diverse team of Parks Canada specialists, and while this may pose some challenges for the artist who may be accustomed to considerably more freedom of creative expression, the results justify the effort. The multidisciplinary team-based approach often filters out errors before they become a part of the interpretive display. The previously mentioned colonial landscape model at Grand-Pré, for instance, by incorporating archaeological, historical, and geographical insights, offers the public a more authentic perspective on a functioning Acadian colonial landscape than has previously been possible, and excludes the unnatural or hybridized forms of farm animals and overly naturalized settings common in previous attempts.

Exhibits, which include research content and artifacts from Parks Canada sites, are not exclusively located at the site itself. The agency often loans materials for traveling exhibits planned by outside institutions. For example, the

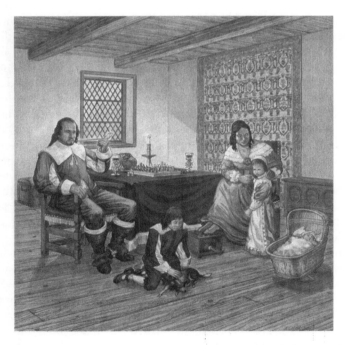

FIGURE 20.6. Re-created 1640s scene showing the family of Charles de Menou d'Aulnay, including archaeological artifacts found at Fort Anne National Historic Site of Canada (courtesy of Parks Canada, painting by Terry MacDonald).

North Atlantic Saga, a Viking traveling exhibit launched by the Smithsonian Institute featured content from the L'Anse aux Meadows World Heritage Site. French artifacts from Atlantic sites were used in the *Once in French America* exhibit that opened in 2004 at the Canadian Museum of Civilization in Hull, Quebec, and for an exhibit created by the Pointe-à-Callière Museum of Archaeology and History in Montreal, which will eventually travel to France. Occasionally Parks Canada will also loan artifacts to smaller local museums provided proper conditions are maintained. This gesture goes a long way toward enhancing relationships in communities that are located near the archaeological sites. Illustrations of artifacts and research information on Parks Canada sites are often used in Parks Canada tourist literature and shared with outside publishers and the media.

20.4. Reaching Students – Outreach Education

In the context of Parks Canada, outreach includes communications and activities that take place off-site, such as marketing, tourism, partnerships, community relations, urban initiatives, traveling exhibits, and web sites. Here we would like to concentrate on *outreach education*, which is aimed at reaching Canadian students through the formal education system. Increasingly, Parks Canada has been turning to the public education system as an audience for its messages, and the rationale for outreach education is straightforward. It communicates the messages and stories of the national historic sites and national parks to those who might not otherwise visit, as many of these places are remotely located (L'Anse aux Meadows, Canso Islands, Red Bay, etc.), and even those located in or near urban centers are closed for many months of the school year. This approach also takes advantage of a natural multiplier effect, in which Parks Canada messages are transmitted, via teachers, to a larger population than would otherwise be reached through standard means such as site visitation. Recently, Parks Canada launched its Parks Canada in Schools Program, a national initiative directed through teachers, to raise awareness and understanding of Canada's natural and cultural heritage among young Canadians and to help build the next generation of heritage stewards. Integration into curricula by partnering with educational communities is crucial for the success of this program.

Education is a provincial jurisdiction in Canada, and each province sets its own curriculum standards and guidelines. Parks Canada, being a federal body, must necessarily work in concert with individual provincial education departments to design curriculum materials that communicate our nation's stories, while at the same time meeting diverse provincial curriculum needs. Clearly, it is desirable for curriculum links to be made in more than one province. Team-based approaches have proven essential to the success of these initiatives, which require not only the clear articulation of joint goals, but sensitivity to a variety of perspectives. Parks Canada's recent Grade 11 (Nova Scotia)

Canadian History Project, for example, which created ten substantial curriculum units showcasing national historic sites, saw a teacher/curriculum consultant working closely with Parks Canada's Heritage Presentation staff (including outreach education specialists) as well as the Nova Scotia Department of Education, historians, archaeologists, and site directors at a variety of national historic sites across the country. The curriculum project also involved members of community groups and other government organizations (e.g., Acadians regarding the unit on Grand-Pré, Mi'kmaq regarding the unit on Fort Anne National Historic Site and the federal Department of Veterans Affairs regarding the unit on Beaumont-Hamel and Vimy Ridge in France). A slow and sometimes agonized process to be sure, involving multiple draft versions circulating for comment and prone to modification, the round table approach nonetheless produced a superior product, one that exhibits not only a high level of historical accuracy, thanks to the input of so many content area specialists, but balance and fairness owing to the broad range of perspectives that shaped it. In fact, the challenges posed by divergent perspectives on the past were actually drawn out into the open and presented to students through a series of activities, particularly in the Fort Anne curriculum unit.

Archaeological analysis offers educators a direct avenue into the process of teaching for critical thinking, and thus forms a strong theme in several of the Grade 11 Canadian History Project units. Units focusing on the national historic sites of Red Bay, a sixteenth-century Basque whaling site in Labrador, and L'Anse aux Meadows, a eleventh-century Norse site in Newfoundland, call on students to construct interpretations of European colonial activity from the ground up. Instead of presenting learners with a piece of text and a list of questions, these units provide students with archaeological evidence, including artifact photographs and site plans, and require students to interpret the nature of the activities that led to the creation of this evidence. Not only is this approach fun, it is also pedagogically sound. The Red Bay unit in particular, has been well received by students and teachers alike. The inquiry method captures intrinsic motivation through problem solving, mobilizes students' previous knowledge in interpretation, and opens the too-often untapped resource of students' imaginations. The associated thinking tasks are of a greater complexity than those typically associated with simple reading, recognition and recall exercises and, perhaps most importantly, the results of the analytical process mirror real life problem solving by yielding a range of probabilities based on rules of evidence rather than a simple and convenient correct or incorrect answer. As in the real world for which we are educating our young people to inhabit, this approach admits ambiguity, as well as the possibility of more than one valid interpretation. The thinking skills required to weigh probabilities against evidence are the very skills we want our future citizens to have.

Presentations to students by the staff of the Parks Canada Archaelogy Section in Halifax are fairly common and our Archaeological Collections Manager, Janet Stoddard, frequently hosts educational programs at the

Trademart Lab facility, offered to students from primary grades to university. Staff members delivering presentations to students often use a copy of the Grassy Island (Canso Islands) National Historic Site education kit (Figure 20.7) called *Discovering Our Past—Through History and Archaeology*. The Grassy Island education kit (copyright 1993) is the recipient of two awards, a Parks Canada Citation of Excellence and a 1994 Outstanding Non-Personal Interpretation award for the Northeastern Region of the National (North American) Association of Interpretation (NAI). The kit is designed to fit the grades 4, 6, and 7 Social Studies curriculum for Nova Scotia and contains two videos, artifacts, and a detailed teacher's guide with lesson plans and classroom activities, all housed in a sturdy camera equipment case.

The *Discovering Our Past* education kit's strongest feature is its interpretive approach. Information is presented thematically by stop/start video with accompanying activities. Canso Islands National Historic Site of Canada is used as a case study in archaeological and historical research, exploring why we need to know about the past, what is involved in the two disciplines, how they work together, and what limitations they are subjected to.

FIGURE 20.7. Parks Canada interpreter with students using the Canso Islands (Grassy Island) National Historic Site of Canada "Discovering Our Past - Through History and Archaeology" education kit (courtesy of Parks Canada, photograph by David Muir).

A total of nine kits were produced and they are sent out on a request basis to schools in Nova Scotia. Although the quality of the Grassy Island education kit is without question, the whole concept of any kit as a wide-reaching communication tool is not. Education kits have become increasingly passé in the age of the Internet and despite their tactile power, only a limited audience can use them since they are expensive to produce in large quantities. Kit maintenance and distribution are also ongoing problems and the Grassy Island kit components have been subject to mail loss, theft, wear, and destruction. As with any educational resource, the kit must be regularly marketed to teachers.

Two national historic sites are featured in the 1992 (reprinted 1997) *Discovering Archaeology—An Activity Book for Young Nova Scotians*. Published by the Nova Scotia Archaeology Society (NSAS) with funding from the now defunct federal Access to Archaeology Program, this book has been something of a success story for the NSAS, a community group with which many Parks Canada staff have been involved over the years. Intended for school-aged children from grades primary to 4, four members of the NSAS with experience as archaeological educators wrote the *Discovering Archaeology* text on a volunteer basis. Children's artist Etta Moffatt engagingly illustrated this book, which has a simple text with creative hands-on activities such as a conservation maze and a mylar layered grid exercise. Several archaeological sites in Nova Scotia are described and located on small maps included in the book. The book was distributed free of charge to every elementary school in Nova Scotia in 1992 and was reprinted by the NSAS in 1997. The society also granted formal permission to a school district in Bel Air, Maryland to formally incorporate activities from the book into its grade 6 curriculum in 30 classrooms. Since its first publication, over 1500 additional copies of the activity book have been sold by the NSAS and through a local book distributor. The book continues to be a popular seller at tourist destinations through out Nova Scotia, snapped up by travel-weary parents eager to entertain their children on the road. Unfortunately the rising cost of reprinting, promotion, and distribution threatens another print run for this worthwhile publication and the NSAS is presently weighing its options. One possibility involves the production of a version of the book without the specialized local flavor in order to reach a wider audience. Publication partners and grant fund sourcing are also being considered.

While there may be no single, perfect method to reach teachers and students, the Internet does have great potential for expansive, cost-efficient outreach education, provided lessons are thoughtfully designed and promoted. Currently the Parks Canada website (www.pc.gc.ca) features a section on Archaeology and until recently there was a *Schoolnet* project featuring Grassy Island (Canso Islands National Historic Site). There is also a *Teacher's Corner* section on the Parks Canada website with lesson plans and *Our Roots, Our Future*, an Internet-based learning resource on national historic sites. Lessons produced recently by teachers attending several successful Teacher's (Training) Institutes at Gros Morne National Park and several national

historic sites in western Newfoundland and Labrador, are currently available online through a partnership with the Newfoundland and Labrador Teacher's Association (NLTA). These lessons are currently hosted on the NLTA website and contain information on sites that feature archaeology, including Red Bay, L'Anse aux Meadows, and others. The Port-la-Joye–Fort Amherst National Historic Site in Prince Edward Island may soon be posting Internet lessons that include archaeological themes. As a possible indicator of one of the directions in which the information superhighway may take teachers and students, a portion of the recently approved funding for the Saint Mary's University field school at Grand-Pré National Historic Site was earmarked to create interactive archaeological curriculum resources. Projects such as this have the potential to situate a diverse and distant student population in the center of the interpretive process like never before. They also have great potential to stimulate students' critical thinking skills and cater to distinct learning styles, provided that the medium's strengths, such as its capacity to facilitate multilinear navigation through multimedia information, are fully utilized.

Parks Canada educational materials must be made available in both English and French and there are strict technical guidelines for Internet posting on the official Parks Canada site that make the process time consuming, although certainly worth the effort. It is also important, however, to remember that the Internet is still more useful as a tool for the distribution of lessons to teachers than to students. Most students in Canada do not have a computer on their desks in the classroom and their teachers must book limited parcels of time in a computer lab, thus interactive lessons that require one-on-one computer use may serve more as homework or project work, provided the student has access to the Internet at home or in their community.

20.5. Keys to Success

If there is one central theme that our experience over the last 20 years has brought to the fore, it is the central importance of the multidisciplinary, team-based approach to erecting solid bridges between professional archaeologists and the public. None of the projects we have mentioned here were the products of lone geniuses working in isolation; rather, all were created through a fusion of diverse talents and skill sets, including the abilities of staff formally trained as classroom teachers. Field excavations, the recent collaborative effort between Parks Canada, Saint Mary's University, and the Société Promotion Grand-Pré being a case in point, are often by their nature multidisciplinary, as is the exhibit development process. In the latter case, we have noted that a healthy collaborative approach can be a boon for the creative process as well as for exhibit accuracy. Outreach education, due to the various levels of government and community stakeholders involved, is also essentially a group-based undertaking, a fact that is likely to intensify with

the increased reliance on web-based approaches and the specialized skills needed to function in this medium.

The approaches to bridge building that we have outlined are not entirely flawless, however, and our experience has brought to light some issues that deserve cautionary comment. A key ingredient in the maintenance of healthy collaborative relationships, whether they be for the purposes of conducting projects in the field, producing exhibits, or creating outreach materials, is time, and the organizational function of group work can place, in itself, a considerable strain on limited human resources. Just as archaeologists must account for the necessary lab time after the fieldwork is done, the team-based approach necessitates some allowance of time and effort just to maintain the web of relationships. Even e-mail can become a very time-consuming duty. Collaborative efforts between groups with differing agendas also have an inherent potential for generating friction. This is particularly true of outreach education work, in which curriculum contributions must fit into a government-mandated framework over which archaeologists really have little or no control, and the pace of ongoing curriculum revision and redesign makes the whole goal something of a "moving target." Within a few short years, the pace of change will almost inevitably break even the most carefully forged links to government curriculum. A commitment to give voice to discrepant and divergent perspectives, whether through curriculum materials or exhibits, sacrifices speed to inclusiveness, and creativity by committee can be a slow, and occasionally contentious, process.

Finding the time necessary to provide the proper logistical support for multidisciplinary partnerships is not easy in an institutional culture preoccupied with CRM. While responsible custodianship of our natural and heritage resources must remain a paramount concern, archaeologists can find their research interests subordinated to the exigencies of road building, drain installation, and storm damage, with the overall result being a reactive rather than a proactive professional climate. Arriving, as they often do, at inopportune times, the demands of CRM can also interfere with an archaeologist's ability to follow up properly through publication. Indeed, Parks Canada has largely backed away from its previously well-known research and publication program, over the years abandoning its *Manuscript Report, History and Archaeology,* and *Occasional Papers in History and Archaeology* series, as well as its more concise *Research Bulletins,* in part due to high translation costs. Although these vehicles largely served the interests of the professional community, students and heritage enthusiasts also read them for research and general interest. Parks Canada archaeological staff communicate their research when the opportunity arises through outside publications such as journals, books, magazines, and a steady stream of newspapers and other media. They also often share their work through conferences, a wide range of public presentations, and more frequently over the Internet. Still much of their professional writing is in the form of internal reports that are rarely seen by the public.

The past decade has seen diminishing resources within CRM in Parks Canada and a reduction in permanent staff. Contracting archaeological services has become more common and the corporate memory is becoming increasingly dim. At the same time, economic decline in the Atlantic fishery places additional demands on tourism. Parks Canada CRM is often under pressure to provide the attraction of reconstructions or new visitor centers which research and financial resources cannot support. These factors make partnering and honest communication even more important within public archaeology in Parks Canada in the Atlantic region. Ultimately, in this corner of the world we are fortunate to live in an environment that is rich in natural and cultural history, and to have access to a professional talent pool capable of interpreting that history in a variety of innovative ways.

References

Fry, B.W., 2004, Designing the Past at Fortress Louisbourg. In *The Reconstructed Past—Reconstructions in the Public Interpretation of Archaeology and History* edited by J.H. Jameson, Jr., p. 212. AltaMira Press, a Division of Rowman & Littlefield Publishers.

Interpretation Canada, 1976, In *Interpretive Master Planning: the Essential Planning Guide for Interpretive Centers, Parks, Self-guided Trails, Historic Sites, Zoos, Exhibits and Programs*, edited by J.A. Veverka, p. 19. Acorn Naturalists.

Parks Canada, 2000, *Grassy Island NHS, Visitor Satisfaction Survey, 1999—Entrance*, p. 6. Parks Canada, Atlantic Service Centre, Halifax.

Veverka, J.A., editor, 1998. *Interpretive Master Planning: the Essential Planning Guide for Interpretive Centers, Parks, Self-guided Trails, Historic Sites, Zoos, Exhibits and Programs*, p. 125. Acorn Naturalists.

21
Making Connections through Archaeology: Partnering with Communities and Teachers in the National Park Service

John H. Jameson, Jr.

> *The present is the past rolled up for action,*
> *and the past is the present unrolled for understanding.*
> —Will Durant and Ariel Durant, from *Lessons of History*, 1997

> *He who controls the past controls the future.*
> *He who controls the present controls the past.*
> —George Orwell, British novelist, 1984

21.1. Introduction

The US National Park Service (NPS) has been a leader in the USA in developing interdisciplinary and more holistic approaches to education and public interpretation of heritage. With both a protection and education mandate, the agency regards interpretation as "a distinct profession encompassing a philosophical framework that combines the essence of the past with the dynamism of the present to shape the future" (NPS IDP, 2006). NPS has championed the teachings and philosophy of Freeman Tilden (1977) who defined the art and process of public interpretation. To NPS, Tilden defined interpretation as a separate discipline and gave it form. Tilden's principles stressed: relevance of the interpretive message to the experience of the visitor; interpretation as revelation and provocation; interpretation as art form; telling whole story rather than a part; and interpretive as a separate, but undiluted, story to younger audiences. He advocated giving citizens the power to make informed decisions about environmental and economic issues, with the effective interpreter seen as an information giver who allows the information receiver to decide what is important and what to do about it.

In this chapter, I present an overview of NPS initiatives in the public interpretation and archaeology at national and regional levels, along with examples of exemplary programs at selected parks. These cases demonstrate that, as NPS standards and programs evolve, efforts expand to facilitate connections between students and the public at large with resource meanings, providing more holistic interpretations that embrace inclusiveness and ethnic sensitivity.

21.2. National and Regional Initiatives

21.2.1. National Programs

NPS archaeology programs emphasize the wise use and preservation of archeological sites, collections, and records. The US Secretary of the Interior, who oversees all NPS programs, has advocated a National Strategy for federal programs that encourages: (1) the preservation, protection, and appropriate research on archeological sites, (2) the curation and research use of archeological collections and records, (3) the utilization and sharing of archeological reports, data and research results, and (4) the incorporation of public education, interpretation, and outreach activities within projects and programs. Staff work as advocates of archaeology education and the public benefits derived from archaeology and have supported the development of education and interpretation programs and training (McManamon, 2000; Little, 2002, 2004; Jameson, 2004).

A critical factor in the recent evolution of archaeology interpretation programs and standards has been the cooperation, interest, and input coming from the NPS interpreters, especially the staffs at parks, NPS training centers, and Washington office involved in the creation and development of the NPS interpretive development program (IDP).

21.2.1.1. The NPS Interpretive Development Program

The NPS IDP, conceived by NPS in the mid-1990s, and still evolving, encourages the stewardship of park resources by facilitating meaningful, memorable visitor experiences. Before the 1990s, training for NPS interpreters included a detailed introduction to significant names, dates, and references to important books. Often this introduction was coupled with an exercise in writing a personal definition of interpretation. The IDP approach incorporates many important aspects of these methods but with a strengthened sense of individual responsibility: professional interpreters are trained to search for understanding the process of interpretation in fostering resource stewardship. NPS interpreters are expected to be able to articulate the outcomes of interpretation to make personal choices in approach and establish the relevance of interpretation for resource decision-makers (NPS IDP, 2006).

21.2.1.2. IDP Education and Training Standards

The IDP program is based on a precept that effective interpretation moves beyond a recitation of scientific data, chronologies, and descriptions. Based on the philosophy that people will *care for* what they first *care about*, the program aims for the highest standards of professionalism. It includes mission-based training and curriculum development, field-developed national standards for interpretive effectiveness, a peer review certification program, and developmental tools and resources. It is designed to foster accountability

and professionalism in interpretation, facilitate meaningful and memorable experiences for visitors, raise the level of public stewardship for park resources, and facilitate learner-driven skills development. It provides professional standards and course of study curricula for employees and has trained a cadre of employee certifiers to evaluate skills and competencies among professional interpreters (NPS IDP, 2006). IDP may be unique in the world among public land management agencies in embracing these standards and provisions.

The IDP program has developed and adopted an interpretation formula expressed as an equation: $(KR + KA) \times AT = IO$ (knowledge of the resource + knowledge of the audience \times appropriate techniques = interpretive opportunities). The interpretive equation applies to all interpretive activities and embraces a discussion of multiple points of view incorporating related human values, conflicts, ideas, tragedies, achievements, ambiguities, and triumphs.

The IDP program attempts to define the art and skill of interpretation, effective interpretation techniques, and modes of delivery. The techniques and modes used are tailored to the backgrounds and identities of target audiences and communities, as well as other constituent stakeholders. The program recognizes that the ultimate role of interpretation is to support conservation by facilitating public recognition and support of resource stewardship. This is accomplished by facilitating opportunities for visitors to forge linkages with resource meanings that contribute to the development of a stewardship ethic: "Interpretation is a seed, not a tree" (NPS IDP, 2006).

To date, 12 training modules for interpretation have been developed, including the first (and to date, only) "shared competency" module, IDP Module 440, for interpretation of archaeology. These modules reflect specialties that relate to a set of competencies developed by NPS for national standards in interpretation. They stand as a goal to foster interpretive excellence nationwide in NPS areas at every stage of an employee's career (NPS IDP, 2006). Besides the Module 440, entitled "Effective Interpretation of Archeological Resources," examples include Module 103, "Prepare and Present an Interpretive Talk," Module 270, "Present an Effective Curriculum-based Program," and Module 311, "Interpretive Media Development."

A standard rubric is applied by peer review certifiers in measuring whether a specific product demonstrates the elements of success in that area, at a point in time. Employees use the rubric as a guide for self-assessment and to determine whether they need to work on skills or complete other preparation before attempting to meet the certification standards. The basic or core assessment rubric is expressed as two interconnected parts (NPS IDP, 2006):

1. The project/program is successful as a catalyst in creating opportunities for the audience to form their own intellectual and emotional connections with meanings/significance inherent in the resource
2. The project/program is appropriate for the audience, and provides a clear focus for their connection with the resource(s) by demonstrating the cohesive development of a relevant idea or ideas, rather than relying primarily on a recital of a chronological narrative or a series of related facts

NPS education and interpretation programs also support and advise other programs and museums. For example, in 2006, NPS staff members attended an advisory panel meeting for the National Children's Museum in Washington, DC. The museum, slated to open in 2009, will feature four national parks as part of an interactive learning experience for children aging 5–9. The museum proposes to develop a Junior Ranger Program that will help guide children and their families through the exhibit while helping them make connections with the park resources and stories represented. NPS staff members assist the museum by providing information, images, and ideas.

21.2.2. Regional Initiatives

21.2.2.1. Southeast Archaeological Center's Public Education
and Interpretation Program

For nearly two decades, through its Public Interpretation Initiative and other activities, the NPS Southeast Archeological Center has made significant, long-term contributions to public education, interpretation, and outreach. These contributions have made the center a regional, national, and international leader in these fields. Through various episodes of agency downsizing and restructuring, the center has stood out in carrying the torch at the federal level in maintaining a productive and effective program that stresses public access to information.

The center's public education activities have substantially aided the NPS in accomplishing the public education and awareness goals set by the US Department of the Interior's National Strategy for federal archeology. However, unlike some organizations that are specifically set up to conduct public outreach and others which receive endowments and private support, the center's public education and outreach programs remain an *unfunded collateral duty* requiring exceptional initiative, innovation, and perseverance to be sustained. Despite these challenges, the center has successfully developed an integrated, professional quality public education program that is accessible and useful to employees, park staffs, and public participants. Programs have been innovative and diverse and strive to reflect new attitudes, greater interaction, effective partnerships, and renewed public obligations. Key activities have encompassed the center's Public Interpretation Initiative, including service-wide leadership in the development of the NPS archaeology interpretation training "Module 440," and an interpretive art initiative.

21.2.2.2. The Public Interpretation Initiative

The center's long-term commitment to public education is evidenced by the success and longevity of its Public Interpretation Initiative. This informally organized program has been a long-term public education and outreach program commitment with a regional, but increasingly national and international, relevance and scope. Its aim has been to facilitate communication and

collaboration among archaeological education practitioners, whether they may be archaeologists, park interpreters, exhibit designers, or educators. The initiative was developed in response to the growing public interest in archaeology and out of the realization within the professional community that archaeologists can no longer afford to be detached from the mechanisms and programs that attempt to communicate archaeological information to the lay public. The program has included the organization and coordination of professional symposia, workshops, training sessions, publications, and exhibits presented in a variety of forums. Center staff members have played key roles in the development of interdisciplinary training courses, workshops, and seminars for park rangers, educators, and archaeologists. Programs contribute to the NPS interpretive goal of fostering opportunities for public audiences to form intellectual and emotional connections to the meanings and significance of archaeological information and to the people and events that created them.

21.2.2.3. Interpretive Art Initiative

Another, closely related activity of the Southeast Archaeological Center has been its Interpretive Art Initiative. Staff works with parks and other partners in using the power of artistic expression to convey archaeological information and insights to the public. Interpretive projects such as interpretive oil paintings utilize the archaeological and historical record to enhance the visitors' experience, and, working with communication partners and colleagues, help to create opportunities for visitors to connect to the meanings and significance of archaeological information. The goal has been to inform and inspire the public, through conjectural interpretive art, about archaeologically documented cultures, sites, and events. Since 1991, projects have supported national parks and other public agencies in producing artworks that help tell the fascinating stories of America's cultural heritage. The program has produced 90+ original oil paintings, drawings, and sketches by contract artist Martin Pate. In producing these works, the artist works closely with archaeologists and interpretive specialists. The images are used in a variety of formats, including posters, book covers, and wayside exhibits. Many images are discussed and illustrated in the 2003 *Ancient Muses: Archaeology and the Arts* book (Jameson et al., 2003) and are featured on the center's Web site at http://www.cr.nps.gov/seac/

21.2.2.4. Training Initiative

Staffs from the Southeast Archaeological Center have led a major development within NPS, through interdisciplinary cross training of employees, to strengthen the relationship between archaeology and public interpretation and to ultimately improve how archaeology is presented to the public. The training initiative stems from a service-wide push in the 1990s to improve training and development of its employees. Center staff collaborated with colleagues at the

Stephen T. Mather and Horace Albright training centers and led a task group of archaeologists, interpreters, and educators collaborated in developing a curriculum-based course of study. Known as IDP Training Module 440, this module is now being used by NPS across the country in the cross training of employees. The training attempts to wed the goals of educational archaeology with goals of IDP and interpretation. It emphasizes interdisciplinary cooperation and communication and sensitive interpretation to multicultural audiences. The training teaches the skills and abilities (shared competencies) needed to carry out a successful archaeology interpretation program. The curriculum is available to employees of other public agencies and sets high standards for public interpretation efforts nationwide (Figure 21.1).

In recent years, Module 440 has been applied successfully at workshops and courses conducted at several venues across the USA. Classes are conducted in partnership with both public and private institutions. For example, a recent course at Fort Sumter National Monument and Charles Pinckney National Historic Site, South Carolina, was a partnership between NPS and the Charleston Museum, Historic Charleston Foundation, the National Trust for Historic Preservation, and the US Forest Service. Attended annually by 20–35 persons from multiple public agencies and private institutions, the 5-day workshop includes classroom instruction as well as field trips to local sites. An important outcome of workshops and courses, besides the

FIGURE 21.1. An interdisciplinary focus group discusses the park archaeology education program at Old Dorchester State Park, South Carolina, in 2004 during an "Effective Interpretation of Archaeological Resources" Module 440 workshop. (Photo: National Park Service.)

knowledge and skills obtained by the participants, is a set of constructive program critiques and recommendations to local parks and sites for effective public interpretation. A Web site for each workshop, including a description of resources, agenda, and outcomes, is maintained by the Southeast Archaeological Center at http://www.cr.nps.gov/seac/course-of-study/.

A byproduct of training module development has been the creation by NPS in partnership with the University of Maryland of two-interactive distance-learning training courses, "Archaeology for Interpreters: A Guide to Knowledge of the Resource," and "Interpretation for Archaeologists: A Guide to Increasing Knowledge, Skills, and Abilities."

"Archaeology for Interpreters" invites learners to explore the world of archaeology through online activities, illustrated case studies, and interesting facts. The course provides the opportunity to learn about basic archaeological methods, techniques, and up to date interpretations. "Interpretation for Archaeologists" encourages archaeologists to learn methods and philosophies of interpretation for engaging the public's hearts and minds with archaeological resources. Guided activities, fun facts, and case studies guide users to realize the important role of interpretation in facilitating meaningful relationships with the resources. Users gain knowledge, skills, and abilities for encouraging people to care about archaeology and to adopt an ethic of stewardship (NPS, 2005).

21.3. Examples of Park-Led Programs and Initiatives

A number of exemplary archaeology education programs in parks apply specialized interpretation standards, skills, and training to formal, state-mandated education standards. Selected examples include the programs at Grand Canyon National Park, Arizona, Fort Frederica National Monument, Georgia, Ocmulgee National Monument, Georgia, Fort Vancouver National Historic Site and Reserve, Washington, and Jimmy Carter National Historic Site, Georgia (Figure 21.2).

21.3.1. Grand Canyon National Park, Arizona

Through a recently developed archaeology education program, the staff at Grand Canyon National Park is using archaeology to make elements of the past come to life. At Grand Canyon, a pot sherd, remnants of a pueblo, or tree rings are used to allow visitors to glimpse ancestral Puebloan life. Visitors are provided opportunities to understand that people everywhere are the same in terms of basic needs—food, water, shelter, and clothing. The program represents the environment as a grocery store and pharmacy to present and past cultures, where the ancestral Puebloans knew the land and where to find valuable resources that allowed them to thrive.

Visitors to Grand Canyon National Park have the chance to see several archaeological sites while visiting the park: Wahalla Glades on the North

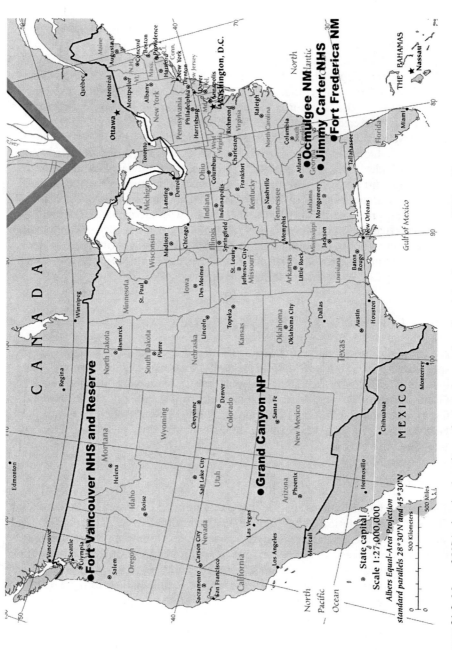

FIGURE 21.2. Map of USA showing locations of selected examples of park-level programs (CIA n.d.)

Rim, Bright Angel Pueblo along the Colorado River, and Tusayan Ruin on the South Rim. Each site uses different types of media, from waysides and site bulletins, to park ranger-guided walks, to interpret these ancestral cultures. The staff at Tusayan Museum uses interpretive displays, artifacts and 3,000–4,000 year old split twig figurines to provide visitors a chance to peer through cultural windows in the hopes of experiencing aspects of the diverse Native American cultures of the past and present that live in and around Grand Canyon today. Archaeologists and interpretive park rangers work together to share current information and consult with tribes. Resulting programs recognize that the Grand Canyon remains a homeland and a sacred place to a number of American Indian cultures and a point of emergence to some. They offer an opportunity to consider the powerful and spiritual ties between people and place (GRCA, 2005, personal communication) (Figures 21.3 and 21.4).

21.3.2. The Desert View Archeology Education Program

In the past, Grand Canyon has offered many curriculum-based education programs to elementary and middle school classes. Most of these programs focus on earth and life sciences with emphasis on geology. A new cultural

FIGURE 21.3. Interdisciplinary focus groups get an overview of U.S. Forest Service public education programs at Elden Pueblo, Flagstaff, Arizona during a 5-day "Effective Interpretation of Archaeological Resources" Module 440 workshop in the fall of 2005. (Photo: National Park Service.)

FIGURE 21.4. Interdisciplinary focus group gives presentation during the "Effective Interpretation of Archaeological Resources" Module 440 training at Grand Canyon National Park, Arizona in 2005. (Photo: National Park Service.)

heritage program was designed that briefly touches on prehistory, and then moves into Euro-American exploration and development.

A teacher recently remarked to the park staff how she would like to teach her students about the native people of Grand Canyon. In response, park staff wanted to design an archaeology studies program but lacked the background to begin such an endeavor. Using available archaeological expertise, coupled with the availability of an excellently preserved study site, park staff took the initiative in developing a curriculum-based education program.

The development of this program has been a collaborative process. The park education staff worked collaboratively with the Desert View District ranger staff in making several on-site visits to the Tusayan Ruins and Desert View Watch Tower sites. Both Hopi and Navaho elders were consulted for Native American input. During a Module 440 "Effective Interpretation of Archaeological Resources" workshop in 2005, staffs were able to tap into the skills and knowledge base of over 30 professionals, including a Native American interpreter. A focus team, made up interpretive rangers educators and archaeologists, hammered out logistic and programmatic issues, wrote themes, goals, and objectives, and designed hands-on field activities. By the end of the training, the program manager Jay Johnstone had a complete outline for a 5-h archaeology/anthropology program, was ready to circulate a plan draft for peer review, and began assembling the equipment and props for the

educational activities. Desert View staff met with representatives of the park's archaeology branch staff many times to review components of the program. They worked with archaeologists in the field to learn more about the archaeological processes and scientific methods. They also visited archaeological education centers in Tucson, Arizona to gain insight into existing programs and to learn from the experience of other educators. Cultural resource specialists of the US Forest Service contributed time and materials to the program and served as expert resources in ancestral Puebloan cultures of this area.

Country Meadows School from Phoenix, Arizona was the partner school for the pilot program in 2006. After an initial visit to the school, Jay Johnstone led several previsit activities with the students such as pot sherd identification, tree ring correlations, and a prehistory trivia game. After many months of work and planning, Johnstone implemented an archaeology program designed to fit official curriculum standards. The program goal is to utilize experiential learning techniques in a scientifically accurate program that successfully connects the present generation to past generations (Johnstone, 2006, personal communication).

Table 21.1 presents an outline of the program designed to conform with Arizona curriculum requirements for learning strands associated with science, social studies, geography, and mathematics, respectively.

21.3.3. Fort Frederica National Monument, Georgia

Fort Frederica National Monument is the site of one of the country's best examples of *in situ* colonial period archaeology. The national monument grounds contain the entire remnants of an early eighteenth century British military town and fort. Named after the Prince of Wales, Frederick Louis, Frederica was established in 1736 by military leader and member of Parliament James Edward Oglethorpe as a defensive military outpost between Spanish Florida and important British settlements and plantations in Georgia and South Carolina. The Spanish attacked the island in 1742 but were repulsed by the outnumbered British colonial forces. The abandonment of the town by the military, coupled with a devastating fire, caused its rapid decline by the 1760s as a strategic frontier outpost. Over the next two-and-a-half centuries, the site was farmed and residences established, including an orphanage for boys.

Since 1994, over 10,000 students have participated in an innovative and unique archaeology education program established in a partnership between Fort Frederica National Monument and the Glynn County School System on St. Simons Island, Georgia. This award-winning program has been a model for the establishment of interagency and local partnerships. The NPS/school district partnership has received technical support from professional archaeologists from local universities and the NPS. Grants and donations were made in both direct and in-kind contributions. Contributing organizations include the Fort Frederica Association, the NPS Parks-as-Classrooms program, and the National Park Foundation, who awarded a

TABLE 21.1. Content outline for the Grand Canyon National Park Archaeology Education Program.

The Grand Canyon National Park Archaeology Education Program
Time Travelers - Connecting the Past, Present and Future
(Johnstone 2006)

Theme- *Anthropology and archaeology teach us how the ancestral puebloan cultures managed to thrive within the restrictions of their environment and how today we are as similar as we are different to (from) cultures of the past.*

Goals - Through hands-on activities and experiential learning, students will develop a connection to the pre-historical cultures and present-day people who call Grand Canyon home.

Objectives - Students will be able to:
1. Describe the similarities and differences between the ancient cultures and their own.
2. Demonstrate proficiency using basic archaeological techniques and tools.
3. Make inferences based upon observations regarding cultural lifestyles of ancestral puebloan people.
4. Recognize limitations of habitat and carrying capacity of an environment and ways they can become better stewards of our natural resources.

Audience- 4th-6th grade students, mainly from AZ. Group size 35 students max.

Staffing requirements- One ranger could do it but two would be much better. In a perfect world, staff from Tusayan and Desert View would be available to welcome and provide orientation (or to help with activities).

Logistical schedule

9:00- Arrive at Desert View- Ranger welcome and restroom break. Picture taking

9:30- Back on bus and ride to Tusayan. Program introduction on bus. Review the terms and familiarize students to the topics of anthropology and archeology. Once at site, orient students to site, review schedule of events and provide instructions for next activity.

9:45- ½ students conduct museum tour/knowledge gathering exercise while other ½ take tour of ruins and collect their site data package.
 - Ruins tour will be a brief walk around the rooms, pointing out different elements, sizes and possible uses. Connections should be made between past and present i.e. agricultural areas, worship sites, chores, play and shelter.
 - At various stop along the way, student work groups will pick up a data packet with specific info. about the room they will be studying. (More info on data packets below.)
 - Knowledge hunt will consist of students reviewing the museum exhibits and answering 5-10 questions designed to facilitate a stronger connection to past cultures.

10:00- Switch groups and repeat tours.

10:15- Meet at picnic area to begin archaeological activity. Assign work groups to sifting stations and give demo on equipment usage. See below for detail of activity.

11:15- Conclude archeological sifting, sorting and i.d. activity. Finish analysis of archaeological findings, begin development of inferences and prep. for group presentations.

11:30- Group presentations with evidence supporting group's hypothesis regarding room use and connected social inferences. The rangers will lead a discussion on comparing archaeological inference and anthropologic/oral history of puebloan cultures and how, without the support of each scientific element, the story isn't as accurate.

12:00- Load bus for Desert View

12:15- Lunch break/restrooms

12:45- Quiet reflections along rim

1:15- Tower tour, journal entries, pictograph sketching

2:00- Conclusion at top of tower

TABLE 21.1. Content outline for the Grand Canyon National Park Archaeology Education Program. — Cont'd

Program content:

Knowledge hunt worksheet for Tusayan Museum- 15 Min.

1. Name two things the ancestral Puebloan people gathered from the local environment. What did they use your two items for?

2. Name three items the ancestral Puebloan people traded for. Where do you think these items came from?

3. What current states contain a portion of the ancestral Puebloan people's homeland?

4. What crops did the ancestral Puebloan people farm? Name and describe one technique they used for farming.

5. How many different ways did the ancestral Puebloan people use a deer?

6. Look at the painting.

 A. What materials did the ancestral Puebloan people use to build their home? (look at the museum walls and ceiling for a clue) Where did they get these materials?

 B. what similarities do you share with the people portrayed in the artwork?

7. What different items can be made from rock material?

8. What was your favorite artifact? Why?

Archaeology activity- 1 Hr, 15 Min.

A) Have class break into 4-5 work groups with 4-5 students ea. Each student will have a field journal and each work group will have a data card on their assigned room along with dimensions, drawings and other pertinent info (pick up card during ruins tour.) Each group will have a work station where they will share the responsibilities of sifting and sorting a 5-gal bucket of fill "collected" from their room, categorizing and compartmentalizing the artifacts, recording the quantity of artifacts and sketching a sample of their artifacts.

B) Students begin by measuring a specified quantity of fill from their 5-gal bucket and sifting it through their two-person shaker screen. All potential artifacts will be placed on a sorting tray and counted and sorted into compartments by the artifact type. The group will be responsible for counting or estimating the number of each type of artifact and recording the data in their field journal. Each student will share in the various responsibilities.

C) After sifting the dirt, student will analyze their findings, compare artifact counts and types and apply their knowledge of culture to draw hypothesis about the use of their room and the further social implications.

D) Students report their findings to the class and the ranger facilitates and helps the students interpret their discoveries.

Props- 5 ea of shaker screens (build in-house), 5-gal buckets, 5 small tarps, 5 sorting trays (utensil trays?), clipboards, field journals, pencils,

Reflections- 30 min.

Students will have an opportunity to sit, by themselves, along the rim. The ranger will encourage the students to consider the human history of Grand Canyon. People have been coming here for thousands of years and have left stories of their connection to the landscape. What story is the canyon telling the student? Have the student explain their personal connection to the canyon through poetry, landscape art or writing a story.

Tower tour and Conclusion- 45 Min.

(*Continued*)

TABLE 21.1. Content outline for the Grand Canyon National Park Archaeology Education Program. —Cont'd

Students will have an opportunity to walk through the tower and see how Mary Colter's architecture was influenced by local culture. Students will be tasked with finding the Snake Alter room and sketching some of the pictographs in the room or from the ceiling above and then interpreting what the pictographs could mean. The ranger will review the pictographic story and lead a short discussion about issues surrounding the Snake Alter and Abo Caves destruction. Once on top, students will have a great view of the region and be able to see portions of Navajo Nation, Hopi Nation, Unkar Delta and the Colorado River.

As part of the conclusion, the rangers will lead the group in a discussion regarding the NPS Mission of providing for the enjoyment of Grand Canyon while balancing the need to protect very important cultural sites from being "loved to death". Students will give their opinions of why archeology and anthropology is valuable and why this history is worth learning.

4) Primitive technology exhibition (optional, time permitting)

A) Rabbit sticks: students get five turns to hit a target with a traditional throwing stick.

B) Corn grinding: students use a mano and metate to grind enough corn to make a corn cake.

C) Pinch pots: students roll and pinch a small take-home pot or bowl and using fingernails and natural tools to aid decorating.

D) Split twig figurines: using pipe cleaners or natural materials, students make a deer or sheep figurine.

E) Native plant i.d.: students identify several local plants useful as medicine, food and textiles.

Primary Parkwide Interpretive Themes

A) Grand Canyon remains a homeland and a sacred place to a number of American Indian cultures, a point of emergence to some, offering us an opportunity to consider the powerful and spiritual ties between people and place.

B) Grand Canyon has sustained people materially and spiritually for thousands of years- wider recognition of its value led to its designation as a national park and world heritage site; however, continuing threats to its preservation generate dialogue about our need and responsibility to conserve our local and global environment.

Arizona State Standards of Learning

Social Studies Standards Grades 4-5

1. ISS-E2 Describe the legacy and cultures of prehistoric American Indians in Arizona, including the impact and adaptations to geography, with emphasis on:

 a) PO 1. How archeological and anthropological research gives us information about prehistoric people.

 d) PO 4. Distinctive culture of the Anasazi (ancestral Puebloan people) including where they lived, their agriculture, housing, decorative arts, and trade networks.

 e) PO 5. How prehistoric cultures adapted to and altered, their environment, including irrigation canals and housing (Grades 4-5)

Geography Standards

1. 3SS-E2. Describe the impact of interactions between people and the natural environment on the development of places and regions in Arizona, including how people have adapted to and modified the environment, with emphasis on:

 a) PO 4. How people have depended on the physical environment and its natural resources to satisfy their basic needs, including the consequences of Arizonans' adaptation to and modification of, the natural environment. (Grades 4 –5)

TABLE 21.1. Content outline for the Grand Canyon National Park Archaeology Education Program. —Cont'd

Mathematical Standards

1. 4MM-E1. Geometric Properties. Analyze the attributes and properties of 2 and 3 dimentional shapes and develop mathematical arguments about their relationships.

 a. PO 3. Draw points, lines and line segments.

 b. PO 8. Draw a two dimensional shape that has line symmetry

2. 4MM-E4. Measurement

 a. PO 3. Select an appropriate tool to use in a particular measurement situation

 b. PO 9. Determine the area of squares and rectangles.

Science Standards

Strand 1: Inquiry Process
Inquiry Process establishes the basis for students' learning in science. Students use scientific processes: questioning, planning and conducting investigations, using appropriate tools and techniques to gather data, thinking critically and logically about relationships between evidence and explanations, and communicating results.

Concept 1: Observations, Questions, and Hypotheses
Observe, ask questions, and make predictions.
PO 1. Differentiate inferences from observations.

PO 2. Formulate a relevant question through observations that can be tested by an investigation. (See M04-S2C1-01)

Concept 2: Scientific Testing (Investigating and Modeling)
Participate in planning and conducting investigations, and recording data.
PO 1. Demonstrate safe behavior and appropriate procedures (e.g., use and care of technology, materials, organisms) in all science inquiry.

PO 2. Plan a simple investigation that identifies the variables to be controlled.

PO 3. Conduct controlled investigations (e.g., related to erosion, plant life cycles, weather, magnetism) in life, physical, and Earth and space sciences.

PO 4. Measure using appropriate tools (e.g., ruler, scale, balance) and units of measure (i.e., metric, US customary).
(See M04-S4C4-03 and M04-S4C4-07)

PO 5. Record data in an organized and appropriate format (e.g., t-chart, table, list, written log). (See W04-S3C2-01 and W04-S3C3-01)

Concept 3: Analysis and Conclusions
Organize and analyze data; compare to predictions.
PO 1. Analyze data obtained in a scientific investigation to identify trends. (See M04-S2C1-03)

PO 2. Formulate conclusions based upon identified trends in data. (See M04-S2C1-03)

PO 3. Determine that data collected is consistent with the formulated question.

PO 4. Determine whether the data supports the prediction for an investigation.

PO 5. Develop new questions and predictions based upon the data collected in the investigation.

(Continued)

TABLE 21.1. Content outline for the Grand Canyon National Park Archaeology Education Program. —Cont'd

Concept 4: Communication
Communicate results of investigations.
 PO 1. Communicate verbally or in writing the results of an inquiry.
 (See W04-S3C3-01)

 PO 3. Communicate with other groups or individuals to compare the results of a common investigation.

Strand 2: History and Nature of Science
Scientific investigation grows from the contributions of many people. History and Nature of Science emphasizes the importance of the inclusion of historical perspectives and the advances that each new development brings to technology and human knowledge. This strand focuses on the human aspects of science and the role that scientists play in the development of various cultures.

Concept 1: History of Science as a Human Endeavor
Identify individual and cultural contributions to scientific knowledge.

 PO 2. Describe science-related career opportunities.

Concept 2: Nature of Scientific Knowledge
Understand how science is a process for generating knowledge.

 PO 3. Explain various ways scientists generate ideas (e.g., observation, experiment, collaboration, theoretical and mathematical models).

Strand 3: Science in Personal and Social Perspectives
Science in Personal and Social Perspectives emphasizes developing the ability to design a solution to a problem, to understand the relationship between science and technology, and the ways people are involved in both. Students understand the impact of science and technology on human activity and the environment. This strand affords students the opportunity to understand their place in the world – as living creatures, consumers, decision makers, problem solvers, managers, and planners.

Concept 1: Changes in Environments
Describe the interactions between human populations, natural hazards, and the environment.

 PO 1. Describe how natural events and human activities have positive and negative impacts on environments (e.g., fire, floods, pollution, dams).

 PO 2. Evaluate the consequences of environmental occurrences that happen either rapidly (e.g., fire, flood, tornado) or over a long period of time (e.g., drought, melting ice caps, the greenhouse effect, erosion).

Strand 4: Life Science
Life Science expands students' biological understanding of life by focusing on the characteristics of living things, the diversity of life, and how organisms and populations change over time in terms of biological adaptation and genetics. This understanding includes the relationship of structures to their functions and life cycles, interrelationships of matter and energy in living organisms, and the interactions of living organisms with their environment.

Concept 3: Organisms and Environments
Understand the relationships among various organisms and their environment.
 PO 1. Describe ways various resources (e.g., air, water, plants, animals, soil) are utilized to meet the needs of a population.

TABLE 21.1. Content outline for the Grand Canyon National Park Archaeology Education Program. —Cont'd

PO 3. Analyze the effect that limited resources (e.g., natural gas, minerals) may have on an environment.

PO 4. Describe ways in which resources can be conserved (e.g., by reducing, reusing, recycling, finding substitutes).

Pre-visit Activities

1) Measure your own bedroom and calculate sq. footage and compare to size of family dwelling at Tusayan.

2) Interview the oldest person you know and find out what life was like when they were kids. What were some of the similarities and differences between their time and yours?

3) Discover your past. Do a genealogical background study. Go back as far as you can.

4) Make a pinch pot, split-twig figurine or grind some corn. Some of these activities were/are chores while others are for ceremonies or were artistic expressions. What are your chores today? How do you express yourself?

5) Crossword puzzle

$40,000 grant to the park. The Glynn County school district dedicated two new state-of-the-art classrooms for use as a regular classroom and archaeological laboratory, respectively. The program is staffed by a full-time Archaeological Education Coordinator and an NPS education specialist. The classroom laboratory, known as the Fort Frederica Archaeological Center, and the program excavation trench, located in the park, is equipped with professional quality equipment and supplies. The program's archaeology education trunks contain archaeology background books and tools and are placed at every elementary school in the county.

Glynn County fourth-grade students (median age 10) are involved in an intense study of historical archaeology using Fort Frederica National Monument as their classroom. This was the first long-term historical archaeology elementary education program of its kind to be established in the USA. The program teaches all aspects of historical archaeology including field research, mapping, concepts and theory, laboratory analysis, report writing, and ethics (see Table 21.2 and Figures 21.5–21.7).

21.3.3.1. The Education Trench

From the 1940s through the early 1960s, extensive trenching supervised by archaeologists was done to expose foundations of the structures related to the original Fort Frederica settlement. Due to the nature of the excavations, a massive amount of artifacts was recovered in and around the settlement area, creating a huge collection of materials in need of treatment and storage. The "treatment" decided upon involved the creation of an artifact disposal trench where artifacts considered "superfluous" or "redundant" were eventually deposited. This was apparently a common practice in the 1940s to 1960s eras at

TABLE 21.2. Purpose, objectives, and activities of the Fort Frederica National Monument Historical Archeology Education Program as outlined by program staff.

Fort Frederica National Monument, Georgia
Historical Archeology Education Program Highlights
(Ellen Provenzano and Ellen Strojan, personal communication, 2006)

The purpose of the education program is to provide the students with a multidisciplinary approach to discovering and learning about history. The goals of the historic archaeology program are: (1) to satisfy Georgia Performance Standards through an innovative and hands-on approach; (2) to facilitate critical thinking skills and active learning through non-traditional learning activities; and (3) to provide a creative method of learning about history that reaches the varied learning styles of today's youth.

Measurable Objectives

The historical archaeology program relates to the National Park Service mission by creating an educated public who will advocate the protection of archaeological resources. The students as life long learners will obtain skills necessary to learn about the past and assist them with shaping the future. After participating in the program, students are able to: (1) Explain the factors that shaped British colonial America by using Frederica as a model of a Colonial town; (2) Study and understand material objects and culture of the colonial time period using appropriate archeological methods; and (3) Use critical thinking skills to construct an archaeological report based on their educational experience which will allow the students to demonstrate what they learned about colonial history.

Activities

Students begin the program learning about the National Park Service and the Fort Frederica colonial site. Students use storytelling, secondary and primary documents to research the fort and the colonial people to prepare for their first field trip. The students arrive at the park and view the new park film "History Uncovered." Students look at a large map of Frederica and discuss the defenses for the fort and the town as well as see where their families lived. Students then travel outdoors to see the "real thing". They see where the families they studied actually lived, and discuss other people who lived at Frederica like Mary Musgrove and the soldiers. They visit the fort and learn why Gen. Oglethorpe built the fort and town at this specific location. They learn about the occupation of a blacksmith as well as the importance of preservation. They then walk to the military barracks and learn about the "drills" the soldiers conducted, much like the drills (tornado and otherwise) the students have to do in school. They practice marching. The last stop is the Hird site. The students have read " Phoebe Hird's Secret Diary" in school. Now they can connect the book, the person, and the site together. They also learn about trash (colonial and modern) and what it tells about culture. An extensive unit on the fundamental concepts and process of archaeology is covered in the classroom before students return to the park to excavate, usually in teams composed of 4 students and one teacher, at the education program's excavation trench (Ellen Provenzano and Ellen Strojan, personal communication, 2006).

By allowing students to work in the excavation trench and discover everyday objects of people who lived here more that 250 years ago, 18th century life becomes something tangible and relevant. Students arrive at the park in five teams and are assigned to one of five units. A ranger, teacher or volunteer works in each unit. The students rotate jobs within their teams: experiencing roles as excavator, site helper, screener, and site recorder. The dig is only a small part of the archaeological process, and comprises only a small percentage of the overall program. Students go to the Archaeology Lab in the afternoon to clean and categorize the artifacts and return the following day and analyze each category of artifact. The lab analysis teaches the students about the plethora of artifacts from the Frederica period as well as later periods. They learn through active participation and critical thinking skills that people continued to live on the land after the British colonial town ceased to exist. Students learn that history is a story that is perennially unfolding. The most common comment heard by students and parents during the field trip, "I didn't know so much was here!" In this program children are coming up with questions, relating cause and effect, learning the answers, and writing stories (reports) based on their experience (Ellen Provenzano and Ellen Strojan, personal communication, 2006).

Measures of Success

The program's success comes from the enthusiasm of the archaeologists, educators and the students. Partnerships from the local community, county school system, the state government, professional archaeologists representing many organizations, and the National Park Service have been the reason for this program's success. Through the combination of these diverse elements working together, these partnerships have strengthened the Archaeology Education Program and have created more educational opportunities in Glynn County and beyond. It has been so rewarding to be part of this program and watch it unfold in the different directions it has taken.
The archaeology education program serves the local community and educators by leading and teaching a historical archaeology education program which provides students the opportunity to become active learners in the pursuit of understanding American history and our common heritage (Ellen Provenzano and Ellen Strojan, personal communication, 2006).

FIGURE 21.5. Teachers receive orientation training in archaeological field methods and procedures during a teacher workshop at Fort Frederica National Monument, Georgia. (Photo: National Park Service.)

sites and parks in the US northeast. With most provenience information lost for the secondarily and recently buried artifacts, the education program staff has used, and periodically reburied, a large body of the artifacts for the field excavation segments of the program (Honerkamp, 2001; Johnstone, 2002).

21.3.3.2. The Curriculum

The program curriculum, entitled *Discovering Our Past through Historical Archaeology,* continues to expand, adding new lessons to fit the program needs and to accommodate new state performance standards. The Glynn County School System has adopted the archaeology curriculum into the framework of its fourth-grade program; this is *not* an add-on for teachers. The program and lessons cover necessary curriculum objectives teachers must teach their students. The program integrates many disciplines in which students develop, practice, and use skills in science, language, social studies, and math in a practical, hands-on and fun approach (Ellen Provenzano and Ellen Strojan, 2006, personal communication).

An important element of the program is the annual teacher workshop. Instructors at the workshop include the park staff, the Glynn County teacher coordinator, and professional archaeologists from NPS, state agencies, and other partner institutions. Participants learn about the history of Frederica,

FIGURE 21.6. Fourth-grade student shows artifacts found during screening at the program education trench. The Historical Archaeology Education Program was created through a partnership between Fort Frederica National Monument and the Glynn County School District, Georgia. (Photo: National Park Service.)

archaeological methodology, hands-on class room activities, and the curriculum. They also experience a "Frederica Families" field trip, perform professionally supervised work at the program excavation trench, and carry out supervised laboratory work as an introduction to archaeological methods and techniques. To date, nearly 200 fourth-grade teachers have attended the mandatory workshop.

21.3.4. Ocmulgee National Monument, Georgia

By the mid-1990s, the results of public surveys indicated a link between middle Georgia's economic concerns and its social and educational problems. Educational deficiencies were shown to be closely associated with elevated school dropout rates, teenage pregnancies, unemployment, neighborhood deterioration, prejudice, crime, and hopelessness. Statistics for the city of Macon, Georgia, showed that one-fifth of all families lived in

FIGURE 21.7. Students and teachers at the Fort Frederica Historical Archaeology Education Program excavation trench. (Photo: National Park Service.)

poverty, half-of-all-births were to unwed mothers, and more than a third of the city's residents did not have a high school diploma. An increasing number of murders and other violent crimes were committed by the area's youth. With this social and economic backdrop, dedicated teachers and other special people nevertheless found ways to alter the lives of many youngsters by capturing their imaginations, providing crucial goals and discipline, setting good examples, and offering encouragement and hope.

Ocmulgee National Monument, Georgia, has long been a leader in educational programs in the US Southeast that focus on connecting prehistoric cultural history to contemporary heritage issues. Starting in the mid-1980s, park staff, led by park ranger and education specialist Sylvia Flowers, developed an exemplary program that involves a partnership between the park and a variety of public and private institutions. Partners include Ocmulgee National Monument Association, the Keep Macon-Bibb Beautiful Commission, the Bibb County Board of Education, Robins Air Force Base, Georgia College and State University, Mercer University, and the Muscogee (Creek) people whose ancestors lived in the region. Additional program partners include the National Park Foundation, the Georgia Trust for Historic Preservation, the Georgia (SHPO), and the Peyton Anderson Foundation. Three of the heritage-based interpretive/educational outgrowths of this project received national recognition and contributed to the creation of the NPS Parks as Classrooms program that began in 1993 under the auspices of the National Park Foundation (OCMU, 2005; Table 21.3).

TABLE 21.3. Highlights of Ocmulgee National Monument's "Georgia's Heartland Heritage Education Project".

Ocmulgee National Monument, Georgia
Georgia's Heartland Heritage Education Project, Program Highlights
(OCMU 2005)

The hands-on heritage education at Ocmulgee National Monument helps youth learn about and appreciate their local, regional and national legacy, and has motive them to become better students and resource stewards. The program realized that the best teachers constantly search for innovative ideas even to the point of spending their own money to obtain supplies and materials.

Through properly directed, in-depth interactions with the area's prehistoric, historic, and environmental resources, teachers and students gain a better understanding of themselves and their role in the cultural and natural continuum. They are exposed to human similarities and differences. They learn the importance of individual initiative and group cooperation. They discover the great store of knowledge and wisdom amassed by people in the past and how it may be tapped to make the present and future better. They learn that their lives have been affected by past events and that decisions they make today will affect the future. Such understanding fosters the development of positive values, encourages social and cultural sensitivity, and promotes community, regional, national, and global environmental awareness, concern, and good stewardship.

The cultural heritage of middle Georgia includes 12,000 years of history, including the legacy of southeastern indigenous people, represented today by the Muscogee (Creek) Nation in Oklahoma. Georgia's Heartland Heritage Education Project brings together educators from middle Georgia and the Muscogee Nation in to effect communication and cultural exchange based on shared interests and mutual present-day concerns.

Group Programs, Tours, Information Requests: Ocmulgee National Monument's Ranger staff annually presents hundreds of programs and tours to thousands of students and members of other organized groups. They also respond to scores of requests for information concerning the park and related resources. These inquiries range from providing information/materials for use in school projects to performing in depth research for scholars and writers from across the nation and abroad. Tours can include the museum, movie "Mysteries of the Mounts," talks, classroom demonstrations, Discovery Lab, the ceremonial earth lodge, the mounds, nature trails, etc. Pre- and post- visit information packets can be provided.

Annual Calendars of Events: Each year the Ocmulgee National Monument Association sponsors a series of heritage education programs, including lectures, films, guided walks, Southeastern Native American arts and crafts demonstrations, traveling exhibits, Lantern Light Tours, Children's Summer Workshops, Artifact Identification Days, etc., with a published schedule of events mailed to schools, welcome centers across the state, and to other organizations and individuals upon request.

Lantern Light Tours: Annually, as Ocmulgee National Monument's special contribution to Macon's acclaimed Cherry Blossom Festival during the third week in March, park staff and volunteers conduct Lantern Light Tours. This is the only regularly scheduled time when the park is open to the public at night. The tours begin around a bonfire where 1700's candle-lit barn lanterns are distributed among the visitors. The tours lasts approximately one-hour and cover about a mile, with stops at major features along the route. Warm clothing and comfortable walking shoes are in order.

National Public Lands Day: A partnership started in 1984 with the Macon-Bibb Beautiful Commission involves students and other organized groups in essay and poster design contests, cleanup projects at the park, and an annual special event to recognize local efforts and promote the projects goals. The "National Public Lands Day" idea was adopted nationally when an annual National Public Lands Day was proclaimed by Congress. The partnership was recognized by two national awards from the U.S. Secretary of the Interior and numerous state awards. In 1990, the park integrated National Public Lands Day activities into it's Ocmulgee Indian Celebration (see below).

Dr. Charles Fairbanks Memorial Discovery Lab: This hands-on facility at Ocmulgee National Monument was developed through community donations of time, funding and materials. Associated with the Lab is an orientation videotape, a Teacher's Guide containing information pre-visit, on-site and post-visit educational activities, and orientation sessions for teachers/group leaders who wish to use the facility, which accommodates over 3,000 students annually.

"Ocmulgee University" Teachers Workshops: Funding from Robins Air Force Base has supported a heritage education workshop for 4th grade teachers. The workshops, planned in association with the Georgia Board of Education, and assisted by several partners including the BLM Anasazi Heritage Center's Education Program, the NPS Southeast Archeological Center, the Ocmulgee National Monument Association, the Keep Macon-Bibb Beautiful Commission, the Cherokee Heritage Museum, Cherokee, NC, and other organizations. In 1998, the workshops became cooperative efforts between Ocmulgee National Monument and Georgia State University, which gives five hours academic credit to participants.

Georgia Archeology Awareness Week: Ocmulgee National Monument annually schedules special programs the first week of May as part of this statewide effort to encourage support for archeology and cultural resources preservation/protection.

Teaching With Historic Places Teachers Workshop: Sponsored by the National Park Service and coordinated by the Trust for Historic Preservation, this workshop brought some 80 educators from across the state to Macon on April 28-29, 1995. The workshop took place at the Hay House, a National Register listed historic landmark, with field sessions conducted at the Ocmulgee National Monument and the Pleasant Hill Historic District. As a result, the Trust for Historic Preservation and the Hay House wish to participate in the Georgia's Historic Heartland Heritage Education Partnership and information, including lesson plans, compiled during this workshop will be incorporated into the Project.

The "Muscogee (Creek) Nation Today" Traveling Exhibit: The U.S. Air Force at Robins Air Force Base funded the creation of two new exhibits that focus on the Muscogee (Creek) people since their removal from this (middle Georgia) area of the Southeast. The exhibits were designed and produced by the Muscogee (Creek) Nation's Cultural Affairs/Historic Preservation Office in Oklahoma and are used at schools in the Macon area as well as

TABLE 21.3. Highlights of Ocmulgee National Monument's "Georgia's Heartland Heritage Education Project". — Cont'd

schools in Oklahoma.

Earth Day/March for Parks: Since 1997, Ocmulgee National Monument has worked with the Keep Macon-Bibb Beautiful Commission to host an Earth Day event for Middle Georgia. Park staff plan and coordinate the event, which is held in conjunction with a March for the Park event sponsored by the Friends of Ocmulgee Old Fields cooperating association. The events involve many federal, state, and local agencies, organizations, educational institutions, and school clubs. Approximately 70 special interest groups and 3,000 visitors attend each year.

Guidebook/Curriculum Supplement, and Videotape: Park staff, area teachers, and local university interns have produced a draft Georgia's Heartland Heritage Guide and curriculum supplement), focusing on the cultural and natural resources of Ocmulgee National Monument and middle Georgia. Volume One of this guidebook consists of three sections: Part I - The Place; Part II - The People, and Part III - How Do We know? Volume Two is a loose-leaf binder of hands-on activities keyed to Georgia's Quality Core Curriculum teaching requirements. The seventeen-tape set of videos recorded during the Ocmulgee University teachers workshops were edited into a training film that reinforces the written materials. The publication and video have replaced the original Teacher's Guide. Copies have been placed in every public school library in middle Georgia, made available to Muscogee (Creek) educators in Oklahoma, and offered as a sales item in the park's museum shop.

Many local teachers who have utilized the ideas, experiences, information, and hands-on activities provided during the program's "Ocmulgee University" workshops have become outspoken advocates for cultural and natural conservation. The program's hands-on heritage-related activities stimulate students who are not easily influenced by other teaching methods. The project also encourages community leaders and private citizens to become better informed concerning the area's cultural and natural resources. This leads to greater appreciation for the aesthetic, educational, recreational, and economic value of irreplaceable heritage resources and promotes public stewardship (OCMU, 2005).

In 1999, Ocmulgee National Monument received a $19,500 grant from the National Park Foundation to further the program. The grant supplemented funding provided by Robins Air Force Base and local Peyton Anderson Foundation earmarked for completion of an education guide, an interpretive handbook, a 2-h teacher training videotape utilizing footage from the Ocmulgee University workshops, project Web pages upgrade, and funds to bring Muscogee (Creek) representatives to visit the park and local schools during the Ocmulgee Indian Celebration (OCMU, 2005).

21.3.5. Fort Vancouver National Historic Site and the Vancouver National Historic Reserve, Washington

Fort Vancouver National Historic Site and the Vancouver National Historic Reserve contain the archaeological remains of the Hudson's Bay Company's Columbia Department headquarters and supply depot. The supply depot operated from about 1825 to 1860. Also in the reserve is the US Army's first military post in the Pacific Northwest that operated from 1849 to 1946. The reserve is a partnership of the NPS, the City of Vancouver, the Washington State Office of Archaeology and Historic Preservation, and the US Army. It includes Fort Vancouver and its village, Vancouver Barracks and Officers'

Row, Pearson Field and Air Museum, portions of the Columbia River water-front, the Water Resources Education Center, and the McLoughlin House unit in Oregon City, Oregon. The artifacts and information from over 50 years of excavations represent the tangible remains of everyday life for the inhabitants of the early settlements of Fort Vancouver, its village, and Vancouver Barracks, but also provide material evidence of Vancouver's position during the mid-nineteenth century as the political, cultural, and mercantile center for the Pacific Northwest. Fort Vancouver was the administrative headquarters and main supply depot for the Hudson's Bay Company's fur trading operations in the northwest. The archaeological collection of 2 million objects has been collected over a half century of archaeological excavations and spans the Native American, Hudson's Bay Company, and US Army occupations of the site. An important part of the program involves Web-based dissemination of research findings and results. Many of the over 1.5-million artifacts that form the core of the site's collection has also been digitally photographed and information and images on these artifacts are available on-line for examination by specialists, students, and the interested public. The catalog of these important collections is available to researchers online at http://www.museum.nps.gov/fova/page.htm (FOVA, 2005, personal communication).

Vancouver National Historic Reserve has become a regional and national leader with its archaeology education program. The public archaeological research program involves students and visitors in the process of learning from, and working to, preserve cultural resources. Through the Volunteers-in-Parks (VIPs) program, budding avocational archaeologists participate in laboratory, and field work at the site. Special interpretive programs by staff archaeologists and interpreters are also geared to share the underground legacy of the park. Walking tours of the fort site, the village, and the parade ground, and special school programs on archaeology, are components of the public archaeology program. The highlight of the program is the annual field school, taught by NPS archaeologists and graduate students from Portland State University and Washington State University, Vancouver. This partnership program teaches university students the fundamentals of field archaeology at a highly significant site, while inviting the public to interact with the archaeologists and students to learn about the site from the unique perspective of archaeology. Lectures by specialists in archaeology, as part of the field school or as brown-bag lunches, are opened to the public to share with them the techniques and results of archaeological research regionally and across the country. Students participate in public interpretation as well as archeological survey, laboratory methods, and excavation. A very popular program with students is "Kids' Digs," which teaches 8–12-year-old children the principles of archaeology and the preservation ethic through excavation of a mock dig site. The integration of highly motivated students with the boundless energy and enthusiasm of children makes for an amazing synergy directed toward teaching the most important aspects of archaeology and site preservation (FOVA, 2005, personal communication).

21.3.6. *Jimmy Carter National Historic Site, Georgia*

Jimmy Carter National Historic Site includes the completely renovated Plains High School Museum, Plains Depot-1976 Carter Presidential Campaign Headquarters Museum, and the Jimmy Carter Boyhood Farm Museum. Coordinated by a full-time teacher employed by the Georgia Department of Education who is stationed at the park, the Jimmy Carter National Historic Site Education Program has established partnerships with the U.S. Federal Highway Administration (FHWA) and the State of Georgia Department of Transportation (GDOT) in a program to help young audiences better understand history as told through archaeology. The goal of the partnership is to teach how to use archaeology as a tool to stimulate creativity and interest in learning about cultural heritage. The program encourages environmental stewardship. Students in two Georgia counties are provided hands-on introduction to archaeology field methods and excavation on a FHWA and GDOT sponsored archaeology project that is fully supervised by professional archaeologists from those agencies in association with personnel from the NPS Southeast Archeological Center. The program teacher works closely with archeologists from GDOT and NPS with public involvement activities associated with Archaeology Day at the Boyhood Farm, where the archaeologists explain the results and answer questions about the archaeological investigations at the park (JICA, 2005).

The program includes an archaeology trunk designed to help teachers integrate archaeology and cultural heritage education in the classroom. The archaeology trunk contains a wide array of diverse archaeological teaching materials that meets the state's mandated Curriculum Objectives. The trunks are designed for teachers to use with students before scheduled field trips. The trunks contain teaching resources, supplies, and lesson plans with required curriculum objectives identified for each activity. Teachers request a trunk by completing an online request form. Trunks are mailed to teachers 2 weeks before their scheduled trip and can be returned the day of the field trip (JICA, 2005; Annette Wise, 2006, personal communication) (Table 21.4).

21.4. The Indispensable Roles of Volunteers and Cooperating Associations

The NPS employs approximately 20,000 diverse professionals–permanent, temporary, and seasonal. These employees manage approximately 380 park units within the National Park System. They are assisted by nearly 140,000 VIPs who donate over 5 million hours each year. This equals 2,400 personnel equivalents valued at $86 million. Most parks could not operate without these volunteers (NPS, 2006).

Cooperating associations are nonprofit nongovernmental organizations (NGOs) that enhance educational and interpretive experiences at the parks

TABLE 21.4. Listing of subject matter and material content for respective traveling trunks, Jimmy Carter National Historic Site Education Program (JICA 2005).

Jimmy Carter National Historic Site, Georgia Education Program, Content of Traveling Trunks	
Plains, Peanuts and a President Books, videos about Plains and President Carter	**An Hour Before Daylight (1)** Class book set with audio of Jimmy Carter read this book
Cotton Books, videos, cotton carders and cotton	**1930's Toys and Games** Common 1930's toys and games
Oral Histories Tape players, tapes and oral history activities	**Christmas in Plains** One book and audio with President Carter reading
Object Analysis 1930's non-electrical objects and activities	**An Hour Before Daylight (2)** One book and audio with President Carter reading
Archeology Tools and information about archeology	**Sumter County Talking Walls** Maps, documents and preservation information
First Lady from Plains Class book set: Rosalynn Carter's autobiography	

by offering programs and park-related retail items in their shops. There are 65 cooperating associations, which provide $26 million to the NPS in annual contributions. Friends groups are nonprofit partners of the parks. There are about 150 Friend Groups supporting 160 parks and provide approximately $50 million in support annually. The National Park Foundation is the NPS's congressionally chartered partner and has given $137 million in grants and program support in the past 7 years. According to the *National Park Service 2005 Cooperating Association Annual Report of Aid and Revenue,* cooperating associations worked in close partnership with the NPS that year, donating $52.8 million in aid to the NPS. The total aid amount was a combination of $23.6 million in financial aid and $29.2 million in program service expense which consists largely of salary expense for association employees providing information assistance to visitors. The report is available online at (http://www.nps.gov/interp/coop_assn/) (NPS, 2006).

21.5. Conclusions

The NPS, US Department of the Interior, with a strong conservation and education mandate, has been a leader in the USA in archaeology public interpretation, outreach, and partnerships. Programs at national and regional levels and in the parks demonstrate a commitment of NPS staff to high education and public interpretation standards. The development of the NPS "Effective Interpretation of Archeological Resources" Module 440 training standards provides opportunities for employees and others to gain knowledge and skills in a multidisciplinary, team approach to program development. Staff initiatives at parks as well as national and regional centers connect with students and the public at large in providing holistic interpreta-

tions that incorporate multiple points of view and related human values. With the indispensable assistance of volunteers and cooperating associations, NPS programs advocate and promote the ultimate role of interpretation to aid conservation of resources as well as public recognition and support. The result is a more informed public and an enhanced public stewardship ethic.

References

CIA (n.d.) United States Map, https://www.cia.gov/cia/publications/ factbook/reference_maps/pdf/united_states.pdf, 2006

Durant, W. and Durant, A., 1997, *Lessons of History*. MJF Books, New York.

Honerkamp, N., 2001, "Large Quantities had to be Marked for Disposal": an Artifact Inventory of Shiner's Trench, Fort Frederica National Monument. Copy of report on file at the Southeast Archeological Center, National Park Service, Tallahassee, Florida.

Jameson, J.H., Jr., 2004, The Archeology Public Interpretation Initiative, online article, http://www.cr.nps.gov/seac/pii.htm, 2006.

Jameson, J.H., Jr., Ehrenhard J.E., and Finn, C.A., editors, 2003, *Ancient Muses: Archaeology and the Arts*. University of Alabama Press, Tuscaloosa.

JICA, 2005, Jimmy Carter National Historic Site Education Program, Sumter County Schools Archeology Dig. http://www.jimmycarter.info/offsite_7.html, 2006.

Johnstone, S., 2002, Archeological Investigations in the Glynn County Archeology Education Trench, Fort Frederica National Monument. Copy of Report on File at the Southeast Archeological Center, National Park Service, Tallahassee, Florida.

Little, B., 2002, *Public Benefits of Archaeology*. University Press of Florida, Gainesville.

Little, B., 2004, The Art of Interpreting Archaeological Resources. In *Marketing Heritage: Archaeology and the Consumption of the Past*, edited by R. Yorke and B. Uzi. AltaMira Press, Lanham, Maryland.

McManamon, F., 2000, Archaeological Messages and Messengers. *Public Archaeology* 1.

NPS, 2005, Archeology Program. http://www.cr.nps.gov/archeology/, 2006.

NPS, 2006, NPS Overview. http://www.nps.gov/pub_aff/refdesk/NPS_Overview.pdf, 2006.

NPS IDP, 2006, The Interpretive Development Program, Aiming for High Ground. http://www.nps.gov/idp/interp/, 2006.

OCMU, 2005, Olmulgee National Monument "Georgia's Heartland Heritage Education Project." http://www.nps.gov/ocmu/Programs.htm, 2006.

Orwell, G., 1949, *Nineteen Eighty-Four*. Penguin Books, London.

Tilden, F., 1977, *Interpreting Our Heritage*. Third Edition. The University of North Carolina Press, Chapel Hill.

22
Engaging the Public: Parks Canada CRM Policy and Archaeological Presentation

Joseph Last

22.1. Introduction: Highlights of the CRM Policy

The focus of this paper is to examine changes to site presentation since the initiation of the Parks Canada Cultural Resource Management (CRM) Policy (Canada, Department of Canadian Heritage [DCH], 1994). It also explores how the Policy has altered dialogue with site visitors, for at least this author. It is a personal view, one that has developed over the past decade and should not be construed as "the party line," although I believe many practicing archaeologists within Parks Canada share similar views.

Officially approved in 1994, the Parks Canada CRM Policy is a value-based framework for decision-making. Unlike proscriptive directives that outline, in detail, specific practices and procedures to follow when managing built, archaeological, or landscape resources, Parks Canada's CRM Policy provides the means to define historic values and to judge the appropriateness of actions affecting them. The Policy utilizes five principles. They are the principles of respect, integrity, understanding, value, and public benefit. Together, they form the basis for sound decision-making. While any one of the principles could influence the care of a cultural resource, good management dictates that all be considered when evaluating the consequences of actions to a site and its resources.

Along with the principles, the 15-page Policy document outlines the practice and activities needed to manage cultural resources. Foremost among the practice of CRM are: inventory, evaluation, consideration of historic value in actions affecting a resource, and monitoring and review. Collectively, they help to integrate the activities of planning, research, conservation, presentation, and corporate direction, by ensuring that "historic character for which resources are valued is identified, recognized, considered and communicated" (Canada, [DCH], 1994:106).

The policy is also knowledge-based, requiring research to furnish information regarding the nature, evolution, and context of a resource. Once inventoried, resources are evaluated in light of the reasons recommended for site commemoration by the Historic Sites and Monuments Board of Canada.

Evaluation is crucial, for only through this practice can the determination of historic values, both tangible and associative, be derived. Significantly, evaluation provides the story line to the visiting public by contributing to resource appreciation and understanding.

22.2. The Impact of the CRM Policy

Compared with other conservation conventions and agreements, the CRM Policy is a rare beast for it enshrines, within one document, the basic elements of protection and presentation. Before the Policy, there was an inherent dichotomy within Parks Canada between those who took a preservationist stand and those who sought to educate the public. On the one hand, archaeologists spent much of their time safeguarding resources, taking on a self-imposed role of "protection police." Often they viewed interpretive programmes, along with general site development, as potential threats to the resource. Conversely, site interpreters or Heritage Presenters, as they are presently called, saw preservationists inhibiting their attempts to tell the story.

While all worked towards a common goal, tension sometimes arose. The CRM Policy has greatly altered this situation by embracing both activities and by underscoring their symbiotic relationship. Preservation is essential for long-term public benefit and enjoyment of valued resources. Presentation, however, allows for the appreciation and understanding of cultural resources and thus fosters and ensures strong heritage advocacy and support. Indeed, one cannot exist without the other.

This marriage of protection and presentation has changed how I deal with the visiting public since it helps refocus attention on what is truly important about the resource under investigation. Parks Canada archaeologists, working on National Historic Sites, strive to enhance our comprehension of cultural resources by addressing their relationships to events and historic persons. However, when conversing with the public, enthusiasm and personal research interests often mask the reasons and rationale for why a National Historic Site was designated. If the CRM Policy has done anything, it has demanded that the message be more coherent and explicit.

With the advent of the Policy, Parks Canada archaeologists are now obliged to provide the site visitor with an awareness of the historic importance of the resources under our trowels. This is not to say that we should ignore discussing the merits and processes of archaeology. As one of the many necessary disciplines contributing to CRM, the stories of how and what we do are important, but they should not overwhelm the underlying aspects of historic value. In short, every visitor leaving a National Historic Site should know something about the significance of the site and its role in Canadian history.

An outcome of the Policy has been the establishment of a Commemorative Integrity Statement (CIS) for each National Historic Site. This mandatory

document articulates the reason(s) for designation and identifies historic values for the site, both for the whole, and for its parts. During the process of drafting a CIS, a multidisciplinary team first focuses on the intent of commemoration and defines the physical boundaries of the designated place. All resources, be they archaeological, architectural, or landscape elements, are then evaluated in light of site commemoration.

For example, Fort George, in Niagara-on-the-Lake, was designated a National Historic Site for its role in the defence of Upper Canada during the War of 1812. Consequently, resources directly associated with war, such as archaeological deposits from the 1813 American bombardment, siege, and occupation, are deemed of national importance and are termed "Level I cultural resources." Those that are not nationally significant but have historic value on a local, regional, or provincial level (e.g., the 1937/38 reconstructed buildings at Fort George that are early examples of Canadian historic reconstruction philosophy) are classified as "Level II cultural resources" (Canada, [DOH], 1994:107).

Legislated reviews, undertaken by teams of specialists, examine the state of the resources noting their condition, threats, and the effectiveness of their presentation to the public. The resulting scorecards highlight achievements as well as areas for improvement. Again, aspects of preservation and presentation are addressed. This provides guidance during archaeological excavation by underscoring the strengths and weaknesses of site messaging and how it contributes to public understanding, knowledge, and appreciation. Using the CIS as a backdrop, we are able to weave a more holistic narrative focusing on archaeological findings that support site messages presented elsewhere through exhibits, literature, and interpretive programming.

Site-specific archaeological research results are generally a component of guide training and are incorporated into interpretive programming. Interpretation is enhanced further whenever excavations are undertaken by virtue of having archaeologists present on site. Occasionally, a guide is assigned to interpret the investigations to the public. Often, however, we interface directly with site visitors, discussing the "what and whys" of the archaeology ourselves. In these instances, we provide briefing sessions showcasing recent finds to site personnel in an effort to harmonize and strengthen messages.

While there are similar themes for all of the National Historic Sites in Ontario associated with the War of 1812, the role of each fort varied. Fort George, in Niagara-on-the-Lake, is valued for being the principle defensive work in the Niagara peninsula; for its importance as the Headquarters of the Central Division of the British Army; and for its occupation by American forces after the Battle of Fort George. Fort Wellington, at Prescott, saw no heated action, nor succumbed to enemy siege craft or entrenchment. Nonetheless, Fort Wellington played an important role during the war. The site is recognized for maintaining vital communication lines between Montreal and Kingston; for its function as a rallying point for the 1813 raid

on Ogdensburg; and for its later involvement as an assembly point for British troops and militia during the American-based Hunter's Lodge invasion of Upper Canada in 1838.

Although historic resources associated with the War of 1812 are presented at both the sites, aspects regarding site evolution are emphasized more at Fort George since British and American engineers had differing views on how best to defend its position. Their legacy of modification and landscape alterations forms the primary conduit for archaeological interpretation at the site. While the uniqueness of Fort Wellington's design is communicated to the public, its later modifications are less relevant than those that underscore the fort's strategic location and role. Here, resources and requisite stories about the Advance Battery, the southern gun positions and the defensible caponnière are more appropriate.

22.3. Applied Archaeology

Before discussing how I engage the public, a discussion of Parks Canada's peculiar niche of archaeology is in order. During the 1960s, we were part of a fledgling organization working within a discipline that was but a decade old. It was a period of "ground-breaking" innovation. Heady with optimism, Parks Canada archaeologists undertook original fieldwork and material culture research. Both resulted in substantive advancements in the field of Canadian historical archaeology and began a tradition of product-oriented research. Regardless of the site, projects were driven by the need to establish site resource inventories, to provide crucial and timely information for restoration projects, or to develop on-site exhibits.

Nearly 50 years on, we at Parks Canada still practice applied archaeology, although our focus has changed. With site inventories generally established and reconstruction initiatives a thing of the past; our attention has turned to assessing impacts of proposed development on cultural resources. If the project is to proceed, mitigation can range from minimal test pitting to full-scale excavation. Regardless of the scope of archaeological intervention, we rarely have the opportunity to choose the study area. Seldom do we do research for research sake, although each foray into the field increases our resource inventory and moves us closer to our research goals.

The research strategies that we develop for any site, or site type, are definitely long-term. While the duration of any project rarely exceeds 2 months, we constantly return to the sites under our administration. Consequently, we must be much more patient about recovering data pertaining to any one research goal or initiative. The trade offs, however, are immense. First, I have the luxury of visiting the same site again and again. Not only does this provide a welcomed "breathing space" allowing me to revisit earlier archaeological interpretations, but it also allows for more refined research strategies, methodologies, and yes, interpretation venues. Having a reoccurring schedule

also affords the opportunity to integrate interpretive programming with site personnel and to instigate guide training, public lectures and, when possible, volunteer programmes.

An added advantage is the potential of relating archaeological findings to familiar faces, both among staff and visitors. Similar to other organizations, personnel movement within Parks Canada has come to a virtual stand still. While this has obvious long-term programme drawbacks, it presently results in site personnel that have a remarkable breath of knowledge. Their familiarity with the site and past archaeological interpretations provides a much more informed and therefore better public presentation. In regards to the visiting public, it results in a more knowledgeable audience who have more than a casual understanding of the site and its history.

Returning to the same sites also has the advantage of evaluating past presentation methods. Seeing what techniques and methods work and what do not is a long-term process. Over the years, I have found the most effective methods are often the simplest and nothing is more engaging to the public than striking up a conversation. One of the easiest ways to inform the public about the evolution of a site is to attach labels to the strata of our profiles, once cleaned. We have found that identifying deposits and features with tags such as "1814 construction fill," "buried 1837 sod line" or "1822 Officers' Quarters foundation" help the public to understand relevant site formation processes, especially when we are absent from the site during the course of a project.

22.4. Case Studies

Although I have enjoyed the rewards of volunteer programmes, I believe that volunteer archaeology can only be run responsibly with the supervision of many assistants. This is especially true on military sites where complex stratigraphic sequences can be easily misread, or unseen, by a crew with untrained eyes. Consequently, we have developed alternative volunteer experiences that focus more on supervised lab work than excavation.

Here, I must stress, that laboratory functions demand the same utmost attention and care as field excavation. Supervision is always a concern, for a wondering mind can quickly undo the meticulous efforts of a crew. Knowing that it is virtually impossible to put the Humpy Dumpy back together again after his pieces go astray, the lab experience has to be adequately supervised. When they are, labs can provide a conducive environment where it is often easier to demonstrate the full range of archaeological practices; to explore the importance of context; and to emphasize the point that there is much more to archaeology than excavation.

Short-term exhibits and on-site laboratories go hand in hand with excavation. If integrated into the project, they can provide a rewarding experience for both volunteer and site visitor alike. During latrine excavations at Fort

Wellington National Historic Site in Prescott, Ontario, we implemented a field lab, where Parks Canada archaeological supervisors undertook artefact processing, inventorying, and computerized data inputting of over 165,000 objects (Figure 22.1). A total of 1,200 volunteer hours were amassed during a 2-year field season. Volunteers assisted in the cleaning and numbering of artefacts and in the floatation of soil samples. However, only trained archaeologists did the inventory.

To enhance the volunteer experience, site Heritage Presenters provided site tours of the fort. Parks Canada archaeologists gave weekly up-dated tours to the volunteers, site staff, and to any visitor who cared to tag along. We also instigated a scholar "in residence" programme. Every week, a Parks Canada material culture researcher specializing in different historic material/period worked on the site, either in the lab or in the field. On Friday afternoons, they presented a hands-on workshop using material recovered from the latrine excavations.

These sessions were immensely popular. Again, we invited the volunteers, sites staff, the general public, and local archaeological contractors. The benefits of the workshops were immediate. Volunteers gained applicably knowledge that moved the project along. Site visitors were exposed to the larger world of archaeology and to the behind the scene activities of a heritage organization. Archaeological contractors took advantage of the sessions to hone their knowledge. Importantly, the material researchers' stint in the field

FIGURE 22.1. Fort Wellington field lab open to the public: Lab personnel using portable artefact display case. (Photo by B. Morin. Parks Canada, Ontario Service Centre. (Cornwall), photo no. 2H1304T.)

connected them with the site, its staff, the archaeological contexts and most significantly, the material.

Unlike the Fort Wellington latrine investigation, many of our field projects involve short-term ventures that do not warrant, or cannot support, on-site labs. Consequently, I have begun to focus more on engaging public interest than harnessing their volunteer efforts and to deal more with archaeology for the public than public archaeology. None-the-less, lessons learned during the Fort Wellington project are continually being applied and modified.

Regardless of the lab size and duration, we always attempt to bring a small, portable artefact case into the field containing site-specific materials dating to the period of commemoration (Figure 22.1). Over the years, we have pulled assemblages illustrative of the major historical events. For Fort George and Fort Malden, which both saw heavy action and were occupied by the US forces during the War of 1812, we include objects that evoke the story of conflict and conquest. Since the story of foreign occupation is a commemorated theme for these border sites, and many visitors to them are American, we ensure the presence of an ample collection of American military uniform insignia.

We have found professionally made portable displays, costing under $300.00, to be extremely useful for re-enactments, special events, and school out-reach programmes. Not only do they augment the larger, and more detailed, on-site fixed displays, their temporary nature provides a sense on immediacy and excitement. Often, if their condition allows, they contain some of the most recent objects recovered. The display exhibits also come in handy when unannounced dignitaries arrive at our Cornwall, Ontario Service Centre lab facility. As a consequence, we attempt to have one exhibit "charged" and ready to go when and where necessary.

On a slightly larger scale, we attempt to establish exhibits in our field labs wherever possible. For example, in conjunction with the St. Lawrence Parks Commission, we have recently installed project-specific wall exhibits at Fort Henry. Their purpose is to outline modifications to the fort, historic events associated with its evolution, and describe the methods by which we are undertaking the stabilization programme. Besides informing the public, they act as a backdrop to more in-depth discussions and permit the development of tiered interpretation depending on the sophistication and interest of the visitor.

The messages are in keeping with the historic values identified in the Fort Henry CIS by a multidisciplinary team of specialists. Employing the recommendations of the Historical Sites and Monuments Board of Canada, the historic values dealing with built heritage of the fort include aspects of its innovative design. Besides representing the pinnacle of smooth bore technology, Fort Henry, with its low, stealth-like profile, signalled the beginning of an entirely new fortification concept that favoured camouflage over visual deterrent. This concept continued as the fort evolved. With the development of the Advance Battery in 1842 and the construction of the silver-roofed Commissariat buildings, it remained but a whisper on the landscape.

The decision to embed the work into the landscape resulted in engineering challenges that, to this day, remain unresolved. Much of the stabilization activity presently underway relates directly to the fort's novel design. Archaeological investigations while supporting the conservation effort have an opportunity to communicate to the public the relationship among our findings, the failings of the initial fort design, and the methods proposed to arrest its deterioration.

By integrating our findings with the on-going repair programme, the Fort Henry lab exhibit is helping us achieve that goal. Covering the walls of the lab, it consists of a series of laminated panels describing the interdisciplinary nature of the Fort Henry stabilization programme, construction mock-ups of the work in progress, and artefact displays relevant to the areas under study. Although modest in design, they have been a resounding success. During our 6-week project in 2004, over 3,040 visitors came to the lab. There, they conversed with lab personnel, got a behind the scenes look at archaeology in progress, and leisurely took in the displays.

Over the last decade Parks Canada has re-evaluated the role of reconstruction within the programme. The fiscal realties of both the initial costs and long-term maintenance implications associated with reconstructions have forced Parks Canada to explore alternative ways of telling the story. In addition, the CRM Policy is quite explicit about the criteria required before reconstruction can be entertained. Reconstruction will only be considered if no significant resources are threatened; if the commemorative integrity of the site is not jeopardized; and importantly, if there is sufficient knowledge of the resource to support and ensure accuracy of detail (Canada, [DOH],1994: 115).

As a result, we have attempted less expensive means of showing the public the results of our endeavours, while focusing on aspects of the resource that have the strong interpretive potential. For military sites, this is especially true for landscape elements and features. To allow visitors the chance to experience them after our excavations are over, we have initiated a programme of casting specific features for present and future exhibits. They range from portions of drainage systems to samples of walking surfaces.

One of the most popular has been resin castings of the macadamized surfaces from Fort Wellington, Fort Mississauga, and Fort Henry (Figure 22.2). Macadamized surfaces are a story onto themselves. Suffice it to say that this type of nineteenth-century paving can be found across the Empire wherever the British Regiments of the line drilled on parade, be it in England, India, or the Caribbean. While only a square metre in size, the castings are powerful presentation devices for in each case they represent an original walking surface dating to the period of site commemoration.

The undulating nature of their surface quickly draws the visitor to question suitability of macadamized pavement as a walking surface. Discussions regarding the ease of construction; the level of skill required in its installation and maintenance; and the importance of drainage and how it sheds water, are but some of the avenues ripe for thought and scrutiny. Importantly,

FIGURE 22.2. Lifting the latex mould of the macadamized parade surface at Fort Henry in preparation for a resin cast of the landscape feature. (Photo by J. Last. Parks Canada, Ontario Service Centre (Cornwall), photo no. 131H0107E.)

because of the ubiquitous nature of macadamized surfacing, the castings can tie many sites together allowing the visitor a chance to view each site as part of a larger defensive system.

We have also initiated a series of latex profile soil peels that capture the stratigraphic sequence of particularly telling profiles or evocative features. Soil peels are not reproductions. Cast in latex, they are imprints or thin sections of the actual excavation unit (Figure 22.3). They are authentic stratigraphic records containing original soil, layers, their inclusions, and any artefact contained within its matrix. They can provide very simple statements about site occupation and evolution and eloquently tie the past to the present.

At Fort Wellington, the profile of the latrine cesspit has served as a prominent focal point for discussions about life and the lot of enlisted men garrisoned at the fort. Sequential layers of ash and soil speak to the methods of waste management and sanitation practices. The complex superposition of the privy deposits and lenses, (over 300 layers) illustrate use over time. The abundance of artefacts captured within the peel present a chronology of artefacts used on-site and show the means of their disposal. Faunal and seed remains embedded it its matrix allude to historic food ways. In short, the soil peel is a versatile interpretive device that can be read and reread, allowing stories fashioned to suit the audience at hand.

Figure 22.3. Top photo: the removal of the soil peel from the Fort Wellington latrine. The peel has been removed from the cesspit wall and is being supported by a backing of plywood. (Photo by J. Last. Parks Canada, Ontario Service Centre (Cornwall), photo no. 2H1460T. Bottom photo: view of soil peel before mounting. Photo by J. Last. Parks Canada, Ontario Service Centre (Cornwall), photo no. 2H1464T.)

Although extremely useful, castings and peels are often beyond the range of the average archaeological project. Besides the costs of supplies (latex and resin), it takes approximately 1 week of a conservator's time to cast and lift the sample. Additional lab time is also required in order to paint, infill, support, and mount the final product. A less expensive alternative is to simply use enlarged photographs of the feature. This I have done at all of the sites I excavate, with very successful results. Called "talks in a bag," they have become a mainstay both during the excavation season and as a post-excavation method of telling the story. I found them useful as props for visitor orientation during excavation, for guide training walk-abouts, impromptu site requests, and conference/group tours.

"Talks in a bag" are nothing more than enlarged digitalized photographs laminated onto a light, core-board backing (Figure 22.4). The collection

FIGURE 22.4. "Talk in a bag," an aid to on-site interpretation. (Photo by J. Last. Parks Canada, Ontario Service Centre (Cornwall), photo no. RDO384E.)

of photographs grows as the season(s) develop and primarily include visuals of post-excavation features. Considering the nature of military sites, I have many photographs of historic plans, engineer drawings, and fortification designs. Some are generic and used at all of the sites to explain the nature of nineteenth-century defensive works. Most, however, are site-specific in keeping with the CRM policy (Canada, [DOH], 1994: 105).

One of the advantages to this type of interpretive talk is that it is conducted close to, if not on, the spot where the excavation occurred. This allows for visitor to move about the site, rather than experience the presentation from a room, divorced from the landscape and setting. Since the talks commonly reference past excavations, they allow the visitor to experience the breath of archaeological activity at a specific site, which sometimes equals three decades or more of investigations.

"Talks in the bag" are also useful for special events, re-enactments, guide training and the like. Their simplicity of production, low cost, and ease of modification make them a viable interpretive tool. They can be altered to suit the size of audience and streamlined to meet time constraints, foul weather, or both. Given the topographic advantage of military sites, I can often speak to a crowd of 30–50 persons by standing on the talus of the rampart. Regardless of audience size, the impromptu nature of the medium is conducive to dialogue and interaction. Can we ask for anything more?

22.5. Conclusions

Although Parks Canada archaeologists used the principles of cultural resource management well before the initiation of the CRM Policy, rarely did they employ them as an ensemble. This, for me, has made the greatest difference in how I undertake archaeology and create narratives for the visiting public. By embracing principles and practices that demand one to ask, "Where does value lie?" a more holistic view of the historic value of a resource emerges. This can greatly affect how one engages the public. Certainly, the principle of public benefit has crucially altered the perspectives of applied archaeology within Parks Canada. It requires that we look beyond elements of preservation to those of presentation. The principle of public benefit forces us to integrate our personal research goals with those that emphasize site significance and reasons for designation. In short, it asks us to relate to the public not only about the how and what we are doing, but also why the resources we manage are of importantance to Canadians and their past.

References

Canada, Department of Canadian Heritage [DOC], 1994, Cultural Resource Management Policy. In *Parks Canada Guiding Principles and Operational Policies*, pp. 99–115. Minister of Supply and Services Canada, Ottawa.

23
Archaeology Outreach: It Takes a Community

Janet L. Pape

23.1. Introduction

As archaeologists we are often called upon to explain the value of our work to the public and to the agencies that fund cultural resource studies. Creative public outreach products associated with archaeological investigations can be effective tools for not only explaining what archaeology is, but in revealing the history of a community. Outreach products that inform and entertain are effective tools for reaching the minds and hearts of people living in a community or having ties to a community. Products such as exhibits, popular reports, and videos can be used to tell important stories of past life that contribute to knowledge of local history and develop an individual's sense of place. The participation of community members in the development of outreach products enhance the result by their own stories and achieve further depth into the richness of their own family history and that of the larger community.

Involving community members and/or local organizations in the planning of cultural resource outreach products, such as an exhibit or an entertaining documentary of an archaeology project, instills within the public a regard for archaeological process and a deeper sense of their heritage. Knowledge of forgotten lifeways shared by individuals in the community past and present are valuable not only to the greater goals of anthropology, but also for the community at large who can then advocate the importance of recognizing a cultural resource and sharing history with others in their community.

The 1989 Loma Prieta earthquake destroyed a portion of the Cypress Freeway in West Oakland, California and precipitated historical archaeological field investigations for the I-880 replacement project by the California Department of Transportation (Caltrans) under the Federal Highway Administration (FHWA). Caltrans contracted with the Anthropological Study Center (ASC) at Sonoma State University to produce several outreach products enriched by oral histories and community involvement. The following is an examination of a few of these creative works. They illustrate how

individuals from the community brought the history of the neighborhood to relevance and contributed to the greater success of each outreach product by sharing their personal experiences and family histories.

23.2. Background—Cypress Project and West Oakland

Among the many damaging effects to buildings and roadways caused by the Loma Prieta earthquake, there was also an over mile-long collapse of a double-deck section of the Cypress freeway. This section of freeway, constructed in the 1960s, divided a community and had been long resented by the people who lived there. After many public hearings, Caltrans made the decision to re-route the freeway along a new path, around the residential district, within railroad right-of-way and through a highly industrial and commercial district. Research showed that this district was formerly a vibrant center of West Oakland with strong community ties to the transcontinental railroad, as this was its western terminus.

A wide diversity of ethnic groups and nationalities inhabited the area since the mid-nineteenth century California Gold Rush. These groups included Irish, Scandinavian, Canadian, Greek, Slovenian, Portuguese, Italian, Russian, Chinese, and German immigrants and African-Americans working in various trades such as butchers, merchants, brewers, fishers, railroaders, carpenters, coopers, and other skilled and unskilled laborers (Olmsted and Olmsted, 1994: 97–127). The immigrants and the American-born worked and lived side by side. While the numbers of immigrants from a single country arriving in West Oakland varied over time, no one or two groups were ever to dominate the neighborhood prior to the 1940s (Stewart and Praetzellis, 1997: 10). There was a sizable African-American community in West Oakland at the turn of the century, with the 1910 census listing 180 heads of households and adult wage earners identifying themselves as black or mulatto (Olmsted and Olmsted, 1994: 114; USBC, 1910). African Americans were to become the dominant racial group in West Oakland during World War II with their recruitment mostly from the southern states to form the labor force for munitions factories, shipyards, and other military facilities (Stewart and Praetzellis, 1997: 10). By the late 1940s, the area was prominent for its flourishing jazz clubs that drew tourists and locals from all over the Bay Area (Collins, 1997b).

23.3. Archaeology, Community Participation, and Creative Works

The thriving historic community of West Oakland produced a high volume of intact archaeological deposits within a 22-block area that became the focus of archaeological mitigation for the rebuilding of the Cypress Freeway on its new

alignment. During the archaeological excavation phase, outreach efforts began with organized tours. These became popular with local college archaeology classes, historical societies, and neighborhood groups (Figure 23.1). Simultaneous with the archaeology field phase, a program was initiated to obtain a more comprehensive social history of the area. Although the experiences of the different ethnic groups was a primary focus of the oral-history research, personal interviews were also used to elicit opinions and facts on a virtually limitless range of topics relating to home, work, family, and community. These interviews were videotaped and later integrated into the historical archaeological record for the Cypress Project, *Privy to the Past*. Interviewees also contributed their personal histories at venues for a mobile exhibit: *Holding the Fort: African American Historical Archaeology and Labor History in West Oakland*. In addition, black barbers interviewed during the oral history project participated in a stationary exhibit, *Barber Poles and Mugs: Black Barbering and Barbers in West Oakland* that was showcased at the Oakland Main Library History Room.

23.3.1. Holding the Fort

The first outreach product created for the Cypress Project was the mobile exhibit *Holding the Fort: African American Historical Archaeology and Labor*

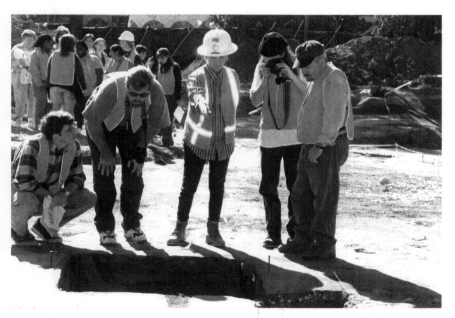

FIGURE 23.1. Archaeology students from Laney College are given a tour by Janet Pape (center) on the Caltrans Cypress Archaeology Project in West Oakland (Photo Courtesy of California Department of Transportation (Caltrans) 1994).

History in West Oakland. This exhibit was created through the partnership of Caltrans, the ASC, and the African-American Museum and Library at Oakland (AAMLO). The idea for the exhibit evolved through project research by the ASC at the museum and the subsequent building of a relationship with the museum curator. The exhibit was based on the Brotherhood of Sleeping Car Porters by researcher Will Spires. This exhibit attracted a high degree of interest from various sectors of the public and stimulated awareness of community history. The idea for a traveling exhibit was included in the Archaeological Research Design and Treatment Plan for the Cypress Project as one of a number of possible outreach products. Specifications for these exhibits were developed later when the scope of the project became more apparent.

The sleeping car porters' exhibit centered on the struggle in the 1920s for fair wages and better working conditions under the Chicago-based Pullman Palace Car Company. Sleeping and dining cars served the middle and upper class passengers on long-distance travels. For many decades, white-controlled unions excluded blacks from numerous occupations, especially the better-paying ones. Although many of the black porters were relatively well educated, having moved to California from northern and southern-border states where blacks had access to education, they were forced to compete with the Chinese at the lower end of the job market. There were no alternatives for blacks other than to work in the less desirable jobs, such as fabricators, waiters, cooks, and porters. The Pullman Company would only hire blacks as porters, but since porters were paid relatively well compared to other types of available wage labor for African-Americans, jobs as porters were highly sought after by the black community (Spires, 1994: 207).

There was prestige associated with working with the Pullman Company, as well as opportunities for a wide range of travel, but the work was hard and with long hours. The typical porter work day consisted of reporting to work at 5:00 p.m. and preparing the sleeping cars until they received passengers around 7:30 or 8:00 p.m. The porters would then make the passengers comfortable until the train left at midnight. When the train arrived at its destination, the porters' pay stopped, but their work continued. They had to re-make the beds and conduct a meticulous count of the linen and tableware. These duties frequently consumed 2 hours of unpaid time. Also, extra porters, who were part-time employees without permanent assignments, were required to report to the company office each day without pay and await assignments. The porter's time was George Pullman's (ibid.).

In the mid-1920s, against overwhelming odds, a movement was begun by the Brotherhood of Sleeping Car Porters to organize and improve the working lives of its members. The movement against the Pullman Company lasted for 12 long years. This effort took even greater courage as the porters put their jobs on the line during the Great Depression.

The local labor movement in Oakland was led by Morris "Dad" Moore, a man who had been born into slavery in Virginia in 1854 (ibid.: 209). Moore had a fierce belief in the movement, which was first started by Asa

Philip Randolph on the East Coast. In a biography of Randolph it was said of Moore that "he preached Brotherhood to every man he saw coming in and out of the railroad yard in Oakland" (Anderson, 1972: 176; Spires, 1997a: 226).

It was the policy of the Pullman Company to provide sleeping quarters for porters who were required to remain on call (Spires, 1994: 209). In Oakland, at the end of the transcontinental lines, and in most cities, these quarters consisted of sleeping cars placed under the care of a porter retired from regular duty.

The Pullman Company viewed A. Philip Randolph and his followers as a menace. Using its network of spotters, the Company soon became aware of Moore's pro-union sympathies, and he was removed from his duties in 1924 after five years in charge of the quarters in the Oakland yards. Moore then opened up his own quarters above a saloon near the railroad yards to house the porters and secure a base for the organization (ibid.: 210). In his advancing years, he struggled to keep the fight alive and was joined in 1924 by fellow-porter, Cotrell L. Dellums, who would bring the movement to life, not only in West Oakland, but also in the western United States.

C.L. Dellums first heard Philip Randolph speak in West Oakland two years later. He went to meet Randolph the next day and told him how he helped Dad Moore organize the porters and that as long as Randolph was leading the movement, he was with him (ibid.: 213). Dellums was soon identified as a labor organizer and was marked by the company for dismissal. Company spotters were placed on the trains worked by Dellums in order to accumulate possible incriminating information against him. Dellums was dismissed in 1928 on a trumped up charge of unsatisfactory service. The Pullman Company began turning up the pressure on the Brotherhood, and in particular, in the Oakland yards. The Brotherhood in Oakland took a vote in 1928 to strike, which was followed by many more firings of the Oakland porters (ibid.: 213–216). Dellums became national vice president of the Brotherhood in 1929 and continued the long bitter strike to its fruition in 1937. The International Brotherhood of Sleeping Car Porters became the first union solely made up of African Americans. "Hold the Fort" was one of the fighting songs the porters sang to keep their spirits high during the long battle (Spires, 1997b: 233–254).

The Holding the Fort exhibit consists of a three-panel, two-sided display, featuring historical photos, documents, newspaper articles, and artifacts that reveal the lives and struggle by the porters and the two men who led the fight in Oakland. A photo of Marcella Ford is also part of the exhibit (Figure 23.2). Marcella was one of the original founders of the AAMLO. Her husband, Jesse, was one of the local sleeping car porters and his photograph, along with some items from his collection, is also displayed in the exhibit.

Opening receptions for the exhibit were held at each Oakland public library branch, making for broad accessibility. A retired porter, Herman

FIGURE 23.2. Marcella Ford
gazes upon her husband's
photograph in the Holding the
Fort: African-American
Historical Archaeology and
Labor History in West
Oakland exhibit displayed at
City Hall, Oakland. (Photo:
Jonathan Eubanks,
Photographer, 1996.)

Simmons, spoke at the festivities telling stories about his former job with the
railroad. He described the duties of the porters in detail and demonstrated
their tasks using tools of the trade, which he brought with him to each venue.
He displayed his uniform and accessories for the audience to see and touch.
Herman Simmons brought this exhibit to life.

Audiences of all age groups were impressed by the stories of Mr. Simmons'
life with the railroad. As people viewed the exhibit, they shared stories of
their ancestors who worked for the Pullman Company or were members of the
Brotherhood of International Sleeping Car Porters, and how they participated
in the union fight for better working conditions and wages.

The exhibit was displayed at numerous venues, moving to a new locale
every several months for over two years. In addition to local libraries, some
of the event locales included: the California State Railroad Museum, the
Oakland Main Post Office, Oakland's new Dellum Amtrack station, and the
1996 American Association of State Highway Transportation Officials
National Civil Rights Conference in Scottsdale, Arizona (exhibit sponsored
by FHWA). It was also displayed at Oakland City Hall, where a reception
was held with television coverage and guest speakers including the Mayor of
Oakland, Elihue Harris, Caltrans management, and local politicians.

The popularity of this exhibit was a surprise not only to Caltrans and FHWA management but also to those who created it: the archaeologists, members of AAMLO, and community members who contributed to it with their shared family memories. It was rewarding to see the involvement by the community in the success of the exhibit, but there was another notable development through the association of the community with the exhibit. In researching the life of Dad Moore, it was learned that he was buried in Evergreen Cemetery in Oakland. A discovery was made during the research that there was no headstone at his burial plot. The word of the absence of a burial marker spread via AAMLO throughout the community and an anonymous donor made a contribution through the African-American Museum to fund the purchase of a marble headstone. The headstone reads:

<div align="center">

Morris Dad Moore

1854–1930

Railroad Union Organizer

</div>

After the placement of the headstone, a dedication ceremony was held at the gravesite to commemorate his life. Family members of Dad Moore, community members, and representatives from AAMLO, the ASC, and Caltrans attended this commemoration. It was an inspiring occasion and truly demonstrated how public outreach can have a far-reaching and demonstrable effect on the community and local history.

23.3.2. Privy to the Past

In view of the fact that the Cypress archaeology project was the largest archaeology project ever conducted in the USA west of Boston's "Big Dig," emphasis was placed on creating public outreach products that corresponded with the size and scope of the field efforts and the results of the investigations. The most complex outreach product produced for the Cypress Project, in terms of cost, effort, and audience reach, was a 29-minute documentary video titled, *Privy to the Past* (Caltrans, 1999). A video incorporates the three dimensions of art, music, and popular writing, and consequently, can have a powerful impact in conveying a message or story.

One of the most difficult aspects in making the documentary was deciding on a theme. My colleague, Dr. Adrian Praetzellis, ASC Director, and the author bounced ideas back and forth during the field investigations and our thought was always to chronicle a history of West Oakland using the archaeology to fill in the historical gaps. During the early part of the field investigations, it became very apparent through contact with such people as contractors, engineers, and increasingly curious community members inquiring as to what we were doing, that the general public was becoming aware of the field of historical archaeology. However, they were commonly confusing it with prehistoric archaeology or paleontology. Also, many project managers, engineers, and environmental planners within Caltrans and local planning

agencies were also unfamiliar with historical archaeology. Therefore, it was decided that the documentary would have a balanced presentation intended to target: college level archaeology students, middle/high school students and their families, and public agencies which must comply with state and federal cultural resource laws. Consequently, the documentary's purpose was to explain what historical archaeology is, what methodologies it employs, how it differs from prehistoric archaeology, and the how, where and why behind historical archaeological investigations, particularly within the framework of cultural resource management. This information would be coaxed out of historical research and archaeological field investigations for the Cypress project.

A principal goal was to finish the documentary soon after the fieldwork was completed in order to keep it fresh in the community's mind. Based on the number of artifacts and intact deposits that were being found during the field investigations (eventually reaching over 250,000 artifacts), we knew early in the process that the analysis of the artifacts would take 12–24 months. Bill Levinson, Ph.D., and his video production firm, Alpha Spectrum Video, Inc., was contracted shortly after the fieldwork began so that video documentation could begin, even though the theme of the video was not fully developed at that early date. It was necessary to videotape the artifacts as they were found in order to illustrate the archaeological process.

Once the theme was developed, the story line began to take shape and Dr. Levinson wrote a rough script. Creating a video documentary that incorporated the separate visions of both the videographer and the archaeologists was a challenging collaboration. Grace Ziesing, staff historical archaeologist at ASC, began working closely with the video director on the script and produced a draft of what the archaeologists envisioned. Script writing and editing became the joint effort of Bill Levinson, Grace Ziesing, Adrian Praetzellis, and the author. It took about a year of back and forth part-time writing and editing to get the script to a point where all parties were finally satisfied. The video would be no longer than 29 minutes in order to accommodate a half-hour segment of television, which would require additional commercial time.

Historical photos of the project area were employed in the documentary to provide the viewer a visual sense of how the project area appeared during the late 1800s and early 1900s. Former residents of this very ethnically integrated neighborhood were interviewed as part of the documentary, along with photos of their ancestors who lived in West Oakland (Figure 23.3). The interviewees were descendants of Greek, Italian, Chinese immigrants, and African-Americans. Through their stories and family photographs, they were able to provide the community a personal connection to the history of West Oakland. Videotaped footage of their early family photos showing them engaged in social events provided an even greater connection to this former industrial community. As layers of time were being exposed by archaeologists, once thriving nineteenth century life in West Oakland was being reborn.

FIGURE 23.3. Videotaping for *Privy to the Past*; Karana Hattersley-Drayton interviews Trula Karnegis, Florence Wong, and Gertrude Blake. (Photo: Janet Pape, 1997.)

The video documents historians at work researching materials such as fire insurance maps, census records, and city directories. Artifacts from three different field components were used for comparison and interpretation in the video. These were the residence of an African-American family, the residence of a German family living two doors away, and a Chinese laundry that was also used for living quarters. Census records and Sanborn fire insurance maps were used in the documentary to provide information on these three different groups and to pose questions relating to information not provided in the historical records. Adrian Praetzellis addressed these questions in the documentary during his interpretation of the artifact collections from the three sites.

After the final footage was taken and the narrative script finalized, the director added additional photos and video culled from the archaeological excavation, conservation, and analysis process as well as oral history interviews in sequential order following the script. As additional information, clarification or transition was needed, either a graphic or narration was used. A preview of the video was done with a nonprofessional narrator. Although the voice was pleasing, we believed the inflection of a professional narrator would give the documentary added credibility and a professional tone. Since there seemed to be a dominant number of male voices in the documentary, a woman's voice as narrator would create a counterbalance. After reviewing several sample tapes of professional narrators, Mary Wings was chosen. Further script editing took place in the studio during readings and Mary was

able to make suggestions regarding flow and wording. Mary's professional delivery gave an entirely different feeling of the video images.

Once the narration was completed, background music was added during the nonspeaking portions of the video. The use of "period" music in the opening scenes of nineteenth century West Oakland immediately takes the viewer back to the actual or imagined time frame of the visuals. Gary Rowe, a professional composer and musician composed the original score of the period music. By using this original score, it was not necessary to obtain permission rights for published music and the melody was not likely to conjure up a particular movie image of the era.

When a draft of the video was completed, it was sent to various professional archaeology and historian colleagues locally and afar for a fresh critique. Their constructive criticisms were helpful in fine-tuning the documentary. Suggestions were also elicited for the title. A title is very important since a title alone can entice someone to view the documentary who may not otherwise be attracted. A title needs to reflect the subject matter, yet also be easy to remember. We tried several titles such as: *Forgotten Americans, The Lost City of Oakland, Unearthing Hidden Stories*, and *Life in 19th Century America.* None of these titles seemed to convey a sense of history and archaeology like the title *Privy to the Past,* which also had a cleverness to it that people are more likely to remember with the double meaning of the word "privy."

Once the documentary was completed, a premiere showing, by invitation, was given at the Caltrans Oakland District office. In addition to the video creators and people appearing in the documentary, community leaders, archaeology professors from local colleges and universities, project engineers, Caltrans and FHWA management, and other interested parties were invited to the debut. This was not the first video sponsored or produced by the California Department of Transportation, but it was the first featuring historical archaeology.

Five hundred complimentary copies of the video were distributed to local schools and universities, public libraries, Caltrans district offices, and local planning agencies. Copies were also sent to local television stations for potential airing. It aired on a local cable television station periodically for over a year after the station received it in late 1998. Documentaries do not usually appear on commercial broadcast television without a sponsor.

After the distribution of the video, the issue of concern was handling future requests for copies. We knew the video would be a valuable aid in the classroom, but Caltrans does not have the infrastructure to advertise it appropriately on a national level or the personnel to handle requests and distribution. The University of California Extension—Center for Media and Independent learning was then contacted. After they reviewed the documentary, they also believed it would be a good teaching tool and requested a teacher's guide, which Dr. Praetzellis created, to be sent out along with the video. Black and white photos of the archaeological investigations were provided for the promotion of the video, as well as testimonials from college professors who reviewed the documentary. The video was marketed by U.C.

Extension under contract for 5 years and Caltrans received royalties for each copy sold. The video is now available through Caltrans for a nominal fee.

The making of *Privy to the Past* was a challenging but rewarding experience by all participants in this public outreach effort. Unfortunately, not every archaeology project lends itself to this magnitude of outreach effort. Production costs totaled $60,000 for this video and was included in the budget of the archaeological investigations. The potential public relations nightmare of such an enormous and complex construction project, including immense political pressures and community disruption, was at least partially offset by replacing the community's angst with anticipation of the archaeological finds and the public outreach products. These public relations benefits generated a feedback system from the community where information was enriched and transformed by those who viewed the archaeology and/or outreach products, each with their own personal perspective. *Privy to the Past* highlighted the ethnic diversity of West Oakland and how the immigrants from many different nations worked together to build a community for themselves and their descendents. Illuminating this rich local history through means of art, music, and popular writing enriched a sense of community values and reinforced or developed a meaningful connection to Oakland's past for its community members.

23.3.3. Barber Poles and Mugs

A small exhibit was developed from the historical research and oral histories collected by Willie Collins, Ph.D., an historian working with ASC on the archaeology project. Dr. Collins, through his historical research, became aware of the many African-American men and women barbers and hairdressers who had businesses in the West Oakland area since the early 1900s. He wanted to celebrate the importance of the little-known tradition of African-American barbering and barbershops in West Oakland, and thus he initiated the creation of an exhibit.

From the beginning of slavery in America, house servants performed barbery services on the plantations. After Reconstruction, many black barbers served white customers in shops and black customers in homes (Collins, 1997a). The first black-owned barbershop in Oakland was established in 1866 in the downtown area; however, this barbershop likely served only a white clientele. The black population only numbered 55 in 1870, a mere half percent of the total population (Hausler, 1998: 9). Ten years later, almost 600 Black Americans lived in the city. During the 1870s and 1880s, other black-owned barbershops began to emerge in Oakland and barbering became an economic force in Oakland's black community. Barbershops appeared as parlors, with ornate wallpaper and tile floor covering, typical of the late nineteenth century. By 1900, 18 black barbers worked in Oakland and by 1910 this number surged to 44. The 1930's census shows 40 male and 42 female barbers (USBC, 1930). Most of the women were likely hairdressers—meaning they only served women clients. Some of the shops provided employment for

other professions, such as manicurists and bootblacks. Besides shining shoes, bootblacks would often keep the barbershop clean and refill bottles with tonics and other supplies. The black barbershops were stable and successful enterprises in West Oakland and were a gathering place where customers traded opinions on politics, sports, and local gossip.

By the 1960s, barbershop businesses in West Oakland were in decline, partly due to changes in hairstyles to a longer and more natural look and partly because of urban renewal with the construction of the Oakland Main Post Office and the Bay Area Rapid Transit station in West Oakland. Shops closed and were torn down and the barbers either retired or relocated out of West Oakland. There is only one black-owned barbershop that continues operating today in West Oakland.

Dr. Collins joined forces with Bill Sturm, director of the Oakland History Room at the Oakland Main Library, in putting together an exhibit honoring the black men and women barbers of West Oakland. They elicited former and current barbers in West Oakland to contribute their antique barber supplies and their memories as to each item's purpose and use and also encouraged them to attend the opening exhibit to share their barbering stories (Figure 23.4). This stationery exhibit, which comprised several display cases, was titled *Barber Poles and Mugs: Black Barbering and Barbers in West Oakland.*

FIGURE 23.4. Retired African-American barbers gather in front of a display case showcasing their tools of the trade at the Barber Poles and Mugs: Black Barbering and Barbers in West Oakland exhibit at the Oakland History Room, Oakland Main Library. Bill Sturm, Oakland History Room, is at far left; Dr. Willie Collins, Historian, is at far right. (Photo: Janet Pape, 1997.)

The California Department of Transportation produced the invitations in-house and mailed them to interested parties for the opening of the exhibit.

The exhibit, using historical photographs, archival records, artifacts, and oral histories, celebrates the tradition of African-American barbering in West Oakland and the central role that black barbers and their barbershops have played in the economic and social life of the black community. Women barbers, especially, made an important impact on the black community after the turn of the century by being important role models in resisting economic marginalization and dependency. They broke down stereotypes while providing an invaluable service to the community. The retired barbers of both genders were proud to be honored for their profession and for having contributed to the social and economic history of West Oakland.

23.4. Conclusion

Community participation in the creation of the Cypress outreach products was rewarding and inspiring. The personal histories of the participants were invaluable to the historical researchers and the participants were excited about the archaeology. They were anxious to contribute pieces of their family history to the community history. Creating a public outreach product that involves the community entails effective coordination, encouragement, and integration. The participants benefit from their involvement by self-enrichment and carrying the message of conservation back to their community.

Archaeology is effective as public education if the creation and maintenance of appropriate attitudes occur, such as valuing our collective history represented in archaeological sites, personal histories, and historic documents. This in turn permits decision-makers (or cultural resource managers) to develop and apply the legal and administrative mechanisms and the funding necessary for participants to work effectively (McGimsey et al., 2000: 5). It is the responsibility of the archaeologist or cultural resource manager to include public outreach products in their projects and communicate the results of the research to the largest audience possible. Public outreach *is* the highest reward in archaeology.

References

Anderson, J., 1972, *A. Philip Randolph: A Biographical Portrait*. Harcourt Brace, Jovanovich, New York.

California Department of Transportation, 1999, California Department of Transportation in association with Sonoma State University, *Privy to the Past*. Produced by Alpha Spectrum Video, Inc., 29 minutes.

Collins, W.R., 1997a, Barber Poles and Mugs: Black Barbering and Barbers in West Oakland. Exhibition Brochure.

Collins, W.R., 1997b, Jazzing up Seventh Street: Musicians, Venues, and Their Social Implications. In *Sights and Sounds—Essays in Celebration of West Oakland*,

California Department of Transportation—Cypress Replacement Project Report No. 1, edited by S. Stewart and M. Praetzellis, pp. 295–324.

Hattersley-Drayton, K., 1997, Melting Pot or Not? Ethnicity and Community in pre-World War II West Oakland. In *Sights and Sounds—Essays in Celebration of West Oakland. California Department of Transportation—Cypress Replacement Project Report No. 1*, edited by S. Stewart and M. Praetzellis, pp. 183–210.

Hausler, D., 1998, The Black Oakland Work Force in the 1870s. From the Archives, VII (2,3),VIII (1). African American Museum and Library at Oakland, pp. 9–15.

McGimsey, III, Charles, R., and Davis, H.A., 2000, The Old Order Changeth; or, Now that Archaeology is in the Deep End of the Pool, Let's not Just Tread Water. In *Teaching Archaeology in the Twenty-First Century*, edited by S.J. Bender and G.S. Smith, pp. 5–8. Society for American Archaeology, Washington, DC.

Olmsted, N. and Olmsted, R.W., 1994, History of West Oakland. In *West Oakland—a place to start from, research design and treatment plan, Cypress I-880 Replacement Project*, Vol. 1: *Historical Archaeology*, edited by M. Praetzellis, pp. 9–127.

Spires, W.A., 1994, West Oakland and the Brotherhood of Sleeping Car Porters. In *West Oakland—a place to start from, Research design and treatment plan, Cypress I-880 Replacement Project*, Vol. 1: *Historical Archaeology*, edited by M. Praetzellis, pp. 205–224.

Spires, W.A., 1997a, The Quest for "Dad" Moore: Theme, Place, and the Individual in Historical Archaeology. In *Sights and Sounds—Essays in Celebration of West Oakland. California Department of Transportation—Cypress Replacement Project Report No. 1*, edited by S. Stewart and M. Praetzellis, pp. 223–232.

Spires, W.A., 1997b, Brotherhood Songs: The West Oakland Songbook of the International Brotherhood of Sleeping Car Porters. In *Sights and Sounds—Essays in Celebration of West Oakland. California Department of Transportation—Cypress Replacement Project Report No. 1*, edited by S. Stewart and M. Praetzellis, pp. 295–324.

Stewart, S. and Praetzellis, M., 1997, Connecting the Sources: Archaeology, Material Culture, Memory, and Archives. In *Sights and Sounds—Essays in Celebration of West Oakland, California Department of Transportation—Cypress Replacement Project Report No. 1*, edited by S. Stewart and M.Praetzellis, pp. 10.

United States Bureau of the Census Oakland, 1910, Manuscript Population Census. Microfilm.

United States Bureau of the Census Oakland, 1930, Manuscript Population Census. Microfilm.

24
Smart Planning and Innovative Public Outreach: The Quintessential Mix for the Future of Archaeology

Pamela J. Cressey and Natalie Vinton

24.1. Introduction

Internationally, historical archaeological resources are managed in a variety of ways to produce varying results for and with the public. To ensure the survival of our finite global historical archaeological resource, we must begin to examine how historical archaeology is managed on a global level—by comparing, contrasting, observing, and questioning the different management practices for historical archaeological research.

The management of historical archaeological resources can influence and shape the public's perception of historical archaeology and its perceived community "value." The comparative analysis of two international case studies—the Quadrant Site in Sydney, Australia, and the Freedmen's Cemetery in Alexandria, Virginia, USA, provides an insight into New South Wales (NSW) legislative-based management of historical archaeological resources in comparison to Alexandria's community-led archaeology programs. Through the close comparison of the strengths and weaknesses of each case study, we can gain a valuable insight into how historical archaeological resources can be managed to achieve valuable archaeological and community outcomes.

24.2. Legislative and Community Practices

Sydney, occupied by Aborigines for more than 50,000 years, was first settled by Europeans in 1788. Today, a mix of highly significant indigenous and European archaeological sites still exists beneath the city's layer. Alexandria's Native American population dates back at least 9,000 years. The town was founded in 1749 at the northeastern edge of the English colony of Virginia. It was later incorporated into the new federal capital, the District of Columbia, after the Revolutionary War through which the colonies gained their independence from Great Britain. Alexandria returned to the Commonwealth of Virginia before the American Civil War. Although there are few remaining prehistoric resources, the 14-sq.-mile town still contains many historical archaeological sites.

While both cities have extant archaeological resources, there are many differences in the way each city manages and conserves significant archaeological remains for the public to appreciate both now and in the future.

In Sydney, non-Indigenous subsurface archaeological resources are afforded a greater level of statutory protection than archaeological resources in Alexandria because the New South Wales state legislation for historic heritage places, the Heritage Act (1977), provides blanket protection for all historical archaeological remains that exist belowground and are older than 50 years, regardless of their location on private or publicly owned lands. The NSW Heritage Act has been used as the basis for managing historical archaeological remains since the 1970s and as a result has had a major influence on how historical archaeological research has been conducted in New South Wales by historical archaeologists.

The NSW Heritage Act does not provide protection for Indigenous archaeological resources. Indigenous archaeological resources are protected under the National Parks and Wildlife Act (1974), using a different set of statutory provisions. This paper deals only with the practice and management of historical archaeological resources in New South Wales, Australia.

The majority of historical archaeological investigations undertaken in New South Wales are driven by developers' need to obtain heritage permits in order to proceed with construction at sites where subsurface historical archaeological relics are likely to be disturbed, destroyed, or uncovered. On average, the Heritage Council receives fewer than five academic "research" permit applications each year as opposed to approximately 250 permit applications to undertake archaeological excavations, as part of the cultural resource management (CRM) required for the redevelopment of sites (NSW Heritage Office Database, 2003). Consequently, a strong "legislation-based" historical archaeology management system has emerged: archaeological permit applications are designed to ensure that the Heritage Act is complied with, salvage archaeological investigation (CRM) can be undertaken, and development is allowed to proceed.

Contemporary community opinion and social values rarely, if ever, shape the historical archaeological research designs and practices being approved by the state government because the community involvement in historical archaeology research occurs only after excavation permit applications have already been approved by the state government. The current laws do not require archaeological excavation permit applications to be publicly advertised prior to approval, which means that the public is not given any opportunity to comment on the impact of the development work proposed or the merits of the archaeological research design. The community consultation is not up front and interactive (Greer et al., 2002). Therefore, the excavation permit approvals are made by agency archaeologists, in a way similar to how they are determined in America. As a result, the preservation of historical archaeological sites for their significant historic, aesthetic, and social values has infrequently been achieved. Sites are usually thoroughly investigated and then destroyed but very rarely are they preserved.

In contrast, community-based archaeology—programs and practices that empower citizens to formulate and shape local archaeological goals—has emerged as the dominant practice in Alexandria. As a result, the outcomes of archaeological research and preservation have value and significance to contemporary society. The goal of the City archaeologists has been to conduct archaeology *with* the public, not only *for* the public (Cressey et al., 2003).

24.2.1. Alexandria, Virginia, USA

The City of Alexandria provides a variety of historic services to the community of more than 130,000 people. In 1946, the town established one of the first historic districts in America, and there is a continuing pride in the general history and how it is reflected in architectural and archaeological preservation efforts. The Office of Historic Alexandria operates a number of museums and Alexandria Archaeology. Four City archaeologists and one educator work with 100 to 200 volunteers each year to conduct research, plan, and preserve resources, operate a museum, provide educational programs, curate the collections, and promote the historic character of the city. The Alexandria Archaeological Commission was first appointed in 1975 and continues to advise City Council on archaeological goals and policies. The Friends of Alexandria Archaeology was founded in 1986 to support the City's archaeology program and expand public access to archaeology (Figure 24.1).

FIGURE 24.1. Members of the Friends of Alexandria Archaeology and Mayor Kerry Donley celebrate the publication of the trail guide for the Alexandria Heritage Trail. (Photo credit: Alexandria Archaeology.)

In the USA, federal legislation provides the mandate for managing cultural resources on federal lands and areas affected by federal projects, funds, and permits. Each state has its own legislation for dealing with cultural resources and can establish its own laws for protection and excavation of human remains. At the smallest level of government (cities and counties), most cultural resource legislation controls standing structures and manages architectural design in historic districts; few localities address archaeological resources in their codes or practices. Due to this situation, most nonfederal and nonstate-owned resources do not have any legislation mandating archaeological management unless a federal or state project, federal funds or federal permits are involved.

Alexandria's interest in archaeology dates back to 1961 when the City undertook its first archaeological project to restore a portion of a Civil War fort. Citizens convinced the city council to save the site, conduct archaeology, restore part of the bastion, and create a park around the historic place. It was at this time, more than 40 years ago, that Alexandrians created the nonlegislative practice through which archaeological work would be carried out. This tradition did not use governmental regulations that forced developers to conduct archaeology. Rather, it was based upon the value that archaeology contributes to the town's knowledge of its heritage and enriches residents and visitors. While the acquisition of knowledge was seen as important, citizens also believed that archaeological resources made places more significant. This historical importance became the reason to protect a place and create a museum, park, or other open space. This formula has been used many times in Alexandria producing heritage parks, a waterfront walk along the Potomac River, the Alexandria Heritage Trail, as well as the Alexandria Archaeology Museum, exhibitions, and publications (Figure 24.2).

By the 1980s, however, development was occurring at a rate too rapid for the City archaeologists to work in the traditional Alexandria manner. Sites could be lost without sufficient time to identify the resources, much less manage them through excavation or *in situ* preservation. In 1989, the Alexandria Archaeological Resource Protection Code was enacted by the City Council. The Alexandria Archaeological Commission, a citizen group appointed by City Council, was the prime mover of this legislation that shared the burden for managing resources with the private sector. The Code requires that the City archaeologists review all building projects larger than a single-family residential structure and state the actions that developers must follow to evaluate the resources, determine if they will be adversely affected, recover the resources if necessary, and produce professional reports. Our comments become Code requirements in the City's conditions that permit the project to go forward. Developers contract with private CRM firms to conduct this work. The collections are then donated to the City of Alexandria for curation in our collections facility. The reports become public records, and the artifacts and associated information can be used for further research, exhibitions, educational programs, and historic interpretive signs.

FIGURE 24.2. Vivienne Mitchell, an original member of the Alexandria Archaeological Commission established in 1975, explains to visitors how she identifies artifacts in the Alexandria Archaeology Museum. City archaeologists and volunteers work in a public setting to encourage discussion. (Photo credit: Alexandria Archaeology.)

24.2.2. Sydney, New South Wales, Australia

In 1977, the New South Wales Government introduced the Heritage Act in response to community concern about the increasing loss of the state's significant places and landscapes of historic, cultural, social, spiritual, archaeological, architectural, or aesthetic significance. It provided the first systematic means of protecting environmental heritage in Australia (NSW Heritage Office, 2002).

Amendments to the NSW Heritage Act in 1999 established the State Heritage Register. Places identified as having state significance are listed on the State Heritage Register and require ongoing conservation under the provisions of the Act. Historical archaeological relics can be afforded protection by listing on the State Heritage Register, either in their own right or as items within the curtilage of another state significant item. The legislation also provides blanket protection for all historical archaeological relics more than 50 years old that are located belowground on public or privately owned land (www.heritage.nsw.gov.au/wwwlinks.htm).

The Heritage Council of NSW was created by the Heritage Act 1977 and is responsible for approving development to any item, place, or area listed on the

State Heritage Register. It is the key agency responsible for issuing historical archaeological excavation permits across the state. The NSW Heritage Office was established in July 1996 to provide support to the Heritage Council and the Minister responsible for administering the Heritage Act. The Heritage Office, some local councils, and other state government agencies, including the National Parks and Wildlife Service, have delegation to carry out certain Heritage Council functions, including various archaeological approvals. Other Australian states also provide legal protection for significant historical archaeological remains on public or privately owned land (Victorian Heritage Act, 1995; Queensland Cultural Record Act, 1987).

The introduction of the *Environmental Planning and Assessment Act* (EP&A Act) in 1979 has also allowed the responsibility for heritage items to be shared by state and local government agencies in New South Wales. Under the EP&A Act, local councils may prepare *Local Environmental Plans* that identify and protect significant heritage items, including historical archaeological resources that exist above and belowground. Local Environmental Plans may also include provisions that require local councils to consider the impact of development on archaeological resources before they determine a development application for a site. These provisions do not, however, negate the need for a developer to seek approval under the Heritage Act to disturb historical resources that exist belowground.

Over the last 10 years, several local councils in conjunction with the NSW Heritage Office have commissioned *Archaeological Zoning Plans* for their local area (see Mider and Lavelle, 1992; Higginbotham, 1994). An archaeological zoning plan identifies sites within the local council area that have the potential to contain historical relics belowground. The majority of local councils do not, however, have the resources to prepare archaeological zoning plans, nor are they equipped with the appropriate in-house archaeological expertise to adequately determine if a proposed development is likely to impact on historical archaeological resources that exist below the ground. As a result, many applications approved at a local council level do not identify whether the approved development has the potential to impact upon or destroy a significant historical archaeological resource.

The earlier condition is further complicated by the fact that many developers do not adequately familiarize themselves with the archaeological provisions of the Act and fail to seek approval from the Heritage Council to disturb or destroy subsurface, historical archaeological resources prior to the commencement of works on-site. Once the Heritage Council discovers that works have commenced in archaeologically sensitive areas, the developer must stop work and address issues of noncompliance with the Heritage Act. By this time, the financial implications associated with development delays, potential prosecution, and development redesign can skyrocket, particularly as refusal of an excavation permit by the Heritage Council overrides any approval granted by local government. As a result, historical archaeology often ends up bearing the blame for expensive delays and costly last-minute redesigns.

Unfortunately, resentment over the cost of conducting archaeological assessments and research has also led to many cases of deliberate noncompliance with the Act. Until 1999, the maximum penalty for noncompliance with the Heritage Act was $10,000. Subsequently, many developers undertook excavation works without approval in a bid to avoid the cost implications of having to design around archaeological remains or to avoid the expense of a comprehensive archaeological investigation. However, since the amendments to the Act in 1999, the maximum penalty for noncompliance with the Act, has increased to $1.2 million and may result in the loss of development rights for a maximum of 10 years. Consequently, due to the changes to the Act, the majority of developers now seek to comply with the legislation prior to commencing works on-site.

The highest number of people who disturb archaeologically sensitive areas without approval are, however, members of the public who carry out such activities as part of their usual domestic, recreation, or daily work activities (such as private homeowners, plumbers, gas fitters, gardeners, landscapers, and farmers). They excavate in archaeologically sensitive areas without approval because they have little to no awareness of the Heritage Act and its provisions. When discovered, these breaches of the Act are difficult and complex to deal with. If handled insensitively or over-officiously, these unintentional and often minor breaches of the Act can escalate, leading to major conflict between communities and the heritage practitioners enforcing the Act. The legislation intended to protect subsurface archaeological resources for the "benefit" of the community begins to be perceived as oppressive, unreasonable, and excessive. Communities can be left feeling frustrated and dumbfounded by the practice of historical archaeology and the legislation that governs it.

Another factor that contributes to the often negative perception of historical archaeology in New South Wales communities relates to the absence of community-led archaeology programs and a lack of "visible" community-based outcomes from the archaeological research typically undertaken from 1977 through the late 1990s. The outcomes from many of the historical archaeological excavations undertaken during this time period have been limited by the funding and timing provided by developers for salvage excavation works and the lack of a strong government resolve to require developers to adequately fund archaeological investigation programs. The funding allocated by developers generally allows only for a basic analysis, cataloging and temporary storage of artifacts recovered from sites because the excavation permit approvals issued by the government archaeologists do not require such facilities to be inspected, standardized, or approved.

Over the last two decades, this has remained a critical problem for professional and government archaeologists in New South Wales as many significant artifact collections have ended up being lost or discarded because of the lack of rigor in the system. The absence of a central repository, a clear policy for the management of artifact collections, and monitoring of collections stored by

developers have resulted in very few artifacts and site records from the 1970s through the late 1990s ever being available for reexamination or reanalysis by other archaeologists (see Crook et al., 2003a–c: Volumes 1–3). It remains a key problem for government archaeologists responsible for issuing excavation permits and for professional archaeologists trying to ensure that adequate collections management practices will be implemented for the long-term management of archaeological artifacts.

In 1999, the Heritage Office recognized that, despite the many advances in the management of historical archaeological resources since the implementation of the Heritage Act, a review of historical archaeology planning systems and practice needed to be undertaken. Completed in 2000, the review identified many areas where state and local government agencies can improve their management of historical archaeological resources, particularly in terms of providing a central artifact repository; involving the community in archaeological research; and providing public outcomes (NSW Heritage Office, 2000). The Heritage Office has identified that public education, interpretation, and community outcomes are necessary for the survival of historical archaeological research in New South Wales and the office has set about developing new systems that will facilitate sound community-based archaeological practices for the future.

24.3. Case Studies

24.3.1. Quadrant Site, Sydney, New South Wales, Australia

In 2001, South Sydney Council, a local government authority, approved the redevelopment of four city blocks within central Sydney for a mix of residential and commercial uses. The implications for the potential archaeological resource likely to exist at the site were major because the development approval issued by the local council allowed for the excavation of more than 90% of the site to facilitate several levels of belowground parking. Unfortunately, the conservation of archaeological resources was not one of the key elements that informed the final building design for the site prior to the approval of the development.

Despite the lack of consideration for archaeology at the predevelopment stage, the developer did commission historical archaeologist Dana Mider to prepare an archaeological assessment for the site prior to the commencement of construction works. Dana assessed the likelihood for significant archaeological resources to exist at the site and developed a series of recommendations for how that resource should be investigated and removed, as part of the Section 140 Excavation Permit Application submitted to the NSW Heritage Office. She prepared the assessment in order to comply with the provisions of the NSW Heritage Act (1977), which are administered by the state, not local government.

Through her research, Dana identified that prior to the arrival of Europeans in Australia, the site was home to the Cadigal people, the indigenous occupants of the site. The site was ideally located adjacent to a freshwater source and had an abundance of natural resources. From the 1790s through the 1820s, Europeans utilized the site for extractive industries, such as timber deforestation, clay extraction, and market gardening. By 1828, the site had been released by the Crown for freeholder and was bought by Thomas May, an entrepreneur who constructed residential premises, the Sportsman Arms Hotel, and a range of other commercial properties. Since the site was located on the fringe of central Sydney, its location led to the emergence of undesirable commercial and residential practices, deemed illegal at sites closer to the central business district. By the 1850s, four slaughterhouses had been built adjacent to the creek, and the site had become tightly packed with dairies, stables, slaughterhouses, commercial premises, and slum residential dwellings (Mider and Lavelle, 2001).

Heavy pollution, frequent flooding, and increasing sanitation problems led to the spoiling of the freshwater creek by the 1860s. The area became well known as an environmental and social disgrace. In 1906, after outbreaks of bubonic plague, scarlet fever, smallpox, and typhoid, the NSW Government empowered Sydney City Council to condemn the property and resume the land. The slum tenements were demolished, and the site was covered by up to 3.5 m of fill. The council constructed new terraces in the early 1900s and the site was retained in local government ownership until its purchase by Australand, a major international development company, in the late 1990s (Mider and Lavelle, 2001).

Dana concluded that the archaeological resource was likely to be largely intact and would relate to the significant pre-European and early nineteenth-century European occupation of Australia (Mider and Lavelle, 2001). She also identified that the redevelopment of all four blocks had the potential to contain significant, undisturbed paleoenvironmental information and recommended that extensive pollen and soil analysis should also be undertaken.

Once the Section 140 excavation permit application was received, the Heritage Office had to decide how to handle the permit. Technically, it was possible for the excavation permit application to be refused on the grounds that the archaeological resource might be too significant to disturb. Realistically though, since the development had already been approved by the local council, it was very difficult to require a complete redesign of the four-city-block development in order to facilitate the *in situ* retention and ongoing conservation of potentially significant archaeological remains. Therefore, it was decided that the Heritage Office should immediately began negotiating with the applicant, Australand, in order to establish tangible community outcomes from the archaeological investigation proposed by Dana. It was decided that this opportunity could be used to work closely with the developer in order to try to increase their awareness of archaeology and to test

several international public archaeology initiatives applied to the research and interpretation of archaeological resources.

One of the main aims of this approach was to test whether it was possible to positively influence how the developer would approach archaeological resources in the future planning for development sites (i.e., deal with archaeology upfront in the predevelopment stage of planning for sites) if it was involved in an archaeological project that had a major focus on public education and resulted in successful community outcomes.

Australand agreed to facilitate the community outcomes proposed by the Heritage Office, including the provision of volunteer opportunities, public tours of the site, and interpretation of the archaeological resources recovered, in order to offset the negative impact associated with the removal of the historical archaeological resource. The Heritage Council placed numerous "public archaeology" conditions of consent on the excavation permit to reflect and reinforce the negotiated requirements for community outcomes. In particular, the excavation permit approval included a requirement for the applicant to prepare a comprehensive interpretation strategy that allowed for an on-site display of significant artifacts, video recording of the site, the preparation of a comprehensive cd-rom, site open days with public tours, and opportunities for volunteers to participate in excavations.

The historical and Aboriginal archaeological excavations commenced in August 2001 and were completed in March 2002. More than 60 archaeologists and scientists were employed to excavate, record, and investigate the site. Volunteers and university students worked alongside the archaeologists during the field program. The developer was also encouraged to set up a special section on its Web page so that people could log on at any time to find up-to-date information about the progress of the archaeological program.

The Web site includes links to the archaeological assessment and research design prepared by Dana Mider, historic photographs of the site, newspaper articles, and images of the archaeologists on-site during the excavation phase of the project. Even now as new information is revealed throughout the postexcavation analysis process, the Web site is updated accordingly (see www.australand.com.au).

In January 2002, when the site was at its most visually impressive, tours were strategically scheduled to coincide with the "Australia Day" long-weekend celebrations. One of Australia's major newspapers, the *Daily Telegraph*, ran a small story about the proposed public tours of the archaeological excavation based on a press release issued by the Heritage Office (*Take a step back in time,* p 8, January 25, 2002). More than 1600 people jammed the Australand phone line and Web site in an attempt to book into the tours. The Web site temporarily crashed because it was unable to accommodate the number of hits it received from members of the public keen to visit the site (Figure 24.3).

Once Australand experienced the overwhelming community response, an extra weekend of tours was hastily planned and, in an unprecedented move, they kept the details of each person who missed out on viewing the site so

FIGURE 24.3. Excavation Director Dana Mider hosting the first of many free Open Day tours at Quadrant. (Photo: Natalie Vinton.)

that they could invite them to visit another historical archaeological excavation due to commence on a different site being redeveloped in a few months time, Bullecourt Place. On completion of the tours at Bullecourt Place, the NSW Deputy Premier and Minister for Urban Affairs and Planning awarded Australand an inaugural certificate of merit for their outstanding contribution to heritage education.

Public awareness of the archaeological excavation in the heart of Sydney began to spread as the media picked up and ran with stories about the site. Increasingly, people stopped by to watch the archaeologists at work on their way to and from work and at lunchtimes. The ABC filmed a short television documentary about the site for its show *Dimensions in Time*. The show was broadcast by the ABC network at prime time on a Monday night (6.30 p.m. on March 4, 2002). It was titled *Excavating the Past—Ultimo, Sydney 1820–1910* (www.abc.net.au/dimensions/dimensions_in_time/Transcripts/s496373.htm).

In addition to the increased public activity around the site, another more significant event occurred—people began to approach the archaeologists working at the site in order to share their knowledge of the site, including oral accounts and historic documentation. Descendants of the people who had lived and worked on the site in the late nineteenth century and early twentieth century began to visit the site on a regular basis to speak with Dana. With them, they brought historic photographs and personal mementos that were associated with the site and its occupants.

Dana discovered that as the public was given access to the archaeological resource as part of the open days, through the Australand Web site and the media a whole new source of information that was previously not publicly accessible, became available through her communications with the public.

At the same time, Australand began to identify that the positive media and overwhelming support from the general public for the archaeological work being done at the site clearly set their company apart from other development companies, in terms of their "commitment to responsible cultural heritage management." They voluntarily doubled their final interpretation budget, produced two videos about the archaeological investigations at the Quadrant site, including an hourlong educative video titled *Trowels and Tribulations*. Two hundred copies were made for free distribution by the developer, the project archaeologist, and the NSW Heritage Office until all copies were distributed. The second video was produced as an in-house source of information for their own project managers in relation to how best to manage archaeology within the planning and construction process.

In 2003, Australand also voluntarily prepared 1,000 student activity sheets and 300 teacher education kits for teachers and students attending a *Year 11 Ancient History Seminars* program. The Heritage Office presented the initial findings of the archaeological excavations at the weeklong series of lectures for students. The lectures were shaped to teach students about the value of archaeology in being able to provide us with new and interesting evidence about the history of Sydney. In demonstrating this type of proactive and dynamic commitment to community education and public interpretation, Australand reached far beyond the initial requirements of the excavation permit issued and far beyond the expectations of the Heritage Office.

The commitment of the developer to provide community education and a quality interpretative display is unprecedented. As a significant flow-on effect, other developers are beginning to see the positive impacts of the Heritage Office and Australand's approach to the challenge of meeting the requirements of the NSW Heritage Act. The combined approach had led to widespread positive exposure for historical archaeology, which continues to build project by project.

The Quadrant project demonstrates that when the historical archaeological research is driven by public outcomes, rather than "legislation-based" outcomes, the results can be positive and relevant to the general public. By refocusing the emphasis of the excavation permit process from "legislation-based" to "community-based" approvals, the Heritage Office can start to use the statutory provisions of the Heritage Act for long-term positive community outcomes.

24.3.2. Alexandria Freedmen's Cemetery, Alexandria, Virginia, USA

This case study started in the 1980s, and has unfolded over the decades. There have been many participants in the discovery, study, and protection of the Alexandria Freedmen's Cemetery. As the City archaeologists, we read with great interest an article by our colleague T. Michael Miller (1987) about an African American burial ground started by the US government during the

Civil War in Alexandria for contraband blacks. The term contraband was used by the federal Union Army to describe enslaved African Americans who escaped from their owners and sought refuge in Union-controlled towns or forts in the South. As the War continued, these refugees became to know as freedmen. At this time, we knew very little about these people, who fled to Alexandria during the Civil War; the cemetery's specific location was not known.

We filed the information with other topical cemetery data, since we did not have a specific address. This archival and records function of a City Archaeologist's office is vital to the long-term study and protection of sites. A few years later, we registered the site in a Virginia state survey of abandoned cemeteries, although we only could provide a general location. We did not know if the site was still preserved; there was certainly no aboveground evidence of the cemetery. Then, local historian, Wes Pippenger, discovered the ledger that recorded the freedmen who died in Alexandria. He alerted us to his findings and published an alphabetical index of the freedmen's names (Pippenger, 1995). He also provided us with a copy of the original ledger, which allowed us to study the pattern of deaths, day by day, season by season, as well as the demographics by age, sex, and location of death within the city.

A few years later, when one part of the area thought to be Freedmen's Cemetery was considered for redevelopment, our Code requirements produced historical research by the developer's private archaeologists that provided some boundary information. This allowed Assistant City Archaeologist, Steven Shephard to develop maps showing how the land parcel was subdivided over the years and delineate the probable location of the Freedmen's Cemetery. The developer did not want to embark upon construction in an African American cemetery, and the project was dropped. But this research provided the first geographical information. We discovered that a gas station, an office building, parking lot, and embankment overlooking Interstate 95 were now on the site of the burial ground. There was a strong possibility that burials extended under the sidewalks and streets. Coupled with the nearly 1,800 names of the people from the ledger, the information produced from background research for this one Code project formed the basis of future preservation efforts.

By the early 1990s, the federal government began a major undertaking—the dismantling and reconstruction of the Woodrow Wilson Bridge, which is part of Interstate 95. As required by federal law, archaeological studies were needed to assess the potential for resources to be adversely affected by this project. Fortunately, we were able to provide our information about Freedmen's Cemetery in the first environmental impact statements of the Federal Highway Administration and Virginia Department of Transportation.

An article appeared January 30, 1997 in the *Washington Post* (Reid) about Freedmen's Cemetery and the possibility that the bridge project might construct a ramp where burials might still be preserved. It just so happened that Lillie Finklea, a resident of Alexandria since childhood, opened the newspaper that morning and read the article. She was concerned that the black refugees had been given so little respect. She read that the cemetery had been abandoned

by the federal government in 1869, then covered over by a gas station in the 1940s, and now apparently might be ignored during this federal project in the 1990s. She was moved to action. After she shared her concerns with long-time civic activist, Ellen Pickering, they came to Alexandria Archaeology knowing of our interest in African American heritage issues.

Lillie became a volunteer and began research into the freedmen. She started networking and partnered with Louise Massoud in the effort, which led to the formation of the Friends of Freedmen's Cemetery in 1997. [Note: not-for-profit groups in America are neither public (government) nor private (business). They hold a special status by virtue of their mandate to do something for the good, not for profit, and receive tax benefits. Friends groups have sprung up in America in the last 20 years in increasing numbers to support places and activities with educational, cultural, health, and environmental purposes.] A board of directors was formed, and the friends group took on the goal of speaking to the community about the significance of the cemetery.

It is important to note that the Friends of Freedmens Cemetery and the City archaeologists worked in partnership with one another, but had different roles. We provided technical expertise and interacted with federal and state agencies involved with the bridge project, as well as with the private archaeologists working under federal regulations. The Friends group and the Alexandria Archaeological Commission promoted awareness and sustained interest in the freedmen's historic plight and the contemporary concerns for the protection and recognition of the cemetery. While the City archaeologists would have coordinated with the agencies and private archaeologists under any circumstance, the Friends group created new goals and had a broader vision of public benefit.

The Friends decided that the first task was to increase local awareness of the cemetery's existence under the gas station and adjoining land. They undertook a series of activities to bring an invisible site into public consciousness: (1) an annual proclamation by city council for a "Week of Remembrance," including a wreath-laying event (Figure 24.4); (2) a fund-raising drive to erect a state historic marker on the site; (3) an exhibit about freedmen at the Alexandria Black History Museum; and (4) development by Tim Dennee of a brochure and Web site (www.freedmenscemetery.org). The Friends also began attending meetings with agencies and archaeologists on the future of the cemetery.

Archaeologists with URS Corporation conducted excavations to determine the boundaries of the cemetery. Although boundaries were not established, 78 grave shafts were identified in the undeveloped parts of the site (Slaughter et al., 2001). The Friends of Freedmens Cemetery expanded their support for the idea of including a memorial park to recognize the freedmen as part of the Woodrow Wilson Bridge project. Then, changes to the project opened the opportunity for increased funding. The Friends proposed that the City of Alexandria purchase the entire cemetery, including the gas station, and create a larger memorial park. Although underground gas tanks had compromised

FIGURE 24.4. The Friends of Freedmens Cemetery's advocacy and the Alexandria City Council's actions to remember the Civil War refugees led to the preservation of Alexandria Freedmens Cemetery. Pictured left to right: Council member David Speck, Lillie Finklea, A.T. Stephens, Mayor Kerry Donley, Vice Mayor Bill Euille, Council member Redella Pepper, and Louise Massoud. (Photo credit: Alexandria Archaeology.)

some of the site, the Friends wanted to protect and interpret as much of the original burial ground as possible. This plan was approved in 2002.

We are working jointly with the Friends to identify suitable methods for protecting graves, recognizing the freedmen, and creating a memorial park. The Friends produced a set of principles to guide the commemoration project, which will maintain the integrity of the site and interpret its historic context. The City archaeologists are conducting the remainder of the archaeology. In 2004, we identified 45 graves in the developed part of the site (Bromberg and Shephard, 2004). After demolition of buildings in 2007, the remainder of archaeological work will occur. Using archaeological and historical information, we will produce a treatment plan to protect the cemetery's graves and other archaeological resources and to guide landscape design.

In Alexandria's community-based archaeology program, citizens actively establish goals and participate in research, preservation, and interpretation. The City archaeologists work with the citizens, the archaeological commission, the Friends of Alexandria Archaeology, and other groups to weave together varied interests into projects that provide public benefit. In this fashion, the Alexandria Canal Tide Lock Park, the Alexandria African American

Heritage Park, and Waterfront Walk were established. Rather than being isolated, the Alexandria Archaeology Museum is located in an arts community of nearly 200 working artists in a historic torpedo factory within the most active part of the historic landmark district. In the Museum, students participate in hands-on lessons linked to state educational standards, and volunteers regularly work in the public laboratory. The African American Neighborhood Archaeology Project helped support citizen preservation efforts that led to the establishment of the Alexandria Black History Museum.

And, most recently, we were able to combine people's love of archaeology and history with recreation. Working with the citizen bicycle committee and our Friends group, we have created the Alexandria Heritage Trail. It is a 23-mile loop from a segment of the Potomac Heritage National Scenic Trail that takes people through 9,000 years of archaeology and historic neighborhoods where the past is sometimes not expected (Figure 24.5). Citizens, civic associations, and developers are now sponsoring interpretive signs along the Trail.

In each of these examples of public products, Alexandrians have been the catalysts. They have articulated goals, taken opportunities, and shaped the role of archaeological information and places long-forgotten. While, it must be acknowledged that dialogue does take time and volunteer efforts have a

FIGURE 24.5. Bruce Dwyer (left), Alexandria Bicycle Committee, speaks at the opening of the Alexandria Heritage Trail. Also pictured (left to right): Laura Heaton, Friends of Alexandria Archaeology, and Alexandria Archaeological Commission members Kathleen Pepper and Walter Hall. (Photo credit: Alexandria Archaeology.)

different rhythm and speed than those who are paid, the results are often far more profound than traditional archaeology. In Alexandria, we call this community archaeology.

24.4. Conclusion

Heritage legislation and community-based archaeological programs can be combined to ensure that archaeological heritage has special value to contemporary society. Archaeologists successfully integrate communities into their mission to conserve, protect, and understand our significant resources. We have found that archaeological systems and practices that emphasize community outcomes are a key management tool. Public outreach programs, such as the Society for Historical Archaeology's "Unlocking the Past: Historical Archaeology in North America" increase public appreciation and enthusiasm. At the community level, innovative programs designed with the public can lead to renewed pride in local cultural heritage and increased activism by the public for the protection and wise use of their significant cultural sites.

References

Bromberg, F. and Shephard, S.J., 2004, *Preliminary report on archaeological excavations at Alexandria's Freedmens Cemetery*. Alexandria Archaeology Office of Historic Alexandria, City of Alexandria, Virginia.

City of Alexandria, 1989, Zoning Ordinance of the City of Alexandria. Virginia, Section 11–411: Archaeology Protection

Cressey, P.J., Reeder, R., and Bryson, J., 2003, Held in Trust. In *Archaeologists and Local Communities: Partners in Exploring the Past: 1–19*, edited by L. Derry and M. Malloy. Society for American Archaeology, Washington, DC.

Crook, P., Ellmoos, L., and Murray, T., 2003a, Assessment of Historical and Archaeological Resources of the Paddy's Market Site, Darling Harbour, Sydney. Archaeology of the Modern City Series. Historic Houses Trust of New South Wales, vol. 1.

Crook, P., Ellmoos, L., and Murray, T., 2003b, Assessment of Historical and Archaeological Resources of Susannah Place, The Rocks, Sydney. Archaeology of the Modern City Series. Historic Houses Trust of New South Wales, vol. 2.

Crook, P., Ellmoos, L., and Murray, T., 2003c, Assessment of Historical and Archaeological Resources of the Cumberland and Gloucester Street Site, The Rocks, Sydney. Archaeology of the Modern City Series. Historic Houses Trust of New South Wales, vol. 3.

Greer, S., Harrison, R., and McIntyre-Tamwoy, S., 2002, Community-Based Archaeology in Australia. *World Archaeology* 4:265–287.

Higginbotham, E., 1994, *Archaeological Management plan, Port Macquarie*, vol. 1, Management Plan Stage 1. Report on file. NSW Heritage Office, New South Wales.

Mider, D. and Lavelle, S., 1992, *The Archaeological Zoning Plan for Central Sydney— 1992*. Report on file. Sydney City Council, Sydney.

Mider, D. and Lavelle, S., 2001, *Historical Archaeological Assessment: Broadway & Mountain St. Development Site*. Report on file. NSW Heritage Office, New South Wales.

NSW Heritage Office, 2000, *Review of Historical Archaeology Planning Systems and Practice in New South Wales*. Report on file. NSW Heritage Office, New South Wales.

NSW Heritage Office, 2002, *Local Government Heritage Guidelines*. NSW Heritage Office, New South Wales.

Pippenger, W.E., 1995, *Alexandria, Virginia Death Records 1863–1868 (The Gladwin Record) and 1869–1896*. Family Line Publications, Westminster, MD.

Reid, A., 1997, Cemetery Prompts Questions on Bridge in The Washington Post. *The Week Arlington*, Falls Church section, January 30, p. 1.

Slaughter, B.W., Miller, G.I., and Janowitz, M., 2001, *Archaeological Investigation to Define the Boundaries of Freedmen's Cemetery (44AX79), Within the Property Owned by the Virginia Department of Transportation, Alexandria, Virginia*. Potomac Crossing Consultants (URS), Florence, NJ.

The Daily Telegraph (2002) Take a Step Back in Time. January 25, p. 8.

25

Beyond Famous Men and Women: Interpreting Historic Burial Grounds and Cemeteries

Harold Mytum

25.1. Introduction

Cemeteries and burial grounds are major resources for historical archaeology, each containing hundreds if not thousands of individual monuments which are still visible, and a vast below-ground archaeology of burials with their fittings and funerary architecture in the form of catacombs, vaults and burial shafts. The preservation and management of such sites is an important element of CRM, associated as they are with emotions and identities in current populations (Bell, 1996). It is in this light that interpretation takes on a special role. The sites already have an importance to a wide range of people in the local community, but many of the historic and anthropological aspects of their value are not perceived and appreciated. Through communicating these aspects, individuals and communities may come to appreciate more such assets and protect them, which can in turn reduce vandalism and degradation. The public may also comprehend more fully the ways in which archaeologists understand the past through their study of material culture. Emphasis is given here to public interpretation rather than the use of graveyards in education. Many of the interpretative themes suggested here have not been offered to a wider public despite being explicitly addressed within curriculum development (Duca, 1974; Hill and Mays, 1987; Christie, 1991; Purkis, 1995; Mytum, 2000).

Most urban cemeteries were established in the nineteenth century to provide suitable burial spaces for the growing populations of the increasingly industrialised cities (Curl, 1972; Brooks, 1989; Sloane, 1991). The motivations varied greatly for the establishment of burial grounds away from the control of the established church. Often a number of factors combined, but frequently included the provision of a less overcrowded burial environment with consequent improvements in health (Mytum, 1989), the ability of religious and ethnic minorities to have appropriate burial (Rugg, 1998), the creation appropriate landscapes for commemoration (Bender, 1974; Linden-Ward, 1989), and making a profit (Sloane, 1991). Rural burial grounds for whole communities, particular religious groups, or individual families, all have opportunities for interpretation on an appropriate scale.

Each cemetery has its own history; its local causes for establishment, increases in size, modifications of policies, and changing landscape use around it. Yet many cemeteries can be placed in regional, national and indeed global perspective, as the reactions to similar problems can be seen to be resolved in a finite number of ways (Mytum, 2003a,b). Thus, the interpretation of cemeteries can be at the very local or regional level, or considering national and international trends. This in itself creates the opportunities for varied and alternative interpretations, without considering theoretical approaches that would also affect the emphases offered in readings of the remains. Examples are drawn from Britain, Europe, America and Australia to illustrate how similar both the evidence and the opportunities for interpretation are over many parts of the globe.

Most cemeteries at present offer no permanent on-site historical or archaeological interpretation, or at most a few small interpretation panels as at the Granary Burial Ground Boston (Figure 25.1). Some, however, have developed materials in the form of leaflets for use by the local population, schools or tourists. Independently produced guides also exist, though most of these cover cities or regions rather than individual sites (Sarapin, 1994; Sive, 1998). With the growth of what has been termed "dark tourism", which includes visits to battlefield and disaster sites as well as burial grounds, academic interest in this aspect of visitor has also received sociological analysis, and has even been provided with its own term, thanatourism (Seaton, 1996, 1999). Aspects of dark tourism often influence guided tours around cemeteries, though other themes

FIGURE 25.1. Information panel at the Granary Burying Ground, Boston.

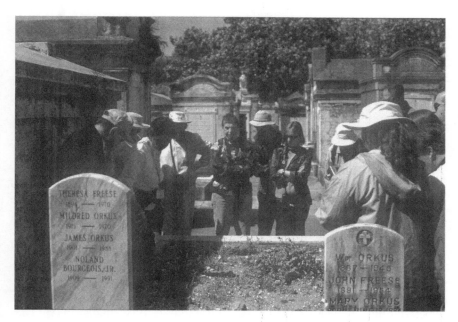

FIGURE 25.2. A guided tour of La Fayette cemetery, New Orleans. This unsensational style of presentation is here comparing the earth burial in the Freese/Orkus family plot with the above-ground family tombs behind the group.

such as history, art, architecture, symbolism, gardening and natural history all play their part. Thus, in New Orleans many tours emphasise voodoo and ghosts, though some offer much less dramatic examples, presented in a historical context (Figure 25.2).

There are four themes that currently dominate cemetery interpretation: Great events; Great individuals; Architecture and oddities; and Carvers. It is worthwhile to examine each of these in turn, though many guides combine at least two themes, and some all four. The popular literature for burial grounds available today is remarkably similar to that produced when many of the cemeteries were newly opened in the nineteenth century. The emphasis is on aesthetics, architecture and famous names, all provided in an optimistic framework designed to be both improving and entertaining (Clark, 1843; Crafts, 1855). These may be fine goals, but there may be more relevant aspects to bring to the attention of visitors in the twenty-first century.

25.2. Great Events

Cemetery interpretation linked to events can be seen to form three main categories. The first relates to war cemeteries, where the events that caused the need for the cemetery often dominate interpretation. With greater interest

TABLE 25.1. Official web sites for military cemeteries.

Commonwealth War Graves Commission
http://www.cwgc.org/
Office of Australian War Graves
http://www.dva.gov.au/commem/oawg/wargr.htm
National Cemetery Administration (United States of America)
http://www.cem.va.gov/index.htm
American Battle Monuments Commission (Overseas)
http://www.abmc.gov/
The Volksbund (Germany)
http://www.volksbund.de/

from avocational military historians as well as descendants of combatants (who did or did not survive the conflict), a whole industry has been formed to cater for and further encourage demand. As a result, accompanied tours, web sites (Table 25.1) and popular books are offered to assist in the location of specific graves, to understand the losses in relation to military campaigns, and to appreciate the aesthetics of the designed spaces and structures at such sites (Nishiura, 1989; Holt, 1992). Academic interest in military battlefields and cemeteries has also burgeoned (Borg, 1991; Bourke, 1996; Inglis, 1998). The second type of event often celebrated in interpretation is that of the creation and design of the cemetery, and this event is often also much celebrated in the case of garden cemeteries, with an emphasis on the purchase of land, and design of the cemetery landscape and buildings (Linden-Ward, 1989; Curl, 2001). The third way in which events may be celebrated within cemetery interpretation is through other sorts of disasters, represented by particular memorials. Events linked to particular individuals are largely set in the context of the person, and so can be considered under the heading of great individuals.

25.3. Great Individuals

By far the most common form of interpretation offered in cemeteries is one based around short biographies of individuals buried there. This may be in the form of guide books indicating where famous people have been buried (Meller, 1981; Greenwood, 1982; Burk, 1996), or they may be based on locations within individual cemeteries or for a region or city, as exemplified by the series by Culbertson and Tom (1987, 1989, 1996a–c). The entries in books and site guides give prominence to short biographies of the deceased, with less attention to the monuments themselves. Detailed cemetery guide books or small leaflets usually provide a map of the cemetery, with the main paths and buildings marked, and then numbered dots indicating the monuments of interest. In many cases the monument has only sufficient description and comment to aid identification on the ground. The materiality of the memorial is often only relevant to help the visitor find the burial plot, and to

indicate the place where a past life can be considered. This cannot be considered archaeology; it is a mixture of biography combined with some emotive linking with the work of the deceased through the burial site. The people listed in guides of this kind tend to be chosen on one of three grounds: their general fame, something odd about their life or death, or the splendour of their memorial. The last is discussed under the next heading, but the first two can be analysed here, using three examples to assess who deserves an entry in a guide.

Undercliffe cemetery, in Bradford, West Yorkshire, is one of the most impressive cemeteries in Britain because of the combination of location overlooking the industrial city, and the presence of a range of fine memorials (Figure 25.3). It is a local cemetery, with few nationally famous individuals, but many both rich and poor who made the city what it is today. The guide (Chapple, 1988) suggests following a heritage trail around the most interesting parts of the 25-acre cemetery, with notable features listed in numerical order. The Quaker burial ground and some communal memorials and sites of now demolished buildings are pointed out. However, it largely identifies the graves of local worthies, with a few memorials chosen because of their size and design. The range of activities by the deceased is wide, but the manufacturers and traders, many of whom were also prominent local politicians, are

FIGURE 25.3. Undercliffe cemetery, Bradford, Yorkshire. This array of pedestal tombs on the terrace shows a good selection of Classical, Egyptian and Gothic revival styles. Many smaller monuments in the same styles occur on the slopes around this focal point in the cemetery.

TABLE 25.2. Details of people whose monuments were selected for two English Guides.

	Bradford Undercliffe[a]	Kensal Green[b]
Royalty	0	3
Arts	0	13
Trade	5[c]	2
Manufacture	6[c]	0
Politics	3	4
Religion	2	1
Armed forces, police	2	4
Medical	0	2
Academia	2	1
Entertainment	2	4
Architecture	1	3
Relative of famous	0	4
Cemetery employee	2	0
Mason	1	0
Strange death	1	0
Other	2	3
Unknown life	3	6
Buildings	5	0
Total	37	50

[a] Chapple (1988).

[b] Coones (1994).

[c] Within the categories of Manufacture and Politics, a total of eight individuals are also noted as having held office as mayor.

notable (Table 25.2). No women are listed at all in the guide, though about half the burials in the whole cemetery were of women, and many have their own memorials. The family groups on memorials are also not normally discussed, with just the leading figure noted for those memorials highlighted in the guide; where others are mentioned, they are other successful males in the dynasty.

Kensall Green cemetery in London was one of the most fashionable cemeteries in which to be buried thanks to the (unusual) interment of royalty there—the Duke of Sussex (died 1843) and Princess Sophia (died 1848). The original cemetery covered 54 acres, and was laid out as a garden cemetery on a grand scale (Coones, 1987; Brooks, 1989; Curl, 2001). The guide that can be purchased at the cemetery entrance indicates 50 major monuments or the burial places of important figures with less impressive memorials, but most monuments are completely ignored (Coones, 1994). The highlights are enough to attract the visitor round the pathways and, by chance, see many other interesting memorials. The importance of the individuals is emphasised by their alphabetical ordering in the guide, causing constant reference back and forth between annotated cemetery plan and text. The contrast with Bradford Undercliffe in the type of individuals selected is most striking. Gone are the manufacturers, but royalty, the arts, and relatives of the famous dominate (Table 25.2).

The guidebook extolling the virtues of Forest Hills, Boston, contains indi-
viduals of national but mainly local importance (Wilson, 1998). Given the
size and splendour of the cemetery setting and many of the memorials, it is
fitting that six different tours are provided, together covering much of the 275
acres. Though giving variable amounts of information on the memorials, all
the tours emphasise the deeds of those commemorated. Each tour covers a
different sector of the cemetery, and in a sense can be considered as guides
for six separate burial grounds.

The range of people on each tour has been tabulated as with the Bradford
and Kensal Green data. The numbers listed in each tour is greater, and there
is some variation between tours, but not as great as one might expect from
their names (Table 25.3). Although it is claimed that 'Each is arranged
around a different theme and presents the history of Forest Hills from a dif-
ferent perspective'(Wilson, 1998: 40), each is really just a modified arrange-
ment along the same theme of famous people, though there is a significant
number of women included. Only with Tour 6, League of Nations, is there
a limited range of professions and some clearer focus; here entertainment is
dominant, and African-Americans and international stars are included.
There is thus more of a multicultural feel to this tour, but this is not explored

TABLE 25.3. Details of people whose monuments were selected for the Forest Hills
Guide.

	Tour number[a]						
	1	2	3	4	5	6	Total
Trade[b]	1	5	3	4	4	1	18
Manufacture	10	6	5	9	2	0	32
Politics/legal	1	3	8	5	2	0	19
Religion	0	1	3	6	1	3	14
Education/science	1	2	3	0	5	2	13
Performing arts	4	0	1	3	5	7	20
Architect/engineering	1	0	0	1	0	3	5
Cemetery employee	3	0	2	1	1	1	8
Medicine	9	0	3	4	0	0	16
Writing	3	4	7	3	4	0	21
Military	4	4	7	2	1	1	19
Reform/philanthropy	2	3	1	2	2	1	11
Strange Death	0	0	2	0	1	1	4
Unknown life[c]	4	12	10	8	12	1	47
Total	43	40	55	48	40	21	247

[a] Tour names: 1, The Revolutionaries; 2, Art for Death's Sake; 3, Pens & Swords; 4, United We
Fall; 5, Glass Houses & Other Stones; 6, League of Nations.
[b] Other smaller categories are not listed. Many individuals had more than one occupation or
notable characteristic; only one is used for each person here, based on what appeared to be most
important on reading the entry.
[c] These entries relate to spectacular monuments to individuals who are either not named, or
about whom no other information is given (Wilson, 1998).

with regard to the memorials, which are largely chosen on the basis of a par-
ticular high art and architecture agenda. Thus, the numerous relevant but less
spectacular monuments are ignored and excluded. Informative and beautifully
produced though the guide is, and a credit to the Forest Hills Educational Trust,
it is a pity that, although the products of carvers and architects are noted, alter-
native issues are not addressed at all, or only briefly. Some of the themes
acknowledged in the history of Forest Hills section of the guide (Wilson, 1998:
10–39) could have been usefully amplified within the tours, to make them more
inclusive.

25.4. Architecture and Oddities

Kensall Green cemetery in London, with its guide to 50 major monuments
or the burial places of important figures, concentrates on architecture and
oddities (Coones, 1994). There is, however, no assistance in giving any con-
text for these memorials. The visit is a voyeuristic experience, a collection of
oddities, often enlivened by snippets from the deeds of the commemorated.
For example, the mausoleum to Andrew Ducrow is a bizarre development of
the Egyptian, combined with neoclassical features. Costing £3000 in 1837,
this celebration of success was an immodest posthumous celebration of the
life of the owner of Astley's circus, "erected by Genius for the reception of
its own remains" (Coones, 1994, Monument No. 15). However, this could be
used to show the fluidity of the nineteenth century middle classes, and con-
trast it with the refined quality of the royal monuments on the one hand,
and the more modest memorials on the other. Many of the latter were the
choices of eminent and valued members of society, and they deserve note en
masse, if not individually. The neoclassical symbolism of the draped urn on
the pediment, the role of imported marbles and granites, the siting of
memorials and their relative visibility, the use of many different rock types
for their ease of carving or polychrome effect, all these examples would be
of interest.

 The oddity theme is present also at Forest Hills, with strange deaths
noted in many tours. Moreover, some of the other figures in entertainment
and other headings were notable because of bizarre features of their lives, and
thus have warranted inclusion (Wilson, 1998). Some memorials are noted even
where there is nothing mentioned of the lives of the deceased, but they are
worthy of mention because of their architecture or some particular feature of
the design; this is particularly the case, as at Kensall Green, with mausolea.

25.5. Carvers

The study of gravestones and their carvers has been an activity mainly con-
centrated in the north-east of America, and it is not surprising to find that
it is in this area that a series of regional guides have been produced. These

allow enthusiasts to identify the makers of memorials in the many small burial grounds in the region, or to search out the products of particular carvers. The guide *Old Burial Grounds of New Jersey* is a good example of its genre, covering a substantial area, with quite short entries for each (Sarapin, 1994). The guides produced for each annual conference of the Association for Gravestone Studies are often excellent in terms of detail, but would need modification to be easily accessible to the casual visitor; nevertheless, they indicate the level of information that can be available for memorials and their carvers.

At Forest Hills, many of the more notable memorials are described with reference to the designer or sculptor; in some cases there is also a description of the deceased, but in others this is not seen as sufficiently interesting. Monuments are almost all the most impressive, and the overwhelming majority are unique, though some substantial "off the peg" examples occur more than once in the cemetery. Monumental masons working on the less impressive memorials are not given any consideration. One mason has his memorial pointed out, as do several cemetery officers, all of whom may have had more substantial memorials than others of similar status in the city because of their professional associations. Otherwise the great majority of the people buried and remembered at Forest Hills do not warrant any attention.

A small number of the Kensal Green monuments have their carvers noted, such as ones by Eric Gill, J.F. Farley, Lander, and Gibson, or have elements such as bronze busts or decorative tiles with notable makers (Coones, 1994). The geology of the memorials is also frequently noted.

25.6. Some Alternative Themes

The richness of detail and symbolism is frequently mentioned in the guides, and some have glossaries (Wilson, 1998) or introductory sections on such matters (Sarapin, 1994), but it is rarely approached in any systematic way within the body of the guide. Of greater concern from an archaeological perspective is that the overwhelming majority of less visually impressive memorials are not utilised. It is here that studies with an appreciation of popular material culture and anthropology could provide new perspectives, and link the visitor not only with the "great and the good" but also with *their* equivalents in the past. The sorts of trends so effectively picked out by Deetz and Dethlefsen (1967) in New England graveyards give a setting for the work of individual carvers subsequently studied in many densely argued case studies (Slater, 1996; Chase and Gabel, 1997). Similar trends have been evaluated by Dethlefsen (1981, 1992) and Clark (1987), for example, with regard to later cemetery data.

An example of the oddity genre described above, which actually manages to raise many interesting issues, is that for the county of Sussex, England

(Arscott, 1997). This popular account of 'strange, striking and humerous epitaphs and memorials' includes evidence for unusual occupations, activities and deaths, but also in passing much useful historical and sociological information. The format, however, prevents these being highlighted and brought more to the fore. It does nevertheless show that by creating interest through the unusual, the typical can be shown to be of value and interest. A more serious but still highly accessible guide has been produced by Lees (1993) on Gloucestershire churchyards and their monuments. Here typical examples of form, decoration and text are all discussed, as well as including some of the more sensational memorials. Indeed, the context of churchyard is also provided. In contrast to the Forest Hills guide, for example, most of the memorials mentioned in both these publications are illustrated, aiding their location on the ground but also allowing the reader to take in other features of the stones than those highlighted in the text.

In an American context, the guide to St. Louis Cemetery No. 1 in New Orleans contains much information about individuals who are commemorated, and architects and designers (Florence, 1996). It is not like most guides, however, in that it gives considerable attention to the various commonly found forms of burial and memorial encountered in the cemetery, and discusses many details common on typical memorials. It also details society tombs, with some background to these. The St. Louis guide is a substantial production, but the simple folded sheet from Oakland Cemetery, Atlanta, also conveys some general information through description of 50 notable memorials (Sherry and Combs, 1977). Some of the brief entries are merely biographical, but others comment on styles, symbolism and comparisons with monuments elsewhere. For such a short guide, there is much packed in, and this reflects the commitment of the Historic Oakland Foundation to interpret the site. Moreover, there are further short leaflets available for specific sections of the cemetery. The Confederate section leaflet is largely historical (Young, 1994), but that for the Jewish section (Goldstein, 1994) provides a key to common symbols and assistance in reading the Hebrew inscriptions.

Despite the more ambitious or open-minded publications, there is still much that archaeologists and anthropologists find exciting and important which is not revealed to the public. The sorts of themes that would be of interest to the public are listed in Tables 25.4 and 25.5. They do not exclude highlighting famous people or unusual memorials, but such fascinating particularistic detail can be set in context, and reveal wider and more important historical and sociological patterns. They are also applicable in less spectacular cemeteries and burial grounds that do not contain famous people or extravagant monuments.

Two main groups of themes are particularly suitable for development in a burial ground context. The first is the nature of material culture and the way it changes through space, time and cultural context; the second is the forms of social identity that can be reflected and created through memorials.

TABLE 25.4. Interpretation of memorial material culture.

Issue	Evidence
Combination of memorial text and form	Inscriptions, memorial form
Symbolism	Memorial form, decoration, inscriptions
Changes through time	Memorial form, decoration, scripts
Spatial arrangement of material culture	Memorials, buildings, landscape features
Craft specialisation in memorial production	Carvers, architect and artist designers, masons

TABLE 25.5. Anthropological themes.

Issue	Evidence
Role of the family	Plots, groups of memorials, members on one memorial
Gender	Inscription order, descriptive terms for deceased
Occupation	Symbols, descriptive terms for deceased
Ethnicity	Language, memorial form, symbols, decoration
Religion	Memorial form, symbols, references to death and afterlife

25.7. Material Culture

Material culture is something that archaeologists find both fascinating and informative, but which the public take for granted rather than explicitly analyse. Memorials give a unique context for exploring both material form and text, the latter itself having many features of materiality (e.g., layout, font, method of inscribing). They also show a wide range of symbolism in memorial form and the decoration applied. These messages may resonate with each other, or apparently conflict (and the same may be true of symbolism and text on the same memorial) showing ambivalence and a range of emotions and attitudes to matters such as death and resurrection (Figure 25.5). These and many other aspects of memorials change over time, and the reasons for such changes can be suggested. Moreover, carrying such trends up to the present situates the contemporary visitor within the discourse, which can help them understand that past decisions also had to be consciously (and unconsciously) made (Table 25.4). It also helps to demonstrate both similarities and differences between then and now, and between different groups both then and now.

Most cemetery and burial ground landscapes have built up over time, but always with a deep sense of spatial order. The style of the order varies from place to place, and indeed over time, but grave and memorial location was an important element in social strategies. The memorials themselves were produced by specialists, whether part or full time, in consultation with clients and perhaps also with designers such as architects or artists. The dynamic here can be understood in many ways, from the degree of standardisation, manner of mistake correction, identification of a craftsperson's stylistic quirks, or inspiration from famous art or architecture. The geology of stones can also be of interest here, as can the techniques used to make memorials (not only stone but bronze, cast iron, concrete and many other materials). The various

FIGURE 25.4. A typical Boston area headstone with the winged death's head symbolising both mortal death and hope for spiritual life. It is for Joseph Kidder, described as son of Deacon Samuel and Mrs Sarah Kidder, despite being 21 years old. The inscription thus indicates several social relationships and identities on the stone.

trends through time and space can also be considered in terms of fashion and emulation of elites or independent stylistic traditions within society.

25.8. Social Identity

The identification and interpretation of past social identities are major interests in archaeology and anthropology, and ones which are easily demonstrated with all memorials, and not just the most elaborate (Table 25.5). Visitors can be provided with the ideas and principles by which social identities were emphasised or negated, and these can then be applied by visitors to the vast array of memorials at the site, or indeed other places they may subsequently visit. Thus, the family may be downplayed on individual memorials, or emphasised within shared monuments or family plots (Figure 25.5). Many gender issues can be linked to the family, with the potentially different treatment by age, sex and role (Figure 25.4). Ethnicity may be just hinted at by names, or proclaimed through language, symbolism, memorial form; the same may be the case with religious affiliation, or occupation.

FIGURE 25.5. View of family plots and monuments of various forms in Mount Auburn cemetery, Boston. Note also the range of vegetation planting to enhance the visual context of the memorials.

25.9. Conclusions

It is thus possible to introduce stimulating yet enjoyable and relevant themes to the public that move beyond some middle-brow modern version of hagiography. Most of the so-called famous people whose graves can be visited in cemeteries would not be of great interest to visitors but for the fact that their memorials are there to be noted. The trends and themes of life, death and remembrance, and the strategies employed over time, are more easily appreciated and remembered, and are more relevant than some faded celebrity, local politician or factory owner of the late nineteenth century. The published cemetery guides mirror the oral guides at many archaeological and historical sites who partake many facts, but convey no understanding. Archaeologists should work with cemetery managers to interpret cemeteries and their monuments so that the historic resource can be managed and utilised (Mytum, 2004); this brings protection to the resource, and an appreciation by both local communities and visitors of the heritage that such cemeteries represent. Those leaving a burial ground should be able to understand more than they did when they entered; they may even have been given food for thought on their own life and faith, their past, present and future. That is what both cemeteries and archaeology each used to aspire to achieve, and in this context they can once more; in combination archaeology and historic cemeteries can be truly memorable!

References

Arscott, D., 1997, *Dead & Buried in Sussex*. S.B. Publications, Seaford, England.

Bell, E.L., 1996, "Where Angels Fear to Tread": Cemetery Preservation Efforts by the Massachusetts Historical Commission. *Northeast Historical Archaeology* 25:13–30.

Bender, T., 1974, The Rural Cemetery Movement: Urban Travail and the Appeal of Nature. *New England Quarterly* 47(June):196–211.

Borg, A., 1991, *War Memorials: from Antiquity to the Present*. Leo Cooper, London, England.

Bourke, J., 1996, *Dismembering the Male: Men's Bodies, Britain and the Great War*. Reaktion Books, London, England.

Brooks, C., 1989, *Mortal Remains. The History and Present State of the Victorian and Edwardian Cemetery*. Wheaton Publishers, Exeter, England.

Burk, M.T., 1996, *Final Curtain: Eternal Resting Places of Hundreds of Stars, Celebrities, Moguls, Misers and Misfits*. Seven Locks Press, Santa Ana, CA.

Chapple, C.E., 1988, *Undercliffe Cemetery. Bradford's Great Heritage in Stone*. Bradford Undercliffe Cemetery Company, Bradford, England.

Chase, T. and Gabel, L.K., 1997, *Gravestone Chronicles*, 2 vols. Second edition. New England Historic Genealogical Society, Boston, MA.

Christie, G.H., 1991, A Grave Experience. *The New England League of Middle Schools Journal* 4(1):25.

Clark, B., 1843, *Hand-Book for Visitors to the Kensall Green Cemetery*. Joseph Masters, London, England.

Clark, L., 1987, Gravestones: Reflectors of Ethnicity or Class? In *Consumer choice in historical archaeology*, edited by M.S. Suzanne, pp. 383–395. Plenum Press, New York.

Coones, P., 1987, Kensall Green Cemetery: London's First Great Extramural Necopolis. *Transactions of the Ancient Monument Society*, New series 31: 48–76.

Coones, P., 1994, *Kensal Green Cemetery. A Concise Introductory Guide & Select list of Notable Monuments Together with a Plan*. Friends of Kensal Green Cemetery, London, England.

Crafts, W.A., 1855, *Forest Hills Cemetery: Its Establishment, Progress, Scenery, Monuments, etc*. John Backup, Roxbury, MA.

Culbertson, J. and Tom, R., 1987, *Permanent New Yorkers: A Biographical Guide to the Cemeteries of New York*. Chelsea Green Publishing, Chelsea, VT.

Culbertson, J. and Tom, R., 1989, *Permanent Californians: an Illustrated Guide to the Cemeteries of California*. Chelsea Green Publishing, Chelsea, VT.

Culbertson, J. and Tom, R., 1996a, *Permanent Italians: an Illustrated, Biographical Guide to the Cemeteries of Italy*. McFarland, Jefferson, NC.

Culbertson, J. and Tom, R., 1996b, *Permanent Londoners: an Illustrated, Biographical Guide to the Cemeteries of London*. McFarland, Jefferson, NC.

Culbertson, J. and Tom, R., 1996c, *Permanent Parisians: an Illustrated Biographical Guide to the Cemeteries of Paris*. McFarland, Jefferson, NC.

Curl, J.S., 1972, *The Victorian Celebration of Death*. David & Charles, Newton Abbot, England.

Curl, J.S., editor, 2001, Kensal Green Cemetery. *The Origins & Development of the General Cemetery of all Souls, Kensall Green, London, 1824–2001*. Phillimore, Chichester.

Deetz, J.F. and Dethlefsen, E., 1967, Death's Head, Cherub, Urn and Willow. *Natural History* 76(3):29–37.

Dethlefsen, E., 1981, The Cemetery and Culture Change: Archaeological Focus and Ethnographic Perspective. In *Modern Material Culture: the Archaeology of Us*, edited by R.A. Gould and M.B. Schiffer, pp. 137–159. Academic Press, New York.

Dethlefsen, E., 1992, Strange Attractors and the Cemetery Set. In *The Art and Mystery of Historical Archaeology: Essays in Honor of James Deetz*, edited by A.E. Yentsch and M.C. Beaudry, pp. 149–164. CRC Press, Boca Raton, FL.

Duca, A.M., editor, 1974, *Journals from the Gloucester experiment: a school community partnership project*. Gloucester Community Development Corporation, Gloucester, MA.

Florence, R., 1996, *City of the Dead. A Journey through St. Louis Cemetery #1 New Orleans, Louisiana*. Center for Louisiana Studies, University of Southwestern Louisiana. Louisiana Life Series 9, Lafayette, LA.

Goldstein, E.L., 1994, *Historic Oakland. A Guide to the Jewish Sections*. Historic Oakland Foundation, Atlanta, GA.

Greenwood, D., 1982, *Who's Buried Where in England*. Constable, London, England.

Hill, J.D. and Mays, S., 1987, *Dead Men Don't Tell Tales? A Graveyard Project for Schools*. Archaeology and Education 5. Department of Archaeology, University of Southampton, Southampton, England.

Holt, D.W., 1992, *American Military Cemeteries: a Comprehensive Illustrated Guide to the Hallowed Grounds of the United States, Including Cemeteries Overseas*. McFarland, Jefferson, NC.

Inglis, K., 1998, *Sacred Places: War Memorials in the Australian Landscape*. Mieyungah Press, Carlton, Victoria Australia.

Lees, H., 1993, *Hallowed Ground. Churchyards of Gloucestershire and the Cotswolds*. Thornhill Press, Cheltenham, England.

Linden-Ward, B., 1989, *Silent City on a Hill. Landscapes of Memory and Boston's Mount Auburn Cemetery*. Ohio State University Press, Columbus, OH.

Meller, H., 1981, *London Cemeteries. An Illustrated Guide and Gazetteer*. Avebury Publishing, Amersham, England.

Mytum, H., 1989, Public Health and Private Sentiment: the Development of Cemetery Architecture and Funerary Monuments from the Eighteenth Century Onwards. *World Archaeology* 26(2):283–297.

Mytum, H., 2000, *The Recording and Analysis of Graveyard Memorials. Practical Handbooks in Archaeology 15*. Council for British Archaeology, York, England.

Mytum, H., 2003a, Death and Remembrance in the Colonial Context. In *The Archaeology of the British*, edited by S. Lawrence, pp. 156–173. Routledge, London, England.

Mytum, H., 2003b, The Social History of the European Cemetery. In *Handbook of Thanatology: Essays on the Social Study of Death*, edited by C.D. Bryant. Sage Publications, Thousand Oaks, CA.

Mytum, H., 2004, *Mortuary Monuments and Burial Grounds of the Historic Period*. Plenum, New York.

Nishiura, E., editor, 1989, *American Battle Monuments: a Guide to Military Cemeteries and Monuments Maintained by the American Battle Monuments Commission*. Omnigraphics, Detroit, MI.

Purkis, S., 1995, *A Teacher's Guide to Using Memorials*. English Heritage, London, England.

Rugg, J., 1998, A New Burial Form and Its Meanings: Cemetery Establishment in the First Half of the 19th century. In *Grave concerns: death and burial in England 1700 to 1850*, edited by M. Cox, pp. 44–53. CBA Research Report 113, Council for British Archaeology, York, England.

Sarapin, J.K., 1994, *Old Burial Grounds of New Jersey. A guide*. Rutgers University Press, New Brunswick, NJ.

Seaton, A.V., 1996, Guided by the Dark: from Thanatopsis to Thanatourism. *International Journal of Heritage Studies* 2(4):234–244.

Seaton, A.V., 1999, War and Thanatourism. Waterloo 1815–1925. *Annals of Tourism Research* 26(1):130–158.

Sherry, G. and Combs, D.W., 1977, *Oakland Cemetery: Atlanta's Most Tangible Link*. Historic Oakland Foundation, Atlanta, GA.

Sive, M.R., 1998, *Lost Villages. Historic Driving Tours in the Catskills*. Delaware County Historical Association, Delhi, NY.

Slater, J.A., 1996, *The Colonial Burying Grounds of Eastern Connecticut and the Men Who Made Them*. Memoir 21. Revised edition. Connecticut Academy of Arts and Sciences, New Haven, CT.

Sloane, D.S., 1991, *The Last Great Necessity. Cemeteries in American History*. Johns Hopkins University Press, Baltimore, MD.

Wilson, S., 1998, *Garden of Memories. a Guide to Historic Forest Hills*. Forest Hills Educational Trust, Boston, MA.

Young, J.H., 1994, *Historic Oakland. A Guide to the Confederate Sections*. Historic Oakland Foundation, Atlanta, GA.

26
Unlocking the Past: A Society for Historical Archaeology Public Awareness and Education Project

Lu Ann De Cunzo and John H. Jameson, Jr.

26.1. Introduction

Each year, historical archaeologists excavate at thousands of historical sites in urban and rural communities across North America. Many project sponsors—professional archaeology consulting firms, government agencies, museums, and colleges and universities—partner with community members and organizations to undertake the research. Many historical archaeologists are sharing the results of their work in exhibits, public lectures and archaeology festivals, World Wide Web pages, newspaper and magazine articles, pamphlets, booklets, and books. These projects have fueled the public's fascination with archaeology and generated important support for preservation. However, no popular books or individual Web pages presented an overview of North American historical archaeology, spotlighting projects and sites from Canada to the Caribbean, from the Viking explorations of 1000 years ago to World War II. This chapter examines the discourse on the identity and representation of historical archaeology generated by SHA's *Unlocking the Past* project and its implications for the book and Web site.

26.2. Politics of Identity, Multiculturalism, and Representation

The politics of identity have us all engaged with our histories in fascinating, threatening, and empowering ways. Racism, multiculturalism, and feminism have shaped the research agenda of historical archaeology. Moreover, a continuous discourse on our identity distinguishes the history of our discipline. In the SHA Public Education and Information Committee project, *Unlocking the Past*, historical archaeologists represent ourselves to the "public," and thus issues of *identity*—ours and the "others" we study and with and for whom we work–have formed the heart of the project.

26.3. Project History

At the 1994 SHA meetings, the officers and Board reconstituted the Public
Education and Information Committee, which had been inactive for several
years, and with newly appointed Committee chair, Martha Williams, devel-
oped a committee action plan in support of SHA's long range goals. The plan
contained this action item: "Develop a slide show on historical and under-
water archaeology to lend to teachers and other interest groups. The slide
show would stress the contributions that historical and underwater archaeol-
ogy has made to our understanding of the past. All regions of the country,
and all time periods (including the twentieth century) would be represented
in this overview" (Williams, 1994). This chapter's authors agreed to chair a
Task Force to develop the slide program, and spent the next year discussing
with each other and our colleagues the project's audience, objectives, and
organization. These initial discussions of *Unlocking the Past* produced this
statement of the program's purpose: to convey the importance of historical
archaeological research and resource preservation by demonstrating how
historical archaeology is enriching and deepening our understanding of the
North American past. The slide program would focus on why we do historical
archaeology and what it can teach us about North America's historical past
that is of special relevance to contemporary society. To meet these objectives,
the program would incorporate the perspectives of avocational archaeologists
and the general public in a conversation about how and why all Americans
can and must be part of the historical archaeology endeavor.

As an introductory program, our goal was breadth and not depth. The ini-
tial Program Outline proposed four themes of recent historical archaeologi-
cal research to present through capsule segments highlighting select places
and projects: (1) Environment—as resource, place, and value; (2) Making a
living, Making a life in rural America; (3) Cultural interaction—immigration,
ethnicity, race; and (4) Cultures in conflict. This program structure aimed
to ensure that we meet our mandate to represent "all regions of the country
and all time periods." Diverse expertise was required to achieve a balanced
and broad-based program, and thus we invited colleagues to serve as Project
Directors to prepare each segment in consultation with other specialists on
the segment topic. The Project Team consisted of 21 historical archaeologists
by mid-1996, when we submitted project and individual thematic segment
outlines for review to the SHA board and all team members. Reviewers
responded with questions about the order of presentation, the mode of pres-
entation and distribution, and the content. Over the next year and a half, the
Project Team revisited these issues, with additional direction offered by the
Gender and Minority Affairs Committee.

At the 1998 SHA meeting, we presented the PEIC and the Board and offi-
cers with a revised outline and a proposal to prepare a basic script adaptable
to a variety of media and formats, including the World Wide Web, videotape,
slide-tape, and a popular book. In the 4 years since the Board, officers, and

Public Education and Information Chair had initiated the project, new options for presentation had developed. In particular, the "communication revolution" playing out on the World Wide Web had prompted us to explore a wider range of distribution media than originally envisioned. At the 1999 mid-year meeting, the SHA Board and Officers approved a feasibility study that recommended the SHA Web site and a popular book as priority presentation media. That fall, the SHA Editor oversaw a content review of a 65-page draft script from which we proposed to develop both Web page and book.

It took 6 years to shepherd *Unlocking the Past* from concept to draft script! A review of a cabinet full of project files and a little reflection made it clear that the project had become the venue for an extended discourse on the identity and value of historical archaeology. Six years of discussion have not yielded a resolution; indeed, the discourse *must* continue. Participants in the discussion centered on the canon of people, sites, studies, and cultures to include, and by extension, to exclude. Responding to reviewers, critics, and editors at the University Press of Florida, which co-published *Unlocking the Past* with SHA, we expanded our representation of our field, more than tripled the manuscript's length, and reconsidered the "voices" through which we converse with our audience. In the final 4 years leading to publication of the book, the Project Team negotiated a path that lends *Unlocking the Past* readers insight into the diversity, scope, substance, and perspectives that define historical archaeology.

26.4. "Representing" and Celebrating (and Defining, and Defending) Historical Archaeology

The discourse has consistently centered on a few key questions of identity and value:

- What do historical archaeologists really study? And what do we think about what we seek to learn, or more broadly, to accomplish through our studies?
- What have we learned that is important to "rewriting" what we have come to believe are "popular misconceptions" about North American history?
- Why must historical archaeologists eradicate those misconceptions—or, what does what we do and learn have to do with the present—in other words, what makes historical archaeology relevant?
- How shall "they" (the public "other") and "we" (professional historical archaeologists) relate to and interact with each other in the practice of historical archaeology?

Project team members voiced diverse and often, conflicting opinions on all the issues discussed. That consensus proved so difficult to achieve is not surprising in a field that has debated and defended itself within the communities of anthropology, archaeology, history, and historic preservation for decades.

Changes in publisher, SHA board and committee composition, and manuscript reviewers over the years contributed to the complexities the team faced in bringing the project to fruition.

Most participants in the conversation believe that the public (and, so the arguments went, even some colleagues) do not understand, or misunderstand, or undervalue what historical archaeology is all about. This justifies the project. However, a contest over authority *in* the discipline and a crisis regarding the authority *of* the discipline shaped the project. Several reviewers questioned who should be speaking for historical archaeology and for SHA on specific topics. They challenged our choices of authors and were never at a loss to recommend others whose perspectives and contributions they valued more highly. Other reviewers emphasized that *Unlocking the Past* must present "the" history of our discipline (assuming there is only one) to legitimize it for a public that may not even know historical archaeology exists. In the end, the UPF board agreed that our goal was to provide neither a critical history of the field nor a textbook overview. Rather, the volume would represent a necessarily subjective perspective on a field characterized by a diversity of approaches, experiences, and views about the most important aspects and contributions of our practice.

Contributors and commentators voiced special concern that many people are not familiar with the geographical scope and temporal depth of our studies, and that they do not understand what we can contribute to rewriting North American history and, in the process, their own identities, political ideologies, and values. The geographic discourse has shifted over the years. The 1994 plan identified the United States' borders as the spatial boundaries, and early reviewers sought assurance that the "heartland" would receive attention equal to that given to the coastal margins. However, an archaeology of imperialism, capitalism, colonialism, and cultural exchange and contest—in other words, *historical archaeology*–requires a perspective that transcends national borders. We broadened our geographic scope to North America and highlighted the global processes and people that have shaped its history. Along with the SHA leadership, we argued that the future of SHA hinges on a more inclusive, less "US centric," internationalism, and that any public programing sponsored by the Society must address the "archaeology of the modern world" *around* the world. Many commentators foregrounded the "modern" in "modern world," worried about the public association of archaeology and "ancient," or in North America at least, "colonial." They emphasized that *Unlocking the Past* must show historical archaeology contributing to our understanding of recent, especially nineteenth - and twentieth-century history, building on and reaching beyond the wealth of written texts, graphic images, and living memories that document it.

Discussions about the contemporary relevance of our work were the most vociferous, taking on the tone of a crusade. They have incorporated and transcended the issues of space (especially regarding the Spanish colonies) and time (contesting public conceptions of the "first" European settlement). At the core lies an assumption that historical archaeologists must use the knowledge

gained from our research to attack insidious misconceptions that pervade "popular" American history. The proposed theme of "Cultural Interaction" was criticized for promoting the ghettoization of "minority" groups such as Spanish colonials and American Indians. Some interpreted the presentation of the important recent work on Jamestown Island in Virginia as reinforcing the "old culturally biased Anglo-centric" history. Appropriating a moral high ground, another practitioner charged that the text "dismissed any possibilities of presenting a more enlightened picture of the archaeological history of North America," a situation that SHA must not tolerate. The politics of identity and a posturing for authority in our discipline and in our Society threatened the future of this project at every step in the process. SHA members just did not agree on the "message." This led us to question whether we should convey this to our audience, and if so, how? How do we represent our notion of a "popular," "mythic" American history and the assumption that the histories *we* write are somehow less mythic, "truer" and "better" than those perpetuated by our predecessors? These questions again challenged us to present the complexity of historical archaeology in contemporary society, and the influence that self-reflexivity has had on our practice.

Another element of the debate revolved around issues addressed in a thematic issue of *Historical Archaeology* entitled "Confronting Class" (Wurst and Fitts, 1999). It centered on the place of historical archaeologists in the American class system, and the implications of our place for readers' perception of our practice. Reviewers of *Unlocking the Past* over the years encouraged us to answer the questions, "who are we, where and for whom do we work?" And in answering them, they requested that we emphasize the "business" of archaeology, or cultural resource management. By establishing our place in the market economy, these proponents believed we could help people understand the professional stature they should assign historical archaeologists. No, we are not Indiana Jones, some need us to say; think of us as you do other professionals whose expertise and services you value, such as architects, engineers, and environmental scientists. Believe that we are who we represent ourselves to be.

This discourse surrounding *Unlocking the Past* also involved the variety of publics with whom the participating archaeologists regularly interact, and all our contributions have reflected our experiences. The lack of consensus regarding the program's message, organization, and media can be a sign of historical archaeology's health and vigor, and we have worked to channel it into products that represent one conversation in an ongoing dialog between historical archaeologists and the public.

26.5. *Unlocking the Past*: Substance, Voice, Message

Unlocking the Past begins with the who, what, where, when, how, and why of historical archaeology told through the work of our colleagues John Cotter, James Deetz, and Kathleen Deagan. The Introduction also sets the book's

mood, collapsing the distance between "us" and "them" that our specialized, mystifying language promotes. The book is personal and conversational. Archaeologists tell their own stories about their work. Co-editor Lu Ann De Cunzo opens it with an invitation to engage in the process of discovery that energizes archaeology:

What comes to mind when you think of archaeology? Pith-helmeted adventurers traversing jungles and deserts in search of great treasures? The thrill of first peering through the dimly lit entrance to a tomb? But how about a white-haired gentleman in a fedora steering an old Volkswagen bus full of students through a picturesque cemetery, stopping to scrutinize marble lambs and praying hands? Or a tall, lanky man with an infectious sense of humor lecturing about clipped poodles and Medusa-headed gravestones? Or a petite blond woman leading a team through the wet heat of Hispaniola's sugarcane fields and banana gardens in search of the places Spanish and Native American peoples first encountered each other? Doesn't sound familiar? Are you wondering what new Hollywood release or New York Times bestseller you've missed? None—at least not if you'd been looking for these three real-life archaeologists.

Fifteen years before I ever met that white-haired archaeologist in a fedora I learned on my own what he spent a lifetime advocating: archaeology has a fundamental role in education, to galvanize kids' interest in discovery. For me the epiphany came when I was 8, as I crept along in a cotton field in search of arrowheads. I was with a family friend who was a collector, not an archaeologist, but the distinction meant nothing to me then. I cared only about discovering those bits of stone that lie scattered on the ground. Someone had shaped them into tools centuries ago, and then broken and thrown them away. No one had touched them since. I was hooked.

In five thematic chapters, *Unlocking the Past* contributors have done their best to hook the readers too. "Cultures in Contact" introduces our studies of the voluntary and forced immigration of peoples from around the world and their interaction with native peoples that in many ways *is* the story of North America. "Environment" considers the archaeology of environmental change wrought by colonization and industrial scale mining. "Building Cities" tells the stories of archaeologists digging up the past of huge cities like New York and World Heritage cities like Quebec. For centuries, most North Americans lived in farming and manufacturing communities; "Making a Living in Rural America" looks into their world. "Cultures in Conflict" focuses on archaeological explorations of colonial wars, the United States Civil War (as fought on and under water), General Custer's infamous last stand at Little Big Horn, and World War II.

A series of concluding essays written by a new generation of historical archaeologists emphasize how archaeology is as much about the present as it is about the past. Audrey Horning has worked in Northern Ireland and has studied communities in the Appalachian Mountains of Virginia during the Depression. Maria Franklin is concerned with other centuries-old tensions that grew out of the diverse origins of North Americans and institutions such as slavery. John Triggs, an archaeologist committed to Canada's urban heritage, advocates community-based archaeology programs. The people that we study from the past have descendants today. In the case of African Americans and

Native Americans, among others, archaeologists in the past did not acknowledge the rights and responsibilities of these descendant communities to participate in determining the fate of their ancestors and writing the histories of their lives, a point John Jameson returns to in the "Epilogue."

In recapping the goals and purposes of the *Unlocking the Past* project, John Jameson reminds us in the Epilogue that the contributions of archaeology transcend empirical data by providing inspiration: while archaeology's compelling stories serve to make and rewrite history, they also act as catalysts in making history, anthropology, and other social sciences more meaningful to people. This is captured in the art work on the book cover, an oil painting by artist Martin Pate, which depicts a metaphor of modern archaeological practice that emphasizes the importance of research and public interpretation of multicultural objects and cultures (Figure 26.1).

FIGURE 26.1. "Unlocking the Past." (Courtesy, National Park Service, Southeast Archeological Center. Oil Painting by Martin Pate.)

26.6. Critical Messages

A few critical threads weave together the book's diverse essays. They emerged from the questions that we posed to each other as the project unfolded, and are thus addressed to archaeologists *and* the public. Make archaeology relevant. Give the past a life in the present. Hear everyone's voices, and see everyone's lives, in the material record they left behind. Include, do not exclude. Question the mythic histories that pervade our consciousness. Work locally, and compare localities around the globe to understand the diversity as well as the commonalities of the human experience. Create partnerships to protect and preserve archaeological sites and conserve archaeological objects that form our heritage.

26.6.1. On Relevance

John Cotter's concern for a relevant archaeology reinforces our point that historical archaeology in North America has always been as much about the present as about the past (Roberts, 1999: 33–4). Specifically, Cotter argued, archaeology's "great use is really for education to galvanize the interest of young people in discovery. Because if education is not discovery, then it's not worth a damn.... But... if you experience discovery literally, and what a thrill it is—something you didn't know before, which is interesting, and means something to you—that changes your life a little" (Roberts, 1999: 33). Writing in *The Excluded Past* about studying and teaching history in Venezuela, Iraida Vargas Arenas and Mario Sanoja Obediente (1990: 54) argue that the past "is important because it is the reason for the present." In North America, the European conquest also provoked contests of cultures that continue to this day. Historical archaeologists have documented the tragedy and costs of these contests. The environmental consequences of people's actions on the lands of North America have been anything but benign. Exploitation and modification have produced wealth and benefits, but at a cost. In the twenty-first century, managing the environment and its fragile ecosystems against human onslaught has become a full-time pursuit. Historical archaeologists' studies of mining in the West, for example, hold relevance as we ponder the future in a world whose resources no longer seem limitless. We must understand the consequences of exploiting our natural resources, and consider the value and applicability of historic technologies in the world today.

Studying single city lots and entire neighborhoods, urban archaeologists are piecing together the stories of individuals and families making their way in the urban environment. The essays on "Building Cities" explore what we are learning about people trying new technologies to *make* land so cities can keep growing. They explain what we are learning about pollution and diseases in cramped urban settings. They illustrate what we are learning about how people built their economic and social order onto the land. They examine what we are learning about how and why people create images of the past that contrast

with reality. And they exemplify how city dwellers are using what we learn to help create livable places for the present, inspired by that history.

Terry Weik and Maria Franklin ask readers to think about how our representations of people in the past influence society today. Archaeology teaches respect and tolerance for other cultures and other peoples; archaeologists work to banish the fear of diversity (Smardz, 1995: 15; Fagan, 1998: 16). Weik portrays Africans and African Americans as freedom fighters challenging racism and slavery in the Americas from the beginning. The survival strategies they contrived offer valuable insights for people seeking self-determination today as they did in the past. Historical archaeological examinations of these strategies can be instrumental in effecting positive social change in today's world. In Virginia, Alexandria Archaeology has invited everyone to work together, as Director Pamela Cressey explains, "to touch our pasts as individuals with a collective spirit, and truly democratize our history." Community archaeology offers a means by which we can bridge our differences through knowledge of the past.

26.6.2. On Bringing the Past to Life, and Giving People a Voice

John Cotter's vision of historical archaeology "worth a damn" also helps introduce our goal of evoking enough of the past to make it a semblance of life (Roberts, 1999: 7). Fundamentally simple in concept, we have found the distances between past and present make this goal profoundly difficult to accomplish. New interpretive approaches and new ways of writing narratives of the past, exemplified in *Unlocking the Past*, begin to bridge these distances (see e.g., Preucel and Hodder, 1996: 601–12). All the contributors emphasize their desire to know the *people* of the past, not just the *things* they left behind. Audrey Horning writes of her respect for the "power of a single artifact to silently yet powerfully convey an important message"—a message about people. Working from a feminist perspective, Janet Spector (1993) wrote of struggling to put the names of Dakota women and men with the artifacts her team excavated, rather than letting the artifacts take precedence over the individuals who used them.

In one concluding essay, Maria Franklin imagines future historical archaeologists offering greater insights into the full spectrum of lived experiences in the past. Contributors to each thematic chapter in the book share this vision of archaeology as engaging the lived world, not a "science of the dead" (Preucel and Hodder, 1996: 612). Jerald Milanich writes of the power of historical archaeologists and bioarchaeologists' collaborations to give voice to people such as the Spanish friars and Indians who together labored at the missions of Spanish Florida. Leland Ferguson explains how the archaeological record brought him, and can bring us all, as close to the personal stories of enslaved Americans as we have ever been. David Starbuck conveys the excitement of examining the lives of soldiers and officers who have not had

a voice until we began to explore the rich record of their encampments in North America's colonial fortifications.

Archaeologists working in Jamestown, Virginia, celebrate the technology that enables microscopic analysis of soils. Even wood *smoke* from a nearby kiln can be detected in the bottom of a pit filled in the mid-seventeenth century. Innovations in underwater archaeology have also made it possible to rediscover the technological wonders of the Civil War ironclad, the *Monitor*. James Bruseth marvels at the potentially planned DNA studies of the intact brain of a sailor who died on La Salle's *La Belle*, wrecked off the Texas coast in 1686. *Unlocking the Past* highlights technologies that assist our efforts to understand and to honor the peoples of North America, but our contributors also confront the ethical and cultural issues that excavation of human remains raise, whether the people were French or Native American, Union or Confederate.

26.6.3. On Inclusion

Archaeologists in North America are accepting the responsibility to teach an inclusive past (see e.g., Mackenzie and Stone, 1990; Connolly, 2000). Through Kathleen Deagan's work, *Unlocking the Past* presents historical archaeology as the study of all Americans and the ways they shaped the world in which they lived. For her, this means we often deal with the "underside" of American history. The stories of immigrants excluded from the "American dream" are as much a part of our history as the stories of those men and women who created the "dream," and indeed, believed they lived it. Historical archaeologists have the rare chance to explore the emergence of varied American cultures through time, from the unique perspective of material culture. Martha Zierden writes of archaeology in cities like Charleston, South Carolina, as a fruitful avenue to study *all* urban dwellers, not just those wealthy and powerful enough to leave a legacy of documents, houses, gardens, and heirlooms. Other contributors reinforce the message that although we cannot celebrate every perspective on the past that archaeology offers us, neither can we ignore them.

Leland Ferguson evokes images of malnutrition, poor health, and heavy work in his portrayal of life for many captive Africans in North America. However, he also argues that we must see more in their story than exploitation. He introduces readers to the creolization process that resulted as Africans and their descendants interwove their ideas with those of Native Americans and Europeans, developing distinctive African–American cultures. Creolization helps us see the cultural substance behind the buildings, landscapes, and objects we find, and to look at the power relations of slavery from a different perspective. We do not know enough, he writes, about those things slaves made for themselves, and we have difficulty seeing the power of the enslaved. Objects of daily life represent a past material world that symbolized people's views of themselves as culturally distinct from others.

26.6.4. On Questioning Mythic Histories

In his essay, Ferguson leads readers through his experiences growing up in the South before the Civil Rights movement. He laments that generations of Americans had been victims of an education that dismissed the importance of blacks and distorted the role of Indians in American history. This mythic history had insinuated itself into archaeology. The essays by Terry Weik and Maria Franklin, African-American archaeologists of the next generation, build on the foundation of pioneers like Ferguson, and demonstrated to readers the significance of an archaeology of empowerment.

Andrew Edwards writes of the "charge" archaeologists get from dispelling myths and "throwing trowels in the cogs of history," and explains that the best part of the project at "England's first permanent settlement in North America" is that it will never really be finished. New research and new perspectives will continue to produce new interpretations of Jamestown's role in the seventeenth-century Atlantic world and its impact on the local environment. In California, Roberta Greenwood articulates a similar message about ways that archaeological remains of buildings, landscape features, and artifacts are forcing us to challenge many traditional myths about Chinese life. And in his studies of human remains excavated at colonial New Spanish missions, Clark Larsen writes of confronting what many call the "Black Legend"—a mythic view of inhumane Spanish conquistadors going to any extreme to acquire gold and glory. Richard Fox offers another important insight into the writing of these mythic histories: they exclude rather than include. He examines the historical interpretations of the Battle of Little Big Horn, noting that they have largely excluded the perspectives of the native victors. Historical archaeology has challenged that bias and replaced myth with a shared history. By listening to the voices of the battle's only survivors—the Indians—and to the artifacts of battle, historical archaeology has painted a more accurate picture of the battle. Finally, archaeologists working in Charleston, South Carolina, and Quebec City, Quebec, highlight their collaborative efforts to challenge myths of a pristine urban past. Martha Zierden and William Moss describe the interdisciplinary nature of historical archaeology, explaining their work with historians, architects, paint analysts, restoration carpenters, furniture conservators, paper and print specialists, as well as specialists in historic objects and past environments, plants, animals, insects, and parasites, unraveling the meaning and the full significance of their finds.

26.6.5. On Stewardship

In the spirit of James Deetz's *Invitation to Archaeology* (1967), *Unlocking the Past* invites readers to partner with the archaeological community in an ethos of stewardship. Sara Mascia reminds readers that as more people move to rural areas, family farms disappear from the landscape. Given their low

visibility, rural industrial sites and technologies are also constantly in danger of destruction. Yet despite the extent of development and growth, we have learned that the archaeological record of much of the past still lies intact beneath North American cities and across the countryside. Cultural resource legislation has ensured that threatened archaeological resources have been studied if not preserved *in situ*. The result has sometimes been archaeology on a massive scale, like the West Oakland, California, project to rebuild an earthquake-damaged highway that impacted 43 city blocks. Community partners in West Oakland undertook oral history, assembled historic photos, and created exhibits, and Mary Praetzellis shares with readers the value of the partnership. Adele Dunne, an Alexandria Archaeology volunteer, offers a similar perspective from the other side of the continent:

I think the community-based archaeology program in Alexandria exists primarily as the result of the exceptionally deep pride that Alexandrians have in their city's unique history and their willingness to become involved in protecting it. Many of our digs have been as a result of private citizens or businesses realizing that they have a "history book" buried in their back yard or under their front parking lots, and wanting to actively participate in reading, interpreting and preserving the pages for future generations.

Janet Spector has written of transforming her approach to archaeology through her work with the Dakota on a nineteenth-century planting village in Minnesota. Getting to know descendants, studying their language and culture, Spector slowly gained their acceptance. Dakota community members contributed much to her multidisciplinary and multicultural team and ensured the preservation of the burial mounds and dance enclosures that were sacred to their people.

Archaeologists dig, Andrew Edwards writes, and the more we dig, the less we preserve. Taking a cue from John Cotter, he explains, NPS archaeologists at Jamestown are committed to leaving something for the future. Underwater archaeologists make the same point with emotionally charged, popular icons, the *Titanic* and the U.S.S. *Arizona* at Pearl Harbor. For them, preserving the integrity of historic shipwrecks has become a battle cry. In all our work, despite differences in the questions we ask and perspectives we take, historical archaeologists share a crucial goal. We want people to discover our complex history and preserve the places in which Americans forged our heritage.

26.7. The *Unlocking the Past* Web Site

Envisioned as both a complement and a supplement to the book (De Cunzo and Jameson, 2005), the *Unlocking the Past* Web site was created in 2006 as a means of reaching a wider public and providing a dynamic dimension to the project. Besides providing an introduction and invitation to buy and explore the book, the Web site provides updated education and outreach links useful to students and teachers, as well as providing subject search capabilities.

The Web site is located on the Web as part of the SHA Web site at URL http://www.sha.org/unlockingthepast/. A mirrored site is maintained on the Southeast Archaeological Center, National Park Service cultural resources server at http://www.cr.nps.gov/seac/Unlocking-web/index.htm.

26.8. Conclusion

The SHA's first attempt to speak to the public with one voice about what historical archaeology is and why we do it has taught us an important lesson. There is little about our discipline about which we speak with one voice. In fact, the multiplicity of our voices, reflecting the diversity of the American public, is an important reason to celebrate historical archaeology in North America. Our challenge lay in engaging the public with those few basic ideals and principles that we share, as well as the differences that our diverse interests, origins, and approaches nurture.

Unlocking the Past contributors demonstrate in their essays what Francis McManamon (2000: 23) describes as the essence of our practice: "the proper study of archaeological remains is careful, painstaking work that involves fieldwork, lab work, report preparation and distribution... and the curation of collections and records." Like the archaeologists who contributed to *The Presented Past*, sponsored by the World Archaeological Congress, these historical archaeologists "are [also] all motivated by the belief that, if there is going to be a shared vision of the future, there must be a recognition of the multiple pasts that have determined the present" (Molyneaux, 1994: 12). They share the goal of archaeology education voiced by *Unlocking the Past* co-editor John Jameson (1997) and contributors to *Presenting Archaeology to the Public*, which he edited, and by the contributors to this volume. Peter Stone (2000: 284) stated it thus: "Public archaeology is about 'enfranchisement' and 'control' and 'empowerment'." It is about finding ways to give "ordinary people a sense of ownership of their past" (Smardz, 1997: 113). So we encourage readers: Look around you. Get involved. Because, as Audrey Horning puts it, "it's your past and it's your future."

Acknowledgments. We wish first to thank all of the members of the *Unlocking the Past* Project Team for their persistence, patience, and perspectives on the representation of historical archaeology: Rebecca Allen, R. Scott Baxter, Kathryn E. Bequette, James Bruseth, David Clark, Julia Costello, Pamela Cressey, Garry Cummins, James Delgado, Robin Denson, Andrew C. Edwards, Leland Ferguson, William Fitzhugh, Richard Fox, Maria Franklin, Roberta Greenwood, Audrey Horning, Clark S. Larsen, Daniel Lenihan, Nicholas M. Luccketti, Sara F. Mascia, Sarah McDowell, Jerald T. Milanich, William Moss, Mary Praetzellis, Margaret Purser, Nan A. Rothschild, David Starbuck, Leslie Stewart-Abernathy, Judy D. Tordoff,

John Triggs, Diana diZerega Wall, Terence Weik, Mark Wilde-Ramsing, Martha Williams, Lisa Young, and Martha Zierden. SHA Editor Ronald L. Michael and SHA reviewers of the draft script, Glenn Farris, James Gibb, and Karolyn Smardz Frost contributed important insights on the distinctions between book and web versions, and encouraged to pursue the project. SHA Editor Rebecca Allen has facilitated marketing the book, and along with SHA Web site Editor Kelly Dixon, has been instrumental in launching the web edition of *Unlocking the Past*. SHA Presidents Elizabeth Reitz, Donna Seifert, Henry Miller, Glenn Farris, Pamela Cressey, Teresita Majewski, Susan Henry Renaud, Douglas Armstrong, Vergil Noble, Julia King, William Moss, and Judith Bense, along with other SHA officers and Board members over the past 10 years have continually challenged us to incorporate the diverse perspectives and approaches of the Society membership and reach the broadest audience possible. SHA Public Education and Information Committee Chairs Martha Williams, Mark Wilde-Ramsing, Diana diZerega Wall, and Kim McBride deserve special recognition for their forbearance in shepherding this complex and contested project toward fruition. Meredith Morris-Babb and John Byram of the University Press of Florida have shown unfailing patience and offered crucial guidance as we have learned to write for new audiences.

Finally, as we attempt to make clear in this chapter, the opinions we express are not shared by all of our collaborators. They represent our perspective on the project's history, and we are responsible for the interpretations of the discourse that the project has engendered.

References

Arenas, I.V. and Obediente, M.S., 1990, Education and the Political Manipulation of History in Venezuela. In *The Excluded Past: Archaeology in Education*, edited by P. Stone and R. MacKenzie, pp. 50–60. Unwin Hyman, London.

Connolly, M., 2000, Who Paints the Past? Teaching Archaeology in a Multicultural World. In *The Archaeology Education Handbook: Sharing the Past with Kids*, edited by K. Smardz and S. Smith, pp. 267–273. Altamira, Walnut Creek, CA.

De Cunzo, L.A. and Jameson, J.H., Jr., editors, 2005, *Unlocking the Past: Celebrating Historical Archaeology in North America*. University Press of Florida and Society for Historical Archaeology, Gainesville.

Deetz, J., 1967, *Invitation to Archaeology*. Natural History Press, Garden City, NY.

Fagan, B., 1998, Perhaps We may Hear Voices. *Common Ground* 3(1:Spring):14–17.

Jameson, J.H., Jr., editor, 1997, *Presenting Archaeology to the Public: Digging for Truths*. Altimira, Walnut Creek, CA.

Mackenzie, R. and Stone, P., 1990, Introduction: the Concept of the Excluded Past. In *The Excluded Past: Archaeology in Education*, edited by P. Stone and R. MacKenzie, pp. 1–14. Unwin Hyman, London.

Mcmanamon, F.W., 2000, Foreword: Public Education: a Part of Archaeological Professionalism. In *The Archaeology Education Handbook: Sharing the Past with Kids*, edited by K. Smardz and S. Smith, pp. 17–24. Altamira, Walnut Creek, CA.

Molyneaux, B.L., 1994, Introduction: the Represented Past. In *The Presented Past: Heritage, Museums and Education*, edited by P. Stone and B. Molyneaux, pp. 1–13. Routledge, London.

Preucel, R.W. and Hodder, I., 1996, Constructing Identities. In *Contemporary Archaeology in Theory*, edited by R.W. Preucel and I. Hodder, pp. 601–614. Blackwell, Oxford.

Pyburn, K.A., 2000, Gatekeeping, Housekeeping, Peacekeeping: Goals for Teaching Archaeology in the Public Schools. In *The Archaeology Education Handbook: Sharing the Past with Kids*, edited by K. Smardz and S. Smith, pp. 274–278. Altamira, Walnut Creek, CA.

Roberts, D.G., 1999, A Conversation with John L. Cotter. *Historical Archaeology* 33(2):6–50.

Smardz, K.E., 1995, Archaeology and Multiculturalism. *Archaeology and Public Education* 5(3):1–3, 15.

Smardz, K.E., 1997, The Past Through Tomorrow: Interpreting Toronto's Heritage to a Multicultural Public. In *Presenting Archaeology to the Public: Digging for Truths*, edited by J.H. Jameson, Jr., pp. 101–113. Altimira, Walnut Creek, CA.

Spector, J.D., 1993, *What This Awl Means: Feminist Archaeology at a Wahpeton Dakota Village*. Minnesota Historical Society, St. Paul.

Stone, P., 2000, Applying the Message to the Medium. In *The Archaeology Education Handbook: Sharing the Past with Kids*, edited by K. Smardz and S. Smith, pp. 280–287. Altimira, Walnut Creek, CA.

Williams, M.R., 1994, SHA Public Education and Information Committee Report. Memorandum, dated January 1994, on file, Department of Anthropology, University of Delaware, Newark, DE.

Wurst, L. and Fitts, R.K., editor, 1999, Confronting Class (special issue). *Historical Archaeology* 33(1).

About the Authors

PATRICIA M. ALLEN recently (2006) retired as New Brunswick Archaeologist. Employed for 33 years by the government of New Brunswick (Canada), Patricia directed a broad range of archaeological research. Her Archaeological Services working titles included staff archaeologist (1973), assistant director (1989) and New Brunswick provincial archaeologist (2002). Patricia's work with Metepenagiag First Nation and her thesis on the Oxbow site (Memorial University of Newfoundland 1981) provided a foundation for various Metepenagiag Mi'kmaq heritage projects including films, exhibits and publications. Co-founder of the New Brunswick Archaeological Society and a former Chair of the Canadian Archaeological Association's Public Communications Committee and Maritime Aboriginal Heritage Committee, Patricia has worked extensively with heritage groups and First Nations throughout her region. Patricia has curated both permanent and traveling exhibits and her publication list includes several pieces for the lay reader.

MADELINE AUGUSTINE is the President of the Metepenagiag Heritage Park. She graduated from Saint Francis Xavier University in Nova Scotia and then went to Dalhousie University for her Certificate in Health Education. She has been working with Red Bank First Nations from 1981 and is still working as Community Health Representative. Her interest in archaeology extends over thirty-five years. Her father, Joseph Augustine was the original discoverer (and she was the co-discoverer) of the ancient burial mound (Augustine Mound) in 1972. She worked with archaeologists from 1975 until 1980 on the site. In addition, she has been actively involved in community outreach work for years. She served as a museum interpreter in 1979 and 1980. She translated the text of a traveling exhibit from English to Mi'kmaq and she is an Historian and storyteller for Metepenagiag.

WHITNEY BATTLE-BAPTISTE is a visiting assistant professor of archaeology at the Africana Studies and Research Center at Cornell University and is associated with the Archaeology Program. She holds a B.A. from Virginia State University, an M.A. from the College of William & Mary, and a Ph.D.

from the University of Texas at Austin. She is a graduate of the African Diaspora Program in Anthropology and her research has primarily focused on slavery at Andrew Jackson's Hermitage Plantation in Nashville, Tennessee. Her interests include the enslaved landscape, black feminist theory, African Diaspora archaeology, and activist archaeology.

SHERENE BAUGHER is an Associate Professor and the Director of the Archeology Program at Cornell University. From 1980 to 1990, she served as the first official archaeologist for the City of New York. For over twenty-five years, Dr. Baugher has been involved in numerous projects to bring archaeology to the public including public lectures, public school presentations, tours of archaeological excavations, indoor and outdoor museum exhibits, museum brochures, and educational films. These outreach efforts involved partnerships with Native American leaders, local community groups, state parks staff, municipal agencies, and museum curators including staff at the Smithsonian. She is the pro bono archaeological consultant for the Onondaga Nation.

DORSEY BODEMAN is Director of Public Programs at Historic St. Mary's City, a museum of history and archaeology at the site of Maryland's first capital. She left teaching high school history after doing summer archaeology field schools and moved into the museum field twenty years ago. She has worked in education and interpretation at Monticello, Poplar Forest, and the Jamestown-Yorktown Foundation. She also served as a consultant to the Virginia Governor's Mansion interpretive program. She has been at Historic St. Mary's City since 1995. Originally from Colorado, she is a graduate of the University of Colorado with a B.S. in History. She has served as a field reviewer for the Institute of Museum and Library Services, and a presenter at professional conferences including ALHFAM, VAM, Preservation Alliance of Virginia, Maryland, and Virginia Councils for the Social Studies, Southern Maryland Museum Association, and various teacher training and in-service workshops, etc.

GEORGE BRAUER is the Director of the Center for Archaeology in the Baltimore County Public Schools, a program he began in 1982. Brauer has been both a teacher and an active avocational archaeologist for more than 30 years. As a social studies curriculum specialist in the Office of Social Studies/BCPS, he integrates archaeology content into the school district's essential curriculum (K-12th grade) providing teachers with archaeology-based instructional activities designed to actively engage students in the learning process.

LISA BREGLIA is a Cultural Anthropologist who has recently published an ethnographic study of the meanings of heritage in Yucatec Maya communities entitled *Monumental Ambivalence: the Politics of Heritage* (University of Texas Press, 2006). She has taught Anthropology and Latin American Studies at

Rice University, Wesleyan University, as well as Wheaton College and currently resides in Washington, D.C.

JULIA CLARK manages interpretation and collections at Port Arthur Historic Site, a large 19th century British convict site in far southern Tasmania, Australia. An archaeologist by training, she has spent most of her working life in museums, in the areas of Anthropology, Exhibition & Design and Portraiture. She has also worked as a museum consultant for large and small collecting institutions, specialising in museum planning, exhibitions and public programmes.

PAMELA CRESSEY is the City Archaeologist of Alexandria, Virginia, and Adjunct Associate Professor at George Washington University in Washington, D.C. She holds a Ph.D. from the University of Iowa and specializes in historical and public archaeology. With more than 30 years of archaeological experience, she has been one of the pioneers of community archaeology. She conducts research in urban and African American neighborhood development and directs a community archaeology program that includes an archaeological protection code, research, a museum, and public programs. She is currently focused upon non-invasive methods of archaeological interpretation through preservation planning, heritage trails, and site protection in open spaces and parks.

LU ANN DE CUNZO is Professor of Anthropology and Early American Culture at the University of Delaware, and president-elect of the Society for Historical Archaeology. Trained in anthropology at the College of William and Mary and in American civilization at the University of Pennsylvania, her career has also included an historic site directorship and consultation on archaeological resource management, research, and site interpretation for regional museums and historic properties. A long-time member of the SHA's Public Education and Interpretation Committee, she co-authored *Unlocking the Past* with John Jameson. Current activities include founding membership in a community-driven program of local history and archaeology in Delaware's colonial capital, and partnering with the state's nature society to design interdisciplinary interpretation and educational programming at an historic farm.

DENA DOROSZENKO has worked since 1978 for a series of public and private agencies resulting in her involvement with a wide variety of historic sites across the Province of Ontario. Prior experience with professional and avocational archaeological societies, teaching public archaeology programs and directing excavations have provided opportunities to be directly involved in policy development, public education, promotion and advocacy. Since 1987, she has been the Archaeologist for the Ontario Heritage Trust, formerly the Ontario Heritage Foundation. Her responsibilities include the design and

implementation of historical and archaeological research programs including publications and collections management, focussing on the wide range of provincially significant sites that fall under the purview of the Trust. Her research interests include urban archaeology, the archaeology of domestic sites, public archaeology and historic material culture. Recent publications include a chapter on the archaeology of Benares in *Mississauga: The First Ten Thousand Years* published by eastend books in 2002.

CAROL J. ELLICK is the Director of Outreach and Education at the SRI Foundation, a nonprofit foundation dedicated to advancing historic preservation through education, training, and research. Ms. Ellick holds a B.A. in anthropology and an M.A. in education. Ms. Ellick was active in Cultural Resource Management for more than two decades, is a certified as a Registered Professional Archaeologist (RPA). Since 1987, the focus of Ms. Ellick's professional involvement has been public education. Her background in both archaeology and education bring together two unique perspectives and professions. Ms. Ellick has created educational materials, taught teachers' workshops, designed displays, and worked within the professional archaeological community on the development of public outreach efforts. Ms. Ellick's publications focus on archaeological education and public outreach. Her articles have appeared in numerous professional journals and she has chapters in several public and archaeological education oriented books. Ms. Ellick has been a member of the Society for American Archaeology, Public Education Committee since 1990 and served as chair from 2004–2007. Through her professional involvement, Ms. Ellick has become one of the leading experts in archaeological education and the development of public programs in the United States.

LANCE M. FOSTER is a landscape historian and anthropologist, with over 20 years of experience in heritage preservation, including service as an archaeologist for the U.S. Forest Service, as an historical landscape architect in the cultural landscapes program of the National Park Service, and as Director of Native Rights, Land and Culture for the Office of Hawaiian Affairs (OHA). An artist, writer and consultant, he is a member of the Iowa Tribe of Kansas and Nebraska, and currently resides with his wife and family in Helena, Montana.

JONATHAN FOWLER teaches archaeology and history at Saint Mary's University in Halifax. A student of the archaeology of colonial encounters, Fowler has spent much of the past decade researching the archaeological landscapes of 17th-18th century Nova Scotia. Since 2001, he has directed the Grand-Pré Archaeological Field School Project, a joint initiative of Parks Canada, Saint Mary's University, and the Société Promotion Grand-Pré. He is currently a doctoral candidate in archaeology at the University of Oxford.

BRUCE W. FRY, after studying archaeology at the University of Cardiff, Wales, joined the Historic Sites branch of Parks Canada to work on the Fortress of Louisbourg reconstruction project. His research on the fortifications and further studies in France on the evolution of French fortifications formed the basis for a doctoral thesis. He later worked for Parks Canada as a research manager in Quebec and in Ottawa, retiring after more than thirty years to live once more in Cape Breton, close to the Fortress of Louisbourg. He taught a course in Historical Archaeology at the University College of Cape Breton for several years and still gives occasional lectures and tours on the fortifications and siege sites around the fortress.

PEDRO PAULO A. FUNARI is Professor, Campinas State University, Brazil, Research Associate, Illinois State University and Barcelona University (Spain). He was Senior South American Representative (1994-2003) and Secretary (2002-3) of the World Archaeological Congress, and is currently Mexico, Central and South America Society for Historical Archaeology Newsletter reporter, since 2002. He is on the editorial board of several international journals, such as Public Archaeology, International Journal of Historical Archaeology, Journal of Social Archaeology, Journal of Material Culture Studies, Inter-national Journal of Cultural Property, co-editor of *Historical Archaeology, back from the Edge* (Routledge) and *Global Archaeological Theory* (Kluwer). He has published scholarly papers in more than fifty leading international journals, such as Current Anthropology, Historical Archaeology and American Journal of Archaeology. He is engaged in a committed archaeological practice and theory.

BROOKE HANSEN, Ph.D., Associate Professor of Anthropology, is the Coordinator for Native American Studies and Integrative Health Studies at Ithaca College. She specializes in medical anthropology, cultural revitalization among indigenous peoples, particularly the Haudenosaunee, and public anthropology with an activist emphasis. Her most recent project involved helping to repatriate land to the Cayuga Nation of New York.

DENISE HANSEN has worked for Parks Canada in Halifax, Nova Scotia for just over 25 years, first as a Material Culture Researcher in the Archaeology Section and most recently as an Education Specialist coordinating the national "Parks Canada in Schools" outreach education program in Atlantic Canada. Denise holds both an Honours BA degree in History and an Education degree with a speciality in Social Studies for secondary schools. During her long career with Parks Canada, she has published reports on artifacts excavated from archaeological sites in Atlantic Canada, worked on a variety of exhibits and education kits with archaeological themes and developed on-site educational programming. She also served as a co-author for the popular *"Discovering Archaeology"* activity book, published by the Nova Scotia Archaeology Society. Her most recent position includes the development of

curriculum-linked educational resources and building relationships with educators in Atlantic Canada.

SILAS HURRY serves as the Curator of Collections and Archaeological Laboratory Director for Historic St. Mary's City, an outdoor museum which celebrates the founding site and first capital of Maryland. He has over thirty years of experience in historical archaeology working in Maryland, Georgia, Michigan, and New Mexico. He is a native of Maryland and an honors graduate of St. Mary's College of Maryland in History and Anthropology. He subsequently attended graduate school at Cambridge University in the United Kingdom where he studied Archaeology. He is active in the Society for Historical Archaeology, and a past officer of the Middle Atlantic Archaeological Conference, the Council on Northeast Historical Archaeology, and the Council for Maryland Archaeology. He is the author of numerous articles and essays on the archaeology of St. Mary's City including the exhibit catalog *"...once the Metropolis of Maryland."* His research interests include material culture, the development of the Atlantic World, and communicating the results of research to the general public.

GREG JACKMAN is employed as the Archaeology Manager at the Port Arthur Historic Site in Tasmania. He has eighteen years experience in historical archaeology and cultural heritage management, and has worked extensively throughout Australia as well as overseas. With a background in geology, archaeology and surveying his particular interests include industrial archaeology, site formation processes and archaeological site conservation and interpretation. Greg is a member of the Committee, and is the Tasmanian State Representative, for the Australasian Society for Historical Archaeology. He is also a foundation member of the Archaeology Advisory Panel of the Tasmanian Heritage Council.

JOHN H. JAMESON JR. is a senior archaeologist and program manager at the U.S. National Park Service's Southeast Archaeological Center in Tallahassee, Florida. His 20-plus years of government service have encompassed a broad range of projects involving archaeological field work and cultural heritage management in several regions of the United States and overseas. A recognized national leader in public archaeology, he is a key player in the development of training courses for park rangers and archaeologists on the effective interpretation of archaeology. He is unique among NPS archaeologists as an education/interpretation program certifier. He is the originator and coordinator of the Center's Public Interpretation Initiative, an award-winning, multifaceted public outreach program. He is active in ICOMOS where he leads national and international subcommittees on interpretation and presentation. In 2005, he received the coveted Sequoia Award from the National Park Service for career contributions to education and interpretation. His publications have addressed wide-ranging heritage

management and interpretation/outreach issues, including *Presenting Archaeology to the Public: Digging for Truths*; *The Reconstructed Past: Reconstructions in the Public Interpretation of Archaeology and History*; *Unlocking the Past: Celebrating Historical Archaeology in North America* , and *Out of the Blue: Public Interpretation of Maritime Cultural Resources.*

PATRICE L. JEPPSON has conducted research on eighteenth- and nineteenth-century historical archaeology sites in the eastern United States and South Africa and nineteenth- and twentieth-century sites in the western United States. Her interest in public archaeology includes civic engagement. Toward this end, between 1988 and 2002, Jeppson undertook participant observation research at the Center for Archaeology in the Baltimore County Public Schools (Maryland) to identify effective strategies for bringing archaeology into formal school education. Jeppson received her Ph.D. from the program in historical archaeology at the University of Pennsylvania.

JOSEPH LAST holds a Masters of Art Conservation degree from Queen's University and a M.A. in Anthropology from the College of William and Mary. Employed with Parks Canada since 1977, he is currently the Senior Archaeologist for Military Sites, Archaeological Services, Ontario Service Centre. His primary research focus has been on 19th century British fortifications in Canada and the West Indies. Major interests involve military engineering, architecture, relationships of fort to community (both past and present), and site interpretation.

ANN-ELIZA LEWIS is the Archaeological Collections Manager for the Massachusetts Historical Commission and the curator of archaeological collections for the Commonwealth of Massachusetts. Her work focuses on preserving and interpreting archaeological collections in the public interest. Her research interests include the management, preservation, and research use of existing archaeological collections; the archaeology and material culture of African-American communities in New England; and interpreting archaeology for the public through education programs and museum exhibits. She has curated numerous exhibits on archaeology, developed curricula in archaeology, and runs regular training workshops for Massachusetts teachers in archaeology. Lewis holds a Ph.D. in Archaeology from Boston University.

DOROTHY LIPPERT is Choctaw and an archaeologist. She received her B.A. from Rice University and her M.A. and Ph.D. from the University of Texas at Austin. She works in the Repatriation Office of the National Museum of Natural History. Dorothy serves on the Executive of the World Archaeological Congress and on the Board of Directors for the Society for American Archaeology. Her research interests include the development of Indigenous archaeology, repatriation, ethics, and the archaeology and bioarchaeology of the Southeastern United States.

HENRY M. MILLER is Director of Research for Historic St. Mary's City, the state museum at the founding site and first city in Maryland. Miller received his Ph.D. from Michigan State University in Anthropology and has worked on colonial Chesapeake sites for 35 years. Activities include preservation efforts at National Historic Landmarks, archaeological excavations, analysis and the conversion of archaeological and historical data into public interpretations. Experience includes design and installation of archaeological site exhibits, gallery exhibit development, design and supervision of reconstructions, and the study and re-creation of landscapes based on archaeological and ecological data. Miller is past president of the Society for Historical Archaeology, served as vice president of the Council for Northeast Historical Archaeology and a member of the Archaeological Advisory Committee for National Historic Landmarks.

STEPHEN F. MILLS is a heritage consultant in St. John's, Newfoundland and Labrador. For many years he worked with Parks Canada in Newfoundland and Ontario and between 2000 and 2003 he coordinated a province-wide community archaeology program at Memorial University in St. John's. He is also a sessional instructor at Memorial University where he teaches archaeology and cultural resource management. His interests include English and French colonial settlement and resource exploitation, military sites, vernacular architecture and traditional music.

HAROLD MYTUM is a member of academic staff at the Department of Archaeology, University of York. Research on public interpretation has focused his excavation, experimental reconstruction, and presentation of the Castell Henllys Iron Age site in Pembrokeshire, Wales, and on graveyard and cemetery conservation and interpretation. Numerous research projects on graveyard monuments have been undertaken in Britian, Ireland, Gibraltar, USA, and Australia, with many subsequent publications. He has produced the standard recording manual, *Recording and Analysing Graveyards*, 2000, and the only international synthesis, *Mortuary Monuments and Burial Grounds of the Historic Period*, 2004. He is a member of the Historical Archaeology Editorial Board, the York Diocesan Advisory Committee, and Campaigns Officer for the Society for Church Archaeology.

NANCI VIEIRA DE OLIVEIRA is senior lecturer, Rio de Janeiro State University (UERJ), director of the Human Anthropology Laboratory, founder of the Brazilian Society for Archaeology (SAB). She is a long-standing public archaeology activist, working with native indigenous populations and also with local communities. Her commitment to an engaged archaeology led to her being included among the most respected Latin American archaeologists dealing with native groups.

JANET LYNN PAPE is a district branch chief/archaeologist in the Office of Cultural Resource Studies at the California Department of Transportation

(Caltrans) in Oakland. She holds B.A. degrees in Psychology and Anthropology from the University of California, Berkeley, and an M.A. in Cultural Resource Management from Sonoma State University, Rohnert Park. Employed at Caltrans since 1988, she has managed numerous archaeological and historical studies in the San Francisco Bay Area. These include the massive Cypress Freeway Replacement Project that resulted from the Loma Prieta earthquake of 1989. Additionally, she has supervised numerous studies in support of other seismic retrofit projects, both terrestrial and underwater, most currently for the San Francisco-Oakland Bay Bridge and West Approach Projects. She co-developed public outreach products for many of these projects and also guest lectures at local universities, historical societies, and other public service institutions at their request.

ELISA PHELPS is Director of the Collections and Library Division of the Colorado Historical Society where her responsibilities include administration of the curatorial, collections management, and library services departments. She holds a B.A. in Southwest Studies from Fort Lewis College, Durango, Colorado and an M.A. in Museum Studies from the University of Leicester, England. She has over twenty years of experience working with anthropological and historical collections in a museum setting. Her prior positions include Director of Collections/Curator of Anthropology at the Witte Museum in San Antonio, Texas and Curator of Anthropology at the Houston Museum of Natural Science, Houston, Texas.

PETER E. POPE is Professor and Head of the Department of Anthropology and Archaeology at Memorial University, in St John's, Newfoundland. He recently published *Fish into Wine: the Newfoundland Plantation in the Seventeenth Century* (Chapel Hill, 2004). He directed the Newfoundland Archaeological Heritage Outreach Program, 2000-2005, and is now working with the French Shore Historical Society of Conche, Newfoundland, on an archaeology of the Petit Nord: the maritime cultural landscape of the French, seasonal, shore-based, salt-cod fishery in northern Newfoundland, 1510-1904.

JACK ROSSEN is Associate Professor and Chair of Anthropology at Ithaca College. He received his doctorate from the University of Kentucky. He has conducted archaeological research in Peru, Chile, and Argentina, and has also analyzed archaeobotanical materials from throughout South America, the Ohio Valley and the northeastern U.S. His work on collaborative archaeological and community projects with the Cayuga and Onondaga in what is now central New York began in 1999.

JODY STEELE is currently the Historic Heritage Consultant for the Parks and Wildlife Service of Tasmania. Jody's recently completed doctoral research was within the area of public archaeology and she has worked interpreting archaeology to the public and communities for the past seven years. During that time Jody has been involved in the teaching of archaeology to several

thousand school children between the ages of 5 to 16 both in the classroom and in the field. Jody is heavily involved in Australia's National Archaeology week being on both the national and state committees, holds a post on the committee for the Australasian Society for Historical Archaeology and is a member of the Tasmanian Heritage Council's Archaeological Advisory Panel. Jody was the co-director of the Port Arthur Public Archaeology programme from 2002-2005.

GAYNELL STONE is an archaeologist, ethnohistorian, anthropologist, and cultural geographer who has researched and published on these aspects of Long Island, N.Y. for over 30 years. As director of the Suffolk County Archaeological Association museum education program, she has introduced over 100,000 students to experiencing archaeology, ethnobotany, primal technology, and colonial technology. She has contributed to and produced eight reference volumes in the S.C.A.A. series, "Readings in Long Island Archaeology & Ethnohistory." Dr. Stone has been a part-time Professor of Anthropology at Suffolk County Community College for over 30 years. She is currently producing three documentary films on the Manors of Long Island and 17th century global trade as revealed through the archaeological and documentary record.

ELIZABETE TAMANINI has worked with public archaeology at the Shell Midden Museum, Joinville, Brazil (Museu de Sambaqui de Joinville) for several years, later on moving to the Lutheran College (IELUSC), as dean of the Institute of Tourism Studies, always dealing with participatory archaeology and the engagement of archaeologists and other heritage scholars with local communities. Currently she is senior scholar, Uniplac, at Lages, Brazil, and research associate, Campinas State University, Brazil.

DIRK VAN TUERENHOUT received his Ph.D. in anthropology from Tulane University. His fieldwork was conducted on a Late Classic period Maya village in the Petén, Guatemala. He is curator of anthropology at the Houston Museum of Natural Science. As such, he is responsible for the permanent displays in the John P. McGovern Hall of the Americas, as well as temporary exhibits on anthropology. He has been the Houston venue's curator for exhibits on topics such as: the Vikings, Forbidden City, the Vatican, Chocolate, Machu Picchu, the Dead Sea Scrolls, Tibet, Mummy the Inside Story, and the Royal Tombs of Ur. During the summers he teaches at the University of Houston, Clear Lake campus. He has been involved in docent and teacher training at the museum. He authored a book on the Aztecs, published by ABC CLIO and is currently preparing exhibits on Ethiopia and Paleoindians in the Americas.

RICHARD TUFFIN is an Assistant Archaeologist for the Port Arthur Historic Site Management Authority, Tasmania, Australia. His focus is

primarily on the documentary and archaeological investigation of this site's convict history, as well as sharing this information through such outreach initiatives as publishing and Public Archaeology programs.

CHRISTOPHER TURNBULL is retired, having served for over thirty years as the first Provincial Archaeologist for the Province of New Brunswick. Graduating from the University of Calgary, the focus of his career was in cultural resource management and in Aboriginal relations in the provincial context of the Canadian federation. In fact, developing a working relationship with the Mi'kmaq and Wolastoqiyik communities of the Province consumed a good portion of the thirty years, often through mutually turbulent times. Notable success with the Wolastoqiyik community installed a management committee that allowed joint decision making over heritage resource issues and served as a platform for developing projects that took results back to the communities. He is currently on the Board of Directors for Enkatasik Wetepeksultik Metepenagiag Heritage Park, which will finally allow public access to Mi'kmaq history and culture in New Brunswick.

NINA M. VERSAGGI, Ph.D. is director of the Public Archaeology Facility (PAF), a research center on the Binghamton University campus. PAF's mission is to train archaeologists within a CRM context, conduct research on the Northeastern U.S., and to share our research with professional, community, and Native American audiences. Versaggi's involvement in community outreach spans over 25 years, and includes positions as a postdoctoral researcher at the Yager Museums of Hartwick College, guest curator at the Roberson Museum in Binghamton, and exhibit collaborator with Native Americans. She is the director of the Community Archaeology Program (CAP) at Binghamton University, and is co-curator (with Charles Cobb) of the traveling exhibit, *Time and Tradition, An Archaeological History of New York State.* Versaggi is the current President of the New York Archaeological Council (NYAC), and a regular contributor to NYAC sponsored community archaeology events. A native of Wildwood, New Jersey, she now resides in Binghamton within the Upper Susquehanna Valley of New York.

NATALIE VINTON has practiced in the field of archaeology for over ten years, working on a diverse range of projects both in indigenous and historical archaeology in Australia. She first developed her enthusiasm and passion for public archaeology when working as the archaeologist for Sydney City in the late 1990s and has since spent many years experimenting with public archaeology programs and ideas whilst working as an archaeologist for the State Government. Much of her work in Australia has been based on research undertaken in relation to the public archaeology programs being run in the United States of America. Natalie currently manages the historic heritage funding program for the New South Wales Department of Environment and Conservation.

PAM WARD is Executive Director of the Metepenagiag Heritage Park Inc., a world-class cultural tourism attraction preserving, protecting and presenting over 3000 years of Mi'kmaq history and heritage at Metepenagiag, in Red Bank, New Brunswick. She is Mi'kmaq, resides at Metepenagiag Mi'kmaq Nation and is the proud mother of two daughters.

PAM WHEAT-STRANAHAN is currently executive director of the Texas Archeological Society (TAS). She has served the TAS as chair of the Education Committee, editor of the newsletter, and president. She also serves as advisor to the Museum of the Coastal Bend in Victoria, Texas. Wheat-Stranahan's interest in interpretive archeology began when coordinating student field trips to historical exhibits. Her contributions to archeology education include a traveling exhibit, "Archeology in Texas;" a teacher's manual, *Clues from the Past* with Brenda Whorton; a video production, "Evidence of the Past;" numerous articles; and most recently *La Salle in Texas: A Teacher's Guide to the Age of Exploration and Colonization.* Wheat-Stranahan specialized in archeological topics while pursuing a career in education. She taught in an intermediate school for fifteen years, serving as curriculum writer, chair of the social studies department and principal. She also taught history at San Jacinto College. Before becoming executive director for TAS, Wheat was director of education at the Houston Museum of Natural Science. She was also education coordinator for the La Salle Shipwreck Project with Texas Historical Commission and director of education at Crow Canyon Archaeological Center, Cortez, Colorado.

Index

Printed in the United Kingdom by
Lightning Source UK Ltd., Milton Keynes
136908UK00001B/4/P